THE PELICAN HISTORY OF ART

‖‖ ‖ ‖‖‖‖‖‖‖ ‖ ‖‖ ‖‖‖‖ ‖‖‖‖‖‖‖‖‖‖ ‖‖ ‖‖
⟨ **W9-AQV-376**

Founding Editor: Nikolaus Pevsner

Joint Editors: Peter Lasko and Judy Nairn

Richard Ettinghausen and Oleg Grabar

THE ART AND ARCHITECTURE OF ISLAM: 650-1250

Richard Ettinghausen was an outstanding and prolific scholar who charted new directions for the study of Islamic art. Born in Germany in 1906, he was for twenty-four years associated with the Freer Gallery of Art in Washington, D.C., and at the time of his death in 1979 Hagop Kevorkian Professor of Islamic Art at the Institute of Fine Arts, New York University, and Consultative Chairman of the Islamic Department at the Metropolitan Museum of Art. The author of many path-breaking articles and important books, including *Studies in Muslim Iconography*, I, *The Unicorn* (1950), *Arab Painting* (1962 and 1977), *From Byzantium to Sasanian Iran and the Islamic World* (1972), and *Islamic Art and Archaeology* (1985), Professor Ettinghausen had also edited *Ars Islamica* and *Ars Orientalis* and co-edited *Kunst des Orients* as well as contributing to these and other publications, arranging exhibitions and the permanent Islamic galleries of the Metropolitan Museum of Art, New York, and advising museums and universities in many parts of the world.

Oleg Grabar, born in France in 1929, is the Aga Khan Professor of Islamic Art at Harvard University. His published work, which includes many articles, shows the wide range of his scholarship: *The Coinage of the Tulunids* (1957), *Islamic Architecture and its Decoration* with Derek Hill (1964), *Sasanian Silver* (1967), *The Formation of Islamic Art* (1973), *City in the Desert* with R. Holod, J. Knudstad, and W. Trousdale (1978), *The Alhambra* (1978), *Epic Images and Contemporary History* with Sheila Blair (1980), and *The Illustrations of the Maqamat* (1984). In the course of his academic career Professor Grabar has supervised some fifty doctoral theses in seven universities. He is also the founding editor of the annual *Muqarnas*.

Richard Ettinghausen and Oleg Grabar

THE ART
AND ARCHITECTURE
OF ISLAM: 650-1250

Penguin Books

PENGUIN BOOKS

Published by the Penguin Group
27 Wrights Lane, London w8 5tz, England
Viking Penguin Inc., 40 West 23rd Street, New York, New York 10010, USA
Penguin Books Australia Ltd, Ringwood, Victoria, Australia
Penguin Books Canada Ltd, 2801 John Street, Markham, Ontario, Canada l3r 1b4
Penguin Books (NZ) Ltd, 182–190 Wairau Road, Auckland 10, New Zealand

Penguin Books Ltd, Registered Offices: Harmondsworth, Middlesex, England

First published 1987
Reprinted 1989

Library of Congress Catalog card number (hardback): 86-62813

I s b n (hardback) o 14 0560. 59 9
I s b n (paperback) o 14 0561. 59 5

Typeset in Monophoto Ehrhardt
Printed by Butler & Tanner Ltd, Frome, Somerset

Designed by Gerald Cinamon

Translation by Professor Maan Z. Madina of the Kufic inscription
on the Samanid plate on the title page as appearing on the outer band,
partially repeated on the inner one:
'He who is confident of his succession will be generous. To whatever
one endeavours to accustom oneself, one becomes accustomed.
Blessings to the owner.'

To the memory of Richard Ettinghausen,
who did not live to see the completion of a book
first entrusted to him, in fond gratitude
for decades of teaching, help, and encouragement.

CONTENTS

PREFACE

It was in 1959 that the late Professor Richard Ettinghausen asked me to collaborate with him on a Pelican volume devoted to Islamic art. Over the following five or six years, we planned the book and wrote a great deal of it. But somehow, when we had in fact completed nearly every chapter up to the Mongol conquests of the thirteenth century, other pressures and commitments took over and the book remained unfinished. At that time it was difficult to argue that a presentation of Islamic art required more than one volume. Over the past twenty-odd years, however, a considerable amount of new information, some imaginative scholarship, a deepening specialization within the study of Islamic art, and especially a greater interest in the world of Islam in general has warranted the decision to deal separately with the properly medieval Muslim art up to *circa* 1260, on the one hand, and the centuries of the great empires, on the other.

The basic framework for this first volume was ready and all that was needed was to bring up to date chapters written sometimes over twenty years ago, to choose new and additional illustrations, and to improve the technical apparatus. Dr Sheila Blair and Dr Estelle Whelan agreed to help in the accomplishment of these tasks and for much of the merit of the work I am in their debt. They looked at texts written long ago with a sense of new requirements and an awareness of new scholarship; they decided on appropriate illustrations and especially were always available when help was needed. I must also record the good-humoured and charmingly competent Judy Nairn and Susan Rose-Smith, the pillars of the series, without whose patience and devotion this book would not have been completed. On a more personal note, I would

also like to record the constant support and concern of Dr Elizabeth Ettinghausen.

Professor Ettinghausen and I had from the very beginning conceived of this book as a survey and as a manual, not as a vehicle for speculation and for broad cultural interpretations. The point of a survey is to provide, as clearly and as interestingly as possible, the basic information on the monuments of an artistic tradition, to identify controversial issues or opposite positions, and to suggest something of the major unresolved scholarly issues; although possibly incompletely and erroneously in several places, I trust that this objective has been met. The point of a manual is to make it possible for students and readers to pursue such questions as may interest them; much of this possibility lies in the notes and in the bibliography derived from them. The latter, with some omissions no doubt, is meant to reflect the state of the field until 1985. Throughout our concern has been historical, to identify and explain what happened in specific areas at specific times. Without denying the value of the interpretative essays on Islamic art cutting across regions and periods which have become so popular over the past decades, our position is simply that this is not what this book set out to do. It is a traditional history of the art of a culture – something, curiously enough, which has, with a few short and unsatisfactory exceptions, not been attempted for Islamic art since the twenties of this century.

It is not, I suppose, possible to dedicate a book to the memory of one of its authors. Yet in this instance I do want to do so and to recall the memory of Richard Ettinghausen. I do so first of all on a personal level, in order to record how much I have owed to him over the years and to

express my gratitude to him for having trusted someone who was not even thirty years old then with the task of helping him with a survey of Islamic art. And then it is only fitting to recall that, after the generation of the great pioneers in Islamic art (Max van Berchem, Ernst Herzfeld, Ernst Kühnel, Thomas Arnold, Georges Marçais), it was Richard Ettinghausen and the only slightly older Jean Sauvaget who charted the new directions taken by the study of Islamic art towards an understanding of the cultural meanings of objects and of monuments of architecture and towards precise definitions of the characteristics of specific times and places. This book, I trust, reflects these directions.

OLEG GRABAR

NOTE: Transliteration from Arabic has been simplified throughout.

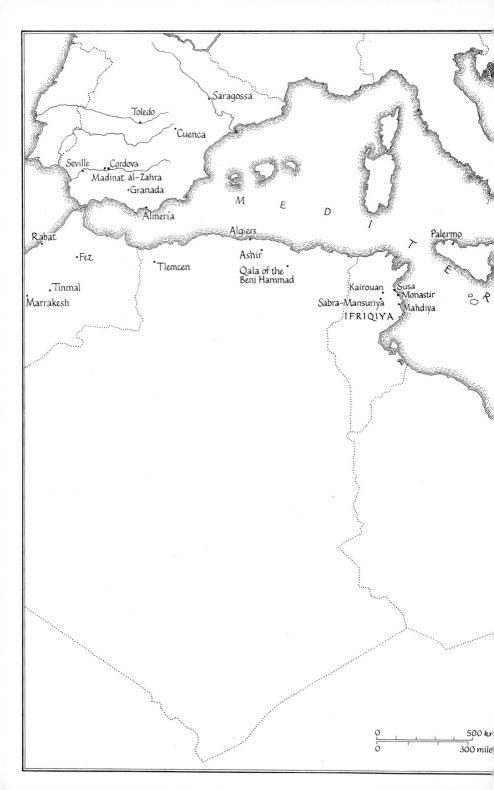

Toledo

Saragossa

Cuenca

Seville · Cordova
Madinat al-Zahra
·Granada

Almería

M E D

Rabat

Algiers I

·Fez

Ashir·
Tlemcen
Qala of the
Beni Hammad

·Tinmal
Marrakesh

Kairouan Susa
Sabra-Mansuriya ·Monastir
IFRIQIYA ·Mahdiya

Palermo

T

E

R

0 ————— 500 km
0 ————— 300 miles

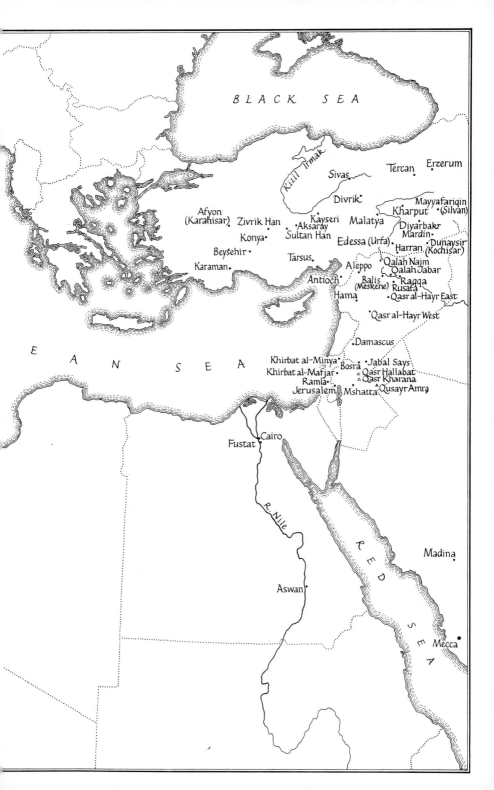

BLACK SEA

Kizil Irmak

Tercan · · Erzerum

Sivas ·

Divrik·

Mayyafariqin
Kharput · · (Silvan)

Afyon
(Karahisar)· Zivrik Han Kayseri Malatya Diyarbakr
·Aksaray · Mardin·
Konya· Sultan Han Edessa (Urfa) Harran · Dunaysir
· · (Kochisar)
Beyşehir · Tarsus · Aleppo · ·Qalah Najm
·Qalah Jabar
Karaman · Antioch· Balis Raqqa
Hama · (Meskene)· Rusafa
·Qasr al-Hayr East

·Qasr al-Hayr West

·Damascus

Khirbat al-Minya Jabal Says·
E A N S E A Khirbat al-Mafjar Bosra· △ Qasr Hallabat
Ramla· △ Qasr Kharana
Jerusalem· Mshatta· ·Qusayr Amra

Fustat · Cairo

R. Nile

Madina ·

Aswan ·

RED SEA

Mecca·

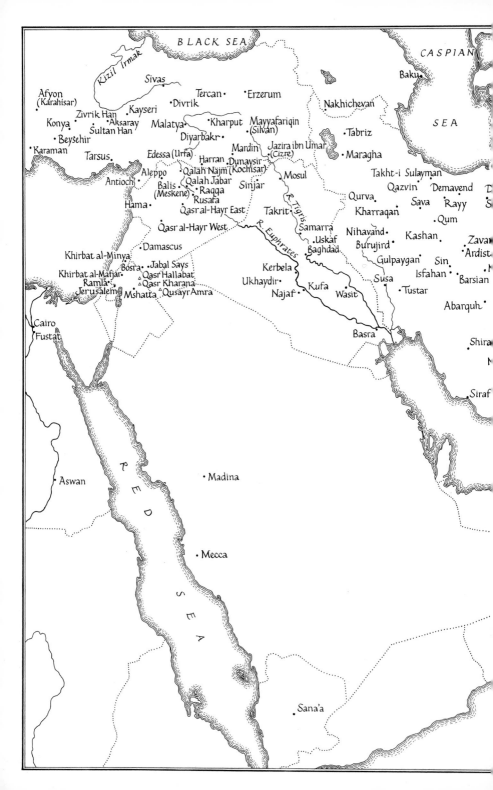

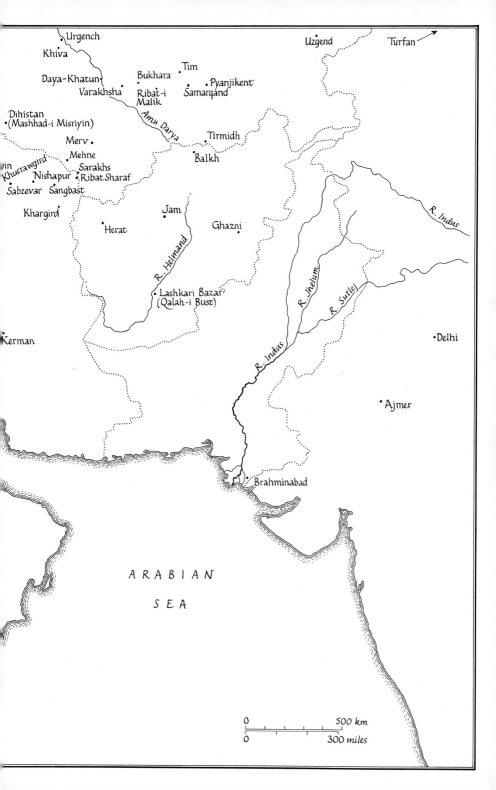

Urgench
Khiva
Daya-Khatun
Varakhsha
Bukhara
Tim
Ribat-i Malik
Samarqand
Pyanjikent
Uzgend
Turfan

Dihistan
(Mashhad-i Misriyin)
Amu Darya
Tirmidh
Merv
Mehne
Balkh
in
Khusrawgird
Sarakhs
Nishapur
Ribat Sharaf
Sabzevar
Sangbast
Khargird

Jam
Herat
Ghazni

R. Helmand
R. Indus

Lashkari Bazar
(Qalah-i Bust)

R. Jhelum
R. Sutlej

R. Indus

Kerman

Delhi

Ajmer

Brahminabad

ARABIAN

SEA

0 500 km
0 300 miles

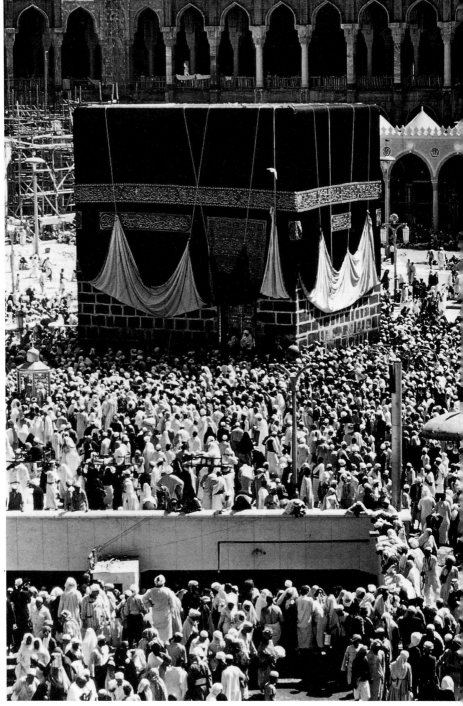

1. Mecca, Ka'ba

THE CALIPHATE

CHAPTER I

THE RISE OF ISLAM AND THE ARTISTIC CLIMATE OF THE PERIOD

The word 'Islamic', as applied to art, refers to those people who have grown and lived under rulers who professed the faith of Islam or in cultures and societies which have been strongly influenced by the modes of life and thought characteristic of Islam. But 'Islamic', unlike 'Christian', refers not only to a faith but also to a whole culture, since – at least in theory – the separation of the realm of Caesar from that of God is not applicable to Islam. Also unlike Christianity, Islam did not develop first as the faith of a few, increasing the numbers of its adherents under the shadow of a huge state alien to it, slowly developing the intellectual and artistic features which were going to characterize it, and, after several centuries, blossoming into an empire and giving birth to an art as well as a philosophy and a social doctrine. Rather, these developments were telescoped into a few decades of the seventh and eighth centuries A.D. In 622, the year of the Hijra, when the Prophet Muhammad left Mecca to found in Madina (originally Madina al-Nabi, 'the town of the Prophet', ancient Yathrib) the first Islamic state, a handful of followers from the mercantile cities of Arabia constituted almost all the Muslims, and the private house of the Prophet was their only centre. But by 750 Arab Muslim armies had penetrated into southern France, crossed the Oxus and the Jaxartes, and reached the Indus. The first Islamic dynasty, the Umayyads, had come and gone. New cities had been created in North Africa, Egypt, and Iraq. The Dome of the Rock had been built in Jeru-

salem, while also in Jerusalem, as well as Damascus, Madina, and many other cities of the Near East, great mosques had been erected as gathering places for prayer as well as to strengthen the political and social ties which bound the faithful together. Dozens of splendid palaces had been scattered throughout the lands of the 'Fertile Crescent'. In other words, Islamic art did not slowly evolve from the meeting of a new faith and of a new state with whatever older traditions prevailed in the areas in which the state ruled; it came forth as suddenly as the faith and the state, for, whatever influences may have been at work in the building and decoration of early Islamic monuments, their characteristic is that they were built for Muslims, to serve purposes which did not exist in quite the same way before Islam.

In order to understand this art and the forms it created as well as the way it went about creating them, it is necessary to investigate first whether the Arabs who conquered so vast an area brought any specific tradition with them; second, whether the new faith imposed certain attitudes or rules which found artistic expression; and, finally, what major artistic movements the Muslims encountered in the lands they took over.

Although textual information about pre-Islamic Arabia is not very secure and a serious exploration of the area has barely begun, it is fairly certain that, at least in the period immediately preceding the Muslim conquest, the Arabs of Arabia had very few indigenous tradi-

tions of any significance. The Ka'ba in Mecca [1], the holiest sanctuary of Arabia, was a very simple, nearly cubic building (10 by 12 by 15 metres), for which a flat roof resting on six wooden pillars was built around the turn of the seventh century, according to tradition, by a Coptic Christian. Its painted decoration of living and inanimate subjects, whatever their symbolic or decorative significance may have been, was also in all probability an innovation of the early seventh century under foreign influences.[1] If the most important and best known building of Arabia, venerated by practically all the tribes, was not too impressive as an architectural creation, it is likely that the other sanctuaries for which we have references in texts were even less so. With respect to secular art, our information is yet slimmer. No doubt the wealthy merchants of Mecca and the heads of other settled communities must have had palaces which showed their rank and wealth,[2] but the only private house of Arabia which has acquired some significance and about which more will be said later, the house of Muhammad in Madina, consisted of a simple square court with a few small rooms on the side and a colonnade of palm trunks covered with palm leaves. Nor do we know much about the artifacts, metalwork, or textiles which must have been used by the inhabitants of Arabia in the first centuries of our era, or whether most of them were local or imported. It seems clear, however, that the dominant ideal of life, that of the nomad, held the artisan in low esteem;[3] this contempt need not have carried over to his work, but pre-Islamic Arabic legend does not appear to have given to manufactured objects the attention it lavished on horses or women, and there is no trace of the specific attachment to sword or armour found in classical, Iranian, or western medieval epics.

Any modification of this impression of poverty in the artistic development of pre-Islamic Arabia produced by excavations, explorations, and a more systematic study of literary documents is hardly likely to be very significant.[4] But the lack of actual remains or descriptions should not obscure the fact that the religious, intellectual, and social milieu out of which Islam grew owned certain concepts and modes of thought and behaviour which exerted an influence on the development of the faith and of its art. For instance, in Mecca and a number of other oases we find the ancient Semitic notion of a *haram*, i.e. of an area, often quite large, physically mapped out in a more or less crude fashion, which was both holy and forbidden except to certain people and at certain times. The word *masjid* (a place for prostration; whence 'mosque') is also of pre-Islamic origin. In the rather simple religious ceremonies of the pre-Islamic Arabs, the symbol of the divinity was often placed in a tent, at times referred to as *qubba* (dome), or covered by a cloth on an apparently domical frame, as can be seen on a well-known Palmyrene relief [2].[5] The *mihrab*, later a characteristic element of the mosque, was the hallowed part of a religious or secular institution.[6] These and other examples show that many of the forms and terms developed by Islam with precise connotations in the new faith and the new civilization already existed in the world of pre-Islamic Arabia, even though they rarely found more than a rudimentary monumental or artistic expression.

In addition to these rather simple notions with few tangible effects, the inhabitants of central Arabia at the time of Muhammad were also conscious of the earlier artistic achievements of other Arabs. Although the monuments of the Nabataeans and the Palmyrenes from the first century B.C. to the fourth century A.D. seem to have left little impression on their minds, two other early Arab cultures made a more lasting impact. One was that of the Lakhmids, an Arab Christian dynasty centred in Iraq which served as a buffer state between the Persians and the Byzantines in the fifth and sixth centuries. Their half-legendary palaces of al-Khawarnaq and Sadir, symbols of a royal luxury unavailable in the Arabian peninsula, counted among the marvels of the world.[7] The other civilization to have struck the imagination of the Arabs before and on the eve of Islam was that of Yemen, at

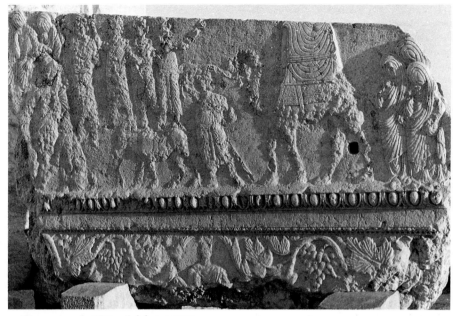

2. Palmyra, temple of Bel, relief, first century

the southern edge of the peninsula, where the Queen of Sheba was assumed to have lived. From recent, but still only fragmentary, explorations we know that many centuries before Islam Yemen had developed a brilliant architecture of temples and palaces, together with a less original local sculpture.[8] From later legends we know also that Yemeni painters were of sufficiently high repute to be called to the Sasanian court.[9] The high level of this civilization was made possible by an extensive and highly organized system of irrigation symbolized by the Marib dam, whose destruction (apparently in the late sixth century) was taken as the main cause of the decline of Yemen. However, in spite of its numerous temples, south Arabia is important in understanding early Islamic art chiefly because of the appeal to the Arab imagination of its secular monuments. The tenth-century writer al-Hamdani's *Antiquities of South Arabia* allows us not so much to reconstruct the architectural characteristics of the

great Yemeni buildings (although some of his information can in fact be verified in remaining ruins) as to perceive a half-imaginary world of twenty-storey-high palaces with domed throne rooms, sculpted flying eagles, roaring copper lions, and black slaves guarding the royal house.[10] Thus the memories of Yemen and of the Lakhmids, kept green by the legends and poems recited at camp fires or at occasional meetings in the richer oases, fed the minds and the imagination of early Muslims with the vision of a splendid secular art created many centuries earlier by Arabs at the two extremities of the arid desert. Together with the rudiments of symbolic forms found in their simple religious life, this vision, based on monuments which were little known, furnished a significant contribution of the pre-Islamic Arabian world to the coming Islamic art.

When we turn to those attitudes and requirements which the faith established and which sooner or later influenced Islamic art, a

number of difficulties arise. First, our only fully acceptable source for the period is the Koran; the Traditions (*hadith*) which sprang up to supplement or clarify the Prophet's thought are not always reliable. Second, since such questions did not arise in his lifetime, Muhammad did not rule on or consider problems which immediately affected the arts or artistic activities either in the Koran or in his otherwise well documented actions.[11] Those statements, attitudes, or prescriptions which were of consequence in these fields were not consciously aimed at them. Their definition has therefore to be based, at least in part, on later intellectual commentaries and artistic developments.

As far as later architecture is concerned, the major contribution of early Islam in Arabia was the development of a specifically Muslim *masjid* (pl. *masajid*) or mosque. Muhammad took over the ancient masjid al-haram of Mecca and transformed it into the *qibla* (place towards which prayer is directed) of the new faith (Koran II, 136 ff.).[12] In addition, every Muslim was enjoined to try once before he died to make the pilgrimage to Mecca. In the time of the Prophet or later the Meccan sanctuary was little modified, and very few buildings in Islam attempted to copy it; in general it remained a unique and inimitable centre towards which all Muslims pray.[13] Muhammad also introduced a ritual of individual prayer (*salat*), a pure act of devotion, to be performed five times a day wherever the worshipper happens to be. On certain occasions however, such as Fridays at noon, it should take place in the *masajid Allah* (Koran IX, 17 'the mosques of God'), because from the time of Muhammad on, a sermon (*khutba*) on moral, religious, and also political and social themes formed an integral part of the ceremony, and because this was the time and the place when through the leader of prayer (the *imam*) the Muslim community expressed its allegiance to its rulers. The corollary – the essential point for understanding early Islamic architecture – was that every major Islamic community required a large masjid for its religious as well as its political and social functions.

The masajid of Muhammad himself are not really known. For certain major ceremonies or feasts, the Prophet used to go outside the town of Madina into large *musallas* (lit. 'places for prayer'), probably more ancient holy areas. In the town itself the major centre was Muhammad's own house. In spite of later embellishments of the story, the sudden and rapid development of Muhammad's new faith certainly transformed what started as a private dwelling into a place of worship. He himself may have considered it merely a convenient centre for his manifold activities (cf. Koran XXXIII, 53, asking the believers not to enter his house at will, although this may have referred to private side rooms only), but numerous later accounts describe it as the first Muslim-built masjid. Not a very spectacular building, it consisted of a square of sun-dried bricks approximately fifty metres to the side [3]. On the east of the southern part of the eastern wall were rooms (nine of them by 632, when Muhammad died) for the Prophet's wives. On the southern and northern sides short colonnades (*suffa*) of palm trunks supporting palm branches were erected after complaints about the heat of the sun in the court. On each of the other sides was a door; the southern wall had become the qibla.[14] The Prophet used to lean on a lance near the northern edge of the southern colonnade to lead prayer and deliver sermons. At times he would climb a simple pulpit known as the *minbar*, a judge's seat in pre-Islamic times which eventually became the symbol of authority in the ceremony of prayer and in all related mosque activities.[15]

Although the reconstruction and interpretation of exclusively written evidence, often hagiographic in character, can be no more than hypothetical, it must be conceded as possible (in spite of very scanty evidence)[16] that the Prophet eventually built a separate mosque near his house. Literary sources refer to Muslim masajid in neighbouring villages or towns,[17] implying a consciousness on the part of the early Muslims that theirs was a new kind of structure, if not in its physical appearance, at least in its

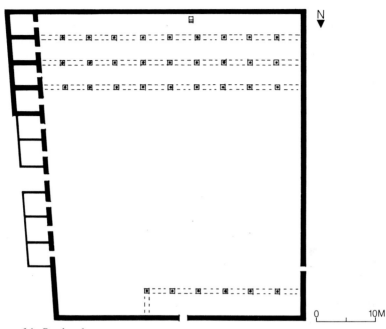

3. Madina, house of the Prophet, 624,
reconstructed plan

purpose of harbouring the believers of the new faith. But of all buildings mentioned in texts, the only one to have had a great impact on later religious architecture is the very one whose contemporary acknowledgement as a masjid is least certain. Perhaps the safest hypothesis is that there occurred in Madina between 622 and 632 a coincidence between the accidental development of the Prophet's house into a centre for the faithful and a general idea of restricted sanctuaries for God. With respect to architecture, not much else can be derived from the Koran or, for that matter, from most other early textual sources.[18] To be sure, specific Koranic texts came to be almost standard in the decoration of certain parts of mosques or other buildings and were taken as references to elements of construction only invented later; for instance, Koran XXIV, 35, the beautiful verse evoking God as 'the Light of the heavens and the earth',

became common on mihrabs many centuries afterwards and a group of three minarets near Isfahan quote Koran LXI, 33, praising those who call men to God. Such later interpretations and uses do not imply a direct impact of the Koran or of the Prophet on future Islamic architecture, but the fact that they occurred points to the uniquely Islamic relationship between the Koran and buildings.[19]

On the aesthetics of painting, sculpture, and other arts the Holy Book is silent. Nevertheless it contains a number of precise statements and general attitudes whose impact on later Islamic art was significant. One such is Koran V, 92: 'O you who believe, indeed wine, games of chance, statues, and arrows for divination are a crime, originating in Satan.' While the word used here (al-ansab) is often translated as 'statue', in fact it refers to idols, many of which were in human form. The same ambiguity exists in a second

passage (Koran VI, 74), in which Abraham chides his father for taking idols in the shape of statues (*asnam*) for gods. While it is uncertain – indeed unlikely – that the Revelation implied a condemnation of representational statuary in these and a number of related passages, its statements are quite unambiguous with respect to idolatry. As we shall see later, at the time of the growth of Islam, in contrast to earlier centuries, images had acquired a meaning much beyond their value as works of art; they were symbols of mystical, theological, political, imperial, and intellectual ideas and were almost the equivalents of the acts and personages they represented. This state of affairs makes it understandable why the opposition to idols, a fundamental principle of Islam, when taken in its setting of almost magically endowed images, eventually led to an opposition to representations of living forms.

The position of Muhammad in Islam also differed radically from that of most religious reformers: he was but a man and the Messenger of God. No miracles were officially attributed to him, and he constantly reiterated that he could not perform them; he did not undergo a Passion for the Salvation of others; and even the example of his life was superseded by the doctrine of the Koran. Thus, despite the rapid development of a hagiography of Muhammad, it never acquired the deep significance given to the lives of Christ or the Buddha, at least not on the level of official Islam. Lacking a specific life as a model of behaviour or as a symbol of the faith, Islam was little tempted by an iconographic treatment of its Revelation.

Opposition to figurative art was also read into another Koranic statement of principle, that of God as the only Creator. 'God is the Creator of everything, and He is the Guardian over everything' (Koran XXXIX, 63) is but one of the ways in which this creed is formulated. And in view of the almost physically meaningful nature of images at that time, one can understand the often repeated tradition that the artist who fashions a representation of a living thing is a competitor of God and therefore destined to

eternal damnation.[20] The one Koranic passage referring to the creation of a representational object (Koran III, 43) strikingly confirms this point. The meaning of the statement there attributed to Jesus – 'Indeed I have come to you with a sign from your Lord; I shall create for you from clay in the form of a bird; I shall blow into it and it will become a bird, by God's leave' – is clear: not only is this a miraculous event, made possible only through God's permission and for the purpose of persuading people of the truth of Jesus' mission, but the act of bringing to life the representation of a living form was the only possible aim of its creation. Therefore, in many later traditions, on the Last Day the artist will be asked to give life to his creations, and his failure to do so – since God alone can give life – will expose him as an impostor as well as one who assumes God's power.

These and other similar texts were not elaborated, nor were corollaries concerning the arts established, for many decades after the death of Muhammad,[21] and all theologians did not propound the doctrine of opposition to images with the same absoluteness.[22] Yet, from the time of the very first monuments of Islam, Muslims evinced reluctance or shyness with respect to human and animal representation. This attitude manifested itself in an immediate veto in the case of religious art, and a subtler reaction concerning secular art. It is, therefore, incorrect to talk of a Muslim iconoclasm, even if destruction of images did occur later; one should rather call the Muslim attitude aniconic.

The final aspect of the Koran's importance to Islamic art is the very nature and existence of the Book. It represents a complete break with the largely illiterate Arabian past. From the very beginning, Islam replaced the iconographic, symbolic, and practical functions of representations in Christian or Buddhist art with inscriptions, first from the Koran and by extension from other works.[23] Writing not only became an integral part of the decoration of a building, at times even of an object, but also indicated its purpose. In addition, the greatest possible care was taken over copying and trans-

mitting the divinely directed Book. As a result, calligraphy spread to works other than the Koran and came to be considered as the greatest of all arts. For a long time it was the only one whose practitioners were remembered by their names, thereby rising above the general level of artisanal anonymity.

These four elements – a ritual or prayer to be accomplished by preference in a mosque, an accidental prototype for the mosque in the house of Muhammad in Madina, a reluctance towards representation of living beings, and the establishment of the Koran as the most precious source for Islamic knowledge – comprise the most important contribution to the formation of Islamic art during the ten years which elapsed between the Hijra (622) and the death of Muhammad (632). With the partial and possibly controversial exception of Muhammad's house, it is a question largely of moods and attitudes; forms and motifs came almost exclusively from the lands conquered by Islam, and we can summarize briefly the major characteristics of Middle Eastern art by the middle of the seventh century.

All the lands taken over by the Muslims in the seventh century, which were for long to be the core of the Islamic empire, had been affected by the classical art of Greece and Rome in its widest sense. Carl Becker put it succinctly: 'Without Alexander the Great there would not have been a unified Islamic civilization.'[24] The significance of this is twofold. On the one hand, Islamic art, like Islamic civilization and Byzantine and Western Christian arts, inherited a great deal from the Greco-Roman world. On the other hand, in varying degrees of intensity, from north-western India to Spain, a remarkably rich vocabulary of formal possibilities had developed more or less directly from the unity-within-variety of the Hellenistic *koiné* and became available to the new culture. In architecture, the main elements of building from central Asia to Gaul were columns and piers, vaults and domes, 'basilical' plans and 'central' plans, stone and brick, with manifold local variations. In the representation of man or nature, the most

illusionistic traditions of the first century A.D. coexisted with the more abstract, linear, or decorative modes which developed after the third century, and the vast majority of the techniques of decorative and industrial arts had been elaborated. The Muslim conquest did not take over large territories in a state of intellectual or artistic decay. Although the empires of Byzantium and Iran had been weakened in the first part of the seventh century by internal troubles and wars with each other, these disturbances barely hampered their intellectual or artistic activities. The Muslim world did not inherit exhausted traditions, but dynamic ones, in which fresh interpretations and new experiments coexisted with old ways and ancient styles. The whole vast experience of ten brilliant centuries of artistic development provided the Islamic world with its vocabulary of forms.[25]

The traditions of this world were many and diverse, and early Muslim writers were fully cognizant of the distinctions in culture between the Byzantine and Sasanian empires, between *Qaysar* and *Kisra*. The Muslims conquered two of the wealthiest Byzantine provinces, Egypt and Great Syria (including Palestine). Syria is best known for the excellence of its stone architecture, still visible in hundreds of ancient churches, the sobriety of its stone-carving, and the wealth of its mosaic floors. In addition, it was a centre of great imperial foundations, such as the Christian sanctuaries of the Holy Land. The impact of imperial Constantinople is less apparent, and then only at second hand: in Coptic art, the art of heterodox Christian Egypt, whose monuments of sculpture, painting, and the minor arts are preserved in large numbers, but whose exact position, as original or provincial, is controversial.[26] In North Africa and Spain the pre-Islamic traditions were less vigorous, because of a more chequered and unfortunate political history. The crucial point in dealing with the Christian art known to or seen by the newly arrived Muslims, however, is not so much its specific character in this or that province (which had mostly a technical impact on the young Islamic art) as the presence in the

background of the awesome and dazzling, even though unfriendly, power and sophistication of the Byzantine ruler, the *malik al-Rum* of the sources. His painters were recognized as the greatest on earth, and the early Muslims had the mixed feelings towards his empire of a *parvenu* for an effete aristocrat. Whenever an early Islamic building was held to be particularly splendid, contemporary or even later legend – the facts are uncertain[27] – asserted that the Byzantine emperors sent workers to execute it.

On the other side, beyond the Euphrates, the Sasanian empire of Iran was entirely swallowed up by the Muslims, and its artists and traditions were almost immediately taken over by the new empire. To contemporaries, the Sasanian ruler was the equal of the Byzantine emperor, but unfortunately our knowledge of Sasanian art is far less complete than our understanding of the Christian tradition. Most of what we know concerns secular achievements: great palaces, with one exception of mediocre construction, but lavishly covered with decorative stucco; rock reliefs and silver plate glorifying the power of the kings; and textiles presumably made in Iran and sold or imitated from Egypt to China. But the paucity of our knowledge – which tends to reduce Sasanian art to a small number of decorative patterns such as pearl borders on medallions, royal symbols like pairs of wings or fluttering scarves, and a few architectural peculiarities like the majestic *iwan* (a vaulted rectangular room with one side giving on to the open) and stucco decoration – should not obscure the fact that at the time of the Muslim conquest it was one of the great arts of its period and, more specifically, the imperial art *par excellence*, in which everything was aimed at emphasizing the power of the King of Kings. Yet, however originally they used or transformed them, the Sasanians derived many of their architectural and representational (but not always decorative) forms from the older classical *koiné*.[28]

The political and artistic importance of the two great empires of the pre-Islamic Near East should not overshadow the existence of other cultural and artistic traditions. Their monuments are less clearly identified, but their importance is considerable because many of them became heavily Islamicized or served as intermediaries between Islam and the rest of the world. An example is furnished by the Semitic populations of Syria and the upper Euphrates region. Although they were Christians and ostensibly part of the Byzantine world, their artistic individualization began before their conversion to Islam, and in general they rejected Hellenization in favour of various heretical movements. They were often supported by the Sasanians and influenced by eastern traditions. In their midst the early Muslims found many supporters and, most probably, converts. We do not know their art well, especially in the centuries immediately preceding the Muslim conquest; but through the monuments of Dura-Europos, Palmyra, Hatra, and the Tur Abdin, we may guess at what must have been their great centre, Edessa; and we may assume that they had begun before the third century and continued most wholeheartedly the transformation of classical motifs and forms into abstract modes and decorative shapes which became one of the aspects of Byzantine art.[29] Another such area, of secondary importance in the seventh century as far as Islam is concerned, acquired a greater significance in later centuries: Armenia. Torn between the rivalries of Byzantium and Iran, it developed an individuality of its own by adopting elements from both sides. Further out in the mountains, in later centuries, Georgia fulfilled a similar role. But despite their specific significance and artistic peculiarities, these cultures depended a great deal on the two imperial centres of Byzantium and Iran.[30]

In addition mention should be made of two peripheral regions, whose impact was more sporadic, at least at the beginning. The first is India, reached by the Muslims in the eighth century and soon a great goal for Islamic mercantilism. The other is central Asia, long thought to be a mere variation on the Sasanian world, but now, after the spectacular discoveries of the past thirty years, identifiable as a culture

of its own, where Chinese, Indian, Sasanian, and even western elements curiously blended with local Soghdian and Kharizmian features into an art at the service of many faiths (Manichaeism, Christianity, Buddhism, Mazdaism) and of many local princes and merchants.[31] Far in the background lies China, whose influence will appear only sporadically.

Beyond its unity of formal and technical origin and its innumerable local variations, the art of the countries taken over by Islam shared several conceptual features. Much was at the service of faith and state and, in the Christian world at least, even part of the faith and of the state. The point is significant because, as was mentioned earlier, it was this Christian use of images that, in part, influenced Muslim attitudes towards representation. The Byzantine crisis of iconoclasm, which followed the Muslim conquest by a few decades, may not have been inspired by Muslim ideas, but it certainly indicates a concern within Christian circles over the ambiguous significance of images.[32] We know

less about the purposes and values of Sasanian art. Yet the very official nature of its iconography on silver plates or on stone reliefs strongly suggests that these were more than mere images; they were symbols of the kings themselves and of their dynasty. Soghdian merchants, Coptic monks, Syriac peasants, petty Turkic dynasts, all sought by means of buildings, decoration, and objects to communicate their power, wealth, and beliefs.

Thus the conquering Arabs, with few artistic traditions of their own and a limited doctrine on art, penetrated a world which was not only immensely rich in artistic themes and forms yet universal in its vocabulary, but also, at this particular juncture of its history, had charged its forms with unusual intensity. The methodological importance and intellectual interest of Islamic art, at least in its formative stages, lies in the encounter between extremely complex and sophisticated uses of visual forms and a new religious and social system with no ideological doctrine or behavioural need for these forms.

THE UMAYYADS AND THEIR ART: 650-750

After the death of Muhammad in 632, four men chosen from the Prophet's immediate circle ruled the Islamic world from Arabia; then supreme power fell into the hands of the Umayyads, the first Islamic dynasty, descended from a wealthy Meccan mercantile family which had accepted Islam late and, at least in part, for reasons of political opportunism. Its power was established in the thirties of the seventh century when its head, Mu'awiya, became governor of Syria. Through his brilliant statesmanship in dealing with Arab tribesmen and the conquered people as well as his astuteness in adapting himself to new circumstances, he soon emerged as the most powerful and able of all Arab governors of his time. In 661 he defeated his main competitor, Ali, and became caliph (*khalifa*), 'successor' of the Prophet in the leadership of the faithful. From then until 750, in spite of vicissitudes, especially during the 680s, his direct or indirect descendants ruled the huge world the Muslim Arabs had conquered.

It is difficult to define the art of the Umayyads or the civilization of which it formed a part.[1] Both are the result of the encounter of the new Muslim faith and state with the ancient traditions of the Near East, and had to be meaningful to the Arabs from Arabia as well as to the old settled population. The nature of the symbiosis thus created varied from one level to another and probably (although our information is scant) from one region to another - even from one city to another. In Iraq and Palestine, the areas of the Near East archaeologically best known, it appears that the material culture - ceramics, everyday metalwork, glassware - changed very little, if at all, between the time of the conquest and the middle of the eighth century. In Iran, silver objects were manufactured presumably under Muslim occupation and continued, with certain differences in quality, the

themes of pre-Islamic Iranian courts destroyed by the conquest; these form the vexatious group of objects known as 'post-Sasanian'.[2] In other aspects of life, such as coinage or administration, the Umayyad world followed the methods and traditions of the older Near Eastern world[3] until the end of the seventh century, when the caliph Abd al-Malik established a specifically Muslim coinage, without images but with the statement of the faith, and changed the administrative language from Greek to Arabic. In theology the impact of Greek philosophy and Christian mysticism began to be felt, which, without altering the substance of the faith, introduced the two trends of rational thought and visionary emotion which played such an important part in the later developments of Muslim religious life.[4] In yet another area, that of royal symbols and royal behaviour, the originally simple relations between shaykh-like prince and subject, between caliph and faithful, were transformed into complex ceremonial relations on the model of ancient Byzantine and Sasanian practices.[5]

These few examples are sufficient to show that Umayyad civilization was both novel and traditional: novel in its search for intellectual, administrative, and cultural forms to fit new people and new ideas and attitudes; traditional in seeking these forms in the world it conquered. Selective of its models, it not only combined them in an inventive way but also slowly modified them, thereby creating a basis for later Islamic developments. With their capital in Damascus and their numerous military campaigns against Byzantium, the Umayyads were more aware of the Christian past of the Near East than of any other, but they were also fully conscious of being rulers of a huge empire; and the East - Iran and central Asia - provided the conquerors with most of their booty and their

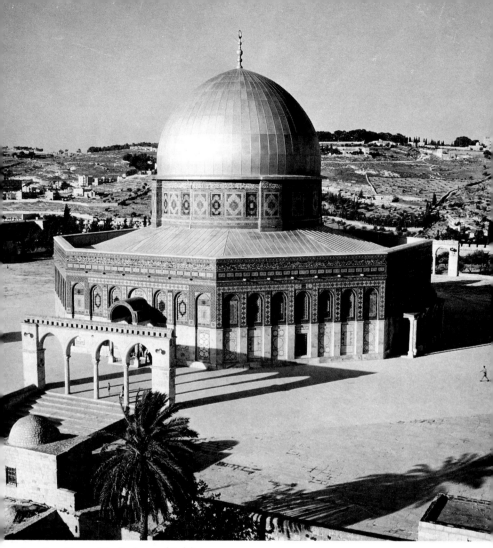

4. Jerusalem, Dome of the Rock, completed 691

most vivid impressions of a new and fascinating world.

Thus, we must consider the art of the Umayyads in the context of an active creation of a new mode of life on old patterns and of a still unsystematized but conscious relationship to several ancient cultures. Even though a few key works are more or less irretrievably lost (the first mosques at Kufa, Basra, Fustat (old Cairo), the second mosque at Madina, the palace of the Umayyads in Damascus, and many of the objects[6] which belonged to the princes and the new Arab aristocracy), fortunately over sixty monuments from the Umayyad period remain or can easily be reconstructed from textual evidence.[7] Almost all belong to the period after 690, following the end of a series of internecine struggles in the new Muslim empire. They can be divided into five groups: the Dome of the Rock in Jerusalem, the early congregational

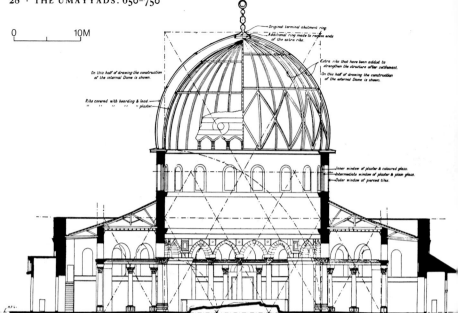

0 10M

mosques, the mosques of al-Walid I, palaces and other secular buildings, and the decorative arts.

THE DOME OF THE ROCK

Completed in 691, the Dome of the Rock in Jerusalem [4] is the earliest remaining Islamic monument, and in all probability the first major artistic endeavour of the Umayyads.[8] The reasons for its erection are not given in literary or epigraphic sources. It eventually became connected with the miraculous Night Journey of the Prophet at the *Masjid al-Aqsa* (the 'remoter mosque', Koran XVII, 1) – generally presumed to be in Jerusalem, although the earliest evidence in our possession is not clear on this point – and with Muhammad's ascent into Heaven from the Rock. This is today the conception of the Muslim believer. In fact, however, the location of the mosque on Mount Moriah, traditionally accepted as the site of the Jewish Temple and associated with many other legends and historical events, its decoration of Byzantine and Sasanian crowns and jewels in the midst of vegetal motifs, its physical domination of the urban landscape of Jerusalem, and its inscriptions with their many precisely chosen Koranic quotations suggest that the original purposes of the Dome of the Rock were to emphasize the victory of Islam that completes the revelation of the two other monotheistic faiths, and to compete in splendour and munificence with the great Christian sanctuaries; it is even possible that to the Umayyads it had the meaning of a dynastic shrine with Solomonic connotations through the representation of paradise-like trees.[9] Only after the full establishment of the Islamic state as the governing body of the Near East did these precise early aims fade away, to be replaced by a religious explanation probably derived from popular piety.

The building is admirably located on an artificial platform, itself part of a huge area known today as the *Haram al-Sharif* (the 'Noble Sacred Enclosure'), created in Herodian times. The platform is ascended by six flights of stairs,

two on the southern and western sides, one each on the other two. An arcade crowns each flight. Both stairs and arcades can only be documented from the tenth century onward, and no information exists about access to the platform in Umayyad times. Not quite in the centre of the platform, the mosque has a large central dome (about 20 metres in diameter and about 25 metres high) consisting of two wooden shells originally gilded on the outside and placed on a high drum pierced by sixteen windows in its upper part [5, 6]. It rests on a circular arcade of four piers and twelve columns; around the central part two ambulatories are separated by an octagonal arcade of eight piers and sixteen columns. The marble columns, together with most

5 and 6. Jerusalem, Dome of the Rock, completed 691, section (*opposite*) and plan (*below*)

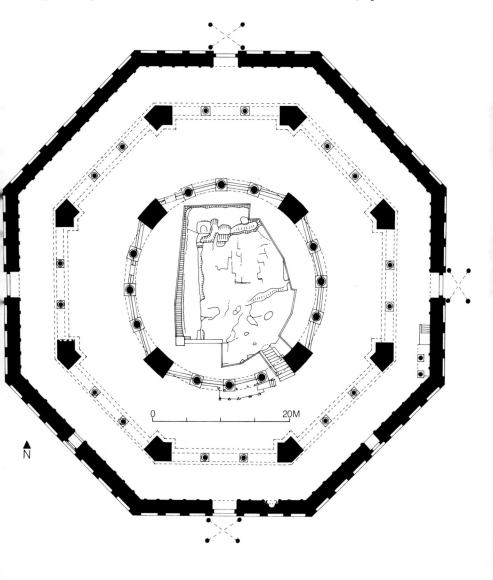

0 20M

N

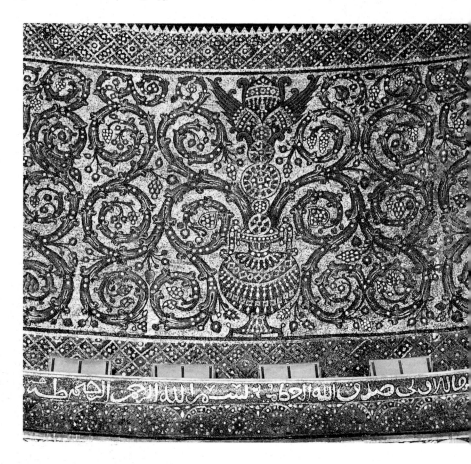

of the capitals, were taken from older buildings; the piers are in heavy stone masonry; a continuous band of tie-beams separates the capitals of the columns and the shafts of the piers from the spandrels. The sloping roof of the octagon abuts the drum of the dome just below the windows. Outside, each side of the octagon is divided into seven tall and narrow panels separated by pilasters. Five contain windows with double grilles dating from the sixteenth century; the original ones probably had marble tracery on the inside and ironwork on the outside.[10] There are four entrances preceded by porches, one on each of the cardinal points. Above the roof of the octagon runs a parapet.

7 and 8. Jerusalem, Dome of the Rock, completed 691, mosaics

The building is richly decorated. The mosaic which – together with marble – adorned the outside were almost completely replaced[11] in Ottoman times by magnificent Turkish tiles, but inside more remains. The walls and piers are covered with marble. Mosaics [7–9] decorate the upper parts of the piers, the soffits and spandrels of the octagonal arcade, the outer spandrels of the circular arcade, and both drums; only the latter show traces of extensive repairs and restorations, which, however, did

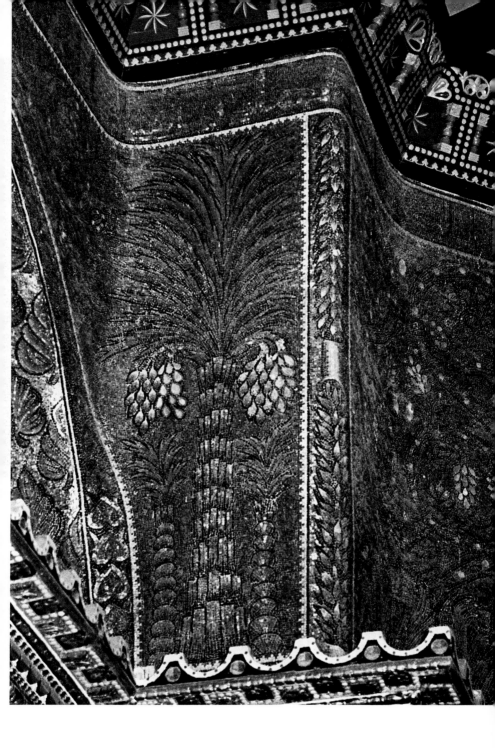

not alter significantly the nature of the designs. Marble now sheaths the inner spandrels and the soffits of the circular arcade as well as three friezes, one between the two drums, the other two above and below the windows of the outer wall. It is likely, however, that these areas were originally covered with mosaics, which – from the remaining decoration of the porch – one can surmise were also used on the vaults of the porches. The ceilings of the octagon and of the dome are Mamluk or Ottoman carved woodwork, which the Umayyads also probably used, for instances exist in other buildings. The tie-beams were covered with repoussé bronze plaques. Finally we must imagine the thousands of lights which supplemented the meagre illumination from the windows, making the mosaics glitter like a diadem crowning a multitude of columns and marble-faced piers around the sombre mass of the black rock surmounted by the soaring void of the dome.

In its major characteristics the Dome of the Rock follows the architectural practices of the Christian empire. It belongs to the category of centrally planned buildings known as *martyria* and, as has often been pointed out, bears a particularly close relationship to the great Christian sanctuaries of the Ascension and the Anastasis. Similarly, most of the techniques of construction – the arches on piers and columns, the wooden domes, the grilled windows, the masonry of stone and brick – as well as the carefully thought out and intricate system of proportions also derive directly from Byzantine church architecture.[12] The same is true of the decoration. Although few examples remain, wall mosaics and marble facings were common in Christian sanctuaries. The endless variations on vegetal subjects, from the realism of certain trees to highly conventionalized garlands and scrolls to all-over carpet-like patterns, are mostly related to the many mosaics of Christian times in Syria and Palestine.[13] The same holds true for the decoration of the tie-beams.

Yet it would be a mistake to consider all this a mere re-use of Byzantine techniques and themes. In addition to the fact that its signific-ance was not quite the same as that of its immediate ecclesiastical models, this first monument of the new Islamic culture departs in three areas from the traditions of the land in which it was built: the nature of the mosaic decoration, the relationship between architecture and decoration, and the composition of the elevation.

The mosaic decoration, which has remained almost entirely in its original state on a huge area of about 280 square metres, does not contain a single living being, man or animal. Evidently the Muslims already felt that such would be inconsistent with the official expression of their faith, and they were selective about the artistic vocabulary offered by the lands they had conquered. However, the mosaics were not entirely decorative: curiously, the inner facings only of the octagonal and circular arcades and the drums introduce jewels, crowns, and breast-plates [9] – the insignia of royal power in the Byzantine and Sasanian empires. Their position, added to the fact that no pre-Islamic artist would willingly mix royal symbols with vegetal designs, indicates that these are the regalia of the princes defeated by Islam, suspended, like trophies, on the walls of a strictly Muslim building.

At the same time, writing, in the form of a long mosaic inscription running below the ceiling of the octagons, appears with both decorative and symbolic significance: decorative because it takes over the function of a border to the rest; symbolic because, although barely visible from the ground, it contains all the Christological passages of the Koran, thereby emphasizing the Muslim message in Christ's very city; and because the later caliph al-Mamun saw fit to substitute his own name for that of the founder, Abd al-Malik, without changing the date of construction, thus showing his acceptance of the aims and purposes of the building.[14] Unable to use the traditional figurative imagery derived from Antiquity, the Mus-

9. Jerusalem, Dome of the Rock, completed 691, mosaics

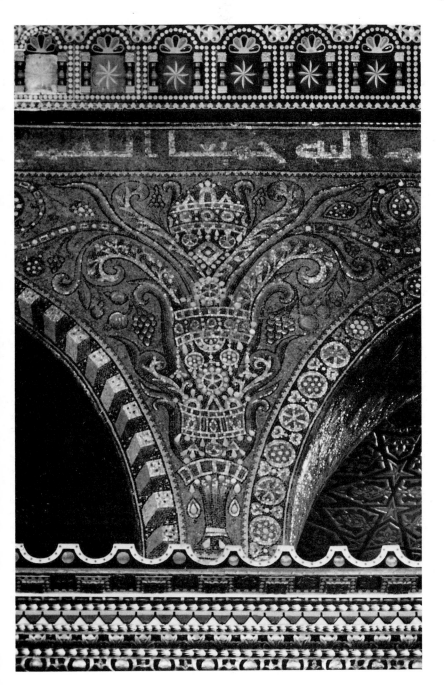

lim world expressed its ideas in non-figurative terms.

Alongside classical motifs the mosaics have palmettes, wings, and composite flowers of Iranian origin. Thus the Umayyad empire drew upon features from the whole area it had conquered, amalgamating them to create an artistic vocabulary of its own.

Finally the mosaics of the Dome of the Rock introduced two decorative principles which were to continue to develop in later Islamic art. The first is the non-realistic use of realistic shapes and the anti-naturalistic combination of naturalistic forms. When they felt that a more brilliant decoration was needed, the artists did not hesitate, for instance, to transform the trunk of a tree into a jewelled box. The possible combinations of forms and themes are limitless, without the restraints imposed by the naturalism of classical ornament.

The second principle is that of continuous variety. On close analysis, the mosaics of the Dome of the Rock show comparatively few types of design – mainly the acanthus scroll, the garland, the vine scroll, the tree, and the rosette. Yet nowhere do we find exact repetition. Certain differences are qualitative, as when an apprentice reproduced the design of a master.[15] But in most instances each variation within a theme represents an individual interpretation.

As far as future development is concerned, the most significant artistic feature of the Dome of the Rock is the establishment of a new relationship between architecture and decoration. Until this time the Mediterranean had continued, albeit with modifications, the classical principle of decoration, especially ornamental decoration, as the servant of architecture, emphasizing certain parts of the building, but rarely suppressing the essential values of the construction itself. The builders of the Dome of the Rock, however, hid almost all their clearly defined, classically based structure with brilliant marble and mosaic. Particularly striking in this respect is one of the soffits of the arches of the octagon. We see three bands of design, two of which take over one half of the surface, the remaining one the other half. However, the composition is asymmetrical, for the wider band is not in the centre but towards the inner side of the building, thus deliberately destroying the basic unity of the surface. Furthermore, one motif, and one only, continues on to the vertical surface of the spandrel, thereby emphasizing one curve of the arch.

This does not mean that the mosaicists of the Dome of the Rock completely rejected the architecture they decorated: in using trees for high rectangular surfaces and scrolls for square ones, they certainly adapted their ornamental forms to the areas provided by the architects. But in the choice of many specific motifs (for instance the rosettes on the soffits) as well as in the total covering of the available walls, they created an expensive shell around the structure which broke away from the traditions of the area. Whether the Umayyads developed this taste on their own, or whether by the end of the seventh century they were already under the influence of an 'oriental' fashion known through Sasanian stuccoes covering mud-brick walls, is still very much open to debate.

The third original feature of the Dome of the Rock is the way in which the dome itself juts out of the octagons. The effect is quite different from that of San Vitale in Ravenna or of the palace church in Aachen (with which the Dome of the Rock is frequently compared – justifiably so, if one looks at plans alone). The Umayyad designer made the dome more significant from the outside than from the inside, where it is in fact nearly invisible because of its height and the location of the Rock. It is as though the building has two messages: one to proclaim to the rest of the city that Islam has sanctified the Jewish Temple; the other to convey the impression of a luxurious shrine for restricted and internal purposes.

Set on a traditional holy site, and drawing on the lands conquered by Islam for methods of construction and decoration, the Dome of the Rock yet created an entirely new combination of artistic conceptions to fulfil its purpose. It is a most splendid and singular achievement.

EARLY CONGREGATIONAL MOSQUES

The development of the mosque began before the construction of the Dome of the Rock, but major monuments remain only from the first years of the eighth century. At Madina, Jerusalem, and Damascus, Abd al-Malik's successor, al-Walid (705-15), established the basis for most later mosques.[16] Of these three, only the one at Damascus has remained comparatively unmodified; those in Madina and Jerusalem can be reconstructed, although at Jerusalem a number of archaeological problems are not entirely solved.[17]

A word must be said, however, about the first religious buildings of Islam, even though most of our information on them is only textual. The best known are those at Basra (635, rebuilt in 665), Kufa (637, rebuilt 670) [10], and Wasit (702), all in newly founded Muslim towns.[18] They were simple, consisting of a large, generally square, area with a deep portico signifying the qibla side and serving as a covered hall of prayer; eventually shallower porticoes were added to the other three sides of the enclosure, resulting in a central courtyard surrounded by porticoes. At first, the covered parts were set on supports taken from older buildings;

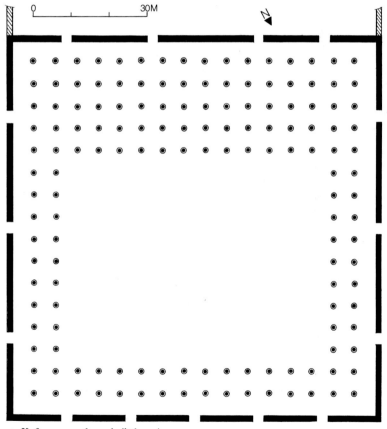

10. Kufa, mosque, 637, rebuilt 670, plan

later they rested on specially built columns or piers. The method of roofing is uncertain; there may at times have been vaults.[19]

This simple plan is based on that of the house of Muhammad in Madina, which became the model in newly founded cities. Although the double purpose of combined dwelling and place of worship was no longer possible or meaningful, these mosques were always set next to the governor's palace and included within their boundaries a small structure serving as the treasury of the Muslim community. They were thus not only religious buildings, but also the main social and political centres - al-masajid al-jami, or congregational mosques. Each quarter of the town had its own tribal mosque or oratory, but we know nothing about their shape.[20] Their significance goes beyond the mere fact that in form and function they imitated the Madinese house of the Prophet, for, primitive and simple as they were, they reintroduced the hypostyle hall into the Middle East as a characteristic architectural form. This was no conscious mutation of the old models of Persian apadanas, Roman fora, or Egyptian temples: it arose rather from the combination of the need for large space in the newly created cities with the accidental prototype of Muhammad's house in Madina and the availability of disused units of construction like columns. The most significant characteristics of the revived hypostyle are that it was generally connected with an interior open space and that, at least in these initial stages, its components could be multiplied at will.

If these were the first steps of mosque architecture in Iraq, can we assume that the Muslims erected similar buildings in other newly founded towns, such as Fustat (old Cairo) in Egypt or Kairouan in Tunisia, and in the cities occupied by the conquerors, in Syria or elsewhere? Our information here is much less secure. The early Fustat mosque (641-2) was an entirely covered building, to which a presumable porticoed courtyard was added only in 673;[21] otherwise its plan is unknown, although it was probably a simple variation of the colonnaded hall. Elsewhere - in Syria, Iran, and

perhaps also Egypt - churches or other cultic buildings were converted for the new faith. Frequently, however, the agreements by which cities accepted Islamic rule guaranteed the preservation of their private and religious buildings; thus in Jerusalem, the Islamic religious centre developed in an area not used by the Christian population. But in the case of Hama,[22] a church was converted into a mosque by the addition of a courtyard in front of it, and, through texts, we may infer the same development in other areas, particularly Iran. In Damascus the Muslims took over part of the ancient temenos on which the Christian church of John the Baptist had been built.

Syria and Egypt provide the first examples of two features which, in different ways and to different degrees, were to play an important part in the history of the mosque. The first is the maqsura, a special enclosure reserved for the prince in the centre of the qibla wall of the sanctuary. Its origin and date of appearance are still uncertain, but it must have involved protection from assassination and separation of the caliph from his subjects.[23] It appeared only in the larger mosques.

The second feature, of equally obscure origin, became a permanent feature of the Islamic landscape: the minaret (from Arabic manara). Its function seems clear: from it the muezzin called the faithful to prayer at appointed times. Wherever Islam went, the minaret followed, almost everywhere taking the shape of a tall tower above the mosque and the city or village.[24] No such construction existed in the Prophet's time, when Muhammad's muezzin would call to prayer from the roof of a house,[25] or in the early mosques of the newly created cities of Iraq. Indeed, the minaret first appeared in settlements with predominantly non-Muslim populations, and its shape - as opposed to its purpose, which had existed since the beginning of Islam - may be explained by the desire of the first Muslims not only to be able to summon their co-religionists scattered all over town (it is doubtful whether the call to prayer could rise much above the prevailing noise), but also to

signify the presence of new Islamic centres in the old cities. The sources, all literary, indicate Syria or Egypt as the land of origin;[26] the priority cannot be established, and in any case it is more important to realize that the minaret was a function both of a need of the faith and of the situation of the Muslims in the lands they had conquered.[27] Very rapidly the first objective overshadowed the second, and minarets appeared everywhere, almost always drawing on some local model for their forms. In Syria the square tower often used for hermits' cells gave rise to the characteristic square minaret, which spread west to North Africa and Spain, and east to Iraq and Iran. Elsewhere other forms were created.[28] Nevertheless, the emphasis given to minarets in faraway lands, as well as the inscriptions found in them,[29] demonstrate that for many centuries – indeed still today in the minaret of the mosque in Washington D.C. – they served also as a spectacular symbol of the presence of Islam.

THE MOSQUES OF AL-WALID

We can best understand the mosques of al-Walid I in the light of these earlier developments. His reign – the first to see the Islamic world secure in its conquest and without major internal troubles – was a period of great expansion to east and west and of consolidation within the empire. A concern for prestige and the expression of newly acquired power led the caliph to build, at least in part, major mosques in Damascus (706), the capital of the empire, Madina (706-10), in which the Muslim state was first created, and Jerusalem (709-15), the holiest city taken by the Muslims. Because it is almost in its original state, we shall deal chiefly with the one in Damascus, even though the mosque of Madina was probably more important and has been most pertinently reconstructed.[30]

The mosque of Damascus [11] is an entirely Muslim structure.[31] An earlier Roman temenos on the site determined its size (157 by 100 metres), its location, and the lower courses of some of the walls, as well as the position of the east and west entrances. A possible Roman triple gate on the south wall is now hidden by shops. All other features date from al-Walid's time, although a fire in 1893 destroyed much of the superstructure; the subsequent rebuilding was done with little taste.

The mosque consists of a courtyard surrounded on three sides by porticoes on piers alternating with two columns; on the fourth side is the qibla [12]. It has three wide aisles, parallel to the southern wall, cut in the centre by a perpendicular (axial) nave[32] over whose second bay rises a high dome, whose present appearance is most unfortunately modern, but whose supports can probably be assigned to the eleventh century. (It is not clear whether an earlier dome in the axial nave was in front of the qibla wall or on the site of the present one.[33]) The aisles have large monolithic columns taken from older buildings, surmounted by capitals, impost-blocks, and arches. Above the arches an additional small arcade lifted the gabled roof even higher. In the qibla wall are four niches known as *mihrabs*, of which one is clearly modern. The date of the others, symmetrically arranged with the central one right in the middle of the axial nave, is uncertain, and it is not likely that all three are Umayyad. The two minarets on the southern side of the building, largely based on Roman corner towers, do however date from that period; the third, over the northern entrance, was built before 985,[34] but it is not certain that it is al-Walid's. The small octagonal building on columns in the north-western corner of the court [13], again Umayyad, was the Muslim community's symbolic or real treasury, traditionally kept in the main mosque of the town. Of the four entrances to the mosque – one on each side – the southern one, next to the axial nave, was reserved for the caliph and connected directly with the Umayyad palace. The major point which still remains obscure is the nature of the entry from the courtyard to the sanctuary. Today there are doors; the curtains reported by a fourteenth-century source may or may not have been the original arrangement.[35]

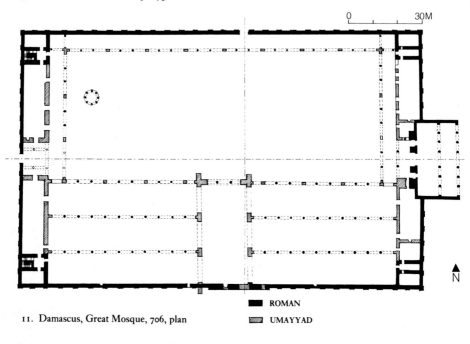

0 30M

N

11. Damascus, Great Mosque, 706, plan

■ ROMAN

▨ UMAYYAD

Just as in the Dome of the Rock, practically all the elements of construction derive from the traditional architecture of Syria.[36] The innovations are two: the plan, and the introduction of the mihrab.

The problem of creating a plan on a pre-established site was solved by the Umayyad architects as follows. They adopted Madina's basic order of a porticoed court with a deeper sanctuary, but instead of transforming their sanctuary into a sort of hypostyle hall on the pattern of the Iraqi mosques, they created a tripartite division – probably under the impact of Christian churches, although the Damascus aisles differ in being of equal width. But a more remarkable innovation, in plan as well as elevation, is represented by the axial nave. Its aesthetic significance in relieving the monotony of a façade 137 metres long is obvious enough: its historical importance is far greater. Creswell pointed out that it closely resembled a façade of the palace of Theodoric as represented on a well-known Ravenna mosaic.[37] Sauvaget was the first to relate the axial nave in Damascus, as well as similar ones in Jerusalem and Madina, to the Umayyad royal ceremonies, and to show that this architectural feature, which appeared first in what we may call Umayyad 'imperial' mosques and was to be frequently copied, originated in an attempt to emphasize the area reserved to the prince, and imitated a palace throne room.[38]

The plan of the mosque of Damascus is important in two major ways. First, the arrangement is more organically conceived than in the diffuse and additive mosques of Iraq, with a clearly defined central focus. Second, its three-aisled sanctuary with axial nave and its proportions partly imposed by the Roman foundations became a standard model in Syria and elsewhere – although not for the other two mosques built by al-Walid, which were both hypostyles with

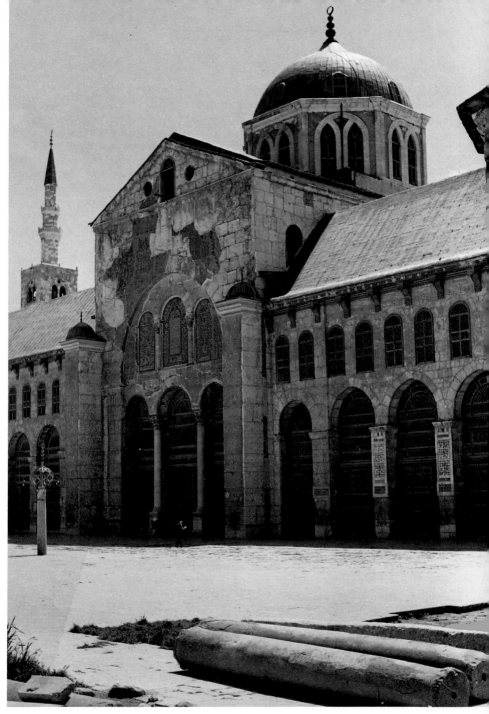

12. Damascus, Great Mosque, 706, qibla façade

many parallel aisles, including a wider central one, leading to the qibla, and which had peculiar features pertaining to their sites.[39]

The mosque in Damascus also has the earliest remaining concave mihrab.[40] The philological and formal background of the mihrab is remarkably complicated:[41] for the sake of clarity we shall consider only its common application to the mosque. It is generally understood today as a niche on the qibla wall of a mosque indicating the direction of Mecca. But it is absent from all earlier mosques; it is never visible from more than a fraction of the area of the building; and the whole plan of a mosque makes the direction of prayer so obvious that there is no need for so small a sign. Nor is it fully satisfactory to explain the mihrab as an abbreviated throne room, as has been suggested,[42] for it became almost immediately a fixture of all mosques, and eventually a common artistic motif on pious objects.

In order to understand its original purpose, we should bear in mind two points. To begin with, medieval writers generally agree that a concave mihrab first appeared at al-Walid's mosque in Madina, which replaced and embellished the Prophet's own house-mosque. Second, the mihrab there was set not in the middle, but by the place where according to the Traditions the Prophet used to stand when holding prayers.[43] We can suggest then that its purpose was to symbolize the place where the first *imam* (or leader of prayer) stood; that it began as a precise memorial in the Prophet's mosque, and then, through the foundations of al-Walid, spread out to the whole Islamic world.[44] Just as the office of the successor of the Prophet had royal connotations, so did the mihrab;[45] but only through its significance as a religious memorial could it have become accepted almost immediately in *all* religious buildings.

The point is strengthened by comparing such immediate adoption with the development in Umayyad times of the *minbar*, the pre-Islamic throne-chair used by the Prophet in Madina. Under the Umayyads the minbar began to

appear in mosques other than the one in Madina, and it was clearly a symbol of authority.[46] As such, its adoption was more carefully controlled than in the case of the mihrab. It was often a movable object which did not properly belong in the religious institution, and for several centuries the existence of mosques with minbars was one of the criteria which distinguished a city or an administrative centre from a mere village. The entirely different destiny of the mihrab suggests that, whatever its relationship with royal ceremonies in the mosque, its primary function was not royal but religious.

The formal origin of the mihrab is certainly to be sought in the niche of classical times, which through numerous modifications appeared as the haikal of Coptic churches, the setting for the torah scrolls in synagogues,[47] or simply as a frame for honoured statues. It is also related to the growth, still unsystematic, in the Umayyad period of a dome in front of the central part of the qibla wall. Domes, of course, are well-known architectural means of honouring a holy place and, as such, already existed in pre-Islamic Arabia. The earliest reference we have to a dome in front of a mihrab is in the eighth-century mosque of Madina.

The axial nave, the concave mihrab, the minbar, and the dome in front of the mihrab were destined to play an important part in the history of Islamic architecture. In Umayyad times their precise functions and purposes emerged from still rather obscure origins; more specifically, all of them appear together in the imperial mosques of al-Walid. They are difficult to interpret because they fulfilled an ambiguous role, and their varying functional and formal origins and destinies are not yet fully understood. Their ambiguity reflects that of the Umayyad mosques built by al-Walid. Just as these features which in Umayyad times can be related to royal functions will tend more and more to acquire a religious meaning, similarly the mosque's sig-

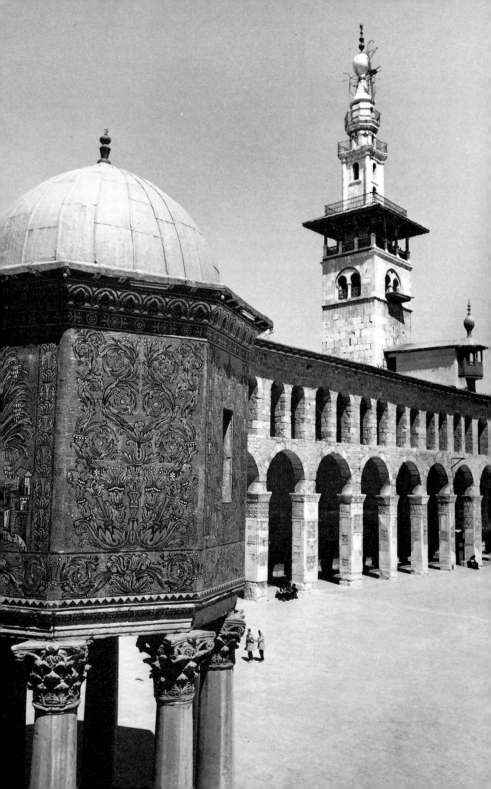

nificance as a place for worship grows in importance without its ever losing completely its function as a social and political centre. This ill-defined shift in emphasis explains the peculiar characteristic of the Umayyad mosque of the early eighth century; the fact that its architectural elements reflect both royal and religious concerns, the former more often creating specific forms and the latter the dimensions of their coming interpretation.

While the architectural characteristics of the three mosques of al-Walid can be reconstructed on the basis of texts and more or less meagre archaeological data, for their adornment we must rely almost entirely on the one at Damascus, which has preserved important parts of its original decoration.[48] Like the Dome of the Rock, it had magnificently carved window grilles. The marble panelling on the lower part of its walls was renowned from the very beginning for the extraordinary beauty of its combinations, of which only a small and poorly reset fraction remains by the east gate. The most celebrated decorative element was however the mosaics [14, 15] which originally covered most, if not all, of the walls, in the porticoes, on the court façade, in the sanctuary, and perhaps even on the northern minaret. There are many literary references to their origins,[49] but much uncertainty remains: we do not know, for instance, whether the many accounts of the importation of Byzantine mosaicists are true, or merely reflect the feeling that works of such quality doubtless are of Constantinopolitan origin. Studies tend toward the first hypothesis.[50]

In spite of the disgraceful restorations to which the sizeable uncovered segments of the original mosaics were unfortunately subjected in the 1960s, large fragments can be identified everywhere in the courtyard, and drawings made shortly before the fire of 1893 record something of the sanctuary mosaics. In most instances, the motifs are vegetal [14], akin to those of the Dome of the Rock, although more realistic in their depiction of specific plants and with fewer mixtures of forms of different origins. Their greatest originality consists in the

14. Damascus, Great Mosque, 706, mosaics from the western portico

massive introduction of architectural themes. On the façade of the axial nave and on some of the spandrels of the northern and western porticoes, buildings of all types appear in the foliage. The best preserved of these compositions is the large (34.50 by 7.15 metres), richly framed panel on the wall of the western portico [15]. In the foreground a number of small rivers flow into a body of water along which stand splendid tall trees, rather irregularly set, but providing a frame for a series of smaller architectural units remarkable both for their thematic variations (small houses clustered around a church; vast piazzas surrounded by porticoes; stately palaces on the banks of a river) and for their stylistic

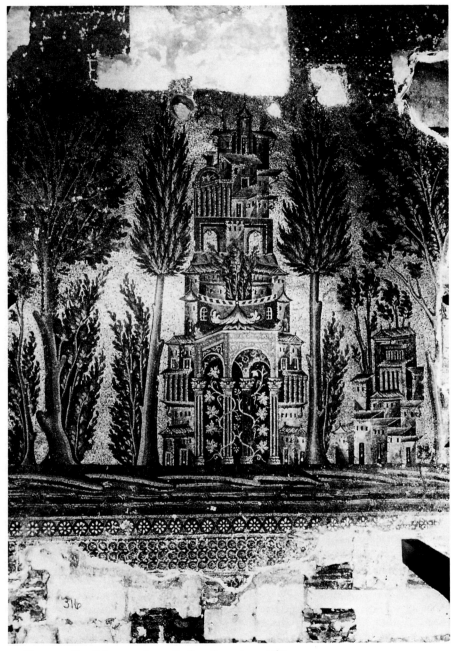

15. Damascus, Great Mosque, 706, mosaics from the western portico

differences (illusionistic techniques next to fantastic constructions of unrelated elements).

These mosaics raise two major questions. The first is stylistic: how should one explain the coexistence of widely different manners of representation, and is there a style specific to them? As has often been said, mosaicists and painters since the first century A.D. had availed themselves of all the different styles of the Damascus wall; the great innovation of the artists of the caliphs was to use them alongside each other. These artists, or their patrons, show a remarkable catholicity of taste, an interest in all available forms, whatever their date or original purpose. To an even greater extent than in the Dome of the Rock, the pre-Islamic models of the Damascus mosaics usually included human or animal forms. None are found here – which implies that the Muslim patrons imposed themes and manners of representation upon the mosaicists, whatever their country of origin. The large trees [15] – although not the main subject matter and amazingly artificial in relation to the rest of the landscape – may have fulfilled the formal function of figures in comparable older work.[51]

The other question raised by the mosaics is their meaning. Certain later medieval writers saw in them images of all the towns in the world, and a few contemporary scholars have interpreted the remaining panel as the city of Damascus.[52] Topographical representations are known in pre-Islamic art, and the Damascus mosaics – like those of the Dome of the Rock – could be explained simply as symbols of the Umayyad conquest. Or perhaps an ideal 'city of God'[53] is intended, derived from classical and post-classical representations of paradise, but omitting all living things. The theme of an idealized landscape could be related to the setting of the Muslim paradise (for instance Koran IV, 46 ff.), and later indications suggest that a mosque court was compared to it.[54]

Objections exist to any of these explanations taken separately. Reference to specific cities throughout the building could hardly have led to the peculiar stylistic and iconographic in-

consistencies of mixing precise depictions with artificial constructions, and to the appearance together of architectural units of such different character (towns, villages, single buildings) and on such different scales. And, while a landscape with water and buildings could be understood as a representation of a Muslim paradise, the idea of illustrating the Holy Book at such an early date does not seem to coincide with the contemporary Muslim view of the Koran.

Instead, a combination of these explanations is likely. Writing in the late tenth century, al-Muqaddasi, our earliest interpreter of the mosaics, pointed out that 'there is hardly a tree or a notable town that has not been pictured on these walls',[55] and a fourteenth-century author redefined the idea, including a precise identification of the Ka'ba.[56] It is, therefore, valid to assume that there was an attempt to portray, within the confines of the imperial mosque, the fullness of the universe – cities even with their churches and surrounding nature – controlled by the Umayyad caliphs. But at the same time, the golden background, the unreal and unspecific character of many of the compositions, the open ensembles of buildings as opposed to the walled cities of pre-Islamic models, and the centrally placed tall trees give these mosaics an idyllic and unearthly feeling, which contradicts any attempt to identify actual cities. Instead one can suggest that the imperial theme of rule over the world of nature and man has been idealized into the representation of a 'Golden Age' under the new faith and state in which a peaceful perfection has permeated all things.[57]

Thus, some fifteen years later, the mosaics of Damascus recall those of Jerusalem, but instead of being an assertion of victory, they reflect the newly acquired security of the Muslim empire. Their most striking feature is that whatever meaning they had does not seem either to have maintained itself within Islamic culture or to have spawned a clearly defined programme for mosques. They should possibly be understood as an attempt at an Islamic iconography which did not take because it was too closely related to the ways of Christian art.

Mosaic decoration existed also in the other two mosques built by al-Walid, but no Umayyad work remains, although the much later mosaics on the drums of the Aqsa mosque in Jerusalem clearly reflect Umayyad models.[58] In spite of the controversy around the subject, the wooden panels preserved from the ceiling of the same mosque, with their remarkable series of decorative motifs, are most likely Umayyad.[59]

The mosques of al-Walid are major monuments because of their patronage and their quality. They exemplify the transformation of the rather shapeless hypostyle into a structured architectural system with a formal relationship between open and covered spaces (court and what is usually called sanctuary),[60] with symbolic and compositional axes (mihrab and axial nave), and with a real or potential programme of decoration. But two points should be kept in mind. First, the evolution from the house of the Prophet at Madina to the Iraqi hypostyle before *c.* 700 is based almost exclusively on textual evidence, for the first (and soon modified) mosque in Wasit is the only reasonably certain seventh-century example of a large hypostyle mosque in Iraq.[61] In other words this evolution is hypothetical and may assume a far more centralized ideology and formal concern than was actually the case.

The second point is that explorations and excavations have brought to light a number of early mosques, or proposed an early, possibly even Umayyad, original date for mosques with a long subsequent history. Examples of the first kind are the mosques at Uskaf-Bani-Junayd,[62] at Qasr Hallabat in Jordan,[63] at Siraf in Iran,[64] at Qasr al-Hayr East,[65] and in Pakistan,[66] secular buildings to be discussed later. The congregational mosques at Sanaa in Yemen[67] and at Bosra in Syria[68] are examples of the second group. Most of them did not reflect the new types created by al-Walid, nor is it likely that they were directly influenced by Iraqi mosques; all, however, were provided with a mihrab. They suggest that, in addition to a tendency toward standardization in large cities

and under direct imperial patronage, there were many variants, either purely local or the results of accidents.

SECULAR BUILDINGS

The Umayyad period is unusual in the Middle Ages for the astonishing wealth of its secular art, and especially architecture. This is largely due to the peculiarities of the Muslim settlement in the Fertile Crescent. In Palestine, Syria, and Transjordan the Muslims, and most particularly the Umayyad aristocracy, took over quite extensive irrigated and developed lands whose Christian owners had left for the Byzantine empire.[69] Furthermore, the conquest transformed, for example, the Syrian steppe, the middle Euphrates valley, and the western edges of Iraq from frontier areas into major centres of commercial and administrative communication and at times into zones of agricultural development. In other words the Muslim leaders became landlords, and the Umayyad state initiated, especially in the middle Euphrates valley (that is, the Jazira), various programmes of economic development such as swamp drainage, irrigation, and transfers of population.

Most of what we know of Umayyad secular architecture comes from this unique socio-economic setting and not from large cities of the empire. The urban palace in Damascus, al-Khadra ('the green one'), is gone; its Iraqi parallel in Wasit has never been excavated,[70] although the *dar al-imara* or Government House in Kufa has been explored and published in part.[71] Yet, against one Kufa known in some architectural details, dozens of country or steppe foundations are available.[72] Their interpretation in the past as reflections of an Umayyad bedouin taste was based on western romanticism about Islam[73] (even though in one or two cases – Qusayr Amra, for instance – something has remained of an Arabian aristocratic taste, as we shall see below). In fact they fulfilled a number of different functions within a new ecological setting.

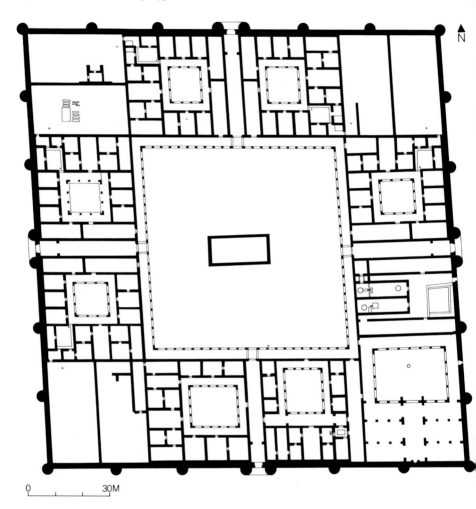

N

0 30M

A most unusual example is Qasr al-Hayr East [16, 17].[74] A hundred kilometres north-east of Palmyra at the intersection of the main roads from Aleppo to Iraq and from the upper Euphrates to Damascus, it consisted of a large (7 by 4 kilometres) walled enclosure probably for animals and agriculture, the earliest known caravanserai in Islam, a large bath, and a 'city' (*madina*) consisting of six large aristocratic houses, a mosque, and an olive oil press. A few more primitive houses were scattered around. The whole ensemble, which may well have been the Zaytuna of Hisham, was probably begun in the early decades of the eighth century, received a major royal funding celebrated by an inscription around 728, was probably never finished according to its planned scale, and continued as a living, although small, city well into the ninth century. To the archaeologist, the historian of techniques (especially for water and for con-

16. Qasr al-Hayr East, early eighth century,
plans of large and small enclosures

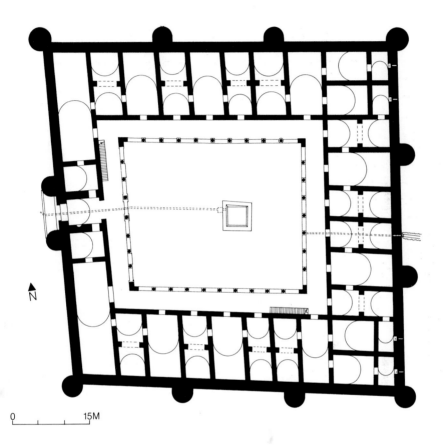

N

0 _____ 15M

struction), and the social historian, Qasr al-Hayr is a document of considerable importance. For the art historian, two points are particularly noteworthy. First, the forms and techniques used (large square buildings with towers filled with rubble, high gates framed by half-towers and decorated with stucco or brick, organization of space around a square porticoed court, whether it be the large space of a whole city or the small space of a house, introduction of brick within predominant stone, highly polished skewed wall surfaces, and skewed vaults) originate in the architectural vocabulary of late antiquity, for the most part from the Mediterranean. There is no technical or formal invention here, but there is a different use of these forms, in many ways just as in the mosque of Damascus. For instance, three of the four gates of the 'city' were walled almost immediately after construction, because the available type of a square

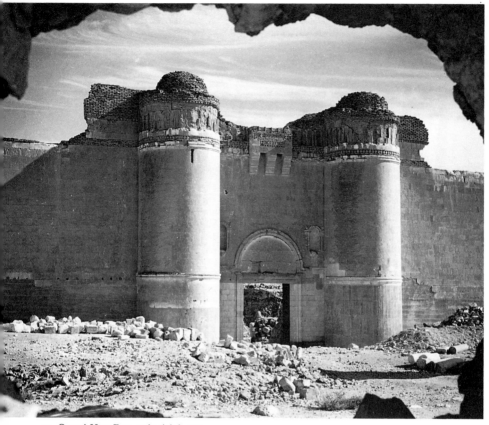

17. Qasr al-Hayr East, early eighth century

with four axial gates was not adapted to the city's purpose. Moreover, while the central authority, probably the caliphate, created the infrastructure of foundations, water channels, and basic layout of nearly everything, the completion was much more haphazard, at times even in contradiction to the original plan.

The second point also derives partly from Roman architecture: utilities such as waterworks or inns are given a striking monumentality. One can only hypothesize about the historical and human conditions which created Qasr al-Hayr, but undoubtedly the exterior monumentality of its buildings served the purpose of demonstrating the wealth and the power of a new empire.

A second unusual example of Umayyad architecture is Qasr Kharana [18, 19],[75] wonderfully preserved on top of a waterless knoll in the Jordanian steppe. Small in size (35 by 35 metres), it has a single entrance, a court, and two floors of halls or rooms, some arranged in apartments and decorated with stucco. Its fortified look is misleading – the arrow slits turn out to be purely decorative. The technique of construction (rubble in mortar) is unusual in the western part of the Fertile Crescent, and the ornament clearly derives from Iraqi-Iranian

sources. Date and purpose have been widely discussed. A graffito indicates that the building was standing by 710, and the general consensus is that this date is close to its foundation. Its function is more puzzling; location and internal arrangements give no clue, and recent soundings confirmed the nearly total absence of sherds or other traces of regular life.

Qasr al-Hayr East and Kharana are unusual within our present state of knowledge. The fact, however, that we can provide them, even hypothetically, with a social significance within the emerging Muslim world suggests that they may have been more typical than has been believed.[76] But this possibility must await further archaeological investigation.

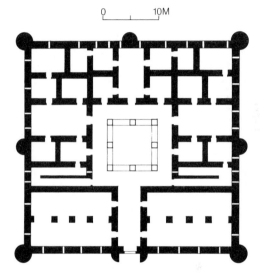

18 and 19. Qasr Kharana, *c.* 710, plan and exterior

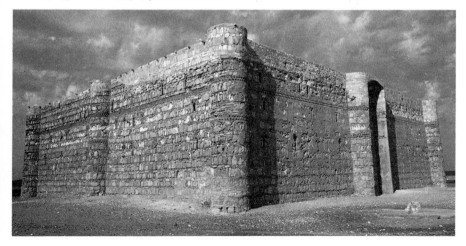

The best known Umayyad monuments are a group built with one exception as places of living, rest, or pleasure for Umayyad landlords. The most important are Kufa (the one exception), Jabal Says, Rusafa, Khirbat Minya, Qasr often a second floor with official apartments, throne rooms, and so on. In addition, Khirbat al-Mafjar has a small private mosque on the south and a small underground bath on the west. Within the same framework, Mshatta

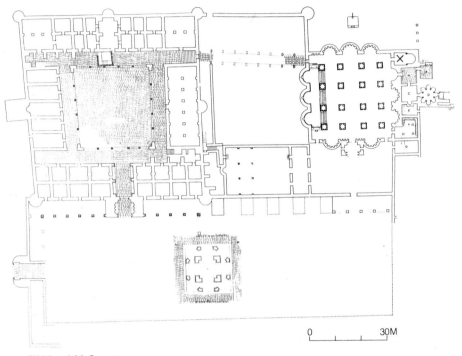

20. Khirbat al-Mafjar, plan

al-Hayr West, Mshatta, Qusayr Amra, and Khirbat al-Mafjar,[77] the last four particularly remarkable for their copious sculpture, paintings, and mosaics.

Khirbat al-Mafjar [20], the best known and best studied, can be used as a basis for discussion. It consists of three separate parts – a castle proper, a mosque, and a bath – linked by a long porticoed courtyard with a most spectacular fountain. With variations, these elements are found in most palaces. The castle always has an entrance, generally quite elaborate, and along the walls full towers often arranged in apartments (*bayts*) of three or five rooms. There was

[21, 22], the most ambitious of all, although unfinished, has a slightly aberrant interior with a large entrance group (with mosque), a courtyard, and a throne-room complex opening on the court, all set on an axis independently from the living quarters. These differences from typical Syrian constructions and plans can be explained by the impact of Umayyad architecture in Iraq, as we know it in Kufa. The origins of the fortress-like plan, improper for defence, lie in the forts and palace-forts which started on the Roman frontier of Syria and spread to imperial palace architecture elsewhere. The construction – both stone, the most common

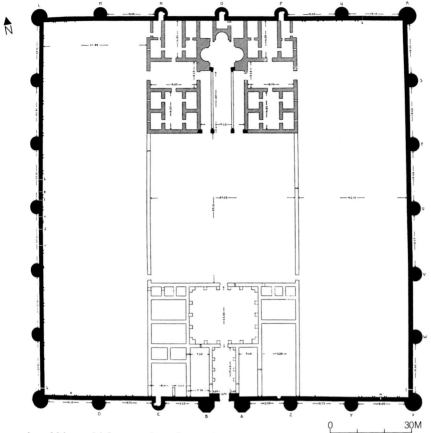

21 and 22. Mshatta, eighth century (second quarter),
plan and view from the entrance

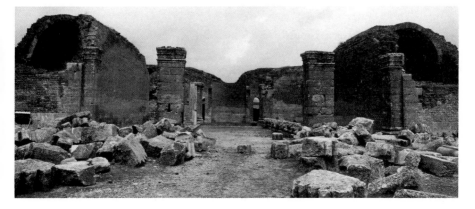

material, and brick used in Mshatta and in some parts of other palaces – follows the traditional methods of Syria, with the addition of a few Mesopotamian and strictly Constantinopolitan features. We know less about the ceremonial rooms, since in most instances they were on the second floor over the entrance. However, the remaining examples at Mshatta and Khirbat Minya used the ubiquitous basilical hall of the Mediterranean world which at Mshatta had an appended domed area and triconch.[78]

(and variable) expansion took place in what corresponds to the Roman *apodyterium*. At Khirbat al-Mafjar it is a large (slightly over 30 metres square) hall, with a pool at one side, a magnificently decorated entrance, and a luxurious small domed private room at one corner (marked X on the plan [20]). The superstructure is more uncertain: there were sixteen huge piers, and clearly a central dome; whether we must assume something like two ambulatories around it, as was suggested by R. W. Hamilton

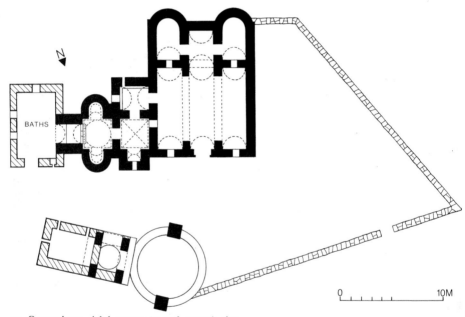

23. Qusayr Amra, eighth century (second quarter), plan

The mosques of these palaces are small and do not add much to our knowledge of architecture. More important are the baths which became a common feature (in the case of Qusayr Amra [23] standing alone in the wilderness).[79] All have small hot-rooms, which follow in all practical respects the heating and water-distributing techniques of Roman baths. But while the heated rooms shrank, a tremendous

[24],[80] or some other system is less certain. The effect was certainly grandiose, especially if one adds the splendid mosaics, the carved stucco, and the paintings which decorated walls and floors. The bath at Qasr al-Hayr East had a simple basilical hall.

The function of such a room is more difficult to define. It has already been pointed out[81] that its size and decoration, as well as the two en-

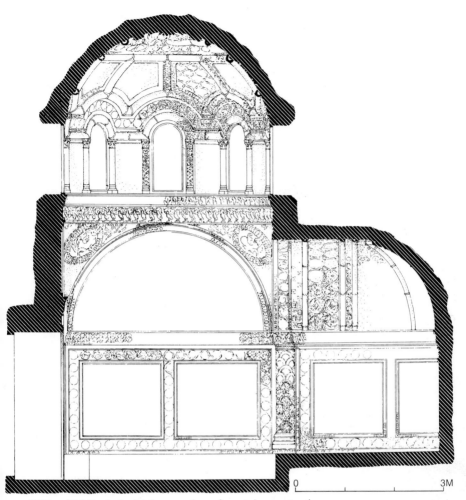

24. Khirbat al-Mafjar, bath, eighth century (second quarter), reconstruction

trances – one public to the east, one princely and private to the south-west – are fully appropriate for the relaxation generally associated with medieval baths.[82] It was certainly not an *apodyterium* in the strict sense of the word: instead, it must have been a place for official royal entertainment, as used by Umayyad princes. Its pre-modern equivalent would be the ballroom of a rich residence, serving at the same time for pleasure and as a symbol of social status; for the bath always had the connotation of well-being (hence, for instance, the importance of astrological and astronomical symbols in baths, as in the domed room at Qusayr Amra) – and royal entertainment (*lahwa*) increased well-being. Furthermore, the Arabs from Arabia considered the bath building one of the higher forms of luxury.

In other Umayyad baths, the large hall had a different shape and fulfilled slightly different functions. At Qusayr Amra it looks like a throne room with a tripartite basilical hall followed by an apse and two side rooms with recently uncovered floor mosaics.[83] Whether it was really a throne room is debatable and depends on the interpretation of the frescoes, to which we shall return presently. At Qasr al-Hayr West, which had a nearby palace with a throne room, the large hall was probably a dressing room.

tion, size, techniques – the Umayyads followed the traditions of Rome and early Byzantium, and in Iraq and Palestine dependence on precise pre-Islamic monuments and types is clear.[84] But at the same time the bringing together of these features and their new use for early Muslim princes, as well as their location outside great urban centres, bestow upon them a specifically Umayyad character.

In addition to their architectural meaning, these secular buildings have yielded an extra-

25. Khirbat al-Mafjar, bath, eighth century (second quarter), mosaic pavement

In summary, the Umayyad châteaux, varying in size and wealth, transformed the fortress and the bath into places for gracious living, according to the norms of the time. In all specific aspects – shapes of rooms, methods of construc-

ordinary number of documents for other aspects of Umayyad art. At Qusayr Amra, Khirbat al-Minya, and Khirbat al-Mafjar, there were many tessellated floors. The most spectacular mosaics are at Khirbat al-Mafjar [25], where the bath

hall was entirely covered with thirty-one different abstract designs, all related to classical themes, but with a decorative, rug-like quality not usually found in pre-Islamic mosaics. These very same characteristics appear at Khirbat al-Minya, where one panel in particular has the colour pattern so arranged as to give the impression of woven threads.

The small private room off the bath at Khirbat al-Mafjar has preserved the best-known of Umayyad floor-mosaics, showing a lion hunting gazelles under a tree [26]. Here again the tassels around the panel suggest a textile imitation. The delicacy of the design, the superior quality of colour-setting in the progressively lighter tones of the tree, and the vivid opposition between the ferocious lion, the trapped gazelle still on the run, and the two unconcerned gazelles nibbling at the tree make this panel a true masterpiece. Its location in the apse of a semi-official room suggests an allegory of Umayyad power, since earlier examples had such a mean-

26. Khirbat al-Mafjar, divan, mosaic of lions hunting gazelles under a tree, eighth century (second quarter)

27. Qasr al-Hayr West, eighth century
(second quarter), detail of the façade

28. Khirbat al-Mafjar, bath,
painted statue of a prince

ing.[85] The stylistic antecedents are to be sought
in the Mediterranean world, but the theme is an
ancient oriental one.

The techniques of painting and sculpture in
Umayyad palaces are not much different from
those of preceding centuries: fresco painting in
the Roman manner, and stone carving as had
been practised for centuries in Syria and Pales-
tine. More important, both for its implication
of oriental influences and for its impact on ar-
chitecture, is the large-scale use of stucco sculp-
ture, probably imported from the east.[86] Its

cheapness and rapidity of execution permit the easy transformation of an architectural unit into a surface for decoration, a tendency common enough in the Sasanian world, and readily apparent on a façade like that of Qasr al-Hayr West [27], where an essentially classical composition was covered with ornamental panels which tended to obliterate or at least minimize and modify the basic architectural forms. But the important issue is why the first Muslim dynasty revived an art of sculpture in the round or in high relief which had all but disappeared. One explanation may be the purely visual impact of the classical monuments which covered most of the Near East and which would have appeared to the Umayyads as characteristic prerequisites of an imperial life;[87] but this question still needs investigation.

Out of the great number of painted or sculpted subjects remaining from Umayyad palaces, the most original are figural representations, which form the majority of paintings at Qusayr Amra and include many fragments from Qasr al-Hayr West and Khirbat al-Mafjar. The subject matter is not always easy to determine, nor is it always simple to distinguish from among the great wealth of identifiable themes – most of which existed in pre-Islamic times – those which were adapted to new Umayyad meanings, and those which were merely used for their decorative value or because they reflected ideas and modes of life taken over by the Arab princes. Various levels of iconographic interpretation exist in the sculptures and paintings which deal with courtly life. Four royal figures remain; whether they were caliphs or not is uncertain. The first, at the gate to the bath of Khirbat al-Mafjar, is a prince standing on a pedestal with two lions [28]. He wears a long coat and baggy trousers in the Sasanian manner and holds a dagger or a sword. The second, at Qusayr Amra, is an enthroned and haloed prince in a long robe under a dais [29]. An attendant with a fly-whisk stands on one side, a more richly dressed dignitary on the other. In front, a Nilotic landscape completes the com-

29. Qusayr Amra, painting of an enthroned prince with attendants, eighth century (second quarter)

position. The other two representations are at Qasr al-Hayr West: on the façade, a standing crowned man in another typical Sasanian outfit [30]; in the court, a seated figure [31] more closely related to the Mediterranean prototype at Qusayr Amra. In all these instances, position as well as iconography imply an official glorification of the prince.[88]

The considerable variations between these images borrowed directly from Sasanian and Byzantine princely representations indicate that, with the exception of a few details,[89] the Umayyads did not develop a royal iconography of their own; this is confirmed by the vagaries

30 and 31. Qasr al-Hayr West,
standing and seated princes

of early Islamic coins.[90] It is, however, important that official representations derived almost exclusively from Sasanian or Byzantine types, for it indicates the level at which Umayyad princes wanted to be identified. An excellent example is the well-known Qusayr Amra painting of the Six Kings [32, 33],[91] where an Iranian

theme of the Princes of the Earth is adapted to
the Umayyad situation by the introduction of
Roderic of Spain, a prince defeated by the Mus-
lims.

These subjects emphasize the strength and
power of the Arab princes. The same theme is
implicit in a number of other representations,

32 and 33. Qusayr Amra,
painting of the Six Kings,
eighth century (second quarter),
with detail

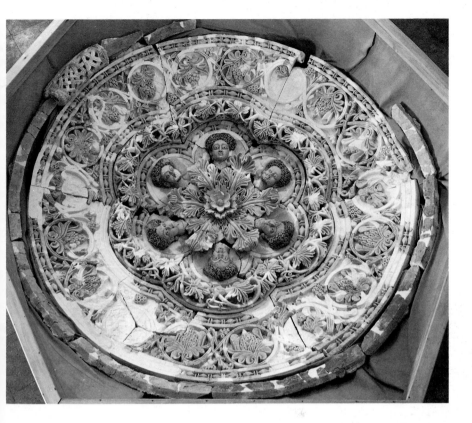

34 (*opposite*). Qusayr Amra, astronomical ceiling,
eighth century (second quarter)

35 (*above*). Khirbat al-Mafjar, divan, dome,
with six heads in a flower,
eighth century (second quarter)

at Qusayr Amra, for example, in the astronom-
ical ceiling [34] with its connotations of cosmic
well-being.[92] Again, in the small room in the
back of the main bath hall at Khirbat al-Mafjar
[35], the striking six heads in a flower on a dome
supported by four winged horses and a proces-
sion of birds may have had some kind of cosmic
symbolism, although here once more a peculiar
ambiguity exists between decorative value and
specific symbolism.

A second royal theme is of particular interest
for three reasons: it was almost entirely bor-
rowed from the Orient through the Iranian
kingdoms conquered by the Muslims; it corres-
ponded to a certain extent to Umayyad prac-
tices;[93] and it remained a constant in later
Islamic princely art and practice. The theme is

the royal pastime. It includes male and female attendants [36], dancers, musicians, drinkers, acrobats, gift-bearers, and activities such as hunting, wrestling, bathing, and nautical games

36. Khirbat al-Mafjar, female attendant, eighth century (second quarter)

37. Khirbat al-Mafjar, dancing figure in a pendentive eighth century (second quarter)

(the latter two shown clearly only at Qusayr Amra). In most instances a prince is the focus, and an idealized court is represented; but as usual there are modifications inconsistent with the official character of the imagery and which illustrate two further aspects of Umayyad art:

its decorative value and its earthiness. At Khirbat al-Mafjar, the use of four acrobats or dancers in pendentives [37] either means a confusion between the court theme and the old motif of Atlantes or, more likely, serves simply to cover the surface of the wall. At Qusayr Amra

the rather crude disembowelment of animals introduces an unfamiliar note to the traditional hunting cycle.

It is not clear why a few non-courtly themes appear: at Qusayr Amra some badly faded erotic scenes and a series of personifications (History, Poetry) with legends in Greek; at Qasr al-Hayr, by Alois Musil.[96] A full study has only begun, and the first investigators concluded that at least the main hall had a formal programme depicting the court and ideology of an Umayyad caliph, either Walid I or, more probably, the rather libertine Walid b. Yazid, who is known to have lived in that area before his brief rule in 744.

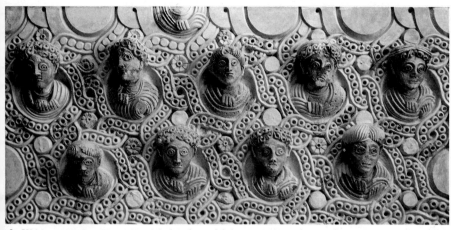

38. Khirbat al-Mafjar, frieze of heads in interlace, eighth century (second quarter)

a curiously classical painting of the Earth, probably to be related to the general theme of royal power,[94] and a sculpture of a prone man with a seated woman reminiscent of Palmyrene funerary sculpture; at Khirbat al-Mafjar, numerous remains too fragmentary to be fully interpreted.[95] Human beings also occur in a decorative context, especially at Khirbat al-Mafjar. Whether painted and fully integrated with a vegetal design, or sculpted and projecting from the decoration [38], their origins are probably to be sought in textiles.

Because of the fragmentary state of the remains, one can only hypothesize about the existence of an iconographic programme at Khirbat al-Mafjar and Qasr al-Hayr West. Matters are quite different at Qusayr Amra [39-43], where removal of soot and dirt from the wall of the bath has brought back to light nearly all the paintings discovered at the turn of the century

However, neither the size of the building nor its remote location point to its being anything other than a private pleasure domain. Its most singular characteristic, apparent as one enters, is that the paintings are so numerous, so closely packed, that none of them, not even a theme, dominates the rooms. It is as though one has penetrated into the tight exhibition space of an art gallery. Then, the coexistence of a prince enthroned in state with a very local round-up of animals [40], of rather lascivious nude dancers with a formally dressed one [41-3], of carefully and vividly drawn figures or animals with miserable drawings, of clear topics with very obscure ones, of highly private images of nude figures taking a bath with the celebrated representation of the Kings of the Earth – all this shows that Qusayr Amra is a rare medieval example of a private work of art, a combination of themes from many sources – from princely typology to

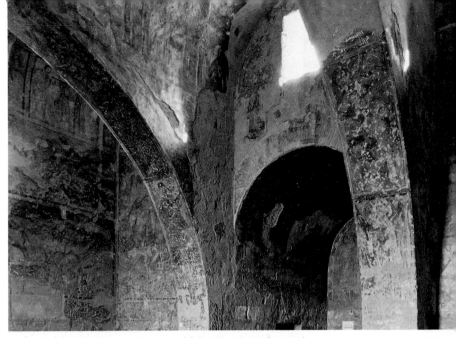

39. Qusayr Amra, bath, detail of interior, eighth century (second quarter)

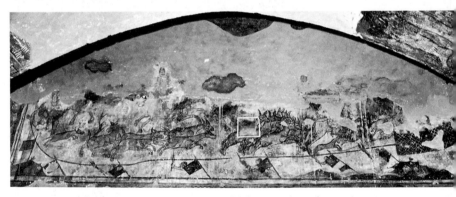

40. Qusayr Amra, bath, painting of animal round-up eighth century (second quarter)

personal whim to local events – which makes sense only from the point of view of a specific patron. What emerges is much less the official statement of a prince than the fascinating personality of someone known only through his private photograph album.[97]

The style, quality, and stylistic origins of these paintings and sculptures vary considerably. In most instances the paintings can be related to 'classical' Mediterranean traditions; but, although a certain loveliness was occasionally achieved, on the whole most figures have such thick outlines, hefty bodily configurations, and lack of subtlety and proportion in the use of shadowing or in composition that the paintings cannot be considered as great works of art.

At first glance, the sculptures are not of very great quality either – witness the crude eroti-

41-3. Qusayr Amra, bath,
paintings of nude and clothed dancers,
eighth century (second quarter)

44. Khirbat al-Mafjar, winged horse in pendentive

cism of the Mafjar female figures. The decadence of sculpture in the round – which is not peculiar to Islamic art at this time – is clearly shown by the fact that the more successful and impressive figures are those in which heavily patterned clothes hide the body. The Umayyads achieved more remarkable results only in a few faces with rough planes and deep sunken eyes reminiscent of the Mediterranean in the fourth and fifth centuries. The background of this sculpture is still unclear. Its main source of inspiration must be sought in Iran, perhaps even in central Asia; but there is some trace also of the local Syro-Palestinian pre-Christian styles of such Nabatean sites as Khirbat al-Tannur[98] or of Palmyra, although we cannot yet tell why this sculpture was revived several centuries after its apparent abandonment. Finally there are instances of simple copying of classical figures.[99]

In addition to human beings, Umayyad painters and especially sculptors represented animals. Most of them are found at Khirbat al-Mafjar: rows of partridges or mountain goats below the bases of domes, winged horses in pendentive medallions [44], and an endless variety of monkeys, rabbits, and pig-like animals in vegetal scrolls. The significance of these frag-

ments is twofold: on the one hand, practically all of them derive from Persian and central Asian models;[100] on the other, they show a far greater imagination and vivacity than the representations of human figures, as is clearly shown in the wild images of Qusayr Amra.

Altogether the representations of humans and animals in paintings or sculpture can hardly be called great art, however interesting they may be, and they do not compare in quality with the mosaics of the great sanctuaries or of Khirbat al-Mafjar and Khirbat al-Minya, or even to the ornament to be discussed shortly. This oddity can be explained in two ways. The artisans responsible for the mosaics may have been more skilled than those practising painting, where local provincials predominated, or sculpture, which was an artificial revival. In addition, the stylistic source of both paintings and sculptures may have been objects, textiles, ivories, silver, gathered by the Umayyads all over western Asia, and the process of magnifying images may have led to the frequent formal awkwardnesses; but this is still hypothetical.

Umayyad palaces have also preserved some purely decorative fragments, mostly carved in stone or stucco and in a few instances moulded in stucco. The greatest number come from the palaces of Qasr al-Hayr West and Khirbat al-Mafjar, but the most elaborate single unit is the façade at Mshatta [22] with its superb twenty triangles of carved stone [45, 46].[101] The variety and complexity of this extraordinary accumulation of material is bewildering. Early attempts to explain it are unsatisfactory because the more recently discovered palaces of Qasr al-Hayr West and Khirbat al-Mafjar have added much more evidence, and because they give a great deal of emphasis to stylistic origins and the division of the twenty triangles into regionally related groups. One example illustrates the unrewarding character of many of these studies. A great deal of discussion has centred around the fact that almost all the panels on the left of the entrance have animals [45], whereas those on the right have no living beings [46]. This led to varying conclusions about the place of origin

of the artists, if not about the symbolic significance of the panels. However a later study proved conclusively that the only reason for the lack of living things to the right of the façade was that this was the back wall of the palace mosque, which could not be decorated in any other way.[102]

Several characteristics of Umayyad sculpted ornament can be defined, albeit tentatively. First, with the exception of capitals and of certain niche-heads, especially at Khirbat al-Mafjar,[103] it follows the mosaics of the Dome of the Rock in developing on its own, unrelated to the architecture. This is true of the large triangles of Mshatta and most of the panels at Khirbat al-Mafjar and Qasr al-Hayr West. Second, except for a few border motifs, the Umayyad artists created their designs within simple geometrical frames – squares, rectangles, triangles, even circles – which occur both on a large scale (for example the triangles of Mshatta or the rectangles of Qasr al-Hayr West) and on a small scale within the single panel. This point is important in explaining the operation of an Umayyad *chantier*. Such a tremendous mass of work was accomplished in such a short time only by means of a large corvée labour force. Some master-mind probably planned the basic outlines and then gave free rein to individual gangs for the details; thence derives the unity of organization as well as the multiplicity of detail.

The third characteristic of Umayyad decoration is the tremendous variety of its themes and motifs. They can be divided into two major categories: geometric ornament, used for borders and frames, but also for such features as the balustrades, parapets, lintels, and windows of Khirbat al-Mafjar (similar to the Damascus ones); and the more frequent vegetal ornament, from the luxurious naturalistic vine of Mshatta to the highly stylized artificial palmette of the Qasr al-Hayr West panel. In between we find almost all the themes and styles prevalent in the Mediterranean, Sasanian, and central Asian worlds of the sixth, seventh, and eighth centuries. It is not yet known whether this eclecticism was due to mass migrations of workers or, as is

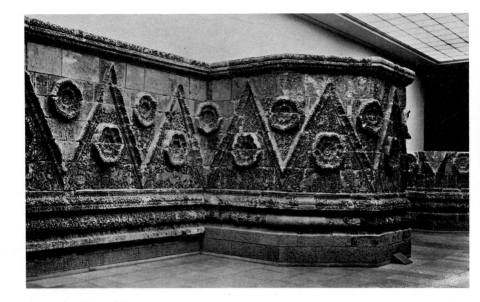

45 and 46 (*opposite*). Carved stone triangles from Mshatta, eighth century (second quarter). *Amman, Department of Antiquities, and Berlin (East), Staatliche Museen*

more probable,[104] to the greater impact, especially in the last decades of the Umayyad period, of men, objects, and impressions from the huge eastern world. The fact remains that the Umayyads provided a sort of showplace and incubator for the decorative arts of all conquered areas. Of course, there are individual characteristics. At Mshatta we have mostly plants of classical origin, in a fairly natural style, with animals from west and east, and, on certain triangles, the superposition of a geometric rhythm of circles. Qasr al-Hayr West has the most stylized decorative motifs, Khirbat al-Mafjar the greatest variety of themes of different origins and in different moods, but none relies on one source only: all express a catholicity consonant with the size of the empire. In addition, many different techniques are drawn on, with a curious predominance of textile patterns. This cheap and rapid reproduction of motifs from expensive sources (the point applies less to Mshatta than to the other palaces) also illustrates something of the *nouveau riche* side of the new civilization.

All this may explain the origins and wealth of Umayyad designs. But is it possible to define the ornament as such? One of its principal features is its cultivation of contrasts. A panel from the façade of Khirbat al-Mafjar contains geometric division of space, highly stylized palmettes symmetrically set in a circle, and a handsomely luxurious double trunk, ending on one side in a fairly natural bunch of grapes and on the other in a geometricized vine leaf. On Mshatta triangles a vigorous and lively movement of stems, leaves, and bunches contrasts with geometrically perfect, static series of circles with artificial pearl borders. At Qasr al-Hayr West the artificiality is more apparent, but even here a simple geometric design appears next to lively palmettes. In every case the background has well-nigh disappeared. All is décor at Khirbat al-Mafjar and at Qasr al-Hayr West, whereas at Mshatta only dark voids remain,

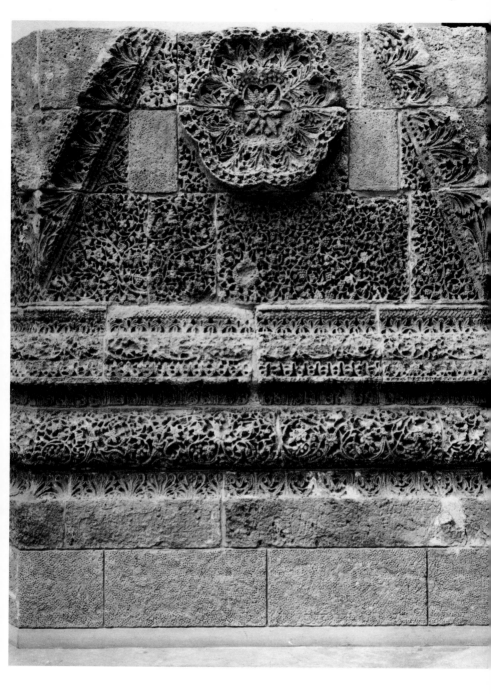

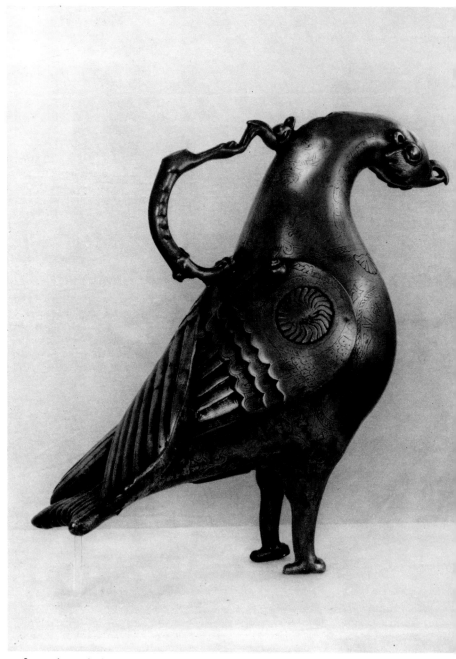

47. Incense burner in the shape of a bird of prey. Bronze.
Berlin (Dahlem), Staatliche Museen, Preussischer Kulturbesitz, Museum für Islamische Kunst

giving the impression of filigree work. It is the opposition between intensely naturalistic and completely stylized features, the tendency to take over the whole surface of the wall, and the presence of so many different elements alongside each other that define Umayyad ornament. It does not yet have the sophistication and cleverness which were later to characterize it, but in feeling it has separated itself from the traditions both of the Mediterranean and of Iran, although individual units and motifs and the general conception of a decoration not fully related to architecture derive directly from one or the other.

THE DECORATIVE ARTS

The study of Umayyad metalwork, ceramics, ivory, and textiles is in a state of flux. In recent years several groups of objects, formerly considered pre-Islamic, have been dated in the seventh and eighth centuries, which could make them Umayyad, if not necessarily sponsored by Muslim patrons. They include metalwork, some so-called post-Sasanian silver pieces, and a group of large and beautifully decorated bronzes,[105] Coptic textiles,[106] ivories,[107] and even stuccoes hitherto thought to be Sasanian.[108] Without taking sides over any particular object, it may be suggested that both the *Prachtkunst* and the more common art of earlier times simply continued, whether or not the new rulers of western Asia or their followers were directly involved in their manufacture, as patrons or as artisans. The wealthy princes and governors of the Umayyad empire collected or were given all sorts of objects from Spain or central Asia, though it is not yet clear whether a new taste or new needs affected any of them. On the other hand, a few objects have stylistic or epigraphic signs clearly indicating Umayyad or early Islamic patronage. These alone will be considered here.

A characteristic metal object of the Umayyad period is an incense burner of yellow bronze in the shape of a bird of prey [47], clearly related to a series of earlier Sasanian zoomorphic thuribles and aquamaniles.[109] With its massive, symmetrically shaped body, broad stylized wings, and ill-boding head, slightly turned to the left in a surprisingly realistic twist, this piece in the Berlin Museum combines a high degree of formalization with an astute characterization of species. At the same time the creature's viability is negated by an elaborate ornamentation on the chest and neck, for the design of birds, rabbits, rosettes, and floral patterns in and around a system of interlocking circles has no obvious connection with the bird. With its stress on a complex design applied to a plain ground and at variance with the object itself, this piece is an early example of a tendency already noted in the surface decoration of the Dome of the Rock, Mshatta, and Khirbat al-Mafjar.

That zoomorphism is not the conditioning factor of this dichotomy is proved by a ewer with a few pronounced Sasanian features, part of a cache of objects discovered near a mausoleum in the Fayyum in Egypt, and traditionally ascribed to the last and then fugitive Umayyad Caliph, Marwan II [48].[110] A series of arcades, which require verticality, is quite non-tectonically applied to a globular body; but the ornamentation is so varied and executed by so many different means (chasing, inlays, ajouré reliefs, and three-dimensional sculpture) that the eye is too preoccupied to observe any contradictions between the motifs and their relationship to the simple shape. In this case the material of the vessel - bronze - is significant, because a luxury object for a Sasanian or Syrian grandee, and even more a king or governor, would have been of silver or gold.

The date of the two pieces so far discussed is approximately fixed by a second, much simpler bronze ewer in the Hermitage, Leningrad. Its massive body and the floral decoration on top of the handle have some of the sculptural qualities of the zoomorphic incense burner, and its designs are outlined by dots, as are some of those on the ewer of Marwan II. An inscription records the date of 67 (or 69)/688-9 and the name of the newly founded town of Basra, an important port and manufacturing centre in lower Iraq.[111] It is the first major Islamic object

to carry the artisan's name - Ibn Yazid - a fact which is all the more remarkable and indicative of future developments because in the first two centuries of Islamic rule, craftsmen generally had a low social standing; only in the ninth century was their importance more readily recognized.[112]

Four pieces of a silk fabric preserved in museums in Manchester, London, Brooklyn, and Brussels have a design in red, green, yellow, and white consisting of roundels with a four-petalled flower in the centre of two concentric circles, stylized flowers in the interstices, and pearl and heart motifs in the border. These motifs have parallels in late Sasanian art, and in particular on a silk now in Liège made at the end of the seventh century in Zandana, a village near Bukhara.[113] The special significance of the four fragments lies, however, in the embroidered inscription which records the place of manufacture as Ifriqiya, that is, modern Tunisia, and the patron as the Umayyad caliph Marwan, probably the second of that name (744-50).[114] This textile from a western region, which uses patterns also found in the heartland and on the eastern border, is an early example of the universal artistic language of the caliphate. The preference of this official court garment for purely floral and ornamental designs, to the exclusion of the animal patterns of other Zandana textiles, reveals the same restrictive tendency as the mosaics of the religious buildings of the Umayyads in Jerusalem and Damascus.

Another textile with Marwan's name which bears confronted roosters in a Sasanian manner indicates that at times the Caliph did employ animal designs, although it is doubtful that this particular Iraqi or Persian piece belonged to the same class of official garments as the silk from Ifriqiya.[115] On the basis of its inscription, the latter is the earliest surviving product of the imperial textile workshops called tiraz, which for centuries supplied enormous amounts of fabric for the caliph's household. They also produced the many robes of honour which the ruler alone could give to his high officials, following an age-old Near Eastern custom attested by Pharaonic history and the Bible (Genesis 41: 42). The immediate prototype here was undoubtedly Sasanian court procedure, although the custom of inscribing patterned textiles with religious texts or with the place of origin was also well established in Coptic Egypt.[116]

The earlier comments about the ornamental character of the stucco decoration apply to wood carving, too - not surprisingly, as it is usually found in an architectural setting. Tie-beams, doors, and decorative panels all betray a decided preference for floral designs, usually executed in a fanciful and luxuriant manner.[117] Unlikely botanical combinations occur, such as vine leaves with pomegranates or cone-shaped fruits. This tendency towards the exuberant is held in check by a strong sense of rhythm and symmetry: the rich floral forms often riot within the framework of simple geometric figures - a circle, ellipse, diamond, a set of spirals, or possibly an arch on columns. Quite a few bone carvings show the same tendencies in a more limited measure, as they are smaller and were made for a humbler clientele.[118]

Little pottery of interest survives. As previously, especially in Iran, ceramics occupied a lowly and mainly utilitarian position. A number of small, rather crude oil lamps, usually unglazed, many with the simplest floral or ornamental designs,[119] were made in Palestine and Transjordan (especially Jerash), probably for a non-aristocratic stratum of early Muslim society. Ultimately derived from Roman relief pottery, and similar to work executed for Christians, they represent a low point in the craft. The signatures on them should, however, be regarded as a 'trademark', which presupposes public recognition of the artisan's work. The dates they bear are of some importance in that Arabic was used as the sole ornamental feature. A few other ceramics with relief decoration may have initiated the art which was to develop later,[120] but on the whole the archaeological record on Umayyad pottery is too spotty to draw many conclusions.

*

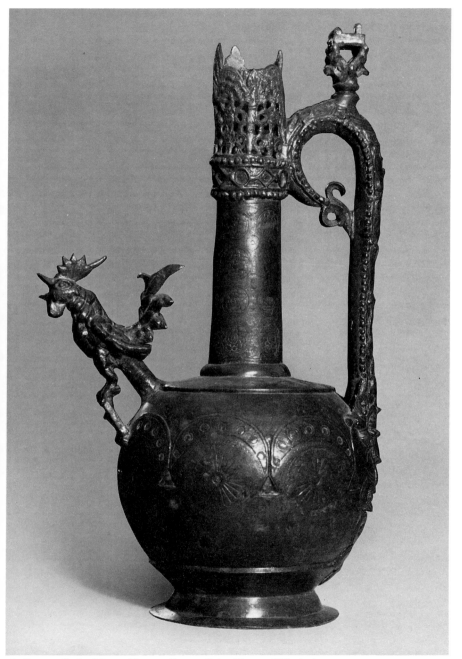

48. Ewer ascribed to Marwan II, *c.* 750. Bronze. *Cairo, Museum of Islamic Art*

It was said many years ago,[121] and has often been repeated, that Umayyad art is an art of juxtaposition and adaptation. This has been confirmed by recent work: the Umayyads indeed took their forms – architectural or decorative – and many of their iconographic ideas from the world they conquered. The only major recent discovery is that they drew much more on the East than has hitherto been supposed, so that their art reflected the full scope of their empire, and not simply its Syrian provinces, where most of the known Umayyad works are found. But we should add the further characteristic of creativity, for the period laid down the traditions which were to shape Islamic art throughout the ages: mosque forms and parts, secular iconography, the use of wall surfaces for decoration, conscious abandonment of religious imagery, new patterns, a tendency towards stylization and non-naturalistic treatment of vegetal forms. The Umayyad world borrowed according to its own tastes and aims. It was a feverish and at times clumsy workshop from which classic Islamic art emerged. Though often unsuccessful or tasteless in its fresco paintings and human sculpture, nevertheless in the Dome of the Rock, Khirbat al-Mafjar, the mosaics of Damascus, and the Mshatta façade it created some of the most significant monuments of the early Middle Ages.

THE ABBASID TRADITION: 750-950

The Umayyad regime was beset by revolts, mostly in Iraq. Occasionally sparked by individual ambition, they more often stemmed from the growing inability of the Arab aristocrats of Syria to cope with the social, religious, and tribal changes brought about by the settlement of so many conquered lands by Arabs and newly converted non-Arabs. By a mixture of punitive expeditions and concessions, the Umayyads at first succeeded in keeping the situation under control, but in 746 an alliance between dissatisfied groups throughout the empire and a greater organization of plotters led to the outbreak of a major revolt in eastern Iran with sizeable support elsewhere. By 750 practically the whole of the Islamic Orient had been taken over, all the Umayyad princes but one had been massacred, and the caliphate had passed to the Abbasids. Formally the Abbasid dynasty lasted until 1258, when the Mongols took Baghdad, but its major cultural and artistic impact was over by 950. This chapter takes us up to that date.

In spite of the importance attached to the Abbasids by medieval chroniclers and by some contemporary scholars, the revolt itself and the change of dynasty did not immediately bring about any major upheaval within the still young Islamic empire.[1] Except for Spain, where the last remaining Umayyad founded an independent principality, the size of the caliphate remained the same. Royal ceremonies were little altered at first,[2] and government personnel came from the same body of Arabs or recent converts as under the Umayyads. Only one early change had momentous consequences: the shifting of the centre of authority to Iraq, which had become economically rich and culturally intense under the Umayyads. This brought the ancient Iranian traditions closer, and permitted a greater infiltration of the Muslim state by Persians. Tensions came to a head after the death of Harun al-Rashid (809), when the Iranian faction defeated the Arab, and authority was temporarily stabilized.

In the ninth and early tenth centuries the Abbasid world appeared to have reached its zenith. The semblance of independence bestowed by dynasties of governors in North Africa, Egypt, and eastern Iran rarely went beyond local matters, and the intellectual and cultural supremacy of Abbasid Iraq - which counted al-Jahiz among its brilliant *littérateurs*, Abu Nuwas among its new poets, and al-Shafi'i among its codifiers of religious traditions, and which was busy with multitudinous translations from Pahlavi, Syriac, and Greek - was not seriously challenged. The clearly defined orthodoxy maintained by the caliphs after al-Mutawakkil (847-61) gave at least the appearance of religious unity. The growth of trade and agriculture led to the accumulation of great wealth in the imperial centres. In spite of the exaggerations of medieval chroniclers, such events as the arrival of a Byzantine ambassador in Baghdad in 917,[3] the marriage of al-Mamun's daughter in 825,[4] and the circumcision of al-Mutazz around 857[5] were celebrated with a conspicuous luxury which struck the contemporary imagination and perpetuated in story and verse the memory of more than one early Abbasid prince. Over time, the ceremonies of the court grew more complex, and the caliph withdrew into mysterious palaces in which chamberlains, guards of all colours, courtiers, eunuchs, executioners, and concubines isolated him totally from his subjects.

The unruliness of the newly formed and mainly Turkish mercenary army, the more profound social dissatisfaction exemplified by slave revolts (the Zanj wars) and by the slow growth of heterodoxies with social doctrines, and the still ill-organized but nonetheless real particu-

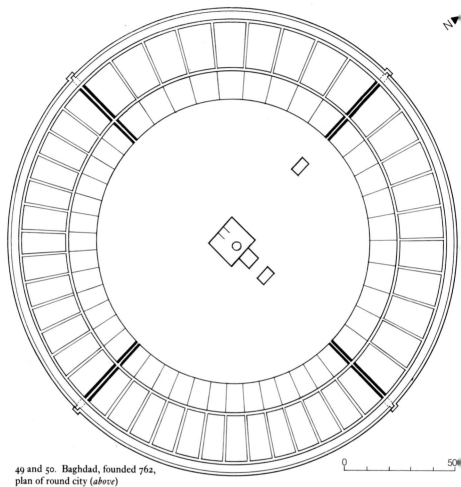

49 and 50. Baghdad, founded 762,
plan of round city (*above*)
and street plan (*opposite*)

larisms in certain provinces all played a part in
bringing about the breakdown of Abbasid
power in the second quarter of the tenth cen-
tury. In 945 a heterodox Shi'ite prince of Per-
sian origin, the Buyid Mu'izz al-Dawla, entered
Baghdad and assumed power under a shadow
caliphate. North Africa, Egypt, parts of Syria
and eastern Iran, and Transoxiana all became
more fully independent and, more important,
developed cultural and economic centres of
their own.

The early Abbasid period, from 750 to 945,
is therefore the last in which one may speak of
the art of the whole Muslim *oikoumené*. Its centre
was Iraq, but its monuments are known as far
west as Kairouan and as far east as Nishapur
and Bukhara. Unfortunately, a great deal has
gone or, like the mosque of Amr in Fustat or
the Aqsa mosque in Jerusalem, been rebuilt
beyond clear recognition. Few archaeological
expeditions have dealt specifically with this
period or uncovered its monuments by chance.[6]

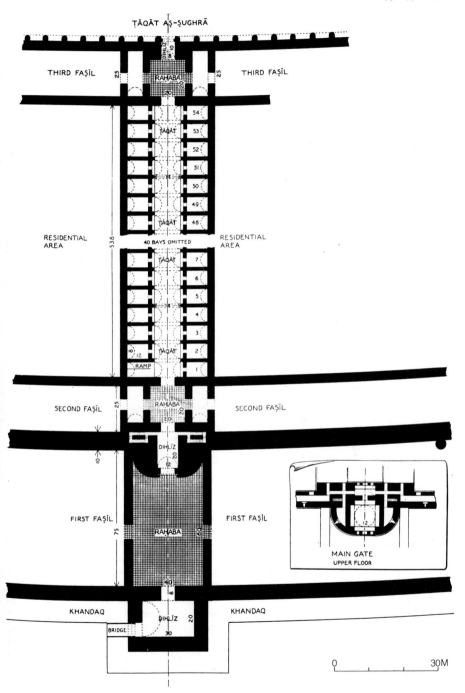

TĀQĀT AṢ-ṢUGHRĀ

THIRD FAṢĪL 25 THIRD FAṢĪL

DIHLĪZ
8 10
RAHABA
20

54
TĀQĀT 53
52
51
50
49
TĀQĀT 48

RESIDENTIAL AREA 538 40 BAYS OMITTED RESIDENTIAL AREA

TĀQĀT 7
6
5
4
3
TĀQĀT 2

8 12
RAMP 1

SECOND FAṢĪL 25 RAHABA 20 SECOND FAṢĪL

10

DIHLĪZ
20
12

FIRST FAṢĪL 75 RAHABA 60 FIRST FAṢĪL

MAIN GATE
UPPER FLOOR

12

40 8

KHANDAQ DIHLĪZ 20 KHANDAQ

BRIDGE 30

0 30M

This lack of information is easy to explain, for, much more than the Umayyads, the Abbasids created urban centres which the Islamic world has developed ever since, and normal growth has obliterated or built over the original work. At the same time, literary sources and some aspects of the decorative arts[7] show that Abbasid artistic traditions had a powerful contemporary impact, tying together monuments from many different regions.

ARCHITECTURE AND ARCHITECTURAL DECORATION

Of the three major Abbasid monuments of the second half of the eighth century, the only one sufficiently well described to lend itself to detailed analysis is also the most important: al-Mansur's Baghdad, founded in 762.[8] Officially called 'City of Peace' (*Madina al-salam*), it was conceived in true imperial style as the navel of the universe, and al-Mansur called engineers and labourers from all parts of Islam to build it. Special bricks were made, and the foundations were begun at a time chosen by two astronomers. It was perfectly round [49] (*c.* 2000 metres in diameter) – a plan by no means new, though Muslim writers considered it so. In the outer ring (reconstructed by Herzfeld and Creswell) were houses and shops protected by heavy walls and cut by four long streets covered with barrel-vaults [50]. Each street opened on the outside through a magnificent two-storied gateway and a complex system of vaults and passages over moats. On the second floor of the gateway, accessible by a ramp, was a domed reception hall (*majlis*), probably to be connected with a Mediterranean imperial tradition, for it was found in Rome and Byzantium and transmitted to the Muslim world by the Umayyads. The entrances were symbolic rather than military; indeed, three of the doors were actually taken from older cities, including one attributed to Solomon.

The extent of the outer ring is uncertain, but the central area was clearly large and, originally at least, mostly uninhabited. At its heart lay a

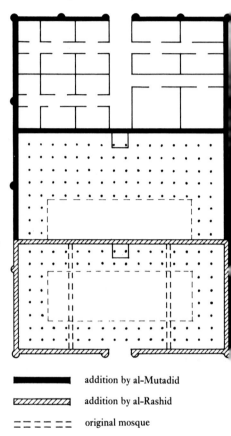

51. Baghdad, mosque of al-Mansur, *c.* 765, with additions to the late ninth century, reconstructed plan

▬▬▬▬▬ addition by al-Mutadid

▨▨▨▨▨ addition by al-Rashid

═ ═ ═ ═ ═ original mosque

palace and a mosque [51]. So far as one can judge from texts, the mosque did not differ much from the earlier hypostyle buildings of Iraq; it was at the same time the royal mosque attached to the palace and the congregational mosque for the whole population of the city. The palace was arranged around a court, an iwan[9] of unknown shape, and two domed rooms, one above the other, all deriving from the Sasanian tradition already adopted in Umayyad buildings in Syria and in Iraq. At the centre of the whole city was a higher dome, the

52. Drawing of automaton rider with lance
on the Green Dome, Baghdad, founded 762

Green Dome, surmounted by a statue of a rider
with a lance [52].[10]

The interest of Baghdad is twofold. First, it
is rare in being conceived and planned with the
cosmic significance of the centre of a universal
empire. Ironically, it remained in its ideal shape
for only a few years, for economic necessity
pushed it out beyond the walls, and caliphs or
major princes abandoned their palaces in the
centre for the quietude and security[11] of sub-
urban dwellings whose names only have re-
mained. Second, many features derive from the

architectural tradition of palaces, for example
both the gates and the domed throne room, and
the overall design with four gates for royal au-
diences. The Abbasid city was thus a magnified
royal palace rather than the rich industrial, ad-
ministrative, and commercial centre that it later
became.[12]

Since nothing is left of the round city of al-
Mansur, it is difficult to say whether new
methods of construction or architectural forms
were introduced. We have only the other two
early Abbasid monuments to compare it with.
One, the complex of cities in the middle Eu-
phrates area known today as Raqqa,[13] is mostly
buried. To the Abbasid city founded in 772
supposedly on the model of Baghdad (it is prob-
ably the horseshoe-shaped city still visible
today), Harun al-Rashid added after 796 a num-
ber of further constructions. There remain
above ground a restored mosque combining
Syrian and Iraqi structural methods and a much
damaged monumental gate [53] whose position
at the corner of the forward city wall suggests
that it was ceremonial or decorative rather than
defensive. This gate is the first surviving work
to have a fully developed four-centred arch and
brickwork used simultaneously for construction
and decoration – two features which were to
play an important part in later Persian architec-
ture.[14] They were probably not invented at
Raqqa; rather they should be connected with
Baghdad. In addition, Syrian excavations
around the city proper have brought to light
some large private 'villas' which are significant
for aspects of decoration (such as elaborate
stucco panels and glass floors, possibly trying to
suggest pools) and as our only illustration of the
growth documented in literary sources of pri-
vate palaces in the city or in suburbs.

More or less contemporary with Baghdad is
the palace of Ukhaydir [54, 55], in the desert
some 120 miles to the south. Creswell related its
construction to events in the caliph's family and
dated it around 778;[15] the date at least is reason-
able. Its location and fortified aspect relate it to
the Umayyad palaces of Syria, but its size (175
by 169 metres for the outer enclosure) and much

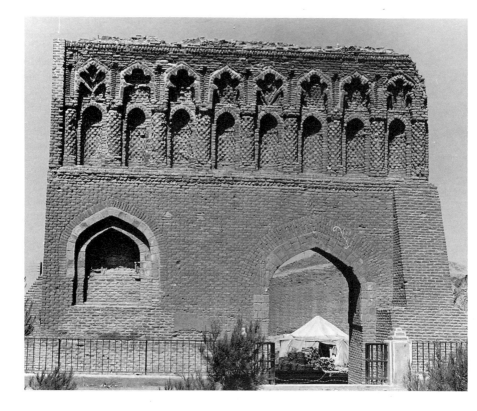

of its construction are quite different. The technique (rubble in mortar covered with stucco and brick for vaults), the heavy pillars making up arched recesses on the side of long vaulted halls, the pointed curve of the vaults, and the use of blind arches for the decoration of large wall surfaces all show the persistence of Sasanian methods. In plan, the entrance complex on several floors preceding a domed room followed by a long vaulted hall [56], plus the central official group of court, iwan, and dome, correspond on a small scale to the textual descriptions of Baghdad. Thus Ukhaydir confirms that in plan Baghdad relied on palace architecture, and in technique on Sasanian methods.[16] In addition, even though the reasons for its location remain obscure, Ukhaydir illustrates the con-

53 (*above*). Raqqa, founded 772, gate, possibly as late as the tenth century

54 and 55 (*opposite*). Ukhaydir, probably *c.* 778, plan and general view

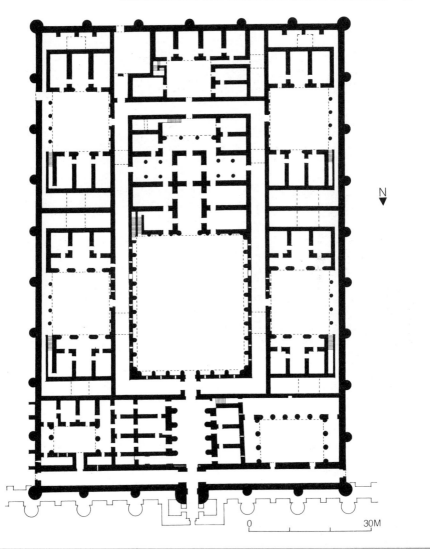

N

0 30M

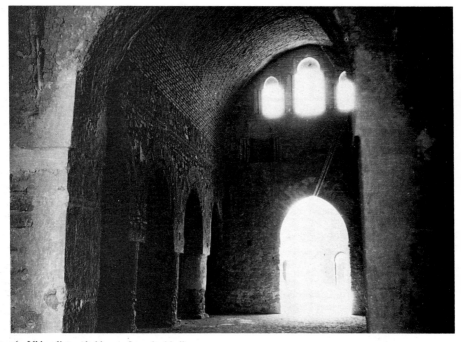

56. Ukhaydir, probably *c*. 778, vaulted hall at entrance

tinuation of the Arab aristocratic tradition of building outside the main cities.

Abbasid architecture of the ninth century shows significant changes. Our knowledge of it derives from two sources. First, in 836, the caliph al-Mutasim founded a new capital, partly because of difficulties between the Turkish guards and the Arab population of Baghdad, partly to express anew the glory of his caliphate. The chosen site was Samarra, some sixty miles up the Tigris from Baghdad. Until 883, when it was abandoned as capital, every caliph added to al-Mutasim's city, creating a huge conglomeration extending over thirty miles [57]. After it declined to a smallish town of religious significance only, the Abbasid city remained in ruins or buried underground, and recent architectural excavations unfortunately remain either unpublished or only sketched out. From texts we know of major Abbasid constructions

in most cities under their rule except in Syria and Palestine (where however there was a significant rebuilding of the Aqsa mosque in Jerusalem).[17] The monuments of Persia have disappeared for the most part, and descriptions, for instance of the ninth-century mosque at Nishapur,[18] are tantalizingly unclear. But fortunately two major mosques of the period, those of Ibn Tulun at Fustat in Egypt and at Kairouan in Tunisia, are still standing, and provide us with our second source of information.

Secular architecture during the century is represented first of all by a series of major public works mainly to do with water conservation and utilization: canals in Samarra, cisterns at Ramla in Palestine and in Tunisia, and the extraordinary Nilometer at Fustat (861) [58],[19] with its magnificent stonework and relieving arches.

Then there are the palaces, of which those at Samarra are the most important, even though

57. Samarra, founded 836, air view

none has been totally excavated. Examination of the available information about the Jawsaq al-Khaqani [59], the Balkuwara, and the Istabulat[20] leads to a number of conclusions. Their most striking feature is their size. All are huge walled compounds with endless successions of apartments, courts, rooms, halls, and passageways, whose functions are not known. From a city in the shape of a palace, as Baghdad was, we have moved to a palace the size of a city.

58. Fustat, Nilometer, 861

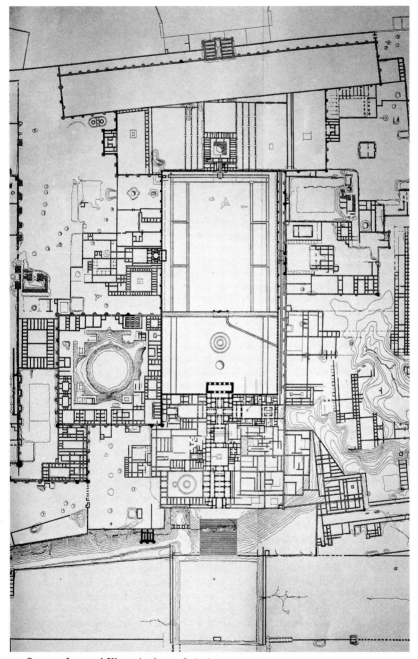

59. Samarra, Jawsaq al-Khaqani palace, c. 836, plan

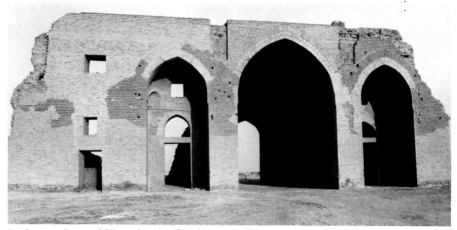

60. Samarra, Jawsaq al-Khaqani palace, 'Bab al-Amma', c. 836-7

Second, each has clearly defined parts. There is always a spectacular gate: at Jawsaq al-Khaqani, an impressive flight of steps led up from an artificial water basin to a triple gate of baked brick, in all probability the Bab al-Amma, the 'main gate', of so many texts [60]. Gates and gateways also appear inside the palaces, and in the Balkuwara a succession of impressive doorways emphasized passage from one court to the other. On the axis of the main entrance a series of courts generally leads to the main reception area, which is cruciform. A central domed room opens on four iwans which, in turn, open on four courts. At times, mosques, baths, and perhaps private quarters fill the areas between iwans. Textual and archaeological sources prove that this cruciform arrangement of official rooms derives from eastern Iran.[21] The only other clear feature of these palaces is the growth of large gardens and parks in and around them, carefully planned with fountains and canals or game preserves or even racing tracks, as is suggested by a rather extraordinary area in the shape of a four-leaf clover discovered through air photographs near the Jawsaq al-Khaqani.[22] The ancient Near Eastern tradition of the royal 'paradise' was adopted by the Abbasids and sung by their poets.

Not much can be said about structural technique: baked and unbaked brick, natural in Iraq, was the usual material and, so far as we can judge, vaulting the prevalent mode of covering. The real importance of these buildings lies in their conception of a royal palace, totally new to Islam, although not unknown in previous civilizations. It is a hidden and secluded world, completely self-sufficient. The fact that its splendour was barely visible from outside sparked the imagination of story-tellers and poets, who began at that time to develop the theme of secret marvels familiar to all readers of the *Arabian Nights*. From Samarra this conception – if not always the scale of execution – spread to the provinces, as we can see from the description of the palace which Khumarawayh b. Ahmad b. Tulun built in Egypt.[23]

Two mosques remain in Samarra, both apparently built under the caliph al-Mutawakkil (847-61). The earlier, the Great Mosque, the largest known in the Islamic world, is an immense rectangle of 376 by 444 metres [61]. Inside a second rectangle, 240 by 156 metres, surrounded by walls and separated from the first by largely empty tracts (used for storage, latrines, ablutions) known as *ziyadas*, is the sanctuary proper – essentially a hypostyle hall

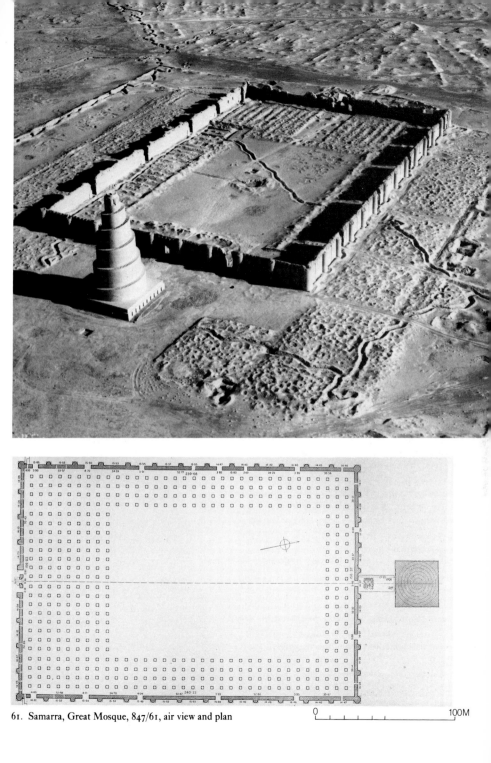

61. Samarra, Great Mosque, 847/61, air view and plan

0 100M

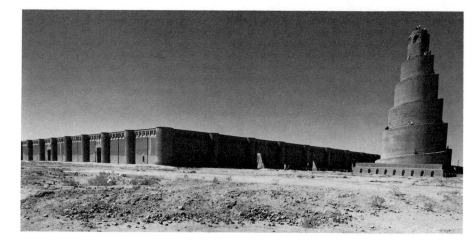

62 and 63. Samarra, Great Mosque, 847/61, outer wall (*above*) and minaret (*right*)

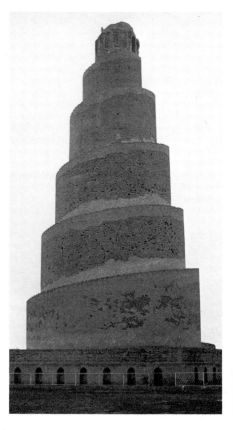

with a court and porticoes. It features octagonal brick piers with four engaged columns on a square base, an inordinately large mihrab decorated with marble columns and mosaics, a flat roof, exterior towers which serve both to alleviate the monotony of a long flat brick wall and as buttresses [62], and a curious spiral minaret [63] on the main axis of the mosque but outside its wall. Such minarets have generally been connected with the ziggurats of ancient Mesopotamian architecture, but this is hardly likely since none has survived in its original shape and they were on an altogether different scale. In fact the source remains a puzzle.[24]

The second Samarra mosque, Abu Dulaf, is also quite large (350 by 362 metres for the larger enclosure; 213 by 135 for the second one) and has the same type of minaret and roof. It introduces two new features, however. First, its arcades stop short of the qibla wall, and two transverse aisles parallel to the qibla separate it from the main part of the sanctuary. Together with the wider axial nave, these aisles form a T with its crossing at the mihrab; hence the type is known as a T-mosque.[25] The mihrab is again

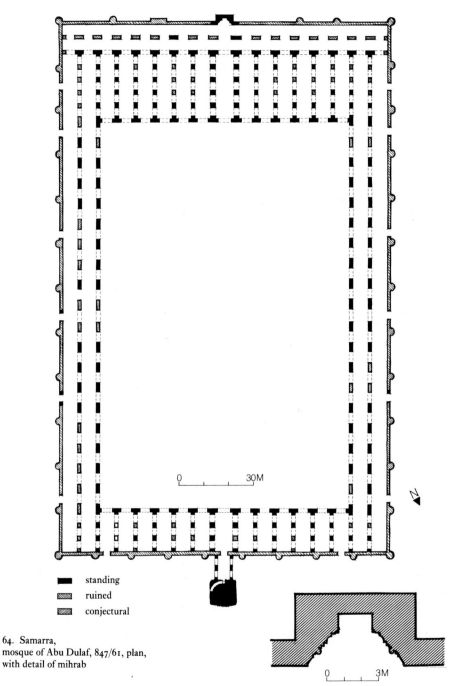

standing
ruined
conjectural

64. Samarra,
mosque of Abu Dulaf, 847/61, plan,
with detail of mihrab

65. Samarra, mosque of Abu Dulaf, 847/61, air view

66. Fustat, mosque of Ibn Tulun, completed 879

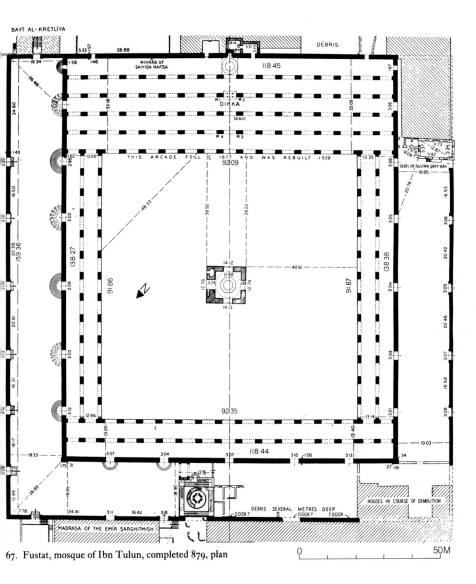

67. Fustat, mosque of Ibn Tulun, completed 879, plan

very large, and excavations have shown that it was connected with a small room behind the building which the prince or the imam could have used before prayer.[26] The second charac- teristic of the mosque is its large rectangular and T-shaped brick piers. Hypostyle buildings usually create the impression of a forest of sup- ports leading the eye in several directions; in

contrast the feeling here is of walls pierced by large and frequent openings leading in a very clearly defined direction.

The inordinate size of these buildings is to be connected with the grandiose scale of all Samarra constructions and not with the need to house a sizeable population.[27] Decoration is simple and sober. The rectangular pier is explained by the custom in the early hypostyle mosque of re-using earlier columns, or of employing wood. As neither was readily available in Iraq, a new support was invented which would not alter the now almost canonical plan. But the very size of the pier entailed a step towards a different equilibrium. For a large simple covered space with small but numerous supports, Abu Dulaf [64, 65] exchanged a more equal balance between fulls and voids arranged in linear fashion, without the possibility of looking in all directions. Iranian architecture was further to refine this new aesthetic approach.

The introduction of the T-plan is more difficult to explain. It may have been an attempt to impose on a large and diffuse plan of equal units a skeleton emphasizing certain major lines; in this sense the T-plan could be understood as a continuation of the axial naves of Umayyad times. In addition, as the Abbasid princes withdrew into their palaces, the mosque began to lose some of its social and political character as the locale where the Commander of the Faithful or his representative met with the faithful to worship and transmit decisions and policies; a professional *khatib* (preacher) replaced the caliph, and the religious and devotional aspects of the building became further emphasized – particularly the wall indicating the direction of prayer and its holiest place, the mihrab. This could be another explanation for the T-plan. However, ruling princes still built all mosques at that time, even if they did not use them regularly, so perhaps the plan was intended to emphasize the *maqsura*, the enclosed area reserved for the prince and his suite; this interpretation coincides with the explanation proposed for the axial nave in Umayyad times and also fits with certain later developments.[28] The

sources do not help us to choose between these technical/aesthetic, religious, and royal ceremonial hypotheses; all provide fruitful lines of investigation, and it can be argued that all contributed to the newly created type.

Outside Iraq, the major remaining mosques of the period are in Egypt and North Africa. In Fustat the old mosque of Amr, though radically redone in 827, remained a rather simple hypostyle structure which was greatly refashioned in the following centuries. Much more important is the mosque built by Ahmad ibn Tulun and completed in 879 [66, 67].[29] Like those of Samarra, it was a monument in a new city to the glory of the talented and ambitious Turkish general who had become the almost autonomous ruler of Egypt. Comparatively little altered during the following centuries (except for the mihrab, the fountain, the minaret, and contemporary restorations), Ibn Tulun is perhaps the most perfectly harmonious of the ninth-century Abbasid mosques. In plan it consists of two squares and a rectangle. Its outer area is a 162-metre square; also a square (of 92 metres) is the court which represents the main interest of the major part, the 122 by 140 m. rectangle. In the centre of the court was a magnificent fountain protected by a gilded dome which fell in 968. The covered parts of the mosque consist of five aisles parallel to the qibla wall and a double arcade on the other three sides of the court. It is entirely of brick, and the supports are rectangular brick piers with engaged columns [68]; the minaret is a fourteenth-century replacement of the original spiral. All these features are atypical of earlier Egyptian architecture and (although later medieval writers embellished them with a great deal of legend) clearly derive from Samarra, where Ibn Tulun had spent many years and to whose Abbasid ideals he was devoted.

The designers of the mosque of Ibn Tulun fully understood the possibilities of the architectural elements with which they were dealing. They opened up those parts of the walls (spandrels of arches, outer walls) which were not essential to the construction and thereby estab-

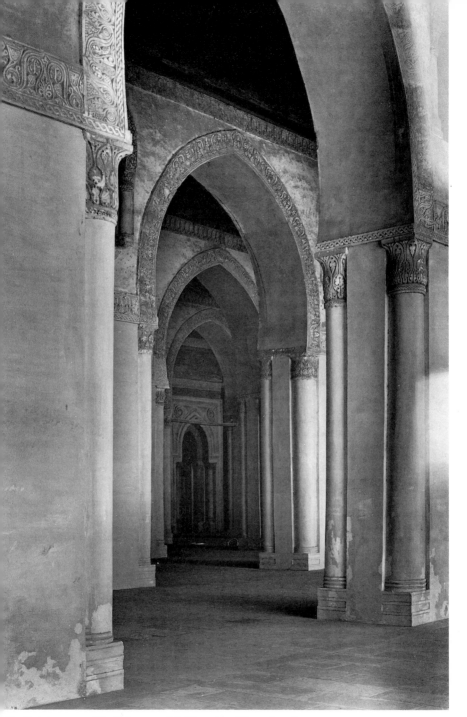

68. Fustat, mosque of Ibn Tulun, completed 879, piers of the east portico

lished a simple but effective rhythm of solids
and voids both on the court façade [69] and in
the sanctuary proper. They also lightened the
outer walls [70] by means of grilled windows
and niches whose position is logically related to
the structure of the interior. In addition, the
decoration was fully subordinated to architec-
tural forms: the narrow band of designs follow-
ing every arch subtly emphasizes the lines of
construction without overpowering them.
Finally, much of the mosque's harmony derives

69 and 70. Fustat, mosque of Ibn Tulun,
completed 879,
court façade (*below*) and outer walls with minaret (*rig*

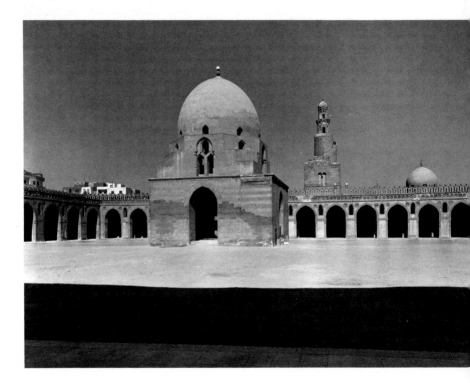

from the artful use of a two-centred pointed
arch slightly returned at the base. It was not
invented here, and its structural advantages are
not of great consequence in this flat-roofed
building, but it provided the architects with a
more refined form to achieve lightness in the
monotonous succession of open bays, and re-
presents the earliest preserved example of the

aesthetic changes implied by the mosque of Abu
Dulaf.

The last major ninth-century mosque related
to the Abbasid group is the Great Mosque in
Kairouan [71, 72].[30] The conqueror of North
Africa, Uqba b. Nafi, had founded a mosque
there around 670, and its memory is preserved
in a wall hidden behind the present mihrab.

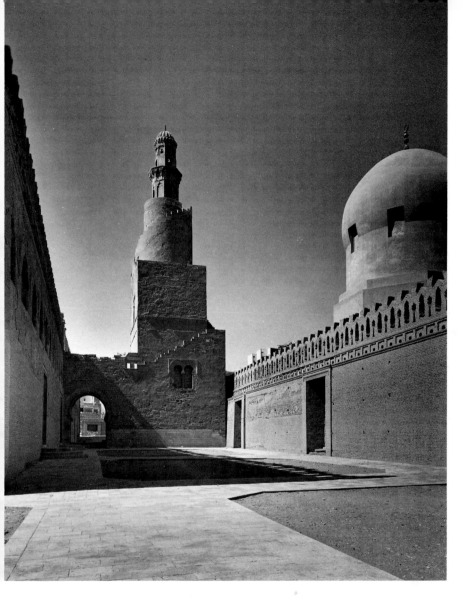

The only other possibly Umayyad survivals are parts of the square minaret; the rest was destroyed in the early ninth century, when the semi-independent Aghlabid governors planned a new building. The first reconstruction took place in 836, and there were major additions in 862 and 875, by which time the mosque had acquired essentially its present form, although Lézine has shown that there was much restoration in the thirteenth century.[31] The building, a rectangle of 135 by 80 metres, was of stone, with narrow rectangular buttresses on the outside. Inside is a perfect example of a hypostyle (its supports mostly columns from older buildings) with courtyard and porticoes. Like Abu Dulaf, it combined the traditional hypostyle

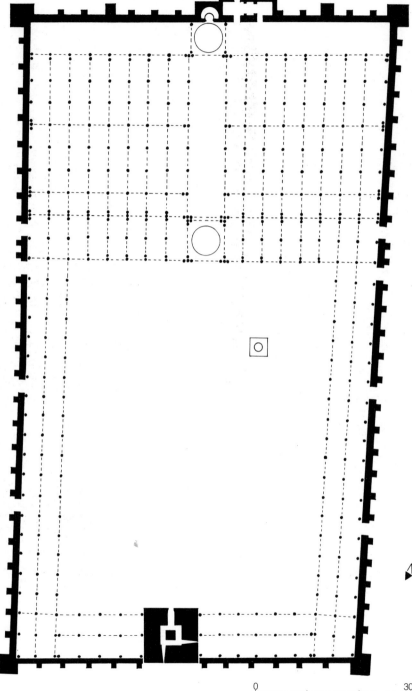

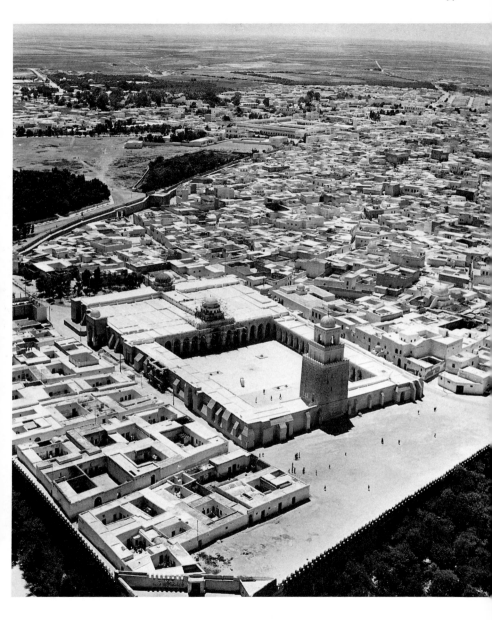

71 and 72. Kairouan, Great Mosque, 836, 862, and 875,
plan and air view

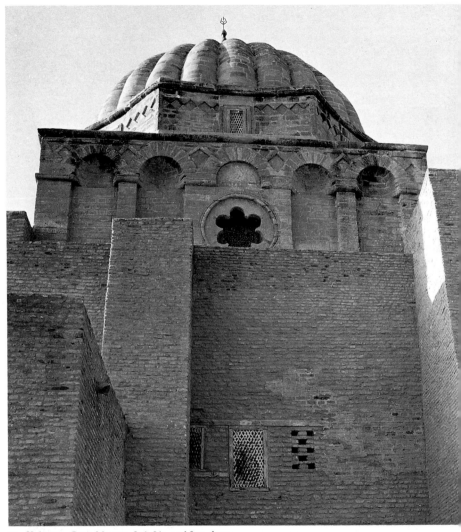

73. Kairouan, Great Mosque, 836, 862, and 875, dome

with a T, which was raised above the rest of the aisles and punctuated by two domes, one at the crossing of the T, the other (later in its present form) at the opening on the court.

Two architectural features deserve further discussion. The first is the domed area in front of the mihrab [73] where, almost for the first time, we see a conscious effort to outshine the rest of the building by the wealth of the brilliant canopy before its holiest place. Magnificent tiles and marble covered the lower part, particularly the qibla wall and the mihrab [74]. Four massive arches support a carefully delineated square; an octagonal arcade on small columns, with four

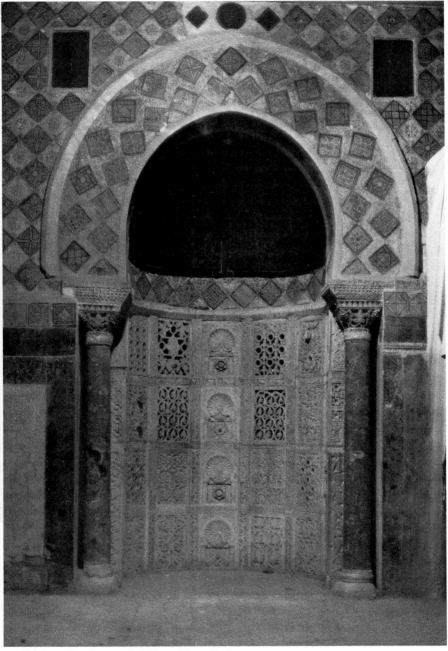

74. Kairouan, Great Mosque, 836, 862, and 875, mihrab

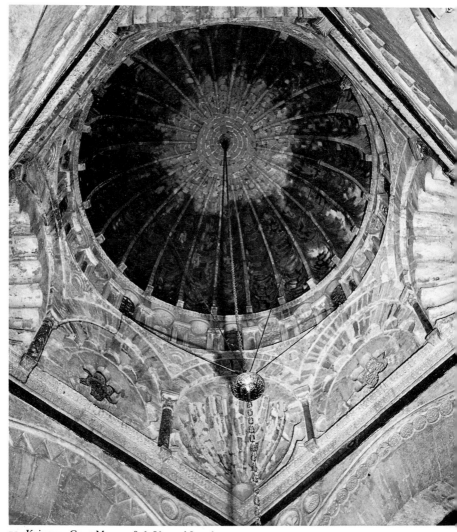

75. Kairouan, Great Mosque, 836, 862, and 875, dome

shell-like squinches and four blind arches of similar profile, effects the transition to the base of the dome; above, a drum with eight windows and sixteen blind niches precedes a cornice and the ribbed stone dome itself [75]. All the empty areas, such as the spandrels of the four lower arches and the transitional arcade, are covered with designs of architectural origin. The outside of the dome is similarly divided into three; but an outer square corresponds to an inner octagon, and an octagon to the twenty-four-sided area.

Marçais astutely brought to light a second significant feature.[32] He showed that the bays opening on to the court are of three sizes: the central one largest, the bays on each side of it and the last one at each end smallest, the other eight of equal and intermediary size. In addition, he demonstrated that the mosque has three axes of symmetry: one through the middle of the axial nave which serves both the whole façade and the equivalent of a triple gate into the covered area, and two lateral axes which pass through the third supporting block of columns from either end. The bays on each side of the central nave can be seen as part of either of the compositions centred on these axes, and serve thereby as a 'relay' between interlocking parts of the façade.

Kairouan illustrates two ninth-century Abbasid characteristics also present in the mosques of Samarra and Fustat. The first is the attempt to organize formally the hypostyle plan almost fortuitously created in the early mosques of Basra, Kufa, Fustat, and probably Baghdad. Second, while the ornamentation of certain parts of the building is intensified, decorative themes are almost totally subordinated to structural forms and often originate with them, and serve mainly to emphasize architectural lines.

A last group of Abbasid monuments are neither mosques nor obviously secular constructions. Their background and significance are not always easy to establish, and they demonstrate how much is still unknown about the period: the octagonal Qubba al-Sulaybiya in Samarra [76],[33] for instance, may be either a mausoleum built for one of the caliphs by his Greek mother or the earliest remaining sanctuary for a Shi'ite imam.[34] An entirely different type of building is the *ribat*, a military monastery developed in early Islamic times on the central Asian, Anatolian, and North African frontiers from which specially trained men engaged in battle against the infidels. Unfortunately it is impossible to say whether the Tunisian examples[35] at Monastir [77] and Susa – small, square fortified buildings with a central court, rooms and oratories on two floors around

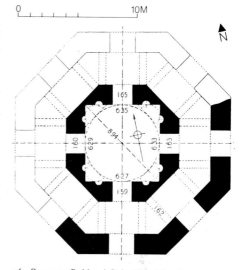

76. Samarra, Qubba al-Sulaybiya, 862, plan

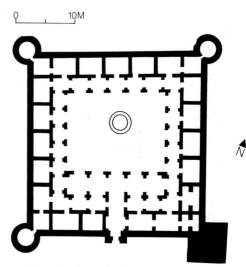

77. Monastir, ribat, 796, plan

the court, and a high corner tower – were peculiar to North Africa or a standard Islamic type.

The Abbasid period, like the Umayyad, is remarkable for its varied architectural ornament. In addition to the decoration of bricks

and arches, painting, ceramics, carved wood, carved or moulded stucco, and a number of other techniques were quite common, although their relative importance varies in different regions. Some pose specific problems and will be examined separately. Stone and stucco, however, and some decorative woodwork, are so intimately tied to architecture that they may more appropriately be considered with it. .

By and large Abbasid mosques were decorated very soberly. At Samarra there is almost no applied ornament, and at Ibn Tulun stucco is used only to emphasize the major architectural lines. At Kairouan and in the Aqsa mosque in Jerusalem - if the latter's fragments are indeed Abbasid[36] - the painted or carved designs on wooden ceilings involved the medium of construction directly. The same subservience to architectural forms or materials appears in the stone decoration of the dome at Kairouan [75], where even the floral designs of the niches and windows of the drum do not detract from the essential sturdiness and massivity of the construction. In other words, much of the architectural decoration of the Abbasid period, especially in mosques, is still quite classical in spirit, even though the themes may have changed. The two major extant exceptions are the qibla wall at Kairouan, where ceramic tiles and marble panels[37] have almost totally transformed the effect of the mihrab area, and the secular buildings of Samarra. The former involve the minor arts, and will be discussed later; here we shall concentrate on the decoration of the palaces and houses of the ninth-century capital in Iraq where, in fascinating contrast to religious buildings, the walls of almost every house and every room in the palaces were covered with decorated and painted stucco (in addition to occasional marble panels), in continuation of Iranian and Umayyad practice.

Most of the material from Samarra was published by Herzfeld, who discovered and studied it in detail;[38] Creswell suggested certain alterations in chronology.[39] Both agreed that, with few exceptions, the Samarra stuccoes can be divided into three basic styles. Their order of

appearance cannot be determined, for the archaeological evidence, however limited, clearly indicates that all three existed, if not always simultaneously, at least throughout the period of Samarra's greatness in the ninth century. Furthermore, they often overlap both on the wall and in treatment of motifs, and any attempt to distinguish them should not obscure the fact that, in spite of some preliminary studies,[40] many problems concerning their origins and relation to each other are far from being solved.[41]

Style A [78] tends to develop within identifiable frames, most commonly in long bands (at times T-shaped), but sometimes in simple rectangles or polygons. Its characteristic feature is the vine leaf, its parts always sharply outlined, with four deeply sunk 'eyes' and often with incised veins. The striking and effective contrast between the theme itself and the deeply carved void of the background can be explained by the peculiar technique of execution *ex situ* on specially prepared mats. Both vocabulary and treatment are related to the vine ornament, already used by the Umayyads, which prevailed throughout the eastern Mediterranean in late antiquity. However, by the ninth century the same few formulas are being dully repeated, and Samarra is not comparable with the façade of Mshatta.

Style B [79] was usually carved freehand, with a greater variety of themes, motifs, and shapes. The motifs develop within much more diversified frames, from all-over patterns to many different polylobes and polygons. Moreover the contrast between subject and background is much less apparent than in the first style, because the design takes over almost the whole surface, and is heightened by the deep grooves around individual motifs. Third, while the vegetal origin of most of the themes is clear,[42] the surface of the individual leaf or flower is almost totally covered with small notches and dots, and its outline has been simplified into an almost abstract shape which acquires its significance only in relation to other units of decoration and to a pre-established pat-

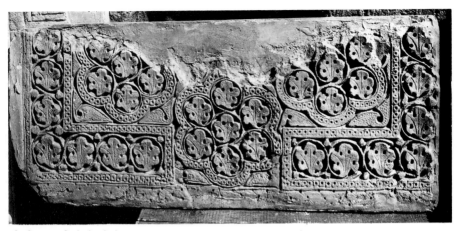

78. Samarra Style A, ninth century.
Berlin (East), Staatliche Museen

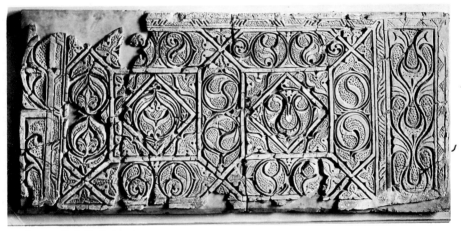

79. Samarra Style B, ninth century.
Berlin (East), Staatliche Museen

tern. While perhaps not very beautiful, this style is peculiarly appealing because in the best examples its symmetrically arranged patterns constantly contrast an inner tension and movement with the rigidity of geometric frames. A Hindu origin has been proposed,[43] but neither the historical context nor other known works of art fully justify it, and the style can best be understood as a variation on late antique ornament suggested by the exuberance of Umayyad art; for the central characteristics described above were already present in the stuccoes of the great Umayyad palaces, and no new and external impetus has yet been identified.

While the first two Samarra styles are related to the tendencies of the first Islamic century,

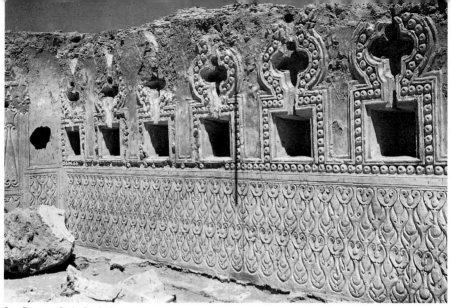

80. Samarra Style C, ninth century.
Berlin (East), Staatliche Museen

the third [80] introduces something quite new and far-reaching in its implications. Its first characteristic results from its technique: the design was moulded, and consists of endless rhythmic repetition of curved lines with spiral endings, at times with additional notches, slits, pearl borders, or other identifiable elements. Moreover, throughout, the lines were 'bevelled' – i.e. they meet the surface obliquely – so that the wall surface has a strongly plastic quality. Next, the style is not identifiable through specific units of design but rather through a certain relationship between lines, notches, and planes; in other words, the unifying factor is no longer the elements themselves but rather their relationship to each other. Furthermore, none of the traditional geometric, vegetal, or animal themes are used, and the background has disappeared, so that in effect the whole surface of the wall is ornament. The final characteristic (at least in stucco) is symmetry on a vertical axis; but (except where the exact size of the wall surface is known, or where the decorator has introduced a geometric unit) the axis is not self-evident from the design, but can vary from place to place.

Thus, the major characteristics of the third Samarra style are repetition, bevelling, abstract themes, total covering, and symmetry. Its significance goes beyond Abbasid architectural decoration, for it is the first – and in certain ways the purest and most severe – example of that 'delight in ornamental meditation and aesthetic exercise'[44] which has been called the *arabesque*. Its impact was immediate, for it appears in the stuccoes of the mosque of Ibn Tulun and in many small objects, and it remained in use for several centuries.

The questions of the origins of Style C and of the exact date of its appearance are more complex. With respect to origins, close analysis reveals possible vegetal patterns of trefoils, palmettes, even cornucopias or vases in the background of many an interplay of line and plane. A series of capitals found in the area of the Middle Euphrates, near or in Raqqa, shows an evolution from vegetal ornament which leads almost to the Samarra pattern,[45] and the third style, like the second, could be another systematized variation on earlier decorative principles which was given striking effect through the use of an original technique and the impact of

metal or wooden moulds. However, the eastern Syrian capitals are not datable with any degree of accuracy; they may be later than Samarra, and therefore perhaps indebted to it. Another explanation, first proposed by Kühnel[46] and amply supported by later archaeological discoveries, is based on the fact that central and even inner Asian wood and metalwork from nomadic areas show a very similar technique and fairly similar transformations of vegetal designs.[47] The difficulty here is the assumption that Turkish soldiers of central Asian descent created a style of decoration based on their memory of their homeland, or on objects brought from it. Samarra's Style C may perhaps better be understood as part of an evolutionary process which would have simplified forms of classical

origin to the point of total abstraction. It is this quality which may explain its widespread impact on the rest of the Muslim world.

THE DECORATIVE ARTS

Carvings, especially in wood, form a natural link with architectural decoration. Made for specific purposes, such as furniture or doors – all objects to be viewed at close range – they were executed on a smaller scale in a more delicate manner, and they encompass a wider repertory of designs. A major work of this period is the minbar in the Great Mosque of Kairouan [81-3], the oldest surviving pulpit (c. 862).[48] It has the simplest possible shape, only two triangular side walls framing the stairs and a platform on top,

81. Kairouan, Great Mosque, mihrab and minbar, c. 862

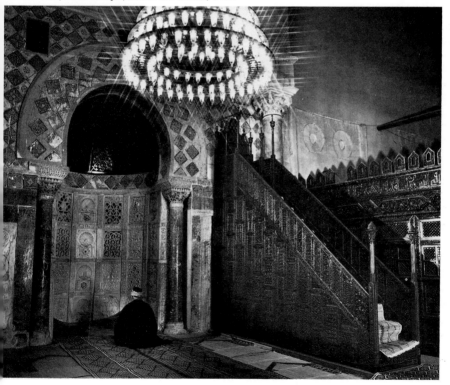

82 and 83 (*opposite*). Kairouan, Great Mosque,
details of geometric and vegetal panels from the minbar

but the function of the side walls is entirely overshadowed by the intricacy of the thirteen vertical rows of rectangular panels on each, exhibiting a rich variety of designs directly based on Umayyad work, though unfortunately modern restoration has obliterated the original composition. The more numerous geometric patterns [82 and 83] are ultimately related to such schemes as those in the window grilles of the Great Mosque at Damascus, whereas the more significant floral compositions go back to the carvings at Mshatta and other sites, except for some new Abbasid stylistic tendencies now being more pronounced. All concern for natural growth and botanical veracity has disappeared, to be replaced by emphasis on abstract floral

84. Door panels, Iraq, early ninth century. Wood. *New York, Metropolitan Museum of Art*

fantasies. Trees, leaves, and fruits of diverse species are shown on the same plant; branches twist in odd, even geometric shapes or have been left out altogether; and familiar forms turn

unexpectedly into others. Although purely de-corative elements are comparatively rare, their richly sculptured surfaces stand out effectively against the deep shadows of the background, and the same elements appear in different com-positions. Such versatility bears witness to rich imagination and inner dynamic force, but the piling up of forms, the unexpected combina-tions, and the ever-changing juxtapositions, as well as the lack of any close relation between the geometric and floral panels, betray an en-deavour that was still unfocused. Although outwardly the artisans had their designs in ad-mirable control, the balance, even spacing, and formal unity in each thematic group show that they were still groping for both the syntax and the vocabulary of the newly developing decor-ative language. The only definite conclusion that can be drawn is that artistic expression tended to be achieved through non-naturalistic and abstract motifs.

In the past, scholars have assumed that these panels were carved in Baghdad, but an early-eleventh-century text[49] states only that the teak beams had been imported from there and the Aghlabid amir had had them made up locally. Similar panels [84], now in the Metropolitan Museum of Art, unearthed in Iraq, perhaps even in Baghdad itself,[50] are less complex and, being quite archaic in style, are obviously to be dated several decades earlier. Furthermore, the carvings on the minbar at Kairouan, though made at a time when Samarra was the Abbasid capital, reflect none of the tendencies towards abstraction of the Samarra stucco styles B and C, and the floral panels lack entirely the hack-neyed quality of style A. Therefore we must assume a cultural time lag, which is easily understandable in so distant a region as Tunisia, belonging to the Mediterranean world of artistic forms rather than to that of the Middle East as Samarra did. This remoteness and distinct cultural tradition explain why, at a time when some artisans of the capital were half-heartedly following old traditions and others had already experimented with new ideas, their fellow-craftsmen in a provincial Mediterranean centre were still employing the ancient vocabulary with full vigour.[51]

Unresolved contradictions in the composi-tion of earlier Abbasid carvings make it clear why products executed in Samarra style C [80] were an immediate and world-wide success. These designs, of unhampered clarity, possess a forcible abstract quality and sculptural full-ness; furthermore, their curves echo an inner relationship among all parts according to a contrapuntal system, so that the all-over com-positions appear entirely integrated. All earlier endeavours are brought into full focus.

The wood carvings made in Tulunid Egypt at the end of the ninth century represent the culmination of the Samarra C style. In the first stages most of the motifs were identical with those of their Iraqi prototypes, although some tendencies became more pronounced. At times there was a marked effort to break up the rather broad sculptured masses into smaller elements and to add secondary surface decoration in the focal areas. Certain small units were frequently used, and in the tenth century a rounded leaf seen from the side became a stereotyped motif [85]. A few features had no counterpart in Samarra, at least so far as is known. The designs, especially in small narrow panels, thus appear as free, asymmetrical compositions.[52] Other new elements were bird and animal motifs, especial-ly the former, rendered wholly or in part [86]. Keeping within the general character of the style, they are abstract, yet can be clearly rec-ognized as related to the floral or vase motifs from Samarra C stuccoes. Their arbitrary and unnatural character is further underscored by the fact that certain parts, for instance the beak, can turn into floral forms. Such metamorphoses from one genus into another had already oc-curred in vegetal decoration, for instance on the minbar at Kairouan [82], but they had now become more deliberate and far-reaching. These fanciful creatures are no mere freaks: the zoological element was preserved and further developed in the subsequent period.

In pottery there had been some advances since Umayyad times, and progress was even

85 and 86. Panels with leaf and bird motifs, Egypt, late ninth century. Wood. *Paris, Louvre*

more rapid during the short Samarra period. In an early phase certain traditional types were simply developed further. The surface of the moulded relief pottery, which in the late Umayyad and early Abbasid periods had been covered with the common, not very appealing green lead glaze,[53] now sparkled with golden lustre, the effect of a metallic pigment applied in a reducing atmosphere during a second firing in the kiln [87]. It had been used before, as early as the eighth century, on Egyptian glass, but in the Samarra period it appeared for the first time on pottery, a technical adaptation which was to achieve a tremendous success in the Muslim East and, via Moorish Spain, even in Italy during the Renaissance. In the Abbasid period the lustred objects were nearly always small, flat-bottomed platters or footed trays closely resembling metal pieces. A similarity to metalwork is also apparent in the decoration, which looks like repoussé. The finished products have therefore no ceramic quality. At one time it was believed that this apparent imitation of gold objects resulted from religious puritanism but,

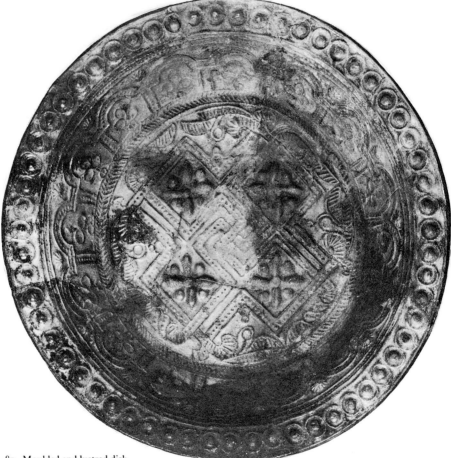

87. Moulded and lustred dish, Samarra, ninth century. *Formerly Berlin*

as contemporary sources speak of the extensive use of gold and silver in the caliph's palace[54] and as the foremost patronage of art emanated from that court, it seems unlikely that the ascetic attitude of official Islam could have brought about such technical innovations. Rather, these pieces were cheap substitutes for more precious objects,[55] and this economic aspect, coupled with the much admired glittering effects, appealed to a wide clientele. Lustre ware was found not only in the palaces but also in the private houses of Samarra, an indication of the eagerness with which the city-dwellers accepted it. It occurred even outside Iraq, in Iran (at Susa) and in Egypt (at Fustat). The same general type of relief ware but with green, brown, and purple glazes – sometimes on one and the same piece – and occasionally with more naturalistic designs, including even animals, was also made in Egypt [88].[56] Although some

dots and splashes in green, yellowish-brown, and purple on white, made a great impression and was at once extensively imitated. The earliest known vessels were found at Tarsus in southern Anatolia,[58] but the type appeared at an early date in all the important centres of the Muslim East, in regions as far apart as Egypt and Central Asia. As always in the Near East, the artisans were aesthetically dissatisfied with the haphazard application of a design – in this instance in the three possible colours of green, ochre, and purple; they tried to control and organize the pigments and, as far as the rather unmanageable materials allowed it, to create simple patterns, in particular radial ones [89]. In other instances, under the inspiration of another decorative technique of the Chinese prototypes,[59] they scratched through the fine white clay to make linear designs by allowing the underlying reddish earthen body of the vessel to show

88. Birds on a glazed moulded dish, probably Egypt, late ninth century.
London, Victoria and Albert Museum

of these pieces are signed by one Abu Nasr of Basra, showing the impact of Iraqi production, the coarser and less glamorous Egyptian variety represents a more archaic stage, still connected with the earlier Graeco-Roman tradition.

The choice of shapes and decoration inappropriate to ceramics and the unappealing coloured glazes were gradually forgotten when Chinese pottery – first more ordinary ware, later even imperial porcelains – began to arrive in the Near East after the middle of the eighth century.[57] These pieces had an enormously liberating and stimulating effect. In particular, colourful 'mottled' pottery of the T'ang period, with its

89. Radial splashware dish, probably Iraq, ninth century. *Oxford, Ashmolean Museum*

through.[59a] There is usually no connection between these sgraffiato designs and the colourful display in the lead glazes overlaying them – a type of uncoordinated juxtaposition also found in the floral and geometric designs of the minbar at Kairouan. Yet, in spite of initially inept results, sgraffiato remained one of the most important ceramic techniques in the Near East

90. Blue and white glazed dish, Iraq, ninth century.
Washington, D.C., Freer Gallery of Art

up to about 1200; apparently through Islamic potters, it also became extremely common in the Byzantine Empire.[60]

The potters could not easily copy imported Chinese white porcelains, for they did not have kaolin, which alone creates the characteristic hard white body. Instead they managed to impart a white colour to the lead glaze by adding tin to it, a practice known earlier in the Near East, particularly in ancient Mesopotamia during the Assyrian period.[61] This white glaze was applied to gracefully shaped bowls and large, wide-rimmed platters. The Islamic craftsmen went even one step farther than their Far Eastern colleagues, skilfully bringing out the fine quality of the glaze by adding contrasting floral, abstract, and geometric patterns, as well as inscriptions, in cobalt blue [90]. The

91. Inscribed blue and white tin-glazed dish, Iraq, ninth century.
Detroit Institute of Arts

whole is often framed by a festooned edge. The inscriptions were executed in an angular type of Arabic script generally (and imprecisely) termed 'Kufic', after the Iraqi town of Kufa [91]. They usually consist of pious invocations, or give the name of the potter,[62] mostly in the very centre, attesting to the increased social standing of the craftsman. At times, however, the legend seems to betray illiteracy through meaningless repetition, just as in other, slightly later pottery types only parts of words are given. This first decorative use of writing for its own sake demonstrates the profound appeal that Arabic script exerted, to the point that a few words, even a syllable or combination of letters, had a strong, possibly magical effect. It seems significant also in this context that such a new function of writing occurred at a time when the

92. Polychrome lustre-painted dish
with palmette design, Iraq, ninth century.
Paris, Louvre

93. Polychrome lustre-painted dish
with winged palmettes, Iraq, ninth century.
New York, Metropolitan Museum of Art

characters themselves began to be transformed ornamentally by the addition of wedge-shaped endings.

Artistically this ware is remarkable on two counts. First, the Near Eastern potters were quite suddenly able to execute free and easily composed designs that stand out on uncluttered surfaces, unaffected by the *horror vacui* of so many earlier and later systems of decoration. Second, we have here the first instance of blue designs on white background, a combination later to be exploited in every possible way by Yuan, Ming, and Ching potters and their European imitators, all using a different process to achieve the same colour contrast. At times the green and yellow pigments of the mottled wares were also introduced, usually in the form of free-flowing streaks, which served as one more means of setting off the more formal blue decoration.

The same workshops produced still another type of pottery, which, unlike the blue and white variety, long remained popular in the Islamic world. Around 850 metallic lustre began to be used, not as before to cover the whole surface of

an object, but in more limited fashion to create patterns on the white tin glaze. The earliest experiments involved at least two different metallic compounds, so that sketchy floral designs came out in ruby red and gold, to which yellowish and purplish tones were shortly added [92].[63] About a decade later the patterns became more precise and complex, and included not only floral themes but also quite often pairs of wings (the so-called winged palmettes) [93] and sometimes, at a slightly later date, highly stylized animal forms, many of them mainly in a brownish lustre combined with yellowish, golden, and greenish tones [94]. Secondary motifs filled the areas between the main sections of the design: dense rows of hatchings, spirals, dots, and often also ovals enclosing thick dots (the so-called 'peacock's eye' design); even the less important outer sides of the vessels were decorated with bold, slanting strokes. The potters were apparently anxious to create as elaborate a lustre surface as possible while always leaving enough of the white background to serve as a foil. In the reduction of shapes to pure abstraction and the density of surface patterns, this is

94. Polychrome lustre-painted dish
with bird design, Samarra, ninth century.
*Berlin (Dahlem), Staatliche Museen, Preussischer
Kulturbesitz, Museum für Islamische Kunst*

95. Monochrome animal design on a lustre-painted
ceramic dish, Iraq, late ninth/early tenth century.
Cambridge, Fitzwilliam Museum

the ceramic counterpart of the Samarra stucco
style B.

About 875, designs began to be restricted to
single tones – yellowish and greenish – and,
perhaps on the inspiration of coloured glass
mosaics and *opus sectile*, lustre was used mostly
for silhouettes of animals set against back-
grounds of heavy dots or tiny chevrons, the
whole still quite often framed by a festooned
edge [95]. The animals were reduced to their
most basic shapes and always rendered in an
absolutely flat style. The pervading incorporeity
was sometimes even further stressed by in-
congruous patterns of inscription panels on the
animals' bodies.[64] Eventually the pottery came
also to include human figures, rather awkwardly
drawn, though they have the appeal of the pri-
mitive [96]. The heaviness of the design is
counteracted by an undecorated white area that
usually follows the outline of the figure, the so-
called 'contour line'. This device, which had
already been used in prehistoric pottery,[65] now
again served the purpose of effectively separat-
ing the main motif from the all-over background
patterning.

96. Monochrome lustre-painted jar, Iraq,
probably tenth century.
Washington, D.C., Freer Gallery of Art

Monochrome lustre production apparently came to an end some time after the middle of the tenth century. Technically not as brilliant as the types made in the second and third quarters of the ninth century, it yet enjoyed a tremendous vogue, as its wide dissemination indicates: pieces have been found in considerable numbers in Egypt and Persia, and some fragments even as far away as Madinat al-Zahra in Spain and Brahminabad in Sind (now Pakistan).[66] All are stylistically identical and have the same material aspect as the majority of the earlier 'Samarra pottery' - which might point to a single production centre.

The popularity of this new technique led to further innovations. Lustre painting was at times applied to vessels already adorned with cobalt blue, clearly demonstrating that the two emanated from the same workshop.[67] This first experiment in combining decoration *in* the glaze with decoration *on top of* the glaze was soon given up, possibly because the lustre motifs were too profuse and too loosely composed to allow proper integration of the two techniques. The idea was, however, taken up again more than three centuries later, with great success.

In another experiment lustre was applied to ceramic tiles, reviving an ancient Mesopotamian form of wall decoration that had flourished in Assyrian and Neo-Babylonian times and was still in use during the Parthian period. The earliest examples from Samarra [97] show a bird framed in a wreath, a motif that had appeared on painted stucco tiles in the early third century - for instance those at the synagogue of Dura-Europos.[68] Just as the first potters of the Islamic period had imitated shapes and decorations of a better-established medium, metal, so the tile-makers copied an older manner of embellishing architectural surfaces. Of greater significance, however, was another feature, the interlocking octagons formed from units of such polygonal tiles framing a square tile. It was the first use of a more complex system in which two different shapes were skilfully combined - yet another artistic idea that had no immediate consequence, but would be successfully taken up

97. Polychrome lustre-painted tile, Samarra, ninth century.
Berlin (Dahlem), Staatliche Museen, Preussischer Kulturbesitz, Museum für Islamische Kunst

again in ceramics in the late twelfth and thirteenth centuries. Another and slightly later type of lustre tile, of which 150 have survived in and around the mihrab of the Great Mosque of Kairouan [98], carries the same decoration as the lustre pottery of Samarra around 860.[69] As these tiles are in excellent condition and more numerous than the scantily preserved and often fragmentary vessels, they yield a better insight into the decorative repertory of Abbasid ceramics. Although they may not have been intended for the area around a prayer niche, it is nevertheless surprising to find that some are upside down or have the patterns turned at angles of forty-five degrees. This must mean that the designs as such were of no real significance; what mattered was the golden brilliance and the ever-changing optical effects of the lustre, with its inherent possibilities for transcendental associations. Here again is the first expression of an artistic idea which would reach full fruition in a sacred setting only much later.

98. Kairouan, Great Mosque, lustre-painted tiles in mihrab frame, c. 862, with other tiles and a capital

Undoubtedly all the pottery found at Samarra was made in Iraq, probably in several cities; the historian Yaqubi reports that potters were brought to Samarra from Basra and Kufa.[70] Another source informs us that about 862 some faïence tiles were imported to Kairouan and that others were made on the spot by a man from Baghdad.[71] Georges Marçais observed that the tiles of the Kairouan mosque – both monochrome and polychrome – are stylistically and technically uniform; they therefore probably all represent the Baghdad type. This example indicates that there must have been other itinerant craftsmen working in the Iraqi manner elsewhere in the Muslim world. That they were in possession of closely guarded trade secrets is attested by the technically less successful imitative lustre wares made in Egypt after the middle of the ninth century; imitations from eastern Persia or Central Asia were not

99. Fragments of
glaze-painted vessels,
Samarra, ninth century.
Formerly Berlin

even executed in lustre but used a yellowish slip in an attempt to create similar coloristic effects, though lacking the metallic sheen.

The experimental character of Samarra-period pottery is apparent from fragments of still another luxury type found in the palace of Jawsaq: the very thin, well-levigated ware in which glaze was used only for the geometric and floral designs or inscriptions, which then stood out as shiny green, blue, and yellow areas on a matt, nearly white clay ground [99].[72] This is a development from the more primitive process of inserting small bits of green or bluish glaze into a reddish body, used for common pottery in the late Sasanian and early Islamic period in Iran.[73] Such glaze-painted ware has been found only rarely at other sites, but knowledge of the process must have been preserved, for it reappeared in Persia during the early part of the thirteenth century. This is especially significant, because it is the first instance of an earthy material being contrasted to glazed particles, an idea which was later applied with great success in architectural decoration from the middle of the eleventh century on, leading finally to the most sumptuous wall coverings in Anatolia and Iran.[74]

THE ART OF THE BOOK

In the ninth century the art of the book – which at that time meant the embellishment of Koran manuscripts – also took on specific forms, of which some became canonical. At first these manuscripts were usually wider than they were high [100], at times close to square, and until the third quarter of the tenth century they were written on parchment or vellum. The peculiar format cannot yet be fully explained; possibly the scribes were following a religious injunction to differentiate the sacred book from ordinary ones,[75] and also from the Hebrew scrolls of the Pentateuch or the vertical Greek Gospel codices. Perhaps monumental inscriptions of large rectangular format as used in architecture were also influential.

100. Page from a Koran, MS. 32, f. 62r, ninth/tenth century. Colours and gilding on parchment. *Washington, D.C., Freer Gallery of Art*

101. Page from a Koran, detail of sura opening, ninth/tenth century. Colours on parchment.
Cairo, Dar al-Kutub

The Koran may first have been illuminated as early as the Umayyad period, although no dated copies survive from that period. Initially there was some theological objection to such interference with the holy writings, but the pious urge to beautify the sacred text prevailed. The ornament also performed the functional task of separating verses and, particularly, chapters (*suras*). From the beginning, sectional headings were rather ambitious in scope, although at first space was available for little more than narrow decorative bands, usually of textile character but still without inscribed titles [101].[76] An important feature from the outset was a complex vegetal design that projected from the decorative band into the margin, apparently an additional sign of a new chapter because in some slightly later manuscripts it was the sole indication beside the chapter headings. Various ornamental marginal devices served as section markers or had other functions. All these were derived from late antique, including Sasanian, art; the idea of combining them with rectangular bands may, however, have come from Roman inscription tablets with projections like handles (*tabulae ansatae*).

In the ninth century the decorative bands separating the suras became wider, so that they could contain the chapter titles, usually reserved from a field of vegetal motifs in gold [102].

102. Page from a Koran, sura opening, MS. 30, f. 6or, ninth/tenth century.
Washington, D.C., Freer Gallery of Art

Marginal decorations, too, took on more ample proportions, in the ever-varying shapes of imaginary floral composites, often of Sasanian derivation, joined directly to the rectangular panels. Gold was generally used in two tones, as certain areas were first coated with a darker brownish pigment. The brilliance of some of the gold designs was also brought out by a subtle use of mainly blue and green.[77]

The most spectacular form of embellishment consisted, however, of a full-page frontispiece [103], or of two with similar large-scale compositions confronting each other; occasionally such pages also occurred at the end of the book. The overall design was usually subdivided into two or three sections, or given a wide frame; unity was achieved by means of an elaborate system of interlacing. Geometric motifs prevail, with floral patterns used only as fillers. Certain parts of the design consist of dots, so that they resemble panels of mosaic and *opus sectile*. The general organization of such pages is related to that of contemporary bookbindings, which, however, to judge from surviving examples [104], were much simpler and less luxurious.[78] The frontispieces, like the sura headings, carry large composite floral arrangements in the outer margins and had become an indispensable feature of all rectangular decorative panels in a book.

103. Frontispiece from a Koran, MS. Rutbi 198, probably tenth century. Colours and gilding on parchment.
Tunis National Library

104. Bookbinding, probably tenth century. Leather with blind tooling.
Tunis National Library

Unfortunately, none of the early Korans is dated. Furthermore, in most instances the full-page illuminations have become detached, and it is very difficult to establish from which part of a manuscript they came, or to date them, let alone to attribute them to specific places of origin. It has been suggested that these decorative pages began in the tenth century; but since a Palestinian Hebrew manuscript of 895 has five [105], most of them in the contemporary Muslim manner, it seems reasonable to suppose that this type existed at least as early as the end of the ninth century.[79] Moreover it can be assumed that the style was universal, for on the whole the arts and crafts of this period reflect an Abbasid *Reichsstil* with few regional differences. The decorative frontispieces seem to correspond to the illuminated pages with portraits of pagan Greek or Christian patrons or authors; in one Koran section we even find the same framework as around the sixth-century dedication portrait of a Byzantine princess, though in the Muslim version it encloses only a simple rosette [106].[80]

105. Illuminated page from a Karaite Hebrew manuscript, Tiberias, 895. *Cairo*

106. Frontispiece from a Koran, MS. 1406, ninth/tenth century. Colours and gilding on parchment. *Dublin, Chester Beatty Library*

Concerning the function of these frontispieces in a Muslim context it is possible only to speculate. They were probably testimonials to religious piety, showpieces of conspicuous wealth, or, like the 'carpet pages' in Hiberno-Saxon manuscripts of the seventh and eighth centuries, had some religious significance. The illuminator, in his endeavour to limit himself to lines and abstract forms, his almost total spurning of the many decorative possibilities of Arabic script, and his reliance on the brilliant yet insubstantial qualities of thinly applied gold, revealed an uncompromising striving towards the spiritual and the absolute. As his artistry was devoted to a task of almost unequalled sacredness, his vocabulary provides insight into what may be called basic Muslim forms of expression. Among them is a tendency to provide a clear, solid, yet interlocked surface organization, and to create within each larger unit a series of coordinated symmetrical compartments whose contents, though distinctive enough on closer inspection, play only a secondary role. Furthermore, there is no intimate relationship among these motifs, which appear rather indistinct and are subordinated to a general impression. Moreover, these secondary features – not unlike those of Kairouan lustre tiles [98] – have a vibrant quality which contributes to the dissolution of the two-dimensional composition by extending it subtly into depth; though the precise range of this spatial addition remains undefined, the artist has actually broached the third dimension. This physical and optical play with spatial forms creates an inner tension that counteracts what would otherwise be a static composition. All these phenomena seem to be more than limited early manifestations of a specific art form, for many of them recurred in later Muslim works of art.

PAINTING

The German and Iraqi excavations at Samarra brought to light many fragments of large mural paintings in dwellings, in bath houses, and, most important of all, in the domed central hall, the harim, in the palace of Jawsaq.[81] As was to be expected from the location of the capital and the political situation, the classical strain still predominant in Umayyad figural representations was overshadowed at Samarra by what may be called a pictorial style in the old Persian tradition. Lively animals in full movement, drawn in the Hellenistic manner, still occurred, and one of the more imposing frescoes of the palace consisted of powerfully composed *rinceaux*, with branches like cornucopias, inhabited by human and animal figures – a theme common in later classical art. The bulk of the paintings, however, represent nearly static, heavily built, expressionless human figures and animals with close parallels in Sasanian silverwork, seals, and a few contemporary textiles; also similar is the treatment of the motifs as patterns and the lack of interest in landscape and the *mise-en-scène*.[82] Comparable material has been found in frescoes from Central Asia and Chinese Turkestan.[83] The physiognomy and coiffure so common at Samarra occurred in Turfan, and frescoes recently excavated by Soviet scholars at Varakhsha and Pyanjikent, though in many respects quite different, also exhibit some related features.[84] As E. Herzfeld, original excavator of the Samarra material and the foremost writer on the finds, already clearly saw, these paintings have to be regarded as a mixture of strongly orientalizing versions of Hellenistic themes on the one hand, and motifs and modes of representation derived directly from the ancient Orient on the other. The use of both three-quarter and frontal views of the human face clearly demonstrates this dichotomy. Some marked differences are also apparent, however, foremost among them the pronounced preference for the female figure, which was already manifest under the Umayyads, while in early and middle Sasanian art it had played a very minor role. Unfortunately, the finds were too limited to allow much generalization about favoured themes, but obviously the pleasures of the court – the hunt, dance, and the drinking of wine – are frequently represented. Other subjects may be of a more

symbolic nature or intended simply to produce rich surfaces; historical sources even tell of a wall painting showing a monastic church.[85]

A typical example of this art is the scene of a huntress from the harim, reproduced here after Herzfeld's reconstruction [107]. The main huntress's garment contribute to the unrealistic quality of this skilfully composed work. All the Jawsaq paintings were designed by Qabiha, mother of the Caliph al-Mutazz, then covered with whitewash by his puritanical successor al-Muhtadi.[86]

107. Huntress fresco (copy) from the Jawsaq palace, Samarra, ninth century

figure has often been compared with the huntress Diana, but the face has a distinctly Oriental cast, with its long hooked nose and fleshy cheeks, as do the bunch of black hair at the back and the slender curl at the temple. She seems animated, as do her prey and the dog, but the movement is both exaggerated and petrified, an effect further accentuated by the expressionless gazes of both huntress and prey. The decorative spots on the animal and the patterned fall of the

Like the other arts, the paintings from Samarra were apparently influential elsewhere in the caliphate. The Tulunids of Egypt even went one step farther: the second ruler had painted wooden statues of himself, his harim, and singing girls put up in his palace,[87] a most unorthodox artistic display yet one that, in its presentation of the courtly pleasures, fitted well into the general picture of themes known to have gratified the lords of this politically complacent period.

THE BREAKDOWN OF THE CALIPHATE

This section is, chronologically and historically, less coherent than those which precede and follow it, for it is impossible to maintain strict chronology over an area extending from the frontiers of China to the Atlantic Ocean and at the same time to identify regional or dynastic peculiarities. The three areas considered here – Spain and the Maghrib, Egypt, north-eastern Iran – began to develop away from the Abbasid caliphate at different times and for different reasons. Two of them, the Muslim West and Egypt, continued quite independently after the momentous changes of the second half of the eleventh century in the east, yet were influenced by some eastern novelties such as the muqarnas and the madrasa. Nor at this stage of research does the study of objects lend itself to as precise a chronological framework as architecture. Thus, while all three areas illustrate the breakdown of the caliphate, our account of two of them will be carried beyond the middle of the eleventh century and, especially in architecture, will imply some awareness of changes not discussed until Part Three.

CHAPTER 4

THE MUSLIM WEST: 750-1260

The only survivor of the Abbasid massacre of Umayyad princes in 750 was Abd al-Rahman b. Mu'awiya, who escaped to Spain. There, thanks to the large number of pro-Umayyad Syrian settlers, he succeeded in becoming an independent governor, and until 1009 his descendants ruled the part of Spain conquered by the Muslims and created there a most remarkable kingdom. It reached its apogee in the tenth century, under Abd al-Rahman III and his son al-Hakam (912-76). At that time the Umayyads of Spain assumed the title of caliphs and their capital, Cordova, was one of the wealthiest and most brilliant cities of the medieval world. Not only were its poets known throughout Islam, also influencing the budding secular poetry of the Christian West, but in many other ways the Umayyad caliphate of Spain was the single most powerful cultural centre of Europe.

After 1009, two crucial changes affected the politics of the Muslim west. One was the new Christian expansion of the Reconquista, which moved relentlessly southward from Castille and Aragon, so that by 1260 only a minuscule Muslim kingdom remained in Granada. The other was the shift of Muslim power from small warring feudal lords (the *muluk al-tawa'if*, 'the party kings') to newly grown Berber dynasties from Morocco, primarily the Almoravids (1056-1147) and the Almohads (1130-1269). These were the centuries during which the Maghrib (today's Morocco and parts of western Algeria) developed from wild frontier areas to major Muslim centres, as the cities of Fez,

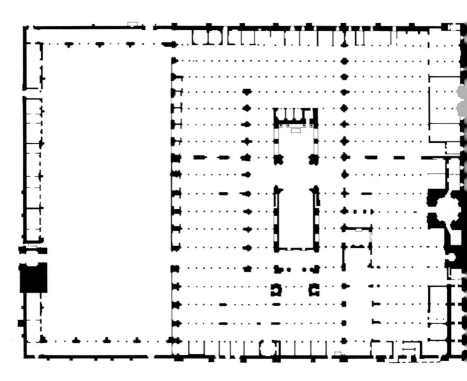

108. Cordova, Great Mosque,
784-6, 833/52, 961/76, and 987, plan

ARCHITECTURE

Marrakesh, Rabat, Tinmal, and Sijilmassa grew wealthy thanks to trade with black Africa. The Berber dynasties tried but failed to stop the reconquest from the north. Yet it would be wrong to see these centuries exclusively in terms of war and conflict, for it was a brilliant intellectual era, as Muslims, Jews, and Christians, sometimes separately, sometimes together, embarked on major philosophical, literary, and scientific adventures. Ibn Hazm, Ibn Rushd (Averroes), Ibn al-Arabi, Maimonides, Ibn Gabirol, and the translators of Toledo all flourished during these centuries of political instability.

The Umayyads of Spain: 750-1009

The most remarkable monument of the Umayyad caliphate in Spain is the Great Mosque at Cordova [108]. Today it is a 190 by 140 metre rectangle of which about a third is occupied by a courtyard planted with orange trees and surrounded on three sides by a much restored portico. On the fourth side is a long hall of seventeen naves on sixteen arcades running south-west-north-east, incorrectly thought to be in the direction of Mecca. The naves are thirty-two bays deep and seven metres wide except for the sixth from the south-west, which is eight metres wide. In the middle of the hall is a whole Gothic cathedral, and there are Gothic or later chapels elsewhere. In the heavily restored buttressed outer wall are eleven ornamented doors.

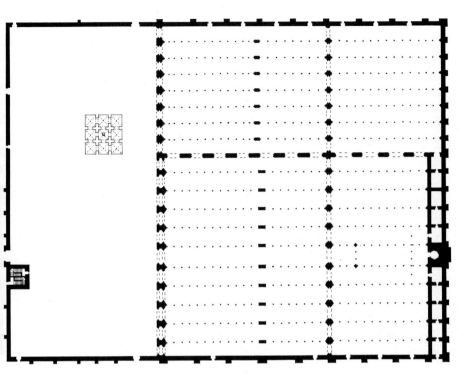

109. Cordova, Great Mosque,
784-6, 833/52, 961/76, and 987, construction

This rapid description makes it clear that the monument was not built all at once. The Muslim work can be divided into four periods [109] distinguished (except in a few details)[1] by literary and archaeological documents. The first mosque, built in 784-6, probably on the site of an older Christian church,[2] consisted of nine or eleven twelve-bay naves, the central one wider than the others, at right angles to the qibla wall. Abd al-Rahman II (833-52) made the first additions, possibly widening the hall by two naves and certainly lengthening it by eight bays.[3] The second expansion, the most remarkable of all, is attributed to al-Hakam II (961-76). He leng-

thened the mosque by another twelve bays, and on the axis provided by the central nave of the first building erected a spectacular group [110] beginning with the dome (the present Villaviciosa Chapel[4]) and ending with three more domes in front of a richly decorated mihrab [111] in the shape of a circular room.[5] The area in front of the mihrab was separated from the rest of the mosque, constituting a maqsura. In 987 al-Mansur, the minister of the caliph Hisham, made the third addition [112]: an eight-nave widening towards the north-east[6] which consciously used the earlier methods of construction[7] and gave the completed work a more traditional ratio of width to length, but destroyed the axial symmetry. The importance of the ninth- and tenth-century additions made by various Umayyad princes is secondary.[8]

The mosque of Cordova, like so many other early hypostyles, re-used features (especially

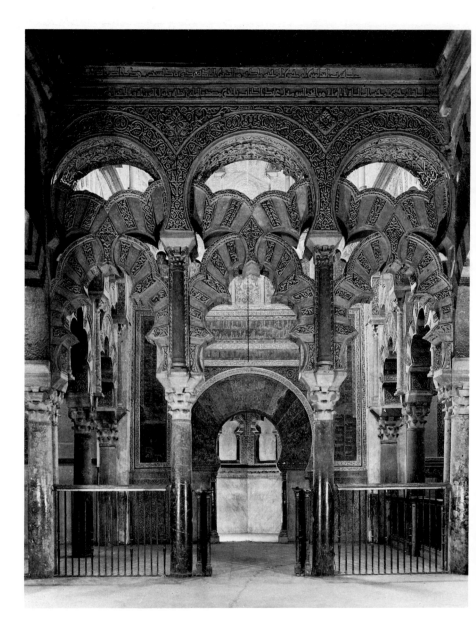

110 and 111. Cordova, Great Mosque, maqsura and mihrab, 961/76

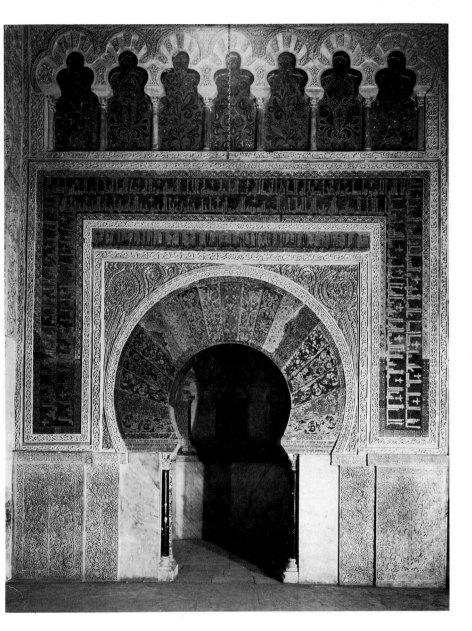

columns and capitals) from pre-Islamic build-ings. However, a number of major innovations transformed it into one of the great monuments of medieval architecture. The first, found in the superstructure over numerous but short sup-ports, creating a most original aesthetic effect which is strengthened by the alternation of col-ours in the stone and brickwork of the arches.

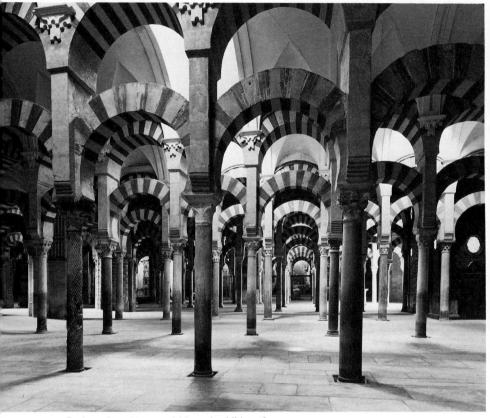

112. Cordova, Great Mosque, al-Mansur's addition, 987

original mosque and maintained in all succeed-ing additions, consists in raising the height of the building by erecting two tiers of arches, the lower supported by regular columns, the upper by long and narrow piers inserted between the lower arches and resting on the columns. Spain could not provide the monumental columns so characteristic of Syria, and the available ones were too small to allow of a large hypostyle area: hence this highly developed and impressive

The second innovation involves the arches, the domes, and the mihrab of al-Hakam's addi-tion. The slightly returned semicircular arches of the first building become polylobed [113]; instead of maintaining the single arch as a com-pleted unit, the architects broke it up into small parts which, in turn, created a complex pattern of intercrossing arches used both as supports in the construction and as decorative designs on the walls and gates. The third innovation con-

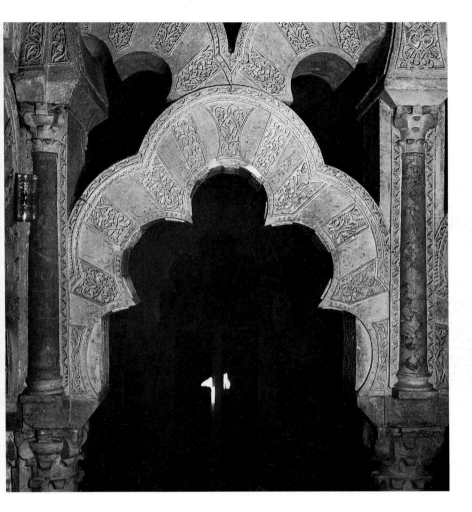

113. Cordova, Great Mosque, polylobed arch, 961/76

114. Cordova, Great Mosque,
dome in front of mihrab, 961/76

cerns the four domes. The main dome in front
of the mihrab preserves the traditional octagon
based on the squinch, but is carried on eight
large ribs resting on small colonnettes fitted
between the sides of the octagon [114]. It is thus
shortened, and its base has a staggered shape
formed by twenty-four mosaic-covered centri-
petal ribs. The other three domes provide vari-
ations on the same theme, the most interesting
occurring in the Villaviciosa Chapel, where the
ribs transform a rectangle into a square.

The structural significance of these innova-
tions is difficult to assess, but one point is quite
clear. Changes in the construction of arches and
in the appearance of domes led to a great in-

crease in the decorative value of both; originally
simple architectural forms and lines are trans-
formed into complex ones and broken up into
smaller units, each of which in turn becomes a
decorated surface or shape, for instance every
single stone of the arches or the newly created
triangular areas between the ribs supporting the
domes. The pure forms of the classical dome
have developed into infinitely complicated com-
binations of lines and shapes, of which almost
all derive more or less directly from specific
units of construction. The Muslim architects of
Spain immediately recognized the decorative
significance of the Cordova innovations, as
shown by the rather unusual small mosque, Bab
Mardum, in Toledo [115, 116] (now the church
of Cristo de la Luz), datable around 1000, in
which nine small domes are decorated with

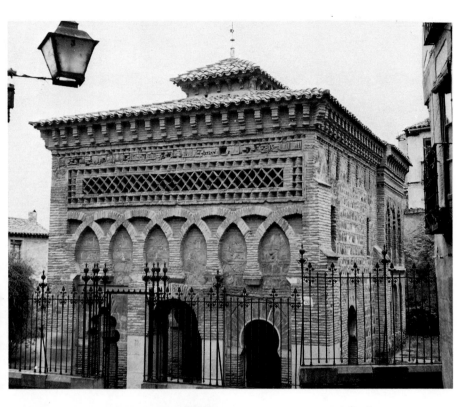

115 and 116. Toledo, Bab Mardum, *c.* 1000,
general view and dome

structurally nearly useless ribs arranged in dif-
ferent patterns.[9]

The ribs of Cordova have often been com-
pared to those of later western Christian archi-
tecture; they have also been related to ribs found
in Armenian churches[10] and to certain features
of Sasanian and later Iranian dome construc-
tion.[11] An oriental origin has also been assigned
to the polylobed arches, which indeed occur in
the decorative niches of certain Abbasid build-
ings (palace of al-Ashir in Samarra, mosque of
Ibn Tulun). Most of these hypotheses are still
uncertain. However, the example of the Villa-
viciosa Chapel, where the masonry of the dome
has been examined,[12] shows that the architects

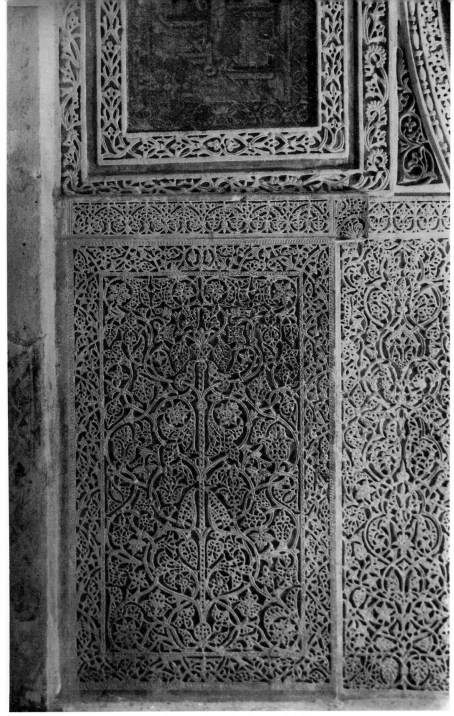

117. Cordova, Great Mosque, marble fragment from mihrab area, 961/76

of Cordova were not fully aware of the structural possibilities of the rib in permitting lighter vaults; nor does later Islamic architecture in the West seem to have truly noticed them. Hence it is hardly likely that these ribs in themselves had any influence on the development of vault construction in the Christian world.

The question of origins is a difficult one. Although the history of Iranian methods of construction in the first Islamic centuries is almost totally unknown, the late-eleventh- and twelfth-century monuments with which Cordova is compared show a similar attitude toward forms rather than the same architectural and decorative motifs. With respect to the polylobed arches, it is questionable whether Spanish builders would have transformed oriental decorative shapes into forms of construction, when in most instances the evolution runs in the opposite direction. Therefore, within the present state of knowledge, the arches and vaults of Cordova are more likely to be local Spanish developments which began with the double tiers of arches in the mosque of 784, while at the same time the relationship between construction and decoration at Cordova finds equivalents in other parts of the Islamic world.

The last important points about the mosque of Cordova concern the mihrab. Its shape of a whole room is unusual, and its original effect must have been either that of a darkened opening into another world or, if a light was put into it, of a beacon for the Faithful. Its numerous inscriptions, almost entirely Koranic,[13] include the proclamation of divine glory on the cupola, statements about ritual obligations, and references to royal rights [114]. Perhaps under the influence of the surrounding Christian world, the mihrab appears to have acquired a much more precise liturgical, ceremonial, and religious meaning, and the tenth-century mosque seems indeed to have developed unusual rites, for instance, the carrying of the Koran in procession.[14] This ceremonial and symbolic aspect of the mihrab and its relationship to royal ceremonies may well explain why its horseshoe shape within a rectangular frame was used for

gates, and most specifically, as early as 855, for San Esteban, one of the main gates into the mosque from the adjoining palace.[15] This formal ensemble will remain characteristic of most of western Islamic architecture, without being always as fully charged.

In spite of its disturbed and irregular plan, the mosque of Cordova, then, is a most extraordinary monument in which the genius of Islamic architects for a perfect blending of architecture and decoration finds one of its first and most brilliant expressions. The tenth-century architects of al-Hakam developed structural and decorative forms which, like those of Samarra and Kairouan, provided the hypostyle building with a new order and a new emphasis; the spectacular display of arches and domes on tiny and insignificant columns is, however, characteristically Spanish Islamic.

The secular architecture of Umayyad Spain is known through some public works[16] and particularly through the large and still mostly unexcavated expanse of Madinat al-Zahra, the palace which Abd al-Rahman III transformed into a city.[17] Work began in 936. In size and complexity Madinat al-Zahra recalls the great Iraqi Abbasid palaces, though it differs in details of plan and construction, in so far as we know them: the reception halls are of the more traditional 'basilical' type with five aisles opening on a foreroom[18] and on a court.

Finally a word must be said about Umayyad Spanish architectural decoration, although little has so far been done on classifying themes[19] or plotting evolution. The mosque of Cordova [117] and especially the palaces of Madinat al-Zahra [118] abound in mosaics, marble sculpture, carved stone and stucco, and carved and painted wood. In the mosque, the decoration of capitals, brackets of the piers supporting the upper tier of arches, alternating stones of polylobed arches, and on cornices and ceilings is largely subordinated to the forms created by the architects. Only in the mihrab and on some of the gates did the need for special luxury lead to a more systematic covering of superb mosaic, marble, and stucco; but even then – for instance,

118. Madinat al-Zahra, begun 936, reception halls

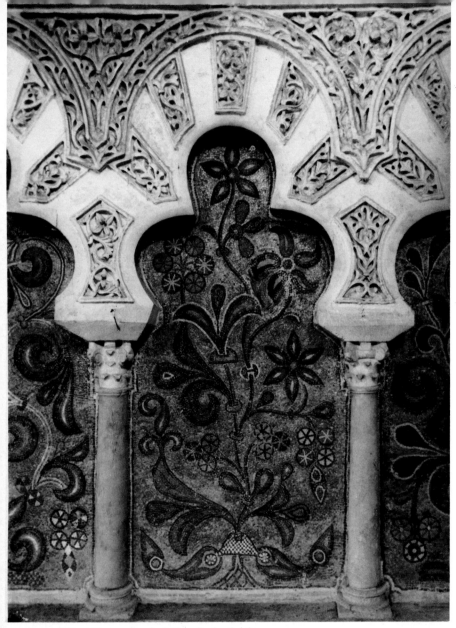

119. Cordova, Great Mosque, mosaics in the mihrab, 961/76

in the way the mosaic patterns follow the complex lines created by the architect [119] – the wealth of ornament serves chiefly to heighten the dramatic effect of the structure. In the palaces, on the other hand, perhaps following the traditions established in Umayyad Syria, decorative panels seem to have covered most of the walls of the main halls, and though (unlike

Khirbat al-Mafjar and Qasr al-Hayr) there is a lack of completely preserved or even securely restored rooms, one should probably imagine the same simple or complex geometric frames enclosing a luxurious tapestry-like decoration.

The morphology of this ornament has not yet been worked out in detail, but certain peculiarities stand out in comparison with ninth-century Samarra or Kairouan. First, in spite of some geometric or figural ornament,[20] the vegetal element predominates, in the form of endless variations on the vine and acanthus of antiquity; the classical element may derive from local Roman or post-Roman tradition, Byzantine influence, or the very eclectic usage of the first Umayyad art of Syria. Second, the ornament of Cordova and of Madinat al-Zahra is much subtler than at Kairouan and even than in much of Syria (except at Mshatta). It refines infinitely upon the same basic themes. On certain capitals, for instance [120], and in a superb marble panel to the side of the mihrab of al-Hakam II, it introduces a fascinating movement of stems and leaves around a rigid axis, in which the basic symmetry is for ever contradicted by the asymmetry of the details, and constant changes in the plane relationships of separate units contrast with the primary effect of an opposition between the plane of the design and the invisible background. Finally, this ornament is conservative; it does not reflect the revolutionary designs of the Samarra stuccoes but relies on interlace and the same few floral shapes. Its quality lies in the inventiveness of its modulations rather than in the discovery of new themes.

Classical, refined, and conservative, Spanish Umayyad architectural decoration did not have the same success in every technique. While the endless fragments from Madinat al-Zahra are monotonous in theme and treatment, and there is an almost schematic simplification of composite capitals, curiously the stucco and marble work is usually of much greater quality than the mosaics, which are technically quite good, but lack the richness and luxury of the stuccoes. The interplay of light and shade and the sharp-

120. Cordova, Great Mosque, capital, 961/76

ness of outline so characteristic of stucco could no longer be adapted to coloured tesserae, and the brilliant designs of older work do not seem to have been available to the artists of the tenth century in Spain. Though Byzantine masters may have executed the mosaics, the designs were apparently supplied by local artists trained in other techniques.[21]

North Africa and Spain: 1009–1260

The most important religious monuments of the time are closely related to the growth or creation of cities in the western part of North Africa and in Spain. Algiers (1096), Tlemcen (1136), Fez (the Qarawiyin Mosque, mostly

1135), Tinmal (*c.* 1035), Marrakesh (1146-96), Rabat (1196-7), and Seville (1171) all acquired new or completely rebuilt congregational mos-ques,[22] varying in size from the comparatively small one in Tinmal (48 by 43 metres) [121] to that in Rabat [122], one of the largest

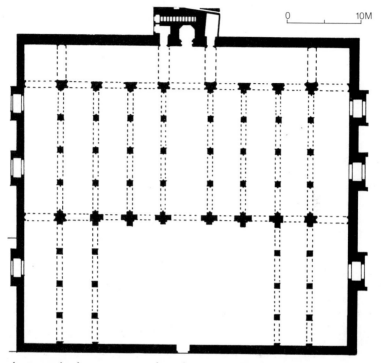

121. Tinmal, congregational mosque, *c.* 1035, plan and general view

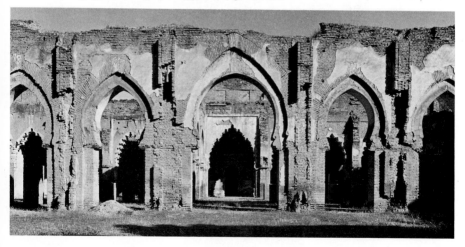

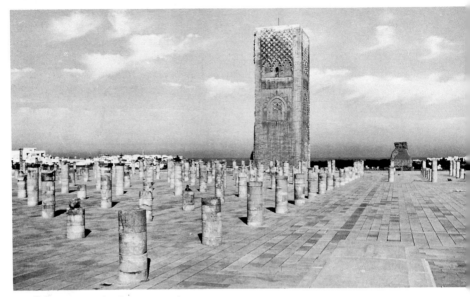

122. Rabat, congregational mosque, 1196-7

123. Rabat, Oudaia Gate, Almohad

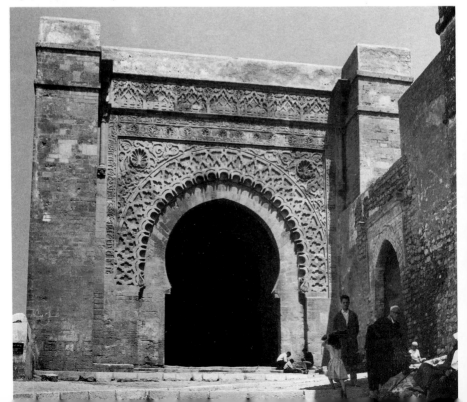

124. Tinmal, congregational mosque, *c.* 1035, dome in front of the mihrab

known.[23]The simple plans continue the early T-hypostyle mosques, but a new emphasis is given to the T by rows of domes pointing to the central nave and the qibla wall, or by three aisles parallel to the qibla, as at Rabat, where twenty-one perpendicular naves abut on these aisles. In Rabat there were two additional small courtyards in the midst of the covered area, while Tinmal, in addition to a central axial nave, has a wide aisle along three of the four walls, as though framing the mosque. Following the earlier Cordovan practice, the mihrabs are deep and usually project beyond the outer wall (perhaps in connection with the movable minbar).[24] The minarets, of which the most celebrated are the three at Seville, Rabat, and Marrakesh, are traditional square buildings. Almost nothing is known of other types of religious architecture, except for a few mausoleums in eastern North Africa,[25] and the still unexplained so-called Qubba al-Ba'adiyin, in Marrakesh.

Finally, a word must be said about military constructions. Many fortresses survive in part in Morocco and Spain,[26] and the Almohad gates of Marrakesh and Rabat [123], with their wide and heavy horseshoe arches on low supports, establish the basic lines for all later western Islamic gates.[27] The palaces of central Algeria seem, at this stage of research, to be more closely tied to central and eastern Mediterranean architecture, and are therefore most appropriately discussed in the next chapter.

Western Islamic constructions of the twelfth and thirteenth centuries continued in nearly all ways the traditions of the past. Supports, columns, and piers are clearly related to earlier practices, and the roofs of many mosques were flat and wooden, often, as in the Kutubiya in Marrakesh, with remarkable structural effects. Of greater interest are the arches, either simple horseshoes or, more often, variations on the polylobes of Cordova. The use of plaster for the polylobes permitted an increased number of profiles for the shaping of the interiors; thus, at Tinmal, the importance of the aisles is indicated by the degree of development of the arches, with the most spectacular ones around the dome in front of the mihrab [124].

The two most important aspects of the western Islamic monuments are the development of the muqarnas and the variety and use of decorative motifs. In the twelfth century the dome on ribs tends to disappear and the dome on squinches (as in the superb Qubba al-Ba'adiyin in Marrakesh) is rare.[28] Both are usually replaced by a dome of muqarnas, first fully developed in the east, to whose meaning and origin we shall return.[29] The muqarnas of North Africa, certainly derivative, is used on square or rectangular plans. It is not structural, but a plaster screen, almost entirely of architectural origin, hiding the actual vault. However intricate some of the plaster muqarnas of Fez [125] or Tlemcen may have been,[30] the feeling remains of a rapidly learned new ornamental routine.

Concerning architectural decoration, two preliminary points must be made. First, in eleventh-century Spain (stemming from the art of Cordova) it tended to be more complex than it was at first in North Africa – compare the stucco panels from the Aljaferia in Saragossa [126], with their wild breaking-up of Cordovan themes, and the simple and severe geometric and architectural designs framing the niche of the mihrab at Tinmal.[31] Much of the history of the decoration consists in the interplay between these two tendencies. Second, plaster was the most common medium; its comparative independence from the construction allowed the decorators considerable latitude of imagination in the development of themes, as we have seen in the muqarnas. They were probably painted as well.

The predominant place must be given to designs derived from architecture for, aside from the muqarnas, the decoration of the minarets, especially the celebrated trio of Seville, Rabat, and Marrakesh, and of the gates consisted in the transformation of the older intersecting polylobed arches into a sort of weaving tapestry covering as much of the surface of the wall as was deemed necessary. Otherwise, epigraphy, geometrical combinations, and floral arabesques continued to be the most common decorative

125. Fez, Qarawiyin mosque, mostly 1135, muqarnas dome

126. Stucco doorway from the Aljaferia, Saragossa, eleventh century.
Madrid, Museo Arqueológico Nacional

themes, emphasizing the spandrels of arches or the sides of mihrabs, or adding some new dimension to the muqarnas, as on many panels of the Qarawiyin domes. The acanthus, palmette, and vine of Umayyad ornament are still present. While something of the great wealth of detail and fascinating interplay of light and shade typical of the best works of the caliphate is occasionally apparent, the designs, especially in Morocco, became more rigid and standardized, the leaves lost their veins, and, in particular in later Almohad monuments such as the Kutubiya, heavier decoration replaced the refinement of Cordova.

The western Islamic world does not display the same brilliance and originality as the contemporary Middle East during the twelfth and thirteenth centuries. Although here too forceful frontiersmen took over old and splendid cultures, the world of North Africa and Spain was not inventive; its conservatism, its comparative isolation from the Orient, its antagonism to its Christian neighbours, and the powerful impact of ninth- and tenth-century masterpieces led it to explore further possibilities within the traditional hypostyle and to develop the old decorative vocabulary into a more complex language. Yet in two ways the Maghribi world also partook of the profound changes which characterized the whole of Islam at that time. First, its monumental architecture spread from a few administrative and cultural centres such as Kairouan and Cordova to dozens of new cities, the Atlas mountains, and the North African coastline - a proliferation similar to that in the east. Second, the buildings of the Muslim west also exhibit a fascination with domes; less structurally impressive than in Iran, the Moroccan examples have a scintillating decorative inventiveness which will remain a hallmark of western Islam for several centuries.

THE DECORATIVE ARTS

A fair number of pottery, glass, and metal utensils or vessels as well as stone carvings of the caliphal period have been found in Spain. There are also precious objects of silver and at least one silk tapestry.[32] Yet it is ivory carvings, surviving in substantial quantity, that must be regarded as the finest products of the period, fully commensurate with the stately and imaginative opulence revealed by the architectural monuments.[33] Fortunately, many are inscribed with the names of the royal personages or court dignitaries for whom they were made, and dates are usually given, ranging from about 960 to the middle of the eleventh century. Most are either pyxides with a hemispherical lid or rectangular containers with a flat or hipped cover.

The earliest pieces carry only rather loosely spaced, wiry vegetal designs. Their special quality lies in the ingenious manner in which leaves and branches grow and curl around one another so that the designs are full of inner movement, reflecting a refined sculptural sense [127]. The same quality, as well as the generally restricted vocabulary of motifs, characterizes somewhat later pieces, which, however, exhibit more ambitious decorative programmes. An example is the pyxis [128], now in the Museo Arqueológico Nacional of Madrid, made for al-Hakam II's celebrated concubine Subh, the mother of the future Caliph Hisham II.[34] Here the vegetal forms, inhabited by peacocks, doves, and antelopes, are somewhat richer than before and the opulent ornamental design is endowed with lively movement. Equally important is the artist's sense of structure, which made a clear organization of the surface possible. The branches trace geometric compartments which serve both as skeletons for the composition and as frames. Geometric and vegetal motifs are thus reconciled not by mere juxtaposition but by integration, a solution that the earlier wood carvers of Kairouan had not yet achieved. This type of arrangement also characterizes the sculptured marble panels flanking the mihrab of the Great Mosque in Cordova [117], but in the delicate ivory box the result is more subtle and effective.

The same organizing tendency found expression in an even richer pyxis (now in the Musée du Louvre, Paris) made in 968 for al-Mughira,

127 (*above*). Casket, front and back views, probably Madinát al-Zahra, *c*. 962. Ivory.
London, Victoria and Albert Museum

128 (*opposite*). Pyxis of Subh, probably Madinat al-Zahra, 964. Ivory.
Madrid, Museo Arqueológico Nacional

129. Prince, fan-bearer, and lutanist, and two falconers, two sides of the pyxis of al-Mughira, probably Cordova, 968. Ivory. *Paris, Louvre*

130. Pyxis with vegetal designs, probably Madinat al-Zahra, *c.* 970. Ivory.
New York, Hispanic Society of America

the younger son of Abd al-Rahman III.[35] Here, human and animal figures are enclosed in large, eight-lobed medallions formed from continuous interlace [129], while other figures and plant forms fill the spandrels. This piece provides the first conscious organization of a complex decorative scheme into major and minor scenes within a unified whole. It is also the first appearance on a Spanish ivory of a cycle of royal themes. In one of the medallions the prince himself appears with a goblet or perfume bottle in his hand; he is seated in the company of his fan-bearer and his lutanist [129A] while falconers stand outside the medallion frame. Other motifs representing royal might, like the lions below the throne platform and the symmetrical arrangement of lions attacking a bull in a second medallion [129B], can be traced to Mesopotamian or Persian origins. Still other motifs are simply decorative. As they often occur in pairs flanking axial trees, Islamic or Byzantine textiles showing an ultimately Sasanian organization may have served as models, but the originally flat patterns have now been successfully transformed into richly modulated reliefs. Furthermore, the sculptural quality is enhanced by the now greater density of the designs. Both the function of such ivories and the degree to which they were appreciated can be deduced from the inscription on a pyxis with purely vegetal designs, now in the Hispanic Society, New York [130].[36] Carved in Kufic script around the base of the domed lid are the following verses in a classical Arabic metre:

The sight I offer is of the fairest, the firm
 breast of a delicate maiden.
Beauty has invested me with splendid raiment
 that makes a display of jewels.
I am a receptacle for musk, camphor, and
 ambergris.[37]

131. Casket of Abd al-Malik, probably Cordova, 1004/5. Ivory.
Pamplona, Museo de Navarra

In pre-Islamic times Arab poets had compared the female breast to the ivory boxes that were at that time made in foreign lands;[38] when in the tenth century a comparable stage of luxury and cultural achievement had been reached in an Arab milieu, the poet reversed the comparison. One verse also may suggest that the little drilled holes along the edges of the leaves may have contained jewels. If so, the colourful casket would have corresponded to a long oriental tradition, for instance the brightly hued wall decorations of Achaemenid palaces and the equally colourful painted stuccoes of Samarra.

On al-Mughira's pyxis the main themes are differentiated only by the lobed frames and the larger size of the figures in two of the four medallions. The division is clearer on a large rectangular casket [131] formerly in the cathedral of Pamplona, and made in 1004/5 for Abd al-Malik, the son of Hisham II's all-powerful vizier, al-Mansur.[39] Here, on the more important long sides, similar polylobed frames enclose boldly rendered royal scenes, which stand out clearly against the density of the small-patterned spandrel areas. This piece, which is signed by no fewer than five artists, set a precedent for accentuated organization that could not have been bettered even in the heyday of Muslim decorative arts, occurring two centuries later in distant Iran and Iraq. Nevertheless, the decoration, pleasing as it is, bears no integral relation to the structure and shape of the casket. Similarly, on an ivory pyxis [132] in the cathedral of Braga made for Abd al-Malik,[40] the arches, in even sharper contrast to tectonic principles, form loops at their apexes as frames around little birds, giving the general impression of a sculptured shroud that envelops the piece. The combination of a richly patterned surface and simple form became standard for the Muslim architect and craftsman, to the degree that the shape often counted for little in comparison with the decoration and the ornament usurped some of the aesthetic functions of the underlying form.

The decoration of the Braga pyxis is even denser than on al-Mughira's, a development

132. Pyxis of Abd al-Malik with arcading, probably Cordova, *c.* 1005. Ivory. *Braga Cathedral*

from the simple to the complex to be found again and again in Islamic art. Neither on the Braga pyxis nor on the earlier pieces, however, is there any trace of the new decorative formulas worked out during the Samarra period, though the utterly unorthodox way of presenting courtly figures without turbans or other headgear and in the act of drinking may have been copied from the caliphal art of Baghdad.[41] Of greater significance is a novel feature on Abd

al-Malik's casket in Pamplona which, even if in a restrained form, was destined to transform the most characteristic aspect of all the ivories. In nearly all the earlier pieces the inscriptions remained austerely aloof from the luxuriant designs. On the pyxides of Subh and al-Mughira, only a few curling leaves enliven the background or float unattached above the severe Kufic characters, which end in simple wedge-shapes at the tops, as at Samarra. On Abd al-Malik's casket, however, the letters are stippled, the interstitial vegetal patterns are more abundant, and, most important of all, some stylized leaf forms are attached to the letters. This 'floriated Kufic' represents the restrained beginning of an ornamental transformation in inscriptions, which from the late tenth century on played a greater and more vital part in western Islamic decorative schemes, following a pattern already apparent in eastern Islam.

According to the greatest Muslim historian, Ibn Khaldun of Tunis (1332–1406), 'as a rule no dynasty lasts beyond the lifespan of three generations,' in the course of which 'the dynasty grows senile and is worn out. Therefore, it is in the fourth generation that prestige is destroyed.'[42] This pattern prevailed in the ancestral Spanish Umayyad caliphate after the death of Hisham II, and the evidence of the luxury objects bears it out. Ivory carvings ceased to be made in the royal workshops of Cordova and the palace precincts of Madinat al-Zahra, but the provincial centre of Cuenca[43] continued to produce decorative and handsome pieces [133], though the style had become dry and repetitive and the designs flat and without movement. Along with political power, artistic genius 'grows senile and is worn out'.

The characteristic quality of the Spanish Umayyad ivories is even better brought out in

133. Casket, Cuenca, 1026. Wood faced with ivory. *Burgos, Museo Arqueológico Provincial*

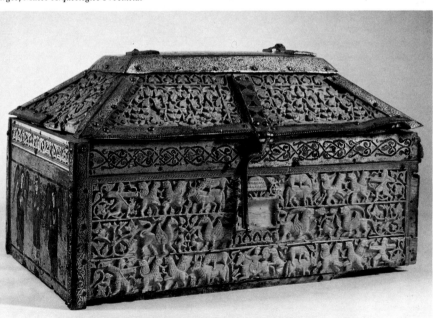

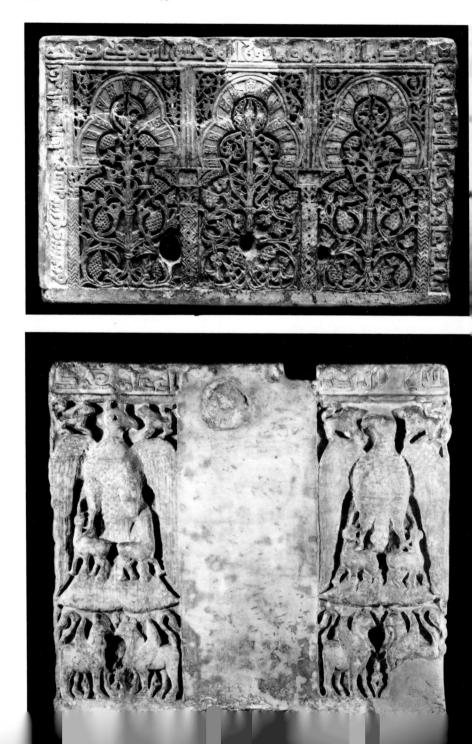

134. Basin, Madinat al-Zahra, after 936. Stone.
Madrid, Museo Arqueológico Nacional

comparison with secular stone carvings of the same period, either well-preserved water basins [134] or fragments of unknown function [135].[44] Some show vegetal designs and have the same austere, abstract quality as the stone panels flanking the mihrab of the Great Mosque of Cordova [117]. Others share with the ivories zoological motifs probably based on patterned textiles and with long traditions in the Near East. Rather severely stylized and even gauche at times, none of them can match the ivory carvings whose delicate workmanship lends an inimitable intimacy, and whose compositions – whether lively or stately – are manifestations of nobly conceived luxury objects.

From the century or so under *taifa* control of the Spanish peninsula very few examples of the decorative arts have survived. The succeeding dynasties, on the other hand, despite their rather puritanical beginnings, soon became renowned for the brilliance of their courts, where some of the most original intellects of the day found a welcome and where the taste for luxury stimulated craftsmen to new peaks of achievement. Owing to a sequence of outstanding dated or datable pieces, it is possible to follow in detail the evolution of carved wooden minbars.[45] The earliest, in the Great Mosque of Algiers, dates from 1097 [136]. Following common Maghribi practice, it is on wheels so that it can be brought out on Fridays and moved into a special storage chamber for the rest of the week. Its composition is similar to that of the much earlier minbar at the Great Mosque of Kairouan [81], but the motifs, though also vegetal and geometric, are more unified and subtle.[46]

By contrast, the late Almoravid minbar in the Qarawiyin mosque in Fez (*c.* 1143) displays a lucid scheme of two interlocking trellises form-

ing squares with eight-pointed stars at their focal points.[47] The arabesques of the interstitial panels are more delicately carved and more finely veined than in the East. A novel feature is the marquetry in ivory and precious woods used for the bands forming the trellises, in the backgrounds of the Kufic inscription, on the stair risers, and in the rear panel at the top.

The apogee of this style is the minbar in the Kutubiya mosque in Marrakesh [137].[48] The geometric interlace of four hexagons surrounding the central eight-pointed star is more spirited than at Fez, the marquetry and the carving of the inset pieces more intricate. The geometric and vegetal parts are beautifully balanced as well. The date is now missing, but according to the fine Kufic inscription the piece was ordered by a member of the Almoravid family and made in Cordova – a piece of information especially valuable because the minbar of the Great Mosque of Cordova has not been preserved.

In the closely related minbar of the mosque of the Kasbah in Marrakesh, ordered about 1195 by the Almohad Abu Yusuf Yaqub al-Mansur, the interlaced geometric configurations have been developed on a larger scale but in a smaller area, creating a heavier appearance.[49] Marquetry is used both for the geometric bands and as part of the filling patterns, so that the total effect is extremely sumptuous. Under the later Almohads this style became less inspired, as can be seen in the minbar of the Andalusiyin mosque in Fez (1203-7),[50] which is devoid of marquetry and has less delicately carved panels, but its portal, a feature apparently given up after the 1097 minbar in Algiers, has been here reintroduced and crowned with a scalloped horseshoe arch on slender columns, which gives the minbar a more ceremonial aspect. It lacks, however, the two richly carved door panels usual in contemporary Syria and Anatolia.

The excellence of these carvings raises the question of what secular woodwork was like, especially pieces with human and animal figures. The gap can be partly filled by comparison with several large groups of woven silk

135. Fragment, Granada, eleventh century. Stone.
Madrid, Museo Arqueológico Nacional

136. Algiers, Great Mosque, minbar, 1097

137. Marrakesh, Kutubiya Mosque, minbar made in Cordova, late twelfth century

textiles, which were much appreciated, not only at court, but also throughout Europe, and have survived largely because they were used for Christian clerical vestments and for wrapping the relics of saints. According to the business records found in the Cairo Geniza, Spain in the Almoravid and Almohad periods was the leading textile-producing country, both for raw materials and finished products. Almería especially 'had the most extensive relations with the rest of the Muslim world', and 'it also had a station for Christian ships'. It boasted no fewer than eight hundred looms for the weaving of silk garments and precious cloaks, a thousand for splendid brocades, and the same number for various other types of textiles, some of which showed 'patterns of circles', while other designs were supposed to have originated in Baghdad, Gurgan, or Isfahan. Further Spanish textile centres were Murcia, Málaga, Granada, Baeza, and Seville.[51]

One of the known textile groups includes several fragments of a chasuble [138] made from pieces of silk inscribed with the name of the Almoravid prince Ali ibn Yusuf ibn Tashfin, who ruled between 1107 and 1143.[52] Because of its distinctive technique and its colour scheme, in which orange-red and dark blue-green on an ivory ground are supplemented with gold brocading, it is possible to associate this silk with several other well-known pieces and to date the entire group to the twelfth century, probably continuing into the thirteenth.[53] The chasuble is patterned with large, slightly elliptical medallions, each enclosing a pair of addorsed lions flanking a stylized tree. Beneath the lions' feet is a pair of small animals; paired sphinxes flanking a plant form are arranged sequentially around the medallion frame between beaded borders. The interstices between the medallions are filled with bilaterally symmetrical palmettes.

138. Chasuble of
Ali ibn Yusuf ibn Tashfin (detail),
probably Almería, 1107/43. Silk.
Quintanaortuña near Burgos

It has been suggested that this arrangement of hieratically composed medallions represents an ancient Near Eastern tradition of textile design. That Spanish weavers in the twelfth century were still very much under the influence of eastern taste is demonstrated by another, closely related silk now in the Museum of Fine Arts, Boston [139]. On this piece, instead of lions, a pair of addorsed sphinxes flanks the central tree, and each medallion frame is divided into four sections by four smaller medallions with Kufic inscriptions, each with a crouching figure in the *Knielauf* position (running position with strongly bent knees) and grasping the forelegs of a pair of griffins. According to the inscriptions, the silk was made in Baghdad; however not only the distinctive technique and colours but also peculiarities of spelling help to identify it as a twelfth-century Spanish 'forgery'.[54] Some silks in this group show variants of the basic hieratic design within a medallion. On one famous piece, for example [140], the composition is similar to those already discussed, but the central tree has been replaced by a frontal warrior figure, his arms wrapped around the necks of the flanking lions, which seem to dangle in the air as if he were strangling them.[55]

Another type of silks within this technical tradition bears large bicephalic birds, their bodies and wings usually patterned in sections. In one example [141] each bird is framed by the top and bottom arc of a circular medallion, but the sides of the medallions open into each other, so that the effect is of two deeply scalloped borders, above and below each row of birds.[56] The bicephalic-bird silks may be slightly later than the pure medallion types, but the basic design must already have been known in France at the time of Philippe-Auguste (1180-1223), for it provided the model for the painted ceiling in the crypt at the cathedral of Clermont.[57] The centre of production, while not yet definitely identified, may well have been Almería, which is known to have produced silks with circle patterns during the twelfth century.[58]

Probably from another centre are the tapestry-woven silks of a second, less hieratic

139. 'Baghdad' silk from Burgo de Osma, probably Almería, twelfth century.
Boston, Museum of Fine Arts

140. 'Lion strangler' silk from Vich, probably Almería, twelfth century.
Cleveland Museum of Art

141. Bicephalic bird silk from Vich (detail), probably Almería, late twelfth/early thirteenth century. *Cleveland Museum of Art*

group, where rows of small medallions usually frame musicians, drinkers, or other courtly figures.[59] Particularly striking is the 'drinking ladies' silk, of which a fragment is preserved in the Cooper Hewitt Museum in New York [142].[60] In each medallion two female figures face each other in profile, one holding out a goblet, the other a bottle. In the relative spontaneity of the composition and attention to such details as fold patterns and hairstyles, these

scenes seem to suggest the freedom of manuscript paintings adapted to the more rigid technical requirements of weaving.

This observation is borne out by comparison with miniatures from the only illustrated manuscript known from medieval Islamic Spain, a copy of the love story *Bayad wa Riyad*, now in the Vatican Library (Ar. 368) [143].[61] The beginning and end of the text are missing, and there is thus no clue to precise date or place of origin. Among the fourteen surviving miniatures are several in which a garden party with musicians is depicted. In one, an old lady in

142. 'Drinking ladies' silk, possibly Seville, twelfth/thirteenth century.
New York, Cooper Hewitt Museum

profile holding up a bottle to pour is nearly identical to one of the 'drinking' ladies, and any of the young handmaidens with goblets could have served as a model for the other. The similarities are underscored by the shape of the platforms in miniature and textile, the concentric arrangements of the folds on the sleeves in both, and even the cross patterns that decorate garments on the textile and window grilles in the miniature.

Bayad wa Riyad was first identified as Spanish because of the architecture depicted in its miniatures: the frequent *miradóres*, the serpentiform lobed arches, and the courses of stone laid in alternating directions are all typical of the medieval Islamic architecture of Spain. Nevertheless, in composition and imagery, the miniatures betray very close connections with the Near East. In illustration 144, for example, the group of the old lady at the left and the rearmost handmaiden echo exactly that of the two students on the double-page frontispiece in the 1229 Dioscorides manuscript in the Topkapı Sarayı Library.[62] Particularly noteworthy is the survival, in the westernmost province of Islam, of the old Samarra facial style - complete with side curls, ragged hairline, and staring eyes - long after it had apparently died out in the eastern Mediterranean. The refinement of the rendering is, however, unmatched in the Near East at this date. In illustration 145 it is especially clear in such details as the delicate outlining of the noses, with both flanges; the convincing distribution of the figures' weight; and the graceful arrangement of hands and especially feet. Details of architecture and palaeography suggest that this manuscript was illustrated in the Almohad period, probably just at the end of the twelfth or the beginning of the thirteenth century. Close parallels with textiles of the 'drinking ladies' group point to a centre where weaving was important, Granada perhaps, or Seville, the latter the Almoravid and Almohad capital in Spain.

143. Bayad entertaining ladies of the court in a garden, from the *Bayad wa Riyad*,
MS. Ar. 368, f. 10r, Spain, *c*. 1200. *Rome, Biblioteca Apostolica Vaticana*

منه نُما فَلِبِحِسْنِها أيا وَمِشْكَتِ شَعْرها وَكَثَبْتَ بِأحْسَنِ الطِّيبِ وأُخْرَتْ بِرِيد
وَأَتِنِيَ السَّيرِ فَلَما دَخِلْتِ ازِ السَّيرِ تَعْرَمْتَ جَارِيَةِ تَمَنَّى لِعِبَةٍ يا البِشارة
الى السَّيْرِ فَالْفَتْ البَهما ما كانَ عِلَمْنا مِنَ البَناتِ ثُمَّ اقبلَ الجِوارِ يَمِينها وَمْعِيَتْقُول
لَمِنْ هَنا كَنِ اللّهُ عِيْشَدَقَ لَهُ خَلَما عَلى السَّيرِ وَمِيَ كَالعاصِمِة حِزِنَتْ
رِفَاضِ بنِ بِرِفِها سا جِرة ﴿٠﴾

صُوَرَةِ رِفَاضٍ وَرِسَرْتَ بَعْرُ

وَصُوَرَةِ العَجُوزِ وَالوَطَاصِ يَمْكُرُنَ تَمِن ﴿٠﴾

14. Riyad prostrate before the Hajib's daughter from the *Bayad wa Riyad*,
MS. Ar. 368, f. 26v, Spain, *c.* 1200. *Rome, Biblioteca Apostolica Vaticana*

145. The old lady expostulating with the lovesick Bayad, from the *Bayad wa Riyad*, MS. Ar. 368, f. 15r, Spain, *c.* 1200. *Rome, Biblioteca Apostolica Vaticana*

THE FATIMIDS IN NORTH AFRICA AND EGYPT: 910-1171

The Umayyad caliphate in Spain resulted from the political separation of the peninsula from the rest of the Muslim empire. The Fatimid caliphate, on the other hand, was only one aspect of a complex series of phenomena aptly called 'the revolt of Islam',[1] which began as an attempt by the heterodox Shi'ites to establish the descendants of the Prophet, through his daughter Fatima, as caliphs for the whole community. The movement was strongly organized and as wide as the Muslim world. Politically it had some local successes in Syria, the Persian Gulf, the Yemen, and Arabia as early as the ninth century, but its most spectacular venture began when its leader Ubaydullah became the first Fatimid caliph in Tunisia in 908. In 969 the fourth caliph, al-Mu'izz, succeeded in occupying Egypt, afterwards controlling most of Syria as well. Other Shi'ite attempts at seizing power failed, but as far as the Muslim world from the Euphrates to Algeria is concerned, the tenth, eleventh, and (partly) twelfth centuries were dominated by the political and intellectual force of the Fatimids from their Egyptian centre. In Syria and Palestine they were overthrown in the eleventh century by the Crusaders; in Egypt, Saladin (Salah-al-Din) gave the *coup de grâce* to the crumbling caliphate in 1171; in North Africa, by 1159, the dynasties which depended on the Fatimids had given way to new ones, mostly from farther west; Sicily was lost as early as 1071 to the Normans.

This period of some 250 years is difficult to define, either historically or culturally, on account both of regional differences and of the growing complexity of contacts with the rest of the Muslim world, the West, Byzantium, and even India and China. The Fatimid era is North African and Sicilian, Egyptian and Arabian; but it is also Mediterranean and pan-Islamic.[2]

Politically, and in many ways culturally and artistically, Fatimid power and wealth were in the ascendant until the middle of the eleventh century. Shortly after 1050, however, in the middle of the long reign (1036-94) of the caliph al-Mustansir, financial difficulties, famines, droughts, and social unrest led to two decades of internal confusion out of which order was not re-established until the 1070s. At the same time, in North Africa, an attempt by the Fatimid-sponsored dynasties to shake off their Shi'ite allegiance led to a new invasion by primitive Arab tribesmen and to a complete change of economic and political structure,[3] as Tunisia and western Algeria lost much of their agricultural wealth and entered by the twelfth century into a western rather than eastern Mediterranean cultural sphere. During the last century of their existence the Fatimids controlled hardly anything but Egypt. Whether the major changes in Islamic art which they had earlier set in motion were the result of their own, Mediterranean, contacts with the classical tradition or of the upheavals which, especially in the eleventh century, affected the whole eastern Muslim world remains an open question.

ARCHITECTURE[4]

North Africa

The Fatimids founded their first capital at Mahdiya on the eastern coast of Tunisia.[5] Not much has remained of its superb walls and gates or its artificial harbour, but surveys and early descriptions have allowed the reconstruction of a magnificent gate decorated on both sides with lions, of parts of the harbour, and of a long hall or covered street similar to those already found at Baghdad, Ukhaydir, and even Mshatta.[6] The

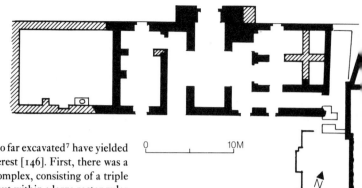

146. Mahdiya, founded 912, palace, plan

parts of the palace so far excavated[7] have yielded two features of interest [146]. First, there was a curious entrance complex, consisting of a triple gate, its centre set out within a large rectangular tower. As one proceeds inward, however, this gate ends in a blank wall, and it is two narrow halls on each side of the central axis that lead into the court; the side entrances, on the other hand, proceed directly into the interior. The purpose of this odd arrangement could hardly be defensive; perhaps the four entries were to accommodate some of the extensive processions which, at least in later times, characterized Fatimid court life.[8] Second, we cannot determine whether the decoration of some of the rooms with geometric floor mosaics sprang from memories of Umayyad palaces or imitated the many pre-Islamic mosaics of Tunisia.

A much restored mosque also remains from Fatimid Mahdiya [148].[9] It was initially a rect-

angular hypostyle with a covered hall of prayer consisting of nine naves at right angles to the qibla. An axial nave led to a dome in front of the mihrab, and a portico in front of the covered hall served as a transition between open and covered areas and as part of a court with four porticoes. But the most significant novelty is the monumental façade [147], involving the whole of the north-western wall of the mosque. It consists of two massive salients at each corner,

147. Mahdiya, founded 912, mosque, entrance façade

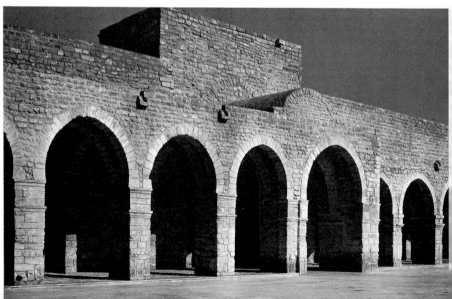

which emphasize and control the limits of the building, and three symmetrically arranged gates, the central one set within another salient decorated with niches. This earliest known instance of a composed mosque façade gives a sense of unity not only to the outer wall but also to the building as a whole. Its origins should probably be sought in royal palace architecture, where such compositions were known as early as the Umayyad period.

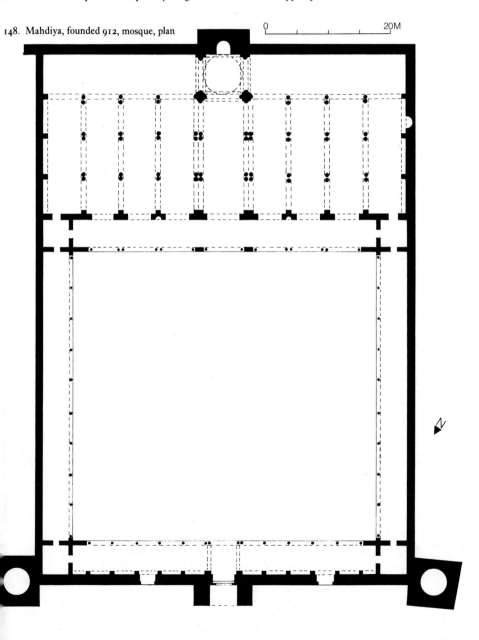

148. Mahdiya, founded 912, mosque, plan

0 20M

From the second capital built by the Fatimids in North Africa, Sabra-Mansuriya near Kairouan, we know so far only of a very remarkable throne room [149] which combines the oriental

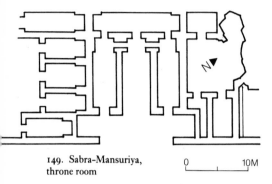

149. Sabra-Mansuriya, throne room

0 10M

iwan with the characteristic western Islamic unit of two long halls at right angles to each other.[10]

The last two major monuments from North Africa are (if we except certain minor utilitarian structures) rarities in that geographical area. The first is the palace of Ashir, in central Al-geria, where under Fatimid patronage the Zirid dynasty founded a capital around 947.[11] It is a rectangle (72 by 40 metres) with towers of varying sizes [150]. The single outer gate is transformed into two entrances into the palace proper. On one side of the court is a portico. What is presumably the throne-room complex comprises a long hall with three entrances and a squarish room extending beyond the outer line of the wall and no doubt dominating the landscape. On each side of the central official unit, lining a courtyard, are two residential buildings consisting mostly of long halls. This symmetrical organization of living quarters around official areas recalls Mshatta or Qasr al-Hayr rather than the sprawling royal cities of Samarra and Madinat al-Zahra. Moreover, the palace is remarkable by its great simplicity: limited design, no columns, probably simple vaults, very limited applied decoration. Though but a pale reflection of the great architecture created on the Tunisian coast, Ashir is nevertheless precious for its completeness of plan and for its strong conservatism, which characterizes so much of North African architecture west from Tunisia.

150. Ashir, founded c. 947, palace, plan

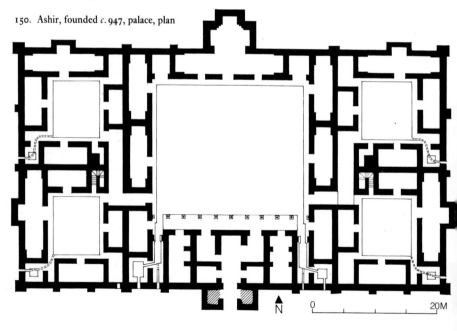

0 20M

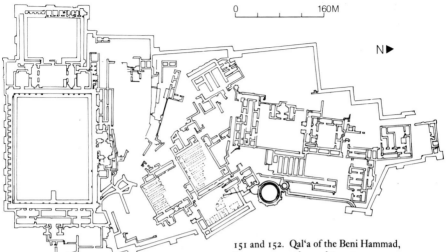

151 and 152. Qal'a of the Beni Hammad, begun c. 1010, plan and tower

The second monument is the Qal'a of the Beni Hammad [151] in central Algeria begun around 1010 by a Berber dynasty related by blood to the Zirids and also under the influence of the Fatimid centres of Tunisia.[12] It was a whole city, with an immense royal compound comprising a huge tower with pavilions at the top [152], a complex of buildings crowded around a large (67 by 47 metres) artificial pool in which nautical spectacles took place, a bath, a mosque with a superb maqsura, and a series of individual houses and palaces. Neither the chronology nor the ceremonial or symbolic meaning of these buildings is clear; typologically, however, the Qal'a belongs to the succession of Samarra's sprawling ensembles, but with the emphasis on a setting for leisure and pleasure. It was probably this North African ideal of luxury that inspired the twelfth-century architecture of the Norman kings of Sicily, whose Cuba and especially Ziza at Palermo are among the very few preserved examples of pavilions and pavilion-like palaces in the midst of exotic gardens.[13]

One group of fragments of unusual importance from the Qal'a of the Beni Hammad is a series of long ceramic parallelepipeds with grooves at one end; they must have projected

unevenly from a ceiling or a cornice, looking like stalactites.[14] Other plaster fragments were certainly more typical muqarnas transitions. Whether these forms were invented in eleventh-century North Africa or brought from the east is still an open question, but they clearly demonstrate that by this time the muqarnas had penetrated into the architectural vocabulary of the area and inspired not only the vaults of Morocco discussed earlier but also those of Norman Sicily, especially the large ceiling of Roger II's Cappella Palatina at Palermo.[15] It is important to note that nearly all these examples occur in secular architecture, suggesting that much of the impact of the muqarnas may have been transmitted through the medium of private dwellings.

Interesting though they may be as forerunners of things to come or as reflections of more ancient artistic traditions, the monuments of North Africa – with one or two exceptions – have not been sufficiently explored to permit a definitive judgment either of their aesthetic value or of their full historical significance. With Egypt, it is a different matter. After their conquest in 969, the Fatimids embarked on a truly grandiose programme of building, some of which survives and much more has been recorded by later Egyptian compilers such as the invaluable al-Maqrizi.[16] These accounts have in turn led to a series of very important, although not complete, systematic topographical surveys by members of the French school in Cairo[17] which are supplemented by a study of epigraphical material by Max van Berchem[18] and Creswell's monumental work. Thus – for once in Islamic art – both documents and studies are numerous.

Egypt until 1060

The centre of the Fatimid world was the imperial and military city of Cairo (al-Qahira, 'the triumphant'[19]). Nothing has remained of the first foundation, inaugurated in great pomp in the presence of astrologers with the purpose of controlling the older Muslim town of Fustat and its communications with the east. Yet its size is known (almost a square, about 1,000 by 1,150 metres), its north–south, almost straight axial street (the present Mu'izz al-Din), its two huge palaces more or less in the middle of each side of the central street, with a wide open space for parades between them, its eight oddly irregularly set gates (two on each side), and even the sites and names of the quarters assigned to the military groups permitted to share the city with the caliph, because so much of the later topography and toponymy of Cairo is based on that of the town built between 969 and 973. Thereafter, little by little, the whole area to the south and south-west was transformed so that by the year 1000 Cairo, with the old city of Fustat, had become one of the largest and most cosmopolitan urban complexes of the medieval world, with its markets, mosques, streets, gardens, multi-storey apartments, and private houses. Fatimid urban developments elsewhere are less well known, except for Jerusalem, Mecca, and Ascalon, where religious considerations dictated new constructions.

The buildings of the early Fatimid period can be divided into three groups. Of the first nothing has remained, but the lengthy compilation of Maqrizi and the on-the-spot descriptions of Nasir-i Khosrow (1047) and al-Muqaddasi (985), as well as archaeological data brought together by Herz,[20] Ravaisse,[21] and Pauty,[22] permit one to make a few points about secular architecture. Most remarkable was the Great Eastern Palace, whose main Golden Gate opening on the central square was surmounted by a pavilion from which the caliph watched crowds and parades.[23] Inside, a complex succession of long halls led to the throne room, an iwan containing the *sidilla*; this was 'a construction closed on three sides, open on the fourth and covered by three domes; on the open side there was a sort of fenced opening known as a shubbak'. Painted hunting scenes constituted much of the decoration.[24] For all its brilliance, the Eastern Palace seems to have been comparatively rambling; the Western Palace (*c.* 975–96, rebuilt after 1055) was smaller but more regu-

lar, centred around a long court with halls and pavilions on both axes.

Fatimid secular architecture can be characterized by two further features. The first (an apparent novelty in Islamic palaces) consisted in the royal pavilions spread all over the city and its suburbs.[25] To these, for amusement or for ritual purposes, the caliph repaired in those extraordinary ceremonial processions which bring the practices of the Fatimid court so close to those of Byzantium.[26] Their shape is un-

known, but most seem to have been set in gardens, often with pools and fountains, very much like the remaining twelfth-century constructions of the Normans in Sicily. The second feature is the layout of a number of private houses excavated in Fustat [153]. In almost all instances, open iwans, or two long halls at right angles to each other which we have already mentioned at Ashir and elsewhere, or both, open on a central court.[27] The interpretation of these features is at present difficult.

153. Fustat, plan of house

0 10M

154-6. Cairo, Azhar Mosque,
founded 969/73 (*above*),
with mihrab (*right*)
and court façade (*opposite*)

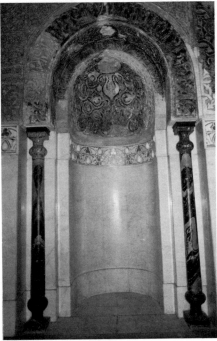

There also remain from the early Fatimid
period in Cairo two large congregational mos-
ques. The celebrated al-Azhar ('the splendid')
was founded together with the city to serve as
its main place for ritual gathering. Because it
grew slowly into a great centre of religious learn-
ing, it has undergone frequent alterations (the
façade on the court, for example [154, 156] is
later). The original mosque can be recon-
structed as a simple hypostyle (85 by 69 metres)
with a prayer hall of five aisles parallel to the
qibla wall and porticoes.[28] The hall of prayer
was bisected by a wide axial nave leading to a
superb mihrab decorated with stucco [155]; in
front of the mihrab was a dome, probably with
another on each side.[29] The dome now in front
of the axial nave, built between 1130 and 1149,
recalls, by its position, a similar later one in

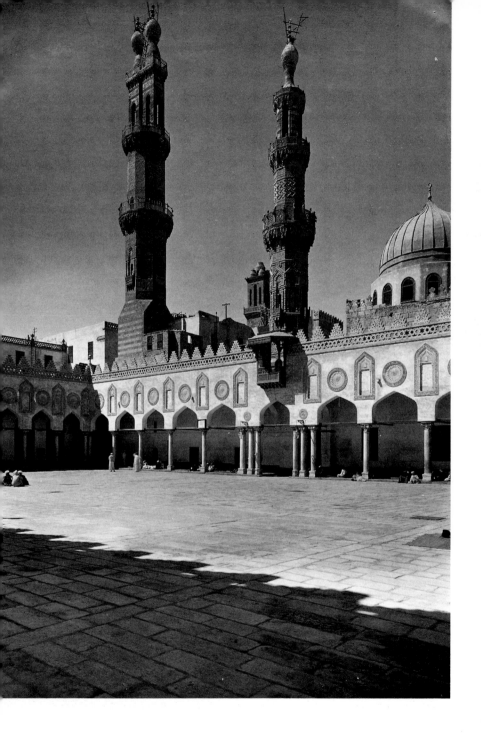

157. Cairo, Azhar Mosque, founded 969/73, early plan

0 20M

Kairouan. Throughout the mosque the supports were columns, single or double, often taken from older buildings. A great deal of decoration – mostly stucco – remains in the spandrels of the axial nave, on the qibla wall, and elsewhere. To its themes we shall return later; its position seemed to emphasize the main directions and lines of the building. The Fatimid exterior has not been preserved. Maqrizi relates that there were royal pavilions and that a number of official ceremonies took place which were probably reflected in architecture. Without these accessories, the first Azhar mosque appears almost as simple as the first hypostyles with axial naves known in Islam [157].

The second early Fatimid mosque in Cairo, al-Hakim, redone and inaugurated by that caliph in 1013, was begun by his father in 990. At first glance its purpose is not evident, for it was outside the city walls to the north, in a sparsely populated area. Clarification is provided by a long passage in Maqrizi.[30] Until 1266 (when it returned to the Azhar), the first and most splendid of a cycle of long and elaborate ceremonies of caliphal prayer, including the *khutba* or allegiance to the sovereign, took place here, to be followed on successive Fridays in Cairo's other three large mosques (early mosque of Amr, Ibn Tulun, al-Azhar). We may, then, interpret this building as an imperial foundation, whose primary function was to emphasize the religious and secular sway of the caliph.[31] While no doubt related to earlier mosques such as those of Damascus, Baghdad, and Cordova, in all of

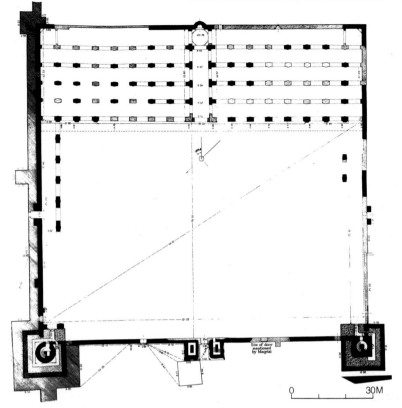

158. Cairo, al-Hakim Mosque, 990 and 1013, plan and drawing

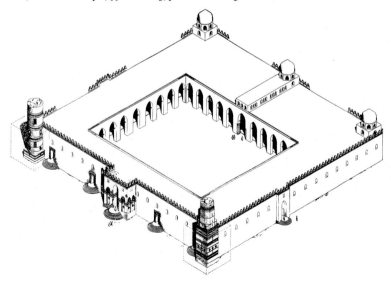

which the nearby presence of the ruler played a part, al-Hakim had a more restricted purpose as a royal sanctuary some way away from the city proper, not far from the mausoleums of the Fatimids, and illustrating the very complex nature of Fatimid kingship. The private oratory in one of the minarets and a possible mystical explanation of some of the decorative motifs[32] lend colour to the idea of the building's special character.

The mosque of al-Hakim was a large and slightly irregular rectangle (121 by 131 metres) [158]. At the west and south, on the corners of the façade, are two minarets now partly enclosed in later constructions, a feature obviously related to Mahdiya's mosque. The minarets are remarkable for their decoration and for being of different shapes, one cylindrical, the other square. Between them in the main façade [159] is the monumental (15 by 6 metres) entrance; four more doors with flat arches and a very classical moulding complete the composition, and there is a further gate on each side of the mosque. The interior hypostyle combines features from the mosque of Ibn Tulun [66–8] (five-aisled sanctuary parallel to the qibla wall, large brick piers with engaged columns, single arcade on the other three sides) with innovations

from North Africa (higher central nave, dome in front of the mihrab with two corner domes on squinches and drums). Thus, compared to the Azhar mosque, al-Hakim is much more carefully thought out, blending several architectural traditions and drawing especially on its North African roots. But it is still in most aspects traditional, and its most suggestive features are the domes, whose outer appearance (square, octagon, cupola) is one step removed from the inside (octagon, drum, cupola), and the façade, whose symmetry is so curiously broken by the different shapes of the minarets which frame it.

Both the Azhar and Hakim mosques are remarkable for their architectural decoration, although themes and style differ considerably. At the Azhar the stucco panels on the wall spaces provided by the arches and the qibla aim, like those at Samarra, to cover the whole surface. The comparison is all the more justified since – except for the epigraphical borders rarely found in Iraqi palaces – the shapes of the panels, the motif of constant interplay of leaves and flowers around symmetrically arranged rigid stems, and the techniques of outlining, notching, and dotting are all certainly related to the art of Samarra, probably through the impact

159. Cairo, al-Hakim Mosque, 990 and 1013, general view, and city walls, 1087

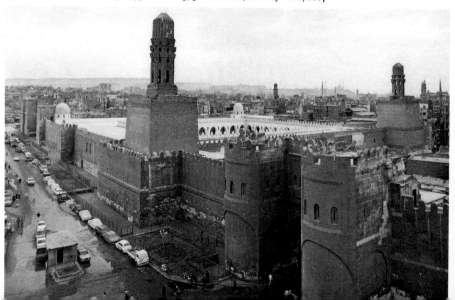

of the latter on Tulunid Egypt.[33] However, the floral element is more pronounced and more clearly recognizable, and the background again plays an important part. After the Samarra-inspired experiments, therefore, the Azhar stuccoes seem to indicate a return to an earlier and more natural treatment of vegetal motifs.

The decoration of the Hakim mosque is quite different. Flat ornamented panels are rarer; when they exist, as on certain niche-heads of the entrance or on the windows of the domes, they consist of symmetrical designs of stems and leaves or of more complex arabesques, always set off by a visible background. Most of the decoration is of stone and is concentrated in a series of horizontal and (more rarely) vertical bands which emphasize certain lines of the architecture, especially the minarets and the gateway block. The designs include vegetal as well as geometric and epigraphical motifs, almost always on a visible background. It may be that some of the devices – such as pentagrams – on the heavily decorated medallions which here and there replace the horizontal bands had a symbolic significance.[34] The Hakim decoration as a whole, however, is most notable, especially when compared to the Azhar, for its sobriety, and for the effectiveness of composition of the façade, in which the basic symmetry is broken by the similarly decorated but differently shaped minarets. Both the sobriety and the thought-out composition recall North Africa rather than the East, although it is possible that the ubiquitous classical background of the Mediterranean reasserted itself here both in the simple ornamentation and in the revival of more naturalistic themes.

A last point about early Fatimid decoration is that it was not limited to stucco or stone. Wood was common, although little has remained *in situ*. Mosaics were also used, which we know mostly from texts and from the superb decoration of the large dome in front of the mihrab of the Aqsa mosque in Jerusalem (early eleventh century). The mosaics of the drum probably copy much earlier Umayyad work,[35] but those of the triumphal arch and of the pendentives are original Fatimid compositions, and their technical quality indicates that the older traditions picked up by the Muslim world in Byzantium were not yet totally lost.

The last group of monuments datable to the first Fatimid decades in Egypt consists of mausoleums, whose erection is attributable both to the Fatimid sense of imperial pomp and to their Shi'ite veneration of the descendants of

160. Aswan, mausoleums, probably early eleventh century

Ali.[36] The earliest royal and religious mauso-
leums are known through texts only, but two
major early groups remain, the smaller one near
Cairo,[37] and another sixty odd in the great
Aswan cemetery in southern Egypt [160].[38]
None is dated, but the indirect evidence of texts
and certain details of construction indicate that
they probably belong to the early decades of the
eleventh century. By then the mausoleum was
no longer either a royal prerogative or a place of
religious commemoration, but a widely avail-
able form of conspicuous consumption. The
social and pietistic conditions of the time sug-
gest that the new patrons of architecture in this
field were the growing middle class of mer-
chants and artisans.

The mausoleums are simple squares with
openings on one, two, or three sides. Built in
brick or stone in mortar, or in combinations of
the two methods, most of them probably had
whitewashed walls with little decoration. All
were covered with domes on simple squinches
with an octagonal drum whose purpose was to
give greater height and more light; some of the
mausoleums had over twelve windows, which
emphasized their openness – perhaps in order
to indicate that they were not fully-fledged
buildings and therefore did not entirely con-
trovert the religious opposition to the expres-
sion of wealth or power after death. Their ulti-
mate origin undoubtedly lies in the ancient
mausoleums and canopy tombs of Syria and
Anatolia,[39] but how this form, which was rarely
used in Christian and early Islamic times, came
to be revived here in the tenth century is still
unclear.

The early Fatimid period saw then not only
the creation and growth of the new city of Cairo
with its great congregational mosques but also
some spectacular, if no longer available, secular
and memorial building. Egypt was asserting
itself as one of the great artistic and cultural
centres of the Islamic world. In addition, major
changes can be observed in architectural decor-
ation and in the patronage of monumental
architecture.

Egypt: 1060-1171

Following the crisis of the middle of the elev-
enth century there was a marked change in the
functions and plans of religious buildings. Con-
gregational mosques are few. Instead, the com-
mon building for prayers was the *masjid*, a small
oratory, usually privately built and endowed,
often with a specific commemorative or phil-
anthropic purpose,[40] and without the city-wide
significance of the first Fatimid mosques. Only
much later did some of them acquire congre-
gational status when they were assigned a
special *khatib* or preacher to represent the state.
In plan, the two remaining examples of the
Aqmar mosque (1125)[41] and al-Salih Tala'i
(1160)[42] are remarkable for their modest di-
mensions, their location, and their external
shape. The Aqmar mosque [161, 162] has a

161. Cairo, Aqmar mosque, 1125, plan

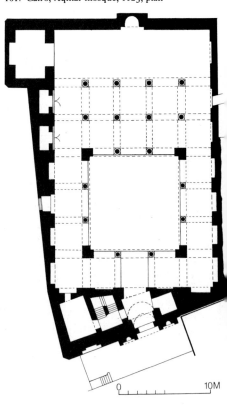

0 10M

curious façade which is not parallel to the qibla; the mosque of Salih could only be reached by bridges, since it was built over shops. In both instances previously existing streets and monuments determined the shape of the building, for each is on or near the main north-south artery of Cairo, where property was expensive, and the religious monument had to adapt itself to the more complex and more stable order of the urban community. The internal arrangement was not very original, unlike that of the vanished Mosque of the Elephants built by al-Afdal in 1085-6. Its peculiar name derives from the nine domes over the sanctuary which were surrounded by balustrades and from afar looked like the howdahs carried by elephants in caliphal processions.[43] Nine-dome mosques, which are otherwise known in Afghanistan and Spain, as well as in earlier times in Egypt,[44] belong to a rare type whose significance remains still unexplained.

Commemorative structures also changed. In addition to mausoleums, sanctuaries usually called *mashhads* (literally places of witnessing), such as those of Sayyidah Ruqqayah (1133) and of Aswan (*c.* 1100),[45] began to appear for purposes of prayer, pilgrimage, and private piety. They include the still somewhat mysterious so-called mosque of al-Juyushi [163, 164] on the Moqattam hills overlooking Cairo. The dedicatory inscription, which dates the building to 1085, clearly calls it a mashhad, yet its function as such is unclear: it does not seem to have been associated with a tomb, and Badr al-Jamali built it during his own lifetime. Koranic inscriptions suggest that it was erected in commemoration of some event which has remained unrecorded.[46] The plans of most of these buildings

162. Cairo, Aqmar mosque, 1125, façade

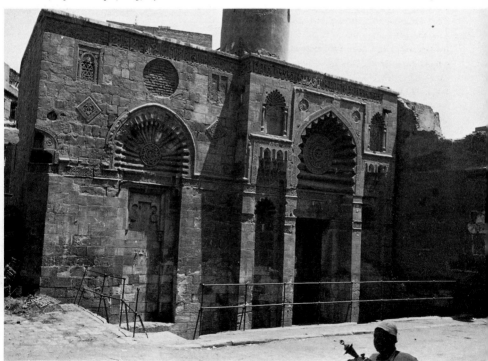

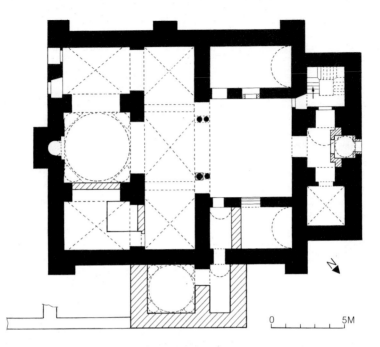

0 5M

163 and 164. Cairo, al-Juyushi mosque, 1085, plan and exterior

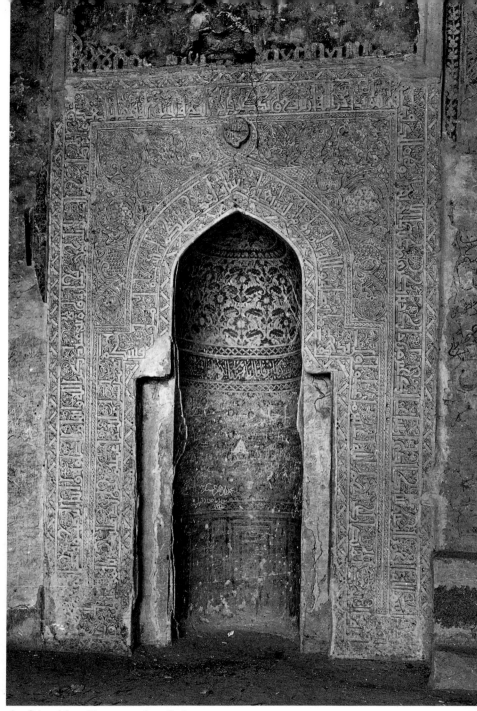

165. Cairo, al-Juyushi mosque, 1085, mihrab

are closely related. An entrance complex (domed at Aswan, topped by a minaret at al-Juyushi) leads to a small courtyard; the sanctuary has a large dome in front of a mihrab [165], always with a vaulted room on either side and usually with halls or rooms between it and the court (at al-Juyushi, three vaulted halls, one of which opened on the court through an ill-composed triple arcade; elsewhere all the rooms were covered with domes). The domes, like the zones of transition, were of brick, covered with plaster, and almost always four-centred in section; their surfaces varied from plain to ribbed. We have no record of how this kind of building was used; but we can say that religious practices must have changed significantly to justify the growth of the new type.

The importance of domes in these mausoleums and martyria explains the second major novelty of the later Fatimid period: a new mode of transition from square to dome. At al-Juyushi, an octagonal drum with eight windows surmounted a classical squinch. But already at Aswan by the turn of the century, and then in most other mausoleums, a muqarnas [166] replaced the squinch. The muqarnas is tripartite. A central niche bridges the corner framed by two sections of vault; above it is a sort of squinch vault approximately equal to the two sections on the lower level. Contrary to contemporary Iranian examples, no arch enclosed the composition. The outline of the motif became standard for windows, so that the openings of the late Fatimid mausoleums are remarkable for their variety and complexity.[47] We do not know whether the muqarnas originated locally or in Iran. Obviously the Egyptian and Iranian motifs are not alike; yet in purpose and basic tripartite composition they are closely related. The Iranian examples, however, are certainly earlier,

166. Aswan, mashhad, probably early eleventh century, muqarnas

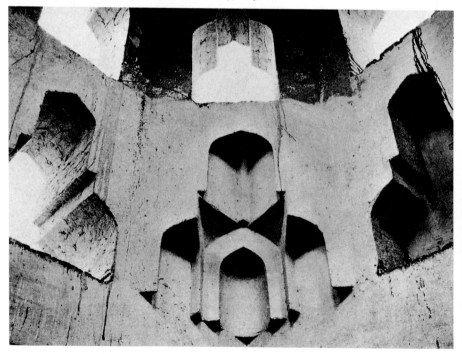

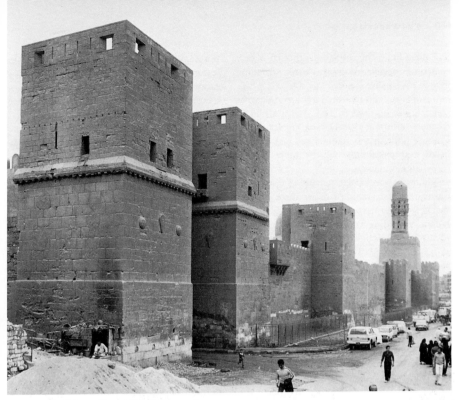

167 and 168. Cairo, walls and Bab al-Nasr, 1087

and their function, ambiguous though it may sometimes appear, is more clearly structural than in the smaller Cairene mausoleums. These two points suggest that the Egyptian muqarnas squinch was inspired by Iran, but not blindly taken over (although awkward imitations existed);[48] rather it was adapted and scaled to the needs and possibilities of the more modest Egyptian monuments.

The most spectacular remaining features of Cairene secular architecture are three gates to the new and enlarged city whose walls were redone, according to tradition, by three Christian architects from Edessa working under Badr al-Jamali [167].[49] The towers of the Bab al-Nasr [168] are square, those of the Bab al-Futuh and the Bab Zuwaylah massive and semi-circular. In his masterly analysis, Creswell not only pointed out their close connection with the military architecture of the northern Mesopotamian region, but also showed that they introduce to Cairo the use of stone as the sole mode of construction, a rejuvenated pendentive, the stone cross-vault, and the round arch – all features of pre-Islamic Mediterranean civilizations which had survived in the upper Jazira and Armenia.

The architectural decoration of the second Fatimid period is less impressive than in contemporary Iran or in the earlier Fatimid period. Much – especially in mihrabs – consisted of the wooden panels discussed later in the chapter, but older techniques remained such as stucco (especially remarkable at al-Juyushi) and stone (especially on the gates). The designs, almost always subordinated to architectural lines, were both geometric (the backbone of the design) and vegetal. One of the more interesting compositions is the façade of the al-Aqmar mosque (partly masked today), in which a Romanesque effect is produced by the central gate framed by two rows of niches, the false gates on the side, the upper band of decorative epigraphy, and the symmetrical arrangement on the walls of rectangular, circular, and rhomboid panels. Most striking are the peculiarly effective transformation of the conch motif in niche-heads, and the

use of muqarnas as a flat decorative design. Both features occur also in mihrabs, and an investigation based in large part on the Koranic quotations of the mosque has proposed that all these motifs carried a Shi'ite message.[50]

Altogether, the later Fatimid period witnessed an extension of architectural patronage reflected in the growth of smaller monuments, the development of the mashhad, the use of the muqarnas in architecture and decoration, and a partial return to stone. Whether or not these features are of local origin is often still a delicate problem; but most of them are also characteristic of Muslim architecture elsewhere, strongly suggesting that, despite its heterodoxy, the Fatimid world fully partook of the pan-Islamic changes of the eleventh and twelfth centuries.

THE DECORATIVE ARTS

Unlike architecture, the various arts of this period are usually devoid of inscriptions or other indications of date. The inscriptions which do exist, however, allow us, as in architecture, to establish two consecutive major phases, even though the division is not always clear-cut. In the earlier period artists continued to explore the possibilities inherent in forms long current in Egypt or more recently imported from the East. Later, new decorative principles were introduced, and artistic problems were approached in an entirely new spirit.

The Fatimid period is of singular importance as the era when Egypt reached its outstanding position in the Muslim world, not only as the focal point of vast trading activities extending as far as Spain in the west and India in the east (and outside the Islamic regions as well), but also as a great manufacturing centre. The arts and crafts were so highly specialized that it has been possible to establish no fewer than 210 different categories of artisans, compared to about 150 in ancient Rome.[51] Production for the lower and middle class was on a very large scale[52] and, at least in the instance of paper, factories were in many cases similar to those of modern times.[53] Stimulating to trade as such

conditions were, they also had a negative effect, giving rise to a tendency to repeat the same motifs on objects made in bulk, particularly textiles and pottery, and a concomitant decline in accuracy and finesse, apparently resulting from haste and poor working conditions. Even the vast output of luxury goods for the sultan and members of his court was affected.

During the reign of al-Mustansir (1036-94) the great treasury of the Fatimids was plundered, and the accounts mention not only great quantities of pearls and jewels, crowns, swords, and other imperial accoutrements but also many art objects in rare materials and of enormous

ture, carpets, curtains, and wall coverings, many embroidered in gold, often with designs incorporating birds and quadrupeds, kings and their notables, and even a whole range of geographical vistas.[55] Relatively few of these objects have survived,[56] most of them very small; but the finest are impressive enough to lend substance to the vivid picture of this vanished world of luxury painted in the historical accounts.

In wood, treasured in Egypt because of its scarcity, the established style was preserved most clearly. A carved tie-beam at the mosque of al-Hakim [169], dated 1003, still represents the true Samarra style C, though its bevelled

169. Cairo, al-Hakim Mosque, tie-beam (carved wooden panels encasing a palm trunk) of north-eastern dome-bearing arch, 1003

size.[54] Eighteen thousand pieces of rock crystal and cut glass were swiftly looted from the palace, and twice as many jewelled objects. Large numbers of gold and silver knives are reported, all richly set with jewels; valuable chess and backgammon pieces; various types of hand mirrors, skilfully decorated; six thousand perfume bottles in gilded silver; and so on. More specifically, we learn of enormous pieces of rock crystal inscribed with caliphal names; of gold animals encrusted with jewels and enamels; of a large golden palm tree; and even of a whole garden partially gilded and with niello. There was also an immensely rich treasury of furni-

decoration is restricted to a small number of motifs[57] and the lines delineating them are slightly wider, so that narrow dark areas separate the patterns, just as they had done in pre-Samarran carvings. This feature is more pronounced on the panels of a wooden door dated 1010, also inscribed to al-Hakim and now in the Museum of Islamic Art, Cairo [170],[58] where the individual bevelled patterns stand out clearly from a dark background. The major design elements are themselves decorated with small-scale surface patterns - another feature foreshadowed in the tenth century. The resulting textures, along with the contrast between

170 (*left*). Carved wooden door of al-Hakim, Cairo, 1010.
Cairo, Museum of Islamic Art

171 (*opposite*). Carved wooden panel, Egypt, eleventh century.
Cairo, Museum of Islamic Art

light and dark, produces more varied, lively, and accented compositions than earlier on. This trend reached a climax in another panel in the Museum of Islamic Art, Cairo [171], where the bevelled elements, reduced to a minimum, are carried on thin, spiral stems against a deeply carved background, and delicate surface patterns lend a leafy character. Moreover the design here, more vigorously accentuated than elsewhere, has an arabesque quality: the tips of leaves turn back into stems which carry other leaves *ad infinitum* according to the exigencies of the overall design, without regard for the forms of natural growth. Instead of starkly abstract, static, and purely sculptural qualities, there is now a dramatic interplay between abstract and more realistic parts, between elements conceived three-dimensionally and purely linear ones, and between light and shadow. In addition, there is a new sense of movement.

The same stylistic trend can be observed in lustre-decorated pottery, though this medium offered more limited possibilities. The decoration is often once again based on Samarra style C, but the motifs that took on sculptural qualities in carved wood had here to be rendered two-dimensionally. On the earliest pieces the main patterns consist of closely spaced series of half-leaves painted in solid lustre, alternating

172 (*above*). Monochrome lustre-painted bowl,
Egypt, late tenth century.
Berlin (Dahlem), Staatliche Museen,
Preussischer Kulturbesitz,
Museum für Islamische Kunst

173 (*above, right*). Monochrome lustre-painted jar,
Egypt, late tenth/eleventh century.
Athens, Benaki Museum

174 (*right*). Monochrome lustre-painted bowl,
Egypt, late tenth/eleventh century.
London, British Museum

with related designs of purely linear execution [172].[59] Slightly later, the white background areas between the solid lustred designs became more extensive [173], and in the end the distribution of lustre areas and background was about even [174], which parallels tendencies noted in the carvings. This type of decoration is at times combined with figural designs; for instance, in the centre of a bowl in the Museum of Islamic Art, Cairo [175], signed by Muslim ibn al-Dahhan, a very productive artisan in the period of the Caliph al-Hakim, is a winged griffin, rendered basically in silhouette, but with parts of its body structure clarified and emphasized by means of interior articulations in white. This attention to naturalistic detail represents a further development from the rather stiff, clumsily drawn animals on the Iraqi lustre bowls of the tenth century, as do the greater grace and innate movement in the griffin's body.

The final phase approximates to that of wood carving. Within the traditional festooned frame, skilfully composed arabesques fill the curved interior of the bowl to best advantage [176]. In spite of the closely grouped and solidly rendered half-leaves, the design produces a feeling of freedom and spontaneity: one leaf form turns with an easy, graceful twist into another, as if they were figures in a weaving dance; moreover the heavier forms are in the centre while the lighter, more rapidly moving elements are on the curving sides, where their mass is optically further reduced through foreshortening. The spirited, even dynamic quality of such designs is all the more remarkable in view of the heavy, undistinguished shapes of Fatimid bowls and vases. As is so often true of Islamic art, whether it be pottery, metalwork, ivories, or architecture – and never, for instance, of the ceramic wares of China – the main interest lies in the decoration, not in the underlying forms.

As the historical records make it clear that cut glass and rock crystal were, next to gold and silver, the most highly esteemed materials in the Fatimid period, their study is of particular importance. Fortunately, three carved Fatimid rock-crystal objects survive with inscriptions

175. Monochrome lustre-painted bowl with griffin, signed by Ibn al-Dahhan, Egypt, late tenth/eleventh century. *Cairo, Museum of Islamic Art*

176. Monochrome lustre-painted bowl with three lions, Egypt, eleventh century. *Cairo, Museum of Islamic Art*

177. Ewer of al-Aziz billah, probably Egypt, 975/96. Carved rock crystal.
Venice, S. Marco, Treasury

referring either to a caliph or to an official of the highest rank [177–9]. These not only provide fixed points of reference but also exemplify the finest quality of workmanship possible at the time; in addition, they are paradigms of the artistic climax that must have occurred between 975 and 1010.[60] Astonishingly, the designs no longer have any connection with Samarra style C; instead, despite the early date, they reflect the new artistic approach of the second phase of Fatimid art. On the other hand, there are a good many other, non-epigraphic rock-crystal objects in the true Samarra tradition. Were these made in the last third of the tenth century for a more conservative clientele? Or was there an extended earlier development in this difficult medium leading to the accomplished style of the inscribed works – a hypothesis supported by some Near Eastern pieces in the Samarra C style, which reached European church treasuries in the period from 973 to 982?[61] An overlapping of styles is possible, but it is more likely that a slow, unilateral growth starting in the first half of the ninth century led up to the climax in the eleventh. This development began with rather dense, still rather naturalistic all-over patterns based on the classical vine leaf [180],[62] then progressed to the bevelled style of the Tulunids [181], to an intermediary stage in the Ikhshidid and early Fatimid periods [182], and finally to the full flowering of the craft, with designs in a new vein under the caliphs al-Aziz and al-Hakim. It is not only the new style itself, apparently reflecting strong eastern influence, which is significant, but its appearance in a rare and valuable material to which the newest artistic ideas were more readily applied. Objects of wood and lustre-painted pottery, though of the highest artistic quality and carrying the caliph's name or that of one of his officials, were apparently regarded as of lesser value and their artisan creators appeared less responsive to the new artistic approach; they followed the Samarra tradition even after the new manner had been adopted for rock crystal.

In view of the close technical and artistic relationship between cut glass and carved rock

178. Crescent of al-Zahir, probably Egypt, 1021/36. Carved rock crystal. *Nuremberg, Germanisches Nationalmuseum*

179. Ewer, probably Egypt, 1000/8. Carved rock crystal.
Florence, Palazzo Pitti, Museo degli Argenti

180. 'Lamp', possibly Egypt, early ninth century. Carved rock crystal.
Leningrad, Hermitage

181. Chess pieces, possibly Egypt, late ninth/tenth century. Carved rock crystal.
Kuwait National Museum, The Al-Sabah Collection, Dar Al-Athar Al-Islamiyah

182. Bottle, possibly Egypt, tenth century.
Carved rock crystal. *Essen Minster*

crystal, the latter mainly worked in Egypt, and
of the great number of pieces reported in con-
temporary accounts, as well as of vessels and
fragments actually found there, we must con-
clude that cut glass was manufactured in Egypt
during the Fatimid period and even earlier. Un-
fortunately, no systematic study has been made
to date, so that it is not yet possible to recognize
any features distinguishing Egyptian pieces

from those made in the eastern caliphate and to
determine the validity of the present-day sup
position that some represent a debasement o
Iranian examples.[63]

The only cut glass whose Egyptian origin has
rarely been questioned consists of a group o
more than a dozen rather thick-walled tumblers
mostly of a smoky metal colour with a few
greenish or yellowish examples, and all but one
richly decorated. They are called 'Hedwig
glasses'[64] because three of them have a tradi-
tional connection with St Hedwig of Silesia
(1243). Four feature abstract decorations de-
rived from Samarra style C. At least one o
these, in the Veste Coburg [183], is in such
pure style that it probably dates from the tenth
century, possibly its beginning. Two other
seem, on account of their more advanced nature
and the wider spacing of the motifs, to have
been made towards the middle and in the second
half of the century.[65] Although these four tum
blers represent different stages in the final phase
of this style in Egypt, they show no sign o
decadence, and the decoration is actually re
markable for its bold forms, entirely appropriate
to the rather stubby shape of the vessels. A
second group of eight bears highly stylized, for-
mally arranged, and closely spaced animal re
presentations of lions, griffins, and eagles [184
185] revealing a decided sense of *horror vacui*
The animals are profusely covered with hatch
ings and cross-hatchings in pursuance of design
rather than of nature, so that especially the
highly stylized lions seem to be massive, fancifu
creatures quite foreign to the precise, more
linear renderings found on eastern cut glass. The
sense of unreality is further heightened by the
transparency of the medium and even more s
by the manner of cutting, which creates spatia
ambiguities and leaves the viewer at first unable
to decide whether certain parts are concave o
convex. Yet these glasses with animal design
do share some mannerisms with the purely for
mal decoration of the first series, so that the
are probably fairly close in date. The laboured
rendition of the zoological figures, however, an
the lack of precision in drawing point to a rathe

THE DECORATIVE ARTS · 197

. 'Hedwig glass', possibly Egypt,
ly tenth century. Cut glass.
ste Coburg

late stage of development, so that at least some
of the figural tumblers may date from the end
of the eleventh century. So far, no fragments of
this type are known from the Near East; all
preserved pieces come from the treasuries of
Western churches and noble houses.

Bronze is another medium in which eastern
inspiration was transfigured in Egypt during
the Fatimid period. A number of sculptures of
various sizes representing griffins, stags, lions,
eagles, and other types of birds were used as
aquamaniles, incense burners, fountain spouts,
padlocks, and possibly vessel supports.[66]
Apparently related to, if not derived from, ani-
mal figures made in the late Sasanian and early
Islamic period, they share not only a high degree
of stylization, which never impairs effective re-
cognition of the subject, but also such secondary
features as frequent all-over decoration and
zoomorphic handles. It is not yet possible to
assign precise dates, but it can be assumed that
in the earlier examples the animals' bodies were

. 'Hedwig glass' with lions, possibly Egypt,
h century. Cut glass.
sterdam, Rijksmuseum

185. 'Hedwig glass' with birds, possibly Egypt,
tenth century. Cut glass.
Minden Cathedral

186. Lion, probably Egypt, eleventh century. Cast bronze. *Copenhagen, National Museum, Department of Ethnography*

187. Bird, probably Egypt, eleventh century. Cast bronze. *Mount Sinai, St Catherine's Monastery*

reduced to basic forms [186], whereas later on greater stress was laid on elegance and grace. In this respect they differ from the more uniformly stylized, and usually severely monumental, zoomorphic bronzes from Iran. Whatever the style, the Fatimid works are impressive as animal sculptures, and the fact that they seem to have served as prototypes for Romanesque pieces with similar functions increases their signifance.[67]

An example of the more developed type is the bird aquamanile in the monastery of St Catherine on Mount Sinai [187]. Its small protruding head with curved beak and jagged wattle, folded wings, high feet, and handle in the form of a quadruped obviously relate it to the Umayyad bird now in the Berlin Museum [47], though it has more natural grace, and the engraving, at least in some areas, follows more freely the natural patterns of the feathers; even here, however, certain parts, especially in the front, carry purely ornamental designs and an Arabic inscription. The most monumental ren-

dition of such an animal is the celebrated bron griffin in the Campo Santo in Pisa [188].[68] He everything is formalized, not only the body a its parts but also the engraved decoration, whi consists of rosettes, inscriptions, and designs small animals – none of them detracting, how ever, from the grandiose impression that th piece, which is more than one metre high, mak on the beholder. Its original function is n known; along with other examples of the sar type, it may have supported a large basin other object.

The superb objects in all the various med even though subject to different requiremen prove that Fatimid artists were well qualified develop imaginatively the shapes and patter usually of eastern derivation, that they had i herited: indeed, within a relatively short tin once-alien forms became thoroughly acclin tized, and soon thereafter many pieces took an easily recognizable Egyptian character. Th are distinguished by more graceful shap greater freedom, and more spirited inner mo

188. Griffin, probably Egypt, eleventh/twelfth century. Cast bronze.
Pisa, Campo Santo Museum

ment, all achieved without any sacrifice of monumentality.

Towards the end of the eleventh century new trends appeared in the Fatimid decorative arts, foremost among them an intensified interest in naturalistic representation of the human figure, which was always greater in Egypt, with its Mediterranean heritage, than in the eastern parts of the Islamic world. This is particularly striking in the medium to which it might seem most alien: lustre-painted ceramics. The even metallic sheen produced by this technique does not permit the use of shading to model figures and suggest depth in the background; nevertheless, the craftsmen managed, by means of a number of other devices, to achieve naturalistic effects quite different from the two-dimensional stylization of Mesopotamian lustre designs, and even from the rather static vegetal and animal motifs of earlier Fatimid pieces.

Among these devices were the use of energetic line, off-balance poses, and dramatic gestures to convey a sense of movement. One example is the scarf dancer represented on a lustre dish at present in the Freer Gallery of Art in Washington [189].[69] The rendering of face and hair betray descent from the figure style of Samarra – especially the large, round face, the staring eyes and small mouth, as well as the side curls – just as the use of a contour line and the sketchy vine scrolls filling the ground provide evidence of continuity with earlier Abbasid and Fatimid ceramics. The animation of the body and exaggerated gestures of the limbs are, however, a great advance over the frozen monumentality of even the most active figures in the wall paintings from Samarra (see, for example, illustration 107 in Chapter 3). Furthermore, the artist of the Fatimid dish has succeeded, through the use of white lines reserved from the lustre, in suggesting the fall of the dancer's garment over the roundness of her body and limbs.

Some of these features are more pronounced on a bowl fragment in the Museum of Islamic Art in Cairo [190] on which a reclining figure pours wine from a bottle into a glass beaker.[70]

189. Monochrome lustre-painted dish with scarf dancer, Egypt, late eleventh/twelfth century.
Washington, D.C., Freer Gallery of Art

190. Monochrome lustre-painted bowl fragment with reclining figure pouring wine, Egypt, late eleventh/twelfth century.
Cairo, Museum of Islamic Art

Again, the old Samarra facial features and hairstyle are present, though much elaborated; but the familiar contour lines and patterned panels have been replaced by a plain white ground. Despite the apparent relaxation of the pose, a

191. Monochrome lustre-painted dish
with reclining lady, Egypt,
late eleventh/twelfth century.
Cairo, Museum of Islamic Art

192. Monochrome lustre-painted bowl
with cockfight, Egypt,
late eleventh/twelfth century.
London, Keir Collection

sense of animation is conveyed by the broad
gestures of the arms: indeed, the use of reserve
for face and arms has permitted the artist greater
flexibility in his use of line, now drawn in lustre
on the white ground; he could accentuate the
fullness of the arms, the grip of the fingers, and
even the dissipation of the eyes. In addition, he
has devoted greater attention to realistic details
of costume, jewellery, and vessels than in earlier
ceramics.

On a similar dish, also in the Museum of
Islamic Art, Cairo,[71] a lady with two female
attendants reclines on a couch [191]. Here,
however, it is the background that is painted in
lustre and the figures and accessories that have
been reserved in white, thus permitting even
greater use of linear modelling and fine detail.
Another innovation worthy of note is the epi-
sodic nature of the theme; instead of human
figures and animals presented singly or serially,
this type illustrates groups engaged in particular
activities. Here the lady seems to be taking up
her lute or relinquishing it to the servant; but in
contrast to the ceremonious quality of courtly
scenes with musicians on Spanish ivory boxes,
for example (see Chapter 4, illustration 129),

193. Monochrome lustre-painted bowl fragment
with Christ blessing, Egypt,
late eleventh century.
Cairo, Museum of Islamic Art

this has the informal flavour of an event
observed from daily life.

This new interest also encompassed such
popular entertainments as wrestling, acrobatics,
and cockfighting [192].[72] Furthermore, pieces

with clearly identifiable Christian subject matter reflect the important role that Coptic Christians played in medieval Egyptian society; clerics, for example, are represented, and on one fragment from the Museum of Islamic Art in Cairo [193],[73] Christ is depicted making the gesture of blessing.

Although none of these ceramics is dated, they are generally attributed to the last century of Fatimid rule on the basis of comparisons with works in other media. Particularly important is a series of carved wooden boards believed to have come from the Fatimid Western Palace in Cairo, which was completely renovated by the Caliph al-Mustansir between 1058 and 1065; this provides a probable date for the carvings. The palace was destroyed by the Ayyubid conqueror Salah al-Din (Saladin) in the late twelfth century, but the boards survived to be re-used in the hospital of Sultan Qala'un, built on the same site at the end of the thirteenth century.[74]

The animals and human figures are organized in elongated lozenges of varying lengths alternating with forms in which four curved lobes are separated by four pointed ones, all carved against a background of formalized vine scrolls in lower relief. The rich repertory of subjects includes many that are also found on lustre-painted ceramics; for example, a number of male and female dancers are portrayed in the same animated posture as that of the scarf dancer on the Freer dish – a basic pose also adopted for the figure of illustration 194, who, however, is clad in the short garment common to labourers in the medieval Near East and brandishes a goad instead of a scarf. In keeping with the new taste for scenes from everyday life, a woman peers out through the open curtains of a palanquin on the back of a camel, which is escorted by a man. In another compartment a drinking party is in progress [195]. Two turbaned figures grasp goblets, one of them pouring from a bottle in a position not dissimilar from that on the lustre fragment in illustration 190. From one side a servant approaches carrying a large vessel, presumably in order to replenish the bottle. Although the roughness of

(opposite, top to bottom)
194. Man with a camel, detail from a wooden board, Egypt, late eleventh century. *Cairo, Museum of Islamic Art*

195. Drinking party, detail from a wooden board, Egypt, late eleventh century. *Cairo, Museum of Islamic Art*

196. Acrobatic scenes, detail from a wooden board from Dayr al-Banat, Egypt, late eleventh/twelfth century. *Cairo, Coptic Museum*

execution means that details are not as clear as on some lustre-painted ceramics, traces of red and blue pigment suggest that specifics of facial features, costume, and so on may have been precisely delineated in paint.

From the Coptic convent of Dayr al-Banat in Egypt comes another wood carving [196], more refined in workmanship but reflecting even more strongly the late Fatimid taste for observation from life.[75] Here formal vegetal motifs alternate with four acrobatic episodes: a man atop a column; a figure probably dancing on a tightrope accompanied by musicians; another figure standing on his head, also to the accompaniment of music; and, finally, a balancing act.

Ivory carvings attributed to Fatimid craftsmen show close parallels in style and iconography to lustre ceramics and wood, but here the workmanship demonstrates the greater refinement appropriate to so expensive a material. Illustration 197 shows an openwork plaque, one of a group in the Museum für Islamische Kunst, Berlin,[76] that apparently once faced a casket or other small object. The familiar pose of the dancer has here been adapted for a huntsman wearing the appropriate short costume, who appears about to spear one of the animals above him. Instead of the usual hunter's quarry, how-

197. Plaque, probably Sicily, twelfth century.
Ivory. *Berlin (Dahlem), Staatliche Museen,
Preussischer Kulturbesitz,
Museum für Islamische Kunst*

ever, the ivory carver has substituted an image
with a long history in the Middle East: a lion
attacking a hump-backed bull.[77] Particularly
noteworthy is the grace of the flautist, her
weight convincingly distributed, her fingers
daintily poised, her headdress precisely knotted.
The naturalism of all the figures is heightened
by the refined technique. Although there are
two main levels of relief, as on the wooden
boards, here the frames and figures are so deli-
cately modelled that they appear fully rounded,
as if they were actually emerging from the ve-
getal scrolls that constitute the background.[78]
A device that contributes to this effect is under-
cutting: the flautist's hands and instrument are
held away from the body, the full sleeves of both
musicians seem to enclose empty space, the hem
of the lutanist's robe is bunched in three-
dimensional folds, and so on. Furthermore, the
vine scrolls in the background put forth leaves
and grape clusters that frequently project for-
ward, so that the two planes of the carving seem
interconnected. Like the lustre-painted ceram-
ics, these ivories are distinguished by the care
lavished on detail, for example in the rendering
of textile patterns, the texturing of animal hair
and bird feathers, and the veining of leaves.

Because of their highly developed style, the
Berlin ivories and comparable pieces in the
Louvre[79] have been dated to the late eleventh
or early twelfth century. Even more advanced
is the carving on a series of six similar plaques
in the Museo Nazionale, Florence.[80] In illus-
tration 198 a labourer carries a pannier full of
grapes on his back; above him a hunter spears
a lion. Again the bodies are delicately rounded,
and there is a subtle interplay between the two
levels of relief. A second plaque from this group
[199] repeats one of the most familiar themes in
the decorative arts of later Fatimid times: the
scarf dancer, skipping, her draperies swirling

198. Plaque with hunter and harvester,
probably Sicily, twelfth century. Ivory.
Florence, Museo Nazionale

199. Plaque with scarf dancer,
probably Sicily, twelfth century. Ivory.
Florence, Museo Nazionale

about her twisted body, her arms gesturing
sinuously.

It has been suggested that this new imagery,
with its animation and fully realized observation
of the details of everyday living, reflected devel-
opments that occurred first in painting.[81] Un-
fortunately, only a few fragments of wall paint-
ing and apparently no miniatures survive from
the period.[82] It is possible, however, to obtain
an idea of what Fatimid painting must have

looked like by studying a monument believed to have been painted by Islamic craftsmen, even though they were working for a Christian king of Sicily, Roger II, in the 1140s.[83]

The monument is the wooden ceiling of the Cappella Palatina, or palace chapel, in the Norman royal residence at Palermo, an elaborate

tration 201. This genre figure, in labourer's garb, is set in front of vine scrolls, which function as a second plane, very much as in Fatimid wood and ivory carvings. Other genre scenes include two servants drawing water from a well and pouring it into vessels [202]. An interest in representation of the mise-en-scène, already

200. Palermo, Cappella Palatina, ceiling painting of scarf dancer, c. 1143

201. Palermo, Cappella Palatina, ceiling painting of porter with barrel, c. 1143

construction of coffering and muqarnas which spans the central nave. Each small surface is painted with an inscription, a decorative band, a centralized floral composition, or a scene with animals or humans. Among the figural representations is the scarf dancer [200], one of several, who betrays a close kinship to renderings in other media examined here; especially to be noted are the contorted body and the fine linear treatment of drapery folds, which accentuate the fleshiness of the body forms beneath. Familiar from Samarra are the facial features and hairstyle of the porter carrying a barrel in illus-

observed in rudimentary form on Fatimid lustre ceramics, is apparent here in the careful rendering of the well head, with its double apparatus for raising and lowering what appear to be skin buckets, and the sheltering vine arbour.

Many other paintings at Palermo combine conservative features harking back to Samarra with reflections of the new concerns characteristic of Fatimid art. In illustration 203 a shepherd carries a ram on his shoulders, an image related to the motif on one of the painted wine bottles from ninth-century Samarra.[84] At Palermo, however, there is a more natural sense of

202. Palermo, Cappella Palatina, ceiling painting of servants drawing water, *c.* 1143

203. Palermo, Cappella Palatina, ceiling painting of shepherd carrying a ram, *c.* 1143

movement, and the turn of the shepherd's arms and hands has been carefully observed. The texturing of the ram's wool and the vine scroll thrusting forward to entwine itself around the shepherd's leg confirm that this painting belongs to a period closer to that of the ivory plaques in Berlin [197].

Nevertheless, courtly scenes of drinkers, musicians, and hunters are the predominant themes on the Palermo ceiling, as befits a royal monument. There are traces, too, of accommodation to the interests of a Christian king. In one rather damaged banquet scene, the prince is seated in western fashion at a cloth-draped table, flanked by standing servants [204].[85] Illustration 205, moreover, shows a combat between a mounted spearman and an elaborately coiled dragon trampled beneath the horse's hooves – a scene which, despite obvious stylistic features related to other works discussed here, seems to have been drawn from a long Christian tradition of representing warrior saints.[86]

The circumstances in which the ceiling was painted have led to considerable speculation about the artists responsible. On the one hand, the conservatism of subject matter and icono-

graphy has suggested painters imported from
an artistic centre dependent upon Mesopotamia,
where the old Samarra styles presumably
retained considerable vitality; on the other, the
interpenetrating planes, the emphasis on ani-
mation and specific detail, and the taste for
genre scenes all point to artists trained in a
Fatimid school, whether in Cairo or elsewhere.

204 (*right*). Palermo, Cappella Palatina,
ceiling painting of banqueting prince, *c.* 1143

205 (*below*). Palermo, Cappella Palatina,
ceiling painting of horseman fighting a dragon, *c.* 1143

IRAN AND CENTRAL ASIA: 800–1025

The history and culture of Iran and central Asia during the first centuries of Islamic rule are still poorly known. Nominally this vast area consisted of several provinces ruled by governors appointed in Baghdad. From the ninth century, however, dynasties of governors such as the Tahirids (821–73), or the aristocratic native Iranian Samanids (819–1005) and the more popular Saffarids (867–963), exercised effective control over generally ill-defined areas. For most of this period, apart from a few cities of western Iran such as the future Isfahan, or Qum, which acquired quite early a holy association with Shi'ism, the main Muslim centres were in the huge province of Khorasan, with its four great cities of Nishapur, Merv, Herat, and Balkh, and the frontier area of Transoxiana, with Bukhara and Samarqand. The real growth of an Islamic western Iran began only with the Buyid dynasty (932–1062), which occupied Baghdad itself in 945.[1]

Cultural life was dominated by two partly contradictory trends, whose symbiosis remained for centuries characteristic of Iran. One is a pan-Islamic Arabic culture, closely tied to that of Baghdad, as practised in the major philosophical, religious, and scientific centres of the north-east by thinkers of universal importance such as al-Farabi, al-Razi, or Ibn Sina (Avicenna). The other is specifically Iranian, as the very same regions witnessed the birth of modern Persian, as the first Persian poetry makes its appearance, and as the epic tradition of Iran is written down in Firdawsi's *Shahnama* (c. 1000). In all likelihood, most contemporaries participated in both these trends, thus creating an amalgam of ethnic awareness and Muslim allegiance.

This cultural blend was to continue for several centuries. However, the social, ethnic, and political structure was slowly being modified by the large-scale movement of Turkic tribes and Turkish soldiers into Iran, beginning in the tenth century and culminating with the capture of Baghdad by the Seljuqs in 1056. The period of adaptation of Islam to Iran and of experimentation with some new forms can be considered to have ended by the first decades of the eleventh century, by which time the arts, and especially architecture, can more easily be related to what follows, in spite of innumerable local variations. It is likely that further research and excavations will modify or clarify what at this stage is a partly arbitrary chronological break.

ARCHITECTURE

Mosques

The large cities were all provided with congregational mosques. Some, such as those of Nishapur, Bukhara, Qum, and Shiraz, are known only through literary references,[2] but three – at Susa,[3] Siraf,[4] and Isfahan[5] – have been made available by archaeology. Susa, possibly as early as of the eighth century, is typical of the Iraqi hypostyle tradition. Siraf [206], excavated in truly exemplary fashion, had two phases, both in the ninth century. The first mosque, 51 by 44 metres, was a simple hypostyle with three naves parallel to the qibla and a single portico around the other three sides of the court. It had a single entrance and an adjoining minaret. Shortly after completion, it was enlarged by four metres on the qibla side; two naves were added on the qibla, and one around the rest of the court. At Isfahan [207] the size, the complexity of the later history of the building,[6] and several obscure texts[7] have made the task of excavators much more complex. It seems clear, however, that a large (c. 140 by 90 metres)

hypostyle mosque was built possibly in the ninth century, and that in the tenth, probably under the Buyids, an additional arcade was built around the court with the bricks of the piers so arranged as to make simple geometric designs into strongly emphasized variations in planar depth.

It is probably no accident that the mosques of the large emporium of Siraf and of the major political centre of Isfahan underwent the same

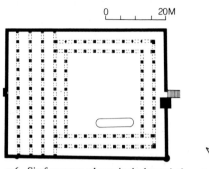

206. Siraf, mosque, plan as in the later ninth century

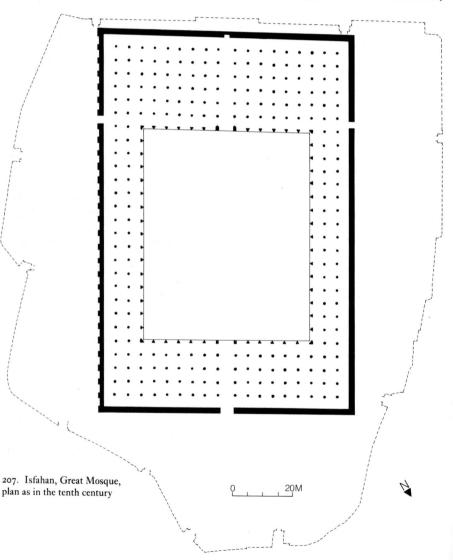

207. Isfahan, Great Mosque,
plan as in the tenth century

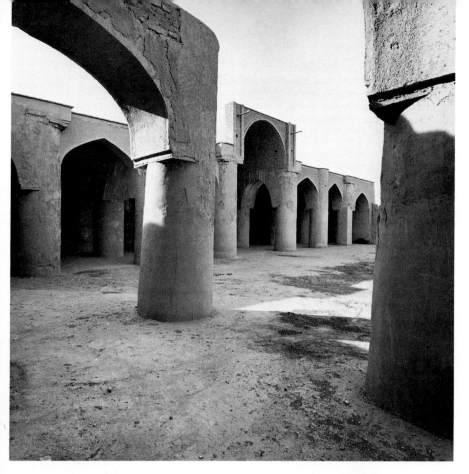

208 and 209. Damghan, mosque,
possibly eighth century, court and plan

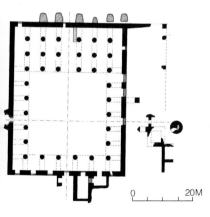

0 20M

change in the ninth and tenth centuries respectively of an arcade added to the courtyard. Just as in contemporary Kairouan, the explanation may lie in a concern for the visual and aesthetic autonomy of the court, and these may well represent the first steps towards one of the major achievements of Iranian architecture: the court façade.[8]

What is more difficult to visualize is the nature of the problems faced in creating a new type of building and in developing new technical or other solutions. Three smaller mosques on the Iranian plateau, at Damghan [208, 209],[9] Nayin [210, 211],[10] and Fahraj,[11] all undated and much restored, suggest some answers. The first two are hypostyle, but covered with vaults; the third has five barrel-vaulted compartments

at right angles to the qibla, three of them cut short in order to provide for a court. Nayin has three domes in front of the mihrab.[12] These three mosques illustrate the problem of adapting an architectural tradition based on long barrel-vaults, often by then pointed in section, to the need for a large space with a minimal number of supports. The solution was to build closely set, heavy, and often ungainly brick pillars of varying shapes, whose rich stucco decoration (at least at Nayin [212, 213]) served to mask the squatness of the architecture and to emphasize the qibla. Interesting though they are for the history of architecture, these buildings can hardly be called successful.

210 (*below*) and 211 (*opposite*). Nayin, mosque, probably tenth century, view towards qibla and plan

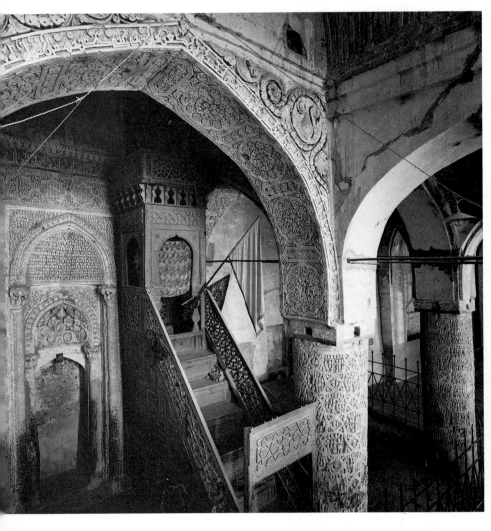

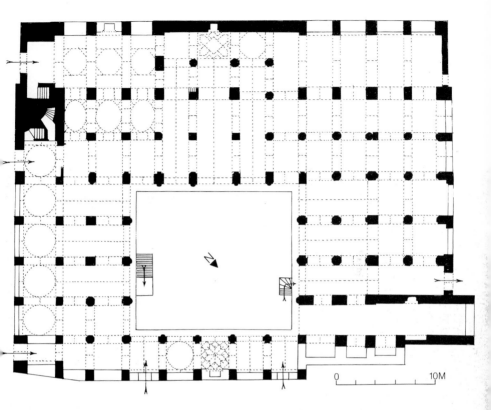

212 and 213. Nayin, mosque,
probably tenth century, details of stucco work

214 and 215. Hazara, mosque,
plan and view of interior

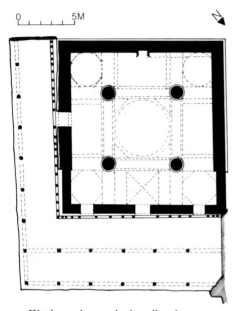

We do not know whether all early congregational mosques in Iran were hypostyle. An undated but certainly archaizing, if not archaic, small mosque at Hazara, near Bukhara,[13] consists of a square hall with a central dome on squinches with vaults on all four sides, and four small domes on the corners [214, 215]. Domes and vaults are carried by thick walls and four heavy brick pillars with curiously shaped arches. The central plan is similar both to that of certain Iranian fire-temples and to a whole tradition of east Christian architecture. But the ultimate significance of this variant from the hypostyle is possibly lessened by the minor importance of the village in which it is found, and we cannot yet tell whether or not it is unique. Similarly, a small nine-domed ninth-century mosque near Balkh [216][14] may be related to a secondary type of sanctuary found in Egypt and in Spain.[15]

Some significant hypotheses proposed in the 1930s by A. Godard,[16] which have found their way into many general accounts, are based on the fact that in many congregational mosques of later times (Isfahan, Ardistan, Gulpaygan, Barsian, etc.) there is on the qibla side a large domical room of a period different from the rest of the mosque. At Niriz [217, 218], instead of a dome, there is an iwan extending from the court to the mihrab and towering above the rest of the mosque; an ambiguous inscription dates the earliest (unidentified) construction there to 973. Godard therefore put forward the thesis that, in addition to a number of hypostyle mosques, there was in early Iran a type consisting of a single domical room, like the ancient fire-temples, or even of a single iwan. An open area in front, perhaps marked off in some simple way, would have served as the main gathering area until, after the eleventh century, more complex

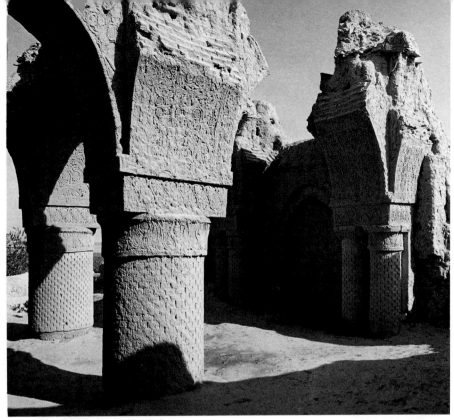

216. Balkh, nine-domed mosque, ninth century
217. Niriz, mosque, 973 and later, iwan

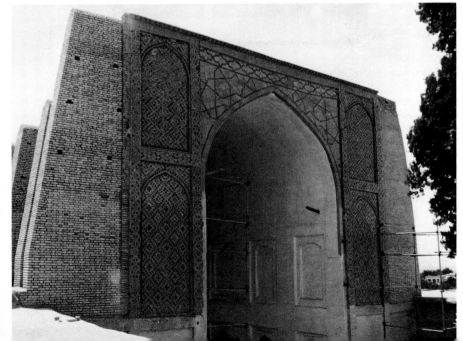

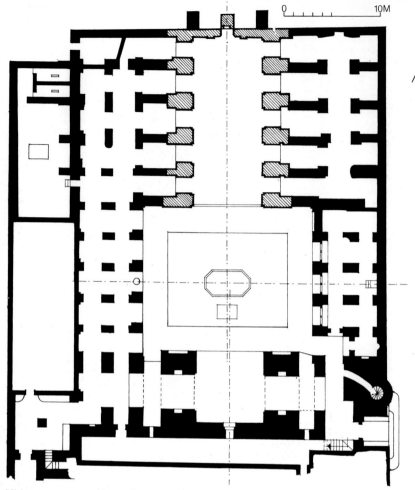

218. Niriz, mosque, 973 and later, plan

and complete constructions were erected. Attractive as it may be in providing a link between the pre-Islamic and Seljuq uses of domes and iwans in monumental architecture, this hypothesis cannot at the moment be accepted, except in regard to the few early cases where a pre-Islamic sanctuary was transformed into a mosque.[17] None of the adduced examples of domes can be dated before the end of the eleventh century, and in no instance is it possible to maintain that a dome alone preceded the present one.[18] Thus, the evidence at present in our possession leads to the conclusions that the hypostyle congregational mosque was adapted to Persian techniques of construction, and that other types belong, in ways yet to be studied, to a range of local or Islam-wide variants.

Mausoleums

Why the earliest consistent group of Islamic mausoleums should appear in tenth-century Iran[19] is not altogether clear. Dynastic pretensions, heterodox movements worshipping the

burial places of descendants of Ali,[20] and attempts to attach a Muslim meaning to traditional holy sites must all have played a part in a phenomenon which may well have spread westward from Iran (where it took permanent root), especially to Fatimid Egypt.[21]

Of the two remaining types of mausoleum the first, of which examples remain throughout the Iranian world, is the canopy tomb, a domed cube generally open on all sides, like the first constructions in Najaf and Kerbela over the tomb of Ali and his descendants. Some may be as early as the tenth century; only two can be securely dated, however, and these happen to be remarkable monuments of architecture.

Recently discovered epigraphical, literary, and archaeological evidence suggests that the mausoleum of Isma'il the Samanid in Bukhara was used for more than one prince, and that it was built a little later than hitherto believed, perhaps under the Samanid prince Nasr (914–43).[22] This slightly tapering cube, about ten metres to the side, is entirely of excellent baked brick, covered by a large central dome with four small domes on the corners [219, 220]. In the middle of each face is a monumental recessed arched entrance within a rectangular frame; a circular, partly engaged, full pier serves to soften the corners and to provide an upward movement to the whole monument. A gallery runs all around, although no access to it exists. Inside [221], the most striking feature is the transition from square to dome: the squinches are framed within an octagonal flat arcade on brick colonnettes, and above a narrow sixteen-sided zone smooths the passage to the base of the cupola. The squinch itself consists of two arches parallel to each other and buttressed by a perpendicular half-arch – almost a sort of rib – which abuts against the gallery, thereby permitting the opening up of the areas on each side of the half-arch and the lighting of the building. To use E. Schroeder's happy expression, the thrust of the dome is carried on a sort of tripod.[23]

This building has two major peculiarities. First, in spite of the harmonious proportions, the corner pillars, the gallery, and the small

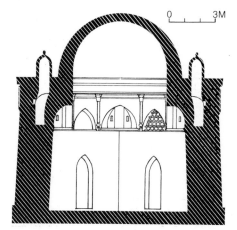

219 and 220. Bukhara, Samanid mausoleum, 914/43(?), section and exterior

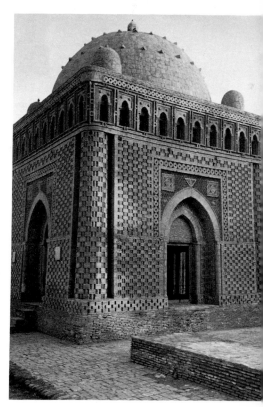

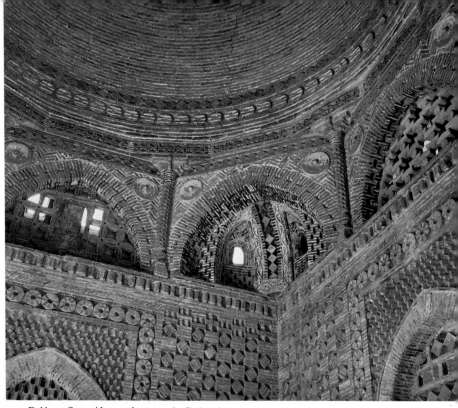

221. Bukhara, Samanid mausoleum, 914/43(?), interior

domes are all structurally completely unrelated to one another – although they are understandable as elements in the decorative composition of the façade or of the roof. A similar point can be made about the multiplication of features marking the transition from square to dome, and about the lack of relationship between inner and outer forms. These apparent contradictions can only be explained as reflections of several architectural traditions in which all these features played some part: they illustrate an architect's keen eye for surface composition rather than for clarity in construction.

The second peculiarity of the Bukhara mausoleum is the unusual use of brick. Almost every visible brick is at the same time an element of construction and part of a decorative design. The designs vary. On the main wall surfaces the same two types are found, one inside, the other

outside, both serving primarily to provide a woven effect, a chequerboard of light and shade. At the entrances and in the zone of transition a greater variety of motifs creates a deeper impression of intensity of decoration without changing the medium or the technique.

Although individual themes or motifs of the Bukhara mausoleum may be related to aspects of pre-Islamic art, the reason for their congregation here at this time is unclear. The plan, though akin to some, is not exactly like that of any known fire-temple - in any case an unlikely model for a mausoleum. It might of course derive from late antique martyria, but it is difficult to explain how such Mediterranean forms could have reached central Asia. Nor is it altogether in the tradition of later Iranian mausoleums. Since it was a princely foundation, its plan and decoration may well have derived from

222. Tim, mausoleum, 977–8, façade

secular building. Even though none has sur-
vived, domical pavilions were common in Mus-
lim palace architecture; such a structure, with
several features similar to those of the Bukhara
mausoleum, is shown on a celebrated Sasanian
or early Islamic salver in the Berlin Museum.[24]
Another possibility is that the building derived

from smaller portable domical objects such as
those represented on the Soghdian frescoes of
Pyanjikent, where they have a clearly funerary
significance.[25]

A second canopy mausoleum of even greater
significance, the *mazar* (holy place) Arab-ata at
Tim in the area of Samarqand [222, 223], is

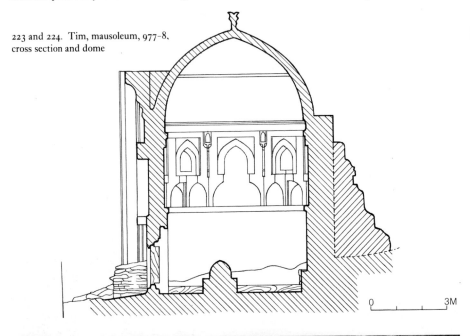

223 and 224. Tim, mausoleum, 977–8,
cross section and dome

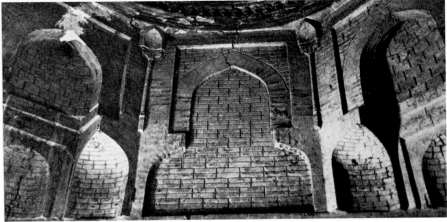

dated 977-8.[26] Square inside (5.60 by 5.60 metres), it is extended on the outside (8 by 8.70 metres) by a splendid, fully developed single façade – a feature hitherto believed to have developed only in the following century. The barrenness of the brickwork throughout contrasts with the decorative wealth of this façade, many of whose themes – such as the three recessed arches – are closely related to those of the outer faces of the Samanid mausoleum, as is the general composition. The use of stucco for decorative designs between layers of brick, however, announces the techniques of the following century. Finally, the Tim mausoleum introduces a type of transition from square to dome, also destined to have a brilliant history in later Iranian architecture, which may be called the 'articulated squinch' [224]. The squinch proper shrinks, and is framed by two sections of domes, one on each side, and by a high arch above, producing a characteristic profile which is then reproduced as a flat arch between the corners, thereby giving the octagonal zone of transition a unified and proportioned aspect. The small purposeless column remaining in each angle, the clumsy framing of the new expedient within rectangles, and the overall heaviness of the system suggest that the device is related to the older type of squinch arrangement found at Bukhara, modified by a new technical concern to which I shall return shortly.

Several tower mausoleums also remain. The most spectacular is the Gunbad-i Qabus [225, 226], built by the Ziyarid prince Qabus b. Vashmgir in 1006-7 near Gurgan, south-east of the Caspian Sea. Circular inside and shaped like a ten-pointed star outside, on an artificial platform and 51 metres high, it dominates the landscape. As no trace of a tomb was found, the coffin could have been suspended inside, as a medieval chronicler related.[27] The excellent brickwork is distinguished from that of the Samanid mausoleum by the intense purity of its lines and shapes. Two inscriptions and a small decorative border under the roof are the only features which break up the solid mass of brick. A totally different aesthetic is present here. The

origin of the Gunbad-i Qabus is no clearer than that of the Bukhara monument. Since it was built by a member of a family recently converted to Islam from Zoroastrianism and still connected with pre-Islamic traditions (as indicated by the use of a solar as well as of a lunar calendar on its inscription), we may very tentatively sug-

225. Gunbad-i Qabus,
1006-7

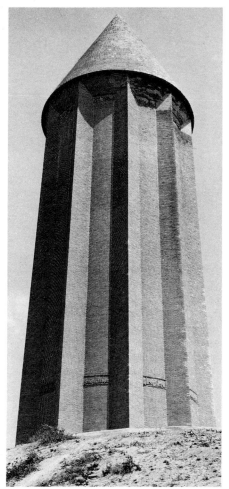

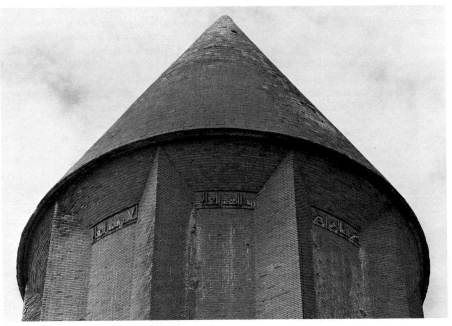

226. Gunbad-i Qabus, 1006-7, detail

gest that its background may be sought in some Mazdean commemorative monument or in the transformation into permanent architecture of a transitory building such as a tent.

Secular Buildings

Most of the great palaces and public works of Iran are known only through texts. Both the Samanids and the Buyids had magnificent palaces with gardens, pools, and pavilions. The American expedition to Nishapur may have discovered part of one such large city building.[28] It contained painted niche-shaped panels of stucco which were possibly arranged in groups so as to form three-dimensional wall surfaces later known as *muqarnas* [227].[29] Moreover Russian exploration of areas devastated by the Mongols in the thirteenth century and not inhabited since has brought to light quite a number of smaller châteaux,[30] similar in purpose to Umayyad castles and preserved for the same

227. Muqarnas niche from Nishapur, tenth century. *New York, Metropolitan Museum of Art*

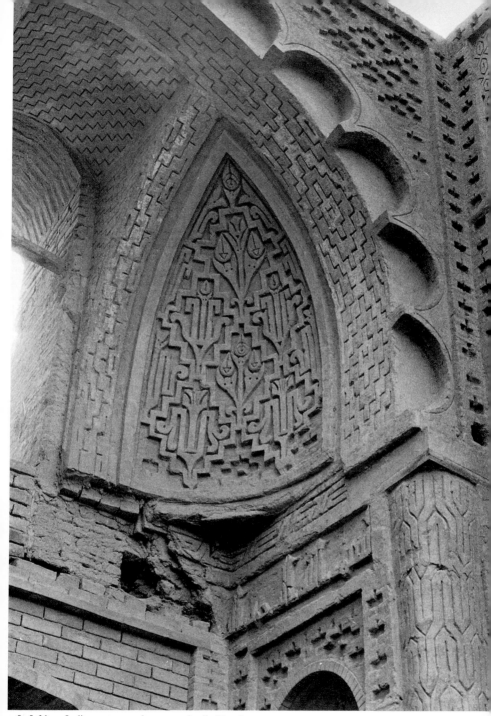

228. Isfahan, Jurjir mosque, tenth century, detail of façade

fortuitous reasons. The residences of the feudal aristocracy or dihqans who owned and cultivated most of the land, they all had the outward semblance of massive donjons; the upper part of the walls consisted of a series of adjoining semicircular towers giving the appearance of silos. Some had a central courtyard surrounded by living quarters, others a central domical room with vaulted halls on the sides. In all instances, vaults and domes were very well developed, and in several cases the builders laid their bricks so as to create a patterned effect.

In most instances, the architectural decoration of these monuments is intimately related to the construction. However, partly published excavations at Nishapur and Rayy have brought to light many fragments of mural paintings and carved stucco [264-7], mostly to be dated in the tenth century,[31] as are the fragments covering some of the columns and part of the qibla wall of the Nayin mosque in Iran. In Afrasiyab (the pre-Mongol ruins of Samarqand) the stucco covering of an entire domed room, possibly part of a Samanid palace, has been reconstructed; the interior probably resembled a brilliant, if overwhelming, museum of designs.[32]

In many ways – such as the division of the wall surface into geometrically defined areas, the patterning of practically the whole field, the vegetal decoration bent into the geometric frames, and the covering of leaves and flowers with dots and notches – this Iranian stucco ornament is closely related to Samarra style B. Occasionally however it shows a freshness and nervous vivacity which contrast with the somewhat jaded Abbasid style, while a few examples introduce purely geometric constructions or all-over patterns earlier unknown. Until the fragments are completely published or new and clearly dated ones come to light, it is impossible to say whether these indicate a vitality of experimental variation on the art of Samarra or an independent evolution from earlier models.

The architecture of Iran in the ninth and tenth centuries is thus elusive. We must draw conclusions from a few monuments whose contemporary significance and often original shape are almost impossible to evaluate. Nothing illustrates these uncertainties better than the so-called Jurjir mosque in Isfahan. An extraordinary recessed façade [228], discovered accidentally, of a complex decoration of brick and stucco was immediately identified as belonging to a Buyid mosque known from texts.[33] Yet, while the Buyid date is correct on stylistic grounds, there is no reason to consider the façade a mosque entrance, a feature of extreme rarity before the twelfth century. Until more archaeological or textual information is provided, the function and meaning of this striking building remain in doubt.

Two conclusions are fairly clear, however: the mausoleum introduces a major architectural type to the Islamic world; and baked brick with comparatively little use of stucco covering, or conversely poor masonry with highly developed painted or carved stuccoes, become the consistent techniques of Iranian architecture. The extensive use of brick also brought a realization of its constructional and decorative possibilities, thus explaining the presence, within less than a century, of monuments as different from each other as the Bukhara mausoleum and the Gunbad-i Qabus. On the other hand, the monuments at Damghan, Nayin, and Bukhara certainly show archaizing tendencies, and the consciousness of the decorative possibilities of architectural forms so typical of contemporary Muslim Spain is also apparent here. At the same time, the Tim mausoleum and the Nishapur stuccoes introduce features which will develop in later centuries, but whose extent, origins, and contemporary significance are still difficult to discern. Among these is the muqarnas, that strikingly novel architectural and decorative form whose first steps are known in northeastern Iran, whose later developments in North Africa and Egypt have been mentioned, and whose significance will be discussed in the next chapter. Mostly however these features can at present but testify to the enormousness of our losses and our ignorance and to the elusive vitality of eastern Iran before the eleventh century.

THE DECORATIVE ARTS

Although only a few architectural monuments of the tenth and early eleventh centuries have been preserved in Iran, we are much more fortunate in regard to objects. Indeed the number of survivals is so large, the designs are so varied, and the techniques so accomplished that by then the country had clearly overcome the shock of Arab domination, had reasserted its identity, and had even achieved a new affluence, which made it possible for large numbers of people to respond to the aesthetic appeal of luxury goods and even household articles with well-thought-out decoration.

In most instances, these objects can be dated only approximately. The majority belong to the tenth century and thus represent mainly the period of the Samanid and Buyid dynasties. Only a few large sites - Nishapur in eastern Iran, Merv in Transoxiana, Lashkari Bazar and Ghazni both now in Afghanistan, and Siraf on the Gulf Coast - have been scientifically excavated, and only some of the results have been published even from these few. Finds from many other places are known, however. They reflect local production, as well as trade far beyond the confines of Iran, for they have been discovered in what are now Uzbekistan, Afghanistan, and Pakistan. As a result of this information we can distinguish between east and west Persian styles of the period, and at times even the style of a third area, the region just south of the Caspian Sea, becomes identifiable. Most attributions are based on the sites where the objects were found, or are alleged to have been found, in large numbers, though the question of export has to be considered. In spite of rather extensive use of epigraphic decoration, only in a few instances - all of them glass vessels - are the cities or regions of origin inscribed on the pieces themselves, though historical inscriptions on textiles do at times permit similar deductions about locality of production.

This period is basically one in which long-standing artistic traditions were adjusted to new conditions, after some experimentation. Naturally, the conditions varied from medium to medium according to the strength of the tradition in each and the new demands that each had now to fulfil. To understand this groping for new artistic possibilities, the various media will be discussed serially, so that the specific achievement of each will become clear.

Of the two major areas, eastern Iran (in the widest sense) seems to have been more creative, both in design and in the range of artistic production. There the most common and perhaps artistically the most outstanding objects were the ceramic wares. The most important centre was Samarqand, where, in the old quarter, Afrasiyab, large numbers of complete vessels and countless sherds have been found since 1914.[34] Hardly less important are the wares discovered at Nishapur, where in the years before the Second World War excavators from the Metropolitan Museum of Art recovered a new chapter in Islamic ceramic history.[35] Ghazna (modern Ghazni) and Lashkari Bazar near Qalah-i Bust have also yielded material, but the finds from the late tenth and early eleventh centuries suggest mainly local variations of the Samarqand and Nishapur wares.[36]

How this vast production began and the precise stages in its development are unknown. The objects themselves show, however, that inspiration came from at least three quarters, though, in adapting designs and techniques to a new spirit and to indigenous materials, the artists often achieved quite different aesthetic effects.

The first source was the art of Sasanian Iran, especially the designs on silver plates. In one group, there are only a few very minor motifs like 'wreaths' of hearts or combinations of

229. Slip-painted bowl with decoration of 'hearts', Nishapur, tenth century.
New York, Metropolitan Museum of Art

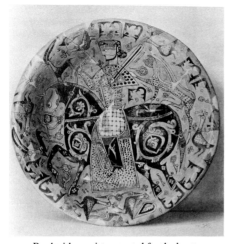

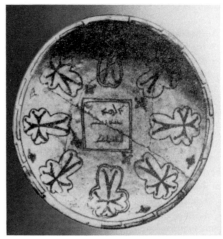

230. Bowl with warrior mounted for the hunt, Nishapur, tenth century.
New York, Metropolitan Museum of Art

231. Bowl with crosses and Syriac inscription, Nishapur, tenth century.
Tehran, Iran Bastan Museum

three dots[36a] - that is, motifs that had originally been used as framing devices or as decorative patterns on garments. The favourite technique, and by far the most characteristic east Iranian production, was painting in thin earthy pigments ('slips') on a ground that had first been covered with another earthy substance of a contrasting hue, usually white, black, or brown. This limited, though aesthetically effective, repertory may have resulted partly from the iconographic restrictions of Islam and partly from impoverishment of the artistic vocabulary. Figural designs were, however, by no means excluded. Indeed, they occur on another type of pottery that owes its inspiration to Sasanian royal art, in particular to portrayals of the fighting hero, the royal hunter, or his prey. There thus came into being exclusively at Nishapur a secular type of pottery on which the noble warrior mounted for the hunt carrying his sword and shield [230], alone or in the company of a friend or of boon companions, is a common theme. In this particular ware, the designs are rendered in purplish black against a background

heightened by yellow, green, and at times even red touches. The potters worked not with slips but mainly with metallic compounds. The designs do not show the great restraint that distinguishes the first type described. Out of a *horror vacui* the motifs - including not only human figures but also animals, floral designs, and bits of script - are crowded into dense and often uncoordinated all-over designs with only enough background showing to permit the distinguishing of individual elements. The single-minded dedication to the royal theme that characterized the original Sasanian compositions is therefore totally lost. As Charles Wilkinson, one of the excavators of Nishapur, has aptly remarked, the vital sense of power or struggle that distinguished the original pieces has gone; there is no sign of excitement while the animal is being hunted nor of any dramatic impact in the heroic moment.

Another unexpected aspect of this ware is the occasional use of a Christian motif.[37] Mostly it is a cross, and on one bowl in the Tehran Museum [231] there is an additional religious

232 and 233. Slip-painted bowls,
Nishapur, tenth century.
New York, Metropolitan Museum of Art

inscription in Syriac. These Christian objects,
of unpretentious size and ordinary function,
were obviously made for simpler people. This
fact, together with the existence of a great mass
of pleasant yet artistically modest pieces, seems
to indicate that pottery had become the favour-
ite medium of the middle and possibly even the

lower classes, who insisted on ornamentation,
even of a complex kind. It also suggests the
vulgarization of the original royal or noble
motifs, which had declined to a level where they
were used in a less discriminating, though more
demonstrative, manner.

A second source of inspiration was Abbasid
Iraq, especially the pottery of the Samarra
period; the large interlace compositions origin-
ally used for the all-over decoration of lustre
ware are found here too (see p. 114). As local
potters lacked the technical ability to achieve
the metallic sheen, they produced the designs in
coloured slips [232] – thus achieving entirely
different artistic effects, for the final products
no longer appear to imitate gold repoussé objects.
In other instances, the potters tried to imitate
the Iraqi white wares with blue decoration and
green splashes. The latter provided no difficul-
ties, but, as cobalt was apparently not available
in medieval eastern Iran, a purplish-black pig-
ment was used, which again lent a different
appearance to the whole [233].

The greatest impact, however, was exerted
by the lustre-painted wares, especially those of
the post-Samarra period of the tenth century,
with silhouette designs framed by white con-
tours against densely dotted or solid grounds,
the whole framed by festooned edges [234].[38]
All these motifs, but particularly birds and floral
patterns, were copied closely in a yellowish-
brown slip on a white background, which
resulted in the same general coloristic effect,
though without the metallic sheen of the true
lustre pieces. As in some of the vessels that
followed Sasanian models, here too the artists
selected secondary semé patterns and used them
as the only decoration. In this manner the
peacock's-eye motif, in brown and reddish slips,
appears as an all-over pattern, set against a dot-
ted background, for instance [235]. Yet another
type of design, curiously, had never before been
applied to pottery, though it had a great vogue
otherwise. It consists of the abstract configura-
tions made up of S curves which had been
characteristic of Samarra style C and which now

234 (*top*). Imitation lustre-painted fragment
of a bowl, Nishapur, tenth century.
New York, Metropolitan Museum of Art

235 (*above, left*). Slip-painted bowl
with peacock's-eye design, Nishapur, tenth century.
New York, Metropolitan Museum of Art

236 (*above, right*). Slip-painted bowl,
probably Samarqand, tenth century.
New York, Metropolitan Museum of Art

237 (*right*). Sgraffiato bowl, Nishapur,
ninth/tenth century.
New York, Metropolitan Museum of Art

appeared on bowls made in Samarqand [236]. It is not known why this decorative style was applied to pottery only there: perhaps it was because of its propinquity to Turkish areas, from which this style is often assumed to have been derived.

China represented the third source of inspiration, though some of the splashed and mottled wares may have reached Central Asia via Iraq and the Near East. As in these latter regions, artists in eastern Iran and Transoxiana combined coloristic effects from the original wares

238. Large plate with Kufic inscription, probably Samarqand, tenth century. *Washington, D.C., Freer Gallery of Art*

with underlying sgraffiato patterns [237]. Here, Nishapur was distinguished by the delicacy of its floral designs, surpassing the similar but less sophisticated counterparts in Samarqand.

The effective absorption and transformation, both artistic and technical, of foreign influences speaks for the originality and resourcefulness of the tenth-century potters. It is therefore not surprising that there are several ceramic types that owe nothing to outside models. Among them none is more attractive than the large platters and bowls decorated solely with bold Kufic inscriptions in black on a white ground, usually applied in circular fashion around the walls: a formal stately manner is typical of Samarqand, whereas the Nishapur epigraphic style is more rapid but less refined. The texts include proverbs and adages like 'Learning is at first bitter to the taste but in the end sweeter than honey' (platter in the Musée du Louvre); 'From much talk comes much damage' (bowl in the Metropolitan Museum of Art); 'Deliberation before action protects you from regret' (dish in the St Louis Art Museum); '... modesty points out the action of a noble man' and '... To whatever one endeavours to accustom

oneself, one becomes accustomed' (two pieces in the Freer [238]); and so on. They are not of a strictly religious nature, as the decorative inscriptions on Umayyad and Abbasid wares had been; rather, they reflect mostly a practical worldly wisdom which suggests that this art was mainly secular, apparently destined primarily for customers in an urban milieu. It is not known whether these vessels served any purpose other than decoration, but from their large size and fine workmanship they must have been made for a discriminating, educated clientele, probably the urban well-to-do such as wealthy merchants. Here we have the first reflections in art of a contemporary literary effort, for collections of Arabic proverbs had been made by noted *littérateurs* from the eighth century on,[39] and indeed these vessels are the earliest surviving 'manuscripts' of this genre of writing.

In some instances, inscribed bowls achieved a contrapuntal effect by means of additional decoration in the centre – sometimes no more than a dot, but at the other extreme assuming such large proportions that it overshadowed the inscription [239]. In either case the colour range could be enlarged, especially by the addition of contrasting red or reddish-brown slips, which appeared in this period for the first time in Near Eastern pottery.

Occasionally, in place of the chaste, gracefully attenuated, but otherwise unadorned Kufic inscriptions, the characters have been transformed into zoological shapes, particularly long-beaked, long-necked water fowl [240].[40] They are the first zoomorphic inscriptions in Islam, which, again, underscores the secular nature of this production. It was a precocious appearance, for this type of writing was not taken up again until two centuries later, during the great flowering of the secular arts in the urban centres of the twelfth and early thirteenth centuries – and even then, in contrast to parallel developments in Europe, on a limited scale. Indeed, though all other types of slip-painted pottery bore floral patterns or interlace or, more rarely, animal designs, it is the epigraphic

239. Slip-painted bowl, possibly Nishapur, tenth century.
Washington, D.C., Freer Gallery of Art

240. Dish, probably Nishapur,
tenth century.
The Hague, Gemeentemuseum

242. Sgraffiato dish, possibly Rayy,
tenth/eleventh century.
Cambridge, Fitzwilliam Museum

variety that seems most significant, for on a great number of both small and large pieces writing is the main decoration, even though the artists used only one or a few characters as repeat motifs. These inscriptions, whether genuine or

241. Sgraffiato dish, possibly Rayy,
tenth/eleventh century.
New York, Metropolitan Museum of Art

simulated, seem to have had a special – even perhaps a magical – appeal for their clientele.

The eastern Iranian potters' originality and their ability to exploit fully the possibilities inherent in their medium are even more impressive when compared with western Iranian production, which may have been concentrated in Rayy (near Tehran). Here a variety of wares, especially bowls in undistinguished shapes, were embellished with various motifs engraved in white slip and then covered with yellowish lead glaze, often enlivened with green stains or green edging [241].[41] These sgraffiato designs consist mostly of friezes of angular stags or of lions or big-breasted birds, usually against a hatched background. In the largest and finest pieces the static quality of the stiffly drawn animals is further stressed by their placement, individually, within heavy frames of meticulously drawn intersecting circles or half-circles [242]. Such precise delineation conveys the impression that these vessels are simply imitations, in a humbler and inappropriate material, of chased metal objects whose dominant influence western Iranian potters – unlike their

counterparts in the east – were unable to throw off. In the choice of designs, too, archaism is at times apparent, for Sasanian themes are not newly interpreted, as they were in the east; for instance, a series of five altars, or an imitation of a Pahlavi inscription, may constitute the main or a major motif. On the other hand, patterns of simple Kufic letters are rare. The deliberate linear effects and stilted archaic style catering to the taste of the Buyid realms in western and southern Iran seem very remote from the free manner of the east.

In this period, especially in the region just south of the Caspian, there appeared a new variety of pottery, even with a new kind of design: sketchily drawn birds in red, brown, and green on a white ground [243],[42] or similarly drawn floral stalks. Although these rather crude pieces in no way measure up to the high standards of the eastern Iranian examples,

243. 'Sari' bowl, probably north central Iran, tenth/eleventh century.
New York, Metropolitan Museum of Art

they at least indicate that decorative household articles had become common at the lower levels of society, even in marginal regions.

Another medium in which Iran excelled was glass, and the centre of production – or at least an important one – was again in eastern Iran, in particular the province of Khurasan. However, the difficulties of attribution are unfortunately even greater than usual, for although a great deal of material has come to light, especially in recent years, nearly all the finest vessels are extremely fragmentary. Furthermore, most offer no ground for specific association with a particular country, let alone a city, and even when the provenance of objects is known, there is no guarantee that they were made in the place in which they were found. Scholarly opinion formerly strongly favoured Egypt and Syria as the fountainhead of glass production, but lately Iraq and more recently Iran have been assigned an outstanding role, although documentary evidence is limited to only a few cases.[43] Technical examination of the glasses may eventually lead to greater certainty; so far, however, the range of articles to be put to the test has not been sufficiently wide to provide definite clues. Finally, no dated Iranian pieces are known, with the possible exception of the fragments found in Samarra, which can be attributed to the ninth century or shortly thereafter.[44] Thus practically all scholarly deductions are based on style, on analogies with objects in better documented media, and on a few other datable associations.

Already in early Islamic times, glass production – whether free-blown or mould-blown – seems to have been of some technical and artistic significance. Decoration was applied in the form of threads or dots, or by means of pinching. Historically particularly interesting are vessels with rolled-in coloured threads in wavy bands, the so-called dragged and marvered decorations, for they continued the tradition of the very earliest glass vessels made in the New Kingdom of Egypt, about 1400 B.C., and favoured in the ancient world. More complex techniques, of much later origin, include mosaic glass and lustre painting.[45]

Most important, however, was cut glass, of which there are two major varieties. In the sim-

244 (*left*). Beaker, probably Iran, tenth century.
Hollow-cut glass.
Berlin (Dahlem), Staatliche Museen,
Preussischer Kulturbesitz,
Museum für Islamische Kunst

245. Bowl, probably Iran, tenth/eleventh century.
Relief-cut glass. *Cairo, Museum of Islamic Art*

ple technique of hollow cutting, concave lines and dots, as well as facets, were abraded, but this procedure was sometimes so much elaborated as to create sculpturally modulated surfaces on which abstract and floral designs were rendered in Samarra style C [244]. By contrast, in relief cutting, all the background was carved away so that the design stands out as protrusions at right angles to or curving more gently from the surface plane. Some of the relief sections are further decorated by hollow-cut hatching, whereas the main part of the internal design is countersunk and thus represents negative moulding. The end result in each instance is relief with a strong linear quality. In some pieces, for instance a bowl fragment in the Museum of Islamic Art in Cairo [245], the craftsman went even farther and added colouristic effects by cutting the animal designs from green, blue, and brown glass overlying a clear body.[46] Considering the difficulty of working with such thin and brittle material, high-relief

glass cutting is a remarkable achievement and often a *tour de force*. It is not surprising that three pieces of this type, two of them later set in western gold and jewelled mountings, were thought precious enough to form part of the Treasury of St Mark's in Venice.[47]

Outstanding among relief-cut pieces are those with highly stylized quadrupeds and birds, some heraldically grouped as in textile designs. In other, quite early instances they are rendered in bands as if pursuing one another; though this rhythmic movement is not always carried through, the most fully realized examples foreshadow a favourite decorative device among metalworkers of the twelfth and thirteenth centuries. Even when the animals are individually conceived, they are usually highly spirited, galloping over the surface at full speed among interspersed floating vegetal sprays which further accentuate the sense of movement [246]. Many vessels are entirely covered with these lithe designs, some even on the foot. This

overwhelming preponderance of decoration, sometimes overshadowing, even negating the existential nature of the vessel, is an early manifestation of what was later to become a typical feature of Islamic art.

Some stylistic peculiarities of the animals strike modern viewers as odd, for instance the rendering of the head and neck as solid raised areas with surface striations while the rest of the body is hollowed out and bare. This peculiarity may have originated in depictions of two of the favourite quadrupeds of this group, the lion and the horse, for both are distinguished by manes, a feature which – as so often in Near Eastern art – soon became a mannerism, no longer understood, and was transferred to such lesser animals

246 (*left*). Beaker, probably Iran, tenth century. Relief-cut glass. *Corning Museum of Glass*

247. Bowl, Khurasan, tenth/eleventh century. Relief-cut glass.
Venice, S. Marco, Treasury

as rabbits, too. Another strange feature is the dots, especially on the countersunk parts of the body. In the earliest pieces these tiny cavities are random and hardly noticeable in the design; as they are mostly in the foot area, it is possible that they were originally meant as anchor points for inlays applied to the large hollowed-out parts. This would have lent both colour to the design and, as a result of increased weight, greater stability to the object. During the tenth century dots also appeared elsewhere on the vessels and, as surface patterns, eventually came to indicate the markings of animals.

A great deal of cut glass of both varieties has been found in Iran, some of it in the scientifically conducted excavations at Nishapur. The most definite clue to an Iranian origin is, however, provided by one of the bowls in the Treasury of St Mark, which has the word 'Khurasan' clearly carved in relief under the foot [247]. As it is of opaque turquoise colour and was obviously meant to imitate a bowl carved from a mineral, we may suggest that the flowering of the craft was an offshoot of the technique for working semi-precious stones, be they turquoise or rock crystal. The close relationship between cut glass and cut stone, especially rock crystal, had been fully understood by medieval Muslims, for they are repeatedly listed together in a report of the Fatimid treasures in Cairo.[48] There seems little doubt, therefore, that the glass-cutting technique was practised in Iran, and in a region that had an age-old tradition of cutting semi-precious stones. Furthermore, despite the mannerisms peculiar to cut glass, other Persian media provide parallels for the rendition of animals; the heraldically composed, rather long, spidery birds, for instance [248], have their counterparts in certain textiles woven with post-Sasanian patterns.[49]

Very probably cut glass was also made in other parts of Iran and - particularly - in Iraq, where in the ninth century Basra had a reputation as an outstanding glass-producing centre, whereas the fame of Iraq as a whole is reflected in both Arabic and Latin sources.[50] The only examples of glass dating from the ninth or tenth

248. Bottom of cup, probably Iran, tenth century. Glass. *Corning Museum of Glass*

century to provide epigraphic evidence of an Iraqi origin, however, are lustre-painted pieces associated with Basra and mould-blown vessels from Baghdad.[51] But neither is in any way an artistic or technical match for the cut glass now associated with eastern Iran. Yet in Iraq, too, the cutting of semi-precious stones probably affected the glass industry, for, according to the famous Iranian scientist al-Biruni, Basra was the outstanding centre for the carving of rock crystal.[52] It must have been a well-organized craft, for al-Biruni speaks of highly paid designers who found the most suitable shape for each rock and of carvers who executed the work. Unfortunately, however, with one possible exception,[53] none of the existing carved rock crystals can be definitely attributed to Basra. Dating, on the other hand, is a little easier: very advanced pieces with relief cutting were found in Samarra, so that the technique must have already been highly sophisticated by the middle of the ninth century.[54] During the tenth century, a further development of the designs can be assumed, though a hardening of the linear quality and schematization of the patterns can also be recognized. However, this decline was

only relative, for at the end of that century this type of work was still vital enough to serve possibly as the inspiration, maybe even the models, for some of the outstanding creations of Egypt, a series of rock-crystal ewers dating from the end of the tenth to the beginning of the eleventh century.

Not enough Iranian metalwork of precious or base materials survives from the seventh to the early eleventh centuries to allow precise attributions to periods and regions. What does exist, however, is important, not only for its intrinsic qualities, but also because it forms the foundation of an extensive production throughout the Islamic world during the high Middle Ages. One major group that followed Sasanian traditions[55] must have continued for a long time, even beyond the period under consideration, up to the early thirteenth century. The only specific dating clues are provided by the palaeographic evidence of the Pahlavi inscriptions, which allow reconstruction of the earlier stylistic development: from the Sasanian angle, this represents a reshaping, if not a decline, particularly of the iconographic features, and a progressive flattening of the designs. There are still examples of 'royal' iconography in the old tra-

249. Dish (central field), Iran, mid eleventh century. Silver. *Formerly Leningrad, Musée de la Société pour l'Encouragement des Beaux-Arts*

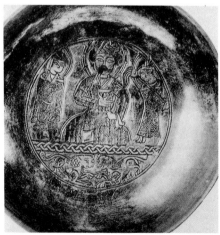

dition, but, as in pottery, the repertory tends to be restricted to minor Sasanian motifs. The turning point was possibly reached in the mid eleventh century, when in one royal scene the ruler was represented not with the traditional crown of Sasanian type but with a turban [249]; moreover, the inscription contains blessings in Arabic as well as in Persian verse, revealing yet another accommodation to the intellectual pressures of the time.[56]

The vogue for pre-Islamic tradition is apparent also in brass and bronze vessels, which are decorated more simply than silver, usually with animal or floral patterns, again of Sasanian derivation. The common motif of paired ani-

250 (*opposite*) and 251 (*left*). Ewer, Iran,
probably tenth century. Bronze inlaid with copper.
Leningrad, Hermitage

252. Bird aquamanile, probably Iran,
tenth/eleventh century. Bronze. *Leningrad, Hermitage*

mals flanking a tree reflects an ancient oriental
scheme much less used in Sasanian times [250,
251]. These vessels are the first efforts of the
Islamic period to revive the much earlier tech-
nique, which later took on enormous impor-
tance, of inlaying metal with another metal,
usually copper, to create a chromatic effect and
to stress certain parts of the design, which is
usually in low relief. In only one known instance
is the inlay in silver on an otherwise undecorated
bronze ewer of Sasanian shape.[57] Other brasses
were decorated with chased designs: here again
the Sasanian tradition is apparent, especially in
a hemispherical bowl of unknown ownership
with a now nearly defaced depiction of a hunting

king on horseback.[58] The inscription mentions
that the maker was an artist originating in Sis-
tan, a province in south-eastern Iran. This is
the sole, tenuous indication of one region where
these bowls of Sasanian type might have been
made, while not precluding the possibility of
other centres as well.

Of our final group of metal pieces in the
Sasanian tradition – a few animal-shaped ves-
sels, especially aquamaniles [252] – none can be
dated with any precision, but there is no doubt
that they form the link between the pre-Islamic
and early Islamic groups on the one hand, and
the Seljuq pieces of the twelfth and early thir-
teenth centuries on the other; they probably

also inspired the similarly shaped vessels and implements made in Fatimid Egypt. All represent highly stylized animals in compact shapes that lend them true monumentality; even their surface decoration does not interfere with this impression.

Intermediate between metal objects of a pronounced Sasanian character and those that show the impact of Islamic concepts is a series of gold and silver figural medallions inscribed with the names of Buyid amirs [253]. The themes are Sasanian, as are certain details, but such royal

253. Medallion of Izz al-Dawlah and al-Ta'i (obverse and reverse), possibly Iran, 975-6. Gold. *Istanbul Arkeoloji Müzesi*

scenes as banquets, hunting, and musical entertainment differ decidedly from previous versions in the reduction of the design to basic elements and in the 'Islamization' of garments and accoutrements.[59] From these pieces it is evident that a new, Muslim orientation was taking shape in Iranian art, which – as one of the basic elements of Islamic art – soon made itself felt throughout the Muslim world.

This process, with experimental variations, can be clearly followed in a series of silver vessels with designs of animals or flowers. A tenth-century vase in the Hermitage, Leningrad, in a shape later to be used for glass mosque lamps, marks a convenient starting point [254].[60] Its chased decoration consists of more or less identical peacock-like birds, set in interlaced bands on both the body and neck of the vessel. The patterns still stand on an undecorated ground, just as they had done in Sasanian times, but the compartmentalization of the flat, linear design and its rather repetitive character reflect a different aesthetic attitude. Owing to a slightly different approach, in another piece in the same museum [255] the shape, though basically the same, is more attenuated, the decoration more varied, and a handle and three feet have been added. Furthermore, the silhouette of the vessel is interrupted by the heads of highly stylized birds, which protrude from it as do the designs of relief-cut glass from this period. In a newly emerging differentiation of designs, the neck here is decorated with various birds in diverse poses within compartments of interlace derived from lettering, whereas the body is covered by an overall floral pattern around the protruding birds. These decorative elements of the most varied derivation are skilfully combined, though the bird and floral forms are juxtaposed rather than integrated, as was to happen later on. Another innovation, the filling of the ground with closely spaced small circular punch marks, makes the main design with its internal delineations stand out as if it were in low relief.

A third tenth-century piece, a flat platter in the Berlin Museum [256], is also covered with

254 and 255. Vases, probably Iran, tenth century. Silver. *Leningrad, Hermitage*

256. Platter, Iran, probably tenth century. Silver, partially gilded. *Berlin (Dahlem), Staatliche Museen, Preussischer Kulturbesitz, Museum für Islamische Kunst*

traced decoration in which highly stylized birds alternate with floral patterns in interlaced bands around an ornate griffin in the centre.[61] The motifs are again rather Sasanian, but the design is stiffer and harder in execution than that of the first vase in the Hermitage, suggesting another workshop, possibly in a different region. Simpler versions of this type in base metals seem to have provided the prototype for *sgraffiato* pottery presumably made in western Iran, a relationship which may imply such an origin for this silver platter. The models for the ceramic dishes were most likely the bronze or brass hemispherical vessels with simple, usually all-over, compartmentalized patterns.[62] The wheel design of stylized birds encircled by fish on one bowl [257] had been current in the Near East since prehistoric times, indicating that objects made of simpler materials for a clientele of lower social standing were more likely to continue or

257. Bowl with incised wheel design,
probably Iran, tenth/eleventh century. Brass.
Washington, D.C., Freer Gallery of Art

revive age-old patterns, even though their ori-
ginal significance may well have been forgotten.

Most definitely in the new Islamic manner is
a set of silver vessels decorated solely with en-
circling niello bands of Kufic writing. Unlike
the ceramic pieces from Samarqand [238], these

do not preach worldly wisdom but invoke divine
blessings for their noble owners, whose names
and high princely titles are given [258].[63] The
well-established figural imagery in the Sasanian
royal tradition, current since the ancient Near
Eastern and classical worlds, has thus given way
to verbalizations of princely aspirations. Indeed
these silver pieces, though secular, show the
impact of the revealed word, and more specifi-
cally the literary character of Islamic civilization
and the all-important place of language in it.

258. Ewer of Valkin, Iran, late tenth/early eleventh century. *Tehran, Museum of the Gulistan Palace*

259. Woven silk fragment, Spain, eleventh century. *León, San Isidoro*

Unfortunately, the owner of this set of vessels is not identifiable, but his rather unusual name, Valkin, occurs, also at the end of the tenth century, in north-western Iran, which suggests that it was current there. His title, Mawali Amir al-Muminin, which appears on the first vase in the Hermitage [254], too, went out of use in the middle of the eleventh century, so that a *terminus ante quem* is provided for these two objects.

Thanks to the custom of including the caliphal imprint and other historical data in the *tiraz*, textiles also carried inscriptions that help to date and localize them. In the tenth century the powerful influence of Sasanian art is still apparent, but it is evident, as in all the other media discussed, that the earlier patterns were being transformed to fit the taste of the period. The technical exigencies of the craft contributed to this stylistic process. All the designs became more rigid, symmetrical compositions on either side of a real or imaginary central axis. The elements are piled one on top of the other to fill every possible empty space. Although the preserved specimens were made in different regions, they all reflect these tendencies, varying only in the manner in which the parts of the design are combined.

As far as the general composition of roundels and interstitial patterns is concerned, a silk fragment in San Isidoro, León [259], though manufactured in eleventh-century Spain, preserves most closely the organization of Sasanian textiles.[64] However, new features have also been incorporated. The leaf forms in the spandrels foreshadow the highly stylized floral patterns of later centuries. The broad drawing without interior designs, neither turning nor twisting, indicates that they lie halfway between Sasanian and later Seljuq floral patterns. The inscription band that has replaced such Sasanian framing devices as rows of hearts or large pearls states that this fabric was woven in Baghdad, and the character of the script suggests the tenth century; but the material and the type of weaving make it quite clear that it is actually a faithful eleventh-century Spanish copy, including the

inscription, bearing out the many historical writers who inform us that certain famous types of textiles were imitated in other regions. We know, for instance, that certain fabrics called *attabi*, after a quarter of Baghdad, were also woven at Nishapur, Isfahan, and Tabriz in Iran, at Antioch in Syria (now southern Turkey), and in Almería in Spain.[65]

The design and the organization of the motifs of the famous textile from the church of Saint-Josse near Caen, now in the Musée du Louvre [260], reflects the angular stylization, even to the framing devices, which are all rectangular. Only the peacock in a corner square, the border of hearts, and the long ribbons floating from the necks of the camels betray an ultimately Sasanian derivation. The procession of camels ought to introduce a certain amount of movement, but their stylization is so rigid that they are hardly less static than the large patterned elephants in the field. The *terminus ante quem* for this piece is provided by the woven name of an amir of Khurasan, a certain Qa'id Abu Mansur Bukhtagin, who died in 961.[66]

The main theme of a fabric preserved in the Textile Museum in Washington, D.C. [261], and the Detroit Institute of Arts is more ambitious: framed by interlacing bands, turbaned falconers on horseback flank a tree.[67] Owing to the absence of purely ornamental features, this design is particularly striking in comparison with other, more dynamic hunting scenes executed in post-Sasanian *milieux*. According to its inscription, the piece was made for an anonymous 'Isfahbad', a title held in princely families south of the Caspian Sea, that is, in an area, closed off by high mountains from the rest of Iran, that had avidly preserved many aspects of its Sasanian heritage. Apart from the stylization, the new framing device, as well as the garments of the falconers and even such a detail as the stirrups, betray a post-Sasanian origin, probably again the tenth century.

Naturally enough illumination of books, particularly of the Koran, showed hardly any Sasanian influence. Important though it is from a Muslim point of view, the development of

260. Silk fragments from Saint-Josse, near Caen, probably Iran, before 961. *Paris, Louvre*

261 (*opposite*). Fragment of woven silk with falconers flanking a tree, Iran, probably tenth century. *Wahington, D.C., Textile Museum*

script cannot be treated here. In this period, in Baghdad, the vizier Ibn Muqlah (d. 939) and the calligrapher Ibn al-Bawwab (d. 1022) were taking the lead in systematizing and perfecting the styles of Arabic writing. To us, the illuminations are of primary interest here. We have little to assist us in differentiating between eastern and western Iranian styles, as only one of the preserved contemporary volumes contains any indication of its place of origin; this distinction seems, however, plausible, based upon the evidence of the eleventh-century manuscripts.

A parchment Koran in the British Library (Add. 11735) [262], which, to judge from related though later manuscripts, must have been written about 950, reveals at once one basic change since the ninth century: the format is now vertical instead of horizontal. Otherwise, this decorative page represents a logical development from the former stage. The tripartite composition had been an early favourite, and the centre field is still composed of interlacings attached to a frame of the same type. Again small, dense braided designs fill the surrounding space. Finally, the margin contains the traditional floral palmette of Sasanian derivation. Indeed, the whole page is an elaboration of the earlier type.

262. Pages from a Koran, MS. Add. 11735, *c.* 950. Coloured inks and gold on parchment.
London, British Library

263 (*opposite*). Illuminated page from Koran copied by Ibn al-Bawwab, f. 9r, Baghdad, 1000. Coloured inks and gold on paper.
Dublin, Chester Beatty Library

By contrast, the Koran written in the year 1000 by Ibn al-Bawwab in Baghdad reveals a radically new attitude towards the composition of full-page illuminations (Chester Beatty Library, Dublin, K16) [263].[68] Instead of the easily contained central pattern of limited size, there is a large-scale arrangement, imbued with

so much dynamic force that it seems to burst its frame. The old softly drawn, rounded lines are replaced by sharply delineated geometric forms in which the painted edges are just as important as the circular motifs. In addition, instead of a rather indistinct and uniform pattern in the field we have a variety of clearly defined floral and geometric designs, all with a specific function in the interplay of parts. Furthermore, unlike the former two-dimensional rendering, movement appears to occur on more than one level, and the patterns themselves are plastically conceived. This interrelation of the various sections, their inner movement, and the three-

dimensional aspect of the whole combine to give the page its lively, sparkling appearance. This effect is also emphasized by the more varied colour scheme, in which sepia and dark blue, formerly used only sparingly in combination with gold, are supplemented by brown, green, crimson, and white. Indeed, only the marginal palmette, though here more articulated and more refined in detail than that in the British Library manuscript, for example, could be called the umbilical cord connecting this composition with those of the past; otherwise this page, like the others in this Koran, points entirely to the future.

Two other revolutionary features separate the Beatty Collection Koran from the British Library manuscript. First, it is written on paper. The secret of paper-making had been wrung from Chinese prisoners captured in Turkestan in the course of the decisive Arab victory over the Chinese in 751, and the industry soon became important in the Islamic world, paper replacing papyrus and parchment as the primary writing material. Already at the very end of the eighth century it was in use in the caliphal chancery, and from the ninth century on there are references to books on paper; the earliest so far discovered was written in 866.[69] It was only natural, however, that the calligraphers were more conservative in their choice of a medium to transcribe the Divine Word, and the earliest dated paper Koran so far found was not written until 972.[70] However, parchment continued to be used in the western Muslim world up to the fourteenth century. The other major innovation was the supplementing of the traditional Kufic script with cursive or *naskhi* styles, a form of writing which had existed from the beginning of Islam but had previously been confined exclusively to secular documents. With so many revolutionary changes in one manuscript, scholars are, of course, all the more appreciative of the colophon, which gives the date and place of origin. Unfortunately, however, one cannot be sure that this evidence is correct, since there is ample literary proof of early and later forgeries (the writings of Ibn al-Bawwab, in particular,

were imitated soon after his death),[71] and although, for intrinsic reasons, this manuscript has a better chance than any so far discovered of being genuine, it could date from a few decades after the scribe's death in 1022.

PAINTING

Certain ninth-century wall paintings from Nishapur share some features with contemporary Koran illuminations: in these brightly painted dado decorations[72] appears the same combination of square and oblong panels that had characterized the frontispieces, and the basic layouts of the larger sections are similarly based on tangential and interlacing circles. There are also reminiscences from other media, for instance the lozenge decoration recalling some quarter-sized marble panels in the Great Mosque in Damascus whose grained motifs were, in the Roman tradition, sometimes imitated in painting.[73] Moreover a scale pattern brings to mind motifs on lustre pottery and on the textiles represented in Samarra paintings. In the dense compactness of the designs and in their peculiar style, which makes it difficult to distinguish between major themes and interstitial patterns, these paintings also resemble stuccoes from Samarra, Nishapur, and other Iranian sites. But such connections are of minor importance in view of the unique character of these decorations. Multifarious elements have been ingeniously combined to form highly imaginative compositions varying from one unit to the next. What is particularly remarkable is the way in which geometric forms, floral patterns [264], cornucopia shapes, intertwined stems, even schematically drawn hands and eyes form part of a lively ensemble. It is probably this unexpected yet convincing mixing of heterogeneous motifs that explains the peculiar appeal of these panels, and makes them stand out as representations of an early and particularly fanciful arabesque. The same playful manner of combining various floral elements with vase forms and what seem to be large, staring eyes is also found on minor architectural units such as

264. Painted stucco wall panel with eyes and hands,
Nishapur, ninth century.
New York, Metropolitan Museum of Art

265 (*right*). Polychrome muqarnas niche
with eyes and floral design,
Iran, probably ninth century.
New York, Metropolitan Museum of Art

little muqarnas niches as part of the overall
setting [265],[74] where one marvels not only at
the adroitness with which quite unrelated
elements are combined harmoniously in places
of little significance but also at the variety of
overall compositions. All this whimsical creativ-
ity reflects an important aspect of the art of this
period.

Of an entirely different nature is a series of
ninth-century fragments with brightly coloured
figural designs, usually representing women,
but occasionally demons and - rarely - men

266. Painted stucco wall panel with human head, Nishapur, ninth century.
New York, Metropolitan Museum of Art

[266], some of them life size.[75] The excavators of Nishapur assumed that they belonged to a large scene depicting one of the victories of the Persian national hero, Rustam, over the powers of evil, with the principal figures bigger than the others. This iconographic identification, attractive in view of the light that it could throw on Firdawsi's later epic, the *Shahnama*, is still, however, uncertain. The type of female beauty which we encounter at Nishapur is akin to that at Samarra, but this is not surprising in view of the strong Iranian influence at the caliphal capital. One feature appears here for the first time in Islamic art: the haloes around the heads. As in all later examples, they are meant to emphasize the importance of the head, without any religious connotation. The only larger fragment of a wall painting from Iran to come to light [267] (now in the Iran Bastan Museum, Teh-

ran)[76] depicts a half-life-size falconer on horseback. The garments and accoutrements connect this rider with Central Asian paintings probably of the eighth century, whereas the long pendants attached to the belt point specifically to a Turkish *milieu*. The one uniquely Islamic feature is the Kufic inscription band applied, as in countless later examples, to the upper sleeve.

At least one type of book can be associated with this period: a treatise on the fixed stars that the Buyid Sultan Adud al-Dawla asked his teacher, Abd al-Rahman al-Sufi of Rayy, to compile about 965. It continued the astronomical researches of the ninth century, which in turn were based on classical writings, particularly Ptolemy's *Almagest*. All copies show the constellations in mnemonic configurations, usually derived from classical mythology or from the animal world. The illustrations are ultimately based on al-Sufi's holograph: one of the oldest surviving copies, probably dated 1009, was made from the author's own manuscript by his son (Oxford, Bodleian Library, Marsh 144).[77] Their unique linear style reflects the fact that these figures were made after designs traced from celestial globes; the constellation pictures also betray their scientific origin in their stress on the stars, which are indicated by both dots and written labels, a deliberately astronomical aspect that had often been lost in late classical renditions. The figures themselves represent reinterpretations of classical themes which were no longer understood at the time. They were also given a more Islamic aspect; thus Andromeda is no longer either half-nude or clothed in a chiton, with outstretched arms chained to rocks on either side,[78] but a bejewelled dancer in the pantaloons and skirt of the contemporary performer, that is in a role consonant with hands outstretched as necessitated by the position of the stars [268]. The type of beauty, the embellishments, and the drawing of the folds are all related to Samarra paintings. But, although the Samarra style lingered on throughout the twelfth century in marginal areas (Sicily and Spain), the images drawn for

al-Sufi's treatise had a much longer life: manuscripts written as late as the seventeenth century continued to follow the established tradition both in the Islamic forms of the constellation figures and their linear treatment. Just as Koran illumination remained conservative owing to its sacred nature, so the illustrations of al-Sufi's book and all other scientific texts tended to be archaic and rather static, closely following the 'correct' prototypes to allow easy identification of specific natural phenomena.

267. Painted stucco wall panel with falconer (copy), Iran, probably tenth century. *Tehran, Iran Bastan Museum*

268. Andromeda, MS. Marsh 144, f. 165, probably Fars, 1009-10.
Oxford, Bodleian Library

THE ELEVENTH TO THIRTEENTH CENTURIES

CHAPTER 7

ARCHITECTURE

Only recently have historians begun to chart the tremendous political, social, linguistic, religious, and intellectual upheavals of Islamic Asia in the eleventh century.[1] There was no revolution, for much had already occurred or was germinating in the preceding centuries; after 1000, however, a new moment crystallized in Islamic civilization, especially in western Asia and (after 1171) in Egypt.[2] What follows is an attempt to identify those changes which seem important for an understanding of the arts.

The Muslim world in the first decades of the eleventh century, apart from Fatimid Egypt, was in a state of political confusion and of social and cultural tension. Internal difficulties and the growing pressure of new waves of Turkish tribes on the frontiers as well as the ambitions of Turkish mercenaries in the army were breaking the aristocratic kingdom of the Samanids in eastern Iran. In western Iran, Iraq, and northern Mesopotamia, several smaller dynasties, mostly heterodox Shi'ite, were in conflict under the shadow of a powerless Sunni caliphate. Syria was hardly able to sustain the pressure of a revitalized Byzantium in the last third of the tenth century.

There were also religious upheavals. The official orthodox faith was being transformed into a dry legalism and living piety channelled into various rigidly organized forms of Shi'ism, while mystical movements (Sufism), with their fascinating interplay of deep personal experience with a sense of social responsibility and organization, acquired more and more adher-

ents. The basic unity of the faith of Islam was being undermined.

Socially and economically, the situation is less clear. The beginnings of a Middle Eastern equivalent to western European feudalism are discernible in the growth of the *iqta*,[3] which farmed out to individuals the revenues of land rather than the land itself. At the same time, city merchants and artisans acquired more and more power as the central authority declined, though the character and significance of the new institutions specifically related to these social changes are not yet very clear.[4] Except perhaps for the continuing rise of city patricians and for the brilliance of Cairo in the early part of the eleventh century, it was a time in which the great Umayyad and Abbasid syntheses between the revealed faith with its system of life and the ancient Hellenized Near East were crumbling away. The best symbol of the age may be the sceptic and pessimist poet Abu al-Ala al-Ma'arri (d. 1057), who denounced the degeneracy and corruption of his age, yet felt that human nature hardly deserved anything better.

The further danger of conquest by a revived Christian world, acutely conscious of the loss of the Holy Land in the seventh century, soon added to these internal difficulties. As early as the second half of the tenth century, Byzantium gained the upper hand in the continuing frontier war, and Antioch was taken in 969. The greatest threat came, however, from the Christian West in the eleventh century, when pressure increased on Muslim Spain from still disorgan-

ized barons. Sicily was lost to the Normans, and finally in 1099 Jerusalem was taken and the Latin Kingdom established in Syria and Palestine.

In the eleventh and twelfth centuries the Muslim world responded vigorously and successfully, though diversely and at different moments, to these external threats and internal divisions and confusion. There are however clear movements from one area to another, and concerted programmes of reform can be established almost for the whole of Islam. The name 'Seljuq' for this period, after the most important Turkish dynasties of the time, is not entirely apt because, in spite of their importance, the Seljuq Turks were but part of the picture. The cultural achievements of Islam's Middle Ages are as striking as its political and military successes, and the great syntheses arrived at between internal trends and movements affected the culture of the Near and Middle East for many centuries to come. It was also, however, the end of an era of constant correlation between ideas, political events, economic life, and individual involvements throughout the entire Islamic world.

The first element of change involves the population of the Near East. Throughout the twelfth and thirteenth centuries (often already in the eleventh) power was in the hands of the former 'fringe barbarians', of whom the most important were the Turks. The main military power of western Asia as early as the ninth century, now, newly converted, they became the formal rulers of much of the Near East and enlarged by their conquests the realm of Islam. Their first major dynasty, that of the Ghaznevids (962-1186), which started under the wing of the Samanids, established its capital in Ghazni in present Afghanistan, conquered much of north-west India, and controlled most of eastern Iran. More important were the Great Seljuqs (1037-1157), who rose to power in north-eastern Iran, moved westward, took Baghdad in 1055, expelled the Shi'ite dynasty of Iraq, sponsored the conquest of Anatolia after the battle of Manzikert (1071), and finally

gained ascendancy over northern Syria. However, political control over so vast an area could not be maintained and, especially after the death in 1157 of Sanjar, the last great prince in the direct line of succession, other Turkic dynasties took over: Seljuqs in Anatolia and south-western Iran, Zengids in northern Mesopotamia and eventually Syria, Ortoqids in the mountains and valleys of the upper Euphrates area, Khwarezmshahs in north-eastern Iran. Turkish princes controlled most of the Muslim Near East, and the infiltration included tribes which continued or initiated the Turkification of Iranian central Asia, Azerbayjan, and Anatolia.

The Turks appear everywhere east of Egypt, but several more localized marginal ethnic groups also entered Muslim history. From the mountains of Afghanistan came the Ghorids, of moot origin, who ruled over an area extending from Herat to India. The Kurds left their mountains, entered the service of Turkish masters, and eventually created their own dynasty – the Ayyubids – whose greatest prince was Saladin (d. 1193). Based in Syria and later in Egypt, the Ayyubids finally succeeded in destroying the heterodox Fatimid caliphate in 1171 and the Latin hold on Jerusalem in 1187. The Fatimid world itself had been rejuvenated by the actions of a remarkable Armenian convert to Islam, Badr al-Jamali; another Armenian convert was the great prince of Mosul in the middle of the thirteenth century, Badr al-Din Lulu. In the West, we have already discussed the two Berber dynasties of the Almoravids and the Almohads.

Invaders were repulsed and the Islamic frontiers enlarged with the help of Turkish, Ghorid, Kurdish, Armenian, and Berber military and political leaders. Their assumption of power – symbolized, among other things, by the new title of *sultan* (lit. 'power'), first restricted to the lord nearest the caliph, but rapidly widened to include almost any prince – did not mean, however, that the whole Near East was taken over by alien cultures; on the contrary, the new princes adopted, fostered, and developed the indigenous Persian and Arab traditions. Fir-

dawsi dedicated his Iranian national epic, the *Shahnama*, to the Turkish Ghaznevid Mahmud. The great Persian scientists and poets Avicenna, Omar Khayyam, Anvari, and Nizami lived and prospered under Turkish rule; a Seljuq prince's vizier, Nizam al-Mulk, wrote the main ideological statement of the period, the *Siyassat-nama*. In effect then, wherever their conquests took them, the Turks, or at least their princes, carried a largely Persian culture and Persian ideas, even the Persian language. The greatest Persian mystic poet, Jalal al-Din Rumi, lived and wrote in Konya in central Anatolia.

Arabic and the Arabs did not make the same kind of cultural impact on the masters of the Near East. In the west, to be sure, the rude mountain Berbers of the Almoravid and Almohad dynasties were soon captivated by the refinements of Andalusian princely courts and the Ayyubid Kurds became the champions of their subjects, most of them Arab. Throughout the Islamic world, intellectual and religious works were still generally written in Arabic; but on the whole contemporary Arabic literature had a more restricted impact than its Persian counterpart. The best known Arabic productions were the tales called *Maqamat*. The most celebrated, by al-Hariri, were later illustrated, but the stories are not so important as the abstruse linguistic and grammatical pyrotechnics, accessible only to highly cultivated readers. Appearing at the same time as many histories of individual cities, the *Maqamat* bear witness to a withdrawal of the Arabic-speaking world into its own fold, especially when contrasted with the tremendous growth and spread of Persian. Thus the first significant change of these centuries involves not only the rise to prominence of newcomers from the frontiers of the Muslim world, but also a new relationship of prestige and importance between the two major linguistic and ethnic groups which had been part of the Islamic system almost from the beginning.

The partial list of dynasties in the eleventh, twelfth, and thirteenth centuries given above introduces the second major change of the time. Authority was carried down through a complex chain of personal and family allegiances from the caliph and, at least at the beginning, a sultan directly associated with him until, at the lowest level, it was vested in a local ruler. As a result, the number of princely courts increased enormously; not only was there a revival in power and prestige of such older centres as Merv, Isfahan, and Damascus, but small or abandoned cities were suddenly transformed into capitals, sometimes ephemeral, as in the case of Dunaysir (modern Kochisar in southern Turkey). All were also manufacturing centres, transit trade depots, and markets for outside products. Princes depended on the support of merchants and artisans often belonging to some official or informal organization. Altogether, below the official level of a military aristocracy with its internal quarrels so carefully recorded by the chroniclers, trade caravans enriched more than just the rulers; they permitted the growth of private sponsorship for monuments and works of art, and led to new kinds of monumental architecture (khans, bazaars, caravanserais, roads, bridges, and so forth) and to a much more varied taste.

The last transformation concerns the religious climate. In all instances, the new conquerors – Turks, Kurds, and Berbers – were dedicated Sunnis and felt it their duty to extirpate heresies and reinstate true orthodoxy. The defeat of Shi'ism was accomplished both by force of arms and by a systematic attempt at re-education through the *madrasa* (lit. 'school'), in which orthodoxy was taught under official or private sponsorship. In order to be effective, orthodoxy was redefined by the new religious impulses of the preceding centuries, especially Sufism, and in the final analysis a rejuvenated Islam – with many variations under a common mantle – became the main source of religious teaching.[5] Shi'ism was weakened, but Sufism, often transformed through affiliations with various social and professional organizations and guilds, remained an active socio-religious force in the background of official Islam.

To sum up, then, the eleventh, twelfth, and thirteenth centuries are characterized by three

essential features which influenced the development of the arts: a new balance between ethnic and linguistic groups; within a loose hierarchy of power rising up to the caliphate, a fragmentation of political authority leading to a tremendous growth of urban centres and urban activities; and a revivified orthodoxy whose implementation was seen as a responsibility of the state and of the individual, but in whose margin Sufism maintained a powerful appeal to individuals and social organizations.

The end of this period is much easier to define than its beginning. The brutal Mongol invasion penetrated into eastern Iran in the second decade of the thirteenth century and advanced westwards, destroying Baghdad and the Abbasid caliphate in 1258, only to be stopped in 1260 in southern Syria by the Mamluks of Egypt, a new power rising from the ashes of the Ayyubids. In Anatolia the Seljuq regime lasted until the end of the thirteenth century, when a period of political fragmentation began, out of which emerged the great power of the Ottomans. Thus, on the whole, this brilliant era – coeval with the Romanesque and early Gothic in the West and with the Sung emperors in China – disappears brutally. Everywhere but in Spain and Sicily it had been successful in meeting both internal and external challenges because it managed to make new and meaningful syntheses from the many features which made up the contemporary Islamic world – a world which in many ways still conceived of itself as a unit, whereas in the following centuries the Islamic west, the Arab Near East, the Turks, Iran, and Muslim India developed their own separate destinies.

The architecture of the eleventh, twelfth, and thirteenth centuries is here described by areas: Iran and central Asia; northern India; Iraq; northern Mesopotamia; Syria and Egypt; Anatolia. With one exception, this division corresponds to ecological and historical differences and to a scholarly and bibliographical apparatus into which has crept a fairly high degree of regional specialization. The exception is Iran and central Asia, where knowledge has been revolutionized over the past twenty years, thanks to large-scale explorations in Iran and Afghanistan and to the systematic work of Soviet scholars, especially in Tashkent and Baku. We shall probably soon be able to discuss separately the architecture of the Ghorids in the twelfth and thirteenth centuries in Afghanistan, of the Bukhara oasis in the twelfth century, of Azerbayjan around 1200; but it has seemed premature to propose such more subtle, even if ultimately more justified, groupings of monuments, for the categories – regional, dynastic, chronological, functional, typological – are still far from clear. The fascinating peculiarity of this rich period is that our knowledge of it is based on such a variety of information – descriptions of nineteenth-century travellers, complete archaeological surveys, partial descriptions, undocumented reconstructions, recent restorations – and of such recent vintage that any generalization is bound to be modified by subsequent research.

It is also a period for which secondary literature is least accessible, partly because it is often hidden in rare periodicals and series, partly because it occurs in an unusually broad spectrum of languages, each with its own specialized architectural vocabulary. It is finally a period whose literary sources have been very unevenly surveyed for their pertinence to architecture: well known for the Arab world and especially for Syria and Baghdad, they have hardly been touched for Iran and Anatolia.[6]

Iran and Central Asia

THE MONUMENTS

Mosques

The edge of the Iranian desert in the centre and west of the country boasts a remarkable and coherent group of mosques: Isfahan, Ardistan, Barsian, Gulpaygan, Zavareh, Burujird, with Qazvin and Qurva farther to the north.[7] In

addition, in the same general area, at Yazd, Kerman, Shiraz, and probably Rayy, many other mosques were constructed or reconstructed, though later restorations have often obliterated the earlier work. This group belongs essentially to the period of the Great Seljuqs, with the earliest dated construction in 1088 (north-eastern dome at Isfahan) and the latest in the eighth decade of the twelfth century (Qurva). Unfortunately our information on mosques built elsewhere in the Iranian world is so limited as to make it almost useless. In Herat,[8] in Lashkari Bazar,[9] in a small town near Merv,[10] in Bukhara,[11] Damghan,[12] Khiva,[13] and Baku[14] there is evidence for major religious buildings, but either no trace is left, or the monuments have not been properly published or even studied, or else they are small hypostyle constructions of little significance. It is therefore partly by default that a consideration of mosque architecture is centred on west-central Iran. But at the same time the area, a favourite of the Great Seljuqs both for residence and patronage, was in fact the most important centre of the Near East in the late eleventh and early twelfth centuries and can be seen as paradigmatic for a twelfth-century Iranian type of mosque.

The most remarkable and celebrated of these monuments is the great Masjid-i Jumah of Isfahan [269, 270]; it is also extremely complex and, in spite of several studies and of partially published excavations,[15] still far from being clearly understood. Like Chartres, with which it has often been compared, it is unique, and thus cannot be adduced to define a period; yet the period cannot be understood without a full awareness of its character. For this reason I shall begin with a description of the structure as it stands now, and then try to single out those of its features which clearly belong to our period.

It is a large, irregular aggregation of buildings whose north-east-south-west axis is 150 metres, with 476 separate vaults, mostly domes. The core is the rectangular courtyard of the tenth-century hypostyle mosque discussed earlier[16]

into which were introduced four iwans of which two are almost square halls ending in a blank wall [271, 272]. The iwan on the qibla side is also squarish but related to a large room, 15 metres square, covered with a dome. The fourth on the opposite side, to the north-east, is much longer and narrower, in a more traditional rectangular pattern, and ends in two massive blocks recalling the towers of the gate, at least in plan (in elevation[17] so much of it is masked by later decoration that it is difficult to ascertain its original shape). The iwans occupy only a fraction of the façade on the court; the rest is taken up by forty-two rectangular panel-like units of two superposed tiers of arches. It is uncertain whether this double arrangement is a relic of the first façade. Each panel leads to an aisle of square bays covered with domes, except where there was systematic later rebuilding, for example on either side of the north-western iwan.

Within this area there is only one approximate date: in the lowest part of the qibla dome [273] an inscription names its builder, some time between 1072 and 1092, as the great Nizam al-Mulk himself. Three areas outside the earlier rectangle however bear dates in the late eleventh and early twelfth centuries. First, on the main axis of the mosque, some twenty-three metres beyond the north-eastern iwan, a square domed room (10 metres to the side) [274] is precisely dated to 1088 by an inscription which names Taj al-Mulk, Nizam al-Mulk's enemy and competitor, as its founder. The area which separates this domed room from the north-east iwan is covered today with later additions, but it is generally assumed that it was originally free from buildings. Second, a gate [275] outside the main rectangle to the east of the north-east iwan is inscribed as 'rebuilt after the fire of 1121-2'[18] – in all probability the one recorded by chroniclers during a local revolt in 1120.[19] Finally, the area beyond the limits of the rectangle in the southern corner of the present mosque exhibits not only a remarkably archaic mode of construction, but also fragments of religious inscription whose epigraphical style is hardly likely to be later than the end of the eleventh century.[20]

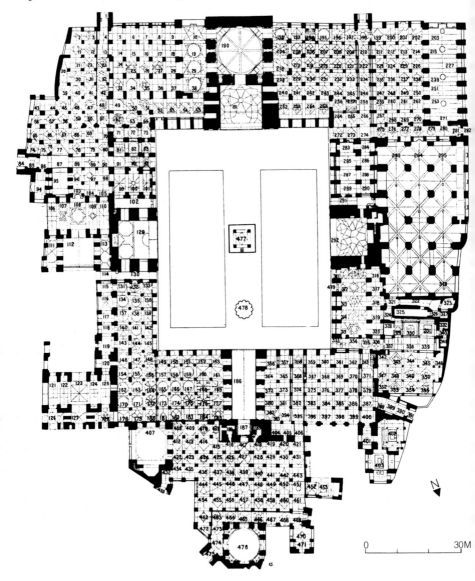

269 and 270. Isfahan, Great Mosque (Masjid-i Jumah), eighth–seventeenth centuries, plan and air view

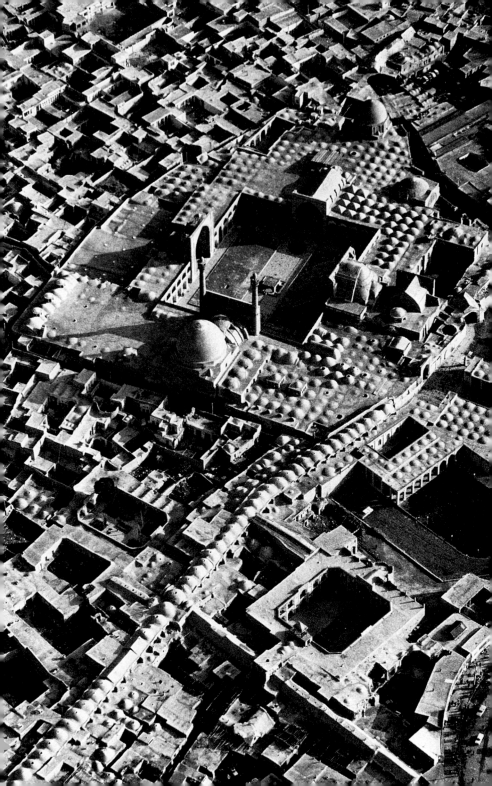

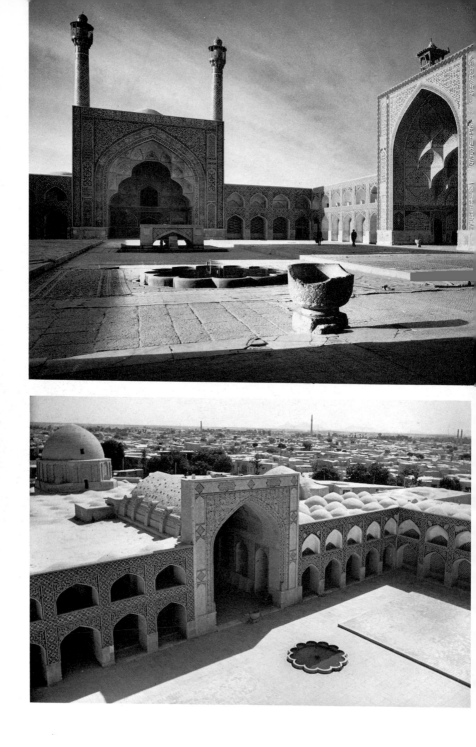

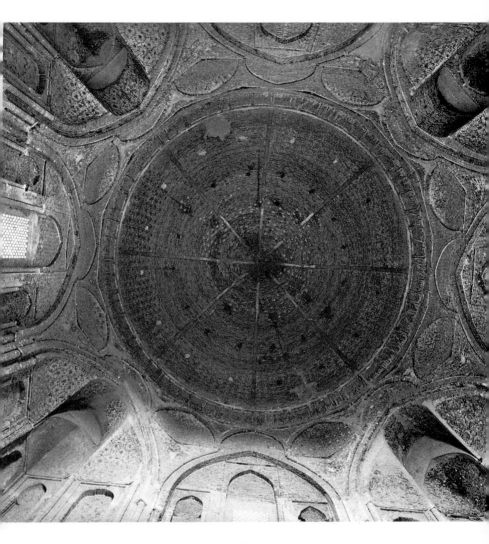

271 and 272. Isfahan, Great Mosque, court, eleventh and twelfth centuries,
facing west (*opposite, above*) and north-east (*opposite, below*)

273 (*above*). Isfahan, Great Mosque, south dome, 1072/92

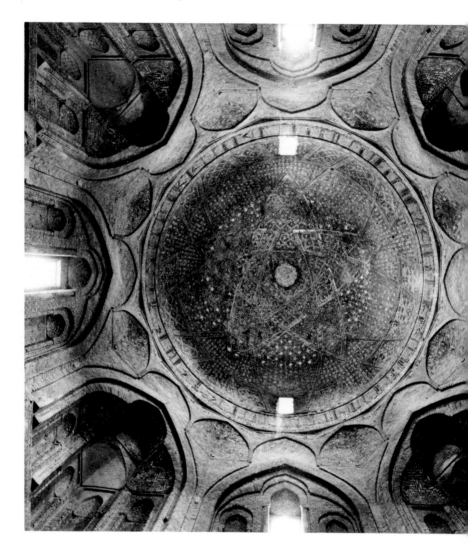

274. Isfahan, Great Mosque, north dome, 1088

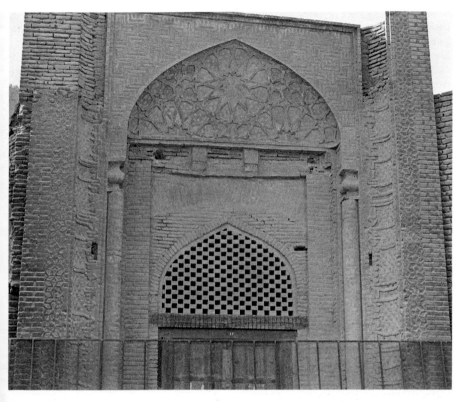

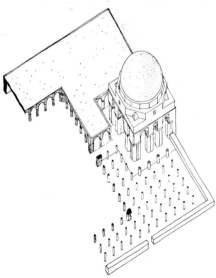

275 (*above*). Isfahan, Great Mosque, gate,
rebuilt after 1121-2

276 (*right*). Isfahan, Great Mosque,
plan as in Seljuq times (after Galdieri)

There are thus three features – a dome in front of the mihrab, a second dome to the north and presumably outside the perimeter of the mosque, and a somewhat eccentric gate – which are clearly dated to the late eleventh and early twelfth centuries. They imply major transformations of the Buyid mosque in several stages; this is partly confirmed by recent excavations. First would have been the large dome in front of the mihrab, sponsored by the great vizier Nizam al-Mulk. It was not in itself a novelty, but its size and majesty are unusual, perhaps reflecting an obscure tradition of a large maqsura in mosques in the area.[21] It is reasonable to interpret this as a reserved princely area, but it is still unclear how the dome was connected with the remaining hypostyle.[22] The outside north dome built in 1088 by Taj al-Mulk also had some royal function – perhaps the prince changed his clothes there before he entered the mosque,[23] as its Koranic quotation (VII,54) is rarely found in mosques and emphasizes the 'royal' character of God. Its asymmetrical openings further indicate that it served some ceremonial function of passage.[24] The gate of 1121–2 is more difficult to explain because of its eccentricity, but several rather cryptic textual references to built areas adjoining the mosque and functionally related to it[25] suggest an earlier expansion or addition which would have been formally incorporated into a single building. It is to this last phase that the four iwans are usually attributed, although there is no archaeological, epigraphic, or literary proof.[26]

The Seljuq mosque of Isfahan can thus be reconstructed, at least hypothetically, in the following fashion [276]. We cannot define its outer limits because it is not known whether the many fourteenth- and sixteenth-century additions were on newly acquired areas or displaced Seljuq or even earlier constructions. Its most characteristic feature was a core of a courtyard with four iwans and a dome behind the qibla iwan, all fitted into a plan imposed by an earlier building. To the origins of this plan and to the construction and aesthetics of this most complex

277 and 278. Zavareh, mosque, 1136, plan and interior

building we shall return after considering more briefly other relevant monuments.

The significant point about the other mosques of central Iran is that all were built or transformed in the first decades of the twelfth century. Moreover, even though at Ardistan and Barsian an older hypostyle and a number of local peculiarities[27] gave rise to unusual features, basically a standard plan type was used throughout. Its first fully dated occurrence is in the small town of Zavareh in 1136 [277, 278].[28] Within a rectangle is a courtyard with four iwans, with a dome behind the qibla iwan. The areas between are covered with pointed barrel-vaults on heavy piers,[29] and a symmetrically planned court façade of arches frames the iwans and connects with the vaults. There is an entrance to the side of the main axis of the mosque, and a minaret usually beyond the limits of the rectangle. With only minor variations this type was imposed on the remains of the hypostyle mosque of Isfahan.

What is the origin of this plan, and why was it adopted at this time and place? Individually, of course, neither the iwan, nor the iwan-dome combination, nor even the court with four iwans is new – all can easily be related to the pre-Islamic traditions of Iran and Iraq. The innovation lay in combining a court with a side entrance and giving it four iwans, the size of each depending on its position in the liturgical orientation of the building and on the large dome behind the qibla iwan. In other words, existing forms were adapted to the liturgical, functional, and symbolic purposes of a congregational mosque.

It is much more complicated to determine the sources of this plan. An older theory was that the court with four iwans and a side entrance is a characteristic of the eastern Iranian private house, which would have had an early impact on monumental secular architecture, as we shall see later.[30] To explain how and why a

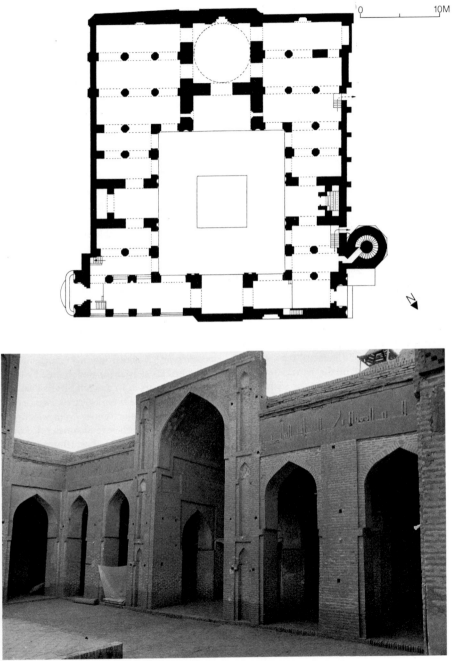

house plan from eastern Iran came to be used in newly built congregational mosques of central Iran, Max van Berchem, followed later by E. Herzfeld and A. Godard,[31] evolved what may be called the madrasa theory. Its starting point is the accepted fact that, after the occupation of Iran and Iraq by the Seljuq Turks, madrasas were constructed for the re-education of the Muslim masses in the principles of orthodoxy, some sponsored privately, others built by the Seljuq princes and their advisers, sometimes at their own expense, but all as instruments of the state. The most celebrated were the Nizamiyas built in Iran and Iraq by Nizam al-Mulk himself, of which the most remarkable was in Baghdad. It has not been preserved, and the existing descriptions are of no help towards a reconstruction.[32] While it was only under the Seljuqs that the government began to sponsor such institutions, privately founded madrasas existed already in north-east Iran, in most instances in houses transformed for the purpose. These facts led to two assumptions: that the Seljuq madrasas, because of the nature of their sponsorship and the rapidity of their construction, tended to be of a standard type; and that the type originated in the private houses of eastern Iran already adapted for such use. It was then concluded that the four-iwan house plan spread throughout the area of Iran and Iraq and was adopted for congregational mosques merely because it was convenient and popular.

Simple and coherent though it may be, this hypothesis cannot be fully maintained. The first argument against it is an argument a silentio: nothing is known of the physical shape of the madrasa before the second half of the twelfth century, and no early madrasa is known in Iran at all – the often quoted one at Khargird is so indistinct as to be useless.[33] It is true, as we shall see later, that Syrian and Anatolian examples generally have but few typological variations, suggesting that the madrasa indeed possessed precise characteristics of plan and construction: but even so, is it likely that twelfth-century architects would have applied systematically to all new or rebuilt mosques of one area a plan identified with a precise and limited function in another? In any case we shall not ascertain the original form of the madrasa until an early example has been excavated. The stronger objection to the theory is, however, that the four iwans with courts are hardly ever found in later madrasas, but became standard for many constructions – secular and religious – in the twelfth century, in Iran and beyond, suggesting a much more powerful force behind the plan than a new religious institution about which we know so little. It may well have been an indigenous western Iranian or Iraqi form which received a monumental shape in local mosques. It is a curious fact – and one that should lead to considerable care in drawing conclusions on this whole question – that of all the major mosques of eastern Iran and central Asia that date from before the Mongol conquest, only one, of the early thirteenth century, at Dihistan (mod. Mashhad-i Misriyin)[34] has an iwan-dome in front of the qibla.

To sum up, in the early decades of the twelfth century a remarkable group of congregational mosques with a similar internal arrangement – even when (as at Isfahan) complicated by local factors – appears in west central Iran. This can be explained by the historical circumstance that these were the major centres from which the Great Seljuqs and their feudatories ruled over much of the Islamic Near East. But the formal origins of the new plan and the degree to which this central Iranian development can be assumed at that time for the rest of the country are problems which, so far, we lack the information to solve. Even though the prevalent theory of an oriental origin cannot be maintained on archaeological or logical grounds, the literary and architectural documentation in our possession does not suggest a more adequate explanation. In any case, the combination of forms thus created became the basis for all subsequent developments of Iranian mosque architecture, to whose aesthetic implications we shall return.

*

Mausoleums

As we have seen earlier, the first Islamic mausoleums were erected in the tenth century, presumably for the glorification of princes and the celebration of Shi'ite imams. In Iran they were either towers or square buildings covered with cupolas on squinches, but with the arrival of the Turks and the subsequent triumph of Sunnism they were transformed in function and in shape. Instead of descendants of Ali, it was holy men, legendary Companions of the Prophets, and often Old Testament figures who were accorded true *martyria* (Ar. *mashhad*, 'place of witnessing'; in Iran often called *imamzade*, 'son of the imam'). These became focuses of popular cults and beliefs, and their growth should be examined in relation to two important pietistic characteristics of the time – the search for personal salvation through the intercession of a holy man or a holy event, and attempts by guilds and Sufi organizations to relate themselves to holy personages. The cemetery became, in some cities at least, a proper place for meditation and gathering in the proximity of long-gone virtuous men. At the same time the development of a feudal order of military lords maintained the need for the commemoration of wealth and importance or for the establishment of dynastic or personal shrines.

Like the mosques, the remaining Iranian mausoleums pose a number of unresolved problems. Is it accidental that by far the largest number from this period are found in the north along a line from Urgench, almost in the Pamir, across Balkh and Merv, in and around the mountains south of the Caspian Sea, and into Azerbayjan? Why is it that in the extreme north-east and the extreme north-west there are groups from the second half of the twelfth cen-

279 and 280. Damghan, tower tombs, 1027 and 1056

281 (*above*). Kharraqan, mausoleums,
1067-8 and 1093

282 (*right*). Kharraqan, mausoleum,
1067-8, façade

tury and a few earlier ones, while in the area
south of the Caspian Sea many dated examples
exist from the second half of the eleventh cen-
tury and the first half of the twelfth? In the
absence of adequate regional or cultural in-
vestigations, which alone could provide answers
to these questions, I shall discuss these mauso-
leums in purely typological fashion.

First, the tower tomb is still present. There
are two examples (1027 and 1056) at Damghan
[279, 280],[35] round and squat, of brick, with a
pointed dome. The brickwork is simple every-
where but on the upper part of the shaft, where
it is heavily decorated. At Rayy (1139)[36] is a
much restored star-shaped tomb, which, like
Gunbad-i Qabus, has very little ornament be-
yond a small area along the cornice below the
dome; the striking elegance of the earlier mon-
ument has however deteriorated into the heavy
semblance of a water tower. In southern Iran
the tower tomb is represented at Abarquh
(1056).[37]

The more interesting and ultimately more
far-reaching development occurred within the
second type: the square or polygonal canopy-
like mausoleum.[38] It appears in small villages

of central Asia and elsewhere,[39] and in large towns like Sangbast and Yazd,[40] in many variants which, at this stage of research, escape easy classification. I shall limit myself to a brief discussion of the Kharraqan tombs, the mausoleum of Sultan Sanjar, and the Azerbayjan group, and to the growth of the pishtaq, a notable feature which appears in many of them.

The two Kharraqan tombs (dated 1067-8 and 1093) [281-4] and the related mausoleum at Demavend are in northern Iran, south-east of Qazvin and east of Tehran respectively.[41] All three are octagonal inside and out and about 13 metres high; each side is about 4 metres long, with heavy semicircular corner buttresses. Inside on a zone of squinches is a dome, double in the case of the second of the Kharraqan buildings – the earliest double dome in Iran. All are remarkable for their brickwork, a series of most elaborately ornamented panels, to which I shall return. One of the Kharraqan mausoleums also has painted decoration which may, however, be later. The Kharraqan towers were built by Muhammad b. Makki al-Zanjani, and the patrons were probably sub-princely Turks or Iranians.[42]

283 and 284. Kharraqan, mausoleum, 1093, plan and section (*left*) and entrance façade (*right*)

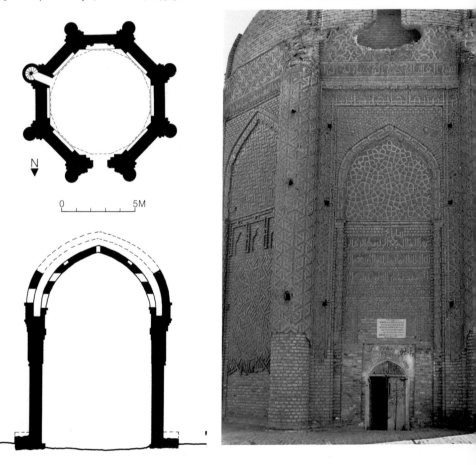

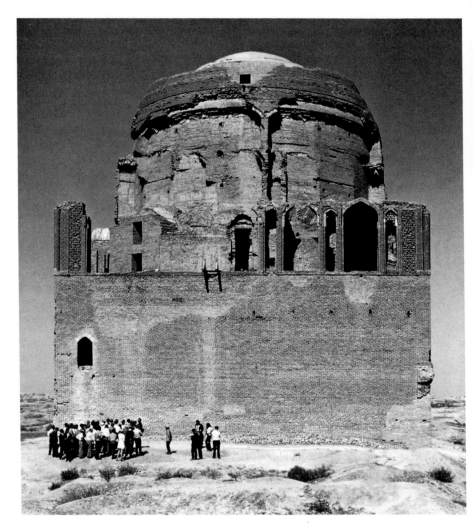

The mausoleum of Sultan Sanjar in Merv (c. 1152)[43] was part of a large complex including a palace and a mosque directly attached to it [285, 286]. It is thus the first dated instance of the mosque-mausoleum, later to become common; the palace on the other side however relates it to a much more ancient tradition, that of Spalato, where tomb, palace, and temple are all part of the same conception. In plan it is square, 27 metres to the side, with two entrances facing each other. Inside is a square domed room (17 by 17 metres). The plan is thus not very original, except for its size, but the elevation is. Remarkably deep and strong foundations support a thick brick wall which goes up to a height of about 14 metres without any major decoration inside or outside. The zone of transition is hidden outside by a gallery, in the manner of the Samanid mausoleum in Bukhara, and above it soars the superb dome, 14 metres high, which

285 and 286. Merv, mausoleum of Sanjar, *c.* 1152, general view (*opposite*) and section (*below*)

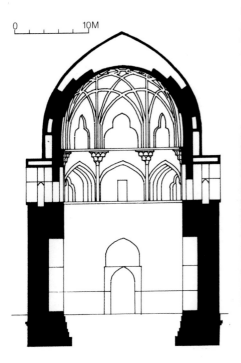

0 10M

287. Maragha, Gunbad-i Qabud, 1197

has unfortunately lost much of its outer brick: it appears to be on a high drum, whereas originally it had the high-crowned shape of a typical Persian arch. We shall return to the elements of construction, especially the double dome and the octagon, meanwhile noting that, although the largest and most spectacular of Seljuq mausoleums, the plan and the basic formal elements are quite simple and traditional.

A third group stands out both for its originality and because it incorporated many of the features developed in earlier mausoleums elsewhere in Iran. It is in the north-west of the area, more or less coinciding with present Azerbayjan,[44] especially at Maragha and Nakhichevan, and dates from 1147–8 ('red' mausoleum

at Maragha) to 1197 (Gunbad-i Qabud [287] also in Maragha). Circular, square, or polygonal, at times in stone, the tombs derive as much from the tower as from the canopy. They all have crypts, a novelty in Iran, and in almost all the façade is differentiated from the other sides by its shape or the extent of its decoration. Furthermore, many have preserved the names of their builders in official inscriptions.

A major innovation in Iranian mausoleums of the time is the *pishtaq*, the high and formal gateway which gives a single façade to the building. It seems to have had a central Asian origin, since at Sarakhs and Mehne in southern Turkmenistan such façades were added to mausoleums as early as the mid eleventh century

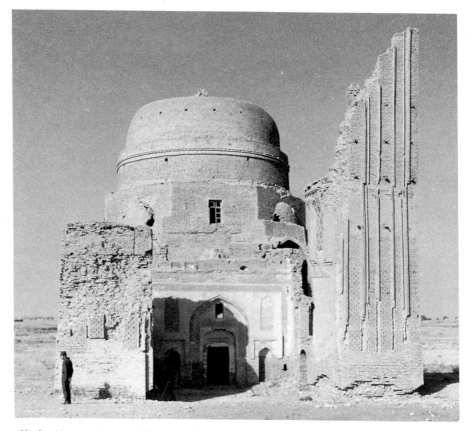

288. Sarakhs, mausoleum, twelfth century (?)

289 (*right*). Sarakhs, mausoleum,
eleventh century, plan

[288, 289].[45] It consists of two dissimilar pro-
jecting towers creating a sort of shallow iwan
with a characteristic arch framed in a rectangle,
at times serving to mask stairways to reach the
gallery. At Mehne and Sarakhs the decoration
is sober on all four sides, but later, for example
at Uzgend (1152 and 1186) and Urgench, the
growing complexity of mouldings and decora-
tive designs accentuates the contrast between
façade and side walls.[46] We can only speculate
as to whether the façade-gateway was an aes-
thetic or a ceremonial or a symbolic develop-

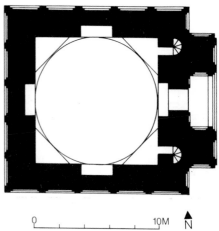

0 10M ▲
 N

ment; it may be related to a general increase in façade-building.

The pishtaq illustrates what seem to be the essential issues of the Iranian mausoleums of the eleventh and twelfth centuries. The distinction between tower and canopy, so clear in previous centuries, tends to become blurred; but the differentiation between sides, their elaborate and varied ornamentation, and their range of structural complexity imply that their architectural and aesthetic development is related to that of contemporary building in general, while their social-contextual meaning must be sought in religious and cultural history.

Towers and Minarets

Apart from congregational mosques and from mausoleums (which are partly secular in character), most of what we know of religious architecture in Iran derives from texts; no madrasa, *khangah* (communal dwelling for mystics), or ribat can be reconstructed. However there remain, from Bukhara to Baku, Isfahan, and Afghanistan,[47] many unusually well and carefully built tall towers, most standing alone [290, 291], but some known to have been attached to mosques; since most mosque minarets resemble them, they have usually been called manars or minarets.[48]

The overwhelming majority consist of a simple cylindrical brick shaft, at times on a square base; except for their magnificent brick and stucco decoration (on which more below), these thin towers could be compared with modern factory chimneys. Anomalous types are found in Afghanistan: the star-shaped manars of Ghazni (early twelfth century) [292], and the extraordinary one at Jam [293] built by the Ghorid prince Ghiyath al-Din (1153–1203),[49] where three cylindrical shafts of decreasing diameter are crowned by a sort of small belvedere, the whole reaching a height of some sixty metres.

None of the hypotheses proposed to explain the shape and purpose of these structures is totally satisfying. Clearly, many served for the

call to prayer and were attached to mosques, although their large number, heavy decoration, height, and epigraphic emphasis on the piety of their patrons suggests that, like medieval chapels in western cathedrals, they may also have served as monumental expressions of individuals' devotion, or, like Italian campanili, as symbols of a certain family or quarter in town.[50] In other instances, in particular at Jam, the setting excludes the possibility of a mosque near the minaret, and the rather unusual choice of Koranic quotations for the inscriptions suggests instead that the manar was a memorial to a prince and to his faith – perhaps indeed a victory tower. Others may have been simple landmarks, literally lighthouses (which is what the Arabic word *manar* means) built by the prince for the convenience of the traveller. This is the likely explanation for the towers on major roads such as those at Khusrawgird and Semnan in northern Iran; even the grand Kalayan minaret at Bukhara (1127) [290] could well be the beacon announcing the oasis from afar.

There is altogether something very puzzling about these towers, which spread to a few places in Iraq and northern Mesopotamia. Considerable effort was expended on them, their striking visual power has long been recognized, and yet their purpose is still obscure. Perhaps in fact a multiplicity of meanings were given the same form. Whence did that form come? The star-shaped towers could have had a pre-Islamic or non-Islamic origin,[51] but the thin or thick cylindrical tube on one or more levels may well have been an invention of the eleventh century.

Secular Architecture

Compared with religious or para-religious monuments, secular structures are poorly preserved and badly known. Pugachenkova and other Soviet scholars have attempted to reconstruct the main features of the great contemporary urban centres such as Merv,[52] with its central walled city (*shahristan*), its citadel (*arq*) astride a section of the walls, and its extensive suburb (*rabad*). Undoubtedly these and the traditional square

290. Bukhara, Kalayan minaret, 1127 291. Damghan, minaret, mid eleventh century

292. Ghazni, manar of Masud, early twelfth century

293. Jam, manar of Ghiyath al-Din, 1153/1203

(*maydan*) in front of the fortress appeared in other Iranian towns, but archaeological and textual research is still needed to find out how the better-known central Asian examples were translated into western and central Iranian terms.

Central Asia also furnishes most of our information about private dwellings,[53] generally centrally planned square buildings. The governor's palace at Merv seems to have been rather small (45 by 39 metres), with a central court surrounded by four iwans. During extensive surveys at Lashkari Bazar in Afghanistan several villa-type buildings were identified, but in the absence of excavations they cannot be discussed in any detail.[54]

294. Lashkari Bazar (Qalah-i Bust), palace, eleventh century, plan

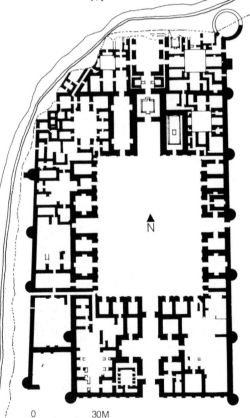

More is known about three very remarkable palaces, one at Tirmidh, datable around 1030,[55] the second built by the Ghaznevids at Lashkari Bazar, in the eleventh century,[56] and the third at Ghazni itself.[57] None of these excavations has been published in its entirety. All three are extremely important for the paintings, sculptures, and objects found in them, but the architecture of Lashkari Bazar is the best preserved and most easily accessible [294]. It is a large rectangle (100 by 250 metres) with additions on the north and west. Like older Islamic palaces such as Mshatta and Ukhaydir, it consists of an entrance complex (here cruciform), a courtyard, an audience complex on the entrance axis (here iwan and dome), and then a superb iwan turned towards the north overlooking the river, as, for instance, in the third-century palace at Dura–Europos. A series of self-contained dwelling units with iwans were grouped around courts. Outwardly it resembles a fortified enclosure. Its decorative arches and recesses, and its basic divisions, continue older traditions – as does the peculiar throne room at Tirmidh with its two halls at right angles to each other, known at Samarra or in western Islamic palaces. The principal innovation in the plan of Lashkari Bazar is its systematic use of four iwans – one directly opposite the entrance – opening on courts, proving that secular monumental architecture had fully realized the planning and aesthetic possibilities of this arrangement as early as the eleventh century. Such palace compositions might perhaps be the source of the features which, at this time, came to characterize the new large congregational mosques.

The last group of secular monuments from the eleventh and twelfth centuries consists of caravanserais. Their appearance as a major architectural type is in itself an important testimony to the social and economic changes of the time. Of the earliest extant example, the superb Ribat-i Malik (*c.* 1068–80) in the desert of central Asia, a wall and a magnificent portal remain [295] (the recently published plan shows an unexplained pavilion at the back of the courtyard).[58] Its spectacular wall surface, composed

295. Ribat-i Malik, *c.* 1068-80, reconstruction

296. Ribat Sharaf, twelfth century

of a series of half-cylinders surmounted by re-
cessed brick arches, no doubt grew from earlier
local practices.[59]

Two other caravanserais should be men-
tioned: Daya-Khatun, of the late eleventh or
early twelfth century,[60] and Ribat Sharaf [296],
definitely of the twelfth.[61] Both are almost
square (Ribat Sharaf has an additional fore-
court), with a superb monumental portal, a
courtyard with a portico interrupted by an iwan
on each side, and long vaulted or square domed
rooms along the walls, at times arranged in small
apartments. The significance of these buildings
for the history of architecture is not only that
they use the four-iwan plan found in mosques
and palaces, but also that in construction and
decoration they show a variety and quality
(about which more will be said below) which
exemplify the care and importance given at this
time to buildings dedicated to trade.

MATERIALS AND TECHNIQUES
OF CONSTRUCTION

This survey of the major monuments of the
huge area extending from the frontiers of China
and India to Anatolia has brought to light the
seeming fact that the most active construction
period in Iran began about 1080 and ended
about 1160. The comparatively large number of
buildings which have survived from a limited
period leads to some tentative conclusions on
techniques and methods of construction - ten-
tative because, with a few exceptions,[62] no truly
monographic studies have been undertaken, nor
have repairs and restorations been catalogued,
even for so central a monument as the mosque
at Isfahan, whose 476 domes and vaults have
not yet been properly published.[63]

Materials

Ubiquitous as a material is high-quality baked
brick. To be sure, unbaked brick, stone, and pisé
are still used, but either in specific areas, for
example stone in parts of Azerbayjan, or in
rustic buildings and secondary parts of major
monuments, particularly secular works. Else-
where baked brick occurs throughout, in walls,
vaults, and decoration. It is significant for its
appearance even in areas, such as central and
western Iran, where it had hitherto been rare,
but chiefly for its fascinating variety of uses. At
one extreme the outer walls of Ribat Sharaf and
the mosque of Isfahan show quite simple pat-
terns of horizontal layers whose variations
enable one to distinguish the techniques of dif-
ferent provinces. The medium follows the lines
and forms imposed by the architect and lends
sobriety and strength. At the other extreme,
perhaps on portals, on the walls and vaults of
central Iranian mosques, on many mausoleums,
and on some of the minarets, brick provided a
rich and luxurious wall surface, giving a sense
of constantly moving lines and forms partly, at
least, independent of the lines suggested by the
architecture. This result was achieved in several
different ways, but the brick used for decorative
effect and to modify the impression of the wall
is always the brick used for construction. This
ambiguity reached absurdity at Ribat Sharaf,
where the stucco covering of the brick wall is
carved with a motif imitating brickwork [297]
– an equivalent to the stones and painted bricks
of the arches in the last addition to the mosque
of Cordova, and another illustration of medieval
Islamic architecture's constant search for inex-
pensive ways of making visual effects.

It is not clear why brick became such a fa-
vourite. Was it a revival of Sasanian techniques,
as they had existed especially in Iraq and parts
of Iran? Had the brick architecture known from
as early as the tenth century in the north-eastern
provinces now spread across the whole of Iran?
Or was it best suited to the need, especially in
the west of the area, for the rapid erection of
permanent religious buildings and for formal
and technological experiments? There probably
is no one explanation; in any case, from the
eleventh century onwards brick remained the
most characteristic material of construction in
Iran and, because of the country's impact on
neighbouring lands, the forms it made possible
were frequently translated into other media.

297. Ribat Sharaf, twelfth century, detail of decoration showing imitation of brickwork

Vaults and Domes

Supports in the eleventh and twelfth centuries in Iran are comparatively simple. Columns as such are almost non-existent; piers, circular or polygonal, are more common, frequently so massive that they come close to being walls, or rather sections of walls. Similarly, the connecting arches more often than not amount to small vaults. At times recesses relieve the piers or sections of walls, especially on court façades, but very rarely (as in some of the iwans and in the north-eastern dome of the mosque at Isfahan) do they represent a serious attempt to relate the form of the pier to the main features of the superstructure.

The heaviness and size of the supports are easy to explain if one considers that brick vaulting was the most common, if not the only,[64] mode of roofing. Barrel-vaults, usually pointed in section, covered rectangular spaces such as iwans; domes covered square ones. Of interest here are both the transition from square to dome and the actual means of construction. The first problem was solved in a bewildering variety of ways – five at Ribat Sharaf alone,[65] at least three at Daya-Khatun.[66] These variations, whether they are the result of constant experimentation or of a virtuosity based on a mastery of basic principles, almost all depend on the squinch,[67] i.e. the arch or niche bridging a corner of the square and transforming it into an octagon [298]. In many cases (e.g. Sangbast [299, 300], Qazvin) a simple traditional squinch arch is used, differing from earlier examples mainly by its greater size. But the most important modifications of the squinch are constructional and aesthetic. Two examples of particular importance may serve to introduce a subject which is only beginning to emerge as a major issue of Iranian architecture: the squinches of the north-eastern dome of Isfahan, which are substantially similar to those of the south-western dome in the same mosque and of most western

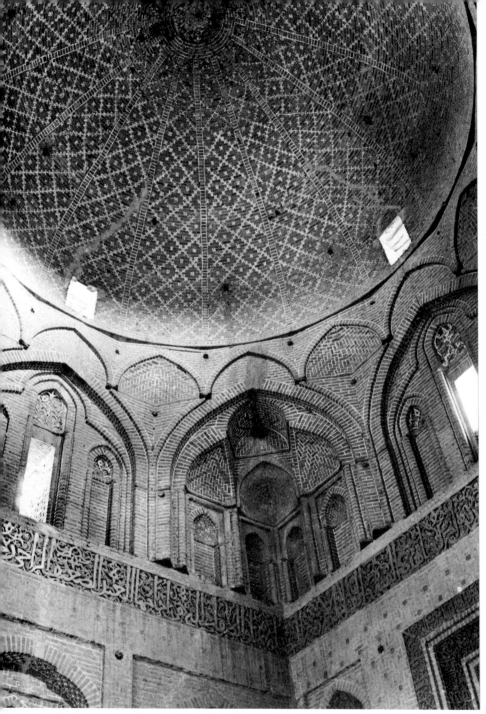

298. Ardistan, mosque, dome, eleventh and twelfth centuries

299 and 300. Sangbast, tomb, *c.* 1028,
dome (*above*) and squinch (*right*)

Iranian domes [273, 274],[68] and those of the
mausoleum of Sanjar in Merv.

At Isfahan there are two types of squinch,
one a traditional high-crowned four-centred
arch, the other with three lobes corresponding
to three sections of vaults: a central barrel-vault
perpendicular to the arch, and two quarters of
domes. Each section is carried down to the level
of the square, the sides through a flat niche
framed in a rectangle, the central one through
a secondary squinch niche over two flat niches.
Instead of being a sort of half-dome in the
classical tradition, the squinch now becomes a
symmetrical combination of flat niches and sec-
tions of vaults which seem to buttress each
other. This muqarnas system is not new – we
have seen it in the second half of the tenth
century at Tim in central Asia.[69] The units of
the composition are similar at Isfahan, but the
rather flat, decorative, and uncertainly balanced

Tim squinch has become a deep, architectonically meaningful, and perfectly poised and composed element. The relationship to Tim is a clear indication of the eastern origin of the theme, but the question remains whether it was architects in eastern or central Iran (where the earliest instance of a muqarnas squinch known so far is in the Duvazde Imam tomb at Yazd

The Isfahan zone of transition does not stop at the squinch. Above the octagon proper is a sixteen-sided area for which the name of squinch net has been proposed.[72] A further step before the base is logical enough in domes as large as Isfahan's; more interestingly, this sixteen-sided zone blends with the octagon because it is directly connected with a

301. Yazd, Duvazde Imam tomb, 1037, squinch

[301], dated 1037)[70] who first transformed the awkward Tim form into a structurally meaningful one which gives the impression of a logical division of weight into five points on the square. It is unlikely that the dome was so heavy that it necessitated a division of the thrusts: rather, the muqarnas was a decorative feature in which architectural forms were so artfully used that they made sense as elements of construction as well as of decoration. In any case, the muqarnas squinch seems to have been a transformation popular in western Iran of an originally northeastern decorative development.[71]

pendentive-like unit filling the spandrels of the squinches. The difference in plane between the eight recesses over units of the octagon and the eight over the spandrels gives a certain relief to this part of the wall and also serves to distinguish them from each other. The Tim squinch had already a peculiar column and console leading up to a zone above the octagon, but the whole of the construction was inorganic.

The extremely logical organization of the zone of transition in Isfahan's north-eastern dome was repeated at the same point in many

other Iranian monuments of the time. The Is-
fahan room is remarkable because every single
element of the construction of the transitional
zone is carried down to the bases of the piers
through a system of articulation reminiscent of
later Gothic piers. This involvement of the
whole of the room in the logic of one part – and
that part not the dome proper but the area below
it – is unique in contemporary architecture. It
is less important to search for possible relations
with western forms of a century later than to
explain why the device was never repeated in
Muslim architecture.

Whatever the reason may be, the zones of
transition in the west of Iran contrast remark-
ably with those of the north-east, where – as at
Merv – the Samanid order of decreasing arches
with a narrow window was still in use. There is
a muqarnas at Merv, but in the spandrels of the
octagon's arches, where it supports an atrophied
sixteen-sided zone and can be related, at least
genetically, to the column and capital of Tim
and Bukhara. Here, the themes of the tran-
sitional zone are much more traditional than at
Isfahan, and the muqarnas is more strictly de-
corative. Elsewhere in central Asia, the same
conservatism prevails, with occasional attempts
at new formulas. It is this conservatism which
may well have led to the frequent preservation
of the gallery around the zone of transition,
transforming domical constructions into two
superposed masses, a cube and a dome, whereas
in western Iran the zone of transition tends to
be visible from outside.

The methods of construction of the dome
proper and of vaults in general pose more com-
plex problems, for, in spite of an important
attempt by Godard,[73] much information is still
lacking. The most important novelty, first en-
countered at Kharraqan, is the double dome in
brick in which the two shells are not quite of the
same profile and are connected by intermittent
brick ties. Ultimately the double dome probably
derived from wooden architecture, though it
has been connected with the nomadic tents of
central Asia. The lightening of weight opened
up new possibilities for the outer shape, and

paved the way for the spectacular domes of the
Timurid period.

Godard's study and M. B. Smith's careful
examination of the Barsian and Sin domes[74]
confirm the visual impression produced by the
domes of Merv, Isfahan, and Ardistan, and the
barrel- and cross-vaults in some of the smaller
mosques of western Iran. Lack of wood pro-
hibited the systematic use of centring, so the
masons created a network of brick ribs –
generally covered up on the outside – which was
slowly filled with bricks laid in a different direc-
tion. In the smaller domes the ribs were prob-
ably erected first, but in the larger ones they
were constructed and filled in at the same time.
Here, two essential points must be made. First,
the ribs are not functional because, once the
vault is completed, their mass is integral with
that of the rest of the dome even when, as at
Merv, they are in relief; they are for construc-
tion, not for support. Second, while sometimes
the network of ribs is simple and straight-
forward, leading from the base of the dome to
its apex, at others it forms decorative patterns
of varying complexity. The masterpiece among
complex domes is Isfahan's unusual north-
eastern pentagram. These two points clearly
demonstrate that, just as at Cordova, the ribs of
Iran are not comparable to western medieval
ribs.

Although their construction was simpler, the
smaller domes of Isfahan, many of them redone
in later times, and smaller vaults and domes in
other contemporary monuments were usually
built on the same principles as the large ones.
Their remarkable feature is the great variety of
minor modifications that the builders managed
to introduce into a few basic themes.[75]

It is probably premature to try to draw defi-
nitive conclusions, but one thing seems incon-
trovertible: whatever the earlier history of vaults
and domes in Iran[76] and regardless of eccentric
monuments like the Samanid mausoleum in
Bukhara, the second half of the eleventh century
is the earliest demonstrable time for the forma-
tion of a uniquely differentiated, highly original,
and stylistically coherent (though extraordi-

narily varied) development of an Iranian architecture of brick domes and vaults.

There developed in fact an aesthetic of the dome, which alone among major forms – whether over a mausoleum or the qibla room of a mosque – was conceived primarily from the interior. Even though the introduction of the double dome portends change, and even though our contemporary taste leans towards the pure, undecorated lines of the exterior of Isfahan's mosque, undoubtedly architects at the time devoted most of their energies to the interiors, with their vibrant logic, their mathematical combinations,[77] their decorative effects, and their muqarnas. A mere landmark from the outside, inside the Iranian dome is a haven from the brilliance of the sun; small wonder that it became accepted as the symbol of the most holy, the qibla and the mashhad. It thus joins a most ancient tradition, but – as so often in the Muslim world – not until required by the development of Islam. Yet ultimately the most remarkable dome of the eleventh and twelfth centuries is the north-eastern dome at Isfahan, whose purpose was probably more secular than religious. The rare refinement of its composition, based on the golden mean, and its decorative patterns indicate a talented designer who was inspired by standard forms to create a work of art. His vision was not followed, either because contemporary technology was not equal to its complexity or because its private functions did not make it available as a model until much later, when other tastes had emerged.

The Minaret, the Pishtaq,
the Court with Four Iwans

The minaret, the pishtaq, and the court with four iwans are all open-air forms. The tall, round, upward-moving minaret was independent of the mosque; when related to it at all, it was generally on one side of the sanctuary. Aesthetically minarets ranged from refined elegance to bejewelled heaviness.

The pishtaq, too, bears little relation to the building towards which it opens. Typical of a group of mausoleums of north-eastern Iran, where at times it was a very spectacular feature, it spread only slowly elsewhere. Its ceremonial and formal origins are still unknown. At Mehne and Uzgend [302] it took the form of a complete façade composition, involving much more than the entry proper, creating a sort of protective screen – as wide as the building[78] and often higher than all of it except the dome – with an iwan in the centre leading to a small door.

The last of the great architectural forms of the time, the court with four iwans, is at once the simplest and the most complex. It is the simplest because the four large iwans with their high screen-like rectangular frames and the rhythmically arranged rows of smaller iwans in two tiers are both prosaically additive and quite ancient, for they are related to blind or real arcades around a court or to various pre-Islamic traditions. Its complexity lies in two twelfth-century innovations. First, it has become adaptable to any kind of building. Its most interesting application is to the mosque, where it transforms the basic imbalance of the parts liturgically required to indicate the direction of prayer into a composition around an empty court with a sort of monumental equality between all four sides. While the qibla iwan is often larger than the others, the south-western dome of the mosque of Isfahan is not visible from the court, and the overwhelming impression is of a rhythm of light and shade with small arcades symmetrically arranged around the four large iwans. Second, this court is in reality a façade which does not fully correspond to the construction behind it, most of which was usually of little liturgical use. Like the Parthenon, the mosque of Isfahan was meant to be seen from the open air, but in this case from the very centre of the building, in an open court. There, as on a stage, a simple, self-sufficient composition created a backdrop for the functions enacted inside.

*

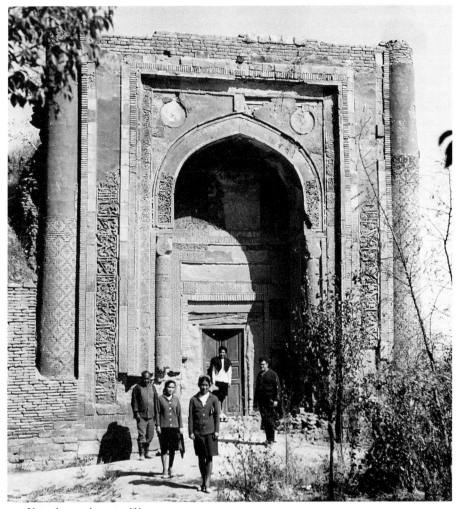

302. Uzgend, mausoleum, twelfth century

ARCHITECTURAL DECORATION

The architectural decoration of the eleventh and twelfth centuries is unusually abundant, varied, and difficult to interpret. The greatest monuments, like the domes of Isfahan, achieved a remarkable balance between architecture and decoration. Others, like some of the mauso- leums and minarets, tended to subordinate ar- chitectonic values to ornamental effects, while the secular buildings of central Asia and Af- ghanistan had rooms entirely covered in decor- ation. It remains to be seen whether there were regional or functional explanations for this var- iety of treatment or whether there was simply an explosion of building activity. As to the

meaning of the decoration, the brilliant analyses of Bulatov and the school of Tashkent have elucidated the complex geometric principles behind some of the designs,[79] and the partial publication of Jam, Tirmidh, Lashkari Bazar, and Ghazni has shown that, through writing or representations, certain ideas were expressed;[80] but we still cannot tell whether the latter were exceptions, and whether the link between geometric design and mathematical thought was purely technical and mechanical or had more profound cultural implications. In view of these difficulties, we shall limit ourselves to a traditional discussion of techniques and themes.

Techniques

The most original technique derives from the actual building materials. The most common is brick, which at Isfahan and in other mosques of western Iran provides some of the main decorative effects. Usually the pattern consists of variations on the zigzag obtained by laying bricks alternately on their long and narrow sides. In some of the small southern domes at Isfahan and in the two large domes there and in other mosques, the network of ribs is both decorative in itself and the frame for other designs. In a series of minarets and in small mausoleums like those of Kharraqan [281–4], Demavend, and Maragha [287] more complex and spectacular effects are achieved through a more sophisticated manipulation of bricks of different sizes, some made for decoration alone. At Damghan [291], Sava, Sabzevar, and Bukhara [290], the minaret is artificially divided into horizontal sections, each with a different motif whose relief often changes according to its height. In the mausoleums, each side consisted of panels with their own designs.

Furthermore, the very interstices between bricks have their part to play. They are either left free, thereby creating, especially in earlier monuments, a surface pattern of light and shade; or they are filled with carved stucco, which contributed a decorative effect of its own to the zigzag of the bricks. This use of brick, the

actual medium of construction, for ornamental purposes originated in north-eastern Iran in the milieu which produced the mausoleum of Bukhara in the tenth century; it is another of the many features which migrated during this period from east to west.

Applied decoration drew on most of the traditional techniques. Painting was used both for its own sake, as at Lashkari Bazar, and to add colour to other media. In Khorezm especially, where some has remained, there was decoration in wood. But the most significant technique of applied ornament was stucco, the *gach* of Persian builders (usually *ganch* in Tajik, hence also among Soviet historians). It appears everywhere, with considerable variations in quantity, purpose, and type, as one moves from one area – almost from one building – to another. In the south-western dome of Isfahan [273] and in the southern iwan of Ardistan, the stucco on the brick spandrels of the octagon is a sort of veil thrown over the surface. At Ardistan [303], Lashkari Bazar [304], Zavareh [305], Merv, and elsewhere, on the other hand, the architects or decorators selected the mihrab, a composition of niches, a frieze, or a gate for isolated stucco

303. Ardistan, mosque, mihrab

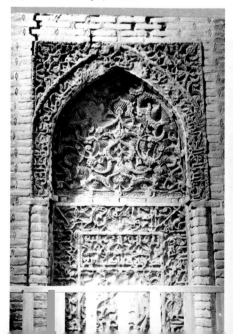

304. Lashkari Bazar (Qalah-i Bust), arch, early eleventh century

305. Zavareh, masjid-i Pamonar, mihrab

covering. Finally at Ribat Sharaf, Tirmidh, and Jam there are walls where the stucco ornament virtually obliterates the architecture proper.

Thus the two main techniques, one relying on the brick construction itself, the other on the stucco covering to provide the ornament, seem to represent opposite approaches, although they often occur together in the same building. It seems odd that one – stucco – should have a long history in pre-Islamic and Islamic art, while the other – brick – began in the tenth century and came to its full flowering in the eleventh. A comparison of the use of brick at Bukhara or of stucco at Nayin with the same techniques in the eleventh or twelfth centuries shows that, without sacrificing ornamental values, the Seljuq monuments in Iran more effectively subordinate their decorative effects to architectural ones. Of course, this point is more obvious with respect to brick; but it suggests once more that in the eleventh and twelfth centuries architectural impulses were generally more powerful than ornamental ones.

One last category of applied decoration involved units prepared in advance and then set either in relief or more often as a sort of mosaic on the surface of the wall, between or over bricks, or on a bed of stucco. They were sometimes of terracotta, as on one of the Isfahan domes, on some of the manars from Afghanistan, and most commonly in central Asia and Azerbayjan. The most interesting variants however are applied coloured tiles or glazed bricks. The tiles are known today as *kashi*, a term which has been applied to the technique as a whole. The use of coloured ceramics in architectural decoration was to become one of the great characteristics of later Iranian art. It certainly began under the Seljuqs in Iran, but exactly where and under what form is less certain. The evidence available so far[81] clearly shows that coloured faience, mostly turquoise blue, was used as early as the eleventh century at Damghan and Kharraqan, and most spectacularly during our period in the Azari mausoleums of Maragha and Nakhichevan. However, except for a number of magnificent tiled mihrabs and inscriptions, this new dimension of colour was still used in a very subdued manner and aimed simply at emphasizing certain decorative lines, not yet transforming the whole wall surface.

Themes

In the absence of monographs dealing with individual monuments,[82] it is idle to try to enumerate the themes of decoration used in Iran in the eleventh and twelfth centuries, to identify their sources, or even to discuss the principles of architectural ornament as a whole. Of the few attempts at generalization so far made, some merely analyse a small number of individual monuments, and others treat only restricted aspects of the decoration or deal with very limited areas.[83] Very few have attempted broader conclusions, usually in an ahistorical context.[84] Therefore a few points will be made about the most common types of composition, followed by an examination of the main themes.

Much of the decoration, especially in mosques, either followed the lines of the architecture or filled wall spaces provided by the construction. The first type consisted either of long straight bands separating one part from another or of curved lines following arches or vaults. The second covered spandrels, tympani, units of muqarnas, or square and rectangular panels, and was on the whole related to the architecture. Sometimes, however, motifs develop independently of any structural necessity; for example, each of the cylindrical units of the brick minarets is decorated separately, and the Jam minaret – simple in itself – is almost entirely covered with complex ornamental brick and, especially, stucco.

In mosques and other religious buildings there are two areas which traditionally merited spectacular decoration: the mihrab and the newly developed pishtaq. Both had several planes and recesses, and the decorative composition was expected to suggest something of the movement of the architecture. Finally, in palaces and in some other buildings both secular and religious a flat wall would be entirely cov-

ered with decorative designs; usually, as for instance at Tirmidh,[85] the decorator preferred to divide the area into polygonal (generally square or rectangular) units.

The great variety of shapes available ultimately resolves itself into two groups: long bands whose width, length, and direction are either imposed by the lines of the architecture or (as in the minarets) serve to subdivide the larger decorated areas; and the surfaces so outlined. The bands mainly consist of simple geometric patterns, or of inscriptions in brick and stucco. On the larger surfaces writing is used more rarely, but there are more complex figural elements as well as geometric and vegetal ones. Most of the decorative vocabulary, however, and the main principles of composition apply to both types of surface.

The overwhelming principle of decoration is geometric. In its purest form it appears on the superb brick minarets and mausoleums, but it is also present in the stuccoes of Tirmidh and in the vegetal compositions of the Jam minaret and most mihrabs in western Iran. According to the painstaking work accomplished by L. Rempel and M. S. Bulatov, the key is the circle. All polygonal figures are related to each other through the circles inscribed in or circumscribing them; in other words, by means of a ruler and compass the motifs can be reduced to a geometric network whose points of intersection are determined either by the complex rules of division of the circumference of a circle or, on certain occasions, by the golden mean. Once the geometric network is established, the artisan uses other themes to fill in the spaces or to introduce more flexibility and suppleness. At times the geometric line itself is broken so as to create a star at the centre of the composition, but usually it is vegetal forms that impart movement and life. Themes of Abbasid origin were still used or revived (especially Samarra styles B and C), but the most common, as in the Ardistan mihrab [303], is an arabesque of stems and leaves (usually half-palmettes) of varying degrees of elegance. The arabesque always has a clearly defined axis of symmetry, but the best

develop on several repeatedly intersecting levels, thus creating movement in depth. Furthermore, the vegetal forms themselves, especially in the bands, may bear a network of geometric punctate designs[86] as decorative supports for inscriptions; their stylistic evolution has not yet been charted, except in the case of a few of the Ghaznevid and Ghorid monuments.[87]

Thus, the architectural decoration of the monuments of the eleventh and twelfth centuries could perhaps best be defined as a dialogue between the basic geometry and the lively movements of a vegetal arabesque. Moreover, as with a Chinese box, analysis produces several different levels of motifs, from the first axis of symmetry to the last single dot of a punctured leaf. Just as in Samarra's third style the composition consisted of an abstract relationship between lines, notches, and planes, so here the dynamism of motifs controlled by an unexpressed modular system gives greatness to the best designs. An equilibrium is created between a living world of nature and the abstraction of man's geometry. The extent to which this contrast was intellectually realized at the time is still unknown,[88] but it is probably not an accident that it was the age of the vulgarization in practical manuals of the high mathematics of the eleventh century. Few periods can offer in one region the contrast between the clear patterns of the brick style of the Damghan minaret [291], the geometric sophistication of the Bukhara minaret [290], and the overwhelming wealth of decoration of the mihrabs at Ardistan and Zavareh [303, 305].

Figural themes occur mostly in secular art. At Tirmidh [306] looms an extraordinary monster with a single head and two bodies, whose origin may perhaps be traced to older images of central Asia, but whose treatment here as a symmetrical composition recalls contemporary arabesque designs. A large number of almost life-size stucco sculptures of individuals [307] – usually princes or princely attendants – and of scenes of courtly life have also been generally attributed to the Seljuq period of Iran, and more particularly to Rayy.[89] Many are, how-

306. Tirmidh, stucco of monster

ever, of doubtful provenance, so that their pur-
pose and significance are difficult to define.

The last decorative motif to be mentioned is
writing. Ubiquitous, it appears in all techniques
and in several styles relatable to the styles of
script developed at the same time in other media
and discussed in the following chapter.[90] Two
aspects of writing are directly pertinent to ar-
chitectural decoration. One is its use as a com-
positional device at the base of domes or framing
units of composition. The other is its varied
semantic function: in the Jam minaret it pro-
claims the mission of Islam and thus gives the
concrete meaning of a tower; in many mauso-
leums and minarets it identifies a patron, or
indicates a date; at Qazvin it comprises a long
waqf document about properties endowed for a
pious purpose; at Ghazni it is in Persian and
provides the text of an epic poem.[91] Proclama-
tory, indicative, or informative, writing has now
become the most specific vehicle for the trans-
mission of at least some of the meanings and
uses of architecture.

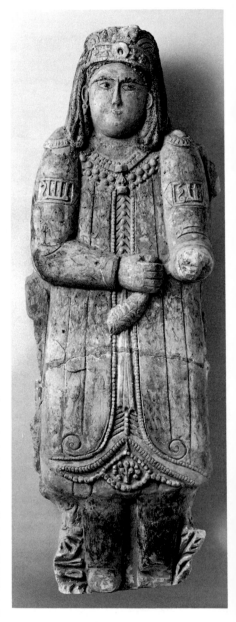

307. Court official, thirteenth century.
Painted stucco relief.
Detroit Institute of Arts

CONCLUSIONS

It is difficult to draw conclusions in the present state of our knowledge of Iranian architecture in the eleventh and twelfth centuries. Building energy was intense, and tremendous numbers of mosques, mausoleums, palaces, and caravanserais were erected, from the steppes of inner Asia to the Caucasus and the Zagros, illustrating both the wealth and growth of Iran, and the range of new social needs, as Islamization was completed. Innovations are more significant than the re-use of elements from preceding centuries. Predominant are the court with its four iwans, the monumental gate, new techniques of construction, baked brick, the spread of the round minaret, the new and logical muqarnas, the 'brick style' of the decoration, the double domes, the ornament with its new tensions between geometry and vegetal themes, and a reappearance of figural sculpture – all of which left a permanent imprint on later Iran and, as we shall see presently, on contemporary architecture elsewhere.

The great mosque of Isfahan, the mausoleum of Sanjar, the minaret of Jam, the decorative designs of the Haydariya at Qazvin and at Ardistan and Tirmidh, and the mausoleums at Kharraqan are masterpieces in which a fascination with decorative effects went hand in hand with a remarkable ability to create new forms from available material. The unremitting search for new formulas, higher domes, and a more significant decoration is to a certain extent comparable to contemporary activity in western Europe. This is an architecture in full movement that will be slightly restrained by internal dissensions in the late twelfth century and then halted by the Mongol conquest.

India

Muslim conquerors reached the Indian subcontinent as early as the first decades of the eighth century, and the province of Sind, at the mouth of the Indus river, has remained Muslim ever since. Between 1001 and 1026 the Ghaznevid

Mahmud led several expeditions to establish Muslim rule in northern India; but the major centres of the Ghaznevids, and of the Ghorids who followed them, were in Afghanistan, and India was mostly a source of booty and wealth to enrich their constructions and collections there, as is amply demonstrated by the objects excavated at Ghazni.[92] Indian monuments were systematically destroyed by the fanatic iconoclasts who formed the backbone of the conquering armies. The turning point from exploitation and conquest to settlement and local development arrived in 1193, when the Ghorid sultan Muhammad, the builder of Jam in Afghanistan, conquered Delhi and made it the centre of Muslim India; here and in a few other cities in the north his governors and successors, the so-called 'slave-kings', sponsored the first monumental architecture of the new province.

The most remarkable ensemble of this time is the so-called Qutb in Delhi [308, 309], erected for the most part in the thirteenth and fourteenth centuries on the platform of an older Indian temple. The first element of the complex was a mosque on a traditional hypostyle plan; its pillars however were in local Hindu style, its arches archaically corbelled. In 1199 a façade was built to the qibla side of the court; peculiarly, a very Iranian iwan arch framed by smaller arches was constructed in the stone technique of India, with heavy ornament which was anything but Iranian.[93] The second element of the Qutb was the celebrated manar of Qutb al-Din [310].[94] The lowest stage of this extraordinary structure, now 73 metres high, probably dates from 1202, the following three from a few decades later, and the last one from the early years of the next century. It was again an Iranian type adapted to the stone techniques of India; its closest prototype is the great manar of Jam [293]. Its purpose (funerary or symbolic of victory) is not clear,[95] but the contrast between the thin vertical masses and the ring-like decorative and epigraphical designs make it one of the most effective buildings of the time. Between 1211 and 1236 Shams al-Din Iltutmish extended the mosque so as to include the manar,

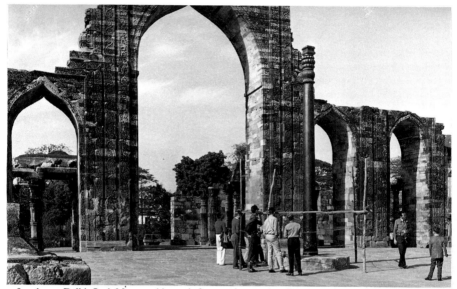

308 and 309. Delhi, Qutb Mosque, thirteenth-fourteenth centuries, view towards the sanctuary, and plan

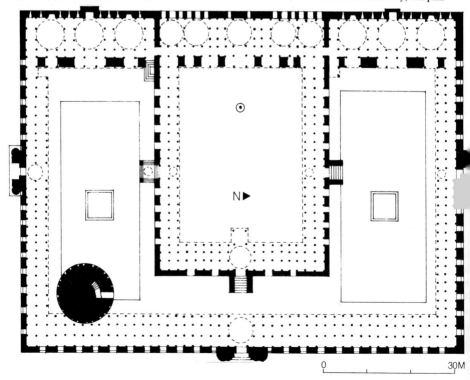

0 30M

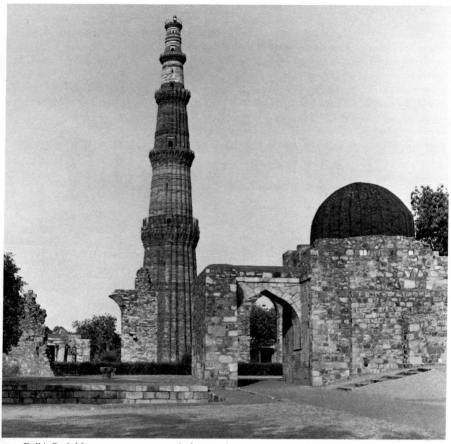

310. Delhi, Qutb Mosque, manar, 1202-early fourteenth century

and built a mausoleum the angular harshness of whose detail can best be explained by the difficulties facing artists who had been trained in Hindu traditions but were here set to execute an aniconic programme.

A number of other mosques of that time, in Delhi and especially in Ajmer, exemplify the same basic characteristics. They are important as rude and powerful expressions of brick designs in stone, but more so as illustrations of a constant feature of Islamic art and architecture: as Muslim culture established itself in new areas, it took over local traditions and modified them according to its own formal and liturgical habits and practices. In India the latter originated from eastern Iran, but the techniques of construction and largely of decoration were local. India had to give up some of its traditional forms, such as figural sculpture, in order to become Islamic; but the Muslim conquerors of the twelfth century were so strongly affected by Indian modes of construction that an architecture was created which, within the Islamic fold, remained more consistently original than in any other province or at any other time, except perhaps in Ottoman Turkey.

Iraq

The history and development of Iraq – defined here in the medieval sense as the lower part of the Tigris and Euphrates valleys – were somewhat overshadowed by the momentous events taking place in Iran, Anatolia, and Syria. Nevertheless, the orthodox Abbasid caliph resided in Baghdad, and in spiritual and intellectual power the city was as great as ever. Nizam al-Mulk founded his most important madrasa there, and the tombs of Ali and of the great founders of schools of jurisprudence in Baghdad, Kufa, and Najaf became the centres of large religious establishments whose impact was as wide as the Islamic world.[96] The port city of Basra in the

311 and 312. Baghdad, Mustansiriya, founded 1233, plan and interior

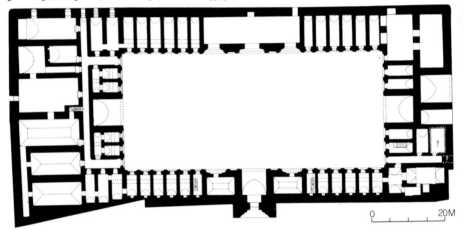

extreme south was still one of the major Muslim gates to the Indian Ocean, and travellers such as Ibn Jubayr and Benjamin of Tudela were struck by the wealth and importance of Iraqi cities, even though Baghdad had lost some of its population. But Iraq's political significance had shrunk, to revive briefly in the first decades of the thirteenth century, when the caliphs al-Nasir and al-Mustansir asserted themselves as more than figureheads.[97] In 1258 the last caliph was killed and the city sacked.

Few monuments survive from this period. Of those mentioned in texts, mostly chronicles,[98] many were reconstructions or comparatively minor additions. The Mustansiriya in Baghdad, inaugurated in 1233 by the caliph al-Mustansir,[99] stands out both ideologically and architecturally [311, 312]. The first recorded madrasa built for all four Islamic schools of jurisprudence, it reflected the idea of the caliphate as the sponsor of an ecumenical Sunnism, a strong feature of the new guidance that the later Abbasids attempted to provide. Built along the Tigris, the Mustansiriya is a huge rectangle (106 by 48 metres) with a large central court (62 by 26 metres). Herzfeld and others believed that six iwans opened on the court, but Creswell showed that it had three, one of which communicated with the entrance; on the fourth side was a long hall with three openings which served as an oratory. Between iwans and oratory lay long halls at right angles to the court, and various other halls and rooms extended to north and south, probably equally divided between the four rites.

Extensive reconstructions and long use of the Mustansiriya as a customs house have greatly altered the internal aspect of the building, but two points about it are of special significance. First, although, with its two superposed arches in rows symmetrically arranged on either side of larger single arches, it was clearly influenced by the Iranian court with four iwans, it differs in that one of the iwans was transformed into an oratory whose function separated it from the rest of the building – a function emphasized by a triple entrance on the qibla side of the court,

balanced by a totally artificial triple façade on the opposite (entrance) side. Thus the openings on the court do not correspond with the same clarity as in Iran to the purposes and forms of the covered parts behind them; from being a meaningful screen, the court façade has become a mask. Second, the ratio between length and width, the multiplication of long vaulted halls,

313. Baghdad, Suq al-Ghazi minaret, probably twelfth century

and the peculiar separateness of the oratory are all anomalous features. They could be due to the location of the Mustansiriya in a bazaar area where previous constructions and a highly organized big-city rhythm of life imposed peculiar forms on the new buildings; on the other hand they may derive from earlier developments in Iraq in the eleventh and twelfth centuries of which as yet we have no knowledge. In any case, the originality of the ecumenical function of the Mustansiriya is indubitable.

A second Baghdadi monument, probably of the twelfth century,[100] the minaret in the Suq al-Ghazi [313] uses the brick technique of Iranian minarets. Stucco decoration on one side shows that it was once attached to some larger construction.

The remaining mausoleums of Iraq are more original. Many of the most celebrated, such as those of al-Hanafi and the Alid ones in Kufa, Najaf, and Kerbela, have either been altered or have never been available for scientific analysis. Two less holy ones which can be examined are the Imam Dur, near Samarra, datable around 1085 [314, 315], and the so-called tomb of Zubayda in Baghdad, datable around 1152, and very much restored in recent times.[101] Their plan is quite simple: a polygon or a square covered with a dome. The curious development occurs in the dome: over an octagon, five (at Imam Dur) or nine (in Baghdad) rows of niches lead up to a very small cupola. The dome has been transformed into a sort of muqarnas cone. In detail, the two monuments vary considerably: the Baghdad one is drier and more obviously logical in its construction than Imam Dur, where there is a much more complex combination of geometric forms, especially inside. In both domes, however, great height was achieved through a geometrically conceived

314 and 315. Samarra, Imam Dur mausoleum, c. 1085, exterior and dome

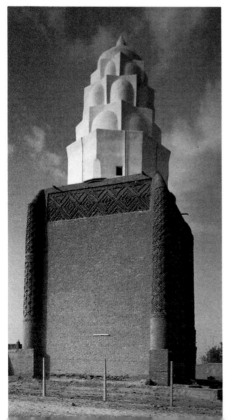

multiplication of single three-dimensional units of architectural origin. It is still unclear whether or not this type, which remained quite popular in the Persian Gulf[102] and influenced Syria, was indigenous.

Secular architecture is represented by a few fragments from thirteenth-century palaces in Baghdad (now much restored and transformed into museums),[103] with iwans and porticoed courts and rich stucco decoration covering most of the walls, and by two gates to the city. The more interesting, the Gate of the Talisman, was blown up in 1918.[104] Built by the caliph al-Nasir in 1221, it was remarkable for its figure of a small personage pulling the tongue of two snakes – possibly a symbol of the caliph destroying the heresies threatening the empire, or perhaps a more general, apotropaic talisman, as was fairly common in the Fertile Crescent at that time.

Northern Mesopotamia

The middle and upper parts of the Tigris and Euphrates valleys and the mountains and semi-deserts between the two rivers and their affluents, known as the Jazira ('island') in medieval times, consisted of three parts: the Diyar Mudar, essentially the middle Euphrates valley, more or less coinciding with present eastern Syria; the Diyar Rabi'a, the middle Tigris valley, corresponding to the present northern Iraq; and the Diyar Bakr, including the more mountainous regions of the upper Tigris and Euphrates, now almost totally in Turkey. Great mountains – the Tauric chains, the Armenian knot, the Zagros and the Kurdish ranges – surround the Jazira on the east, north, and north-west. To the west and south-west lies the Syrian desert; to the south, Iraq. For centuries the main battleground between Mediterranean and Iranian empires, northern Mesopotamia was conquered by the Muslims in the first years of their expansion. For several hundred years thereafter it remained a marginal area, a passageway from Baghdad to Syria through Raqqa and Aleppo for trade and armies guarding the

Anatolian frontier against the Byzantines. In inaccessible mountain valleys ancient Christian and Kurdish communities continued an ancestral way of life unperturbed by the rise and fall of empires. Some fortified towns – Raqqa, Harran,[105] Diyarbakr[106] – have remains of Umayyad and Abbasid constructions. It was not an area of economic growth, and, as central power degenerated in the tenth century, it suffered further from incursions by desert beduins.

However, in the twelfth and thirteenth centuries, enormous changes took place. The conquest of Anatolia, the Crusades, Turkish and Kurdish population movements, the necessity of providing for large armies marching against Christians and Fatimids led to the transformation of the Jazira into one of the liveliest regions of the Muslim world. Old towns were revived, small villages transformed into major centres. As the beduin danger from the desert was checked, agriculture developed around some of the more important settlements. Large Turkish and Kurdish families – the Seljuqs, the Ortoqids, the Zengids, the Ayyubids – divided the towns among themselves. From impregnable fortresses enterprising robber barons exacted taxes and tribute from passing caravans and armies. The cities of Mosul, Sinjar, Diyarbakr, Mayyafariqin (mod. Silvan), Mardin, Hisn Kayfa, Jazira ibn Umar (mod. Cizre), Harran, and many others suddenly hummed with power and activity. Moreover Armenian, Nestorian, and Jacobite Christians, long dormant in their cities and villages, fully participated with the Muslims in the wealth and growth of northern Mesopotamia, and the building of new churches and monasteries is almost as remarkable as that of forts and mosques.

Prosperity did not last long; the Mongol invasions came, and, as the destinies of Iran, Anatolia, and Syria moved in different directions in the following centuries, the Jazira reverted for the most part to an impoverished and largely deserted region of a few strongholds separated by menacing wastes. Such it remained until the twentieth century. This fate, as well as its modern division between three different countries

and current inaccessibility, explains why its numerous monuments are still very little known and, with a few exceptions in present Turkey, unplanned and unrecorded. Yet the significance of the Jazira both for Syria and for Anatolia cannot be overestimated, for here, almost for the first time, the styles and techniques of Iraq and Iran encountered a traditional construction of stone as well as significant remains of Hellenistic, Roman, and Early Christian monuments neither re-used nor destroyed by the sparse

316. Mosul, Great Mosque, minaret, perhaps 1170-2

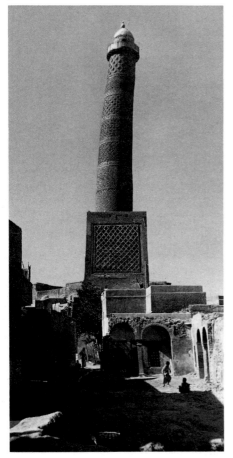

Muslim waves of conquest. From this area, too, came the Zengids and the Ayyubids, future rulers of Syria and Egypt. Finally, in the middle of the twelfth century under Nur al-Din and in the second quarter of the thirteenth under Badr al-Din Lulu in Mosul, the Jazira was one of the truly great centres of Islamic economic and political life, widely known for its textiles and for its metalwork. Builders were busy, as a list of Nur al-Din's constructions proves,[107] but investigation so far is very incomplete, so that all that can be done here is to point out some of the more significant monuments and summarize the main influences at work.

New congregational mosques were constructed and older ones rebuilt. In Mosul, almost all of the mosque built in 1148 under Nur al-Din (rebuilt in 1170-2) to replace an early Islamic shrine has disappeared or been redone; Herzfeld reconstructed it as a hypostyle with vaults in the Iranian manner.[108] Its superb minaret [316], cylindrical on a square base and curiously leaning, shows the impact of Iran in both construction and decoration. It may not date from the time of Nur al-Din, for another minaret certainly sponsored by him at Raqqa[109] is a simple round structure, hardly showing the same Iranian influence; on the other hand, possibly the western part of the Jazira was slower to adapt than the eastern, for the earliest minaret in the middle Euphrates area clearly to show such brick influence is the one erected in 1210-11 at Balis (mod. Meskene).[110]

One of the most remarkable congregational mosques of the period, begun in 1204, is at Dunaysir (mod. Kochisar) [317].[111] All that remains is the prayer hall, a 63 by 16 metre rectangle divided, like the mosque of Damascus, into three naves parallel to the qibla – a Syrian Umayyad plan to which was added a feature of undoubted Iranian origin: a huge dome in front of the mihrab which takes up two of the aisles. Also Iranian is the squinch arch filled with muqarnas and the decoration of the spandrels of the squinches [319]; but the superb stone piers and brick vaults are in the pure classical tradition of late antiquity and of Byzantium.

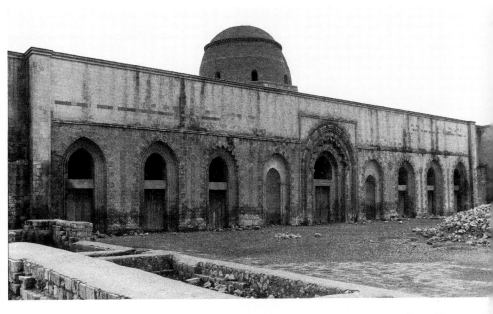

317 and 318. Dunaysir (Kochisar),
congregational mosque, begun 1204,
general view and mihrab

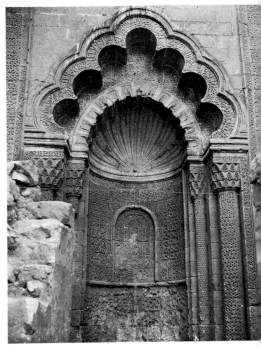

Equally classical is the traditionally moulded
lintel gate, but the luxurious and monumen-
tal mihrab with its complex geometric, floral,
and epigraphic designs reflects oriental influ-
ences [318], while the rather strange interlace
motif of the façade recalls Armenian or Geor-
gian themes and hardly fits with the decorative
imagery of the Islamic Near East. The minaret
was square, just like the one of 1211-13 farther
west at Edessa (mod. Urfa).[112]

The mosques of Malatya (1247-8, restored
1273-4),[113] Mayyafariqin (1157-1227),[114]
Kharput (1165),[115] Mardin,[116] and a number of
other cities of the area, though by no means
yet thoroughly studied, plainly share charac-
teristics drawn from various sources. The muqar-
nas squinch at Malatya is an almost perfect copy
of a central Iranian type; indeed inscriptions
confirm that there were Persian builders there.
All exhibit a fascinating variety of decorative
themes, from bricklaying and incrustation in

319. Dunaysir (Kochisar), congregational mosque, begun 1204,
wall beneath dome in front of mihrab

the Persian tradition to portals with half-muqarnas domes of an Iraqi type here translated into stone, epigraphy on an arabesque background, and rude but striking geometric themes also carved from stone. At Harran, even classical ornament was literally copied. Nowhere is this relation to a pre-Islamic world more apparent than in the well-known mosque of Diyarbakr (anc. Amida). Quite close to Damascus in plan and proportions, its most remarkable feature is its court façades [320], an extraordinary jumble of antique and medieval elements. Undoubtedly the mosque was, in its main parts, erected in the twelfth century,[117]

adding new decorative motifs to elements of construction from older ruins, so that late antique vine rinceaux appear cheek by jowl with Islamic arabesques and epigraphy. The resulting hodge-podge is less appealing aesthetically than it is fascinating as one of the most remarkable instances of the catholicity of taste which characterized the period and the area.

Besides congregational mosques, the cities of the Jazira boasted many smaller religious buildings. Madrasas - none of which remain - are known from Mosul (seventeen of them),[118] Diyarbakr,[119] and most other cities. Some were attached to the tomb of the founder - the first

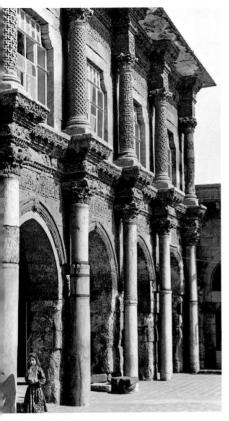

320. Diyarbakr, mosque,
mainly twelfth century, court façade

321. Mosul, mashhad of Awn al-Din, dome, 1248-9

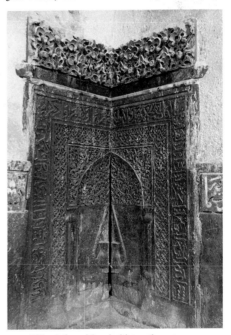

322. Mihrab from Mosul, thirteenth century.
Baghdad Museum

instance of the combination of the mausoleum with some endowed public function which later became so popular in Syria and Egypt. Still standing in and around Mosul however are a considerable number of sanctuaries dedicated to saints, prophets, and holy men,[120] including Jonah and St George as well as medieval Muslims, indicating that ancient holy places were often taken over by the predominant faith. Their central feature was always a domed room – often conical or pyramidal on the outside – and the more elaborate ones frequently had an inner muqarnas dome (often in stucco, as in the mashhad of Awn al-Din [321], dated 1248-9) in complex polyhedral shapes related to Iraqi types, and handsomely carved mihrabs [322]. Christian churches took this form as well.[121] In

323. Diyarbakr, city walls, eleventh-early thirteenth centuries

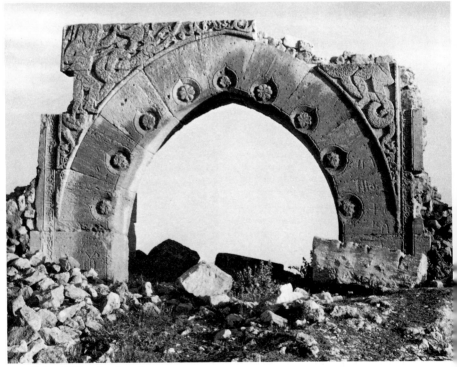

324. Sinjar, al-Khan, façade sculpture

mosques the entrance proper is framed by interlaced polylobed niches filled with decorative designs, in churches by figures. The few known mausoleums and sanctuaries in and around Mosul are no indication of the numbers erected in the Jazira: a guidebook to places of pilgrimage written in the late twelfth century lists many more.[122] Several are visible on the cliffs which border the Euphrates in Syria, and others could probably be found along the roads of the upper valleys of the two rivers. The great sanctuaries of Edessa and Harran remain uninvestigated.

These sanctuaries differ from known Iranian and Iraqi buildings in two ways. First, instead of being purely tombs they are often associated with constructions dedicated to some cultic, philanthropic, or ceremonial purpose. Second, the architectural qualities of Iranian mausoleums are not consistently displayed. This may be because some of the best examples have disappeared, though it is more likely to be a reflection of a wider social basis among patrons and users in the Arab countries of northern Mesopotamia: the long and complex history of Arab cities – with their many religious, artisanal, and tribal components – might easily have led to greater differentiation in patronage and function than was likely in the constantly shifting and more ephemeral cities of Iran.

The secular architecture of the Jazira is equally varied and significant and even less well known. The area became studded with castles, fortresses, and citadels: along the Euphrates Qalah Jabar,[123] Qalah Najm;[124] at Diyarbakr [323] the striking black basalt wall and massive round towers built over older foundations and often decorated with curious examples of animal sculpture;[125] at Harran strong walls and towers with long vaulted halls and impressive gates.[126] Other remains have not yet been systematically studied. Only small fragments remain of palaces. At the Qara Saray in Mosul,[127] generally identified with the thirteenth-century residence of Badr al-Din Lulu, but a few mud brick walls remain from what must have been a great pavilion on the Tigris; the only interest of the building now is its stucco decoration of

interlaced niches with figures, as already encountered in religious architecture. The most significant feature of the single remaining caravanserai, al-Khan near Sinjar,[128] is its two façade sculptures of a bearded man transfixing a snake-like dragon [324]. Of several surviving bridges, most of them ruined, the most interesting is at Jazira ibn Umar (mod. Cizre), with its astronomical sculptures on the piles.[129] Excavation will probably bring to light other bridges, caravanserais, and bazaars so far known only from texts.

In the present state of our knowledge, two conclusions may be drawn. First, except perhaps for military architecture, northern Mesopotamia absorbed much from Iran, Iraq, and Syria, and even from the Christian and other pre-Islamic traditions in and around it, and it is this mixture of themes, in ways often as unsuspected as they are numerous, that characterizes the area. Second, monumental decoration – except in Mosul – tended to the classical in its sober relationship to architecture and, at times, even in its themes; as stone became the main mode of construction, decoration grew more localized. The figural sculpture on secular buildings is best considered later, in relation to iconographic themes on contemporary objects.

Syria and Egypt

Around 1060, as the first Seljuq armies descended on northern Syria, the Fatimid empire of Syria and Egypt was emerging from the major crisis which had shaken it in the preceding decade. Forty years later the Latin Kingdom was established on most of the Mediterranean coastline and in parts of the interior, in Palestine and Transjordan, and, at least for a while, as far east as Edessa. Aleppo and Damascus always escaped Frankish domination. The Turkish Zengid and Kurdish Ayyubid princes who assumed control in Muslim Syria first succeeded in ejecting the Crusaders from Edessa (1146), then took over Egypt (1171), and finally pushed the Crusaders back until, by the time of the Mongol invasion in 1258–60, only a few fortresses re-

mained in Christian hands in Syria and Palestine, and a constantly diminishing Armenian Kingdom barely subsisted in Cilicia. The changes in Fatimid Egypt after the middle of the eleventh century have already been discussed; this section will concentrate on Syria and Palestine under Seljuq, Zengid, and Ayyubid rulers, and on Egypt after its conquest by Saladin. It was a time when the two old cities of Aleppo and Damascus were totally revitalized,[130] and when small and at times almost abandoned towns and villages were transformed into major centres.[131]

THE MONUMENTS

Few congregational mosques were built, since most towns had had them since the first Muslim century, when Syria was the centre of power. But the old establishments in Aleppo,[132] Damascus,[133] Bosra,[134] and Jerusalem after the re-conquest,[135] were refurbished or repaired, increased or modified: at Aleppo, for example, while the plan and setting of the mosque are Umayyad, the porticoes (1146-7), courtyard, and minaret (1090) are later. But, as in late Fatimid Egypt, large institutions are rarer than smaller masjids or less ambitious jamis serving either one of the many suburbs which sprang up at the time or some precise social or symbolic purpose: such are the Hanbalite mosque in the Salihiya suburb of Damascus (before 1215-16),[136] the Mosque of Repentance in a formerly ill-famed part of the same city,[137] and various similar institutions in Aleppo known from texts or inscriptions.[138] They are usually traditional hypostyles based more or less directly on the early model of the mosque of Damascus.

Of greater interest and importance are the institutions of learning sponsored by the new masters of Syria and Egypt. Most were madrasas for one or, more rarely, two of the four Sunnite schools of jurisprudence; at the Salihiya in Cairo,[139] built in 1242, however, as at the Mustansiriya in Baghdad and probably under its influence, all four rites were united. In addition to madrasas, there were dar al-hadith for

the expounding of Traditions;[140] in many cases they also housed the tomb of the founder or a member of his family. The number of these schools is quite staggering: later texts record the construction of forty-seven in Aleppo, eighty-two in Damascus, nine in Jerusalem, and nineteen in Cairo around the twelfth and thirteenth centuries. They were the most popular form of piety at the time, fulfilling more than a simple teaching function: for while undoubtedly their systematic construction by great conquerors such as Nur al-Din and Saladin reveals their political and religious intentions, many madrasas, especially in the thirteenth century, with large endowed properties attached to them, were also examples of conspicuous consumption and a way of restricting private fortunes to certain families.

In contrast to those in Iran, these institutions were usually small, especially in Damascus, squeezed between other buildings in older parts of cities, often with only a narrow façade to the street but spreading out at the back. This apparent constriction - at times avoided by building in the suburbs - arose from the power of the landowning bourgeoisie in Arab countries,[141] which made urban sites far more expensive in Syria than they were further east.

In spite of considerable variations in plan, and of differences both within one city and from one city to another, almost all these buildings are related, as can be seen by an analysis of six of them: the madrasa in Bosra of 1135 [325], the earliest known in Syria; Nur al-Din's dar al-hadith (1171-2) [326] and madrasa (1167-8) [327] in Damascus; the Adiliya (1123) [328] in the same city; and two of the greater Aleppo madrasas, the Zahiriya (1219) [329] and the Firdaws (1235-6) [330, 331]. All are rectangular structures around a central court often with a pool; at Bosra, however, a curious corbel seems to suggest that the court was not open but vaulted. The entrance is usually in the middle of one of the narrow sides [332], although a significant number of side entrances exist. Around the courtyard there is always at least one iwan, and sometimes three or four, in which

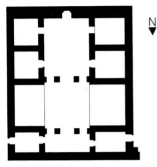

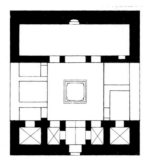

325. Bosra, madrasa, 1135, plan

326. Damascus, dar al-hadith of Nur al-Din, 1171-2, plan

327. Damascus, madrasa of Nur al-Din, 1167-8, plan

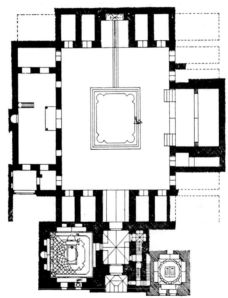

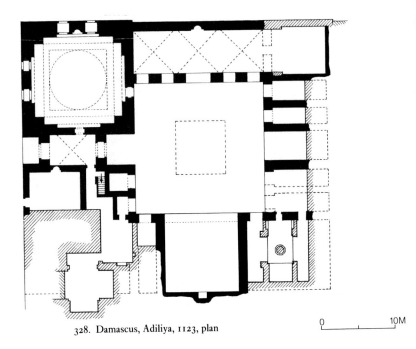

328. Damascus, Adiliya, 1123, plan

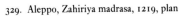

0 10M

329. Aleppo, Zahiriya madrasa, 1219, plan

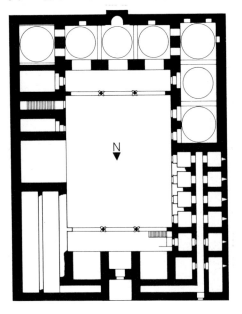

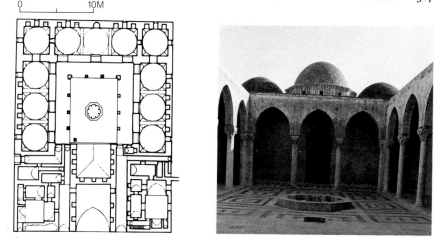

330 and 331. Aleppo, Firdaws madrasa, 1235-6, plan and interior

case one is a small one connected with the entrance. The oratory is generally a long hall occupying one of the sides of the court - not necessarily that facing the entrance, since

332. Damascus, Adiliya, 1123, façade

proper orientation is often precluded by the exigencies of the site. In a few instances the iwan facing the entrance is also the oratory with a mihrab, as in the Sahibiya in the Damascus suburb of Salihiya.[142] A simple triple (or, in the madrasa of Nur al-Din and al-Adil in Damascus, quintuple) arcade led from the court to the oratory. Elsewhere, vaulted halls occupied the space between main iwan entrance and oratory. In the great buildings of Aleppo, all was larger and more monumental, and the courtyard was generally colonnaded.

The origin of the plan of the Syrian madrasa has been the subject of much controversy.[143] There is general agreement that it was imported from the east, as the madrasa evolved there, as the iwan was hardly known in Syria, and as a frequent awkwardness in planning, construction, and decoration (on which more below) can best be explained through new influences. Yet it is remarkable how rapidly the Syrian madrasa became a type with a number of variables which was used also for other sorts of structure; in view of this, and in the absence of earlier Iraqi examples, the hypothesis of a local Zengid creation, with no doubt some imports, cannot be excluded.

Most of the extant free-standing mausoleums are of archaeological interest only. An exception

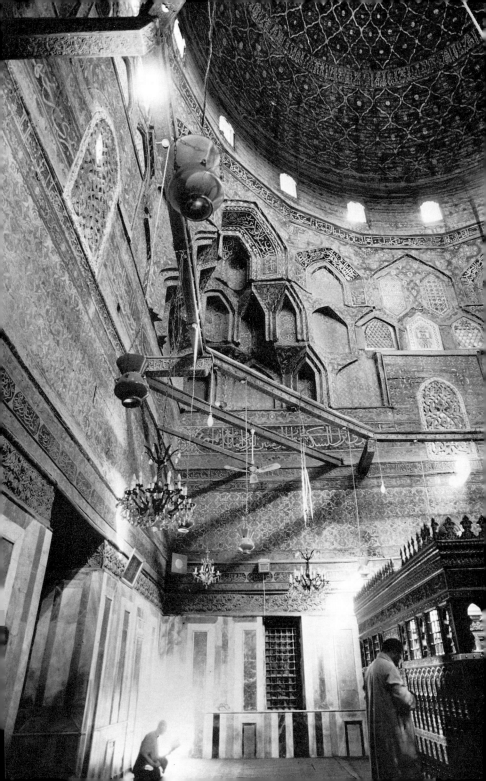

is the spectacular (and often restored) tomb of al-Shafi'i in Cairo (1217) [333], on a simple and traditional plan, but superbly decorated, with one of the largest domes (15 metres wide) of the time.[144] Also in Cairo is the smaller so-called mausoleum of the Abbasids, dated around 1240.[145] In Aleppo and Damascus are a number of mashhads and *khangahs* (houses for Sufi orders) on madrasa-like plans. Finally the extensive architecture of the Crusaders must at least be mentioned, although their churches and monasteries were straight transplants from the west, with little trace of local influence.

Much of Zengid and Ayyubid secular architecture is gone: of the more than three hundred public baths recorded in Aleppo and Damascus, only a handful remain.[146] The quality of construction and decoration of the caravanserais still standing on the main roads of Syria[147] is not nearly so high as in Iran or Anatolia; nevertheless, together with the great markets, such as the one in Aleppo, they testify to the Seljuq and Ayyubid princes' interest in commerce which is borne out by an account of a military leader buying a palace in Aleppo and transforming it into a warehouse and oil press.[148] Hospitals were the most common philanthropic foundations; Nur al-Din's [334, 335], built in Damascus in 1154 on the ubiquitous four-iwan plan, still stands.[149]

334 and 335. Damascus, hospital of Nur al-Din, 1154, façade and plan

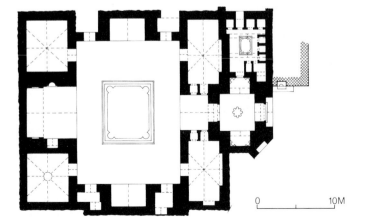

0 10M

The most spectacular architecture is basically military. The walls of Aleppo, Damascus, Jerusalem, and Cairo all remain in part. Some (at later repairs and additions, goes back to the early thirteenth century and the sultan al-Zahir Ghazi, who was responsible for the spectacular

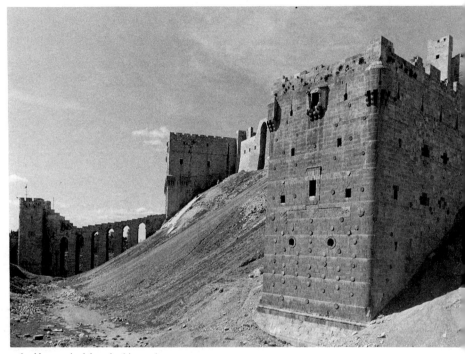

336. Aleppo, citadel, early thirteenth century

Jerusalem in particular) were reconstructions, but more often a new enceinte was needed to correspond to the growth of the city. Many of the new gates, generally with several turns for better defence, are still major landmarks. But even more striking were the citadels. The *qala*, the residence and symbol of the sultan, usually overlooking the city and often set across its walls for combined control and independence, revived a very ancient Near Eastern tradition. In Aleppo, work done on the citadel as early as the tenth century at the time of Byzantine attacks was continued under the Midrasids (1025–79) and the Zengids, who built one of the sanctuaries inside. The magnificent construction now towering over the city [336], in spite of many

glacis, the triple entrance, most of the towers, the great water tanks and food stores of the interior, and the mosque.[150] At Damascus, which is not as striking, Saladin's brother entirely rebuilt some more primitive constructions, including private quarters, official and defensive gates, and an oratory.[151] In Jerusalem the Crusaders and Saladin transformed the ancient Herodian, and even earlier, citadel. The spectacular but often-repaired *qala* on a hill overlooking Cairo has been thoroughly analysed by K. A. C. Creswell.[152] The one at Bosra grew up round an ancient Roman theatre.[153] The interiors, later rearranged, were probably rather monotonous, as in most military architecture, with long halls, narrow openings, various de-

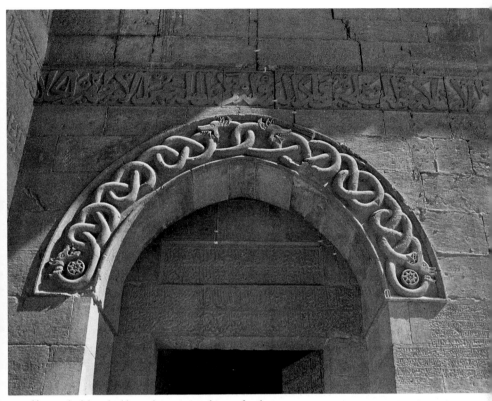

337. Aleppo, citadel, early thirteenth century, sculpture of snakes at gate

vices for defence, courts, stables, and originally austere living quarters. The gates were the most impressive feature, at times bearing figurative symbolic sculptures [337], always with the magnificent inscriptions which were symbols both of possession and of the power and prestige of the individual sultan. It is unlikely that the often ephemeral rule of constantly warring princes gave rise at that time to any significant ceremonies inside the citadels, and hence to an architecture to accommodate them. The later quite luxurious baths and halls of Aleppo and Cairo were built over earlier palaces about which we know a little from texts.[154]

The Crusaders' practice was to build a single château at a strategic spot. A great many survive, of which the Crac des Chevaliers in Syria and the Crac de Monréal in Jordan are perhaps the best known. They were eventually taken over and transformed by the Muslims, who, however, built few themselves (an example exists in Ajlun in northern Jordan), preferring to operate from urban citadels.

CONSTRUCTION AND DECORATION

Unusually for Islamic studies, much work has been done (especially by Sauvaget and Creswell) on the methods of construction and decoration of this time in Egypt and Syria: consequently quite fine distinctions can be drawn between the individual architectural idioms of

Cairo, Aleppo, and Damascus.[155] At the same time, it is clear that there were constant influences and movements of craftsmen and ideas from one city to another.[156]

Materials are traditional: stone in Syria, with brick fairly common for vaults in Damascus, basalt in the Hauran; brick and stone in Egypt; wood throughout for limited purposes. Foreign techniques exerted an occasional influence: the use of wood in the dar al-hadith of Nur al-Din in Damascus (between courses of stone - a feature common in brick, but in stone serving only to weaken the wall)[157] indicates dependence on northern Mesopotamia or Iraq. But in general the masonry is simple, except on certain façades and arches where joggled voussoirs and the *ablaq* technique of alternating stones of different colours are used. Rubble in mortar - both inexpensive and quick - was fairly common in vaulting in caravanserais and citadels.

The supports consisted of traditional columns with capitals (sometimes with the new muqarnas) and piers carrying the arches. But, more and more, heavy walls, often pierced by bays, appear in new buildings, as they did in Iran. This is largely due to the spread of vaulting, which came about partly through influence from the north and east, partly because often wood could not be used (particularly in military architecture) for fear of fire. A few masjids and the oratories of some madrasas[158] have old-fashioned wooden ceilings, but barrel-vaults, often of simple semicircular section, as well as cross-vaults are usual on rectangular spaces and are especially typical of the long galleries of military architecture. Flat arches, usually in combination with relieving ones, are also occasionally revived.[159]

Domes and zones of transition are of almost unbelievable variety. Creswell established that the wooden dome and the muqarnas zone of transition of the mausoleum of al-Shafi'i in Cairo date from the fifteenth century, but a comparison with authentic Ayyubid monuments, such as the tomb of the Abbasids, suggests that the Ayyubid model probably transformed the Fatimid muqarnas squinch into a composition covering the whole zone of transition. The citadel of Cairo and the Syrian monuments use the squinch and pendentive alone or combined with muqarnas. The mosque of Bosra may have had a corbelled zone of transition, in line with the corbelled roofing of the pre-Islamic Hauran, but it is still unclear whether a dome covered the centre of the madrasa. The Iraqi and northern Mesopotamian technique of high domes on rows of muqarnas did not reach Egypt in Ayyubid times, but became fully acclimatized in Syria with the first Zengid monuments. Translated into stone, it provided some of the most effective domes over tombs and entrances and half-domes on façades, probably endowing them at the same time with a rather cold and dry mathematical quality.

Decoration in Syria and Egypt was on the whole remarkable for its sobriety and simplicity. It was limited to gates, where single sculpted panels were often put on the walls; to plaques and bands of writing, using Koranic quotations or established formulas to point up the purpose of the building and the glory of its founder; to the elaborate stone or stucco grilles of windows and oculi; and to mihrabs in wood, stone, stucco, or the peculiarly characteristic new technique of marble incrustation.

Themes were traditional, including arcades (as in the minaret of the Great Mosque in Aleppo); classical and Early Christian, re-used from older material; or further developments on the Fatimid geometric based on the star pattern. Three newer features are particularly significant. The first is a motif of interlacing heavy lines, varying in the complexity of their geometry and in the relationship between right angles and curves. It occurs most commonly in mihrabs - more specifically, in the rectangle framing the niche-head - and also in gates, creating a strong but unsubtle visual effect. The motif reflects a simpler and ruder tradition and taste than the minute arabesques of Fatimid times, but its influence was to be quite strong in Anatolia and in Mamluk Egypt. The second characteristic theme is writing, often used in conjunction with floral motifs. Like contem-

porary objects, architecture bore both angular, somewhat artificially archaizing inscriptions and the more common cursive ones. Their style has often been analysed individually[160] but never yet synthesized. Like contemporary sculpture in western cathedrals, the epigraphy both illustrates the purpose of the building and emphasizes its main axes and lines, fulfilling the function of a moulding in classical architecture.

The third motif involves the windows and medallions used on qibla walls,[161] domes, and façades, geometric in Syria, but often incorporating magnificent floral arabesques of leaves and stems. Related though they are to Fatimid or Iranian themes, the main quality of these complex designs – as can be seen for instance in the Abbasid mausoleum in Cairo[162] and the Maydaniya in Damascus[163] – is their remarkable clarity, which enables the eye to catch the major lines of the movement without being bored with endless repetition. Such arabesques do not have the wealth of their Iranian or Iraqi counterparts, the variety of early Fatimid floral themes, or the originality of Samarra's, but they make up for everything by their elegance and restraint.

Two more original techniques are those of mosaic and of representational sculpture. Mosaics occur in some mihrab niches in Egypt[164] and in Saladin's reconstructions in Jerusalem; not of the highest quality, they yet attest to the persistence of a technique common in early Islamic times. Saladin probably used mosaic in a conscious attempt to revive the decorative methods of the first conquest of Jerusalem by the Muslims.

The second technique, representational sculpture, was applied chiefly to secular architecture, most interestingly at Aleppo, where intertwined snakes and lions guard each of the three gates to the citadel. Their iconography and their simple but effective style relate them to similar images in Iraq and northern Mesopotamia and their prophylactic aim is confirmed by several texts,[165] but their origin and their application to contemporary Aleppo are unclear.

*

Seljuq and Ayyubid Syria was the second of the Muslim regions after Iran to evolve a great architecture. Although the citadels of Aleppo and Cairo are the only monuments to rival some of those farther east in size and in the complexity of their history, Syria must nevertheless be singled out for the variety of its constructions, the growth of military architecture, the impact from the east and from the north, the importance of cities in determining the sizes and types of buildings, and the muqarnas – all reflecting the political, social, economic, and religious needs of the time and illustrating phenomena wider than either Syria or the Arab world. The simplicity and clarity of construction, excellence of workmanship, successful use of stone, the sobriety of decoration, fondness for geometric lines and for clear surfaces all reflect the qualities of the great late antique and early Christian eras.

Anatolia

After the battle of Manzikert in 1071 opened Anatolia to Islam, Muslim settlement and conversion took an unusually long time; not until the turn of the thirteenth century was the regime of the Seljuqs of Rum sufficiently established to begin sponsoring monuments. The dynasty lasted longer than those which followed the revolts of the eleventh century; only indirectly affected by the Mongol conquests, in so far as streams of refugees from Iran and Iraq poured into Anatolia in the early decades of the thirteenth century, the Seljuqs of Rum did not disappear from the scene until the beginning of the fourteenth century, when internal dissensions gave rise to a number of more or less independent principalities. Thus Anatolian Muslim architecture developed mostly after the main features of Iranian and Syrian Seljuq architecture had been established.

A second peculiarity was the cultural, social, and ethnic make-up of Seljuq Anatolia. As a newly conquered Islamic province, it counted many non-Muslims and recent converts, with the twin consequences of eclecticism and of a

wide range of cultural influences. As a frontier area it attracted Muslim militants, from ghazi warriors to the adherents of mystical Sufi orders. An interesting quirk, so far unexplained, is the prevalence on monuments of signatures of masons, decorators, and architects.[166]

THE MONUMENTS

The Seljuqs of Anatolia had the task of erecting all the buildings which had by then become characteristic of Islamic civilization.[167] The most important was the congregational mosque. An early one at Mayyafariqin (perhaps of the eleventh century) was a simple rectangle (65 by 61 metres) with a court and a hall of prayer of eleven naves at right angles to the qibla; pillars and arches carried a flat wooden roof.[168] The mosque of Ala al-Din in Konya [338] (built between 1156 and 1220 with later additions) is historically more complicated because it was not built at one time and because it was included within the palace area and also served as a place

of burial for princes. In spite of this, it was a simple hypostyle in an early Islamic tradition even to the point of using columns and capitals from older buildings.[169] A number of other such simple hypostyles, for example at Beyšehir and Afyon, lacked courts, and several were almost entirely of wood, reflecting both its availability in the mountains of Anatolia and, perhaps, the impact of central Asian traditions.[170]

More original plans occur in the much restored Ulu Cami at Kayseri,[171] and in the mosques belonging to privately sponsored philanthropic and religious institutions, such as the Khuand Khatun complex of mosque, madrasa, and tomb also at Kayseri (1237-8),[172] and the mosque and hospital at Divrik (1228-9).[173] The courts have all shrunk to simple central squares. The naves of the Ulu Cami are at right angles to the minuscule court (later domed). In front of the mihrab is a large Persian-style dome. The mosque of Khuand Khatun [339, 340] is divided into square bays, plus a sort of axial nave of two wide bays and a

338. Konya, mosque of Ala al-Din, 1156-1220 and later, plan

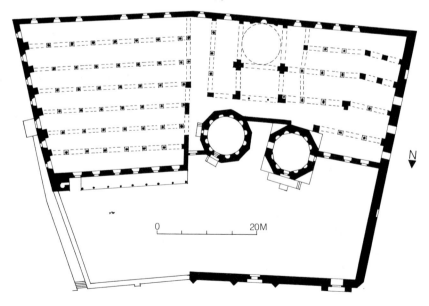

0 20M

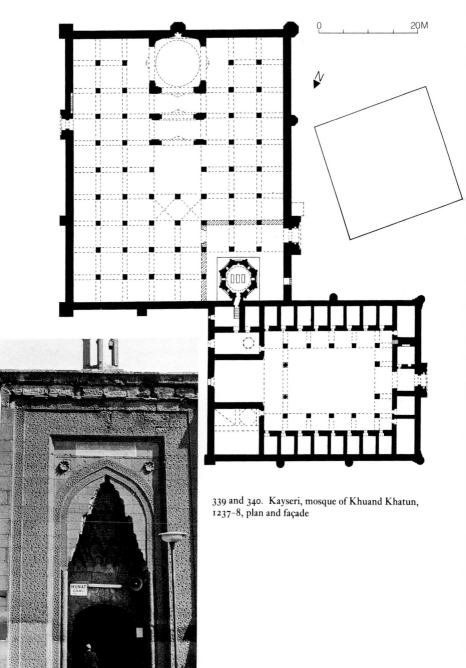

339 and 340. Kayseri, mosque of Khuand Khatun,
1237-8, plan and façade

large dome. At Divrik (Divriği) [341-3] it is a five-aisled basilical hall with a wider central aisle, the naves consisting of rectangular bays except for the square one in front of the mihrab. All three mosques have three entrances, one on each side other than the qibla, symmetrically arranged only in the Ulu Cami. As can be ex-

pected in a newly conquered area with an old history, aberrant types exist as well, for example the three-aisled mosque of the castle at Sivas (1180-1),[174] and the Iplikçi mosque (1182-1202) with its three rows of seven square bays with the qibla on one of the long sides and three domes leading from the door to the mihrab.[175]

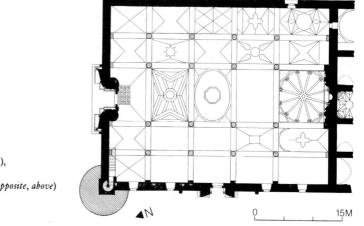

341-3. Divrik (Divriği),
mosque, 1228-9,
plan, view, and gate (opposite, above)

▲N 0 15M

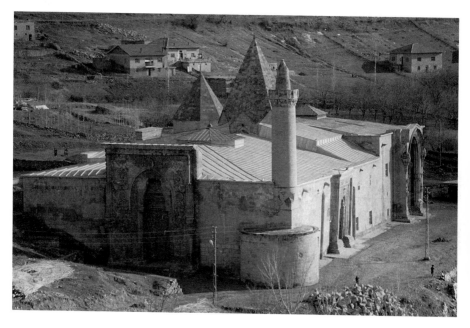

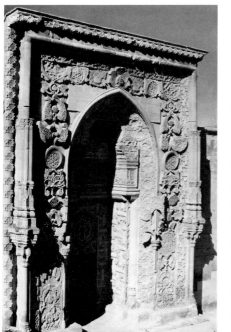

Madrasas were also common. They are of two types. The first, exemplified by the Saraj al-Din (1238-9), Khuand Khatun, and Sahibiya (1267) madrasas at Kayseri,[176] the Gök (1271) at Sivas,[177] and the Sirçali (1242-3) at Konya,[178] is closely related to the Syrian and farther eastern types. On a court with porticoes open varying numbers of iwans, of which one is always connected with the entrance. The tomb of the founder is usually by the entrance or on the side opposite it. The interior consists of long halls at right angles to the court. Different from Syrian prototypes are the protruding iwan-like entrances, sometimes framed, as in the Gök madrasa, by two high minarets. The most monumental and remarkable variant of this type, a transformation of an Iranian tradition, is the Çifte Minareli madrasa at Erzerum (1253) [344-6]. Here is one of the earliest instances of a façade with two minarets. The circular mausoleum is on the axis of the building at the back of a long iwan, and the iwans have two-storey arcades.[179]

The main centre of the second group, which is more peculiar to Anatolia, is Konya, the cap-

344. Erzerum, Çifte Minareli madrasa, 1253, plan

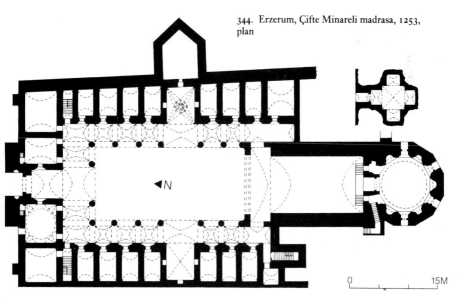

◄N

0 15M

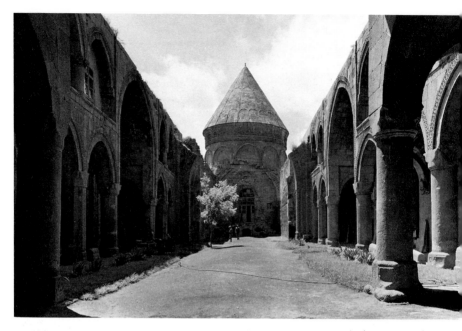

345 and 346. Erzerum,
Çifte Minareli madrasa, 1253,
interior (*above*)
and façade (*opposite*)

ital of the Seljuqs of Rum. There, in the Karatay (1252) and Ince Minareli (1258) madrasas [347–50],[180] the single iwan-like feature, the long halls, the domed rooms on either side of the iwan, and the magnificent façades are clearly connected with earlier traditions. However the court has been replaced by a dome and the buildings are understandably smaller, a development related of course to the similar abandonment or diminution of the court in congregational mosques, without any major modification of the rest of the building. This change, generally explained as a consequence of the rigorous climate on the Anatolian plateau, had a far-reaching formal significance, especially for the madrasa, for the characteristically Iranian monumental inner court façade based on the iwan was replaced by a building with a large outer façade, planned around a central dome. One wonders whether, beyond climatic reasons, the Christian architecture of Armenia and Byzantium, which consisted wholly of such centrally-planned buildings, affected Muslim architects.[181]

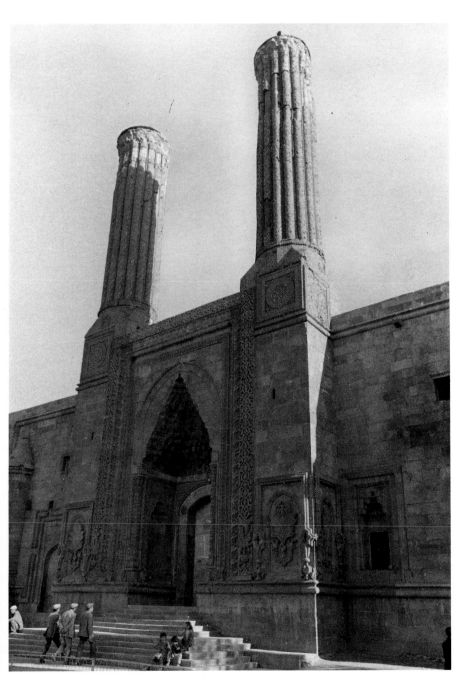

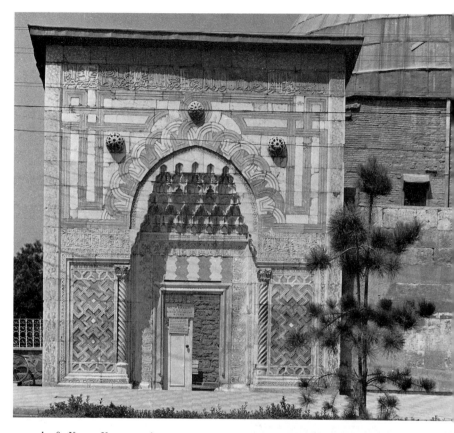

347 and 348. Konya, Karatay madrasa, 1252,
façade (*above*) and plan (*below*)

0 10M

349(A). Konya, Ince Minareli madrasa,
1258, detail of façade

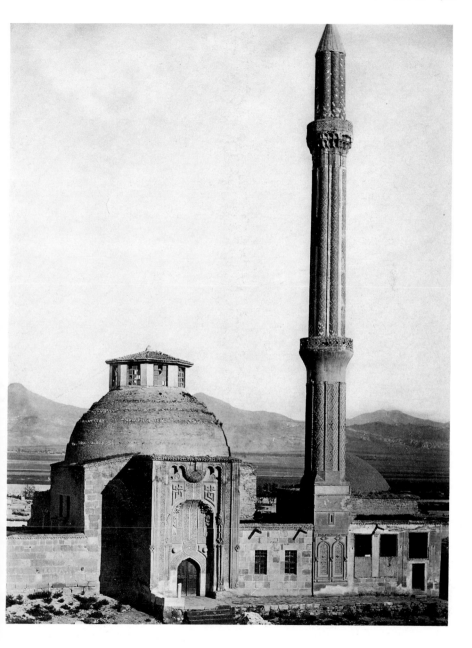

349(B). Konya, Ince Minareli madrasa, 1258

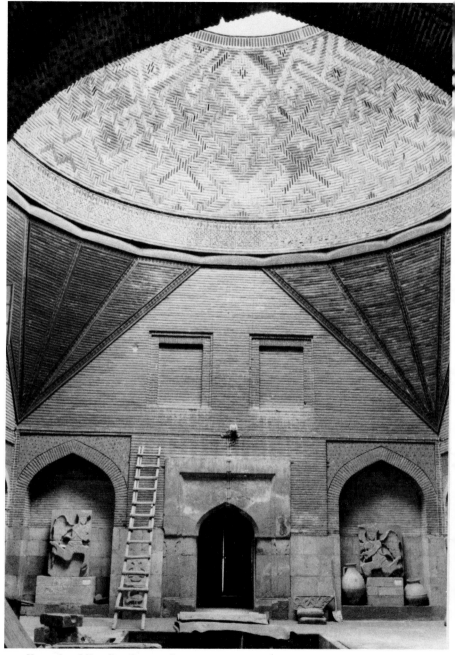

350. Konya, Ince Minareli madrasa, 1258

Now for mausoleums. As in Iran and Azerbayjan, the single mausoleum was much more common than in Syria. A few were square,[182] but the vast majority were polygonal or circular, on high bases, usually with a crypt and domed inside, with pyramidal or conical roofs and richly decorated façades. At the curious Mama Hatun mausoleum at Tercan, a circular enclosure surrounded the *türbe* like an ancient temenos. These tombs are most closely related to those of Azerbayjan; oddly enough they seem to have come straight from the Iranian world, whereas mosques and madrasas apparently often arrived through Syria and the Jazira.

As to secular architecture, remains exist of hospitals, for example the one at Divrik whose plan is so similar to that of a madrasa; there must have been others, since Seljuq Anatolia was known for its great medical schools. Of the great palaces of the Seljuqs, whose wonders are related by the chroniclers,[183] only a few walls have remained in Konya, although older travellers saw more.[184] K. Erdmann identified as Seljuq a widespread number of curious small structures which he called *Seraibauten*[185] - perhaps hunting lodges or bases for agricultural exploitation, as in central Asia and Umayyad Syria. Of numerous remains of Seljuq fortifications many were destroyed in the twentieth century to make way for new towns.[186]

By far the most spectacular secular constructions of Seljuq Anatolia are the superb caravanserais, nearly a hundred of them of the thirteenth century.[187] There are three basic plans. The first - which is comparatively rare and closely related to Syrian examples - consists of a rectangular or even square building with a central court from which open halls of varying sizes. The second, exemplified by Zivrik Han [351],[188] is square or rectangular and lacks a court. The best examples have a central nave abutted by others at right angles, often with a central dome for light and air. The third plan - that of the two Sultan Hans, one near Kayseri[189] - is the most remarkable [352, 353]. A court with halls at right angles to its sides precedes a long covered building with a central

nave and others at right angles. Superb portals led often to an oratory (at times a separate pavilion in the middle of the court) and to a bath. While their monumentality and construction are peculiarly Anatolian, the last two plans are clearly related to earlier ones in Iran and central Asia and may well be pan-Islamic.

Why did chains of caravanserais of such quality emerge so suddenly? Sponsored by the ruling princes themselves, they are in all likelihood a rare attempt to capture international trade at a time of shifting directions for commerce and of constantly moving populations; but how they fit within the economic policies and activities of the time remains to be investigated.

CONSTRUCTION AND DECORATION

By far the most common building material in Anatolia was stone, though brick was used for secular vaults and also in cities such as Konya. Wood also was sometimes employed, occasionally for entire buildings. Rubble in mortar was common for simpler vaults and walls.

351. Zivrik Han, plan

0 10M N

352 and 353. Sultan Han, 1232–6,
interior and plan

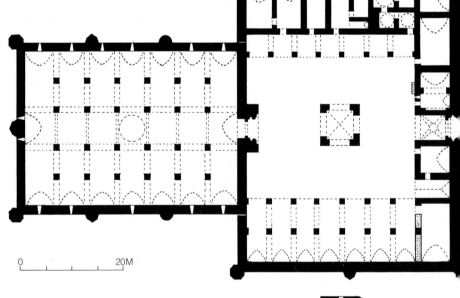

0 20M

N▲

Most structures were vaulted. Supports might consist of long and solid walls, especially in the madrasas, where the Iranian iwan had imposed its plan and elevation. A more common and original type, however, used piers and columns, ranging from borrowed older columns to new ones with muqarnas capitals, from polygonal, round, or even cross-shaped low piers carrying high and wide arches to the superb high piers and arches of the caravanserais. The arches are usually carefully outlined, even when bonded with the masonry. Like the piers and columns, they are an interesting revival of early Christian practice in the Near East.

Vaults display an equally fascinating variety. The most common system of roofing a long space, for instance in the khans, was by means of tunnel-vaults, often divided by transverse arches. Small rectangular areas, as at Divrik, show endless variations on the simple theme of the cross-vault, with a multiplication of decorative rather than structural ribs. Domes were usually on pendentives, at times with muqarnas, although squinches are also known. At Konya an original mode of transition is the 'Turkish triangle', a rationalization of the pendentive into simple geometric forms. Sometimes a combination of several long triangles gave greater, but still very angular, movement to the passage from square to dome.

Seljuq architectural decoration reflects the same multiplicity of influences.[190] The portals of the Ala al-Din mosque in Konya and of the Karatay madrasa are typically Syrian in style, while other mosques and caravanserais use the muqarnas half-dome of Syria and Mesopotamia. At Divrik, Kayseri, and in the Sultan Hans, stone carvings on façades and along the major lines of the architecture reflect the brick decoration of Iran. Apparently more original is the use of mosaics of glazed tiles, not merely as an element of emphasis, but completely to cover large wall surfaces. The best preserved examples are at Konya, in the iwan of the Sirçali madrasa and in the zone of transition of the Karatay madrasa. The technique originated in Iran,[191] but it first occurs independent of other decorative devices in Anatolia.

However, the most spectacular results were achieved in stone carving and on façades. Almost every monument warrants a detailed study, for each presents peculiar problems. Of the two groups which define the most striking characteristics of this decoration, the first comprises certain monuments of Konya. The impact of Syria is obvious, but on the portal of the Ince Minareli madrasa the reserve of the Karatay façade has given way to an odd composition of columns, recesses, and mouldings – i.e. of architectural elements – transformed in elevation into a non-architectural combination of thick interlacing epigraphic bands and geometric or floral designs in both very low and very high relief. The arches of the portal are absurdly composed, and the architectural elements do not lead into an architectural composition. In addition, the constant opposition between kinds of relief and the lack of appropriate proportion between such diverse elements as a column and an epigraphic band contribute to the fascination as well as to the ultimate nonsense of the façade.[192]

The second and much more spectacular group includes the façades of the main buildings of Sivas and Divrik [342].[193] The whole wall is involved in the composition. Highly developed corner towers frame it, while two tall thin minarets emphasize a huge central portal. The portal at Divrik is even splayed. The decoration includes both the traditional Islamic epigraphy, and geometric or floral arabesques and fantastic combinations of vegetal and even animal forms which, in their tortured violence, recall Celtic miniatures and Romanesque façades. Even the geometric designs – like the ones on the Sultan Hans – are not always of the Islamic symmetrical and organized type but recall the endless meandering of northern, so-called 'barbarian' jewellery. As in numerous secular buildings now disappeared, figural sculpture was often used:[194] snakes, lions, elephants, fantastic animals, astronomical figures, princes and court

attendants. Although crude, this sculpture exhibits intense variety.

Thus in decoration as well as in plans and construction, the Seljuq architecture of Anatolia can be identified as highly original. The last Islamic province to develop, it took its inspiration from Iran, Syria, and northern Mesopotamia, drawing also on the strong indigenous Christian traditions of the soil of Anatolia and through them discovering northern themes of decoration. The great achievement of this architecture was that it drew together so many disparate elements to create monuments which may at times seem overcharged and ill composed, but which always express the powerful spirit of the conquerors.

Conclusions

We cannot enumerate every difference and every similarity in summarizing the development and significance of Islamic architecture over an area extending from the Pamir almost to the Pyrenees during three centuries of amazing creativity. Yet so many permanent features of Islamic architecture evolved at that time that some attempt at synthesis may be useful. Much must of course be tentative for, as has been amply shown, monographs, archaeological surveys, excavations, and historical investigations are still largely lacking.

This survey has illustrated the two major changes valid for most of the Islamic world. The first concerns the relationship between works of monumental architecture and the people who built and used them. A striking feature throughout Iraq, northern Mesopotamia, Anatolia, Syria, and Egypt is the widening of the social basis of architecture: there were more and different patrons, including women, a greater consciousness of the individual artist, smaller buildings reflecting the means of the sponsors and the availability of city land, increased concern for the needs of trade, diversification of religious buildings to reflect the greater complexity of the faith, a rise in the number of philanthropic or socially useful

buildings and in the importance of citadels and of military architecture, and influences from many areas illustrating the great contemporary movements of peoples and ideas. Princes were still the most common sponsors of large congregational mosques (usually in new cities), but often as individual believers or as investors rather than as instruments of the Muslim state (exceptions are the Mustansiriya and some of the early madrasas). In almost independent Tunis in the ninth century, a congregational mosque was built in the name of the caliph in Baghdad without reference to the local ruler; now, however, an individual sultan, 'craving the mercy of God', would endow a school or hospital attached to his tomb, with no mention of an overlord. The monumental architecture of the preceding centuries consisted mostly of large prayer halls for the whole community and of huge and secretive palaces; but from the middle of the eleventh century, and especially from the middle of the twelfth, Islamic cities were transformed into an agglomeration of small places for worship, tombs, private and public institutions, all closely interrelated with the living forces of the urban unit. While these facts seem assured, two problems remain: whether the seeds for these developments – or some of them – were already sown in the tenth century, since some of the related institutional changes seem to have begun earlier; and whether the very obvious social and functional differentiation of architecture in Arab countries and in Anatolia was found in Iran as well.

The second important change concerns modes of construction. Everywhere but in the west, the court with one or more iwans, like the basilical hall of late antiquity, became ubiquitous and served a variety of purposes. Whether this represented the monumental transformation of a theme long common in houses in many parts of the Near East, or whether it came from Iran, is perhaps more difficult to decide.

Another novelty is the pre-eminence of vaulting for roofs, the reasons for which have already been discussed. In Iran and Anatolia, stone or brick vaults had always been a major mode of

covering, but they were far less prevalent in Christian and early Islamic Syria or Egypt. In Syria and Anatolia however – more interestingly for the art historian – vaulting was not so much a new phenomenon as a return to the great traditions of Roman art in these provinces.

At this time, too, the muqarnas was ubiquitous throughout the Islamic world. Much has been written about it, but neither its meaning nor its origin has ever been clearly understood. Two facts, however, seem indisputable. First, in this period, the primary function of the muqarnas – structural or decorative – was related to vaults, most often to the transition to the dome, although it occasionally adorned façades. Second, it always consists of three-dimensional features, usually of architectural origin. In other words, the muqarnas is a solid composition of separate architectural elements (or fragments thereof) most commonly used in vaults. In Iran and Egypt it had a precisely defined structural function; in the west it had none. More curiously, in the west as well as in Iran the earliest presumed examples were purely ornamental plaster shapes, suggesting that the muqarnas began at some unknown time as a decorative design in plaster, which in the eleventh century – though only in Iran and Egypt and in countries under their influence – was given architectural and structural significance, and later resumed (or had always maintained) an exclusively decorative meaning. Many intermediary steps are far from clear, and it would be unusual for an ornamental feature to become a structurally meaningful one. In any case, the intriguing feature is that, almost at the same time and in different ways, widely separated regions of the Islamic world picked up the muqarnas, developed it, and thereafter retained it in their vocabulary. The fact that the

early Iranian, Egyptian, and North African examples are so different from each other makes it unlikely that there was a single formal source, but it is possible that there was a single idea behind it. What this idea was is a matter of speculation; without endorsing it entirely, one can quote the hypothesis first suggested by L. Massignon that a fascination with the breaking up and reconstruction of the visible world in order to proclaim the unreality of matter was a deeply characteristic feature of the Muslim ethos. What we have seems to be an architecture that chose elements not merely for structural purposes, or for their beauty or symbolism, but because they were abstract and susceptible of compositions regulated by principles other than those of the architecture itself.

These three features – the iwan, vaulting, the muqarnas – lend a unique importance to Iran in the eleventh and early twelfth centuries. It was fashionable not so many years ago to understand the architecture (and many other arts) of this time in terms of an imposition of Iranian themes and ideas all the way to the Mediterranean, largely through the movement of Turkic leaders and tribes, whose first encounter with Islam was in Iran. However it seems more likely that the reason for this spectacular development in western and northern Iran before much had happened in Syria, Egypt, Mesopotamia, or Anatolia was the lack until then of a functional Islamic infrastructure, and the need for the large congregational mosques and sanctuaries which existed elsewhere. Instead of positing the pre-eminence of an area because of its chronological antecedence, it may be more fruitful to assume that individual areas answered differently to the pan-Islamic challenges of growth and momentous change from the eleventh to the thirteenth centuries.

THE DECORATIVE ARTS

General Remarks

During the Seljuq era, particularly towards its end in the late twelfth and early thirteenth centuries, the Islamic decorative arts were perhaps at their most inventive and brilliant – brilliant not only metaphorically but literally, for their glittering materials and sparkling forms were both decoratively outstanding and technically startling. Even whole categories of rather humble objects, made for simple people, were of high quality.

In many cases distinctive, often elaborate forms of decoration make it easy to differentiate among certain workshops. On the other hand, the universal character of media such as textiles and metalwork is so pronounced that, in spite of copious literary evidence, specific objects can rarely be associated with places of production known from the sources. This is due to the mobility, not only of the works themselves, which were shipped throughout a very extensive and mostly tranquil world, but also of the men who produced them. In times of peace craftsmen would try to find better employment at such newly flourishing centres as the court of the Khwarazmshahs or the Gurgan region.[1] On the other hand, the advance of the conquering Mongols towards the end of the period engendered analogous results: a tremendous displacement of artisans, whose enforced migration from east to west contributed greatly to an eventual blending of styles. This general fluidity is noticeable even in the decorative themes themselves: for instance patterns favoured by one class were readily acceptable to another.[2] Moreover themes from manuscript painting invaded the decorative arts, especially the polychrome overglaze-painted pottery and lustre tiles of Persia, and vice versa.[3] In fact some degree of iconographic levelling was apparent

in all regions and classes. On the other hand – as in the case of pottery attributed to Rayy – the aristocratic character of some pieces is quite obvious, even without the specific inscriptions, while others have all the earmarks of speeded-up mass production for *hoi polloi*.

In spite of artistic excellence and many innovations, however, the styles and technical procedures of the Fatimids, the Ghaznavids, and others continued. Moreover, the achievements were not equally significant in all media. The best work stemmed from crafts that may be considered basic: textile weaving, pottery and tile making, metalwork, jewellery, and manuscript illumination. Glass became significant only towards the end of the twelfth century, largely owing to the development of the enamelling process, which was, however, probably practised only in Syria and perhaps slightly later in Egypt. In other regions glass production was less outstanding than in the previous century, which was characterized by complex wheel-cut designs, and was not artistically equal to the new enamelled works. Two other crafts, carpet knotting and bookbinding, which were to reach great heights in subsequent centuries, remained elementary in technique, although aesthetically speaking they were already fully developed.

Decorative Themes

New vessel shapes introduced in this period, particularly in metalwork and pottery, were subsequently widely adopted; but the real artistic achievement lay not in the shapes but in the extraordinary wealth of decorative schemes and individual motifs applied to them. The use of certain well-established decorative elements continued, although elaborated in detail and more complex in composition. The prevalent designs were abstractions, as is apparent from

the rarity of recognizable floral forms. Instead, arabesques – flat or in relief – were widely applied. Strapwork outlining polygonal compartments was common, particularly in the eastern Mediterranean, but less in Iran, and in most instances it functioned as a sort of skeleton to be decorated. The interstices contained smaller, more delicate, and often rather dense patterns. Inscriptions continued to be widely used, and *naskh*, the cursive type of writing, became more common, either alone or in combination with the various decorative types of Kufic, among which the elaborate plaited version was outstanding.

These three traditional forms of decoration – abstract floral designs, geometric configurations, and inscriptions – were further enriched by elaborations on earlier limited themes, particularly in the form of figural designs including animals and increasingly human beings as well. The previous rather stiff stylizations gave way to figures ranging from the purely formal to the naturalistic. Particularly in the latter half of the Seljuq period, the aim of the artist was towards a more 'realistic' rendering of the figure, often in motion, yet – even in the liveliest representations – it remained as nearly as possible two-dimensional, and the bodies have little substance, as in the decorations on Kashan pottery, where the figures sometimes seem to disappear altogether, merging into the patterned background; even the more vividly represented faces remain rather stereotyped and mask-like. By contrast, the animals, often rendered in rapid motion, appear better observed and closer to nature. Here, however, the artists were working in the mainstream of a very long Eastern tradition.

While figural motifs are very often only decorative, at times iconographic content or even deliberate symbolism are quite obviously intended. As it was the courts of the Seljuqs and the many smaller successor states that provided the main sources of patronage, it is only natural that various manifestations of lordship and royalty constituted the main themes: the formally enthroned ruler with his entourage, the princely hunter, reveller, hero. The usual attendants at courtly functions – musicians, dancers, huntsmen, polo players, and grooms – are also frequent motifs. Although these themes represent actual aspects of courtly life, royalty was also represented symbolically: lions, griffins, and peacocks often carried royal connotations, as did attacks by felines, eagles, or falcons on animals of lesser, though often sinister, force like bulls and snakes.

A second category of figural motifs permeating Seljuq art includes supernatural creatures whose physical aspects derive from the ancient oriental or the more recent classical repertory – for instance the surprisingly ubiquitous sphinxes, harpies, and unicorns.[4] It speaks for the universal character of the art of this period that these fantastic animals of the ancient past are to be found even on objects of rather lowly function, like rubbing stones used in bath houses. Some of the designs are among the oldest known to mankind; they occur on early prehistoric pottery, and even in the Middle Ages they may still have carried some of their primordial cosmic associations. Other creatures were drawn from later, historical phases of antiquity; for example, a heroic king may be shown slaying a monster, just as may be seen on the Achaemenid reliefs of the fifth century B.C. at Persepolis.[5]

Altogether the range of figural imagery is extraordinarily wide. At one end of the spectrum are subjects from folklore, such as the pursuit of the elephant by the unicorn, which goes back to sailors' stories of the ferocious attack by the rhinoceros on the hapless elephant. At the other end are cosmic images centring upon personifications of the constellations and planets, which, in spite of official monotheism, were still thought powerful enough to be invoked by rulers or merchants mindful of the constant dangers of long caravan or sea voyages.[6] Even more astonishing are symbolic references to the ineffable presence of the deity himself, in the form of a glass lamp suspended in a niche or arch. They are based on a Koranic passage (from the Sura of Light):

Allah is the Light of the heavens and the earth. The likeness of His light is as a niche wherein is a lamp. The lamp is in a glass. The glass is as it were a shining star (XXIV, 35).

This image became current because it was the *leitmotif* of the treatise *Mishkat al-Anwar* (*The Niche of the Lamps*) by the leading theologian of the period, al-Ghazzali (d. 1111).[7]

The efflorescence and widespread use of figural and symbolic imagery seems strangely at odds with the generally aniconic attitude of the Islamic world, and requires some explanation. As Iran was in many respects the artistic leader in this period, and as a large part of the figural repertory is primarily associated with that area, it is appropriate to turn to contemporary Persian writing, particularly two aspects of it, to help solve the riddle. The romances of Nizami (d. 1202) especially embody an abundance of brilliant protean images in the form of metaphors. They are not the simple, objective pictorial comparisons found, for instance, in Firdawsi's version of the *Shah-nama*; rather, they are more personally conceived and emotionally charged visions, which force themselves on the imagination and seem to have an existence of their own.[8] Then, too, in mystical poems like those in the *Mathnawi* of Jalal al-Din Rumi (d. 1273), an Anatolian mystic writing in Persian, for the first time figural representations were treated, not as chimeras to be condemned on religious grounds, but as valuable didactic aids in explaining the mysteries of divine nature:

And if you say that evils too are from Him,
 [that is true], but how is it a defect in His
 grace?
[His] bestowing this evil is even His perfec-
 tion: I will tell you a parable [in illustra-
 tion], O respected one.
A painter made two kinds of pictures – beau-
 tiful pictures and pictures devoid of
 beauty.
He painted Joseph and fair-formed houris,
 he painted ugly afreets and devils.

Both kinds of pictures are [evidence of] h
 mastery: those [ugly ones] are not [ev
 dence of] his ugliness; they are [eviden
 of] his bounty.
He makes the ugly of extreme ugliness –
 is invested with all [possible ugliness] –
In order that the perfection of his skill ma
 be displayed, [and that] the denier of h
 mastery may be put to shame.
And if he cannot make the ugly, he is de
 ficient [in skill]: hence He [God] is th
 Creator of [both] the infidel and the since
 [faithful].
From this point of view, then, [both] infide
 ity and faith are bearing witness [to Him
 both are bowing down in worship befor
 His Lordliness.[9]

No wonder, then, that, in a time so steeped
freely accepted imagery, the traditional icon
graphic fetters on the visual arts were broken
last, allowing the blossoming of suppressed im
agination as well as the reproduction of age-ol
pictorial concepts and the invention of ne
ones. In spite of the ubiquitous adoption
figurative elements, however, there remained
the decorative arts a curiously formal handlir
of often stereotyped motifs that contrasts wi
the intensity of the equally stereotyped senti
ments and expressions of poetry. This formali
is probably due to the aristocratic origin
much of the visual iconography involvir
human figures, as is borne out by the great
naturalism of attitude and movement in th
rather rare non-royal subjects, including scene
with entertainers or representing such commo
place work as the preparation of wine.

Whatever the milieu in which decorated ob
jects were produced and whatever meaning
aesthetic intent specific decoration may hav
had, the use of a thousand and one means
enriching the surface – as well as the immens
variety of surviving beautiful, even though un
decorated, pieces – implies a personal, even
social, significance, aside from the practic
functions of the objects. It may be assume
that these pieces served as what are now calle

status symbols, or at least as expressions of higher ambitions in life. As medieval houses in the Islamic world had hardly any furniture in the modern sense, textiles and carpets, as well as vessels of bronze, clay, and glass, had to bear the social implications now associated with large tables, cupboards, and other elaborately constructed or decorated pieces in the Western world.

Technical Complexity

Besides vastly expanded imagery, this period is characterized by richness of decoration. An obvious new opulence and complexity of ornamentation distinguish, for instance, the carved stucco and stone decorations on architectural surfaces; in spite of a limited vocabulary, these designs encompass an unprecedented wealth of massed forms teeming with inner life and opulent with ever-changing surface patterns. Clearly, the artists of this period were not satisfied with the mere coordination or rhythmic combination of simple patterns. One major advance was the creation of interpenetrating shapes of great complexity, varied density, and tension, which resulted in 'polyphonic' assemblages, especially on inlaid metalwork and, to a somewhat lesser degree, on textiles. Even minor decorative schemes (in the form of arabesque spirals and vegetal stems) in a repetitive combination with major motifs (like inscriptions and animal friezes) are often placed within a welter of small curving elements that lend an additional vibrant quality to the overall design.

The enrichment of the colour range is another novelty, as is obvious in the wealth of pigments used on pottery and textiles, and in the inlays of silver, copper, gold, and niello even on base metal pieces. Also at this time enamelling on metal was occasionally introduced, which was significant, even though the attempts proved to be abortive. Even in manuscript illumination, which is normally colouristically restrained, the range was expanded through the introduction of a deep blue

obtained from powdered lapis lazuli.[10] Another striking aspect of the period was the endeavour of the artists to attain effects that seem to go well beyond the physical limitations of the material; for example, the highly admired translucency of Chinese porcelain, impossible to achieve with ordinary potter's clay, was simulated by means of puncturing the interstices of carved designs and allowing transparent glazes to flow into the holes. A delicate, lacy effect was sought for the surfaces of such hard metallic utensils as candleholders, tray stands, and incense burners; the potters also built outer shells in openwork around the fluid-retaining inner walls of vessels.

Application of rich and dense imagery to a vessel or any other surface led naturally to the concealment of the shape, in the sense that the viewer is no longer conscious of it. This is most vividly apparent in lustre designs on pottery, where the opalescent sheen optically effaces the vessels. In addition, there were other means of dematerializing basic shapes, such as fluting glass beakers or faceting bronze candlesticks so that they are reminiscent of cut diamonds. Whatever its practical function, the object came to serve primarily as the infrastructure, even the pretext, for rich iconographic or decorative designs catering mainly to the visual sense.

This lack of interest in solid shapes was also manifest in other playful treatments that transfigured basic forms. A pottery or metal vessel may be partly or wholly in the shape of an animal or human being. Through inscriptions, objects are made to speak and to express sentiments as if they were human. The most striking innovation, however, is the various forms of zoomorphic and anthropomorphic writing that occur on metalwork from this period and the next. It is a clear indication of the mood and general intent of the artists and their patrons that Arabic script, previously sacrosanct, was now physically transformed and combined with human and animal parts.

The production of so many artistically sophisticated pieces reflects a high level of

technical proficiency. Of the various processes adopted, only a few were novel in the Islamic world: underglaze and polychrome overglaze painting on pottery, for example. Others, though known in earlier times, had apparently disappeared in the immediately preceding periods: the inlaying of bronze and brass, enamelling on glass, and carpet knotting. This resurgence of ancient techniques provides a curious parallel to the revival of ancient iconographic motifs. Although the Seljuq period was characterized by a great deal of self-consciously individual work, as reflected in the many artists' signatures (often accompanied by dates) on metalwork and pottery, it was also probably the first in which mechanical means - block printing in one or more colours on paper or cloth - were used to duplicate designs.[11] The results were not outstanding, but these endeavours were nevertheless important, because the techniques ultimately came to be used on a large scale and led to a decline in design.

The Turks

A basic question that must be raised here involves the assumed Turkish aspects of the arts of this period. The Seljuqs were Turks, and a number of scholars have claimed that they stamped the art and architecture of their period with a Turkish hallmark. However, no specifically Turkish examples of the decorative arts survive from the period preceding the invasion of the Seljuqs, and these rulers' predilection for Persian culture (especially among the Ghaznavids and the Seljuqs of Anatolia) and their deliberate identification with Iranian heroes speak against the 'Turkishness' of their art.[12] Furthermore, Turkish rulers have always made good use of local art forms, even in peripheral regions.

It is quite possible, however, that there is a Turkish aspect to jewellery, weapons, and horse trappings - all personal objects whose owners might have insisted on certain traditional features. The famous bevelled style (style C), introduced at ninth-century Samarra, may have

been of Turkish origin (see Chapter 3), in which case the claim of a similar origin for a stylistically related twelfth-century silver treasure said to have been found in Nihavand in Iran (and now in the British Museum) can perhaps be sustained.[13] This trove of thirty-nine personal ornaments, many of them gilded and nielloed, belonged to the Hajib (Chamberlain) Abu Shuja al-Din Injutakin, who, to judge from his name, must have been Turkish; many of the pieces were executed in the bevelled style, which otherwise does not appear to have been common in this period. Thus the treasure may indeed represent a Central Asian Turkish influence in the art of Iran,[14] as may some carpet patterns which reflect a specifically Turkish mode of life. To be excluded, however, are carpets that paraphrase woven fabrics from other regions. No such considerations apparently apply to pottery, metalwork, glass, and textiles.

The Arts of the Book

The great flowering of the arts in the Seljuq period was also reflected in crafts connected with the production of books. The prophet Muhammad had proclaimed the Muslims along with the Jews and Christians, to be 'peoples of the Book', since these three religions are based on scriptures. Decoration of the holy Koran was thus an act of piety, which inspired artists to their most stunning efforts. The volume of literary production was great and the level of intellectual activity high in the Seljuq period; moreover, the prevailing affluence permitted even manuals and other ordinary books to be preserved between covers that were more than merely protective.[15]

Of the various aspects of medieval Islamic books, leather bindings were probably artistically the most modest, for the specialized craft was then in its infancy. It was uniform throughout the Muslim world, which is not surprising in view of the remarkable mobility of scholars accustomed to travel freely from centre to centre in order to study with the most renowned teachers, and of the portability of books, which were

small and light. At this stage bindings were characterized by a simple medallion scheme, which was later to be considerably elaborated in other media as well. The central medallion is generally round with a polylobed frame, each lobe crowned by a radiating stroke [354]; in addition, there are sometimes trilobed appendages along the vertical axis. The medallion

354. Bookbinding, Köprülü 1321, Baghdad, 1205. Leather. *Istanbul, Suleimaniye Library*

itself may be filled with interlacings, grouped rosettes, or geometric figures. Simple triangular shapes are set in the corners, and a series of stamped impressions or interlaces, placed between parallel framing lines, serve as outer borders. The pentagonal flap attached to the back cover and folding over the front carries similar, sometimes even richer, designs. The prevailing technique was blind tooling, although a technical treatise on the processes involved in book production written by the Zirid prince Tamin ibn al-Muiz ibn Badis of

Tunisia (1031-1108) gives the formula for gold stamping; furthermore, an Egyptian binding of 1168, now in the British Museum, actually shows a number of gold dot punches.[16] There may, of course, also be surviving examples of this novel technique from more easterly regions, but so far they have not been noticed.

Much more important than binding was the highly esteemed art of calligraphy. The celebrated scribe Ibn al-Bawwab (d. 1022) lived just before the inception of the Seljuq period; Yaqut al-Mustasimi (d. 1298), called the 'sultan of calligraphers', worked for the reigning caliph in Baghdad at the time of the Mongol invasion.[17] The finesse of their work was not only endlessly praised but also frequently imitated by followers and forgers.[18] Many less famous scribes also produced splendid Korans in the interval between these two luminaries; by then paper had become the universal medium.

The really striking innovation in the arts of the book, however, was the 'painting explosion', which had an impact in all the main Islamic centres from Spain to Iran. Manuscripts had been provided with pictures before, especially scientific treatises and fables, but apparently only sporadically.[19] However, many richly illustrated examples have survived from the short span of time just before and just after 1200, despite the destruction caused by the Mongol invasion and by Muslim iconophobes throughout subsequent history. Of the scientific works, many are translations or adaptations of illustrated Greek sources, and it is not surprising that pictorial features useful in clarifying the texts were also taken over, though modified to the taste of Islamic patrons. Pictorial material, however, was not limited to scientific treatises alone and, astonishingly enough, from the late twelfth century on, illustrations were also provided for new, indigenous texts, primarily in Arabic but also in Persian, for which no earlier iconography existed. This phenomenon is so unusual that the explanation, given earlier in this chapter, for the generally favourable attitude towards images in the Seljuq period seems to require amplification.

Three factors must be considered. First, there was the folk art of shadow plays, to which there are many references in contemporary Arabic and Persian literature.[20] Neither plays nor figures have been preserved from the twelfth century, but there still exist three dramatic texts written in Cairo in the second half of the thirteenth century by the Mosul-born physician Ibn Daniyal (1248-1310). They represent a literary form of the genre, but, as Georg Jacob has pointed out, they probably followed earlier, more popular plays, which may never have been written down.[21] The verses of Umar ibn al-Farid (d. 1235) reveal that shadow plays included images of camels traversing the desert; boats on the high seas with men climbing to the tops of the masts; battles on land and sea in which foot soldiers and horsemen fought with swords, spears, and arrows; attacking and fleeing armies; sieges in which catapults were used to hurl large stones at fortresses; fishermen casting nets; bird trappers setting snares; sea monsters wrecking boats; lions tearing their prey; and wild birds and animals pouncing on victims.[22] Most of these images have close counterparts in book illustrations and could very well have inspired the painters. Particularly important is the fact that, unlike the rather static subjects of scientific manuscripts, shadow figures represented action. They were most likely made of painted skins, like the later Chinese, Indonesian, and Turkish ones, and thus even their colourful surfaces were related to polychrome book paintings. Moreover, shadow figures were theologically permissible – indeed they were readily cited as similes for the transitory, unreal nature of this world – and the art of book painting may have benefited from this attitude.

A second source of inspiration for miniatures may have been wall paintings such as those that have been found in the Soviet Central Asian republics.[23] Some predate the Islamic period, but their subjects, especially those relating to epic themes, must also have been known in Iran and were taken up again in Muslim times, as is proved by a small number of fragmentary Persian frescoes of the period under discussion. Limited as this evidence is, it does suggest that there was a pictorial reservoir upon which Iranian and perhaps other artists could draw.[24]

Finally, in the Seljuq period there was a strong didactic tendency which was expressed in the vast number of madrasas erected for orthodox religious instruction as well as in the proliferation of handbooks and encyclopedias, which was also reflected in many illustrations. On the other hand, what was long thought to be a primary source of inspiration – the paintings of the Christian minorities dispersed throughout the Muslim East – has been proved to have been practically non-existent, for Hugo Buchthal has shown that the Nestorians had no school of painting of their own, and that the art of the Jacobites, far from offering artistic prototypes, was actually influenced by Iraqi Islamic miniatures.[25]

IRAN

Textiles

Iran, the main bastion of early Seljuq power, was also the Seljuq cultural centre, exerting a widespread influence on the art of other countries. Foremost among more than 250 arts and crafts practised in the highly specialized economic world of medieval Islam, and comparable in importance to that of steel and other metals in modern times, was the production of textiles – not only clothing (including turbans, stockings, kerchiefs, and belts) but also wrappings, towelling, bedding, napkins, upholstery for couches and cushions, canopies, draperies, storage bags, and carpets.[26] Moreover, textiles in the form of 'robes of honour', bestowed in large numbers on deserving officials, functioned as medals and decorations do in modern western society.

Iran not only provided for most of its own textile requirements but was also the main supplier (or one of the main suppliers) of high-priced fabrics to the Mediterranean countries. Its people also had the most extravagant colour

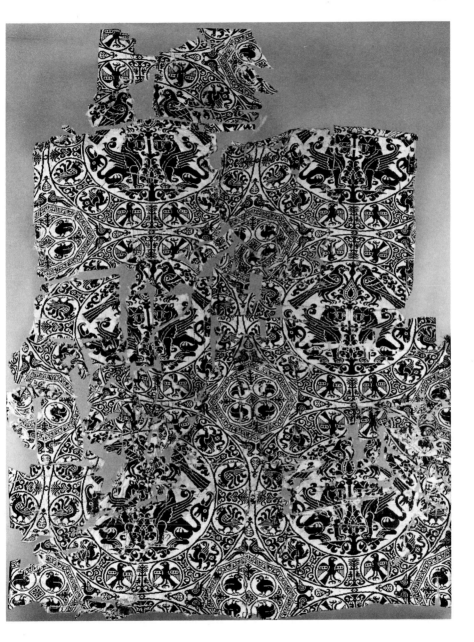

355. Fragment of silk textile, probably Iran, twelfth century.
London, Victoria and Albert Museum

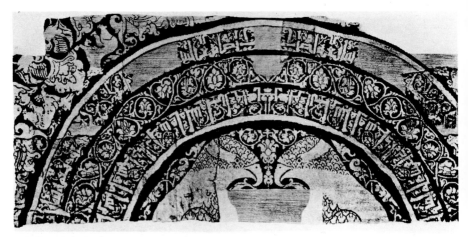

356. Fragment of silk textile, probably Iran, twelfth/early thirteenth century.
Formerly Berlin (Dahlem), Staatliche Museen,
Preussischer Kulturbesitz, Museum für Islamische Kunst

sense; for male clothing, too, greens, reds, blues, and an intense yellow were popular, and, along with ordinary stripes, waves, and other common patterns, there was a marked fondness for the effects of gold, glitter, gloss, and iridescence. Such fabrics were objects of conspicuous consumption, and enormous prices were paid. The brocades from Tustar in Khuzistan, for example, were proverbial for their brilliance and were cited as metaphors for the beauty of poetry, spring flowers, even the dewy freshness on the cheek of a mistress. Besides this region in south-western Iran, others along the southern shore of the Caspian Sea and also the eastern province of Khurasan were famous for textiles all over the Islamic world. The outstanding material was silk, woven into brocades, velvets, and many other cloths. There was also fine cotton.[27]

The few Iranian textiles that survive from this period represent the culmination of the Sasanian manner of organizing surfaces in a series of large framed circles, each one enclosing animals, with a secondary interstitial design often of a vegetal nature, but sometimes consisting of small animals. The stark, monumental grandeur of the early Iranian silks has, however,

given way to a much denser, small-patterned arrangement. There are often more than the traditional one or two animals in the centre of each circle, and, in addition, vegetal forms serve as central axes and as background fillers [355]. Writing often plays an important part [356], probably reflecting some influence from the *tiraz* fabrics made in special court workshops. Usually they included, in a line or occasionally two lines of fine Kufic script, the caliph's or prince's name and other official data, and were bestowed on deserving public officials.[28] So far it has not been possible to assign any Iranian textiles of this period to a specific locality, except for *tiraz* fabrics on which the city of manufacture is mentioned; this is all the more regrettable in that the medieval sources mention many such centres.

Metalwork

Although corrosion, melting down, and other abuses have caused the destruction of a very large number of objects, especially in precious metals, much more metalwork has survived than the more perishable and easily cut-up textiles. The amount of well-preserved vessels

and utensils in many shapes is impressive: bowls, caskets, boxes, inkwells, penboxes, buckets, ewers, flasks, bottles, jugs, rosewater sprinklers, and strongboxes. Then there are trays and mirrors, as well as objects as diverse as keys, lamps, lampshades, candleholders, incense burners, mortars, tray stands, bottle supports, pumice-stone holders, astrolabes, and celestial globes, as well as more unusual types, like animal-shaped incense burners and aquamaniles. Only one mace has been preserved, partly owing to its more solid mass; also helmets, swords, and body and horse armour seem to have almost all disappeared, along with braziers, window grilles, and drums.[29]

By far the most common materials were brass and bronze, which are not usually clearly differentiated by art historians. Some silver vessels with parcel gilding and designs in niello have also been preserved. Gold survives only in jewellery, though, to judge from the number of personal names incorporating the designation 'goldsmith' and from literary references, its use must have been fairly common.

Chasing was the prevalent technique of decoration for brass and bronze, particularly before the middle of the twelfth century. Openwork was popular for such pieces as the bases of candleholders and tray stands, and for incense burners it was a natural choice. Relief, achieved mainly by means of casting in moulds, and often combined with chasing, was the usual technique for mirrors and mortars. Repoussé was limited primarily to friezes of lions or birds and to the hexagonal faceting on a group of late-twelfth-century candleholders and ewers made in Herat.[30]

Another technique, which came to the fore about the middle of the twelfth century, was inlaying of metals with silver, red copper (which disappeared about 1232), and, after 1250, gold. It had been used in early Islamic times, but very few examples have so far been discovered, which implies that it was not common in the intervening period.[31] Its sudden reappearance was apparently a result of a new affluence in the large mercantile cities of north-eastern Iran,

reflecting the urge for conspicuous consumption among the *nouveaux riches*. Indeed, one of the showiest early pieces, a water bucket [357], was made in 1163 by two artisans, a caster and a decorator, in Herat (in the part of Khurasan

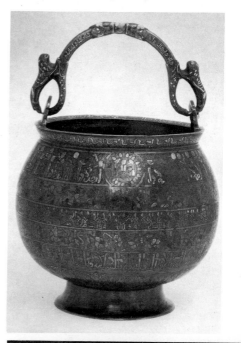

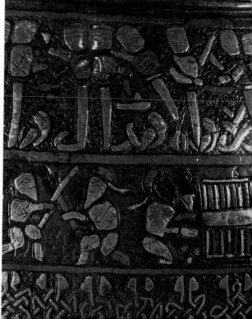

357. 'Bobrinsky' bucket, Herat, 1163, with detail. Bronze inlaid with copper and silver.
Leningrad, Hermitage

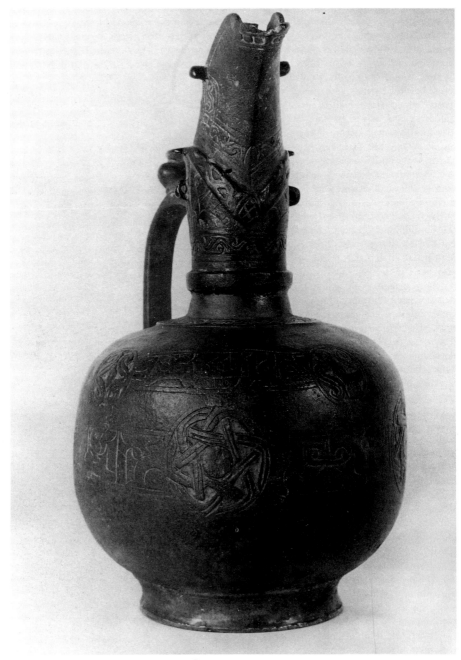

358. Ewer, Iran, probably eleventh century. Bronze.
Berlin (Dahlem), Staatliche Museen, Preussischer Kulturbesitz, Museum für Islamische Kunst

that is now in western Afghanistan) as a gift for a merchant; as such vessels were used in the public baths, the happy owner must have had ample leisure to study its elaborate decoration and to show it off to his friends.[32] The technique involved more than simple encrustation with silver wires or cut-out sheets, however; the latter were also carefully chased with the finer details of the design, like facial features and garment folds. The Iranian examples, which include the earliest surviving object on which this combination of inlay and chasing was employed, a penbox of 1148,[33] are technically still rather simple, often with only round units for heads and rectangular ones for bodies and legs. Another, less common technique which offered additional variety was the solid casting of animal figures to serve as handles or decorations for handles [359] and as feet for small dishes and other utensils.

The most remarkable aspect of Iranian Seljuq metalwork is the variety of decoration, even on single pieces. Generally it is well spaced and perfectly suited to the underlying shape. The motifs are aligned according to simple rhythms or in bands of almost equal size and importance [358]. Prominent among them are animals, framed singly or in friezes; after the middle of the twelfth century human figures also appear in individual scenes or in elaborate friezes of revels and hunting. The instinctive flair of the artisans kept them from the painterly subjects that were at times represented on pottery; even the rather rare genre scenes do not seem out of key. Only on a few deliberately showy pieces such as the 1163 bath bucket is the decoration crowded, but there the intent was to impress the viewer specifically with the wealth and density of the motifs.

Inscriptions occur on nearly every piece. They usually consist of sequences of anonymous wishes, but sometimes they provide important information about patrons, makers, and dates, though hardly ever about places of manufacture. They are mostly in Kufic, including the very complex plaited variety that often defies all attempts at decipherment, but some are in simple *naskh* or are of the novel anthropomorphic and zoomorphic kind.[34] Inscriptions are usually given the same emphasis as the other decorations, and are therefore not as prominent as they are on mosques. Geometric figures such as braided stars, knots, and so on are generally more rounded and therefore less harsh than purer designs made with ruler and compass. Narrow interlacings often framed and connected individual motifs, and in addition there were many more formal or abstract patterns. The novel and very characteristic small configurations of seven circles or of flowers in a tall vase seem to have been the hallmarks of certain workshops in Khurasan [359].

359. Jug-shaped oil lamp, probably Khurasan, twelfth century. Bronze inlaid with copper and silver. *New York, Metropolitan Museum of Art*

In spite of the wealth of surviving material, which includes a limited number of dated pieces, it is still hardly possible to give a detailed account of the stylistic development within the Seljuq period. As in other media, bolder designs and sparser use of the available surface for decorative purposes generally reflect an early stage. The advent of inlay work, however, gradually led to more tightly packed all-over designs on a reduced scale, resulting in densely textured surfaces reminiscent of textiles.

There was also a conservative undercurrent, best seen in a unique brass sculptural group now in the Hermitage in Leningrad [360].[35] Made in 1206, apparently for an Iranian lord, it represents a zebu cow nursing a calf; a diminutive lion has leapt onto the cow's back to serve as a handle. The main group is reminiscent of Sasanian aquamaniles, which is not surprising in view of the persistence of Sasanian metal traditions into Islamic times. The motif of the lion attacking the bovine is much older, however. It may have been an astronomical symbol in prehistoric times; by the Achaemenid period, or perhaps somewhat earlier, it had been adopted as an emblem of royal power.[36] The awkward, internally unjustified disproportion of the two animals and the transformation of the original bull into a nursing cow demonstrate the weakening of these old traditions concomitant with a reduced sculptural sense, as wit-

360. Zebu aquamanile, probably Khurasan, 1206. Brass. *Leningrad, Hermitage*

361. Pencase, probably Merv, 1210. Bronze inlaid with silver. *Washington, D.C., Freer Gallery of Art*

nessed by the inappropriate use of figural inlay work in silver on the body of the cow, negating its basic form. These changes may reflect a cultural dichotomy between indigenous Iranian and Islamic forces, which is also suggested by the mixed Arabic and Persian inscriptions on the piece. Indeed, the man who cast the sculpture in the ancient Persian manner had an Iranian name (Ruzba ibn Afridun), while that of the decorator was purely Arabic (Ali ibn Muhammad ibn Abu'l-Qasim). The persistence of such traditional forces, even at the end of the Seljuq period, is in stark contrast to the overwhelming majority of well integrated, fully harmonious pieces in which these conflicting historical forces have been successfully fused. The end result was a novel style whose development was interrupted at a critical moment in Iran itself by the Mongol invasion; in the Jazira and in Syria, however, it had still to reach its full flowering.

Khurasan was the main early production centre for metalwork in Iran; Herat is specifically mentioned on the bucket of 1163 (where also a division of labour between the caster and the inlay worker is indicated), as well as on a ewer of 1182 in the Tbilisi Historical Museum. The *nisba* 'Haravi' ('of Herat') also occurs in the artist's signature on an inkwell of about 1200 in

the Walters Art Gallery in Baltimore. There are pieces with the signatures of masters from Isfarayin and Nishapur, also in Khurasan, and a pencase of 1210 in the Freer Gallery of Art may have been made in Merv or Herat [361].[37] Herat, Nishapur, and Merv were sacked by the Mongols in 1221 and Herat again in 1222; other north-eastern centres suffered a similar fate. These disasters brought about the flight of many artisans to western Iran and particularly to the Jazira, where their designs and techniques exerted some influence. Other metalworking centres undoubtedly existed but have not so far been identified.

The Iranian brass and bronze objects made before the Mongol invasion were apparently destined for a broad clientele, who must have gone to the bazaars to buy anonymous works inscribed with general eulogies. Courtly pieces, as for instance the silver-inlaid pencase of 1210 made for the grand vizier of a Khwarazmshah in Merv [361], seem to have been hardly superior in artistic quality and technical finesse to those made for the merchant classes. Indeed, a footed cup with purely epigraphic decoration made for another eastern grand vizier is a rather modest, though dignified, piece, entirely lacking the splendour of many anonymous objects.[38] That the finer pieces were highly regarded,

however, can be assumed both from their self-laudatory inscriptions and from the frequency with which craftsmen signed their works. One – not even the best – is inscribed with no fewer than four stanzas, including the following lines:

Nobody can find anything to match this ewer
Because there is nothing like it ...
All the seven heavenly bodies, however
Proud they may be,
Protect him who makes an object of this kind.[39]

Besides the numerous brass and bronze objects, a fairly large number of silver vessels has also survived, comprising jugs, rosewater sprinklers, cups, spoons, trays, boxes, and incense burners. In form and decoration there are obvious connections with work in brass and bronze, but some aspects are unique, reflecting relations with other luxury media. The shapes of long-necked rosewater sprinklers, for example, go back to tenth-century cut-glass versions, whereas rectangular covered boxes may be connected with earlier containers made of ivory. Occasionally, just as in pottery and in the base metals, there was a deliberate use of Sasanian motifs, reflecting a particularly strong tradition in silver work. On a bowl in the Berlin Museum a lute-playing king in high relief on a throne dais [362] is a direct descendant of the main figures in earlier banqueting scenes; he is an active music maker, however, whereas in former times the performers would have been attendants. Engraving was the most important technique, but niello also played a major role, analogous to that of inlay on objects made from bronze and brass; further colouristic enrichment was achieved by partial gilding. Repoussé inscriptions, animal motifs, and cast ornamentation were all rather rare. Niello also occurs on gold jewellery, of which much has been preserved, but the major decorative technique was granulation and – especially for openwork – filigree. Bracelets, rings, crescent-shaped earrings, necklaces consisting of round beads linked by narrow bands, and highly stylized animal pendants [363], often in the shape of lions, are known, as are amulet cases.

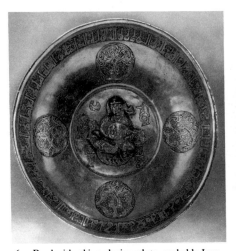

362. Bowl with a king playing a lute, probably Iran, eleventh century. Silver, partially gilt and nielloed. *Berlin (Dahlem), Staatliche Museen, Preussischer Kulturbesitz, Museum für Islamische Kunst*

363. Fish pendant, probably Iran, twelfth century. Gol *New York, Metropolitan Museum of Art*

None of this gold or silver material has been found in scientific excavations, so that the provenance, dating, and, in the case of the necklaces, even the original forms are still highly problematical.[39a]

Pottery and Tiles

The various ceramic wares constitute the richest and most extensive of all the surviving array of medieval industrial production in Iran, their numbers running into the thousands. They also differ from the preserved specimens of other media, produced both in Iran and elsewhere, in that they reflect a broad original clientele.

At one end of the spectrum are vessels made for royal patrons and inscribed with the full panoply of official titles, though sometimes the owners' exalted status is implied only by the de luxe technique and the iconography of princely leisure activities or heroic exploits.[39b] The ceramic tiles are also outstanding, for the most demanding and expensive techniques were involved, since they were made for the mansions of the well-to-do and for mosques and mausoleums endowed by wealthy patrons. It should also be remembered that it was from approximately 1100 on that the principles of polychrome faience mosaic were slowly and systematically evolved, culminating in the first half of the thirteenth century in the complete sheathing of large wall areas and a resulting total shift in the aesthetic of Iranian architecture.[40]

At the other end of the spectrum of patronage are pieces made for the lower classes. Because they are anonymous and universal in their appeal, it is sometimes difficult to decide whether the original owners were urban artisans or the more affluent members of the rural population. The more precisely observed zoological features and the liveliness of many animals may point to the latter group, which lived in closer contact with nature.

The wide range, technical finesse, and richness of design imply a rising social standing for the ceramic crafts, which is confirmed by the increasing frequency of artisans' signatures after the late twelfth century, even on unglazed pottery. More significant is the fact that, whereas potters had previously imitated the forms and decorations of metal vessels (and continued to do so), the reverse, technically very difficult process also began to occur: ceramic vessels were imitated in bronze.[41] Moreover, ceramics began to be associated with literature. First, many scenes from the national epic appear on vessels and tiles; they are all the more precious now, as no illustrated Iranian copies of the *Shahnama* have been preserved from this period.[41a] Second, ceramics were frequently inscribed with verses, whether lines from major poets like Firdawsi and Nizami, or anonymous *ruba'iyat* with their commonplace expressions of unrequited love.[42] The latter are not entirely without literary interest, for on the one hand they preserve popular versions of classical poems, and on the other they provide examples of dialects found among the provincial lower classes.

Just about every known ceramic technique was used: vessels were thrown on the wheel, moulded, or formed by hand. The shapes range from the ubiquitous simple bowls, which are often unglazed, to elaborately decorated water jugs and large animal and human sculptures, at times intended to serve as vessels. They are covered with various glazes: transparent clear or turquoise; opaque monochrome in green, light or dark blue, white, or purple; or, more rarely, in polychrome. They are carved, engraved, pierced, and painted with underglaze and overglaze designs. The last category included the difficult luxury techniques of painting in lustre or 'enamels' – even at times in combinations of both. In spite of a general excellence and mastery of the production processes, however, the application of glazes and even of designs was at times quite casual, especially at the end of the Seljuq period. Apparently the aesthetic impulse was directed towards more vigorous colour and dashing design, rather than towards the meticulous execution that characterizes, for example, the contemporary Sung pottery of China.

Because of the enormous wealth of decorative themes, a specific discussion of each and every one of them is impossible. Briefly, all types of design known earlier continued in use, and arabesques, other stylized vegetal forms, animals, and (during the last hundred years of the period) single human figures or whole groups, as well as many space-filling motifs, were favoured. Large, formal Kufic inscriptions (in contrast to common scribbles in *naskh*) and geometric configurations were on the other hand infrequent. From about 1170 on, there was a progressive tendency towards combinations of many different motifs and complex compositions. Although little archaeological evidence is available on which to base a firm chronology, it is possible to construct a convincing sequence based on style. Perhaps characteristic of the first half of the twelfth century are carved single animals on glazed dishes [364], and large heraldic animal designs boldly carved and painted in glazes, usually in the centre of large plates [365]. They seem to have been followed by equally bold but more spirited designs of animals or princely figures, which, together with large arabesques, were reserved in white from a deep lustre background [366]. These pieces are widely labelled as having been manufactured at Rayy (just south of Tehran) in the middle of the century,

364 (*top left*). Carved and glazed ceramic plate, probably Iran, twelfth century.
London, Victoria and Albert Museum

365 (*top right*). 'Lakabi' carved plate with polychrome glazes, Iran, twelfth century.
Washington, D.C., Freer Galley of Art

366 (*above*). Monochrome lustre-painted bowl, Iran, twelfth/early thirteenth century.
New York, Metropolitan Museum of Art

367 (*opposite*). Monochrome lustre-painted bowl, Iran, 1191.
Chicago, Art Institute

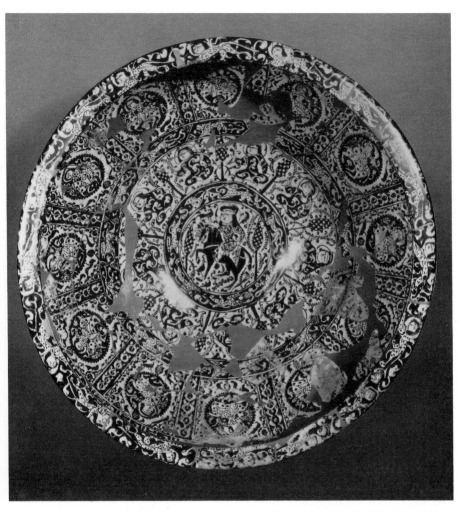

but so far little evidence has been adduced to link them with that city.[43]

It has been claimed – also without concrete proof – that this first important lustre production of the Seljuq period arose from the influx of potters from the declining court of the Fatimids, where both lustre-painted designs and motifs reserved from the lustre ground were known (see Chapter 5).[44] Although this connection is not impossible, it must be stressed that, in the present state of knowledge, Iran cannot be ruled out as the place of origin of the shift to the more complex reserved lustre technique, for already the first dated Iranian pieces, of 1179 and 1191 [367], are decorated with sophisticated combinations of both techniques. Whatever the final conclusion turns out to be, the bold scale of these early pieces, as well as their vigorous draughtsmanship and real or potential movement, are artistically far superior to anything previously created in lustre; furthermore, they were never again to be equalled.

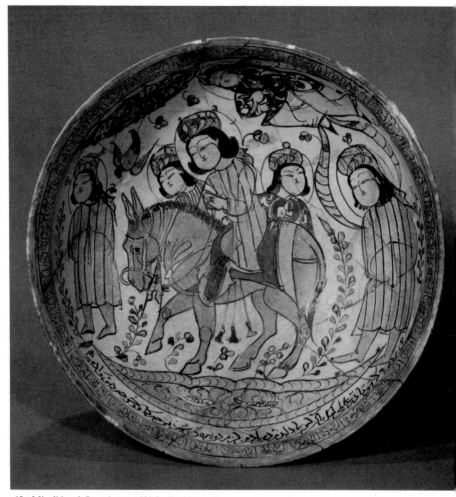

368. Mina'i bowl, Iran, late twelfth/early thirteenth century.
New York, Metropolitan Museum of Art

Probably the most luxurious of all types was the so-called *mina'i* ware, on which polychrome 'enamels' and gold were painted over a white glaze, with dark-blue and turquoise. One group is decorated with representations of the royal court or legendary scenes [368], whereas a second shows impressive large-scale figures, mostly aristocratic couples or horsemen [369]. Still another type, equally attractive though more restrained in colour, is characterized by *sgraffiato* designs reserved from a black slip painted over a white slip and then covered with a colourless or transparent turquoise glaze [370].

The early lustre- and polychrome-painted wares were soon succeeded by much more commonplace pieces with small-scale motifs, often rather untidily applied, and the sgraffiato group came to exhibit simpler linear designs. An

369. Mina'i bowl with gilding, Iran,
thirteenth century.
Washington, D.C., Freer Gallery of Art

370. Underglaze slip-painted bowl with sgraffiato design,
probably Iran, twelfth century.
Oxford, Ashmolean Museum

approximate date for this change in style and
quality can be deduced from the two earliest
surviving lustre pieces of this type [367].

However, this tendency towards either care-
less or simplified mass production was not
universal. At the beginning of the thirteenth
century, if not earlier, Kashan emerged as a lead-
ing ceramic centre where for several decades
carefully made wares in several distinct tech-
niques were produced.[45] There was, first, an
underglaze-painted category, represented by
bowls of two standard but very appealing shapes
and by trays and jugs. The designs, small in
number, consisted primarily of large or small
fleurs-de-lis, undulating leafy stems, and fish.
There were also poetic inscriptions in *naskh*
painted in black or blue on white, often in radial
arrangements, under shiny clear or turquoise
glazes. The more spectacular pieces carry re-
presentational designs – the signs of the zodiac,
sphinxes, harpies, and human figures; in some
instances the ambitious artisans painted them
on elaborately pierced outer shells [371]. Dates
on a number of these pieces indicate that the
best were produced between 1204 and 1215.

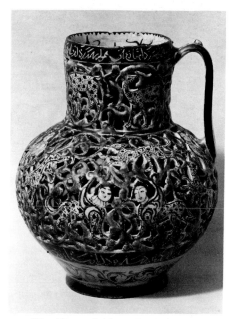

371. 'Macy' jug, underglaze-painted and reticulated,
Iran, 1215-16.
New York, Metropolitan Museum of Art

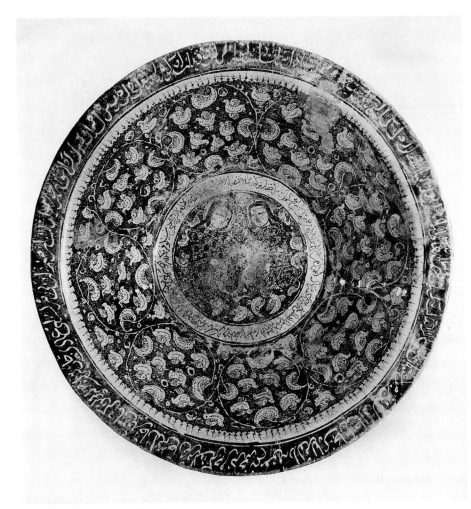

372. Monochrome lustre-painted bowl, Iran, 1211.
Philadelphia, University Museum

A second large Kashan group includes lustre pieces [372], primarily bowls, trays, vases, jugs, and ewers of various shapes, as well as wall tiles, and slabs forming mihrabs. Whatever the shape, the decorations show several common motifs – a fat flying duck, a stemmed kidney-shaped leaf, and spirals scratched in the lustre ground – which point to a common production centre.

Although there have never been excavations at Kashan, inscriptions on some tiles, combined with literary evidence, leave no doubt that it was their place of origin – an attribution corroborated by the Persian term for tiles, *kashi*, that is *Kashani*, 'from Kashan'. Large bowls and trays are particularly rich in representations of princely figures, especially of enthroned rulers

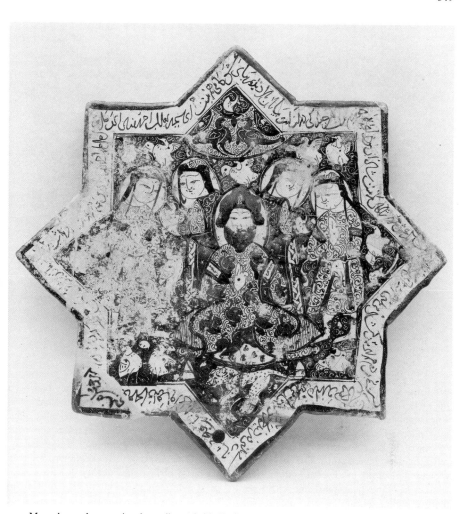

373. Monochrome lustre-painted star tile, probably Kashan, 1211-12.
New York, Metropolitan Museum of Art

and horsemen.[45a] Similar, though less evolved, designs are found on tiles shaped like eight-pointed stars (which were fitted together with cross-shaped ones), from which human faces framed by haloes stand out [373]. On the other hand, their bodies and even the horses are so densely covered with dots, arabesques, and other foliate motifs that they merge into the lustre background, itself filled with leaves, birds, and small spirals. Various stylistically related vegetal arrangements of a more formal nature were used for the star and cross tiles in the dados of mosques and mausoleums [374].

More restrained in their decorative repertory, but nevertheless on a grandiose scale, are the mihrab ensembles [375]. A graduated series of

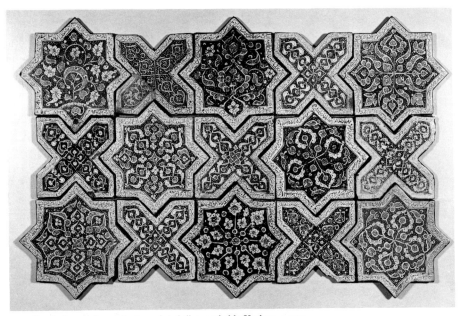

374. Panel of monochrome lustre-painted tiles, probably Kashan, *c.* 1220.
London, Victoria and Albert Museum

flat niches is encapsulated one within the other, the whole framed by a strong projecting cornice. The component slabs are mostly articulated by inscriptions in large *naskh* and, to a more limited degree, in Kufic, which stand out boldly in relief in dark blue against the dense lustre ground. The centre of the composition usually consists of a large pentagonal slab with a symmetrical arabesque motif in relief and the typical Kashan foliage in the background. As with the vessels and tiles, the mihrabs were usually signed and dated by their makers; indeed, from such pieces it has been possible to trace one family of mihrab makers through several generations.[46]

In the last few decades before the Mongol invasion some Kashan potters may have migrated to other centres, where they continued to make monochrome underglaze-painted and lustre-decorated vessels. Many such works are said to have been discovered in Gurgan, sup-posedly in large jars in which they had been hidden before the onslaught of the Mongols, which would explain why, unlike most other Persian vessels, they are unbroken and their glazes in pristine condition. Unfortunately, there is no record of their excavation, and they are rarely of first-class quality.[47] Kiln wasters in a style closely related to that of Kashan have, however, been scientifically excavated at Takht-i Sulayman in north-western Iran.[48] They, too, are of lesser quality.

In the thirteenth century several centres, including Kashan, produced a variety of pottery with small patterns painted in polychrome 'enamels' over white or turquoise glazes. Figural and arabesque compositions were common, and at times both the insides and outsides of vessels were covered with paintings. Just as lustre designs from tiles appeared on vases, there are signs of cross breeding on the polychrome-painted pieces. In addition to the more formal

375. Underglaze- and lustre-painted ceramic mihrab, Kashan, 1226.
Berlin (East), Staatliche Museen

376 and 377. Mina'i plate
with battle scene (interior; *above*)
and representations of heroic deeds (exterior;
opposite), Iran, mid thirteenth century.
Washington, D.C., Freer Gallery of Art

figural compositions usually applied to pottery, genre scenes appear; there are even subjects inspired by, and possibly copied from, book paintings, especially episodes from the *Shahnama* including, for instance, the proofs of Bahram Gur's marksmanship, and a whole series of consecutive scenes such as the victory procession of Faridun and the love story of Bizhan and Manizha.[49] On one large plate in the Freer Gallery of Art [376] is a large battle scene like a fresco representing an attack on a fortress by a large army of horsemen, foot soldiers, and

elephants. All the main figures are labelled with Turkish names, which has made it possible to identify the battle as one in which an Assassin stronghold was attacked by a petty Iranian prince and his troops.[50] The painting is remarkable for its large scale and precise detail; equally noteworthy is the uncommon portrayal of a contemporary event which, unlike the *Shahnama* subjects, was not readily recognizable. The labels were thus necessary, and, furthermore, the historical event itself evoked the legends of the past, which were recalled in

appropriate parallels of heroic exploits on the plate's exterior [377].

The Arts of the Book

One important group of Seljuq Korans continued the 'East Persian type', with its highly attenuated and angular Kufic script. Usually each page contains only three or four lines of this boldly conceived calligraphy, and thus the ample remaining space could be devoted to delicately drawn floral or arabesque patterns [378].

378. Two pages from a Koran, no. 4316, ff. 2v–3r, probably Iran, 1073–4.
Mashhad, Imam Riza Shah Shrine Library

The grandeur of the writing is further enhanced by contour lines, which echo the forms of the letters and function as a kind of *cordon sanitaire*, sharply segregating the sacred script from the playful decoration. A second novel type of composition probably reflects specifically Iranian ingenuity. Three lines of large script, at the top and bottom and across the centre of the page, demarcate two areas of text written in smaller script [379]. These organizing lines, which can be either in Kufic or in a monumental form of *naskh*, function as do the horizontal boards of wooden doors between which the carved panels are set. The type of composition is an early endeavour to break the monotony of the evenly written page. Decorative framing bands and verse markings also helped to turn text passages into remarkable and varied compositions.

379. Page from a Koran, no. 1438, f. 40a, probably Iran, 1186.
Dublin, Chester Beatty Library

For those who do not read Arabic or who are not specialists, the most spectacular and aesthetically pleasing features of the Koran manuscripts are, however, the illuminations. Chapter headings and verse indications in the text, as well as rosette markers in the margins, are drawn in the most sophisticated manner, often in gold with designs outlined in white and sometimes set against red-washed (or possibly red-burnished) backgrounds or blue areas painted with powdered lapis lazuli. The arabesques and floral patterns are highly formalized and handled with consummate skill.

The finest decorations of all are the large 'carpet pages' at the beginning of the books (and sometimes at the end as well). In the boldness of their compositions, which consist mainly of arabesques and sometimes also of geometric designs, they equal the more massive, three-dimensional stucco decorations around the mihrabs of great Iranian mosques; in finesse of execution they often surpass them [380]. It can indeed be argued that the sombre and subdued bindings of the period are not merely the fledgling endeavours of an infant art but rather the low-keyed overtures to these dazzling spectacles; similar decorative themes are lightly touched upon, but there seems to have been no intention to compete with the main creations, which burst forth as transfiguring experiences. This view is borne out by a few fragmentary stone moulds for pressing designs into leather pieces, like those used for saddles or bags.[51] The most elaborate floral scrolls or strapwork enlivened by animals and even human figures provide clear evidence that leather craft as such had reached a high point in the Seljuq period; had complete pieces been preserved, they would no doubt be among its finest decorative specimens.

380. Carpet page
with geometric designs from a Koran,
no. NE-P27, Hamadan, 1164.
Philadelphia, University Museum

It is possible to view the arts of the book, in particular the work of the illuminator, as mother arts, providing the models, perhaps even the cartoons, for other decorative arts. Although not much has been preserved, the 'Iranian action style' of an undated copy of the romantic Persian poem *Warqa wa Gulshah* probably represents the Seljuq figural style *par excellence*.[52] The illustrations consist of scenes in a kind of ribbon format, wider than it is high. The figures usually extend over much of the height between the lower and upper edges of the picture band [382]. The background is most often uniformly coloured, especially in red or, less frequently, in blue. One of the pages is signed in large letters by the miniaturist, Abd al-Mumin ibn Muhammad of Khoy, a town in the far northwest of Iran [381]. The manuscript may very well date from the end of the twelfth century, for the backgrounds of several of its miniatures are patterned with arabesques that are stylistically between those of the bold early lustre-painted designs on pottery and those of the early-thirteenth-century Kashan styles [382]. Indeed, although this manuscript is the only one to have survived from Seljuq Iran, it is not the only extant example of the Iranian figure style, which is also to be found on the polychrome-painted ceramics discussed earlier. This type was virile enough to withstand the Mongol cataclysm and continued on ceramics until about the middle of the fourteenth century. Its prototypes have not yet been properly traced, but certain of its features had already occurred in Central Asian wall paintings discovered in this century by Soviet archaeologists.[53]

A variant of the basic compositional type was used in this copy of *Warqa wa Gulshah* specifically for crowded scenes, like battles. The figures are arranged in loose tiers, one atop the other and without any indication of ground lines or spatial depth [383]; when the story demands it, however, the locale is indicated by a few landscape or architectural elements. This variant can also be studied on Iranian lustre- and polychrome-painted pottery, especially on works like the Freer battle plate. Once again, it is possible that it shares common roots with central Asian wall paintings.

381-3. Two figures in a tent (*opposite*), king between Warqa and Gulshah (*top*),
and Warqa in battle (*above*), from *Warqa wa Gulshah*, MS. Hazine 841, possibly late twelfth century.
Istanbul, Topkapı Sarayı Library

IRAQ AND THE JAZIRA

In contrast to the great mass of material that has been preserved from Iran, fairly limited numbers of objects have survived from the other regions of the Seljuq empire and its successor states. Although these pieces throw some light on certain decades of the period and on the status of some media, precise attributions and proper understanding of historical development are nevertheless not always possible.

Of the various Iraqi products we know most about textiles, primarily through literary references, which are, however, not precise enough to permit definite identification with preserved fabrics.[54] Yet the reputation of Iraqi textiles reached medieval Europe, and the fabrics themselves were much in demand there; indeed, European languages have been enriched by terms drawn from their names. From Baldacco, the Italian designation for Baghdad, is derived the term *baldacchino* for luxury textiles, especially those used for canopies; in England the fabrics of Baldak were called *baudekin*, or *baldachin*. Matthew Paris mentioned that Henry III wore a robe *de preciosissimo Baldekino* at an investiture at Westminster Abbey in 1247. Inventories of St Paul's Cathedral from 1245 and 1295 indicate that these baudekins were patterned with roundels containing griffins' heads and diminutive lions, double-headed birds with wings displayed, griffins and elephants, men on horseback, archers, and 'Samson the Strong'.[55]

Happily there are two textiles that, though made in Spain, do give some clue to the appearance of these costly fabrics: a fragment in the Colegiata de San Isidoro in León that is approximately contemporary with the beginning of the Seljuq period, and a silk in the Museum of Fine Arts, Boston, which is most likely of the first half of the twelfth century (see pp. 243, 159 and illustrations 259 and 139).[56] Although in the inscriptions on both Baghdad is claimed as the city of origin, technical features as well as palaeographic details reveal that the silks are actually Spanish copies of Iraqi originals. Their compositions, based on a series of roundels framing pairs of animals or fantastic creatures in symmetrical arrangements, represent medieval paraphrases of old Sasanian textile designs and are thus closely related to contemporary Iranian silks (see the section above: Iran – Textiles). Such circumstantial evidence is corroborated by al-Idrisi's and al-Maqqari's statements mentioning that attabi fabrics (named after the Attabiyya quarter of Baghdad) were made at Almería in Spain.[57] There are many other such references to the copying of textile patterns in distant parts of the medieval Muslim world, and this testimony helps to explain the difficulty of distinguishing between the products of different regions.

In the thirteenth century Mosul in the Jazira was also an important centre of textile manufacture,[58] as is again attested by words still current in European languages: *muslin*, *mousseline*, *muselina*, and *mussolina*. It has not yet, however, been possible to isolate this type of fabric from among those that have come down to us.

More can be said about the metalwork of the Jazira. The most important early work is the *chef d'œuvre* of Islamic cloisonné enamel, a two-handled copper bowl curiously prefiguring the Limousin *gemellions* [384]. Now in the Ferdinandeum in Innsbruck,[59] it was made for a son of the Artuqid Da'ud (1114-44), who ruled a principality between the upper Tigris and Euphrates rivers (now in Turkey). In the centre of the bowl is a roundel showing the ascension of Alexander the Great, a theme that must have come from a western source, probably within the vast confines of the Byzantine Empire; on the other hand, Arabic and possibly Persian inscriptions underscore the Islamic aspect of the piece. The conception of apotheosis as prefigured by the famous conqueror of the world is set in a wider regal ambiance. Inside and outside the rim are images of animals and animal combats, possibly symbolizing princely aspirations, and also court attendants and entertainers: dancing girls, musicians, acrobats, and a princely cupbearer.

The dearth of surviving metalwork from the later twelfth century is partly made up for by a

384. Enamelled bronze bowl, probably northern Mesopotamia, twelfth century (third quarter). *Innsbruck, Tiroler Landesmuseum Ferdinandeum*

wealth of objects from the first half of the thirteenth century. At that time the sudden flowering of the local craft tradition, which perhaps drew its raw materials from copper mines in the Jazira, seems to have been helped along by an influx of refugee metalworkers from Iran, whose presence can be construed from the *nisba* of one of them,[60] as well as from stylistic evidence. The more traditional aspects are represented by cast bronze mirrors bearing figural reliefs on their round backs. Although a portable object, a royal aspect was imparted to a large mirror made in the mid thirteenth century for Artuq Shah, a member of the Artuqid dynasty, by placing an eagle in high relief in the centre and framing the mirror back with a long princely inscription [385]. In the intermediary space are figures of the zodiac constellations and 'classical' busts of the planets. This dependence upon classical or Byzantine prototypes and emphasis on propitious heavenly bodies is also reflected in contemporary copper coins issued in the Jazira and helps to define its iconographic preferences.[61]

385. Mirror of Artuq Shah (back),
probably northern Mesopotamia,
mid thirteenth century. Bronze.
Harburg, Graf Oettingen-Wallerstein Collection

386 (*opposite*). Ewer, Mosul, 1223.
Brass inlaid with silver.
Cleveland Museum of Art

Artistically the most important metal pieces
from this region were those inlaid with silver.
The earliest dated example is a miniature box
of 1220 in the Benaki Museum, Athens, but
production must have begun around the turn of
the century, for the maker of the piece, Isma'il
ibn Ward, was a pupil of an already-practising
master called Ibrahim ibn Mawaliya.[62] Both
artisans ended their signatures with the generic
'al-Mawsili', 'of Mosul' – a designation used on
twenty-eight objects[63] (one as late as 1321) by
twenty metalworkers – thus implying metal
production in that city; but only one, Shuja ibn

Mana, stated specifically that he made his piece, a ewer, in Mosul in 1232; a second named Damascus, and five others Cairo. In other instances names of the owners suggest that Mosul itself was not the city of origin. Indeed, only six pieces, besides the one by Shuja, can be said certainly to have come from Mosul, for they were ordered by the local ruler Badr al-Din Lulu (1237–59) or by members of his court.[64] Many Mawsili artists worked in styles quite different from those attested by these six pieces, and in the work of one single artist there are stylistic differences that may imply various locales.[65] This pattern reveals how difficult it is to make attributions of metal objects from this period when historical inscriptions are lacking.

There are, however, certain features that do distinguish the metalwork of the Jazira, including that of Mosul, from contemporary Iranian production. First, representations of princes, still rather rare in Iran, are frequent, which is only natural in view of the high percentage of pieces known to have been ordered by royal patrons. Indeed, the princely theme is the keynote of these works, and it is further developed into an encompassing royal ambiance. On the other hand, genre scenes extend well beyond the stock Iranian motifs of revellers, hunters, and polo players. Their variety is astonishing: gardeners with spades and mattocks, peasants ploughing with pairs of oxen, a flute-playing shepherd in the shade of a tree surrounded by his flock and faithful dog, boys shooting at birds with blowpipes, a relaxed youth reclining on a couch with his cupbearer and *sommelier* in attendance, a noble lady admiring herself in a mirror while a servant girl stands by with a box of toiletries, and so on [386].[66] Even the more formal royal images are set outdoors and are connected with merrymaking and hunting. Like the ceramic decorators of Iran, the Mosul metalworkers owed much of their rich repertory to the inventiveness of manuscript illustrators. Although it is not always possible to distinguish the painting styles of Iraq, the Jazira, and Syria in this period, their fundamental importance as sources of imagery for the decorative arts in

their regions can be observed again and again (see discussion of manuscript painting, below).

More surprising still is the novel organization of themes. Whereas parallel bands, unrolling without interruption, and differently shaped spaces filled with closely packed motifs of equal importance are typical of Iranian work, in the Jazira they were replaced by sequences of vignettes, some of them relatively large, some small. Such a display of individual motifs could easily have resembled disjointed samplers, but the craftsmen knew how to organize vessel surfaces by connecting the frames around the images and by using smaller ornaments as links. In addition, the vessels are encircled at various levels by bands that tie the compositions together. Furthermore, the even flow of main elements, which might otherwise be monotonous, is punctuated at intervals by secondary motifs. Even the spaces between the vignettes have an artistic function. They are no longer undecorated and therefore neutral, as they are on Iranian works; instead they are covered with delicate webs of arabesques or interlocking fret patterns based on swastikas or Ts,[67] which lend tension to the surfaces and serve as foils for the main features. By these means the monophonic coordination of equal parts has been replaced by a polyphonic form of graded subordination, in which the many different parts of a complex composition are made to interact and interrelate. As a result, both aesthetic and intellectual requirements are fully satisfied. No wonder, then, that metalworkers of Mosul origin were in demand in the highest places everywhere: their works 'were exported to kings', according to a contemporary Spanish Muslim,[68] and that is why they signed their products with the name of the town from which they hailed.

Mosul, like Sinjar and Takrit, was also renowned at this time for large unglazed water jars, which attained a high artistic level in response to the demands of the affluent in the twelfth and thirteenth centuries. This is the culmination of a long development of such household vessels whose antecedents predate the arrival of Islam in the Near East and whose

descendants have continued in use down to the modern period. All the parts above the rounded bottoms of the storage jars (which were set into the ground or placed on stands) were covered with relief decoration, adroit combinations of moulding, engraving, carving, piercing, and barbotine work [387].[69] The motifs constitute

387. Ceramic *habb* (water storage vessel), probably northern Mesopotamia, thirteenth century. *Damascus, National Museum*

a fascinating potpourri of ancient gods and their sacred animals juxtaposed with the latest images of Seljuq princes, musicians, revellers, and court officials. The owner of such a piece could thus demonstrate his prosperity in a single product based on folklore and splendidly decked out for conspicuous consumption.

Other ceramic products apparently peculiar to Mesopotamia include rather large, individually moulded, unglazed relief figures of courtly attendants, many of them found at excavations and now in the Iraq Museum in Baghdad.[70] Their undecorated flat backs suggest that they must have been applied to large flat surfaces. Possibly they had a function similar to that of the more three-dimensional bronze figures still attached to the walls of a mortar in the Gulistan Museum, Tehran, and a strongbox with number locks of 1197 in the Museum of Fine Arts, Boston, both probably made in Iran.[71]

SYRIA

Syria functioned as a bridge between the East (particularly Iraq and the Jazira) and Egypt and the West. In the same way Raqqa, artistically a particularly active city on the left bank of the Euphrates, served as a natural link between Syria and the Jazira. In Seljuq times terrritories on both sides of the river were united under the rule of a single or several related princes; thus Zanki (1084–1146), who first drove the Crusaders from the state of Edessa (modern Urfa in Turkey), reigned over both north Syria and the Jazira. When he was murdered, his eldest son took control of Mosul, while a younger son, Nur al-Din, the famous enemy of the Crusaders, ruled in northern Syria, at first with Aleppo as his capital. There was thus considerable cultural interchange, and Syria was much influenced by the Jazira.

Woodwork

Of the outstanding wood carvings salvaged from mosques, many reflect the mainstream of historical events. The chief production centre at this time seems to have been Aleppo, where several masters signed their works and we know of at least one son following his father in making mosque furniture – a parallel to the family of potters producing mihrab tiles in Kashan.[72]

388. Screen, formerly used in the Musalla al-Idayn, Syria, 1104. Wood.
Damascus, National Museum

One early piece (dated 1104), a *maqsura*, or screen, probably intended as an enclosure for a tomb in a cemetery at Damascus and now in the National Museum there [388],[73] clearly reflects the pivotal position of Syria, for it incorporates certain principles of the abstract style C of Samarra and also closely parallels contemporary Fatimid pieces (see pp. 187-8 and illustrations 170 and 171). This archaizing tendency was to continue for at least another sixty years. A minbar of Nur al-Din, formerly partly preserved in the Great Mosque at Hama and dated to 1163, was also executed to some extent in the purely linear style C; other sections, however, were deeply carved to produce a carefully planned lacework of spiralling, bifurcating, and intersecting stems, all of the same width [389]. In their clarity and formality these coiling stems, which produce few leaves or flowers, are remote from natural forms. They cross and recross the arched configuration of the fillet, 'which is no longer a boundary but a melody running through a fugue', as Ernst Herzfeld aptly described it, thus emphasizing the innate musical quality of the design.[74] This austere, almost abstract style is an appropriate reflection of the age of Islamic scholasticism, dominated by the puritan, even ascetic Nur al-Din, who had devoted his life to waging 'war against the enemies of his faith', as he claimed in his minbar inscription, and to leading the *jihad* against the Crusaders. The closest stylistic parallels are the carvings on a stone mihrab in Mosul executed by a Baghdadi artist during the reign of Nur al-Din's brother Ghazi. A more developed version of the same type can be seen on a wooden door of 1209 donated by the reigning Caliph al-Nasir al-Din Allah (1180-1225) to a sanctuary in Samarra.[75]

Other wood carvings connected with Nur al-Din include a door in his hospital at Damascus (1154), a mihrab in the citadel of Aleppo (1168), and, most important of all, the minbar (now destroyed) for the Aqsa mosque in Jerusalem, begun in 1168 but not finished until 1174, after Nur al-Din's death [390]. The minbar was to be a thankoffering for the reconquest

389. Hama, mosque of Nur al-Din, minbar (destroyed), 1163

of the holy city, which Nur al-Din did not live to see; in the meantime, it was kept in the Great Mosque at Aleppo, where three carvers had produced it under the guidance of a master 'unequalled in the perfection of his art', in the words of the historian Abu Shama (1203-68). After Jerusalem was finally taken in 1187, Nur al-Din's successor as leader of the *jihad*, the famous Salah al-Din (Saladin), placed the minbar in its destined home.[76]

It is clear that this style could hardly have been developed further. A pair of wooden doors

390. Jerusalem, Aqsa mosque,
minbar (destroyed), Aleppo, 1168–74. Wood

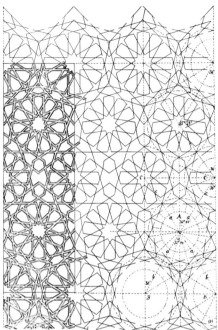

391. Geometric design on a pair of wooden doors
dated 1219 in the citadel of Aleppo

Herzfeld described the composition of eleven-pointed stars intercalated with twelve- and ten-pointed stars as an 'almost unsolvable problem' and the 'most complicated design ever produced by that branch of art'.[77]

Metalwork

While the woodwork just discussed served sacred purposes, in other media – particularly inlaid metalwork – secular aspects prevailed.

With the possible exception of some courts in cities of the Jazira, Syria was the first main region in the Ayyubid period (1175–1260) to attract the migrating Mosul metalworkers. Consequently the distinction between Mesopotamian and Syrian inlaid pieces is not easy to draw,[78] as D. S. Rice, one of the foremost modern students of Islamic metalwork, has noted. The stylistic differences are more subtle

dated 1219 in the citadel of Aleppo [391] reflects a different tendency, towards geometric configurations related to those developed in Egypt after the middle of the twelfth century. The Syrian craftsmen's mastery is still amazing, and

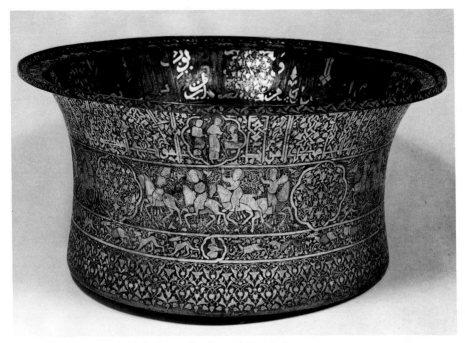

392. 'Arenberg' basin, probably Syria, 1239/49. Brass inlaid with silver.
Washington, D.C., Freer Gallery of Art

and the borrowings more wholehearted than, for example, those between Persian and Mesopotamian work. The complex 'polyphonic style' of the Jazira continued, including the fretted backgrounds, but in Syria the work was in general dryer and more meticulous; representations such as throne scenes became more formal and the arabesque spirals in the background more pronounced. Nevertheless, the short Ayyubid period is commemorated by some remarkable and varied pieces of inlaid metalwork, often with novel features. Foremost among them is the use of Christian motifs, including New Testament scenes and, within arcading, figures of ecclesiastics and saints: one example is the so-called Arenberg basin (Freer Gallery of Art, Washington, D.C.) [392] made for the Ayyubid Sultan of Cairo and Damascus al-Malik al-Salih Ayyub (1239-49).[79] An anonymous canteen in the same museum bears Christian subjects alongside a battle scene between several Crusading knights and a lone Muslim, thus implying an owner with pronounced pro-Frankish leanings.[80] Another feature found first on a Syrian piece is gold inlay, which was used on a basin made in 1250 by another Mosul metalworker, Da'ud Ibn Salama.[81]

An even better aid to attribution than stylistic and iconographic clues, however, are inscriptions, which give the dates and original owners (usually royal) of many distinguished objects. The earliest inlaid piece with an Ayyubid association, a ewer made in 1232 by Qasim ibn Ali of Mawsili origin [393],[82] has a unique decorative scheme that would be difficult to place without the evidence of the inscription. Both body and neck are covered, not with the usual figural designs, but exclusively with fine arabesques enclosed in a network of ovoid compartments - the first occurrence of the all-over,

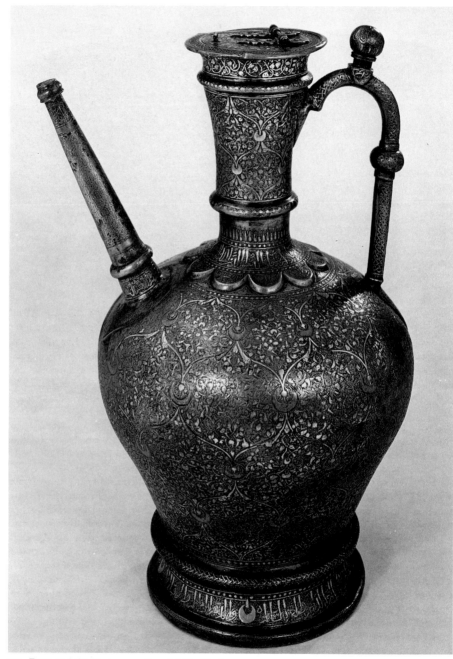

393. Ewer, probably Syria, 1232. Brass inlaid with silver.
Washington, D.C., Freer Gallery of Art

purely abstract vegetal pattern on metalwork which was to be more common as time went on, especially in the late fifteenth century.

Pottery

The city of Raqqa was the centre of the one region outside Iran that produced a sizable quantity of artistically inventive and technically varied ceramic wares and tiles during the final period of the Seljuq successor states (c. 1175–1259).[83] Here Iranian and some Egyptian influence is apparent side by side with borrowings of shapes from other media in such pieces as low triangular, square, rectangular, and octagonal tables; réchauds with relief decoration or ornamentation derived from turned wooden originals; and pierced mosque lamps imitating metal prototypes. There are also several purely ceramic shapes, like bowls with strongly contracted side walls, high-necked pitchers on tall feet, compotiers, high-shouldered vases with low necks carved in high relief, and bath scrapers, often in the shape of animals. Compared with eastern wares the range of techniques is fairly small but in some respects distinct: Syrian lustre – of a deep purplish tint often combined with a somewhat paler deep blue – was used either for silhouette effects or for designs reserved from a ground of small spirals. There are also two types of underglaze painting, one with black patterns silhouetted under a turquoise glaze [394], the other with delicate designs, often including human figures or animals, painted in black and green, black and blue, or black, blue, and brown-red pigments under a transparent greenish glaze. Finally, there are turquoise-glazed monochrome pieces, one with bold but sketchy ornamentation, another with repetitive chevrons, spirals, staggered ovoids, connecting rings, and chequers. Regardless of decoration, the ceramic body is rather coarse and sandy, whereas the glazes are prone to decay, so that iridescence often covers large areas of the surviving pieces.

As with metalwork, there was a connection with the Crusaders, primarily with ceramics

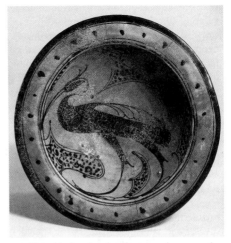

394. Plate, black-painted under turquoise-green glaze, Raqqa, Syria, late twelfth/early thirteenth century. *Washington, D.C., Freer Gallery of Art*

originating in the Holy Land itself.[84] Craftsmen working for the Frankish barons apparently produced a sgraffiato ware with designs of cavaliers, animals, and patterns in brown and green on a white ground, and this influence seems apparent in a piece from Raqqa with the unusual motif of a Norman shield with a two-coloured chevron band.[85]

Glass

The appearance of a piece of glass decorated with gilding, polychrome enamelling in white, blue, turquoise, red, yellow, and occasionally black pigments, and outline drawing in red has not yet been fully clarified, but undoubtedly owes a great deal to the dispersion of Egyptian craftsmen after the fall of the Fatimid dynasty in 1171.[86] Indeed, the major techniques involved had already been practised separately in the Nile valley, and during an intermediary period at the end of the twelfth century the monochrome gold painting was occasionally enlivened with enamelled dots. The rich polychromatic combinations of various techniques

were probably inspired by the rise of miniature painting (see below), and therefore it is not surprising that the repertory of designs included figural scenes as well as arabesques, vegetal patterns, animals, formal motifs, and inscriptions in both *naskh* and, to a lesser extent, Kufic. The few complete pieces surviving and the small fragments on which historians must rely for evidence fortunately suffice to show that the figural scenes were for the most part courtly, including such universal Seljuq favourites as the enthroned prince, galloping horsemen, falconers, hunters, polo players, musicians, and revellers. Unusual in comparison with contemporary Seljuq book paintings, however, is the predilection for architectural frames with specific and realistic details; but it should be remembered that architectural features, popular in pre-Islamic floor mosaics in Syria and occurring at the beginning of the eighth century in the wall decorations at the Great Mosque of Damascus [15], continued on mosaics, metalwork, pottery, and wood carvings and therefore constituted a regional feature, adopted even for the rather unlikely medium of glass. They are thus an important clue to the nearly lost art of Ayyubid painting.[87]

There was no sharp break between the Ayyubid and Mamluk periods in the tradition of glassmaking, for decoration by enamelling and other processes of glass painting, probably reaching its apogee around 1250, continued at a high level of quality into the latter half of the century. Even before Raqqa – probably the earliest centre – was destroyed by the Mongols in 1259, workshops producing characteristic wares appear to have been established in Aleppo and Damascus, too. Most popular were tapering beakers with outward-curving rims, a shape which also served for single lamps or polycandela (of which at least one example from Iran has been preserved, now in the Walters Art Gallery in Baltimore[88]). The glasses had a wide distribution: many – of whose provenance we cannot be sure – are said to have been found as far away as in Tartar graves in southern

Russia.[89] Other characteristic shapes include rosewater sprinklers with tall, tapering necks, straight-sided mugs, and buckets. The production of mosque lamps with high, wide, flaring necks also began at this time, reaching its peak in the fourteenth century.

Historical inscriptions in this medium are much less common than on metalwork in Mesopotamia and Syria, and it seems that the glass industry was not at first a royal one. A few additional clues come from finds in Crusader castles whose destruction dates are known. The popularity of enamelled glass among the Frankish invaders of the Holy Land is attested not only by fragmentary vessels found in the ruins of their châteaux and by objects brought back for deposit in European churches, but also by the

395. 'The Luck of Edenhall', probably Syria, thirteenth century. Glass with enamelling. *London, Victoria and Albert Museum*

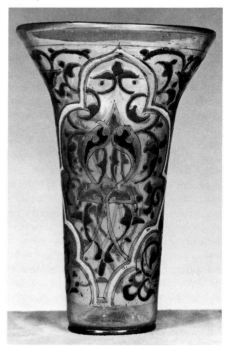

fact that this de luxe technique is the only one the Franks seem to have copied from the Muslims while they were in Syria: an example of it is the beaker in the British Museum signed by Magister Aldrevandin.[90] Unquestionably Near Eastern products greatly influenced also Venice, the foremost European glass-manufacturing centre, in its formative years, as is amply demonstrated by the enamelled dots common to both of them. The mystique of these vessels continued to enthral the West long after the Middle Ages, as is evident from Ludwig Uhland's poem 'Das Glück von Edenhall' and Henry Wadsworth Longfellow's English version of it.[91] The 'Luck of Edenhall' was shattered; but fortunately the enamelled Syrian beaker that inspired the poems exists today in perfect condition in the Victoria and Albert Museum, London [395].

Manuscript Illustration

Painting in Mesopotamia and Syria was so closely related in theme, style, and iconography that it seems best to treat it under a single heading. Thematically the material falls into two, perhaps even three, major groups: illustrations of technical and scientific subject matter as visual aids to ensure proper identification and to facilitate explanation; illustrations accompanying works of *belles-lettres*; and possibly also illustrations to philosophical treatises.

The first category consists mainly of self-contained pictures accompanying works by authors such as al-Sufi, ibn al-Ahnaf, ibn Bukhtishu, al-Zahrawi, and al-Jazari, as well as the anonymous writers known as Pseudo-Aristotle and Pseudo-Galen. Arabic translations of works by Dioscorides and Heron of Alexandria were also copied and illustrated.[92] The subjects depicted range from personifications of constellations to animal representations, illustrations of veterinary procedures, medicinal plants, surgical instruments, and automata 'gadgets'. Episodic action is relatively rare and reflects the influence of the next thematic category.

This second group consists primarily of illustrated copies of two books that were very popular in the Middle Ages. The first, *Kalila wa Dimna*, was a compendium of fables named after the two main characters, a pair of jackals; allegedly composed by the wise Brahman Bidba (or Bidpai), it belongs to the literary genre of 'mirrors for princes', which embodies precepts for rulers about proper government, made palatable by the animal guises of the characters. These stories originated in the Indian *Pañchatantra*, of which a Middle Persian version had been translated into Arabic under the title *Kalila wa Dimna* in the eighth century.[93] The second 'best seller' was an indigenous Muslim creation, *Maqamat* (*Assemblies*, or *Entertaining Dialogues*), originally written in Arabic by the Iranian al-Hamdhani (968-1007), though it is the popular version by the Iraqi al-Hariri (1054-1122) that was frequently copied and lavishly illustrated.[94]

The text consists of fifty picaresque tales narrated by al-Harith ibn Hammam, each set in a different part of the Muslim world. In every story a group of people is so overwhelmed by the astounding eloquence and erudition of an aged stranger, Abu Zayd of Saruj, that in the end they amply reward him with money, which he as often as not spends improperly. The real purpose of the book is a demonstration of most elaborate linguistic fireworks, and therefore only the barest indications of action and setting are given. A painting cannot, of course, reproduce philological artifice, and the book is thus in principle totally unsuited to illustration: yet several copies are enriched by a series of imaginative compositions in appropriate, often quite detailed settings in which the characters express by attitude and gesture the liveliest interest and even active participation in the proceedings. The wealth and variety of scenes – often several episodes in one story – is astonishing, and varies from manuscript to manuscript.[95] There are episodes on land and sea; in towns, villages, and deserts; indoors and

outdoors; involving human beings, animals, or both. Scenes in mosques and palaces occur, but those of everyday urban life constitute the characteristic settings. Keen insight into the psychology of situations and personality types is the hallmark of this art. Also noticeable is a tendency towards satire, directed against the Turkish ruling class,[96] which reveals sentiments then apparently shared by much of the Arab population of the Middle East. Indeed, these miniatures provide a unique mirror of contemporary civilization.

A special kind of painting, common to both groups of miniatures, is the frontispiece. There seems to have been no hard and fast rule, but scientific treatises are generally introduced by 'author portraits', while manuscripts dealing with *belles-lettres* frequently include idealized 'portraits' of rulers, sometimes of the patrons of the books.[97]

A sparsely represented and therefore vaguely defined third group – illustrations to philosophical treatises or wisdom literature[98] – exhibits most features of the second group in addition to the introductory 'author portraits' of the first.

From the stylistic point of view, and occasionally, it would seem, reflecting regional origins, three major categories can be established, which to some extent cut across the boundaries of the thematic groups. At present, however, the number of manuscripts and the historical data they contain are too limited to permit further, more precise classification.

In the first stylistic category there is heavy reliance on Byzantine prototypes, including scientific works and Bibles, Gospels, and lives of saints.[99] Although human figures are shown in Islamic garb and settings, quite often their postures and even groupings derive from Greek manuscripts. Identical copies of whole compositions, feature by feature, are rare; usually different elements have been adapted and rearranged, and motifs from other sources as well as contemporary additions are incorporated. Most important from an artistic point of view is the frequent 'humanization' of the figural scenes: personal relations exist between figures, usually between a speaker and a listener; and, compared to the Greek models, the action has far greater immediacy and relevance [396].[100] On the other hand, vegetal forms are more

396. Solon and his students from al-Mubashshir, *Mukhtar al-Hikam*, MS. Ahmet III, 3206, f. 24r, probably northern Mesopotamia, early thirteenth century. *Istanbul, Topkapı Sarayı Library*

397. Dimna and the lion from *Kalila wa Dimna*, MS. Ar. 3465, f. 49v, probably Syria, 1200-20.
Paris, Bibliothèque Nationale

٢٨

سِفَاكٌ وَعَيْنِيَّةٌ مُخَالٌ عَلَى مَنْ لَبِّنْ بِغَنَا لَا فَقَالَ الْوَالِي لِلشَّيْخِ إِنْ شِهِدَ لَكَ عَدْلَانِ مِنَ الْمُطِينِ
وَإِلَّا فَأَسْتُوفُ مِنْهُ الْيَمِينَ فَقَالَ الشَّيْخُ إِنَّهُ جَعَلَهُ خَاسِئًا وَأَفْجَأَ خِدْمَهُ خَالِبًا فَأَنِّي لِي بِشَاهِدِ وَلَكِنْ

٣٩٨ and ٣٩٩. Abu Zayd before the governor of Merv (*above*) and scene before a village (*opposite*)
from al-Hariri, *Maqamat*, MS. Ar. 5847, ff. 26r and 138r, Baghdad, 1237.
Paris, Bibliothèque Nationale

stylized, and the treatment of animals more varied: sometimes they are conventionalized, but often they take on human traits [397]. The influence of Greek originals is especially clear in the three-dimensional modelling of figures by means of shading and the relatively natural fall of garment folds.

In this category are to be found many of the illustrated scientific texts, of which the finest are two Dioscorides manuscripts in Istanbul, one dated 1224, the other 1229.[101] Of several al-Sufi manuscripts, the most spirited are in Istanbul, Paris, and London, the first dated 1130, the last two undated but of the thirteenth century.[102] Some literary works, primarily a Maqamat of 1222, also belong to this group.[103] The Dioscorides copy of 1224 and a Pseudo-Galen of 1199[104] incorporate features from the second stylistic category, too, pointing up the cross-fertilization that occurred in much of the art of this period. The colophon of the 1229 Dioscorides contains expressions in Syriac, perhaps indicating an origin in Syria or the Jazira; furthermore, some of the architectural details in the 1222 Maqamat and two related copies of Kalila wa Dimna are characteristic of the area of Aleppo.[105]

The second stylistic category, apparently without a single firm tradition, is basically original, despite some Byzantine borrowings for garments and landscape and the adoption from western India of the device of drawing faces in three-quarter view with the 'projecting farther eye' [398]. This group is best represented by three fine Maqamat manuscripts copied and illustrated in Baghdad: an undated one in Leningrad, probably executed between 1225 and 1235; a second painted by Yahya ibn Mahmud al-Wasiti in 1237; and, possibly the most elaborate but unfortunately also the most desecrated by iconophobes, a copy made during the reign of the last Abbasid caliph, al-Mutasim billah (1242–58).[106]

In contrast to the first group, the emphasis here is on action and on realistic detail in settings and trappings. Instead of moulding the body, garments swirl around it under the impetus of rapid motion, and this effect is underscored by energetic gesture and lively facial expression [399]. Despite the originality of this 'Iraqi action style', medieval artists in the Near East, as in the West, customarily worked from earlier models, so that related or parallel sources probably furnished catalysts, if not prototypes; the most likely are the brightly coloured figures and evocative scenery from the shadow plays discussed earlier in this chapter. Whatever their sources, the Maqamat miniatures must be regarded as the outstanding pictorial creations of the period and the finest ever produced in the Arabic-speaking world. Indeed, the Iraqi action style had so much vitality that it survived the sack of Baghdad by the Mongols in 1258 and the collapse of the ruling caliphate. A double frontispiece with 'author portraits' in the same animated manner appears at the beginning of a copy of Rasa'il Ikhwan al-Safa (The Epistles of the Sincere Brethren) of 1284.[107] Even as late as 1297 or 1299 the same style enlivened eleven miniatures of mammals in the first part of a Persian copy of Manafi al-Hayawan (Uses of Animals) by ibn Bukhtishu, painted in Maragha in north-western Iran.[108] After this the style disappeared.

The third, 'hieratic' category comprises two specific types of miniatures rather than the sum total of illustrations in a given manuscript. The first is the 'princely frontispiece' where the enthroned, frontally rendered large ruler is flanked by smaller attendants standing stiffly at attention or ready to serve. These compositions are akin to the royal representations on Sasanian rock reliefs, which were also adapted to various 'post-Sasanian' scenes (see Chapter 6); they occur particularly in manuscripts attributable to Mesopotamia, including several volumes of one set of the Kitab al-Aghani (The Book of Songs) probably copied for a prince of Mosul in the second decade of the thirteenth century and the 1237 Maqamat from Baghdad.[109] The second type is the antithetical scene, especially as found in Kalila wa Dimna illustrations, in which pairs of animals flank central trees or plants.[110] This device, too, is known from Sas-

anian and 'post-Sasanian' silver, stuccoes, and silks. Other ancient traditions must also have persisted in medieval compositions, but, as almost all Sasanian and eastern Islamic figural painting of the early period has been lost and can be only partially reconstructed by means of imagery from other media, it is difficult to identify them. Nevertheless, the fact that these two types of miniatures occur in manuscripts attributable to several different regions of the Near East attests to the thoroughness with which Sasanian traditions had been absorbed into the arts of the Islamic world.

ANATOLIA

Although objects known to originate from, or fairly certainly attributable to, Seljuq Anatolia are limited in number, they often display originality and high quality. Compared with the prevailing eclecticism in architecture, as demonstrated both by an unusual range of experimentation with established building types and by the often unintegrated sculptural decorations on portals, the decorative arts were much more mature. As Anatolia had been taken from the Byzantines only after 1071 and had then been settled by heterogeneous groups of Muslims, this rapid cultural consolidation was a major achievement. Nearly all surviving objects date from the thirteenth century; indeed, as the Mongols did not at first interfere with the indigenous culture after their significant Anatolian victory in 1243, the Seljuq style continued to evolve until about 1300.

Anatolian art differs in several ways from the art of other Seljuq and successor states. The human figure is much less important, especially in complex 'polyphonic' compositions: the stress is on formal pattern, particularly arabesques, and, to a lesser degree, on calligraphy. Animal designs are frequent, even in religious contexts, partly perhaps reflecting totemistic or cosmological concepts adapted to princely symbolism; similar designs, first adopted for religious buildings in the Jazira, seem to have been particularly popular for the same purpose in Anatolia under the Seljuqs and related princes.[111]

Several outstanding religious objects exhibit all these stylistic features at once. An example is a folding wooden Koran stand (Turkish *rahle*) made, according to its elegant cursive inscriptions, in 1279 for the tomb of the mystic poet and saint Jalal al-Din Rumi in Konya, the Seljuq capital of Anatolia [400].[112] The four outer surfaces, all originally painted and gilded, are each carved with a rhythmic arabesque composition. On the two upper surfaces is a twice repeated design of a double-headed bird of prey

400. Koran stand from the tomb of Jalal al-Din Rumi, probably Konya, 1279. Walnut, painted and gilded. *Konya Museum*

401. Fragment of lion silk,
probably Anatolia, 1219/37.
Lyon, Musée Historique des Tissus

on a field of arabesque spirals and leaves sprouting lions against a gold background. On two sets of doors with similar motifs, one from the Öğle mosque,[113] the other from the public soup kitchen (Turkish *imaret*) of Ibrahim Bey in Karaman, the basic repertory of arabesques and inscriptions is enriched by an infinite pattern of twelve-pointed stars in the large central medallion; in addition, despite the religious and public settings of the doors, there are large pairs of confronted winged lions and addorsed griffins, as well as a frontal sphinx.

Particularly splendid is a bronze mosque lamp, originally gilded, known from its inscription to have been made at Konya in 1280.[114] On its body are graceful arabesques in repoussé, a technique otherwise rare on bronze objects of this period. The chief decoration on the neck is a Koranic passage referring to the lamp as a symbol of Allah (see p. 330). The entire surface is pierced to allow light to shine forth from a glass container within, casting intricate and beautiful shadows. Three bulls' heads serve to attach the suspension chains.

On at least two of these three objects made for shrines at Konya the animal imagery was fairly unobtrusive, but no such restraint was necessary for a textile probably belonging to Sultan Kayqubad ibn Kaykhusraw (1219–37).[115] Two addorsed lions in roundels form the main design, in gold on a crimson ground, with the ever-popular arabesques filling the space within and between the circular frames [401]. Once again the general layout, juxtaposed animals, and interstitial configurations betray distant Sasanian origins, but a new elegance and lightness permeate this design, which surpasses even those of the few known approximately contemporary Iranian fabrics (see p. 336).

The polished grace and virtuosity of the pieces discussed before are in stark contrast to the characteristics of knotted wool carpets, generally regarded as historically the most significant works of Seljuq Anatolian art. Eighteen fragments were discovered in the main mosques of Konya in 1903 and of Beyşehir in 1925; more recently smaller pieces have turned up in the rubbish heaps of Fustat (old Cairo).[116] All had been finely woven on looms up to about ten feet wide – too big to be easily transported; the average density is seventy-seven 'Turkish' knots to the square inch. The carpets were thus

402. Wool carpet (detail) from the mosque of Ala al-Din, Konya, early fourteenth century. *Istanbul, Türk ve Islam Eserleri Müzesi*

in all probability produced in urban work-shops.[117]

The field designs consist of small patterns of hexagons, octagons, stars, stylized flowers, or arabesques in staggered rows or in diaper networks; the borders, on the other hand, include combinations of Kufic letters larger in scale than the field units [402].[117a] What lends these carpets true monumentality, however, is their strong, usually dark colours, five to eight to each carpet, often with two tones of the same colour on a single piece, suggesting more than ordinary artisanal skill. According to one scholar, 'these oldest carpets are at the same time the most magnificent ... Such monumentality was never again attained ... The finish of this group is amazing, no less the wealth of forms displayed.'[118]

The most important of the fragments were found in the mosque of Ala al-Din at Konya (c. 1235); it was thus at first assumed that the carpets were brought there on the order of one of the Seljuq sultans, dated from the thirteenth century, and were probably from Konya itself.[119] More recently, however, Geijer has recognized that one of them is an angular version of a Chinese silk with staggered stemmed flowers dating from about 1300, so that the carpet paraphrase cannot have been made much before 1325.[120] As the general character, colour scheme, and border design of this piece are typical of the 'Konya carpets', the whole group apparently ought not to be dated before the early fourteenth century. One of the Beyşehir fragments, which has a design different from the others, may even be of the early fifteenth century: it reflects a fourteenth-century Italian textile pattern of twigs with erect and drooping flowers which have been turned into angular arabesques.[121] As 'Konya carpets' were never represented in European paintings, and as only one or two closely related fragments occurred among more than a hundred found at Fustat, they seem to have had chiefly local distribution.

Marco Polo's 'best and most handsome carpets in the world' (*tepedi ottimi e li piu belli del mondo*) were apparently those he saw in Konya, Sivas, and Kayseri in 1271.[122] Contemporary Muslim authors also praised the Turkish carpets of Anatolia, mentioning Aksaray as yet another production centre.[123] But the only group known to have appealed to Italians in the late Middle Ages are 'early animal carpets', examples of which can be found in fourteenth-century sacred paintings, especially before the throne of the Madonna.[124] Stylized birds and quadrupeds, mostly lions, are represented in rows of octagons within squares, all the units being either of the same hue or alternating two sets of colours. Erdmann thought that these carpets might be of the late thirteenth century, i.e. shortly after the time of Marco Polo, but it has now been established that, in at least one instance, there was a greater time lag between manufacture of a carpet in the Near East and its copying by an Italian artist than had been assumed. The whole group may thus belong to the thirteenth century.[125]

As the animal carpets must have been made in a region that traded with Italy, a production centre or centres in or close to western Anatolia seem likely; but since at least one appears in a mid-fourteenth-century Persian miniature probably painted at Tabriz, the neighbouring Caucasus, which also entertained an active trade with Italy through the Black Sea ports, cannot be ruled out either.[126] In any case it has long been recognized that the animal carpets represent angular versions of the repeat patterns typical of Byzantine as well as of Islamic textiles, both ultimately dependent on design principles of Antiquity.[127]

LIST OF THE PRINCIPAL ABBREVIATIONS

AIEO	*Annales de l'Institut d'Études Orientales, Université d'Alger*
Bull. MMA	*Bulletin of the Metropolitan Museum of Art*
Creswell, *EMA*	K.A.C. Creswell, *Early Muslim Architecture*, 2 vols. (Oxford, 1932, 1940), vol. 1 rev. (Oxford, 1969)
Creswell, *MAE*	K.A.C. Creswell, *The Muslim Architecture of Egypt* (Oxford, 1952)
Grabar, *Formation*	Oleg Grabar, *The Formation of Islamic Art* (New Haven, 1973)
Marçais, *Architecture*	Georges Marçais, *L'architecture musulmane d'Occident* (Paris, 1954)
MIFAO	*Mémoires de l'Institut français d'Archéologie Orientale du Caire*
MMAF	*Mémoires de la Mission archeólogique française au Caire*
Sauvaget, *Mosquée Omeyyade*	Jean Sauvaget, *La mosquée omeyyade de Médine* (Paris, 1947)
SPA	A.U. Pope and P. Ackerman, eds., *A Survey of Persian Art from Prehistoric Times to the Present*, 8 vols. (London and New York, 1938 ff.)

NOTES

Numbers in **bold** type are page references.

CHAPTER I

18. 1. For the Ka'ba, as well as for most oriental technical, geographical, and historical terms and names, the best source is the *Encyclopaedia of Islam*, 1st ed. (Leyden, 1913-42); 2nd ed. (Leyden, 1954 ff.).
2. A verse in Abul Faraj al-Isfahani, *Kitab al-Aghani*, 20 vols. (Cairo, 1968-9), I, 15, among many such sources, refers to Madinese palaces decorated with paintings and with high donjons, but it is uncertain whether the reference is to pre-Islamic or early Islamic works.
3. Ignaz Goldziher, 'Die Handwerke bei den Arabern', *Globus*, LXVI (1894), 203-5.
4. Richard Ettinghausen, 'The Character of Islamic Art', in Nabih Faris, ed., *The Arab Heritage* (Princeton, 1946), 252; Charles J. Lyall, ed., *The Mufaddaliyat* (Oxford, 1918), 92 ff., and *The Diwans of Abid b. al-Abras* (Leyden, 1913), 23. For archaeology, see Peter J. Parr, G. L. Harding, and J. E. Dayton, 'Preliminary Survey in N.W. Arabia, 1968', *Bulletin, Institute of Archaeology, University of London*, VIII, 9 (1970), 193-242, and *Atal*, the journal of the Saudi Department of Antiquities. For Christian art in Arabia, see Irfan Shahid, 'Byzantium in South Arabia', *Dumbarton Oaks Papers*, XXXIII (1979), 85-94.
5. Often reproduced, for instance in Richard Ettinghausen, 'Notes on the Lusterware of Spain', *Ars Orientalis*, I (1954), figure 13.
6. Sauvaget, *Mosquée Omeyyade*, 145 ff.; Robert B. Sarjeant, 'Mihrab', *Bulletin of the School of Oriental and African Studies*, XXII (1959), 439-52; Grabar, *Formation*, 120-2.
7. The standard study is still Gustav Rothstein, *Die Dynastie der Lahmiden in al-Hira* (Berlin, 1899).
19. 8. Richard le Baron Bowen and Frank Albright, *Archeological Discoveries in South Arabia* (Baltimore, 1958); Paolo M. Costa, *The Pre-Islamic Antiquities at the Yemen National Museum* (Rome, 1978).
9. Arthur G. and Edmond Warner, trans., *The Shahnama of Firdausi*, 9 vols. (London, 1905-10), VI, 385.
10. Al-Hasan b. Ahmad al-Hamdani, known as Ibn al-Ha'ik, *al-Iklil*, trans. Nabih Faris, *The Antiquities of South Arabia* (*Princeton Oriental Texts*, III) (Princeton, 1938), 13, 14, 17, 26-7.

20. 11. M. Hamidullah, 'Ästhetik und Kunst in der Lehre des Propheten', *Akten des 24. Orientalisten-Kongresses* (Wiesbaden, 1959), 359 ff., and Grabar, *Formation*, chapter 4, present some views and examples.
12. Koranic quotations refer to the standard Egyptian edition.
13. This is only true for the Ka'ba itself; up to very recent times the surrounding areas underwent enormous changes, which have never been fully analysed. For a unique attempt see R. A. Jairazbhoy, 'The History of the Shrines at Mecca and Medina', *Islamic Culture*, Jan.-Feb. 1962.
14. The best summary of the history of the mosque is Saleh Lamei Mostafa, *Al-Madina al-Munawwara* (Beirut, 1981); his reconstructions are the most accurate.
15. Carl H. Becker, 'Die Kanzel im Kultus des alten Islam', *Islamstudien*, I (Leipzig, 1924), 450-71; Sauvaget, *Mosquée Omeyyade*, 140-4; Creswell, *EMA*, I, 13-14.
16. On the basis of one poetical fragment, the suggestion has been made that the Prophet built a separate masjid (Ghazi Bisheh, *The Mosque of the Prophet in Madinah*, University of Michigan thesis, 1981); the possibility does exist, although the evidence at this stage is not conclusive.
17. On these see now Mostafa, *op. cit.*, 135 ff.
21. 18. Koranic passages and passages from the Traditions dealing with mosques have been gathered by Husayn Munis, *Al-Masajid* (Kuwait, 1981), 11-29.
19. Erica C. Dodd and Shereen Khairallah, *The Image of the Word* (Beirut, 1981), for examples.
22. 20. Thomas Arnold, *Painting in Islam* (Oxford, 1928), 5.
21. Grabar, *Formation*, chapter 4; and *idem*, 'Islam and Iconoclasm', in Anthony Bryer and Judith Herrin, eds., *Iconoclasm* (Papers given at the ninth Spring Symposium of Byzantine Studies, University of Birmingham, March 1975) (Birmingham, 1977), 45-52.
22. Bishr Farès, *Essai sur l'esprit de la décoration islamique* (Cairo, 1952).
23. Erica Dodd, 'The Image of the Word', *Berytus*, XVIII (1969), 35-79.
23. 24. Carl Becker, 'Der Islam als Problem', *Der Islam*, I (1910), 16.
25. The high level of economic development of con-

quered areas has been demonstrated for Iraq by the surveys carried out by Robert McC. Adams, *Land Behind Baghdad* (Chicago, 1965) and *The Uruk Countryside* (Chicago, 1972). Matters are less clear in Syria and Palestine, but the extraordinary and still largely unpublished body of sixth- to eighth-century mosaics in Transjordan must be connected with an equally high level of growth. The same is true of Central Asia. For other areas investigations still need to be conducted.

26. For an introduction to Coptic art, see Klaus Wessel, *Koptische Kunst* (Recklinghausen, 1963), which is hardly the last word on the subject.

24. 27. See below, p. 42.

28. The exact character and importance of Sasanian art are still a matter of debate, and the view expressed here is in part that of the medieval Muslim tradition and of the Iranocentrism of certain recent scholarship. In reality matters may have been less brilliant. Compare Roman Ghirshman, *Persian Art: the Parthian and Sassanian Dynasties* (New York, 1962) and Prudence Harper, *The Royal Hunter: Art of the Sasanian Empire* (New York, 1978) with Oleg Grabar, *Sasanian Silver* (Ann Arbor, 1967) and Lionel Bier, *Sarvistan, A Study of Early Iranian Architecture* (University Park, Pa., 1986).

29. Daniel Schlumberger, *L'Orient hellenisé* (Baden-Baden, 1969).

30. Sirarpie Der Nercessian, *Armenian Art* (Paris, 1978). Most recent books on Georgia are either in Russian or in Georgian.

25. 31. Guitty Azarpay, *Soghdian Painting* (Berkeley, 1979), is the most accessible introduction.

32. André Grabar, *L'iconoclasme byzantin* (Paris, 1959).

CHAPTER 2

26. 1. The best introduction to early Islamic civilization is Dominique and Janine Sourdel, *La civilisation de l'Islam classique* (Paris, 1968).

2. See Chapter 1, Notes 28 and 31, for works that discuss this problem.

3. John Walker, *A Catalogue of the Arab-Sassanian Coins* (London, 1941) and *A Catalogue of the Arab-Byzantine and Post-Reform Umaiyad Coins* (London, 1956).

4. Joseph Schacht, *An Introduction to Islamic Law* (London, 1964), and various works by Joseph Van Ess, for instance *Zwischen Hadit und Theologie* (Berlin, 1975).

5. Oleg Grabar, 'Notes sur les cérémonies umayyades', in Myriam Rosen-Ayalon, ed., *Studies in Memory of Gaston Wiet* (Jerusalem, 1977), 51-60.

27. 6. For the few remaining examples, see below, p. 71.

7. These include only remains which have been either properly studied or are otherwise dated or datable. There is a large number of houses, mosques, at times larger establishments for which an Umayyad or early Islamic date is possible. In most cases, these are all works of what is now called vernacular architecture, essentially an architecture for which the *time* of construction is not a significant factor. For examples, see Jean Sauvaget, 'Observations sur les monuments omeyyades', *Journal Asiatique*, CCXXXI (1939), 1-59, and Geoffrey King, 'A Mosque Attributed to Umar', *Journal of the Royal Asiatic Society* (1978), 109-23.

28. 8. Creswell, *EMA*, I, 65-131 and 213-322. For interpretation, see Oleg Grabar, 'The Ummayad Dome of the Rock', *Ars Orientalis*, III (1959), 33-62, and *idem, Formation*, 48-67.

9. Much of this is still hypothetical and controversial. See Werner Caskel, *Der Felsendom und die Wallfahrt nach Jerusalem* (Cologne, 1963), with a poetic fragment on p. 28 which I interpret differently, and Priscilla Soucek, 'The Temple of Solomon in Islamic Legend and Art', in Joseph Gutman, ed., *The Temple of Solomon* (Ann Arbor, 1976), 73-124.

30. 10. Creswell, *EMA*, I, 78-9.

11. A few fragments of mosaic seen by Ch. Clermont-Ganneau, *Archaeological Researches in Palestine during the years 1873-4*, 2 vols., vol. 1 trans. Aubray Stewart, vol. 2 trans. John Macfarlane (London, 1899 and 1896), I, 187 ff., were rediscovered during the restorations carried out in the early 1960s; they were never published and their whereabouts are unknown to me.

32. 12. For a brilliant, if erratic, statement of the issue, see Michel Écochard, *Filiation des monuments grecs, byzantins et islamiques* (Paris, 1977).

13. Marguerite van Berchem, 'The Mosaics of the Dome of the Rock in Jerusalem and of the Great Mosque in Damascus', in Creswell, *EMA*, I, 252 ff.

14. Max van Berchem, *Matériaux pour un Corpus Inscriptionum Arabicarum*, 3 vols., *MIFAO*, XLIII-XLV (Cairo, 1920-2), vol. 2, *Syrie du Sud*, 2X, 237 ff.

34. 15. Quite often one half of a symmetrical motif on the soffits of the arches was done with greater care than the other half.

35. 16. Sauvaget, *Mosquée Omeyyade*. Although still the most forceful and logical statement of a thesis, Sauvaget's interpretative chapter should be reviewed in the light of a lot of new evidence.

17. R. W. Hamilton, *The Structural History of the Aqsa Mosque* (Jerusalem, 1949). The main issue lies in the dating of Aqsa I, which could be earlier than al-Walid; see Henri Stern, 'Recherches sur la mosquée al-Aqsa', *Ars Orientalis*, V (1963), 28-48.

18. Creswell, *EMA*, I, 22-8; F. Safar, *Wasit* (Cairo, 1945). See below, p. 45.

36. 19. In his description of the rebuilding of the

mosque at Kufa, Muhammad Ibn Jarir al-Tabari (*Annales*, ed. M. J. de Goeje, 3 vols. (Leyden, 1879-1901), I, 238-9) says that the roofs were 'built like the roofs of Greek churches'; Creswell (*EMA*, I, 25) believes that this referred to trussed gabled roofs, although it is not likely that this was very common.

20. Louis Massignon, 'Explication du plan de Qufa (Iraq)', *Mélanges Maspero*, 3 vols., *MIFAO*, LXVI-LXVIII (Cairo, 1934), III, 337-60; A. Dietrich, 'Die Moscheen von Gurgan zur Omaijadenzeit', *Der Islam*, XL (1964), 1-7.

21. Creswell, *EMA*, I, 35-7 and 58-61.

22. See the controversy between Sauvaget, *Mosquée Omeyyade*, 103 ff., and K. A. C. Creswell, 'The Great Mosque of Hama', in R. Ettinghausen, ed., *Aus der Welt der islamischen Kunst: Festschrift für Ernst Kühnel* (Berlin, 1959), 48-53, and *EMA*, I, 17-21.

23. Sauvaget, *Mosquée Omeyyade*, 149 ff.; Creswell, *EMA*, I, 32-3; Grabar, *Formation*, 122.

24. Although very common, the minaret is not compulsory; at times it was added long after the mosque was built (Jean Sauvaget, 'Les inscriptions arabes de la mosquée de Bosra', *Syria*, XXII (1941), 53 ff.).

25. Joseph Schacht, 'Ein archäischer Minaret-Type, in Ägypten und Anatolien', *Ars Islamica*, V (1938), 46-54, and 'Further Notes on the Staircase Minaret', *Ars Orientalis*, IV (1961), 137-42.

37. 26. R. J. H. Gottheil, 'The Origin and History of the Minaret', *Journal of the American Oriental Society*, XXX (1909-10), 137 ff.

27. Grabar, *Formation*, 118-20.

28. For example the spiral type used in Samarra [63] and copied at Ibn Tulun in Fustat [66] or the cylindrical ones found in Iran (Janine Sourdel-Thomine, 'Deux minarets d'époque seljoukide en Afghanistan', *Syria*, XXX (1953), 108-36, and Myron Bement Smith, 'The Manars of Isfahan', *Athar-e Iran*, I (1936), 313-65).

29. Gaston Wiet and André Maricq, *Le minaret de Djam* (Paris, 1959), where this extraordinary structure and related ones in India are discussed.

30. Sauvaget, *Mosquée Omeyyade*, 69 ff.

31. Creswell, *EMA*, I, 151 ff.

32. Sauvaget, *Mosquée Omeyyade*, 152.

33. Shams al-Din Abu Abd Allah Muhammad b. Ahmad al-Muqaddasi, *Kitab Ahsan al-taqlim*, ed. M. J. de Goeje, *Bibliotheca Geographorum Arabicorum*, III (Leyden, 1906), 157, shows that the dome was in front of the mihrab.

34. Al-Muqaddasi was the first to mention it.

35. Étienne Quatremère, *Histoire des sultans mamlouks de l'Égypte*, 2 vols. (Paris, 1837-45), II, 273.

38. 36. Oleg Grabar, 'La grande mosquée de Damas et les origines architecturales de la mosquée', in André Grabar, ed., *Synthronon* (Paris, 1968), 107-14.

37. Creswell, *EMA*, I, 197 ff.

38. Sauvaget, *Mosquée Omeyyade*, 152-3.

40. 39. For Madina, see Sauvaget's work on the mosque; for the Jerusalem mosque, see Hamilton, *op. cit.*, and especially Stern, *op. cit.* (Note 17).

40. Two flat mihrabs may be earlier: one in the Dome of the Rock which Creswell (*EMA*, I, 100) believed was contemporary with the construction of the monument, the other in Kufa (Safar, *op. cit.* (Note 18), figure 11).

41. R. B. Serjeant, 'Mihrab', *Bulletin of the School of Oriental and African Studies*, XXII (1959), 439-53.

42. Sauvaget, *Mosquée Omeyyade*, 145 ff.; Serjeant, *loc. cit.*

43. Sauvaget, *Mosquée Omeyyade*, 83 ff.; Henri Stern, 'Les origines de l'architecture de la mosquée omeyyade', *Syria*, XXVIII (1951), 272-3.

44. As a symbol it may in fact have already been used on a rare early Islamic coin: George C. Miles, 'Mihrab and Anazah: A Study in Early Islamic Iconography', in George C. Miles, ed., *Archaeologica Orientalia In Memoriam Ernst Herzfeld* (Locust Valley, 1952), 156-71, although the theme there may have been simply the reflection of a triumphal arch.

45. Serjeant, *loc. cit.* (Note 41), has fully shown the complicated history of the word and its relation to royal buildings even after Islam.

46. These points emerge from the previously mentioned studies by Sauvaget, *Mosquée Omeyyade*, and Joseph Schacht, 'An Unknown Type of Minbar and Its Historical Significance', *Ars Orientalis*, II (1957), 149-73.

47. Élie Lambert, 'La synagogue de Doura-Europos et les origines de la mosquée', *Semitica*, III (1950), 67-72.

42. 48. The exception is the Aqsa mosque, from which carved woods have been preserved and some indications about the mosaics; cf. below, p. 45.

49. Marguerite van Berchem in *EMA*, I, 229 ff.

50. For example, H. A. R. Gibb, 'Arab-Byzantine Relations under the Umayyad Caliphate', *Dumbarton Oaks Papers*, XII (1958), 219-33; Marguerite van Berchem, however, did not accept this hypothesis.

44. 51. For example in Saloniki; Marguerite van Berchem and G. Clouzot, *Mosaïques chrétiennes* (Geneva, 1924), 67 ff. The point has already been made by Eustache de Lorey, 'L'Hellenisme et l'Orient', *Ars Islamica*, I (1934), 26.

52. Marguerite van Berchem in *EMA*, I, 371 ff., where all the texts are gathered.

53. André Grabar, *L'iconoclasme byzantin* (Paris, 1957), 165.

54. The theme has not been studied yet, but cf. such features as the courts of the Islamic mosques in Seville and Cordova, as well as the fountain built by Ibn Tulun in his mosque in Fustat (as it is known to us from a text of Taqi al-Din Ahmad b. Ali al-Maqrizi,

al-Mawa'iz wal-Itibar bi-Dhikr al-Khitat wal-Athar, 2 vols. (Cairo, 1853), I, 268-9). For a full discussion of the Damascus mosaics as images of a Muslim paradise, see Barbara Finster, 'Die Mosaiken der Umayyadenmoschee', *Kunst des Orients*, VII (1970), 83-141.

55. Al-Muqaddasi, 157.

56. Ibn Shakir, as quoted in Quatremère, *op. cit.* (Note 35), 2.

57. Richard Ettinghausen, *Arab Painting* (Geneva, 1962), 22 ff.

45. 58. Stern, *op. cit.* (Note 17).

59. *Ibid.* and Hamilton, *op. cit.* (Note 17), 83 ff.

60. I am not certain whether already in Umayyad times there was a formal term for the covered part of a mosque. Later it is known as the *bayt al-salat* ('house of prayer'); earlier it is simply the *mughatta* ('covered place'). The history of these terms needs investigation.

61. Safar, *op. cit.* (Note 18). The reasons for the early change of the mosque's qibla have never been properly elucidated (see the provocative but highly controversial remarks in Patricia Crone and Michael Cook, *Hagarism* (Cambridge, 1977), 21-8).

62. Robert McC. Adams, *Land Behind Baghdad* (Chicago, 1965), 95.

63. Creswell, *EMA*, I, 502-5; Jean Sauvaget, 'Remarques', *Journal Asiatique*, CCXXXI (1939), 20-2.

64. David Whitehouse, *Siraf III: The Congregational Mosque and other Mosques from the Ninth to the Twelfth Centuries* (London, 1980).

65. Oleg Grabar, Renata Holod, James Knustad, and William Trousdale, *City in the Desert: Qasr al-Hayr East (Harvard Middle Eastern Monograph Series*, XXIII-XXIV) (Cambridge, 1978).

66. For an early mosque in Sind see F.A. Khan, *Banbhore* (Pakistan Department of Archaeology, Karachi, n.d.).

67. Paolo Costa and Ennio Vicario, *Yemen, Land of Builders*, trans. Daphne Newton (London, 1977), and Paolo Costa, 'La moschea grande di Sana', *Annali Istituto Orientale di Napoli* (1974), 487-506.

68. Sauvaget, *op. cit.* (Note 24); Creswell, *EMA*, I, 484-91.

69. Oleg Grabar, 'Umayyad "Palace" and the Abbasid "Revolution"', *Studia Islamica*, XVIII (1963), 5-18.

70. Oleg Grabar, 'al-Mushatta, Baghdad, and Wasit', *The World of Islam (Studies in Honour of P. K. Hitti)* (London, 1959), 99-108.

71. Creswell, *EMA*, I, 48-58.

72. It is difficult to give an exact number, because only excavations can demonstrate an Umayyad date; compare, for instance, the very different lists made by Sauvaget, *op. cit.* (Note 63), and Creswell, *EMA*, I, 514; or else the controversy surrounding Qasr al-

Abiyad (Heinz Gaube, *Ein arabischer Palast in Südsyrien, Hirbet el-Baida*, Beirut, 1974). I omit from this list the peculiar site of Anjarr in Lebanon (Creswell, *EMA*, I, 478-81), because I am not convinced that it is an Umayyad foundation; but the site needs more work.

73. For example, Creswell, *EMA*, I, 403-6; opposition by Sauvaget, *op. cit.* (Note 63), and 'Châteaux omeyyades de Syrie', *Revue des Études Islamiques*, XXXIX (1967), 1-42, and Oleg Grabar, review of *EMA*, *International Journal of Middle Eastern Studies*, III (1972), 217-22, and *op. cit.* (Note 65), 162-5; see also Gaube, *op. cit.* (Note 72).

46. 74. Grabar *et al.*, *op. cit.* (Note 65).

48. 75. Creswell, *EMA*, I, 447-9; Stephen Urice, *Qasr Kharana, An Early Islamic Monument in Transjordan* (Harvard University, 1981).

49. 76. Grabar *et al.*, *op. cit.*, 29-33.

50. 77. Most of these sites are treated by Sauvaget, *op. cit.* (Note 63). More recent publications include Martin Almagro, Luis Cabellero, Juan Zazaya, and Antonio Almagro, *Qusayr Amra: Residencia y baños omeyas en el desierto de Jordania* (Madrid, 1975).

52. 78. On the triconch, see Irving Lavin, 'The House of the Lord', *Art Bulletin*, XLIV (1962).

79. See, however, Sauvaget, *op. cit.* (Note 63), 15-16.

80. Robert Hamilton, *Khirbat al-Mafjar* (Oxford, 1959), 67 ff.

81. *Ibid.*, 47.

53. 82. Edmond Pauty, *Les Hammams du Caire* (Cairo, 1932).

54. 83. These were already noted by J. A. Janssen and R. Savignac, *Mission archéologique en Arabie* III: *Les châteaux arabes de Qesair Amra, Haraneh, et Tuba* (Paris, 1922), 81; see also Christel Kessler, 'Die beiden Mosaikböden in Qusayr Amra', *Studies in Islamic Art and Architecture in Honour of Professor K. A. C. Creswell* (Cairo, 1965), 105-31, and Almagro *et al.*, *op. cit.* (Note 77), 54-5, figures 9-10 and plate XIII.

84. For baths this has been demonstrated several times, for instance by Frank Edward Brown in *Preliminary Report of the Sixth Season at Dura Europos* (New Haven, 1936), 59-61.

56. 85. Ettinghausen, *op. cit.* (Note 57), 36 ff., and *idem, From Byzantium to Sasanian Iran and the Islamic World* (Leiden, 1972), whose conclusions are not entirely acceptable.

86. Robert Hamilton, 'Carved Plaster in Umayyad Architecture', *Iraq*, XV (1953), 43 ff.

57. 87. O. Grabar, 'Survivances classiques dans l'art de l'Islam', *Annales Archéologiques Arabes Syriennes*, XXI (1971), and *idem, Formation*, 160-1.

58. 88. Ettinghausen, *op. cit.* (Note 57), 29 ff.

89. The crown on one of the Qasr al-Hayr West figures seems to be an original Umayyad one; Daniel

Schlumberger, 'Les fouilles de Qasr el-Heir el-Gharbi (1936-1938): rapport préliminaire', *Syria*, XX (1939), 353.

90. Miles, *op. cit.* (Note 44).

91. Oleg Grabar, 'The Painting of the Six Kings at Qusayr Amrah', *Ars Orientalis*, I (1954), 185-7; Ettinghausen, *op. cit.* (Note 57), 32.

61. 92. The astronomical meaning of the ceiling has been elucidated by Fritz Saxl in Creswell, *EMA*, I, 424-31.

93. Grabar, *op. cit.* (Note 5).

63. 94. Ettinghausen, *op. cit.* (Note 57), 33 ff.

95. This is especially true of paintings: Oleg Grabar in Hamilton, *op. cit.* (Note 80), 308-14.

96. Almagro *et al.*, *op. cit.* (Note 77). The full publication of the technical side of the restoration is necessary before its accuracy is entirely established: for instance, one would want to know whether all the paintings are of the same date, as there are qualitative distinctions which are difficult to explain.

64. 97. Many of these points need an elaboration to which I hope to return soon.

66. 98. No complete publication of the site exists; excellent photographs are published in several works by Nelson Glueck, for instance, *Rivers in the Desert* (New York, 1959), figures 51 ff.

99. At Qasr al-Hayr East a few fragments are quite close to classical Roman prototypes.

67. 100. For example Kara Shahr (Sir Aurel Stein, *Serindia*, Oxford, 1921, CXXXV ff.) or Varakhsha (Vasilli Afanasevich Shishkin, *Varakhsha*, Moscow, 1963).

101. Analysis by Creswell, *EMA*, I, 596-603; see also Leo Trümpelman, *Mschatta: ein Beitrag zur Bestimmung des Kunstkreises, zur Datierung und zum Stil der Ornamentik* (Tübingen, 1962).

102. Stern, *op. cit.* (Note 43).

103. Hamilton, *op. cit.* (Note 80), 139 ff.

68. 104. The notion of liturgy long used to explain this art has been criticized by Sauvaget, *Mosquée Omeyyade*, 114 ff.

71. 105. Boris Marshak, 'Ranneislamskie bronzovye bliuda', *Trudy Hermitage Museum*, XIX (1978).

106. Deborah Thompson, *Coptic Textiles in the Brooklyn Museum* (Brooklyn, 1971).

107. Henri Stern, 'Quelques œuvres sculptées en bois, os, et ivoire de style omeyyade', *Ars Orientalis*, I (1954), 119-31.

108. Deborah Thompson, *Stucco from Chal Tarkhan-Eshqabad near Rayy* (Warminster, Wilts, 1976).

109. Friedrich Sarre, 'Bronzeplastik in Vogelform, ein sasanidisch-frühislamisches Räuchergefass', *Jahrbuch der preussischen Kunstsammlungen*, LI (1930), 159-64; Museum für Islamische Kunst, Berlin, *Katalog* (Berlin/Dahlem, 1971), no. 234, plate 37.

110. Friedrich Sarre, 'Die Bronzekanne des Kalifen Marwan II. im Arabischen Museum in Kairo', *Ars Islamica*, I (1934), 10-14.

111. M. M. Diakonov, 'Ob odnoi rannei arabskoi nadpisi', *Epigrafika Vostoka*, I (1947), 5-8; English résumé by Oleg Grabar in *Ars Orientalis*, II (1957), 548. However Boris Marshak, 'Bronzovoi Kuvshin', *Iran i Srednia Azia* (Leningrad, 1973), dates it later.

72. 112. Mehmet Aga-Oglu, 'Remarks on the Character of Islamic Art', *Art Bulletin*, XXXVI (1954), 191-2.

113. Dorothy G. Shepherd and W. E. Henning, 'Zandaniji Identified', in Ettinghausen, ed., *op. cit.* (Note 22), 15-40, figure 16.

114. A. R. Guest, 'Notice of some Arabic Inscriptions on Textiles in the South Kensington Museum', *Journal of the Royal Asiatic Society* (1906), 390-1.

115. Ernst Kühnel and Louisa Bellinger, *Catalogue of Dated Tiraz Fabrics, Umayyad, Abbasid, Fatimid* (Washington, 1959), 5 and plate 1.

116. *Encyclopaedia of Islam*, 1st edn, s.v. 'tiraz', by Adolph Grohman (plus Addendum); R. B. Serjeant, 'Material for a History of Islamic Textiles up to the Mongol Conquests', *Ars Islamica*, IX (1952), 60-8; S. D. Goitein, 'Petitions to Fatimid Caliphs from the Cairo Geniza', *Jewish Quarterly Review*, XLV (1954), 34-5.

117. Creswell, *EMA*, II, plates 25-7.

118. Stern, *op. cit.* (Note 107).

119. Florence E. Day, 'Early Islamic and Christian Lamps', *Berytus*, VII (1942), 65-79; P. B. Bagatti, 'Lucerne fittili (la cuore) nel Museo della Flagellazione in Gerusalemme', *Faenza*, XXXV (1949), 98-103.

120. Arthur Lane, *Early Islamic Pottery* (London, 1947), 5-9, plates 4B-C, 5A; Richard Ettinghausen, 'Dated Faience', in *SPA*, IV, plate 125B.

74. 121. Ernst Herzfeld, 'Die Genesis der islamischen Kunst', *Der Islam*, I (1910), esp. p. 32.

CHAPTER 3

75. 1. The most concise historical introduction is the article 'Abbasids' by. Bernard Lewis in the second edition of the *Encyclopedia of Islam*. The subject is being constantly re-examined; see Tilman Nagel, *Untersuchungen zur Entstehung des abbasidischen Kalifates* (Bonn, 1972). See also Jacob Lassner, *The Topography of Baghdad in the Early Middle Ages* (Detroit, 1970), and *idem, The Shaping of Abbasid Rule* (Princeton, 1980). M. M. Ahsan, *Social Life Under the Abbasids* (London and New York, 1979), provides details of social history.

2. Dominique Sourdel, 'Questions de cérémonial abbaside', *Revue des Études Islamiques*, XXXVIII (1960), 147.

3. The original English translation of the text by G. LeStrange ('A Byzantine Embassy', *Journal of the Royal Asiatic Society*, 1897) has been superseded by Lassner, *op. cit.* (1970), 87-91.

4. P. K. Hitti, *A History of the Arabs* (London, 1937), 302.

5. Ernst Herzfeld, *Geschichte der Stadt Samarra* (Hamburg, 1948), 121.

76. 6. The large-scale German expedition to Samarra, shortly before the First World War, never published its architectural findings except in a shortened version in Creswell's *EMA*, and the published results are not entirely reliable.

78. 7. Richard Ettinghausen, 'The "Beveled Style" in the Post-Samarra Period', in George Miles, ed., *Archaeologica Orientalia In Memoriam Ernst Herzfeld* (New York, 1952).

8. Main summary in Creswell, *EMA*, II, 1-38, modified in part by Oleg Grabar, 'Mshatta, Wasit, and Baghdad', *The World of Islam* (London, 1959), 99 ff., and *idem, Formation*, 165-71; Lassner, *op. cit.* (1970), and *idem, op. cit.* (1980), part 2.

9. Grabar, *op. cit.* (1959). The meaning of the word *iwan* in the sources is unclear; it is unlikely that it implied the architectural form known today as an iwan.

79. 10. A later representation of this rider exists in manuscripts of the Automata by al-Jazari; see F. R. Martin, *The Miniature Painting . . . of Persia* (London, 1912), 11, plate 2, and Grabar, *Formation*, plate 11. His significance is unclear; he can hardly have acted as a weather vane. Medieval texts indicate that the lance always pointed towards approaching enemies, so perhaps the rider had some magical or symbolic meaning.

11. Curiously enough it was a Greek ambassador who pointed out to the caliph that his palace was like a prison to him; al-Khatib al-Baghdadi, *Tarikh Baghdad* (Baghdad, 1931), I, 100-5.

12. The relation of Baghdad to earlier palaces has already been sketched by Jean Sauvaget, 'Les ruines omeyyades de Andjar', *Bulletin du Musée de Beyrouth*, III (1939), 111. See also Qasr al-Hayr East (Grabar *et al., op. cit.* (Chapter 2, Note 65), 80).

13. Summary and bibliography in Creswell, *EMA*, II, 39-49; one should add some of the reports of excavations carried out by the Syrian Department of Antiquities in *Annales Archéologiques de Syrie*, especially vols. IV-V (1954-5), 69 ff., and VI (1956), 25 ff.

14. Although generally accepted, the early Abbasid date of this gate is not entirely satisfactory, as both the superb shape of its arch and its brickwork seem to me to fit better with later times than with the eighth century. Excavations around Raqqa in progress in 1982 may solve the problem.

15. Creswell, *EMA*, II, 94-100, with full bibliography; more recently, Werner Caskel, 'al-Uhaidir', *Der Islam*, XXXIX (1964), 28-37, and R. Pagliero *et al.*, 'Uhaidir, an Instance of Monument Restoration', *Mesopotamia*, II (1967).

80. 16. In recent years some questions have been raised about the date of many Sasanian buildings related to Ukhaydir; see Lionel Bier, *Sarvistan, A Study of Early Iranian Architecture* (University Park, Pa., 1986), who reopened the debate as to whether techniques of construction and decoration are Sasanian or new.

82. 17. Hamilton, *op. cit.* (Chapter 2, Note 17), and above, p. 37.

18. Al-Muqaddasi, *Al-Aqalim* (Leyden, 1906), 319.

19. The main study on Tunisia is by M. Solignac, 'Recherches sur les installations hydrauliques', *AIEO*, X (1952). The other monuments are all in Creswell's *EMA*, II.

83. 20. These palaces have been published on the basis of Herzfeld's notes by Creswell, *EMA*, II, 232-43, 265-70; see also Iraq Government Department of Antiquities, *Excavations at Samarra 1936-9*, I, *Architecture* (Baghdad, 1940), and J. M. Rogers, 'Samarra: A Study in Medieval Town Planning', in A. H. Hourani and S. M. Stern, eds., *The Islamic City* (Oxford, 1970).

86. 21. The main textual source is Istakhri's description of the palace Abu Muslim (cited in Creswell, *EMA*, II, 3-4). The archaeological sources are the palaces of Qyrq Qyz (plan published by E. Herzfeld, 'Damascus', *Ars Islamica*, IX (1942), 35) and Haram Köshk (G. A. Pugachenkova, *Puti razvitia arhitektury iuzhnogo Turkmenistana* (Moscow, 1958), 154), among many central Asian examples.

22. Herzfeld, *op. cit.* (Note 5), plate XXXIV.

23. Maqrizi, *Kitab al-Mawa idh*, trans. P. Casanova in *MIFAO*, III (1906), 215-18.

88. 24. L. Vanden Berghe, *Archéologie de l'Iran ancien* (Leiden, 1959), plate 67^b, p. 47, shows a Sasanian fire tower which bears a superficial resemblance to the minaret, but its structure is in fact quite different, and it too is an unusual building.

25. E. Pauty, 'L'évolution du dispositif en T', *Bulletin d'Études Orientales*, II (1932).

91. 26. B. Fransis and M. Ali, 'Jami abu Dulaf', *Sumer*, III (1947), 60 ff.

92. 27. Herzfeld, *op. cit.* (Note 5), 137 has estimated a million inhabitants.

28. Above, p. 38, and below, p. 264.

29. Creswell, *EMA*, II, 332-59.

94. 30. *Ibid.*, 208-26 and 308-20, and Marçais, *Architecture*, 9 ff. Creswell and Marçais defend two slightly divergent interpretations on the evolution of the building in the ninth century.

95. 31. Alexandre Lézine, *Architecture de l'Ifriqiya* (Paris, 1966), esp. 25 ff.; Léon Golvin, *Essai sur l'architecture religieuse musulmane* (Paris, 1974), 123 ff.

101. 32. Georges Marçais, 'Remarques sur l'esthétique musulmane', *AIEO*, IV (1938), 62 ff.

33. Creswell, *EMA*, II, 283-6.

34. S. Blair, 'The Octagonal Pavilion at Natanz: A Re-examination of Early Islamic Architecture in Iran', *Muqarnas*, I (1983), 69-94.

35. O. Grabar, 'The Earliest Islamic Commemorative Structures', *Ars Orientalis*, VI (1966), 7-46; A. Lézine, *Le ribat de Sousse* (Tunis, 1956).

102. 36. Discussion of these fragments by Marçais in Creswell, *EMA*, II, 127-37, and by Hamilton, *op. cit.* (Chapter 2, Note 17), 74 ff. These authors consider the woods Abbasid; for a different view see H. Stern, 'Recherches sur la mosquée al-Aqsa', *Ars Orientalis*, V (1963), 33 ff.

37. The use of *ajouré* marble in the mihrab in Kairouan is, partly at least, to be explained by certain peculiar religious circumstances; Marçais, *Architecture*, 11.

38. Ernst Herzfeld, *Der Wandschmuck der Bauten von Samarra* (Berlin, 1923).

39. Creswell, *EMA*, II, 286-8.

40. Maurice Dimand, 'Studies in Islamic Ornament I', *Ars Islamica*, IV (1937), and 'Studies in Islamic Ornament II', *Archaeologia Orientalia In Memoriam Ernst Herzfeld* (New York, 1952).

41. Full panels only are here considered, for in borders certain additional problems occur which require a more developed analysis.

42. Herzfeld, *op. cit.* (Note 38), figures 222, 228, 230, and a few others are exceptions.

103. 43. Dimand, *op. cit.* (1952).

104. 44. Ernst Kühnel, *Die Arabeske* (Wiesbaden, 1949), 5.

45. The most recent discussion is by Dimand, *op. cit.*, following Kühnel and Herzfeld.

105. 46. E. Kühnel, 'Die islamische Kunst', in A. Springer, *Handbuch der Kunstgeschichte* (Leipzig, 1929), VI, 395.

47. See, for instance, S. I. Rudenko, *Kultura Naseleniia Gornogo Altaia* (Moscow, 1953), plates XLVII, XLVIII, LIII, LVII, etc.

48. For this, see Creswell, *EMA*, II, 317-19, plates 89-90.

108. 49. Al-Tujibi, quoted by Ibn Naji in his *Ma'alim al-imam*, as established by Georges Marçais, *Les faïences à reflets métalliques de la grande mosquée de Kairouan* (Paris, 1928), 9-10: Creswell, *EMA*, II, 314.

50. Dimand, 'Studies I' (*op. cit.*), 294, figures 1-3, where the piece is thought to be from Takrit; but Edmond Pauty pointed to a more likely Baghdad origin ('Sur une porte en bois sculpté provenant de

Baghdad', *Bulletin de l'Institut Français d'Archéologie Orientale*, XXX (1930), 77 and 81, plate IV).

51. See the still very classical design of the vine *rinceaux* in the half-dome over the mihrab at Kairouan; Marçais, *Architecture*, 53.

52. E. Pauty, *Les bois sculptés jusqu'à l'époque ayyoubide*, Catalogue général du Musée Arabe du Caire (Cairo, 1931), plates XII, nos. 4720 and 4721; XIV, nos. 3801 and 4616; XV-XVIII.

110. 53. R. Ettinghausen, 'Parthian and Sasanian Pottery', *SPA*, IV, plate 193B.

111. 54. Masudi, *Les prairies d'or*, VI, ed. and trans. by C. Barbier de Meynard and Pavet de Courteille (Paris, 1861-77), 295; VIII, 19, 298.

55. F. E. Day, 'A Review of "The Ceramic Arts, A History" in *A Survey of Persian Art*', *Ars Islamica*, VIII (1941), 24. For a more recent historical survey, see M. Jenkins, 'Islamic Pottery', *Bull. MMA*, XL, 4 (1983).

56. A. Lane, 'Glazed Relief Ware of the Ninth Century A.D.', *Ars Islamica*, VI (1939), 56-65; idem, *Early Islamic Pottery* (London, 1947), 12-13; Day, *op. cit.*, 22. Miss Day's conclusion that the Egyptian ware is an offshoot of Iraqi moulded pottery seems preferable to Lane's hypothesis that Egyptian potters introduced the type into Iraq. Only in the former way can the work of an Iraqi potter in Egypt be explained. Apparently there is another instance here of cultural lag between the capital and the more conservative provincial centre, which was still under the spell of Mediterranean artistic traditions.

57. Lane, *op. cit.* (1947), 10, referring to al-Bayhaqi, an eleventh-century Persian historian, for the importation of Chinese imperial porcelains and wares in the time of Harun al-Rashid (786-809).

58. F. E. Day, 'The Islamic Finds at Tarsus', *Asia*, XLI (1941), 144, figure 2.

59. *Die Ausgrabungen von Samarra*, II, *Die Keramik von Samarra* (Berlin, 1925), plate XXVII, no. 4.

59a. *Ibid.*, plate XXXIV.

112. 60. D. T. Rice, 'The Pottery of Byzantium and the Islamic World', *Studies in Islamic Art and Architecture in Honour of K. A. C. Creswell* (Cairo, 1965), 194-236.

61. Day, *op. cit.* (Note 55), 26.

113. 62. E. Herzfeld, 'Epigraphisches', in F. Sarre, *Die Keramik von Samarra* (Berlin, 1923), 83-5. Many other such signed pieces have become known since 1925.

114. 63. The historical sequence of the various lustre-painted types was first established by E. Kühnel, 'Die abbasidischen Lüsterfayencen', *Ars Islamica*, I (1934), 149-59.

115. 64. Iraq Government, Department of Antiquities, *Excavations at Samarra, 1936-1939*, II (Baghdad, 1940), 8, plate CXXVII bottom.

65. E. Herzfeld, *Iran in the Ancient East* (London and New York, 1941), plate VI top.

116. 66. See 'El fragmento de ceramica dorada hallado en Madinat al-Zahra', *al-Mulk*, I (1959–60), 43–62, and R. L. Hobson, 'Potsherds from Brahminabad', *Transactions of the Oriental Ceramic Society* (1928–30), 21–3.

67. Victoria and Albert Museum, *Review of the Principal Acquisitions during the Year 1930* (London, 1931), 14–15, figure 8; Victoria and Albert Museum, *Review of the Principal Acquisitions during the Year 1934* (London, 1935), 8–10; photograph of fragment from Rayy in Herzfeld Archive, Washington, D.C.

68. C. H. Kraeling, *The Excavations at Dura-Europos ... Final Report*, VIII, part I: *The Synagogue* (New Haven, 1956), plate XI.

69. Marçais, *op. cit.* (Note 49); Creswell, *EMA*, II, plate 86 c and d.

117. 70. al-Yaqubi, *Kitab al-Buldan*, ed. M. J. de Goeje (*Bibliotheca Geographorum Arabicorum*, VIII) (Leiden, 1892), 264; trans. in Herzfeld, *op. cit.* (Note 5), 117.

71. See Note 49 above.

119. 72. *Ausgrabungen* (*op. cit.*, Note 59), 30, plates VII, VIII; see also R. Koechlin, *Les céramiques musulmanes de Suse au Musée du Louvre* (*Mémoires de la Mission archéologique de Perse*, XIX) (Paris, 1928), plate X; M. Rosen-Ayalon, *Mémoires de la Délégation archéologique en Iran*, L, *Mission susiane: Ville royale de Suse*, IV, *La poterie islamique* (Paris, 1974), 136–42.

73. R. Ettinghausen, 'Interaction and Integration in Islamic Art', in G. E. von Grunebaum, ed., *Unity and Variety in Muslim Civilization* (Chicago, 1955), 116, plate 111b.

74. The link between these early wares and the later faience mosaic was probably the folk custom of inserting parts of blue or green tiles in house walls near the door, most likely for magical purposes.

75. T. Nöldeke, ed., *Geschichte des Qorans*, III, *Die Geschichte des Korantexts* by G. Bergsträsser and O. Pretzl, 2nd ed. (Leipzig, 1938), 253.

120. 76. B. Moritz, *Arabic Palaeography* (Cairo, 1905), plates 1–16.

121. 77. Colour reproductions of several pages from early Koran manuscripts can be found in *The Quranic Art of Calligraphy and Illumination* (London, 1976), plates I–V. See also M. Lings and Y. H. Hamid Safadi, *The Quran: Catalogue of an Exhibition of Quran Manuscripts at the British Library, 3 April–15 August 1976* (London, 1976).

78. G. Marçais and L. Poinssot, *Objets kairouanais du IXᵉ au XIIIᵉ siècle*, I (Tunis, 1948), plates I–XXX.

123. 79. P. Kahle, *Der hebräische Bibeltext seit Franz Delitzsch* (Stuttgart, 1961), figures I, 7–10.

80. Compare this page with the dedication portrait

of Princess Juliana Anicia in an early-sixth-century Dioscorides manuscript in the National Library at Vienna (Cod. Med. Grec. 1); D. Talbot Rice, *The Art of Byzantium* (London, 1959), plate 24; J. Beckwith, *Early Christian and Byzantine Art* (*The Pelican History of Art*), 2nd ed. (London, 1979), illustration 105. This relationship was first noted by Grohmann in T. W. Arnold and A. Grohmann, *The Islamic Book* (Leipzig, 1929), 125 and note 107.

124. 81. *Die Ausgrabungen von Samarra*, III, *Die Malereien von Samarra* (Berlin, 1927), plates XLVI–LIII, CIV.

82. This point has been demonstrated in *ibid.*

83. See, for example, Sir Aurel Stein, *Ancient Khotan*, II (Oxford, 1907), plate LXIII, D.S.4; *idem*, *Serindia*, IV (Oxford, 1921), plates XLIV, especially MIII.0019, and XLV, M.V. 004. See also *Along the Ancient Silk Routes: Central Asian Art from the West Berlin State Museum* (New York, 1982).

84. Including the pearled frame, animals with non-naturalistic all-over spots, and the monochrome background. See A. Y. Yakubovsky *et al.*, *Zhivopis drevnevo Pyandzhikenta* (Moscow, 1954), figure 13, plates VII–XI and XXXIII; A. Belenitsky, *Asie centrale* (Geneva, 1968), chapter IV.

125. 85. Herzfeld, *op. cit.* (Note 81), 3: the source is Yaqut's *Mujam al-Buldan*.

86. Herzfeld, *op. cit.* (Note 5), 240.

87. Taqi al-Din Ahmad al-Maqrizi, *Kitab al Mawa'iz wal-Itibar bi Dhikr al-Khitat wal-Athar*, I (Bulaq, 1853); P. Casanova, trans., *Description historique et topographique de l'Égypte*, *MIFAO*, III (1906), 216–17.

CHAPTER 4

129. 1. The major points of uncertainty concern the exact nature of the first addition and the significance of the Villaviciosa Chapel (cf. Note 4 below).

2. Some (Creswell, *EMA*, II, 138–61) have doubted its existence, claiming that a later legend about a Christian church was only invented in imitation of what happened in Damascus under al-Walid. Actually, remains of a church were found on the site, but it was probably not as significant as the sanctuary of John the Baptist in Damascus, and its impact on the mosque was probably limited. Cf. M. Ocana Jiménez, 'La basilica de San Vicente', *Al-Andalus*, VII (1942), 347–66.

3. The uncertainty about the lateral enlargements of the first mosque is due to the apparent contradiction between a text published by É. Lévi-Provençal in *Arabica*, I (1954), 89 ff. (discussed by E. Lambert, 'L'histoire de la grande mosquée de Cordova', *AIEO*, II (1936), 165 ff.) and certain decorative motifs (E.

Lambert, 'De quelques incertitudes', *AIEO*, I (1934-5), 176 ff.) on the one hand, and the lack of trace of foundation wall (L. Torres Balbás, in *Al-Andalus*, VI (1941), 411 ff.) on the other. For an attempt to reconcile the conflicting evidence, see L. Torres Balbás, *La mezquita de Córdoba* (Madrid, 1965), 36, and F. H. Giménez, 'Die Elle in der arabischen Geschichtsschreibung', *Madrider Mitteilungen*, I (1960), 190-1.

4. While it is generally agreed that the Villaviciosa dome dates from al-Hakam's time, there are some documents which may suggest that Abd al-Rahman III made some sort of addition there. The main one is a passage in Ibn Idhari, *al-Bayan*, ed. G. S. Colin and É. Lévi-Provençal, II (Leiden, 1951), 228; cf. Marçais, *Architecture*, 139.

5. Christian Ewert, *Spanisch-islamische Systeme sich kreuzender Bögen* (Berlin, 1968), Klaus Brisch, *Die Fenstergitter und verwandte Ornamente der Hauptmoschee von Cordoba* (Berlin, 1966), and Henri Stern, *Les mosaïques de la grande mosquée de Cordova* (Berlin, 1976) are all excellent and detailed studies of various parts of the mosque, but they need to be put into a wider framework for full understanding of the building.

6. The reason for the addition was the increase of the city's population; it was done towards the northeast because the palace occupied the area to the south-west.

7. Al-Mansur's masons did, however, cheat in details; for instance, in order to give the effect of two colours, they used not brick and stone but painted plaster.

8. The most important is the minaret, in its present shape built by Abd al-Rahman III around an earlier minaret; Felix Hernandez Giménez, *El Alminar de Abd al-Rahman III en la Mezquita Mayor de Córdoba* (Granada, 1975), with some interesting considerations on the history of form.

135. 9. Marçais, *Architecture*, 151-2; Geoffrey King, 'The Mosque Bab Mardum', *Art and Archaeology Research Papers*, II (1972), 29-40; Christian Ewert, 'Die Moschee bei Bab al-Mardum', *Madrider Mitteilungen*, XVIII (1977), 287-354.

10. Auguste Choisy, *Histoire de l'architecture* (Paris, 1899), II, 22-3.

11. André Godard, 'Les voûtes iraniennes', *Athar-e Iran*, IV (1949).

12. Henri Terrasse, *L'art hispano-mauresque* (Paris, 1932), 139-40.

137. 13. Évariste Lévi-Provençal, *Inscriptions arabes d'Espagne* (Leyden, 1931), 13 ff.

14. A. Dessus-Lamare, 'Le mushaf de la mosquée de Cordoue', *Journal Asiatique*, CCXXX (1938), 555.

15. Klaus Brisch, 'Zum Bab al-Wuzara', in Charles

Geddes, ed., *Studies in Islamic Art and Architecture in Honour of K.A.C. Creswell* (Cairo, 1965), 30-48.

16. Listed in Marçais, *Architecture*, 156 ff.

17. Brief study and bibliography in Marçais, *Architecture*, 154-5.

18. On the theme of the foreroom see G. Marçais, 'Salle, Antisalle', *AIEO*, X (1952), 274 ff.

19. Marçais, *Architecture*, 171 ff., for a full bibliography on more precise subjects, to which must be added the works of Brisch and Ewert mentioned in Note 5.

140. 20. Marçais, *Architecture*, 178-80; *Ars Hispaniae*, III, figure 245.

21. This conclusion varies slightly from the one developed by H. Stern, above, Note 5.

141. 22. All these mosques are in Marçais, *Architecture*, 191 ff. See also Terrasse, *op. cit.* (Note 12), 298 ff., and L. Torres Balbás, *Artes almorávide y almohade* (Madrid, 1955). For a photographic survey, see Derek Hill and Lucien Golvin, *Islamic Architecture in North Africa* (London, 1976).

143. 23. J. Caillé, *La mosquée de Hassan à Rabat* (Paris, 1954).

24. J. Schacht, *Ars Orientalis*, II (1957), 170 ff.

25. Marçais, *Architecture*, 75-6; cf. also the examples given by M. Zbiss, 'Documents d'architecture fatimite d'occident', *Ars Orientalis*, II (1959).

26. H. Basset and H. Terrasse, *Sanctuaires et forteresses almohades* (Paris, 1932).

27. They may have been preceded by the earlier Toledo gate of Visagra; Marçais, *Architecture*, 217-18.

144. 28. For a remarkable example of a ribbed dome at Tlemcen, *ibid.*, 196; also in the Qarawiyin mosque, H. Terrasse, *La mosquée al-Qaraouiyin à Fez* (Paris, 1968); Torres Balbás, *op. cit.* (Note 22), plates 8 and 14.

29. See below, pp. 184-6.

30. Terrasse, *op. cit.* (Note 28), figures 21-3, plates 28 ff.

31. For the Aljaferia, see Christian Ewert, *Islamische Funde in Balaguer und die Aljaferia in Zaragoza* (Berlin, 1971).

145. 32. See M. Gómez-Moreno, *El arte árabe español hasta los Almohades; arte mozárabe* (*Ars Hispaniae*, III) (Madrid, 1951), 180-91.

33. For descriptions, transcriptions of inscriptions, and bibliographies E. Kühnel, *Die islamischen Elfenbeinskulpturen, VIII.-XIII. Jahrhundert* (Berlin, 1971), supersedes J. Ferrandis, *Marfiles árabes de occidente*, I (Madrid, 1935). See also J. Beckwith, *Caskets from Cordoba* (London, 1960).

34. Kühnel, *op. cit.*, 32-3, no. 20, plate VIII. This piece was formerly in the cathedral of Zamora.

151. 35. *Ibid.*, 38-9, no. 31, plates XVII, XVIII.

36. *Ibid.*, 36-7, no. 28, plates XIII, XIV. This pyxis is signed by Khalaf, who also made a rectangular box with a flat cover for Subh in Madinat al-Zahra in 966.

37. W. Caskel, *Arabic Inscriptions in the Collection of the Hispanic Society of America* (New York, 1936), 35-6.

152. 38. I. Lichtenstädter, 'Das Nasib in der altarabischen Qaside', *Islamica*, V (1931), 46.

39. Kühnel, *op. cit.*, 41-3, no. 35, plates XXII-XXVI.

40. *Ibid.*, 43-4, no. 36, plates XXIX-XXX.

41. H. Nützel, 'Eine Porträtmedaille des Chalifen al-Muktadir billah', *Zeitschrift für Numismatik*, XXII (1900), 259; Beckwith, *op. cit.*, 22, figure 24.

153. 42. Ibn Khaldun, *The Muqaddimah: An Introduction to History*, I, trans. Rosenthal (New York, 1953), 343, 345.

43. Kühnel, *op. cit.*, 46-7, no. 40, plates XXXII-XXXIV.

155. 44. Gómez-Moreno, *op. cit.*, figures 246-51.

45. They were judged to be of such remarkable craftsmanship that, by comparison, the Muslims of the East seemed unable to carve wood elegantly. See Ibn Marzuq, *Masnad*, quoted in Basset and Terrasse, *op. cit.* (Note 26), 234, and Terrasse, *op. cit.* (Note 12), 383.

46. G. Marçais, 'La chaire de la Grande Mosquée d'Alger', *Hespéris*, I (1921), 359-85; Basset and Terrasse, *op. cit.*, 238, with correction of date; Gómez-Moreno, *op. cit.*, 282-3, figure 348; and Torres Balbás, *op. cit.* (Note 22), 3, plate 39. Of forty-five original panels twenty-eight are square, whereas along the steps there are seven trapezoidal and ten triangular panels. Only seven panels have geometric designs, which, unlike those in the minbar at Kairouan, are not pierced.

47. H. Terrasse, 'La mosquée d'al-Qarawiyin à Fès et l'art des Almoravides', *Ars Orientalis*, II (1957), 145-7, plates 17-18.

48. Basset and Terrasse, *op. cit.*, 234-40; Terrasse, *op. cit.* (Note 12), 383-95; J. Sauvaget, 'Sur le minbar de la Kutubiya de Marrakech', *Hespéris*, XXXVI (1949), 313-19; and Torres Balbás, *op. cit.* (Note 22), 31, 45-6, plates 40-1.

49. Basset and Terrasse, *op. cit.*, 310-35, figures 119-28, plates 40-4.

50. H. Terrasse, *La mosquée des Andalous à Fès* (Paris, n.d.), 35-6, 50-2, plates 49, 53, 93-6.

159. 51. See R. B. Serjeant, 'Materials for a History of Islamic Textiles to the Mongol Conquest', *Ars Islamica*, XV-XVI (1951), 29-40, 55-6.

52. The largest fragment of the chasuble is still in a reliquary in the church of Quintanaortuña near Burgos in Spain.

53. D. G. Shepherd, 'A Dated Hispano-Islamic Silk', *Ars Orientalis*, II (1957), 373-82. The technical features peculiar to this group include a diaper weave with a 2-2-4 grouping of warp threads in the ground weave, as well as a distinctive 'honeycomb' method for binding the gold wefts.

54. F. E. Day, 'The Inscription of the Boston "Baghdad" Silk: A Note on Method in Epigraphy', *Ars Orientalis*, I (1954), 191-4.

55. This 'lion-strangler' silk was found in the tomb of Bishop Bernard of Calvó (d. 1243) at Vich, and a piece of it is now in the Cleveland Museum of Art. See D. G. Shepherd, 'A Twelfth Century Hispano-Islamic Silk', *The Bulletin of the Cleveland Museum of Art*, XXXVIII (1951), 59, and *idem*, 'Another Silk from the Tomb of St Bernard Calvo', *ibid.*, 75.

56. This silk, also from the tomb of Bishop Bernard, has been dispersed among the collections of the Cleveland Museum of Art; the Kunstgewerbemuseum in Berlin; the Musée des Arts Décoratifs in Paris; and the Metropolitan Museum of Art and the Cooper Hewitt Museum in New York. See D. G. Shepherd, 'The Third Silk from the Tomb of Saint Bernard Calvo', *The Bulletin of the Cleveland Museum of Art*, XXXIX (1952), 13-14.

57. P. Deschamps, 'Les fresques des cryptes des cathédrales de Chartres et de Clermont et l'imitation des tissus dans les peintures murales', *Monuments et mémoires publiés par l'Académie des Inscriptions et Belles-Lettres*, XLVIII (1954), 91-106, figures 11-12; and M. Vieillard-Troiekouroff, 'La cathédrale de Clermont du Ve au XIIIe siècle', *Cahiers archéologiques*, XI (1960), 231, 245-7.

58. Shepherd, *op. cit.* (Note 53), 381-2.

162. 59. For a general discussion of the technique and style of this group, see D. G. Shepherd, 'A Treasure from a Thirteenth-Century Spanish Tomb', *The Bulletin of the Cleveland Museum of Art*, LXV (1978), 111-34. See also *idem*, 'The Hispano-Islamic Textiles in the Cooper Union Collection', *Chronicles of the Museum for the Arts of Decoration of the Cooper Union*, I (1943), 351-405.

60. See Shepherd, *op. cit.* (1943), 382, figure 16.

163. 61. For a translation of the text into Spanish and ten of the fourteen surviving miniatures, see A. R. Nykl, *Historia de los amores de Bayad y Riyad: Una chantefable oriental en estilo persa* (New York, 1941).

62. R. Ettinghausen, *Arab Painting* (Geneva, 1962), 125 ff.

167. 1. B. Lewis, *The Arabs in History* (London, 1950), 166 ff.

2. S. D. Goitein, *A Mediterranean Society*, 3 vols.

(Berkeley, 1967-77), among many studies by this scholar, and essays by B. Lewis, G. von Grunebaum, O. Grabar, and others in A. Raymond, M. Rogers, and M. Wahba, eds., *Colloque international sur l'histoire du Caire* (Leipzig, 1973).

3. G. Marçais, *La Berbérie musulmane et l'Orient* (Paris, 1946).

4. The main book on Fatimid architecture is K. A. C. Creswell, *Muslim Architecture of Egypt* (Oxford, 1952).

5. Creswell, *MAE*, 1-10; Marçais, *Architecture*, 78 ff.; S. M. Zbiss, 'Mahdia et Sabra-Mansouriya', *Journal Asiatique*, CCXLIV (1956), 78 ff.; Alexandre Lézine, *Mahdiya* (Paris, 1965).

6. For two different views on the interpretation of the remains, see Creswell, *MAE*, 3-5, and Marçais, *Architecture*, 90-2; mostly superseded by Lézine, *op. cit.*, 17 ff.

168. 7. Marçais, *Architecture*, 78-9; Zbiss, *op. cit.*, 79 ff.

8. M. Canard, 'Le cérémonial fatimite et le cérémonial byzantin', *Byzantion*, XXI (1951).

9. Creswell, *MAE*, 5-9; Marçais, *Architecture*, 69-70; Lézine, *op. cit.*, 65 ff., with many improvements.

170. 10. Zbiss, *op. cit.*; on the whole theme see G. Marçais, 'Salle, Antisalle', *AIEO*, X (1952), 274 ff.

11. L. Golvin, *Le Maghrib central à l'époque des Zirides* (Paris, 1957), 180 ff.

171. 12. Latest statement by Lucien Golvin, *Recherches archéologiques à la Qala des Banu Hammad* (Paris, 1965).

13. Giuseppe Bellafiori, *La Ziza di Palermo* (Palermo, 1978).

172. 14. Golvin, *op. cit.* (1965), 123 ff.

15. Ugo Monneret de Villard, *Le pitture musulmane al soffitto della Cappella Palatina in Palermo* (Rome, 1950).

16. Maqrizi, *Khitat*, 2 vols. (Cairo, 1270 H).

17. Published in *MMAF* and *MIFAO*.

18. M. van Berchem in *MMAF*, XIX (1903), with supplement by G. Wiet in *MIFAO*, LII (1929).

19. The origin of the word is discussed by Creswell, *MAE*, 21-2.

20. M. Herz, *Die Baugruppe von Qalaun* (Hamburg, 1919).

21. In *MMAF*, I (1887-9).

22. E. Pauty, *Les palais et les maisons d'époque musulmane au Caire*, *MIFAO*, LXII (1933).

23. Maqrizi, *op. cit.*, I, 432-3.

24. Nasir-i Khosrow, *Sefer Nameh*, trans. C. Schefer (Paris, 1881), 127 ff.

173. 25. Ten are enumerated by Maqrizi, *op. cit.*, I, 465 ff.

26. M. Canard, 'La procession du nouvel an',

AIEO, XIII (1955), based on Inostrantzev's great work on the subject.

27. Creswell, *MAE*, 129 ff.; Aly Baghat and A. Gabriel, *Les fouilles de Foustat* (Paris, 1921).

174. 28. Creswell, *MAE*, 59, figure 21.

29. Whether this was so hinges on the interpretation of Maqrizi, *op. cit.*, II, 273, II, 21-7; Creswell, *MAE*, 36, believed that there were domes at the corners of the hall of prayer, although the text mentions a dome 'in the first arcade to the right of the mihrab'.

176. 30. Maqrizi, *op. cit.*, II, 280-1.

31. For a new interpretation of the Hakim mosque see Jonathan Bloom, 'The Mosque of el-Hakim in Cairo', *Muqarnas*, I (1982).

178. 32. Creswell, *MAE*, 94 ff.

179. 33. S. Flury, *Die Ornamente der Hakim- und Ashar-Moschee* (Heidelberg, 1912), whose comparative material is, however, much out of date.

34. Creswell, *MAE*, 104.

35. H. Stern, in *Ars Orientalis*, V (1963).

180. 36. O. Grabar, 'The Earlier Islamic Commemorative Structures', *Ars Orientalis*, VI (1966), 7-46. For a different view see Youssef Ragheb, 'Les premiers monuments funéraires de l'Islam', *Annales Islamologiques*, IX (1970), 21-36. One should note the peculiar earlier occurrence of the Tabataba mausoleum in Cairo, if this is what it was; Creswell, *MAE*, II ff., and Grabar, *op. cit.*, II.

37. Creswell, *MAE*, 107 ff.

38. *Ibid.*, 131 ff., with a full account of the disaster which led to the disappearance of the inscriptions.

39. *Ibid.*, 111-13.

40. Maqrizi, *op. cit.*, II, 289.

41. Creswell, *MAE*, I, 241 ff.

42. *Ibid.*, 275 ff.

181. 43. Maqrizi, *op. cit.*, II, 289.

44. Creswell, *MAE*, I, 11; above, pp. 134-5, and below, p. 214.

45. *Ibid.*, 222 ff. and 247 ff.

46. *Ibid.*, 155 ff.; Max van Berchem, 'Une mosquée du temps des Fatimides au Caire', *Bulletin de l'Institut d'Égypte*, III (1899), 605 ff.; Grabar, *op. cit.* (Note 36), 27-9.

184. 47. Creswell, *MAE*, I, 110 ff.

186. 48. Such is my interpretation of an example in a Coptic church which was taken by Creswell to be an experimental one (*MAE*, I, figure 131).

49. *Ibid.*, 162-3.

50. Caroline Williams, 'The Cult of the Alid Saints in the Fatimid Monuments of Cairo', *Muqarnas* (1982).

51. S. D. Goitein, 'The Main Industries of the Mediterranean Area as reflected in the Records of the Cairo Geniza', *Journal of Economic and Social History of the Orient*, IV (1961), 168-9.

52. Textile production, for example, was 'comparable to that of steel and other metals in the modern economy' (*ibid.*). For documentation, see R. B. Serjeant, 'Material for a History of Islamic Textiles up to the Mongol Conquest', *Ars Islamica*, XIII–XIV (1948), 88–113.

53. Goitein, *op. cit.*, 168.

187. 54. These data have been recorded by Maqrizi in *al-Mawa'iz wal Itibar fi Dhikr al-Khitat wal-Athar*, I (Bulaq, 1853), 414–16, trans. by P. Kahle, 'Die Schätze der Fatimiden', *Zeitschrift der Deutschen Morgenländischen Gesellschaft*, N.F. XIV (1935), 338–61. They form the basis of Zaky M. Hassan, *Kunuz al-Fatimiyin* (*The Treasures of the Fatimids*) (Cairo, 1937).

55. Serjeant, *op. cit.*, 111–13, again quoting Maqrizi.

56. In spite of the enormous numbers mentioned by Maqrizi, only about 181 carved rock-crystal pieces have been discovered so far; see K. Erdmann, 'Neue islamische Bergkristalle', *Ars Orientalis*, III (1959), 201.

57. R. Ettinghausen, 'The "Beveled Style" in the Post-Samarra Period', in G. C. Miles, ed., *Archaeologica Orientalia In Memoriam Ernst Herzfeld* (Locust Valley, N.Y., 1952), 75, plate x no. 3.

58. E. Pauty, *Catalogue du Musée Arabe du Caire* (Cairo, 1931), plates XXIII–XXV.

191. 59. Most of this early Fatimid material is dealt with by R. Pinder-Wilson, 'An Early Fatimid Bowl Decorated in Lustre', in R. Ettinghausen, ed., *Aus der Welt der islamischen Kunst: Festschrift für Ernst Kühnel* (Berlin, 1959), 139–43. See also Abd al-Ra'uf Ali Yusuf, 'Khazzafun min al-asr al-fatimi ...', *Majallat Kulliyat al-Adab Jami'at al-Qahira* (Cairo, 1962), figures 1–2, 22–3.

193. 60. K. Erdmann, '"Fatimid" Rock Crystals', *Oriental Art*, III (1951), 142–6; D.S. Rice, 'A Datable Islamic Rock Crystal', *Oriental Art*, N.S. II (1956), 85–93.

61. C. J. Lamm, *Mittelalterliche Gläser und Steinschnittarbeiten aus dem Nahen Osten*, I (Berlin, 1930), 211, nos. 10, 11, plate 75 no. 10. For a list of other early arrivals in Europe, see Erdmann, *op. cit.* (1951), 142.

62. *Ibid.*, 144–5, figures 3 and 5.

196. 63. See, for example, R. J. Charleston, 'A Group of Near Eastern Glasses', *Burlington Magazine*, LXXXI (1942), 218. For a new general discussion, see M. Jenkins, 'Islamic Glass', *Bull. MMA*, XLIX, 2 (1986).

64. Robert Schmidt, 'Die Hedwigsgläser und die verwandten fatimidischen Glas- und Kristallschnittarbeiten', *Schlesiens Vorzeit in Bild und Schrift*, N.P. VI (1912), 53–78; Lamm, *op. cit.*, I, 171–5, II, plate 63;

K. Erdmann, 'An Unknown Hedwig Glass', *Burlington Magazine*, XCI (1949), 244–8. Schmidt and Lamm dated them in the twelfth century.

65. Schmidt, *op. cit.*, figures 11, 9b, and 10.

197. 66. The largest published group of such animal bronzes is to be found in G. Migeon, *Manuel d'art musulman* (Paris, 1927), figures 182–91; the only more critical evaluation is by K. Erdmann, 'Islamische Giessgefässe des 11. Jahrhunderts', *Pantheon*, XXII (1938), 251–4. See also E. C. Dodd, 'On the Origins of Medieval *Dinanderie*: The Equestrian Statue in Islam', *Art Bulletin*, LI (1969), 220–32; and *idem*, 'On a Bronze Rabbit from Fatimid Egypt', *Kunst des Orients*, VIII (1972), 60–76.

198. 67. Meyer, 'Romanische Bronzen und ihre islamischen Vorbilder', in Ettinghausen, ed., *op. cit.* (Note 59), 317–22.

68. M. Jenkins, 'New Evidence for the History and Provenance of the So-called Pisa Griffin', *Islamic Archaeological Studies*, V, 1 (1978) (Cairo, 1982), 79–81. For a different view of the origin of the griffin at Pisa, A. S. Melikian Chirvani, 'Le griffon iranien de Pise', *Kunst des Orients*, V (1968), 68–86.

200. 69. 46.30. For a brief description and illustrations in colour, see E. Atil, *Art of the Arab World* (Washington, D.C., 1975), 44–5.

70. 14987. M. Mostafa, 'Fatimid Lustered Ceramics', *Egypt Travel Magazine*, II (1954), figure 10.

201. 71. 13080. For a general discussion of ceramics see M. Jenkins, 'Islamic Pottery', *Bull. MMA*, XL, 4 (1983).

72. For a description and colour picture of the dish in our illustration 192 see E. J. Grube, *Islamic Pottery of the Eighth to the Fifteenth Century in the Keir Collection* (London, 1976), 138–42, plate facing 136, top.

202. 73. The fragment of illustration 193 is 5397/1. See also a dish with an image of a priest swinging a censer, now in the Victoria and Albert Museum, London, in A. Lane, *Early Islamic Pottery* (London, 1947), plate 26A.

74. These boards have been fully published in E. Pauty, *Catalogue du Musée Arabe: Les bois sculptés jusqu'à l'époque ayyoubide* (Cairo, 1931), 48–50, nos. 3465–73, 4063, plates XLVI–LVIII. Some of the themes have been analysed by G. Marçais, 'Les figures d'hommes et de bêtes dans les bois sculptés d'époque fatimite conservés au Musée Arabe du Caire: Étude d'iconographie musulmane', *Mélanges Maspero*, III, *Orient islamique* (Cairo, 1940), 241–57. See also M. Jenkins, 'An Eleventh-Century Woodcarving from a Cairo Nunnery', in R. Ettinghausen, ed., *Islamic Art in the Metropolitan Museum of Art* (New York, 1972), 227–30.

75. Three boards from Dayr al-Banat are now in

the Coptic Museum, Cairo; the one illustrated here is 835. See R. Ettinghausen, 'Early Realism in Islamic Art', *Studi orientalistici in onore di Giorgio Levi della Vida*, I (Rome, 1956), 259–62.

76. J6375. For complete descriptions and detailed photographs of all these plaques, see E. Kühnel, *Die islamischen Elfenbeinskulpturen VIII.-XIII. Jahrhundert* (Berlin, 1971), 68–9, plates XCVII–XCVIII.

204. 77. For a study of this motif, see W. Hartner and R. Ettinghausen, 'The Conquering Lion: The Life Cycle of a Symbol', *Oriens*, XVII (1964), 161–71.

78. That this illusion of three dimensions was highly appreciated in eleventh-century Egypt is clear from al-Maqrizi's report of an artistic competition in which an Iraqi painted a dancing girl in such a way that she seemed to be emerging from a niche, but was outdone by his Egyptian rival, who painted a dancing girl as if she were entering a niche. For references to this passage and a discussion of its significance, see R. Ettinghausen, 'Painting in the Fatimid Period: A Reconstruction', *Ars Islamica*, IX (1942), 112–13.

79. The two Louvre plaques are described and illustrated in Kühnel, *op. cit.*, 69, plates XCVII, XCVIII.

80. *Ibid.*, 70–1, plate XCIX.

205. 81. For example, see Ettinghausen, *op. cit.* (Note 75), 267–9; *idem, Arab Painting* (Geneva, 1962), 54–6; and E. J. Grube, *The World of Islam* (London, 1966), 67.

82. The wall paintings came from a bath outside Cairo; see G. Wiet, *Exposition d'art persan*, 2 vols. (Cairo, 1935), 75–6, plates 52–3. A few drawings on paper, in vernacular styles, have been found on the dumps at Fustat, but they offer little help in establishing the characteristics of the 'Fatimid school'. See, for example, B. Gray, 'A Fatimid Drawing', *British Museum Quarterly*, XII (1938), 91–6, plate XXXIII; G. Wiet, 'Un dessin du XIe siècle', *Bulletin de l'Institut d'Égypte*, XIX (1936–7), 223–7; D. S. Rice, 'A Drawing of the Fatimid Period', *Bulletin of the School of Oriental and African Studies*, XXI (1958), 31–9.

206. 83. Monneret de Villard, *op. cit.* (Note 15), 13–22.

84. This bottle is published in E. Herzfeld, *Die Malereien von Samarra* (Berlin, 1927), plate LXIX; its theme is discussed by J. Sauvaget, 'Remarques sur les monuments omeyyades, II. Argenteries "sassanides"', *Mélanges Asiatiques* (1940–1), 53–6.

207. 85. See the discussion in Monneret de Villard, *op. cit.*, 41–2.

86. Monneret de Villard, *op. cit.*, 44–5, dismissed this idea. Nevertheless, such images had a long history in both European and Eastern Christian art; in the latter it was St Theodore who was most often represented. On the other hand, such representations are not known in Islamic art before the late twelfth century. See especially copper coins with images of St George killing the dragon issued by the Norman Prince Roger of Salerno, who ruled at Antioch between 1112 and 1119; G. Schlumberger, *Numismatique de l'Orient latin*, 2 vols. (Graz, 1954), 48–9, plate II no. 12.

CHAPTER 6

209. 1. R. N. Frye, ed., *The Cambridge History of Iran*, IV, *From the Arab Invasion to the Seljuqs* (Cambridge, 1975), contains most of the historical and cultural information about Iran, including a chapter on the arts by O. Grabar, pp. 329–63.

2. al-Narshakhi, *The History of Bukhara*, trans. R. N. Frye (Cambridge, 1954), 48 ff.; for Nishapur, al-Muqaddasi, *Ahsan al-taqalim* (Leyden, 1906), 316, with a curious dome in the mosque; for Qum, see the *Tarikh-i Qum* (Tehran, 1934), 37–8; for Shiraz, Donald N. Wilber, *The Masjid-i Atiq of Shiraz* (Shiraz, 1972).

3. R. Ghirshman, 'Une mosquée de Suse du début de l'Hégire', *Bulletin d'Études Orientales*, XII (1947–8), 75–9.

4. David Waterhouse, *Siraf III The Congregational Mosque* (London, 1980).

5. Eugenio Galdieri, *Isfahan: masgid-i guma*, 2 vols. (Rome, 1972–3).

6. See below, pp. 257 ff.

7. Summary in A. Godard, 'Historique du masjid-e djuma', *Athar-e Iran*, I (1936), 216 ff.

211. 8. See below, p. 284.

9. Main publication by A. Godard, 'Le Tari-khana de Damghan', *Gazette des Beaux-Arts*, XII (1934); *SPA*, II, 933–4.

10. *SPA*, II, 934–9.

11. K. Pirnia, 'Masjid-e jami-e Fahraj', *Bastan-Chenassi va Honar-e Iran*, V (1970), 2–14; Bianca M. Alfieri and Ricardo Zipoli, 'La moschea gami di Fahrag', *Studi iranici* (Rome, 1977), 41–76.

212. 12. It is not absolutely certain whether the present domes, two of which are later, necessarily correspond to earlier ones.

214. 13. Copious bibliography in Russian. Main description by A. Iu. Iakubovskij in *Gos. Ermitazh, Trudy otdela Vostoka*, II (1940), 113 ff., who dates it no later than the ninth century. V. A. Nilsen, *Monumentalnaia Arhitektura Buharskovo Oazisa* (Tashkent, 1956), 27 ff., proposes a date in the eleventh century. Both authors use ceramic evidence for their dates but do not discuss it. From the tenth century may also date the foundation of the small mosque at Bukhara, the Magoki Attari.

14. Lisa Golombek, 'Abbasid Mosque at Balkh', *Oriental Art*, XV (1969), 173–89.

15. Above, pp. 134-5 and p. 181.
16. A. Godard, 'Les anciennes mosquées de l'Iran', *Athar-e Iran*, I (1936), 185-210; also in *III International Congress on Persian Art* (Leningrad, 1939), 70-7, summarized in *L'art de l'Iran* (Paris, 1962), 340 ff.
216. 17. In Yazd and perhaps other cities some remains of this type survive; see M. Siroux, 'Le masjid-e jumah de Yazd', *Bulletin de l'Institut français d'Archéologie Orientale*, XLIV (1947).
18. J. Sauvaget, 'Observations sur quelques mosquées', *AIEO*, IV (1938); answer by Godard in *Arts Asiatiques*, III (1956), 48-97.
19. Discussion in O. Grabar, 'The Earlier Islamic Commemorative Structures', *Ars Orientalis*, VI (1966), 7-46.
217. 20. E. Diez, *Churasanische Baudenkmäler* (Berlin, 1918), 89 ff.
21. Above, pp. 179-80.
22. The best description in English is by L. Rempel in *Bulletin of the American Institute for Persian Art and Archaeology*, IV (1936), 198-208; among the most comprehensive of the Russian contributors is V. L. Voronina, 'Kharakteristike arhitektury Srednei Azii epohi Samanidov', *Trudy Akad. Nauk Tajik SSR*, XXVII (1954), 41-55.
23. *SPA*, II, 946.
220. 24. Illustrated in *SPA*, IV, plate 237; for the latest discussion, see B. I. Marshak, 'Ranneislamskie Bronzovye Bliuda', *Trudy Gos. Ermitazh*, XIX (1978), 26-52.
25. A. Iu. Iakubovskij and others, *Zhivopis Drevnego Piandzhikenta* (Moscow, 1954), plate XX.
221. 26. G.A. Pugachenkova, 'Mazar Arab-Ata v Time', *Sovietskaia Arheologiia* (1961), 4, pp. 198 ff.; *eadem, Mauzolei Arab, Ata* (Tashkent, 1963).
27. Diez, *op. cit.* (Note 20), 40; Godard, *SPA*, II, 970.
222. 28. These excavations have not been published, and I am most grateful to Mr C. K. Wilkinson for having allowed me to study the existing plans and photographs.
29. W. Hauser, J. M. Upton, C. K. Wilkinson, 'The Iranian Expedition, 1937', *Bull. MMA*, XXXIII, no. II (1938), 9-11; Grabar, in *Cambridge History of Iran* (*op. cit.*, Note 1), 344.
30. Pugachenkova, *op. cit.*, 131 ff.
224. 31. W. Hauser, in *Bull. MMA*, XXXII, no. 10 (1937), 23 ff., and subsequent reports.
32. I. Ahrarov and L. Rempel, *Reznoi Shtuk Afrasiaba* (Tashkent, 1971).
33. André Godard, 'The Jurjir Mosque in Isfahan', *SPA*, XIV, 3100-3.
225. 34. Z. Maysuradze, *Keramika Afrasiaba* (Tbilisi, 1958); C. K. Wilkinson, 'The Glazed Pottery of

Nishapur and Samarkand', *Bull. MMA*, N.S. XX (1961), 102-15.
35. C. K. Wilkinson, *Nishapur: Pottery of the Early Islamic Period* (New York, 1973).
36. J. C. Gardin, *Céramiques de Bactres* (Paris, 1957).
226. 36a. A. Lane, *Early Islamic Pottery* (London, 1947), plate 16A, and Wilkinson, *op. cit.* (Note 35), 172, no. 14.
37. See, for instance, Wilkinson, *op. cit.* (Note 34), 105, figure 6.
227. 38. M. Pézard, *La céramique archaïque de l'Islam et ses origines* (Paris, 1920), plates XCI and XCVIII b; Pope, *SPA*, V, plates 562B and 563; and M. Jenkins, 'Islamic Pottery', *Bull. MMA*, XL, 4 (1983).
230. 39. R. Sellheim, *Die klassisch-arabischen Sprichwörtersammlungen insbesondere des Abu Abaid* (The Hague, 1954).
40. R. Ettinghausen, 'The "Wade Cup" in the Cleveland Museum of Art, Its Origin and Decorations', *Ars Orientalis*, II (1957), 356-9, text figure w, and plate 8, figure 23.
231. 41. Pézard, *op. cit.*, plates XIII-XXV; Arthur Lane, 'The Early Sgraffito Ware of the Near East', *Transactions of the Oriental Ceramic Society*, XI (1938), 40-1, plate 14a, c; *idem, Early Islamic Pottery* (London, 1947), 25, plates 30, 31A.
232. 42. Pope, *SPA*, V, plate 621.
43. For some useful literature on this question see R. J. Charleston, 'A Group of Near Eastern Glasses', *Burlington Magazine*, LXXXI (1942), 212-18; A. von Saldern, 'An Islamic Carved Glass Cup in the Corning Museum of Glass', *Artibus Asiae*, XVIII (1955), 257-70; P. Oliver, 'Islamic Relief Cut Glass: A Suggested Chronology', *Journal of Glass Studies*, III (1961), 9-29; K. Erdmann, 'Neuerworbene Gläser der islamischen Abteilung', *Berliner Museen*, XI (1961), 35-9, figures 4-11. See also A. A. Abdurazakov, 'Medieval Glasses from the Tashkent Oasis', *Journal of Glass Studies*, XI (1969), 31-6. The most recent general discussion: M. Jenkins, 'Islamic Glass', *Bull. MMA*, XLIV, 2 (1986).
44. C. J. Lamm, *Das Glas von Samarra* (Berlin, 1928), nos. 184, 243, 245, 246, 249, plates IV, VI, VIII.
45. Examples are published in *Glass from the Ancient World: The Ray Winfield Smith Collection* (Corning, 1957), 232-63.
233. 46. Corning 591.489. Mohammed Mostafa, *The Museum of Islamic Art: A Short Guide* (Cairo, 1955), figure 75; Oliver, *op. cit.*, 11, 22, figures 23, 24.
47. H. R. Hahnloser, *Il tesoro di San Marco: Il tesoro e il museo* (Florence, 1971), plates LXXXIX-XC (top); XCI-XCII; XCIV (top); *Treasury of San Marco, Venice* (Milan, 1984), 216-27.
235. 48. See P. Kahle, 'Die Schätze der Fatimiden',

Zeitschrift der Deutschen Morgenländischen Gesellschaft, N.F. XIV (1935), 329-62, especially items 8, 10, 27.

49. C. J. Lamm, *Cotton in Mediaeval Textiles of the Near East* (Paris, 1937), figures 10, 27, 48, plate VII, D and E.

50. C. J. Lamm, *Mittelalterliche Gläser und Steinschnittarbeiten aus dem Nahen Osten*, II (Berlin, 1930), 496-8, especially nos. 76, 81, 82, 83, 91, 92.

51. R. Ettinghausen, 'An Early Islamic Glass-Making Center', *Record of the Museum of Historic Art, Princeton University*, I (1942), 4-7; D. S. Rice, 'Early Signed Islamic Glass', *Journal of the Royal Asiatic Society* (April 1958), 12-16, figure 4, plates IV-VI.

52. P. Kahle, 'Bergkristall, Glas und Glasflüsse nach dem Steinbuch von el-Beruni', *Zeitschrift der Deutschen Morgenländischen Gesellschaft*, N.F. XV (1936), 332.

53. A small flacon found during the excavations of Wasit, the first important town to the north of Basra on the Tigris route; K. Erdmann, 'Neue islamische Bergkristalle', *Ars Orientalis*, III (1959), 202, text figure A and figure 4.

54. As coins were issued in Samarra till 953, the town seems to have continued as an important and probably still fairly prosperous centre even after it ceased to be the caliphal capital in 892 (see G. C. Miles, 'The Samarra Mint', *Ars Orientalis*, I (1954), 187-91); it is therefore just possible that such luxury products as cut glass were still in use.

236. 55. This group has not been systematically studied so far. Characteristic examples are to be found in J. Orbeli and C. Trever, *Orfèvrerie sasanide* (Moscow and Leningrad, 1935), plates 9, 11, 12, 14, 18, 22, 31, 33, 49, 66-78, 82, 84.

56. Y. I. Smirnov, *Vostochnoe Serebro*; *Argenterie orientale* (St Petersburg, 1909), plates LXXIX, LXXX no. 141; Max van Berchem, 'Inscriptions mobilières arabes en Russie', *Journal Asiatique*, 10ᵉ ser., XIV (1909), 404, no. 141.

237. 57. See Ettinghausen, *op. cit.* (Note 40), text figure W and plate 11, figure 36.

58. G. Wiet, *L'exposition persane de 1931* (Cairo, 1933), 17, no. 7, plate IVa.

238. 59. Most of those known are published in *Propyläen Kunstgeschichte*, IV. See also Mehdi Bahrami, 'A Gold Medal in the Freer Gallery of Art', in G. C. Miles, ed., *Archaeologica Orientalia In Memoriam Ernst Herzfeld* (Locust Valley, N.Y., 1952), 5-20. It is questionable whether or not the medallion published by Bahrami is of the alleged date. Unfortunately there are many such questions of authenticity in connection with Buyid objects, particularly textiles and pieces made of wood or gold. Owing to the lack of scientifically conducted excavations, knowledge of

this period is limited, and it has not been possible so far to deal with these questions properly.

60. For the dating of this and the next object on epigraphic grounds see Van Berchem, *op. cit.*, 402-3, nos. 127, 128.

239. 61. Smirnov, *op. cit.*, plate LXX.

62. Ettinghausen, *op. cit.* (Note 40), plates 4-7, figures 13-17, 22.

240. 63. Wiet, *op. cit.*, 10-21, nos. 8-14, plates Ib, II, III.

243. 64. E. Kühnel, 'Some Observations on Buyid Silks', *SPA*, XIV (1960), 3080, 3089; *idem*, 'Die Kunst Persiens unter den Buyiden', *Zeitschrift der Deutschen Morgenländischen Gesellschaft*, N.F. XXXI (1956), 90; H. A. Elsberg and R. Guest, 'Another Silk Fabric Woven at Baghdad', *Burlington Magazine*, XLIV (1934), 271-2; and F. E. Day, 'The Inscription of the Boston "Baghdad" Silk', *Ars Orientalis*, I (1954), 191-4 (with bibliography).

65. For the original attabi fabrics, see the references collected by R. E. Serjeant, 'Material for a History of Islamic Textiles up to the Mongol Conquest', *Ars Islamica*, IX (1942), 82. For imitations, see *ibid.*, X (1943), 99, XI-XII (1946), 107-8, 116, 138, and XV-XVI (1951), 33.

66. E. Combe, J. Sauvaget, and G. Wiet, eds., *Répertoire chronologique d'épigraphie arabe* (Cairo, 1933), IV, no. 1507, with bibliographical data.

67. Schmidt, 'Persian Silks of the Early Middle Ages', *Burlington Magazine*, LVII (1930), 290, plate IIIA; G. Wiet, 'Un tissu musulman du nord de la Perse', *Revue des Arts Asiatiques*, X (1936), 173-9.

246. 68. D. S. Rice, *The Unique Ibn al-Bawwab Manuscript in the Chester Beatty Library* (Dublin, 1955), is the main source of information on this and other early illuminated manuscripts.

248. 69. For a discussion of the early history of paper, with full bibliography, see N. Abbott, 'A Ninth-Century Fragment of the "Thousand Nights", New Light on the Early History of the Arabian Nights', *Journal of Near Eastern Studies*, VIII (1949), 144-9. Now see also A. Grohmann, *Arabische Paläographie* (Graz, 1967), 105 ff.

70. F. E. Karatay, *Istanbul Üniversitesi Kütüphanesi: Arapça yazmalar kataloğu*, I (Istanbul, 1951), 3, 8, plate V. See also Rice, *op. cit.*, 9-10.

71. Rice, *op. cit.*, 2-3, 30-1, 35. For the official attitude that permitted a secretary to do occasional forging when it was for an important reason, see Levey, ed., *The Nasihat-nama, known as Qabus-nama* (London, 1951). See also Levey's translation of this work, *A Mirror for Princes, The Qabus-nama* (New York, 1951), 200-10.

72. *Bull. MMA*, XXXVII (1942), 99-100, figures 28 and 29.

73. O. Grabar in R. W. Hamilton, *Khirbat al Mafjar* (Oxford, 1959), 316-17.

249. 74. *Bull. MMA*, xxxiii, section 11 (1938), 9-12, figures 4-6.

250. 75. *Ibid.*, 12-14, figures 7-9.

76. *Bull. MMA*, xxxvii (1942), 116, 118, figure 45.

77. For the author see S. M. Stern, 'Abd al-Rahman b. Umar al-Sufi', *The Encyclopedia of Islam*, i, 2nd edn (Leiden, 1954), 86-7; for the Oxford manuscript and later versions, see E. Wellesz, 'An Early al-Sufi Manuscript in the Bodleian Library in Oxford', *Ars Orientalis*, iii (1959), 1-26. A colour reproduction of the constellation Virgo can be found in R. Ettinghausen, *Arab Painting* (Geneva, 1962), 51. Another early manuscript, dated 1005-11, also copied from the author's holograph, is in Leningrad.

78. For a Carolingian version in the Hellenistic tradition see G. Thiele, *Antike Himmelsbilder* (Berlin, 1898), 105-7, figure 31.

CHAPTER 7

253. 1. The best introduction consists in the chapters written by H. A. R. Gibb, B. Lewis, and C. Cahen in K. M. Setton, ed., *A History of the Crusades*, i and ii (Philadelphia, 1958-62). Since then, the following have added significantly either to information about this period or to its interpretation: Marshall Hodgson, *The Venture of Islam* (Chicago, 1974), ii, esp. pp. 1-368; D. H. Richards, ed., *Islamic Civilisation 950-1150* (Oxford, 1973); J. A. Boyle, ed., *The Cambridge History of Iran*, v (Cambridge, 1968).

2. For Egypt and parallel developments in the West, see above, Chapters 4 and 5.

3. C. Cahen, 'Buwayhids', *Encyclopedia of Islam*, part ii.

4. C. Cahen, 'Mouvements populaires et autonomisme urbain', *Arabica*, v and vi (1958-9).

255. 5. See J. Pedersen, 'masdjid', *Encyclopedia of Islam*, part i, sections E and F, part iii. For a more recent statement on the teaching done in the madrasas, see G. Makdisi, 'Muslim Institutions of Learning', *Bulletin of the School of Oriental and African Studies*, xxxiv (1961); J. Sourdel-Thomine, 'Locaux d'enseignement', *Revue des Études Islamiques*, xliv (1976); and D. Sourdel, 'Réflexions sur la diffusion de la madrasa, en Orient', *ibid*.

256. 6. A notable exception is K. Erdmann, *Ibn Bibi als kunsthistorische Quelle* (Istanbul, 1962).

7. None of these buildings has been properly published; photographic surveys (generally incomplete), plans, and partial descriptions can best be found in several articles by A. Godard in *Athar-e Iran*, i (1936), and in E. Schroeder's contribution to *SPA*, 981 ff.,

with a large number of photographs and plans. The only well published monument is Barsian, by M. B. Smith in *Ars Islamica*, iv (1937). Many details about these mosques are still uncertain. See also Sauvaget's remarks in *AIEO*, iv (1938), 82 ff., and above, p. 214. Among more recent investigations leading to nearly all the available information are Robert Hillenbrand, 'Seljuq Dome Chambers in Northwest Iran', *Iran*, xiv (1976); D. Wilber, 'Le masgid-i gami de Qazwin', *Revue des Études Islamiques*, xli (1973); J. and D. Sourdel, 'Inscriptions seljoukides', *ibid.*, xlii (1974), 3-43. The enumeration of all the mosques which can reasonably be attributed to the eleventh, twelfth, and early thirteenth centuries is still a task ahead. Nearly every travel or survey account (for instance the series published in *Archäologische Mitteilungen aus Iran* or the many volumes of the Historical Society in Iran, as in Note 40 the work of I. Afshar) contains potential information. For example, for specific buildings see S. R. Peterson, 'The Masjid-i Pa Minar in Zavareh', *Artibus Asiae*, v, 39 (1978), or C. Adle, 'Le minaret du masjed-e jame de Semman', *Studia Iranica*, iv (1975).

257. 8. A. Lézine, 'Hérat', *Bulletin d'Études Orientales*, xviii (1964).

9. D. Schlumberger, 'Le palais ghaznévide de Lashkari Bazar', *Syria*, xxxix (1952), figure 1; *idem*, *Lashkari Bazar* (Paris, 1978), 1A, 67-70, 23.

10. G. A. Pugachenkova, *Puti razvitia arhitektury iuzhnogo Turkmenistana* (Moscow, 1958), 245 ff.; R. Hillenbrand, 'Saljuq Monuments of Iran III', *Kunst des Orients*, v-x (1976).

11. V. A. Nilsen, *Monumentalnaia Arhitektura Buharskogo Qazisa* (Tashkent, 1956), 70 ff.

12. Only indicated from a minaret; below, p. 286.

13. G. A. Pugachenkova and L. I. Rempel, *Vydaiuchtiecia Pamiatniki Arhitektury Uzbekistana* (Tashkent, 1958), 155 ff.

14. Known from a minaret; see below, p. 273.

15. In addition to the ones mentioned in Note 5, A. Gabriel, 'Le masdjid-i djumah d'Isfahan', *Ars Islamica*, ii, part i (1935). See now E. Galdieri, *Isfahan: masjid-i guma*, 2 vols. (Rome, 1972-3), and 'Précisions sur le Gunbad-e Nizam al-Mulk', *Revue des Études Islamiques*, xliii (1975).

16. Above, pp. 209-10.

17. The best photograph of this part is figure 174 in A. Godard, *Athar-e Iran*, i (1936). The study of this area was begun by the Italian expedition.

18. All the inscriptions are published in E. Combe *et al.*, *Répertoire chronologique d'épigraphie arabe* (Cairo, 1931-54), nos. 2775, 2776, and 2991.

19. Ibn al-Athir, *Tarikh, sub anno* 442.

20. This part of the mosque, to the left of the present entrance, may have served as a sort of deposit for

earlier fragments. Its archaeological investigation has not been fully undertaken.

264. 21. Abu Nu'aym, *K. Akhbar Isfahan*, ed. Sven Dedering (Leyden, 1931-4), 17-18.

22. Galdieri's reconstruction in *Revue des Études Islamiques*, *op. cit.* (Note 15), is archaeologically reasonable (though of course sketchy), but its visual implications are not satisfactory.

23. J. Sauvaget, in *AIEO*, IV (1938), 82 ff.

24. This is the generally accepted explanation. Yet its decoration (see below, pp. 282-3) and its open oculus make other hypotheses possible, for instance that it was an observatory; but at this stage we can only speculate.

25. Abu Nu'aym, *loc. cit.*; al-Mafarrukhi, *Kitab-e Mahhassin-e Isfahan* (Tehran, 1933), 84 ff.

26. The contemporaneity of the four iwans is far from proven, and only the archaeological investigation abruptly interrupted by the Iranian revolution would have provided the answer. There is little point in devising speculative answers for questions which cannot be resolved.

27. At Ardistan, these include two dates and remains from an earlier mosque; the most sensible explanation has been provided by Sauvaget, *op. cit.*

28. A. Godard discovered it; *Athar-e Iran*, I (1936), 298 ff.

29. The size of the piers varies from place to place, and often instead of barrel-vaults domes were used.

30. Below, p. 276.

266. 31. The theory has been stated categorically only in A. Godard, 'L'origine de la madrasa', *Ars Islamica*, XV-XVI (1951), 1 ff.; its elements can be found in M. van Berchem, *Matériaux pour un Corpus Inscriptionum Arabicarum*, I, *Égypte* (Cairo, 1899 ff.), I, 265-6; E. Herzfeld, 'Damascus', *Ars Islamica*, IX and X (1942 and 1943), *passim*; see also Pedersen, *op. cit.* (Note 5).

32. A. Talas, *La madrasah nizamiyya* (Paris, 1939), 27-8; Mustafa Jawàd, 'al-Madrasah al-Nizamiyya', *Sumer*, IX (1953), 317-42.

33. Creswell, *MAE*, II, 104 ff.; Pugachenkova, *op. cit.* (Note 10), 341 ff. The earliest archaeologically retrieved madrasa is the one discovered by Nemtseva in Samarqand; see N. B. Nemtseva, 'Istoki Kompositsii i etapy formirovaniya Ansabla Shakhi-Zinda', trans. J. M. Rogers, *Iran*, XV (1977). Her functional identification and dating to the middle of the eleventh century are possible, but the reconstruction of the building's plan is very uncertain. The next known madrasa is in the mountains of Afghanistan; see M. J. Casimir and B. Glatzer, 'Sah-i Mashad', *East and West*, II (1971).

34. Pugachenkova, *op. cit.*, 260-4; M. E. Masson, 'O nadpicia', *Epigrafika Vostoka*, VII (1953), 7 ff.

268. 35. F. Sarre, *Denkmäler Persischer Baukunst* (Berlin, 1910), 1311.

36. *Ibid.*, 56-7.

37. *SPA*, plate 335.

38. In more than one instance, including the Kharraqan 'towers', the distinction between tower and canopy has been blurred, and one of the problems of Iranian mausoleums is precisely one of devising an appropriate typology and the vocabulary to go with it. Such a work is being prepared by Dr R. Hillenbrand on the basis of his doctoral dissertation at Oxford.

269. 39. Pugachenkova, *op. cit.*, 286; see also R. Hillenbrand, 'Saljuq Monuments in Iran II', *Iran*, X (1970), for the Takistan example datable in two phases, *c.* 1100 and 1174-5.

40. For Sangbast see D. Sourdel and J. Sourdel-Thomine, 'À propos des monuments de Sangbast', *Iran*, XVII (1979). For Yazd, see R. Holod, 'The Monument of Duvazdah Imam in Yazd', in D. K. Kouymjian, ed., *Studies in Honor of George C. Miles* (Beirut, 1974); I. Afshar, *Yadgarha-i Yazd* (Tehran, 1354 A.S.), II, 311 ff.

41. D. Stronach and T. Cuyler Young, Jr, 'Three Octagonal Seljuq Tomb Towers from Iran', *Iran*, IV (1966).

42. S. M. Stern, 'The Inscriptions of the Kharraqan Mausoleums', *Iran*, IV (1966).

270. 43. Pugachenkova, *op. cit.*, 315-28.

271. 44. A. Godard, *Les monuments de Maragha* (Paris, 1934). *Arhitektura Azerbayyana epoha Nizami* (Baku, 1947) has excellent summaries on most monuments; for a concise analysis of their significance see L. C. Bretanitskij, *Zodchestvo Azerbayyana XII-XV vv* (Leningrad, 1961). The Nakhichevan mausoleums were described by Sarre, *op. cit.*, 9 ff.

272. 45. A. M. Pribytkova, *Pamiatniki arhitektury XI veka v Turkmenii* (Moscow, 1955), 6-38; O. Grabar, *Ars Orientalis*, II (1957), 545; E. Diez, *Khorasan* (Munich, 1923).

46. E. Cohn-Wiener, *Turan* (Berlin, 1930), 34-6, plates x ff.

273. 47. J. Sourdel-Thomine, 'Deux minarets d'époque seljoukide en Afghanistan', *Syria*, XXX (1953), 131 ff., which includes only north-eastern Iranian minarets; for an earlier list, see M. B. Smith, 'The Manars of Isfahan', *Athar-e Iran*, I (1936), 316, note 2; Diez, *op. cit.*, 166-7; G. C. Miles, 'Inscriptions on the Minarets of Saveh', *Studies for Professor K. A. C. Creswell* (Cairo, 1965).

48. Max van Berchem in Diez, *op. cit.*, 112 ff.

49. A. Maricq and G. Wiet, *Le minaret de Djam* (Paris, 1959).

50. This is particularly true of the many minarets in the Isfahan area.

51. E. Diez, 'Siegesthürme in Ghazna', *Kunst des Orients*, I (1950); G. Azarpay, 'The Islamic Tomb Tower', in A. Daneshvari, ed., *Essays in Islamic Art and Architecture* (Malibu, 1981).

52. Pugachenkova, *op. cit.*, 184 ff.; A. M. Belenitsky, I. B. Bentovich, and O. G. Bolshakov, *Srednevekovyi Gorod Srednei Azii* (Leningrad, 1973), esp. 132 ff.

276. 53. Belenitsky *et al.*, *op. cit.*, 203 ff.

54. Schlumberger, *op. cit.* (1978) (Note 9), 89 ff., and esp. plates 3 and 25 ff.

55. Architectural remains published in *Trudy Akedmiy Nauk Uzbek SSR*, ser. I, vol. II (Tashkent, 1945), 133 ff.; stucco in B.P. Denike, *Arhitekturnyi Ornament Srednei Azii* (Moscow, 1939), 49 ff.

56. Schlumberger, as Note 9.

57. Still unpublished in their details; see A. Bombaci, *The Kufic Inscription in the Royal Palace of Masud III at Ghazni* (Rome, 1966), and below, Note 92.

58. *SPA*, plates 271-2; I.I. Umniakov, 'Rabat-i Malik', *V. V. Bartoldu Turkestanskie Druzia* (*Festschrift V. V. Barthold*) (Tashkent, 1927), 179 ff.; for a different date, see Nilsen, *op. cit.* (Note 11), 55. For the most recent plans, after excavations, see N. B. Nemtzeva, 'Ribat-i Malik', in L. I. Rempel, ed., *Hudozhestvennaya Kultura Srednei Azii* (Tashkent, 1983).

278. 59. Above, p. 222.

60. Pribytkova, *op. cit.* (Note 45), 39 ff.

61. A. Godard, 'Khorasan', *Athar-e Iran*, IV (1949), 7 ff. See also examples in E. Herzfeld, 'Damascus II', *Ars Islamica*, X (1943), figures 2 and 31.

62. M. B. Smith in *Ars Islamica*, IV; the same scholar's study of the monuments of Sin in *Ars Islamica*, VI (1939), is also very important for techniques of construction. For Central Asia, the major works are those of Nilsen, Pribytkova, and Pugachenkova.

63. Hillenbrand's various monographs show the beginnings of a more systematic definition of techniques.

279. 64. Wood, however, was certainly used in some areas, as appears at Khiva; cf. Note 13.

65. A. Godard, *Athar-e Iran*, I (1936), figures 21, 34, 40, 43, 44.

66. Pribytkova, *op. cit.*, figures 49, 51, 48.

67. The only major exception known to me is the mausoleum at Alamberdar (Pribytkova, *op. cit.*, figure 77), where bricks are arranged so as to form a sort of pendentive.

281. 68. Gulpaygan shows an interesting and unexplained variation in *SPA*, plate 309.

69. Above, p. 221.

282. 70. *SPA*, plate 274A.

71. An alternative explanation, perhaps historically more logical but, at this stage of knowledge, more difficult to demonstrate, is that this development of the muqarnas had already taken place in Iraq.

72. J. Rosintal, *Le réseau* (Paris, 1937); *idem, Pendentifs, trompes et stalactites* (Paris, 1928).

283. 73. A. Godard, 'Voûtes iraniennes', *Athar-e Iran*, IV² (1949).

74. M. B. Smith in *Ars Islamica*, IV, and note 46; *ibid.*, VI, for Sin.

75. Photographs of vaults and drawings in *SPA*, plates 294-300, figures 332-4, 365-6.

76. The issue is clouded by the paucity of documents and plethora of theories on Sasanian vaulting. The hopefully forthcoming posthumous publication of a study by M. B. Smith on Iranian vaulting should at least provide accurate information on this topic.

284. 77. E. Schroeder in *SPA*, 1027-9.

78. At times even wider; Pugachenkova, *op. cit.*, figure on p. 311.

286. 79. M. S. Bulatov, *Geometricheskaia Garmonizatziia v Arhitektury Srednei Azii IX-XV vv* (Moscow, 1978).

80. For instance, the proclamation of the faith in the minaret at Jam, the secular poetry of the palace at Ghazni, or the sacred preservation of legal documents in Qazvin. The iconography of ornament still awaits its study.

288. 81. D. N. Wilber, 'The Development of Mosaic Faience', *Ars Islamica*, VI (1939).

82. A rare exception is J. Bergeret and L. Kalus, 'Analyse de décors épigraphiques à Qazvin', *Revue des Études Islamiques*, XLV (1972).

83. A. U. Pope in *SPA*, 1284 ff.; L. I. Rempel, *Arhitekturnyi Ornament Uzbekistana* (Tashkent, 1961); B. Denike, *Arhitekturnyi Ornament Srednei Azii* (Moscow, 1939).

84. I am thinking in particular of general books like S. and H. Scherr-Thoss, *Design and Color in Islamic Architecture* (Washington, 1968), with excellent photographs.

289. 85. Denike, *op. cit.*, figures 33-66, and J. Sourdel in Schlumberger, *Lashkari Bazar* (*op. cit.*, Note 9).

86. List in *SPA*, 1299 ff.

87. S. Flury, 'Le décor épigraphique des monuments de Ghazni', *Syria*, VI (1925); J. Sourdel-Thomine, *Syria*, XXX.

88. Cf. the quotations in Rempel, *op. cit.*, 252 ff.

89. R. M. Riefstahl, 'Persian Islamic Stucco Sculpture', *Art Bulletin*, XIII (1931); *SPA*, plates 514 ff.

290. 90. See below, pp. 333, 336, 339, 341-2, 343, 350, 353-6.

91. J. Sourdel in *Revue des Études Islamiques*, XLII (1974).

291. 92. U. Scerrato, 'The First Two Excavations at Ghazni', *East and West*, N.S. X (1959).

93. P. Brown, *Indian Architecture* (*The Islamic Period*) (Bombay, 1949), 7; Sir John Marshall, 'The Monuments of Muslim India', *The Cambridge History*

of India, 111 (Cambridge, 1928), 575 ff. See now also J. C. Harle, *The Art and Architecture of the Indian Subcontinent (Pelican History of Art)* (Harmondsworth, 1986), chapters 30-3.

94. G. Wiet and A. Maricq, *Le minaret de Djam* (Paris, 1954), 53.

95. *Ibid.*, 67; H. Goetz, 'Arte dell'India musulmana', *Le civiltà dell'oriente*, IV (Rome, 1962), 784.

294. 96. Topography and bibliography of Baghdad in G. Makdisi, 'The Topography of Eleventh Century Baghdad', *Arabica*, VI (1959).

295. 97. Bergeret and Kalus, *op. cit.* (Note 82); A. Hartmann, *An-Nasir li-Din Allah* (Wiesbaden, 1975).

98. For the eleventh century and earlier the main source is al-Khatib al-Baghdadi, ed. and trans. G. Salmon, *L'introduction topographique* (Paris, 1904); then ibn al-Jawzi, *al-Muntazam* (Haydarabad, 1938 ff.). See also J. Lassner, *The Topography of Baghdad in the Early Middle Ages* (Detroit, 1970).

99. Creswell, *MAE*, II, 124 ff.; H. Schmid, 'Die Madrasa al-Mustansiriyya in Baghdad', *Architecture*, IX (1979).

296. 100. L. Massignon, *Mission en Mésopotamie*, II (Cairo, 1912), 41 ff.; see also F. Sarre and E. Herzfeld, *Archäologische Reise im Euphrat- und Tigris-Gebiet (Forschungen zur islamischen Kunst, no. 1)* (Berlin, 1911), I, 44-5.

101. E. Herzfeld, 'Damascus', *Ars Islamica*, IX, XIII-XIV (1942), 18 ff.; also M. Jawad, 'al-Imarat al-islamiyah', *Sumer*, III (1947), 38 ff.

297. 102. Herzfeld, *op. cit.* (Note 101), figures 64 ff.

103. M. Awad, 'al-Qasr al-Abbasi', *Sumer*, I (1945).

104. Sarre and Herzfeld, *op. cit.*, II, 151 ff.; Massignon, *op. cit.*, II, 47 ff.

105. Creswell, *EMA*, I, 644 ff; D. S. Rice, 'Medieval Harran', *Anatolian Studies*, II (1952).

106. See Max van Berchem and J. Strzygowski, *Amida* (Heidelberg, 1910), I; A. Gabriel, *Voyages archéologiques* (Paris, 1940), I, 85 ff.; M. Sozen, *Diyarbakirda Türk Mimarisi* (Istanbul, 1971); also a general attempt at Ortoqid architecture by A. Altun, *Anadoluda Artuklu devri Türk Mimarisinin Gelişmesi* (Istanbul, 1978).

298. 107. N. Elisséev, 'Les monuments de Nur al-Din', *Bulletin des Études Orientales*, XIII (1949-50). Dr Yassir al-Tabba wrote a thesis on the monuments of Nur al-Din, New York University, 1982.

108. Sarre and Herzfeld, *op. cit.*, II, 215 ff.

109. Elisséev *op. cit.*, 37-8.

110. Sarre and Herzfeld, *op. cit.*, I, 123 ff.; D. Sourdel and J. Sourdel-Thomine, 'Notes d'épigraphie et de topographie', *Annales Archéologiques de Syrie*, III (1953), 103 ff. (The minaret has now been relocated.)

111. A. Gabriel, 'Dunaysir', *Ars Islamica*, IV (1936), 352 ff.

299. 112. Gabriel, *op. cit.* (Note 106), 277 ff.

113. *Ibid.*, 263 ff.

114. *Ibid.*, 221 ff.; see also Sauvaget in *AIEO*, IV (1938), 82 ff.

115. Gabriel, *op. cit.* (Note 106), 255 ff.

116. *Ibid.*, 3 ff.; see also Ara Altun, *Mardinde Türk devri mimarisi* (Istanbul, 1971).

300. 117. This had been established by Gabriel and Sauvaget in *Voyages*, 184 ff.

118. S. al-Diwahji, 'Madaris al-Mausil', *Sumer*, XIII (1957).

119. Gabriel, *op. cit.* (Note 106), 195 ff.

301. 120. Sarre and Herzfeld, *op. cit.*, II, 234 ff. More recently some archaeological work has been accomplished in some of these shrines; Sa'id al Diwahji in *Sumer*, X (1954). It should be added that the plans published by Sarre and Herzfeld are far from reliable.

121. For these see mostly C. Preusser, *Nordmesopotamische Baudenkmäler* (Leipzig, 1912), 2 ff. For related Christian monuments see J. M. Fiey, *Assyrie chrétienne* (Beirut, 1965) and *Mossul chrétienne* (Beirut, 1959).

303. 122. al-Harawi, *Guide des lieux de pélerinage*, trans. J. Sourdel-Thomine (Damascus, 1957), 135-59.

123. G. Bell, *Amurath to Aurath* (London, 1924), 48-51; Elisséev, *op. cit.* (Note 107), 36.

124. Elisséev, *op. cit.*, 36-7.

125. Gabriel, *op. cit.* (Note 106).

126. Rice, *op. cit.* (Note 105).

127. Sarre and Herzfeld, *op. cit.*, II, 239.

128. *Ibid.*, 11.

129. W. Hartner, 'The Pseudoplanetary Nodes of the Moon's Orbit', *Ars Islamica*, V (1937), has explained them. The main publication is by Preusser.

304. 130. For Aleppo see J. Sauvaget, *Alep* (Paris, 1941); for Damascus there is no overall survey except by Sauvaget, 'Esquisse d'une histoire de la ville de Damas', *Revue des Études Islamiques*, VIII (1934), 421-80.

131. See e.g. J. Sourdel-Thomine, 'Le peuplement de la région des "villes mortes"', *Arabica*, I (1954).

132. E. Herzfeld, *Matériaux pour un Corpus Inscriptionum Arabicarum: Syrie du Nord: Alep* (Cairo, 1954), 143 ff.; Sauvaget, *Alep (op. cit.)*, and 'Inventaire des monuments musulmans de la ville d'Alep', *Revue des Études Islamiques*, V (1931), 73.

133. J. Sauvaget, *Les monuments historiques de Damas* (Beyrouth, 1932), 16.

134. J. Sauvaget, 'Les inscriptions arabes de la mosquée de Bosra', *Syria*, XXII (1941).

135. Best account in Max van Berchem, *Matériaux pour un Corpus Inscriptionum Arabicarum. Deuxième partie: Syrie du Sud: Jérusalem (MIFAO, XLII-XLV)*, 2 vols. (Cairo, 1920-7).

136. Sauvaget, *op. cit.* (Note 133), 95-6; E. Herzfeld, 'Damascus: Studies in Architecture - IV', *Ars Islamica*, XIII-XIV (1948), 118 ff.

137. Sauvaget, *op. cit.* (Note 133), 64; Herzfeld, *op. cit.* (Note 136), 123 ff.

138. Sauvaget, 'Inventaire', *op. cit.* (Note 132), 82 and 86 for a few remains; D. Sourdel, ed., *La description d'Alep d'Ibn Shaddad* (Damascus, 1953), 42 ff.

139. Creswell, *MAE*, II, 94 ff.

140. J. Sauvaget and others, *Monuments ayyoubides de Damas*, 4 vols. (Paris, 1938 ff.), I, 20.

141. E. Herzfeld, 'Damascus: Studies in Architecture – III', *Ars Islamica*, XI–XII (1946), 32–8.

307. 142. Sauvaget, *op. cit.* (Note 133), 100–2.

143. Summarized in Creswell, *MAE*, II, 104 ff.

309. 144. *Ibid.*, 64 ff.

145. *Ibid.*, 88 ff.

146. J. Sauvaget and others, *op. cit.* (Note 140), III, 92 ff.; M. Écochard, *Les bains de Damas*, 2 vols. (Beirut, 1942–3); for Aleppo, see 'Inventaire' (Note 132).

147. J. Sauvaget, 'Caravanserails syriens', *Ars Islamica*, VI (1939).

148. Ibn Shaddad, *op. cit.* (Note 138), 2.

149. Sauvaget, *op. cit.* (Note 133), 46; E. Herzfeld, 'Damascus: Studies in Architecture – I', *Ars Islamica*, IX (1942), 1–53.

310. 150. S. Saouaf, *The Citadel of Aleppo* (Aleppo, 1958); Herzfeld, *op. cit.* (Note 132); 77 ff.; M. Rogers, *The Spread of Islam* (Oxford, 1976), 43 ff.

151. D. J. Cathcart King, 'The Defences of the Citadel of Damascus', *Archaeologia*, XCIV (1951), with references to earlier works by Sauvaget and Soberhelm.

152. Creswell, *MAE*, II, 1–63.

153. A. Abel, 'La citadelle ayyubite de Bosra', *Annales Archéologiques de Syrie*, VI (1956).

311. 154. Ibn Shaddad, *op. cit.*, 24; Herzfeld, *op. cit.* (Note 132), 134–5.

312. 155. The most accessible synthesis is by J. Sauvaget, 'L'architecture musulmane en Syrie', *Revue des Arts Asiatiques*, III (1934); many further remarks in later works by Sauvaget, in Herzfeld's studies, and in articles on specific monuments found in the *Monuments ayyoubides de Damas* and in J. Lauffray, 'Une madrasa ayyoubide de la Syrie du Nord', *Annales Archéologiques de Syrie*, III (1953).

156. Forthcoming studies by young, mostly British and German, scholars engaged in systematic surveys of Jerusalem, Damascus, and Aleppo are bound to modify many of the older conclusions.

157. *Monuments ayyoubides*, I, 21–3. However it was already used in the eighth century when, at Qasr al-Hayr East, stone and brick construction techniques were found alongside each other.

158. In Damascus the Hanbalite mosque, the mosque of Repentance, parts of the dar al-hadith of Nur al-Din; and so forth.

159. Creswell, *MAE*, II, plate 19; many instances in Syria.

313. 160. Besides Herzfeld's work and J. Sourdel-Thomine's contribution to *Monuments ayyoubides*, IV, see the classic article by Max van Berchem, 'Inscriptions arabes de Syrie', *Mémoires de l'Institut Égyptien*, III (1900).

161. *Monuments ayyoubides*, II, plate XV.

162. Creswell, *MAE*, II, 84 ff.

163. *Monuments ayyoubides*, III, 121 ff.

164. Creswell, *MAE*, II, plate 42b.

165. For instance, J. Sauvaget, '*Les perles choisies*' *d'Ibn ach-Chihna* (Beyrouth, 1933), 136.

314. 166. A convenient but partial list has been drawn up by T. Rice, *The Seljuqs* (London, 1961), 136.

167. The study of Seljuq Anatolia has been very much modified by recent Turkish scholarship, including the creation of an Institute for Seljuq History and Civilization in Ankara which publishes occasional volumes of articles and discussions. New ideological and intellectual positions have been developed by, among others, Doğan Kuban, whose *Anatolia-Türk Mimarisinin, Kaynak ve Sorunlari* (Istanbul, 1965) set a new tone in research. I cannot say that I have been able to keep up with a truly immense flow of new or revised information, but it is clear that any further work on Seljuq Anatolia must take this research into account.

168. A. Gabriel, *Monuments turcs d'Anatolie*, 2 vols. (Paris, 1931–4), II, 143 ff.

169. No complete study of this building exists; see F. Sarre, *Reise in Kleinasien* (Berlin, 1896), 47–8; *idem, Konia* (Berlin, 1921); I. H. Konyali, *Konya Tarihi* (Konya, 1964), esp. 293 ff.

170. K. Otto-Dorn, 'Seldschukische Holzsäulenmoscheen', in R. Ettinghausen, ed., *Aus der Welt der islamischen Kunst* (Berlin, 1959), 59 ff.

171. Gabriel, *op. cit.* (Note 168), I, 32 ff.

172. *Ibid.*, 39 ff.

173. *Ibid.*, II, 174 ff.

316. 174. *Ibid.*, II, 173 ff.

175. B. Ünsal, *Turkish Islamic Architecture* (London, 1959), 17. The mosque is attributed to a vizier of Kiliçarslan II in the late twelfth century; for justification see E. Diez and O. Aslanapa, *Türk Sanati* (Istanbul, 1955), 55.

317. 176. Gabriel, *op. cit.*, I, 62 ff., 46 ff.

177. *Ibid.*, II, 155 ff.

178. Sarre, *Reise* (*op. cit.*, Note 169), 51–4; Konyali, *op. cit.* (Note 169), 523 ff.

179. Ünsal, *op. cit.*, 36–8; S. K. Yetkin, *Turkish Architecture* (London, 1966), 22 ff.; for the problem of the building's date, see J. M. Rogers, 'The Date of the Çifte Minare Madrasa', *Kunst des Orients*, VIII (1974).

318. 180. Sarre, *op. cit.*, 48–51, 54 ff.; Yetkin, *op. cit.*, 28 ff.; Konyali, *op. cit.*, 1049, 950.

181. The key point made by D. Kuban in the book quoted in Note 167 is precisely that of the convergence between Islamic needs and local practices.

323. 182. Thus Amasya in Ünsal, *op. cit.*, 45; Yetkin, *op. cit.*, 35 ff.

183. H. W. Duda, *Die Seldschukengeschichte des Ibn Bibi* (Copenhagen, 1959), 146-8.

184. F. Sarre, *Der Kiosk von Konia* (Berlin, 1936).

185. K. Erdmann, 'Seraibauten', *Ars Orientalis*, III (1959).

186. S. Lloyd and D. S. Rice, *Alanya* (London, 1958), 9 ff.; lists of monuments in Rice, *op. cit.* (Note 166), 196 ff.

187. K. Erdmann, *Das Anatolische Karavanseray*, 2 vols. (Berlin, 1961).

188. *Ibid.*, 169 ff.

189. *Ibid.*, 83 ff.

325. 190. Fundamental new studies on architectural decoration have appeared recently. The main ones are: G. Öney, *Anadolu Selçuklu Mimarisinde Süsleme ve El Sanatlari* (Ankara, 1978); S. Ögel, *Anadolu Selçuklularının Tas Tezyinatı* (Ankara, 1966); and M. Meinecke, *Fayencedekorationen seldschukischer Sakralbauten in Kleinasien*, 2 vols. (Tübingen, 1976).

191. A. Lane, 'The Ottoman Pottery of Isnik', *Ars Orientalis*, II (1957), 248 ff., is an earlier statement.

192. See the formal analysis made by H. Glück, *Die Kunst der Seldschuken* (Leipzig, 1923), 6-8.

193. For Divrik see Y. Crowe, 'Divrigi: Problems of Geography, History and Geometry', in W. Watson, ed., *Colloquies on Art and Archaeology*, no. 4 (London, 1974).

194. A list of such sculpture in Anatolia is found in Diez and Aslanapa, *op. cit.* (Note 175), 208-11; see also K. Otto-Dorn, 'Türkische Grabsteine', *Ars Orientalis*, III (1959). Add now K. Erdmann, 'Die beiden türkischen Grabsteine im Türk ve Islam Eserleri Müzesi in Istanbul', *Beiträge zur Kunstgeschichte Asiens In Memoriam Ernst Diez* (Istanbul, 1963), 121-30; G. Öney, 'Dragon Figures in Anatolian Seljuk Art', *Belleten*, XXXIII (1969).

CHAPTER 8

328. 1. For examples of the mobility of artists in this and other periods, see R. Ettinghausen, 'Interaction and Integration in Islamic Art', in G. E. von Grunebaum, ed., *Unity and Variety in Muslim Civilization* (Chicago, 1955), 110-13. The maker of a bronze pencase for Majd al-Mulk al-Muzaffar, grand vizier of the Khwarazmshah Ala al-Din Muhammad (1200-20), was working in a style associated with Herat; see E. Herzfeld, 'A Bronze Pen-Case', *Ars Islamica*, III (1936), 35-43. A well-known potter of Kashan, Muhammad ibn Abu Tahir, worked on a mausoleum in Gurgan, and a bowl inscribed with the name of a Nishapuri potter living in Kashan has also been attributed to Gurgan; M. Bahrami, *Gurgan Faïences* (Cairo, 1949), 75-81, 127-8.

2. The imitation of 'lower-class' subjects on works of art for the upper classes has been discussed in Ettinghausen, *op. cit.*, 124, plates Xb, XIa; for an example of the reverse phenomenon, in which courtly iconography was imitated and courtly titles paraphrased for a member of the merchant class, see R. Ettinghausen, 'The Bobrinski "Kettle", Patron and Style of an Islamic Bronze', *Gazette des Beaux-Arts*, 6e sér., XXIV (1943), 199-203.

3. One cycle of illustrations from the *Shahnama* painted on a ceramic vessel has been discussed in G. Guest, 'Notes on a Thirteenth Century Beaker', *Ars Islamica*, X (1943), 148-52. See also M. S. Simpson, 'The Narrative Structure of a Medieval Iranian Beaker', *Ars Orientalis*, XII (1981), 15-24. Large-scale arabesques in light colours against darker grounds occur in several miniatures from an illustrated copy of *Warqa wa Gulshah* in the Topkapı Sarayı, Istanbul (Hazine 841). They reflect the influence of Persian lustre pottery designs. For illustrations of ff. 21v, 37v, 46r, 57v, and 58v, see A. S. Melikian-Chirvani, 'Le roman de Varqe et Golsah', *Arts Asiatiques*, XXII, special number (1970), plates facing pp. 98 top and 99 top, and figures 21, 36, 46, 57, and 59, and A. Ateş, 'Un vieux poème romanesque persan: récit de Warqah et Gulshah', *Ars Orientalis*, IV (1961), figure 36. For related ceramics, see, for example, A. U. Pope, 'The Ceramic Arts in Islamic Times, A. The History', *SPA*, X, plates 632-5, 702-3; and R. Ettinghausen, 'Evidence for the Identification of Kashan Pottery', *Ars Islamica*, III (1936), 44-5.

329. 4. E. Baer, *Sphinxes and Harpies in Medieval Islamic Art* (Jerusalem, 1965); R. Ettinghausen, *Studies in Muslim Iconography*, I. *The Unicorn (Freer Gallery of Art Occasional Papers*, I, no. 3) (Washington, D.C., 1950).

5. F. Sarre, 'Die Tradition in der iranischen Kunst', *IIIe Congrès International d'Art et d'Archéologie Iraniens: Mémoires* (Moscow and Leningrad, 1935), 227-8, plates CV-CVI.

6. For the story of the unicorn and the elephant, its origins, and its variations, see Ettinghausen, *op. cit.* (Note 4), 29-31.

330. 7. W. H. T. Gairdner, trans., *Al-Ghazali's Mishkat al-Anwar* (London, 1924); see also A. J. Wensinck, 'Ghazali's Mishkat al-Anwar (Niche of Lights)', *Semitische Studien uit de Natalenschap van Prof. Dr A. J. Wensinck* (Leiden, 1941), 192-212, and R. Ettinghausen, 'Al-Ghazzali on Beauty', in K. B. Iyer, ed., *Art and Thought: Issued in Honour of Dr Ananda K. Coomaraswamy on the Occasion of His 70th Birthday* (London, 1947), 160-5.

8. These metaphors have been studied by H. Ritter, *Über die Bildersprache Nizamis* (Berlin, 1927).

9. R. A. Nicholson, trans., *The Mathnawi of Jelaluddin Rumi*, 11 (London, 1926), 352.

331. 10. A brief discussion on the use of powdered lapis, with references to the medieval literature, can be found in A. Grohmann, *Arabische Paläographie*, 1 (Vienna, 1967). Manuscripts in which it was employed include a Koran of 1164, now in the University Museum, Philadelphia (R. Ettinghausen, 'A Signed and Dated Seljuq Qur'an', *Bulletin of the American Institute for Persian Art and Archaeology*, 1 V (1935), 92-102).

332. 11. For the dating of block printing on paper, see T. F. Carter, *The Invention of Printing in China and its Spread Westward*, 2nd ed. (New York, 1955), 176-82. For printed textiles from Egypt in this period, see C. J. Lamm, *Cotton in Medieval Textiles of the Near East* (Paris, 1937), 131-2, and E. Kühnel, *Islamische Stoffe aus ägyptischen Gräbern* (Berlin, 1927), 85-8.

12. The written version of the *Shahnama*, the Persian epic, was completed by Firdawsi under the patronage of the Ghaznavid Sultan Mahmud (998-1030). Persian was the official language of the Anatolian Seljuq court at Konya and Persian literature was much in vogue there; see C. Cahen, trans. J. Jones-Williams, *Pre-Ottoman Turkey: A General Survey of the Material and Spiritual Culture and History c. 1071-1330* (New York, 1968), especially 251-8. The prestige of the heroic Iranian past among the Turkish princes of the Middle Ages can also be observed in the titulary of this period, in which epithets like 'Khusraw' and 'Shah' occur repeatedly; many of these titles can be found in the inscriptions collected in E. Combe, J. Sauvaget, and G. Wiet, *Répertoire chronologique d'épigraphie arabe*, VII-XI (Cairo, 1936-41).

13. B. Gray, 'A Seljuq Hoard from Persia', *The British Museum Quarterly*, XIII (1939), 73-9.

14. R. Ettinghausen, 'Turkish Elements on Silver Objects of the Seljuk Period of Iran', *Communications of the First International Congress of Turkish Art, Ankara, 1959* (Ankara, 1961), 128-33.

15. A number of examples are included in the extensive catalogue provided by M. Weisweiler, *Der islamische Bucheinband des Mittelalters nach Handschriften aus deutschen, holländischen und türkischen Bibliotheken* (Wiesbaden, 1962).

333. 16. The relevant passage from the treatise on book production has been translated by M. Levey, M. Krek, and H. Haddad, 'Some Notes on the Chemical Technology in an Eleventh Century Arabic Work on Bookbinding', *Isis*, XLVII (1956), 241; for identification of the author, see J. Karabacek, 'Neue

Quellen zur Papiergeschichte', *Mitteilungen aus der Sammlung der Papyrus Erzherzog Rainer*, 1 V (1888), 79, 82-3, and G. K. Bosch, 'The Staff of the Scribes and Implements of the Discerning: An Excerpt', *Ars Orientalis*, 1 V (1961), 1. The Egyptian binding of 1168 is discussed in K. B. Gardner, 'Three Early Islamic Bookbindings', *The British Museum Quarterly*, XXVI (1962), 28-9.

17. On these calligraphers see D. S. Rice, *The Unique ibn al-Bawwab Manuscript in the Chester Beatty Library* (Dublin, 1955), 5-10, and Grohmann, *op. cit.* (Note 10), 19-23.

18. Examples of forgeries are given with documentation in 'Calligraphy, A. An Outline History', *SPA*, 1 V, 1718.

19. The earliest illustrated scientific manuscript to have survived from the Islamic world is a copy of al-Sufi's treatise on the fixed stars, dated 1009-10 (see pp. 250-1); Wellesz, *op. cit.* (Chapter 6, Note 77). In the tenth century the popular series of Indian animal fables known in the Arabic-speaking world as *Kalila wa Dimna* are said to have been translated into Persian and illustrated at the Samanid court; V. Minorsky, 'The Older Preface to the *Shah-Nama*', *Studi orientalistici in onore di Giorgio Levi della Vida*, 11 (Rome, 1956), 168.

334. 20. Some of these references are given in R. Ettinghausen, 'Early Shadow Figures', *Bulletin of the American Institute for Persian Art and Archaeology*, VI (1934), 10-15; and in G. Jacob, *Geschichte des Schattentheaters im Morgen- und Abendland*, 2nd ed. (Hannover, 1925), 39-55.

21. Jacob, *op. cit.*, 56, 61.

22. For a translation of the relevant verses by Umar ibn al-Farid, see R. A. Nicholson, *Studies in Islamic Mysticism* (Cambridge, 1921), 189-91.

23. Convenient general discussions of the most important of these frescoes, with illustrations and references, are to be found in M. Bussagli, *Painting of Central Asia* (Geneva, 1963); L. Hambis, 'Sogdiana', *Encyclopedia of World Art*, XIII (New York, 1967), cols. 121-33; A. Belenitsky, trans. P. A Aillig and J. Marcadé, *Asie centrale* (Geneva, 1968); and, most recently, G. Azarpay, *Soghdian Painting* (Berkeley, 1979).

24. A few frescoes have been excavated at Nishapur, apparently in ninth- to twelfth-century contexts; see W. Hauser and C. K. Wilkinson, 'The Museum's Excavations at Nishapur', *Bull. MMA*, XXXVII (1942), 99-100, 117-19.

25. A major presentation of the argument for East Christian influence on Islamic painting can be found in T. W. Arnold, *Painting in Islam: A Study of the Place of Pictorial Art in Muslim Culture* (Oxford, 1928), chapter III. For a refutation of this view, see

H. Buchthal, 'The Painting of the Syrian Jacobites in its Relation to Byzantine and Islamic Art', *Syria*, xx (1939), 136-50.

26. S. D. Goitein, 'The Main Industries of the Mediterranean Area as Reflected in the Records of the Cairo Genizah', *Journal of the Economic and Social History of the Orient*, IV (1961), 172; and *idem*, *A Mediterranean Society*, I. *Economic Foundations* (Berkeley and Los Angeles, 1967), 99, 101-8.

336. 27. For information on the Iranian textile industry, see R. B. Serjeant, 'Materials for a History of Islamic Textiles up to the Mongol Conquest', *Ars Islamica*, x (1943), 71-104, xi (1946), 98-119, 131-5; for Tustar in particular, see x, 72-5.

28. 'Tiraz', *The Encyclopaedia of Islam*, I, 1st ed. (Leiden, 1934), 825-34. No detailed study of the development of tiraz fabrics in the Seljuq period has yet been undertaken, but a beginning can be made by gathering scattered examples in Combe *et al.*, *op. cit.* (Note 12).

337. 29. The mace head, now in the Museum of Islamic Art, Cairo, no. 15207, was published without discussion in R. Harari, 'Metalwork After the Early Islamic Period', *SPA*, XII, plate 1289B. A group of medieval Iranian bronzes has been tentatively identified as bucklers used in duelling; A. S. Melikian-Chirvani, 'Bucklers, Covers or Cymbals? A Twelfth-Century Riddle from Eastern Iran', in R. Elgood, ed., *Islamic Arms and Armour* (London, 1979), 97-111.

30. For this attribution, see M. S. Dimand, 'A Review of Sasanian and Islamic Metalwork in *A Survey of Persian Art*', *Ars Islamica*, VIII (1941), 208.

31. The known early pieces with silver inlay are discussed with references in R. Ettinghausen, 'The "Wade Cup" in the Cleveland Museum of Art, its Origin and Decorations', *Ars Orientalis*, II (1957), 332-3, and *idem*, 'Further Comments on the Wade Cup', *ibid.*, III (1959), 198.

339. 32. This object has been studied in detail by Ettinghausen, *op. cit.* (1943) (Note 2).

33. L. T. Giuzalian, 'The Bronze Qalamdan (Pen-Case) 542/1148 from the Hermitage Collection (1936-1965)', *Ars Orientalis*, VII (1968), 95-119.

34. On the development of these new scripts, see D. S. Rice, *The Wade Cup in the Cleveland Museum of Art* (Paris, 1955), chapter IV, and Ettinghausen, 'The "Wade Cup"', *op. cit.* (1957) (Note 31), 356-9.

340. 35. The object has been studied by M. M. Dyakonov, 'Un aquamanile en bronze daté de 1206' (in Russian with French summary), *IIIe Congrès International d'Art et d'Archéologie Iraniens: Mémoires* (Moscow and Leningrad, 1939), 45-52.

36. For a study of the image of a lion attacking a bull in ancient and Islamic times, see W. Hartner and

R. Ettinghausen, 'The Conquering Lion, the Life Cycle of a Symbol', *Oriens*, XVII (1964), 161-71.

341. 37. See respectively Ettinghausen, *op. cit.* (1943) (Note 2); Giuzalian, 'Bronzov'ui kuvshchin 1182', *Pamyatniki Epokhi Rustaveli* (Leningrad, 1938), 227-36; R. Ettinghausen, 'Sasanian and Islamic Metal-Work in Baltimore', *Apollo*, LXXXIV (December 1966), 465-9; M. Aga-Oglu, 'A Preliminary Note on Two Artists from Nishapur', *Bulletin of the Iranian Institute*, VI (1946), 121-4; and Herzfeld, *op. cit.* (Note 1). Also cf. S. Melikian-Chirvani on two more recently discovered works: 'Les bronzes du Khorasan I', *Studia Iranica*, III (1974), 29-50.

38. The present whereabouts of the piece, known as the Peytel Cup, is not known; for a drawing and discussion, see Ettinghausen, 340-1, and for a photograph, Rice, plate XIVb (both *op. cit.*, Note 34).

342. 39. Giuzalian, *op. cit.* (Note 37), 230-1.

343. 39a. M. Jenkins and M. Keene, *Islamic Jewelry in the Metropolitan Museum of Art* (New York, 1982).

39b. See, for instance, Lane, *op. cit.*, plate 63A.

40. For a preliminary study of polychrome faience mosaic, see D. Wilber, 'The Development of Mosaic Faience in Islamic Architecture in Iran', *Ars Islamica*, VI (1939), 16-47. The earliest surviving dated example (1242) of total surface tiling is not in Iran but in the Sırçalı Madrasa in Konya, Anatolia; the master responsible hailed from Tus in Khurasan, however, and it may therefore be assumed that such colourful assemblages were already known in eastern Iran. For a discussion of this building, with references, see Wilber, *op. cit.*, 39-40.

41. D. S. Rice, 'Studies in Islamic Metal Work - III', *Bulletin of the School of Oriental and African Studies*, xv (1953), 232-8.

41a. See Notes 3 and 49.

42. Some of these verses have been translated in M. Bahrami, *Recherches sur les carreaux de revêtement lustré dans la céramique persane du XIIIe au XVe siècle (étoiles et croix)* (Paris, 1937), 52-69.

345. 43. For a valuable contribution on this subject, see O. Watson, 'Persian Lustre-Painted Pottery: The Rayy and Kashan Styles', *Transactions of the Oriental Ceramic Society*, XL (1973-5), 1-19, esp. 9-13.

44. A. Lane, *Early Islamic Pottery: Mesopotamia, Egypt and Persia* (London, 1947), 37-8.

347. 45. Ettinghausen, *op. cit.* (Note 3); *idem*, 'Dated Faience', *SPA*, IV, 1667-96.

349. 45a. Lane, *op. cit.*, plates 62-4.

350. 46. Pope, *op. cit.* (Note 3), 1665-6.

47. Bahrami, *op. cit.* (Note 1); Watson, *op. cit.*, 5-6.

48. R. Naumann, 'Eine keramische Werkstatt des 13. Jahrhunderts auf dem Takht-i-Suleiman', in O. Aslanapa, ed., *Beiträge zur Kunstgeschichte Asiens In Memoriam Ernst Diez* (Istanbul, 1963); and *idem*, *Die*

Ruinen von Tacht-e Suleiman und Zendan-e Suleiman und Umgebung (Berlin, 1977), 102-3. See especially *idem*, 'Takht-i-Suleiman und Zendan-i-Suleiman: Vorläufiger Bericht über die Grabungen im Jahre 1961', *Archäologischer Anzeiger*, IV (1962), 659-65.

352. 49. M. Aga-Oglu, 'A Rhages Bowl with a Representation of an Historical Legend', *Bulletin of the Detroit Institute of Arts*, XII (1930), 31-2; and Guest, *op. cit.* (Note 3).

353. 50. This identification was first made by Renata Holod in a paper delivered at the Freer Gallery of Art, Washington, D.C. in January 1973; it has not yet appeared in published form.

358. 51. See R. Ettinghausen, 'The Covers of the Morgan *Manafi*' Manuscript and Other Early Persian Bookbindings', in D. Miner, ed., *Studies in Art and Literature for Belle da Costa Greene* (Princeton, 1954), 472-3.

360. 52. The most complete publication of this manuscript is Melikian-Chirvani, *op. cit.* (Note 3).

53. See references in Note 23.

362. 54. For information on the textile industry in northern and central Mesopotamia, see R. B. Serjeant, 'Materials for a History of Islamic Textiles up to the Mongol Conquest', *Ars Islamica*, IX (1942), 69-92.

55. O. von Falke, *Kunstgeschichte der Seidenweberei*, I (1913), 107-8; A. C. Weibel, 'Francisque-Xavier Michel's Contributions to the Terminology of Islamic Fabrics', *Ars Islamica*, II (1935), 221-2. F.-X. Michel, *Recherches sur le commerce, la fabrication et l'usage des étoffes de soie, d'or et d'argent, et autres tissus précieux en Occident, principalement en France, pendant le moyen âge*, 2 vols. (Paris, 1852-4).

56. For discussion of these two Spanish copies, see F. L. May, *Silk Textiles of Spain: Eighth to Fifteenth Century* (New York, 1957), 24-7, and F. E. Day, 'The Inscription of the Boston "Baghdad" Silk - A Note on Method in Epigraphy', *Ars Orientalis*, I (1954), 191-4.

57. R. B. Serjeant, 'Material for a History of Islamic Textiles up to the Mongol Conquest', *Ars Islamica*, XV-XVI (1951), 33-4.

58. *Ibid.*, IX (1942), 91-2.

59. H. Buchthal, 'A Note on Islamic Enameled Metalwork and its Influence in the Latin West', *Ars Islamica*, XI-XII (1946), 195-8; R. Ettinghausen, *Treasures of Turkey* (Geneva, 1966), 164, 167.

363. 60. For this inference drawn from the *nisba* 'al-Turabi', see Rice, *op. cit.* (Note 41), 230.

61. These coins are illustrated in S. Lane Poole, *Coins of the Urtukid Turkumans (Foes of the Crusaders)* (London, 1875).

364. 62. The box is discussed and illustrated in D. S. Rice, 'Studies in Islamic Metal Work - II', *Bulletin of the School of Oriental and African Studies*, XV

(1953), 62-6. For further reference to Isma'il ibn Ward, which provides evidence that this artist may have been a resident of Mosul, see D. James, 'An Early Mosul Metalworker: Some New Information', *Oriental Art*, XXVI (1980), 318-21.

63. For the complete list, with references, see D. S. Rice, 'Inlaid Brasses from the Workshop of Ahmad al-Bhaki al-Mawsili', *Ars Orientalis*, II (1957), 325-6.

366. 64. D. S. Rice, 'The Brasses of Badr al-Din Lulu', *Bulletin of the School of Oriental and African Studies*, XIII (1951), 627-34.

65. G. Wiet, 'Un nouvel artiste de Mossoul', *Syria*, XII (1931), 160-2, and Harari, *op. cit.* (Note 29), 2496-7.

66. The scenes enumerated here are all to be found on a ewer, no. 56.11 in the Cleveland Museum of Art, illustrated in Rice, *op. cit.* (Note 63), 287-301.

67. *Ibid.*, 323.

68. Ibn Sa'id, writing about 1250; for a translation of the relevant passage, see *ibid.*, 284.

367. 69. F. Sarre, 'Islamische Tongefässe aus Mesopotamien', *Jahrbuch der Königlich Preussischen Kunstsammlungen*, XXVI (1905), 69-88; and G. Reitlinger, 'Unglazed Relief Pottery from Northern Mesopotamia', *Ars Islamica*, XV-XVI (1951), 11-22.

70. F. Safar, *Wasit: The Sixth Season's Excavations* (Cairo, 1945), 36-7, plates XVIII-XXII.

71. For an illustration of the strongbox, see *SPA*, XII, plate 1303B.

72. See p. 350. For bibliographies on Ma'ali ibn Salam and his son Salman, see L. A. Mayer, *Islamic Wood Carvers and Their Works* (Geneva, 1958), 48-9, 63-4; see also E. Herzfeld, 'Damascus: Studies in Architecture - II', *Ars Islamica*, X (1943), 57-8.

369. 73. C. J. Lamm, 'Fatimid Woodwork, Its Style and Chronology', *Bulletin de l'Institut d'Égypte*, XVIII (1936), 77; and Herzfeld, *op. cit.*, 63-5. Herzfeld identified the donor as a son of the great Seljuq vizier Nizam al-Mulk (1018-92).

74. The mosque of Nur al-Din was destroyed in 1982 during disturbances in Syria. The minbar is discussed by Herzfeld, *op. cit.*, 43-5.

75. *Ibid.*, 45. The Mosul mihrab is illustrated in F. Sarre and E. Herzfeld, *Archäologische Reise im Euphrat- und Tigris-Gebiet*, II (Berlin, 1920), figures 234-5, 241, the Samarra door in E. Herzfeld, *Bab al-Ghaibah (Door of Disparition) at Samarra* (Baghdad, 1938).

76. The minbar was destroyed by arson in the late 1960s. For discussion, see M. van Berchem, *Matériaux pour un Corpus Inscriptionum Arabicarum*, part 2, *Syrie du Sud*, II, *Jérusalem 'Haram'* (Cairo, 1925), 393-402; and Herzfeld, *loc. cit.* (Note 72). A complete list of the monuments of Nur al-Din, with references,

is given in N. Elisséeff, 'Les monuments de Nur ad-Din: inventaire, notes archéologiques et bibliographiques', *Bulletin d'Études Orientales*, XIII (1949-51), 7-43.
370. 77. E. Herzfeld, *Matériaux pour un Corpus Inscriptionum Arabicarum*, part 2, *Syrie du Nord: Inscriptions et monuments d'Alep*, I (Cairo, 1955), 124-8.
78. Rice, *op. cit.* (Note 63), 321-5; see also M. Aga-Oglu, 'About a Type of Islamic Incense Burner', *The Art Bulletin*, XXVII (1945), 28-45.
371. 79. See E. Atil, *Art of the Arab World* (Washington, D.C., 1975), 65-8, and references given there.
80. L. T. Schneider, 'The Freer Canteen', *Ars Orientalis*, IX (1973), 137-56; see also Atil, *op. cit.*, 69-73, and, most recently, R. Katzenstein and G. Lowry, 'Christian Themes in Thirteenth Century Islamic Metalwork', *Muqarnas*, I (1983), 33-68, in which the Freer canteen and related pieces are discussed.
81. Rice, *op. cit.* (Note 63), 322.
82. Rice, *op. cit.* (Note 62), 66-9; Atil, *op. cit.*, 61-3.
373. 83. Lane, *op. cit.* (Note 44), 38-9, 44-5; J. Sauvaget, 'Tessons de Rakka', *Ars Islamica*, XIII-XIV (1948), 31-45; and E. J. Grube, 'Raqqa Keramik in der Sammlung des Metropolitan Museum in New York', *Kunst des Orients*, IV (1963), 42-78. See also P. J. Riis and V. Poulsen, *Hama: Fouilles et recherches 1931-1938*, IV (part 2), *Les verreries et poteries médiévales* (Copenhagen, 1957), 120-283; A. Lane, 'Medieval Finds at Al Mina in North Syria', *Archaeologia*, LXXXVII (1937), 19-78; and F. Sarre, 'Die Kleinfunde', in *Baalbek: Ergebnisse der Ausgrabungen und Untersuchungen in den Jahren 1898 bis 1905*, III (Berlin and Leipzig, 1925), 113-36. For a recent general discussion of ceramics, see M. Jenkins, 'Islamic Pottery', *Bull. MMA*, XL, 4 (1983).
84. Lane, 'Medieval Finds' (Note 83), 45-53.
85. The piece is illustrated on the title page of *Berliner Museen*, XLVIII (1927), and discussed in F. Sarre, 'Drei Meisterwerke syrischer Keramik, Neuerwerbungen der islamischen Kunstabteilung', *Berichte d. k. preussischen Kunstsammlungen*, XXXIII (1911), 8-9.
86. The discussion in this section is based largely on observations by C. J. Lamm, *Oriental Glass of Mediaeval Date Found in Sweden and the Early History of Lustre-Painting* (Stockholm, 1941).
374. 87. It should be noted, however, that one group of illustrated manuscripts, distinguished by the use of architectural frameworks in the compositions, has been attributed to Aleppo in this period; H. Buchthal, ' "Hellenistic" Miniatures in Early Islamic Manuscripts', *Ars Islamica*, VII (1940), 125-33.
88. This polycandelon is discussed and illustrated in R. Ettinghausen, 'Sasanian and Islamic Metalwork

in Baltimore', *Apollo*, LXXXIV (1966), 466-7, figure 6.
89. R. Zahn and F. Sarre, 'Die Erwerbung einer in Südrussland gebildeten Sammlung von Werken der Kleinkunst aus antiker Völkerwanderungs- und islamischer Zeit', *Amtlicher Bericht aus den Königlichen Kunstsammlungen* (Berlin), XXIX (1907), columns 57-60, 66-71.
375. 90. C. J. Lamm, *Mittelalterliche Gläser und Steinschnittarbeiten aus dem Nahen Osten*, I (Berlin, 1930), 278-9, with earlier bibliography; and A. E. Berkoff, 'A Study of the Names of the Early Glass-Making Families as a Source of Glass History', *Studies in Glass History and Design: Papers Read to Committee B Sessions of the VIIIth International Congress on Glass, held in London 1st-6th July, 1968* (London, n.d.), 62-5. For a new general discussion on glass, see M. Jenkins, 'Islamic Glass', *Bull. MMA*, XLIV, 2 (1986).
91. Uhland's poem, written in 1834, can be found in many collections, for example *Gedichte von Ludwig Uhland: Jubiläums-Ausgabe* (New York, 1887), 352-4; for Longfellow's translation of 1841, see *The Complete Poetical Works of Longfellow* (Cambridge ed.) (Boston, n.d.), 613, 677.
92. For al-Sufi and ibn Bukhtishu, see articles 'Abd al-Rahman b. Umar al-Sufi' and 'Bukhtishu', in *Encyclopaedia of Islam*, 2nd ed. (Leyden, 1954 ff.). Illustrations of the *Kitab al-Baytara* by Ahmad ibn Hasan ibn al-Ahnaf are discussed by Grube in 'The Hippiatrica Arabica Illustrata: Three 13th Century Manuscripts and Related Material', *SPA*, XIV, 3138-55. For al-Zahrawi, see S. K. Hamarneh, 'Drawings and Pharmacy in al-Zahrawi's 10th-Century Surgical Treatise', *United States National Museum Bulletin*, CCXXVIII (1961), 81-94; on the Dioscorides manuscripts see, for instance, M. Sadek, *The Arabic Materia Medica of Dioscurides* (Québec, 1983); and D. R. Hill, trans. and ed., *The Book of Knowledge of Ingenious Mechanical Devices (Kitab fi Marifat al-Hiyal al-Handasiyya) by ibn al-Razzaq al-Jazari* (Dordrecht and Boston, 1974). For a general discussion of the tradition of Arab borrowing from Greek scientific texts see K. Weitzmann, 'The Greek Sources of Islamic Scientific Illustrations', in G. C. Miles, ed., *Archaeologia Orientalia In Memoriam Ernst Herzfeld* (Locust Valley, N.Y., 1952), 244-66.
93. See 'Kalila wa-Dimna', in *Encyclopaedia of Islam* (*op. cit.*). A brief discussion of the 'mirrors for princes' is to be found in T. Benfey, trans., *Pantschatantra: Fünf Bücher indischer Fabeln, Märchen und Erzählungen*, I (Leipzig, 1859), introduction, xv-xxviii.
94. See the articles 'al-Hamadhani' and 'al-Hariri', in *Encyclopaedia of Islam* (*op. cit.*). For a translation of the latter, see T. Chenery and F. Steingass, *The*

Assemblies of Al Hariri, 2 vols. (London, 1867–98).
95. The manuscripts are, respectively, Topkapı
Sarayı Ahmet III 3493; Bibliothèque Nationale, Paris,
Ar. 5847; and Academy of Sciences, Leningrad, S23.
The first has been published by O. Grabar, 'A Newly
Discovered Illustrated Manuscript of the Maqamat
of Hariri', *Ars Orientalis*, V (1963), 97–109; a number
of illustrations from the Paris and Leningrad copies
have been published in colour in R. Ettinghausen,
Arab Painting (Geneva, 1962), 104–24. See also H.
Corbin *et al.*, *Les arts de l'Iran: l'ancienne Perse et
Baghdad* (Paris, 1938), for a complete list of minia-
tures in the Paris manuscript; most recently, O. Gra-
bar, *The Illustrations of the Maqamat* (Chicago and
London, 1984).
376. 96. See, for example, Ettinghausen, *Arab
Painting*, 114.
97. *Ibid.*, 61–70; D. S. Rice, 'The Aghani Minia-
tures and Religious Painting in Islam', *The Burling-
ton Magazine*, XCV (1953), 128–36; S. Stern, 'A
New Volume of the Illustrated Aghani Manuscript',
Ars Orientalis, II (1957), 501–3; and B. Lewis, ed.,
Islam and the Arab World: Faith, People, Culture
(New York, 1976), 22, top, left and right.
98. The leading example is a thirteenth-century
illustrated copy of al-Mubashshir, *Mukhtar al-hikam
wa mahasin al-kalim*, Topkapı Sarayı Ahmet III 3206.
See Ettinghausen, *Arab Painting*, 75–7; idem, 'Inter-
action and Integration in Islamic Art', in G. E. von
Grünebaum, ed., *Unity and Variety in Muslim Civili-
zation* (Chicago, 1955), plates VI, VIIa; F. Rosenthal,
Das Fortleben der Antike im Islam (Zürich and Stutt-
gart, 1965), plate I facing p. 48; and M. Ş. Ipşiroğlu,
Das Bild im Islam (Vienna and Munich, 1971), 20,
figure 5. The text is discussed in F. Rosenthal, 'Al-
Mubashshir ibn Fatik: Prolegomena to an Abortive
Edition', *Oriens*, XIII–XIV (1960–1), 132–58.
99. Weitzmann, *op. cit.* (Note 92); E. Grube,
'Materialien zum Dioskurides Arabicus', in R. Etting-
hausen, ed., *Aus der Welt der islamischen Kunst: Fest-
schrift für Ernst Kühnel* (Berlin, 1959), 163–94;
and Buchthal, *op. cit.* (Note 87).
100. Ettinghausen, *Arab Painting*, 67–80.
380. 101. Grube, *op. cit.*; Ettinghausen, *Arab Paint-
ing*; F. E. Day, 'Mesopotamian Manuscripts of Dios-
corides', *Bull. MMA*, N.S. VIII (1950), 274–80; and H.
Buchthal, 'Early Islamic Miniatures from Baghdad',
The Journal of the Walters Art Gallery, V (1942), 16–
39. Many of the miniatures from the 1224 manuscript
have been removed and dispersed among Western
collections: a number are in the Freer Gallery of Art
(see Atil, *op. cit.* (Note 79), 53–60).
102. They are Ahmet III 3493 in the Topkapı Sar-
ayı, Istanbul; Ar. 2898 in the Bibliothèque Nationale,
Paris; and Ar. 5323 in the British Library, London.
For some discussion of these manuscripts, see Emmy

Wellesz, 'An Early al-Sufi Manuscript', *Ars Orien-
talis*, III (1959).
103. Ar. 6094, Bibliothèque Nationale, Paris;
Buchthal, *op. cit.* (Note 87).
104. The Pseudo-Galen manuscript, Ar. 2964, Bib-
liothèque Nationale, Paris, has been published by B.
Farès, *Le livre de la thériaque: manuscrit arabe à
peintures de la fin du XIIe siècle conservé à la Biblio-
thèque Nationale de Paris* (Cairo, 1953).
105. Buchthal, *op. cit.* (Note 87).
106. See Note 95 above.
107. Ettinghausen, *Arab Painting*, 100–3.
108. *Ibid.*, 135–7.
109. See Note 97 above.
110. Ettinghausen, *Arab Painting*, 61–2.
381. 111. O. Aslanapa, *Turkish Art and Architecture*
(New York, 1971), and T. T. Rice, *The Seljuks in Asia
Minor* (London, 1966) provide introductory surveys
of the relevant monuments.
112. Konya Museum 374; R. M. Riefstahl, 'A Sel-
juq Koran Stand with Lacquer-Painted Decoration
in the Museum of Konya', *The Art Bulletin*, XV
(1933), 361–73.
383. 113. Illustrated in K. Otto-Dorn, *Kunst des
Islam* (Baden-Baden, 1965), 161.
114. Ethnographic Museum, Konya, 7591; D. S.
Rice, 'Studies in Islamic Metalwork, V', *Bulletin of
the School of Oriental and African Studies*, XVII
(1955), 207–12.
115. Musée Historique des Tissus, Lyon, 23.475.
The most complete publication is C. de Linas, *Anciens
vêtements sacerdotaux et anciens tissus conservés en
France* (Paris, 1860), 17–32.
116. C. J. Lamm, 'The Marby Rug and Some Frag-
ments of Carpets Found in Egypt', *Svenska
Orientsällskapets Årsbok* (1937), 52–130; H. Erdmann,
'Zu einem anatolischen Teppichfragment aus Fostat',
Istanbuler Mitteilungen, VI (1955), 42–52; and K. Erd-
mann, in H. Erdmann, ed., *Seven Hundred Years of
Oriental Carpets* (Berkeley and Los Angeles, 1970),
41–6.
384. 117. Erdmann, *Seven Hundred Years*, 44.
117a. O. Aslanapa, *Turkish Art and Architecture*
(London, 1971), 292–4, plates XII–XVII (in colour).
118. H. Erdmann, *Oriental Carpets* (New York,
1962), 18.
119. Erdmann, *Seven Hundred Years*, 44.
120. A. Geijer, 'Some Thoughts on the Problems
of Early Oriental Carpets', *Ars Orientalis*, V (1963),
83.
121. *Ibid.*
122. There are many editions and translations of
Marco Polo's account of his travels in the East; the
relevant passage appears in chapter 21 on the province
of Turcomania.
123. Ibn Sa'id (d. 1286) specifically mentioned car-

pets from Aksaray; there is no published edition or translation of his *Kitab al-mughrib fi hula al-maghrib*, in which the relevant passage can be found. Ibn Battuta (1304-*c*. 1377) also spoke of a carpet industry in Aksaray; see Ibn Batouta, ed. and trans. H. Defremery, *Voyages* (Paris, 1879-1914), II, 286.

124. Erdmann, *Seven Hundred Years*, 47-51; *idem*, 'Orientalische Tierteppiche auf Bildern des XIV. und XV. Jahrhunderts: Eine Studie zu den Anfängen des orientalischen Knüpfteppichs', *Jahrbuch der Preussischen Kunstsammlungen*, L (1929), 261-98; and R.

Ettinghausen, 'New Light on Early Animal Carpets', in Ettinghausen, ed., *op. cit.* (Note 99).

125. Erdmann, 'Orientalische Tierteppiche', 292-8; and Ettinghausen, 'New Light' (both *op. cit.*, Note 124).

126. The miniature is 23.5, Freer Gallery of Art, Washington, D.C., from the so-called Demotte *Shahnama*, probably painted in the 1330s. For illustrations see Ettinghausen, 'New Light', 99-105.

127. Erdmann, *Seven Hundred Years*, 47-8, and *idem*, 'Orientalische Tierteppiche'.

BIBLIOGRAPHY

I. GENERAL

ADLE, C., ed. *Art et société dans le monde musulman.* Paris, 1982.
ASLANAPA, O. *Turkish Art and Architecture.* New York, 1971.
BELENITSKY, A. *Asie centrale*, trans. P. A. Aellig and J. Marcadé. Geneva, 1968.
BRISCH, K. *Studies in Islamic Art and Architecture in Honour of K. A. C. Creswell*, 30–48. Cairo, 1965.
ETTINGHAUSEN, R. 'The Flowering of Seljuq Art', *The Metropolitan Museum Journal*, III (1970), 113–31.
ETTINGHAUSEN, R. *Islamic Art and Archaeology.* Berlin, 1985.
ETTINGHAUSEN, R. 'The Man-Made Setting', in B. Lewis, ed., *The World of Islam*, 55–88. London, 1976.
ETTINGHAUSEN, R. 'Originality and Conformity in Islamic Art', in A. Banani and S. Vryonis, Jr, eds., *Individualism and Conformity in Classical Islam*, 83–114. Wiesbaden, 1977.
ETTINGHAUSEN, R., ed. *Aus der Welt der islamischen Kunst: Festschrift für Ernst Kühnel zum 75. Geburtstag am 26.10.1957.* Berlin, 1959.
GHIRSHMAN, R. *Persian Art: The Parthian and Sassanian Dynasties.* New York, 1962.
GOETZ, H. 'Arte dell'India musulmana e correnti moderne', *Le civiltà dell'oriente*, IV, 781–832. Rome, 1962.
GOMEZ MORENO, M. *El arte árabe hasta los Almohades; arte mozárabe (Ars Hispaniae: Historia universal del arte hispánico*, III). Madrid, 1951.

GRUBE, E. J. *The World of Islam.* London, 1966.
KÜHNEL, E. *Islamic Art and Architecture.* Ithaca, 1966.
Kühnel Festschrift. See ETTINGHAUSEN, R., ed.
MONNERET DE VILLARD, U. *Introduzione allo studio dell'archeologia islamica.* Venice, 1966.
OTTO-DORN, K. *Kunst des Islam.* Baden-Baden, 1964.
PAPADOPOULO, A. *Islam and Muslim Art.* New York, 1979.
POPE, A. U., ed. *A Survey of Persian Art from Prehistoric Times to the Present.* 12 vols. London and New York, 1938–9.
RICE, T. *The Seljuqs in Asia Minor.* London, 1961.
ROGERS, M. *The Spread of Islam.* Oxford, 1976.
SOURDEL, D. and J. *La civilisation de l'Islam classique.* Paris, 1968.
SOURDEL-THOMINE, J., and SPULER, B. *Die Kunst des Islam.* Berlin, 1973.
TERRASSE, H. *L'art hispano-mauresque.* Paris, 1932.
TORRES BALBAS, L. *Arte almohade; arte mozárabe; arte mudéjar (Ars Hispaniae: Historia universal del arte hispánico*, IV). Madrid, 1949.
TORRES BALBAS, L. *Artes almorávide y almohade.* Madrid, 1955.

II. LITERARY, HISTORICAL, ARCHAEO-
LOGICAL, AND EPIGRAPHIC SOURCES

ABU'L FARAJ AL ISFAHANI. *Kitab al-Aghani.* 20 vols. Cairo, 1968–9.
ABU NU'AYM. *Kitab Akhbar Isfahan*, ed. S. Dedering. Leiden, 1931–4.

AFSHAR, I. *Yadgarha-yi Yazd.* 3 vols. Tehran, 1348-54/1970-6.

AHSAN, M. M. *Social Life under the Abbasids.* London and New York, 1979.

BAGHAT, A., and GABRIEL, A. *Fouilles d'al-Foustat.* Paris, 1921.

BELL, G. *Amurath to Amurath.* London, 1911.

BERCHEM, M. VAN. 'Inscriptions arabes de Syrie', *Mémoires de l'Institut égyptien,* III (1897), 417-520.

BERCHEM, M. VAN. *Matériaux pour un Corpus Inscriptionum Arabicarum. Égypte,* I (*MMAF,* XIX). Cairo, 1894-1903.

BERCHEM, M. VAN. *Matériaux pour un Corpus Inscriptionum Arabicarum. Deuxième partie: Syrie du Sud: Jérusalem* (*MIFAO,* XLIII-XLV). 2 vols. Cairo, 1920-7.

BOWEN, R. LE B. and ALBRIGHT, F. *Archaeological Discoveries in South Arabia.* Baltimore, 1958.

CANARD, M. 'Le cérémonial fatimite et le cérémonial byzantin: essai de comparaison', *Byzantion,* XXI (1951), 355-420.

CANARD, M. 'La procession du nouvel an chez les Fatimides', *AIEO,* X (1952), 364-95.

CARTER, T. F. *Invention of Printing in China and its Spread Westward.* 2nd ed. New York, 1955.

COMBE, É., SAUVAGET, J., and WIET, G. *Répertoire chronologique d'épigraphie arabe.* 16 vols. Cairo, 1931-64.

DODD, E. 'The Image of the Word', *Berytus,* XVIII (1969), 35-79.

DODD, E. *The Image of the Word.* 2 vols. Beirut, 1981.

ERDMANN, K. *Ibn Bibi als kunsthistorische Quelle.* Istanbul, 1962.

GIBB, H. A. R. 'Arab-Byzantine Relations under the Umayyad Caliphate', *Dumbarton Oaks Papers,* XII (1958), 219-33.

GOITEIN, S. D. 'The Main Industries of the Mediterranean Area as Reflected in the Records of the Cairo Geniza', *Journal of Economic and Social History of the Orient,* IV (1961), 168-97.

GOITEIN, S. D. *A Mediterranean Society.* 4 vols. Berkeley, 1967-82.

GRABAR, A. *L'iconoclasme byzantin.* Paris, 1959.

GRABAR, O. 'Umayyad "Palace" and the Abbasid Revolution', *Studia Islamica,* XVIII (1963), 5-18.

GROHMANN, A. *Arabische Paläographie.* 2 vols. Vienna, 1967-71.

AL-HARAWI. *Guide des lieux de pèlerinage,* trans. J. Sourdel-Thomine. Damascus, 1957.

HERZFELD, E. *Matériaux pour un Corpus Inscriptionum Arabicarum,* part 2, *Syrie du Nord: Inscriptions et monuments d'Alep.* 2 vols. Cairo, 1955.

HILL, D. R., trans. and ed. *The Book of Knowledge of Ingenious Mechanical Devices* (*Kitab fi Marifat al Hiyal al-Handassiya*) *by ibn al-Razzaq al-Jazari.* Dordrecht and Boston, 1974.

HODGSON, M. *The Venture of Islam.* Chicago, 1974.

IBN IDHARI. *al-Bayan,* ed. G. S. Colin and E. Lévi-Provençal. 2 vols. Leiden, 1951.

IBN SHADDAD. *al-Alaq alkhatiri fi dhikr umara al-Sham wal Jazira,* ed. D. Sourdel. Beirut, 1953.

LESTRANGE, G. 'A Greek Embassy to Baghdad in 917 A.D.', *Journal of the Royal Asiatic Society* (1897), 19-34.

LÉVI-PROVENÇAL, E. *Inscriptions arabes d'Espagne.* Leiden, 1931.

LEWIS, B., ed. *Islam and the Arab World: Faith, People, Culture.* New York, 1976.

AL-MAFARRUKI. *Kitab-i Mahhassin-i Isfahan,* ed. Jalal al-Din Tihrani. Tehran, 1933.

MAKDISI, G. 'Muslim Institutions of Learning', *Bulletin of the School of Oriental and African Studies,* XXXIV (1961), 1-56.

AL-MAQRIZI. *Description historique et topographique de l'Égypte,* trans. P. Casanova (*MIFAO,* III). Cairo, 1906.

AL-MAQRIZI. *Kitab al-Mawa' iz wal Itibar bi Khikr al-Khitat wal-Athar.* 2 vols. Bulaq, 1853.

MARÇAIS, G. *La Berberie musulmane et l'Orient.* Paris, 1946.

MASSIGNON, L. *Mission en Mésopotamie (1907-08).* 2 vols. Cairo, 1910-12.

AL-MASUDI. *Les prairies d'or,* ed. and trans. C. Barbier de Maynard and P. de Courteille. Paris, 1861-77.

AL-MUQADDASI. *Kitab ahsan al Taqlim,* ed. M. J. de Goeje (*Bibliotheca Geographorum Arabicorum,* III). Leiden, 1906.

AL-NARSHAKHI. *The History of Bukhara,* trans. R. N. Frye. Cambridge, Mass., 1954.

NASIR-I KHOSROW. *Sefer-Nameh,* trans. C. Schefer. Paris, 1881.

PARR, P. J., HARDING, G. L., and DAYTON, J. E. 'Preliminary Survey in N.W. Arabia, 1968', *Bulletin, Institute of Archaeology, University of London,* VIII-IX (1970), 193-242.

QUATREMÈRE, E. *Histoire des sultans mamlouks de l'Égypte.* 2 vols. Paris, 1837-45.

RAVAISSE, P. 'Essai sur l'histoire et sur la topographie du Caire d'après Makrizi', *MMAF,* I (1886-9), 409-80.

RICHARDS, D. H., ed. *Islamic Civilization 950-1150.* Oxford, 1973.

ROSENTHAL, F. *Das Fortleben der Antike im Islam.* Zürich and Stuttgart, 1965.

ROTHSTEIN, G. *Die Dynastie der Lahmiden in al-Hira.* Berlin, 1899.

SARRE, F. *Reise in Kleinasian - Sommer 1895.* Berlin, 1896.

SARRE, F., and HERZFELD, E. *Archäologische Reise im Euphrat und Tigris-Gebiet.* 4 vols. Berlin, 1911-20.

SAUVAGET, J. 'Les perles choisies' d'Ibn ach-Chihna. Beirut, 1933.

SHAHID, I. 'Byzantium in South Arabia', Dumbarton Oaks Papers, XXXIII (1979), 85-94.

SOURDEL, D. 'Questions de cérémonial abbaside', Revue des Études Islamiques, XXVIII (1960), 121-48.

AL-TABARI. Annales, ed. M. J. de Goeje. 13 vols. Leiden, 1879-1901.

Tarikh-i Kum, ed. Sayyid Jalal al-Din Tihrani. Tehran, 1935.

VANDEN BERGHE, L. Archéologie de l'Iran ancien. Leiden, 1959.

WIET, G. Matériaux pour un Corpus Inscriptionum Arabicarum: Égypte 2 (MIFAO, LII). Cairo, 1929-30.

YAQUBI. Kitab al-Buldan, ed. M. J. de Goeje (Bibliotheca Geographorum Arabicorum, VII). Leiden, 1892.

III. ARCHITECTURE

1. General

CRESWELL, K. A. C. Early Muslim Architecture. 2 vols. Oxford, 1932 and 1940.

ÉCOCHARD, M. Filiation des monuments grecs, byzantins et islamiques. Paris, 1977.

GODARD, A. 'L'origine de la madrasa, de la mosquée et du caravanserail à quatre iwans', Ars Islamica, XV-XVI (1951), 1-9.

GOLVIN, L. Essai sur l'architecture religieuse musulmane. 3 vols. Paris, 1974-8.

GRABAR, O. 'The Earliest Islamic Commemorative Structures', Ars Orientalis, VI (1966), 7-46.

HILL, D., and GRABAR, O. Islamic Architecture and its Decoration. London, 1967.

HOAG, J. Islamic Architecture. New York, 1975.

LAMBERT, É. 'La synagogue de Doura-Europos et les origines de la mosquée', Semitica, III (1950), 67-72.

MARÇAIS, G. 'Salle, antisalle. Recherches sur l'évolution d'un thème de l'architecture domestique en pays d'Islam', AIEO, X (1952), 274-301.

MICHELL, G. Architecture of the Islamic World. London, 1978.

MUNIS, H. al-Masajid. Kuwait, 1981.

PAUTY, E. 'L'évolution du dispositif en T dans les mosquées à portiques', Bulletin des Études Orientales, II (1932), 91-124.

RAGHEB, Y. 'Les premiers monuments funéraires de l'Islam', Annales Islamologiques, IX (1970), 21-36.

SAUVAGET, J. 'Observations sur quelques mosquées seldjoukides', AIEO, IV (1938), 81-120.

SOURDEL-THOMINE, J. 'Locaux d'enseignement et madrasas dans l'Islam médiéval', Revue des Études Islamiques, XLIV (1976), 285-97.

2. Forms and Decoration

BECKER, C. 'Die Kanzel im Kultus des alten Islam', Islamstudien. 2 vols. Leipzig, 1924.

BERGERET, J., and KALUS, L. 'Analyse de décors épigraphiques et floraux à Qazvin', Revue des Études Islamiques, XLV (1977), 89-130.

BULATOV, M. S. Geometricheskaia garmonizatsiia v arkhitekture Srednei Azii IX-XV vv.: istoriko-teoreticheskoe issledovanie. Moscow, 1978.

DENIKE, B.P. Arkhitekturnyi ornament Srednei Azii. Moscow, 1939.

DIMAND, M. S. 'Studies in Islamic Ornament, I. Some Aspects of Omaiyad and Early Abbasid Ornaments', Ars Islamica, IV (1937), 293-337.

DIMAND, M. S. 'Studies in Islamic Ornament, II', Archaeologica Orientalia In Memoriam Ernst Herzfeld, ed. G. C. Miles, 62-8. Locust Valley, 1952.

ETTINGHAUSEN, R. 'The 'Beveled Style' in the Post-Samarra Period', Archaeologica Orientalia In Memoriam Ernst Herzfeld, ed. G. C. Miles, 72-83. Locust Valley, N.J., 1952.

ETTINGHAUSEN, R. 'Islamische Architekturornamente', Du, XXXVI (August 1976), 20-62.

FARÈS, B. Essai sur l'esprit de la décoration islamique. Cairo, 1952.

FLURY, S. 'Le décor épigraphique des monuments de Ghazna', Syria, VI (1925), 61-90.

FLURY, S. Die Ornamente der Hakim und Ashar Moschee. Heidelberg, 1912.

GOTTHEIL, R. H. J. 'The Origin and History of the Minaret', Journal of Oriental and African Studies, XXX (1909-10), 132-54.

HAMILTON, R. W. 'Carved Plaster in Umayyad Architecture', Iraq, XV (1953), 43-55.

REMPEL, L. I. Arhitekturnyi Ornament Uzbekistana. Tashkent, 1961.

ROSINTHAL, J. Pendentifs, trompe et stalactites dans l'architecture orientale. Paris, 1928.

ROSINTHAL, J. Le réseau. Paris, 1937.

SCHACHT, J. 'Ein archaischer Minaret-Typ in Ägypten und Anatolien', Ars Islamica, V (1938), 46-54.

SCHACHT, J. 'Further Notes on the Staircase Minaret', Ars Orientalis, IV (1961), 137-42.

SCHACHT, J. 'An Unknown Type of Minbar and its Historical Significance', Ars Orientalis, II (1957), 149-73.

SERJEANT, R. B. 'Mihrab', Bulletin of the School of Oriental and African Studies, XXII (1959), 439-52.

SOURDEL, D. 'Reflexions sur la diffusion de la madrasa en Orient', Revue des Études Islamiques, XLIV (1976), 165-84.

3. Anatolia

ALTUN, A. *Anadolu'da Artuklu Devri Türk Mimarisinin Gelismesi.* Istanbul, 1978.

ALTUN, A. *Mardin'de Türk Devri Mimarisi.* Istanbul, 1971.

BERCHEM, M. VAN, STRZYGOWSKI, J., and BELL, G.L. *Amida.* Heidelberg, 1910.

ERDMANN, K. *Das anatolische Karavansaray des 13. Jahrhunderts.* 2 vols. Berlin, 1961.

ERDMANN, K. 'Seraybauten des dreizehnten Jahrhunderts in Anatolien', *Ars Orientalis,* III (1959), 77-94.

GABRIEL, A. *Voyages archéologiques dans la Turquie orientale.* 2 vols. Paris, 1940.

KONYALI, I.H. *Konya Tarihi.* Konya, 1964.

KUBAN, D. *Anadolu-Türk Mimarisinin, Kaynak ve Sorunlari.* Istanbul, 1965.

ÖGEL, S. *Anadolu Selçuklularının Taş Tezyinatı.* Ankara, 1966.

ÖNEY, G. *Anadolu Selçuklu Mimarisinde Süsleme ve El Sanatları.* Ankara, 1978.

OTTO-DORN, K. 'Seldschukische Holzsäulenmoscheen in Kleinasien', *Aus der Welt der islamischen Kunst,* ed. R. Ettinghausen, 59-88. Berlin, 1959.

ROGERS, J.M. 'The Date of the Çifte Minare Medrese at Erzurum', *Kunst des Orients,* VIII (1972), 77-119.

SARRE, F. *Konia: Selschukische Baudenkmäler.* Berlin, 1910.

SÖZEN, M. *Diyarbakır'da Türk Mimarisi.* Istanbul, 1971.

ÜNSAL, B. *Turkish Islamic Architecture in Seljuk and Ottoman Times 1071-1923.* London, 1959.

YETKIN, S.K. *L'architecture turque en Turquie.* Paris, 1962.

4. Central Asia

AKHAROV, I., and REMPEL, L. *Reznoi Shtuk Afrasiaba.* Tashkent, 1971.

BELENITSKY, A.M., BENTOVICH, I.B., and BOLSHAKOV, O.G. *Srednevekoyyi Gorod Srednei Azii.* Leningrad, 1973.

BOMBACI, A. *The Kufic Inscription in Persian Verses in the Court of the Royal Palace of Masud III at Ghazni.* Rome, 1966.

CASIMIR, M.J., and GLATZER, B. 'Sah-i Mashad, a Recently Discovered Madrasah of the Ghurid Period in Gargistan (Afghanistan)', *East and West,* N.S. XXI (1971), 53-68.

COHN-WIENER, E. *Turan.* Berlin, 1930.

DIEZ, E. 'Die Siegestürme in Ghazna als Weltbilder', *Kunst des Orients,* I (1950), 37-44.

GARDIN, J.C. *Lashkari Bazar: Une résidence royale*

ghaznévide, II, *Les trouvailles: Céramiques et monnaies de Lashkari Bazar et de Bust.* Paris, 1963.

GOLOMBEK, L. 'Abbasid Mosque at Balkh', *Oriental Art,* XV (1969), 173-89.

MASSON, M.E. 'Novye dannye o nadpisyach odnogo Mesched-i-Misrainskogo minareta', *Epigrafika vostoka,* VII (1953), 7-16.

NEMTSEVA, N.B. 'Istoko Kompositsii i etapy formirovaniya Ansamblya Shakh-i Zinda', trans. J.M. Rogers, *Iran,* XXV (1977), 51-74.

NILSEN, V.A. *Monumentalnaia Arkhitektura Bukharskovo Oazisa.* Tashkent, 1956.

PUGACHENKOVA, G.A. *Mavzolei Arab-ata.* Tashkent, 1963.

PUGACHENKOVA, G.A. 'Mazar Arab-Ata v Time', *Sovietskaia Arkheologiia,* IV (1961), 198-211.

PUGACHENKOVA, G.A. *Puti razvitia arkhitektury iuzhnogo Turkmenistana.* Moscow, 1958.

PUGACHENKOVA, G.A. *Vydaiuschchiesia pamiatniki arhitektury Uzbekistana.* Tashkent, 1958.

REMPEL, L.I. 'The Mausoleum of Ismail the Samanid', *Bulletin of the American Institute for Persian Art and Archaeology,* IV (1936), 198-208.

REMPEL, L.I., ed. *Hudozhestvennaia Kultura Srednei Azii.* Tashkent, 1983.

RUDENKO, S.I. *Kultura Naseleniia Gornogo Altaia.* Moscow, 1953.

SCERRATTO, U. 'The First Two Excavation Campaigns at Ghazni, 1957-1958', *East and West,* N.S. X (1959), 23-55.

SCHLUMBERGER, D. *Lashkari Bazar.* Paris, 1978.

SCHLUMBERGER, D. 'Le palais ghaznevide de Lashkari Bazar', *Syria,* XXIX (1952), 251-70.

SHISHKIN, V.A. *Varakhsha.* Moscow, 1963.

SOURDEL-THOMINE, J. 'Deux minarets d'époque seljoukide en Afghanistan', *Syria,* XXX (1953), 108-36.

UMNIAKOV, I.I. 'Rabat-i-Malik', *Sbornik v chest' v.v. Bartol'da,* 179-92. Tashkent, 1927.

VORONINA, V.L. 'K kharakteristike arkhitektury Srednei Azii epokhi Samanidov', *Trudy Akademii nauk Uzbekskoi SSR,* XXVII (1954).

YAKUBOVSKII, A.Y. 'L'expedition de Zaravchan en 1934', *Musée de l'Ermitage, Travaux du Départment Oriental,* II (1940), 113-63.

5. Egypt and the Arab World

ABEL, A. 'La citadelle ayyubite de Bosra Eski Cham', *Les Annales Archéologiques de Syrie,* VI (1956), 95-138.

ADAMS, R.MCC. *Land Behind Baghdad.* Chicago, 1965.

ADAMS, R.MCC. *The Uruk Countryside.* Chicago, 1972.

ALMAGRO, M., CABALLERO, L., ZOZOYA, J., and ALMAGRO, A. *Qusayr 'Amra: Residencia y baños omeyas en el desierto de Jordania.* Madrid, 1975.

BERCHEM, M. VAN. 'Une mosquée du temps des Fatimides au Caire', *Mémoires de l'Institut égyptien,* 11 (1899), 605-19.

BLOOM, J. 'The Mosque of al-Hakim in Cairo', *Muqarnas,* I (1983), 15-36.

CASKEL, W. *Der Felsendom und die Wallfahrt nach Jerusalem.* Cologne, 1963.

CASKEL, W. 'al-Uhaidir', *Der Islam,* XXXIX (1964), 29-37.

CATHCART KING, D. J. 'The Defenses of the Citadel of Damascus', *Archaeologia,* XCIV (1951), 57-96.

Colloque international sur l'histoire du Caire, ed. A. Raymond, M. Rogers, and M. Wahba. Leipzig, 1973.

COSTA, P. 'La moschea grande di Sana', *Annali Istituto Orientale di Napoli* (1974), 487-506.

COSTA, P. M. *The Pre-Islamic Antiquities at the Yemen National Museum.* Rome, 1978.

COSTA, P., and VICARIO, E. *Yemen, Land of Builders,* trans. D. Newton. London, 1977.

CRESWELL, K. A. C. 'The Great Mosque of Hama', *Aus der Welt der islamischen Kunst,* ed. R. Ettinghausen, 48-53. Berlin, 1959.

CRESWELL, K. A. C. *Muslim Architecture of Egypt.* Oxford, 1952-60.

DAYWAHJI, SA'ID AL. 'Jami al-Nabi Yunis', *Sumer,* X (1954), 250-66.

DAYWAHJI, SA'ID AL. 'Madaris al-Mausil fi ahd al-atabiki', *Sumer,* XIII (1957), 101-18.

ÉCOCHARD, M., and LECOEUR, C. *Les bains de Damas.* 2 vols. Beirut, 1942-3.

ELISÉEFF, N. Les monuments de Nur ad-Din: Inventaires, notes archéologiques et bibliographiques', *Bulletins des Études Orientales,* XIII (1949-51), 5-43.

ETTINGHAUSEN, R. *From Byzantium to Sasanian Iran and the Islamic World.* Leiden, 1972.

FIEY, J. M. *Assyrie chrétienne.* Beirut, 1965.

FIEY, J. M. *Mossul chrétienne.* Beirut, 1959.

FRANCIS, B., and ALI, M. 'Jami Abu Dulaf fi Samarra', *Sumer,* III (1947), 60-76.

GABRIEL, A. 'Dunaysir', *Ars Islamica,* IV (1937), 352-68.

GAUBE, H. *Ein arabischer Palast in Südsyrien, Hirbat el-Baida.* Beirut, 1974.

GHIRSHMAN, R. 'Une mosquée de Suse au début de l'Hégire', *Bulletin des Études Orientales,* XII (1947-8), 77-9.

GRABAR, O. 'La grande mosquée de Damas et les origines architecturales de la mosquée', *Synthronon,* ed. A. Grabar, 107-14. Paris, 1968.

GRABAR, O. 'al Mushatta, Baghdad, and Wasit', *The World of Islam, Studies in Honor of P. K. Hitti,* 99-108. London, 1959.

GRABAR, O., HOLOD, R., KNUSTAD, J., and TROUSDALE, W. *City in the Desert: Qasr al-Hayr East* (Harvard Middle East Monograph Series, XXIII-XXIV). Cambridge, 1978.

HAMILTON, R. W. *Khirbat al-Mafjar.* Oxford, 1959.

HAMILTON, R. W. *The Structural History of the Aqsa Mosque.* Jerusalem, 1949.

HERZ, M. *Die Baugruppe des Sultans Qalaun in Kairo.* Hamburg, 1919.

HERZFELD, E. 'Damascus: Studies in Architecture', *Ars Islamica,* IX (1942), 1-53; X (1943), 13-70; XI-XII (1946), 1-71; XIII-XIV (1948), 118-38.

HERZFELD, E. *Geschichte der Stadt Samarra.* Hamburg, 1948.

HERZFELD, E. *Der Wandschmuck der Bauten von Samarra.* Berlin, 1923.

IRAQ DIRECTORATE OF ANTIQUITIES. *Bab ul-Ghaibah (Door of Disparition) at Samarra.* Baghdad, 1938.

JAIRAZBHOY, R. A. 'The History of the Shrines at Mecca and Medina', *Islamic Culture* (January-February 1962), 19-34.

JAUSSEN, J. A., and SAVIGNAC, R. *Mission archéologique en Arabie,* III, *Les châteaux arabes de Qesair Amra, Haraneh et Tuba.* Paris, 1922.

JAWAD, M. 'al-Imarat al-islamiya al-atiqa al-qaima fi Baghdad', *Sumer,* III (1947), 38-59.

JAWAD, M. 'al-Madrasa al-Nizamiyya', *Sumer,* IX (1953), 317-42.

JAWAD, M. 'al-Qasr al-Abbasi', *Sumer,* I (1945), 61-104.

KESSLER, C. 'Die beiden Mosaikböden in Qusayr Amra', *Studies in Islamic Art and Architecture in Honour of Professor K. A. C. Creswell,* 105-31. Cairo, 1965.

KING, G. 'A Mosque Attributed to Umar', *Journal of the Royal Asiatic Society* (1978), 109-23.

LASSNER, J. *The Topography of Baghdad in the Early Middle Ages.* Detroit, 1970.

LAUFFREY, J. 'Une madrasa ayyoubide de la Syrie du Nord. La Sultaniya d'Alep', *Les Annales Archéologiques de Syrie,* III (1953), 49-66.

LOREY, E. DE. 'L'Hellénisme et l'Orient dans les mosaïques de la mosquée des Omaiyades', *Ars Islamica,* I (1934), 22-45.

MAKDISI, G. 'The Topography of Eleventh Century Baghdad: Materials and Notes', *Arabica,* VI (1959), 178-97, 281-309.

MASSIGNON, L. 'Explication du plan de Kufa', *Mélanges Maspero (MIFAO,* LXVI-LXVIII). 3 vols. Cairo, 1934.

MOSTAFA, S. L. *Al-Madina al Munawwara.* Beirut, 1981.

PAUTY, E. *Les palais et les maisons d'époque musulmane au Caire (MIFAO, LXII)*. Cairo, 1932.

PREUSSER, C. *Nordmesopotamische Baudenkmäler altchristlicher und islamischer Zeit*. Leipzig, 1911.

RICE, D. S. 'Medieval Harran: Studies on its Topography and Monuments', *Anatolian Studies*, 11 (1952), 36–84.

ROGERS, J. M. 'Samarra: A Study in Medieval Town Planning', *The Islamic City*, ed. A. H. Hourani and S. M. Stern, 119–56. Oxford, 1970.

SAFAR, F. *Wasit: The Sixth Season's Excavations*. Cairo, 1945.

SAOUAF, S. *The Citadel of Aleppo*. Aleppo, 1958.

SAUVAGET, J. *Alep*. Paris, 1941.

SAUVAGET, J. 'L'architecture musulmane en Syrie', *Revue des Études Islamiques*, VIII (1934), 19–51.

SAUVAGET, J. 'Caravansérails syriens du moyen-âge', *Ars Islamica*, VI (1939), 48–55; VII (1940), 1–19.

SAUVAGET, J. 'Châteaux omeyyades de Syrie', *Revue des Études Islamiques*, XXXIX (1967), 1–42.

SAUVAGET, J. 'Esquisse d'une histoire de la ville de Damas', *Revue des Études Islamiques*, VIII (1934), 421–80.

SAUVAGET, J. 'Les inscriptions arabes de la mosquée de Bosra', *Syria*, XXII (1941), 53–65.

SAUVAGET, J. 'Inventaire des monuments musulmans de la ville d'Alep', *Revue des Études Islamiques*, V (1931), 59–114.

SAUVAGET, J. *Les monuments historiques de Damas*. Beirut, 1932.

SAUVAGET, J. *La mosquée omeyyade de Médine*. Paris, 1947.

SAUVAGET, J. 'Observations sur les monuments omeyyades', *Journal Asiatique*, CCXXXI (1939), 1–59.

SAUVAGET, J. 'Les ruines omeyyades de Andjar', *Bulletin du Musée de Beyrouth*, III (1940), 5–11.

SAUVAGET, J., ÉCOCHARD, M., and SOURDEL-THOMINE, J. *Les monuments ayyoubides de Damas*. 4 vols. Paris, 1938–50.

SCHLUMBERGER, D. 'Les fouilles de Qasr el-Heir el-Gharbi (1936–1938): Rapport préliminaire', *Syria*, XX (1939), 195–238.

SCHMID, H. 'Die Madrasa al-Mustansiriyya in Baghdad', *Architectura*, IX (1979), 93–112.

SOURDEL, D., and SOURDEL-THOMINE, J. 'Notes d'épigraphie et de topographie sur la Syrie du Nord', *Les Annales Archéologiques de Syrie*, III (1953), 81–105.

SOURDEL-THOMINE, J. 'Le peuplement de la région des "villes mortes" (Syrie du Nord) à l'époque ayyubide', *Arabica* (1954), 187–200.

STERN, H. 'Les origines de l'architecture de la mosquée omeyyade', *Syria*, XXVIII (1951), 272–3.

STERN, H. 'Recherches sur la mosquée al-Aqsa', *Ars Orientalis*, V (1963), 28–48.

TALAS, A. *La madrasa Nizamiyya*. Paris, 1939.

TRUMPELMAN, L. *Mschatta: Ein Beitrag zur Bestimmung des Kunstkreises, zur Datierung und zum Stil der Ornamentik*. Tübingen, 1962.

WILLIAMS, C. 'The Cult of Alid Saints in the Fatimid Monuments of Cairo. Part I: The Mosque of al-Aqmar', *Muqarnas*, I (1983), 37–52.

6. India

BROWN, P. *Indian Architecture (The Islamic Period)*. Bombay, 1949.

HARLE, J. C. *The Art and Architecture of the Indian Subcontinent (The Pelican History of Art)*, chapters 30–33. Harmondsworth, 1986.

KHAN, F. A. *Banbhore*. Karachi, 1982.

7. Iran

ADLE, C. 'Le minaret du masjed-e jamie de Semnan', *Studia Iranica*, IV (1975), 177–86.

ADLE, C., and MELIKIAN-CHIRVANI, A. S. 'Les monuments du XIe siècle à Damgan', *Studia Iranica*, I (1972), 229–97.

AZARPAY, G. 'The Islamic Tomb Tower: A Note on its Genesis and Significance', *Essays in Islamic Art and Architecture in Honor of Katherine Otto-Dorn*, ed. Abbas Daneshvari, 9–12. Malibu, 1981.

BLAIR, S. 'The Octagonal Pavilion at Natanz', *Muqarnas*, I (1983), 69–94.

BRETANITSKII, L. S. *Zodchestvo Azerbaidzhana XII–XV vv.* Leningrad, 1961.

DADASHEV, S. A. *Arkhitektura Azerbaidzhana. Epokha Nizami*. Baku, 1947.

DIETRICH, A. 'Die Moscheen von Gurgan zur Omaijadenzeit', *Der Islam*, XL (1964), 1–17.

DIEZ, E. *Churasanische Baudenkmäler*. Berlin, 1918.

DIEZ, E. *Islamische Baukunst im Churasan*. Hagen i.W., 1923.

GABRIEL, A. 'Le masdjid-i Djumah d'Isfahan', *Ars Islamica*, 11 (1935), 7–44.

GALDIERI, E. *Isfahan: Masgid-i guma*. 2 vols. Rome, 1972–3.

GALDIERI, E. 'Quelques précisions sur le Gunbad-e Nizam al-Mulk', *Revue des Études Islamiques*, XLIII (1975), 97–122.

GODARD, A. 'Abarkuh (Province de Yazd)', *Athar-e Iran*, I (1936), 47–72.

GODARD, A. 'Les anciennes mosquées de l'Iran', *Athar-e Iran*, I (1936), 187–210.

GODARD, A. 'Les anciennes mosquées de l'Iran', *Arts Asiatiques*, III (1956), 48–63 and 83–8.

GODARD, A. 'Historique du masdjid-e Djuma d'Isfahan', *Athar-e Iran*, I (1936), 213–82.

GODARD, A. 'Khorasan', *Athar-e Iran*, IV (1949), 7–150.

GODARD, A. *Les monuments de Maragha*. Paris, 1934.

GODARD, A. 'Le Tari-khana de Damghan', *Gazette des Beaux-Arts*, 6 sér., XII (1934), 225-35.

GODARD, A. 'Voûtes iraniennes', *Athar-e Iran*, IV (1949), 187-360.

HERZFELD, E. *Iran in the Ancient East*. London and New York, 1941.

HILLENBRAND, R. 'Saljuq Dome Chambers in Northwest Iran', *Iran*, XIV (1976), 93-102.

HILLENBRAND, R. 'Saljuq Monuments in Iran I', *Oriental Art*, N.S. XVIII (1972), 64-77.

HILLENBRAND, R. 'Saljuq Monuments in Iran II', *Iran*, X (1970), 45-56.

HILLENBRAND, R. 'Saljuq Monuments in Iran III: The Domed Masgid-i Gami at Sugas', *Kunst des Orients*, X (1975), 45-79.

HILLENBRAND, R. 'Saljuq Monuments in Iran: The Mosques of Nushabad', *Oriental Art*, N.S. XXII (1976), 265-77.

HOLOD, R. 'The Monument of Duvazdah Imam in Yazd', *Studies in Honor of George C. Miles*, ed. D. K. Kouymjian, 285-8. Beirut, 1974.

MILES, G. C. 'Inscriptions on the Minarets of Saveh, Iran', *Studies in Islamic Art and Architecture in Honour of Professor K. A. C. Creswell*, 163-78. Cairo, 1965.

NAUMANN, R. *Die Ruinen von Tacht-e Suleiman und Zendan-i Suleiman und Umgebung*. Berlin, 1977.

NAUMANN, R. 'Takht-i-Suleiman und Zendan-i-Suleiman, vorläufiger Bericht über die Grabungen im Jahre 1961', *Archäologischer Anzeiger*, IV (1962), 659-65.

PETERSON, S. R. 'The Masjid-i Pa Minar at Zavareh', *Artibus Asiae*, XXXIX (1977), 60-70.

PIRNIA, K. 'Masjid-i Jami-yi Fahraj', *Bastan Shinassi va Hunar-i Iran*, V (1970), 2-14.

SARRE, F. *Denkmäler persischer Baukunst*. Berlin, 1901-10.

SIROUX, M. 'La mosquée Djuma de Yezd', *Bulletin de l'Institut français d'Archéologie oriental*, XLIV (1947), 119-76.

SMITH, M. B. 'The Manars of Isfahan', *Athar-e Iran*, I (1936), 313-65.

SMITH, M. B. 'Material for a Corpus of Early Iranian Islamic Architecture. II. Manar and Masdjid, Barsian (Isfahan)', *Ars Islamica*, IV (1937), 7-40.

SMITH, M. B. 'Material for a Corpus of Early Iranian Islamic Architecture. III. Two Dated Seljuk Monuments at Sin (Isfahan)', *Ars Islamica*, VI (1939), 1-10.

SOURDEL, D., and SOURDEL-THOMINE, J. 'À propos des monuments de Sangbast', *Iran*, XVII (1979), 109-14.

SOURDEL-THOMINE, J. 'Inscriptions seljoukides et salles à coupoles de Qazwin en Iran', *Revue des Études Islamiques*, XLII (1974), 3-43.

STERN, S. M. 'The Inscriptions of the Kharraqan Mausoleums', *Iran*, IV (1966), 21-7.

STRONACH, D., and CUYLER YOUNG, JR, T. 'Three Octagonal Seljuq Tomb Towers from Iran', *Iran*, IV (1960), 1-20.

THOMPSON, D. *Stucco from Chal Tarkhan-Eshqabad near Rayy*. Warminster, Wilts, 1976.

VASSALLO, G. V. 'Su una iscrizone selgiuchide della Moschea del Venerdi di Isfahan', *Iranica*, 313-18. Naples, 1979.

WHITEHOUSE, D. *Siraf III: The Congregational Mosque and Other Mosques from the Ninth to the Twelfth Centuries*. London, 1980.

WILBER, D. N. *The Masjid-i Atiq of Shiraz*. Shiraz, 1972.

WILBER, D. N. 'Le masgid-i gami de Qazwin', *Revue des Études Islamiques*, XLI (1973), 199-229.

ZIPOLI, R., and ALFIERI, B. M. 'La moschea gami di Fahraj', *Studi Iranici*, 41-76. Rome, 1977.

8. The Muslim West

BASSET, H., and TERRASSE, H. *Sanctuaires et forteresses almohades*. Paris, 1932.

BELLAFIORI, G. *La Ziza del Palermo*. Palermo, 1978.

BRISCH, K. *Die Fenstergitter und verwandte Ornamente der Hauptmoschee von Cordoba*. Berlin, 1966.

CAILLÉ, J. *La mosquée de Hassan à Rabat*. Paris, 1954.

DESSUS LAMARE, A. 'Le mushaf de la mosquée de Cordoue et son mobilier mécanique', *Journal Asiatique*, CCXXX (1938), 551-76.

EWERT, C. *Islamische Funde in Balaguer und die Aljaferia in Zaragoza*. Berlin, 1971.

EWERT, C. 'Die Moschee bei Bab al-Mardum', *Madrider Mitteilungen*, XVIII (1977), 237-354.

EWERT, C. *Spanisch-islamische Systeme sich kreuzender Bögen*. Berlin, 1968.

GIMÉNEZ, F. H. *El Alminar de Abd al-Rahman III en la Mezquita Mayor de Córdoba*. Granada, 1975.

GIMÉNEZ, F. H. 'Die Elle in der arabischen Geschichtsschreibung über die Hauptmoschee von Cordoba', *Madrider Mitteilungen*, I (1960), 182-224.

GOLVIN, L. *Le Maghrib central à l'époque des Zirides*. Paris, 1957.

GOLVIN, L. 'Le mihrab de Kairouan', *Kunst des Orients*, V (1968), 1-38.

GOLVIN, L. *Recherches archéologiques à la Qala des Banu Hammad*. Paris, 1965.

HILL, D., and GOLVIN, L. *Islamic Architecture in North Africa*. London, 1976.

KING, G. 'The Mosque Bab Mardum', *Art and Archaeology Research Papers*, II (1970), 29-40.

LAMBERT, É. 'L'histoire de la grande mosquée de Cordoue aux VIIIe et IXe siècles, d'après des textes inédits', *AIEO*, II (1936), 165-79.

LAMBERT, É. 'De quelques incertitudes dans l'histoire de la construction de la grande mosquée de Cordoue', *AIEO*, I (1934-5), 176-88.

LÉVI-PROVENÇAL, E. 'Les citations du *Muqtabis* d'Ibn Hayyan relatives aux agrandissements de la grande-mosquée de Cordoue au IXᵉ siècle', *Arabica*, I (1954), 89-92.

LÉZINE, A. *Architecture de l'Ifriqiya*. Paris, 1966.

LÉZINE, A. *Mahdiya*. Paris, 1965.

LÉZINE, A. *Le Ribat de Sousse*. Tunis, 1956.

MARÇAIS, G. *L'architecture musulmane d'Occident*. Paris, 1954.

OCAÑA JIMÉNEZ, M. 'La basílica de San Vicente', *Al-Andalus*, VII (1942), 347-66.

SOLIGNAC, J. M. 'Recherches sur les installations hydrauliques de Kairouan et des steppes tunisiennes du VIIᵉ au XIᵉ siècle (J.C.)', *AIEO*, X (1952), 5-273; XI (1953), 60-170.

STERN, H. *Les mosaïques de la grande mosquée de Cordoue*. Berlin, 1976.

TERRASSE, H. *La mosquée al-Qarawiyin à Fez*. Paris, 1968.

TORRES BALBAS, L. *La mezquita de Córdoba y las ruinas de Madinat al-Zahra*. Madrid, 1952.

TORRES BALBAS, L. 'Nuevos datos documentales sobre la construcción de la mezquita de Córdoba en el reinado de Abd al-Rahman II', *Al-Andalus*, VI (1941), 411-22.

ZBISS, S. M. 'Mahdia et Sabra-Mansouriya: nouveaux documents d'art fatimite d'Occident', *Journal Asiatique*, CCXLIV (1956), 79-93.

IV. CALLIGRAPHY, PAINTING, AND THE ARTS OF THE BOOK

ABBOTT, N. *The Rise of the North Arabic Script and its Ku'ranic Development, with a Full Description of the Ku'ran Manuscripts in the Oriental Institute*. Chicago, 1939.

ARNOLD, T. W. *Painting in Islam: A Study of the Place of Pictorial Art in Muslim Culture*. Oxford, 1928.

ARNOLD, T. W., and GROHMANN, A. *The Islamic Book: A Contribution to its Art and History from the VII-XVIII Century*. Leipzig, 1929.

ATEŞ, A. 'Un vieux poème romanesque persan: Récit de Warqah et Gulshah', *Ars Orientalis*, IV (1961), 143-52.

AZARPAY, G. *Soghdian Painting*. Berkeley, 1979.

BOSCH, G. K. 'The Staff of the Scribes and Implements of the Discerning: An Excerpt', *Ars Orientalis*, IV (1961), 1-13.

BOSCH, G. K., CARSWELL, J., and PETHERBRIDGE, G. *Islamic Bookbindings and Bookmaking*. Chicago, 1981.

BUCHTHAL, H. 'Early Islamic Miniatures from Baghdad', *The Journal of the Walters Art Gallery*, V (1942), 13-39.

BUCHTHAL, H. '"Hellenistic" Miniatures in Early Islamic Manuscripts', *Ars Islamica*, VII (1940), 125-33.

BUCHTHAL, H. 'The Painting of the Syrian Jacobites in Its Relation to Byzantine and Islamic Art', *Syria*, XX (1939), 136-50.

BUCHTHAL, H., KURZ, O., and ETTINGHAUSEN, R. 'Supplementary Notes to K. Holter's Check List of Islamic Illuminated Manuscripts before A.D. 1350', *Ars Islamica*, VII (1940), 147-64.

BUSSAGLI, M. *Painting of Central Asia*. Geneva, 1963.

DAY, F. E. 'Mesopotamian Manuscripts of Dioscurides', *Bull. MMA*, N.S. VIII (1950), 274-80.

ETTINGHAUSEN, R. *Arab Painting*. Geneva, 1962.

ETTINGHAUSEN, R. 'Arabic Epigraphy: Communication or Symbolic Affirmation ...', in D. K. Kouymijan, ed., *Studies in Honor of G. C. Miles*, 297-317. Beirut, 1974.

ETTINGHAUSEN, R. 'The Covers of the Morgan Manafi Manuscript and Other Early Persian Bookbindings', *Studies in Art and Literature for Belle da Costa Greene*, ed. D. Miner, 459-73. Princeton, 1954.

ETTINGHAUSEN, R. 'The Decorative Arts and Painting: Their Character and Scope', in J. Schacht and C. E. Bosworth, eds. *The Legacy of Islam*, 274-92. Oxford, 1974.

ETTINGHAUSEN, R., et al. 'Islamic Art', *Bull. MMA*, N.S. XXXIII, 1 (1975).

ETTINGHAUSEN, R., et al. 'Islamic Painting', *Bull. MMA*, N.S. XXXVI, 2 (1978).

ETTINGHAUSEN, R. 'Kufesque in Byzantine Greece, the Latin West, and the Muslim World', *A Colloquium in Memory of G. C. Miles*, 28-47. New York, 1976.

ETTINGHAUSEN, R. 'Manuscript Illumination', *SPA*, V, 1937-74.

ETTINGHAUSEN, R. 'Painting in the Fatimid Period: A Reconstruction', *Ars Islamica*, IX (1942), 112-24.

ETTINGHAUSEN, R. 'A Signed and Dated Seljuq Qur'an', *Bulletin of the American Institute for Persian Art and Archaeology*, IV (1935), 92-102.

FARÈS, B. *Le livre de la Thériaque: Manuscrit arabe à peintures de la fin du XIIe siècle conservé à la Bibliothèque Nationale de Paris*. Cairo, 1953.

GARDNER, K. B. 'Three Early Islamic Bookbindings', *The British Museum Quarterly*, XXVI (1962), 28-30.

GRABAR, O. *The Illustrations of the Maqamat*. Chicago, 1984.

GRABAR, O. 'The Painting of the Six Kings at Qusayr Amrah', *Ars Orientalis*, I (1954) 185-7.

GRAY, B. 'A Fatimid Drawing', *British Museum Quarterly*, XII (1938), 91-6.

GRAY, B. 'Islamic Charm from Fostat', *British Museum Quarterly*, IX (1934), 130-1.

GRUBE, E. J. *The Classical Style in Islamic Painting.* Lugano, 1968.

GRUBE, E. J. 'The Hippiatrica Arabica Illustrata: Three 13th Century Manuscripts and Related Material', *SPA*, XIV, 3138-55.

GRUBE, E. J. 'Materialien zum Dioskurides Arabicus', *Aus der Welt der islamischen Kunst*, ed. R. Ettinghausen, 163-94. Berlin, 1959.

HAMARNEH, S. K. 'Drawings and Pharmacy in al-Zahrawi's Tenth-Century Surgical Treatise', *United States National Museum Bulletin*, CCXXVIII (1961), 81-94.

HERZFELD, E. *Die Malereien von Samarra (Die Ausgrabungen von Samarra*, III). Berlin, 1927.

HOLTER, K. 'Die Galen-Handschrift und die Makamen des Hariri der Wiener Nationalbibliothek', *Jahrbuch der Kunsthistorischen Sammlungen in Wien*, N. F. XI (1937), 1-48.

HOLTER, K. 'Die islamischen Miniaturhandschriften vor 1350', *Zentralblatt für Bibliothekswesen*, LIV (1937), 1-34.

IPŞIROĞLU, M. Ş. *Das Bild im Islam.* Vienna and Munich, 1971.

JAMES, D. *Qurans and Bindings from the Chester Beatty Library.* London, 1980.

KARABACEK, J. 'Neue Quellen zur Papiergeschichte', *Mitteilungen aus der Sammlung der Papyrus Erzherzog Rainer*, IV (1961).

KHATIBI, A., and SIJELMASSI, M. *The Splendour of Islamic Calligraphy.* New York, 1976.

LEVEY, M., KREK, M., and HADDAD, H. 'Some Notes on the Chemical Technology in an Eleventh Century Arabic Work on Bookbinding', *Isis*, XLVII (1956), 239-43.

LINGS, M. *The Quranic Art of Calligraphy and Illumination.* London, 1976.

LINGS, M., and SAFADI, Y. H. *The Quran: Catalogue of an Exhibition of Quran Manuscripts at the British Library April-August 1976.* London, 1976.

MARTIN, F. R. *The Miniature Painting and Painters of Persia, India and Turkey from the Eighth to the Eighteenth Century.* London, 1912.

MASAHIF SANA. *Kuwait National Museum.* Kuwait, 1985.

MELIKIAN-CHIRVANI, A. S. 'Le roman de Varqe et Golsah', *Arts Asiatiques*, XXII, special number (1970), 1-262.

MONNERET DE VILLARD, U. *Le pitture musulmane al soffito della Cappella Palatina in Palermo.* Rome, 1950.

PINDER-WILSON, R. H. 'Die Abbildung des Kairoer Prophetencodex des Mosche ben Ascher', *Der hebräische Bibeltext seit Franz Delitzsch*, ed. P. Kahle, 54-9. Stuttgart, 1961.

RICE, D. S. 'The Aghani Miniatures and Religious Painting in Islam', *The Burlington Magazine*, XCV (1953) 128-36.

RICE, D. S. 'Deacon or Drink: Some Paintings from Samarra Re-examined', *Arabica*, V (1958), 15-33.

RICE, D. S. 'A Drawing of the Fatimid Period', *Bulletin of the School of Oriental and African Studies*, XXI (1958), 31-9.

RICE, D. S. *The Unique ibn al-Bawwab Manuscript in the Chester Beatty Library.* Dublin, 1955.

SADEK, M. *The Arabic Materia Medica of Dioscurides.* Québec, 1983.

SAFADI, Y. H. *Islamic Calligraphy.* London, 1978.

STERN, S. 'A New Volume of the Illustrated Aghani Manuscript', *Ars Orientalis*, II (1957), 501-3.

STROHMAIER, G. 'Die bemalten Weingefässe aus Samarra', *Klio*, LXIII (1981), 123-30.

WEISWEILER, M. *Der islamische Bucheinband des Mittelalters nach Handschriften aus deutschen, holländischen und türkischen Bibliotheken.* Wiesbaden, 1962.

WEITZMANN, K. 'The Greek Sources of Islamic Scientific Illustrations', *Archaeologica Orientalia In Memoriam Ernst Herzfeld*, ed. G. C. Miles, 244-66. Locust Valley, 1952.

WELLESZ, E. 'An Early al-Sufi Manuscript in the Bodleian Library in Oxford: A Study in Islamic Constellation Images', *Ars Orientalis*, III (1959), 1-26.

WIET, G. 'Un dessin du XIe siècle', *Bulletin de l'Institut d'Égypte*, XIX (1936-7), 223-7.

V. APPLIED AND DECORATIVE ARTS

1. General

Arts de l'Islam des origines à 1700 dans les collections publiques françaises, Orangerie des Tuileries, *22 juin–30 août 1971.* Paris, 1971.

The Arts of Islam, Hayward Gallery, *8 April-4 July 1976.* London, 1976.

ATIL, E. *Art of the Arab World.* Washington, D. C., 1975.

ETTINGHAUSEN, R. 'The Man-Made Setting', in B. Lewis, ed., *The World of Islam*, 57-88. London, 1976.

ETTINGHAUSEN, R. 'The Islamic Period', in *Treasures of Turkey.* Geneva, 1966.

GOLDZIHER, I. 'Die Handwerke bei den Arabern', *Globus*, LXVI (1894), 203-5.

GRABAR, O. 'Les arts mineurs de l'Orient musulman à partir du milieu du XIIe siècle', *Cahiers de civilisation médiévale*, XI (1968), 181-90.

GRABAR, O. 'Imperial and Urban Art in Islam: The Subject Matter of Fatimid Art', *Colloque International sur l'histoire du Caire, mars-avril 1969*, 173-90. Cairo, 1972.

HASSAN, Z. M. *Kunuz al-Gatimiyin*. Cairo, 1937.

HAUSER, W., and UPTON, J. M. 'The Iranian Expedition, 1936', *Bull. MMA*, XXXII (1937), 3-39.

HAUSER, W., UPTON, J. M., and WILKINSON, C. K. 'The Iranian Expedition, 1937', *Bull. MMA*, XXXIII (1938), 9-11.

HAUSER, W., and WILKINSON, C. K. 'The Museum's Excavations at Nishapur', *Bull. MMA*, XXXVII (1942), 81-119.

IRAQ DEPARTMENT OF ANTIQUITIES. *Excavations at Samarra, 1936-1939*, II, *Objects*. Baghdad, 1940.

JENKINS, M., ed. *Islamic Art in the Kuwait National Museum*. Kuwait, 1983.

KEENE, M. *Selected Recent Acquisitions*. Kuwait, 1984.

KÜHNEL, E. 'Die Kunst Persiens unter den Buyiden', *Zeitschrift der Deutschen Morgenländischen Gesellschaft*, CVI, N. F. XXXI (1956), 78-92.

MARÇAIS, G., and POINSSOT, L. *Objets kairouanais du IXe au XIIIe siècle: Reliures, verreries, cuivres et bronzes, bijoux*. 2 vols. Tunis, 1948-52.

MIGEON, G. *Manuel d'art musulman*. 2 vols. Paris, 1927.

ZAHN, R., and SARRE, F. 'Die Erwerbung einer in Südrussland gebildeten Sammlung von Werken der Kleinkunst aus antiker, Völkerwanderungs- und islamischer Zeit', *Amtliche Berichte aus den Königlichen Kunstsammlungen (Berlin)*, XXIV (1907), columns 57-60, 66-71.

2. Studies and Interpretation

BAER, E. *Sphinxes and Harpies in Medieval Islamic Art: An Iconographic Study*. Jerusalem, 1965.

ETTINGHAUSEN, R. 'The Character of Islamic Art', *The Arab Heritage*, ed. N. Faris, 251-67. Princeton, 1946.

ETTINGHAUSEN, R. *From Byzantium to Sasanian Iran and the Islamic World*. Leiden, 1972.

ETTINGHAUSEN, R. 'Al-Ghazzali on Beauty', *Art and Thought: Issued in Honour of Dr Ananda K. Coomaraswamy on the Occasion of His 70th Birthday*, ed. K. B. Iyer, 160-5. London, 1947.

ETTINGHAUSEN, R. 'Interaction and Integration in Islamic Art', *Unity and Variety in Muslim Civilization*, ed. G. E. von Grunebaum, 107-31. Chicago, 1955.

ETTINGHAUSEN, R. *Studies in Muslim Iconography*, I, *The Unicorn (Freer Gallery of Art Occasional Papers*, I, no. 3). Washington, D.C., 1950.

GRABAR, O. 'Fatimid Art, Precursor or Culmination', *Ismaili Contributions to Islamic Culture*, ed. S. H. Nasr, 207-24. Tehran, 1977.

GRABAR, O. *The Formation of Islamic Art*. New Haven, 1973.

GRABAR, O. 'Islam and Iconoclasm', *Iconoclasm*, ed. A. Bryer and J. Herrin, 45-52. Birmingham, 1977.

GRABAR, O. 'Survivances classiques dans l'art de l'Islam', *Annales Archéologiques Arabes Syriennes*, XXI (1971), 371-80.

HAMIDULLAH, M. 'Ästhetik und Kunst in der Lehre des Propheten', *Akten des 24. Orientalischen Kongresses*. Wiesbaden, 1959.

HARTNER, W. 'The Pseudoplanetary Nodes of the Moon's Orbit in Hindu and Islamic Iconographies', *Ars Islamica*, V (1938), 113-54.

HARTNER, W., and ETTINGHAUSEN, R. 'The Conquering Lion: The Life Cycle of a Symbol', *Oriens*, XVII (1964), 161-71.

HERZFELD, E. 'Die Genesis der islamischen Kunst und das Mshatta-Problem', *Der Islam*, I (1910), 105-44.

KÜHNEL, E. *The Arabesque*, trans. R. Ettinghausen. Graz, 1977.

MARÇAIS, G. 'Remarques sur l'esthétique musulmane', *AIEO*, IV (1938), 55-71.

MILES, G. C. 'Mihrab and Anazah: A Study in Early Islamic Iconography', *Archaeologica Orientalia In Memoriam Ernst Herzfeld*, ed. G. C. Miles, 156-71. Locust Valley, 1952.

ÖNEY, G. 'Dragon Figures in Anatolian Seljuk Art', *Belleten*, XXXIII (1969), 193-216.

SOUCEK, P. 'The Temple of Solomon in Islamic Legend and Art', *Temple of Solomon*, ed. J. Gutman, 73-124. Ann Arbor, 1976.

3. Ceramics

ADAMS, R. M. 'Tell Abu Sarifa: A Sassanian-Islamic Ceramic Sequence from South Central Iraq', *Ars Orientalis*, VIII (1970), 87-119.

AGA-OGLU, M. 'A Rhages Bowl with a Representation of an Historical Legend', *Bulletin of the Detroit Institute of Arts*, XII (1930), 31-2.

ATIL, E. *Ceramics from the World of Islam*. Washington, D.C., 1975.

BAGATTI, P. B. 'Lucerne fittili "a cure" nel Museo della Flagellazione in Gerusalemme', *Faenza*, XXXV (1949), 98-103.

BAHRAMI, M. *Gurgan Faiences*. Cairo, 1949.

BAHRAMI, M. *Recherches sur les carreaux de revêtement lustré dans la céramique persane du XIIIe au XIVe siècle (étoiles et croix)*. Paris, 1937.

DAY, F. E. 'Early Islamic and Christian Lamps', *Berytus*, VII (1942), 65-79.

DAY, F. E. 'The Islamic Finds at Tarsus', *Asia*, XLI (1941).

DAY, F. E. 'A Review of "The Ceramic Arts. A. History" in *A Survey of Persian Art*', *Ars Islamica*, VIII (1941), 13-48.

ETTINGHAUSEN, R. 'Dated Faience', *SPA*, II, 1667-96.

ETTINGHAUSEN, R. 'Evidence for the Identification of Kashan Pottery', *Ars Islamica*, III (1936), 44-75.

ETTINGHAUSEN, R. 'Notes on the Lusterware of Spain', *Ars Orientalis* I (1954), 133-56.

GRUBE, E. J. *Islamic Pottery of the Eighth to the Fifteenth Century in the Keir Collection*. London, 1976.

GRUBE, E. J. 'Raqqa-Keramik in der Sammlung des Metropolitan Museum in New York', *Kunst des Orients*, IV (1963), 42-78.

GUEST, G. D. 'Notes on the Miniatures on a Thirteenth Century Beaker', *Ars Islamica*, X (1943) 148-52.

HOBSON, R. L. 'Potsherds from Brahminabad', *Transactions of the Oriental Ceramics Society* (1928-30), 21-3.

JENKINS, M. 'Islamic Pottery: A Brief History', *Bull. MMA*, N.S. XL, 4 (1983).

JENKINS, M. 'Muslim: An Early Fatimid Ceramist', *Bull. MMA*, N.S. XXVI (1968), 359-69.

JENKINS, M. 'The Palmette Tree: A Study of the Iconography of Egyptian Lustre Painted Pottery', *Journal of the American Research Center in Egypt*, VI (1967), 65-84.

KOECHLIN, R. *Les céramiques musulmanes de Suse au Musée du Louvre*. Paris, 1928.

KÜHNEL, E. 'Die abbasidischen Lusterfayencen', *Ars Islamica*, I (1934), 149-59.

LANE, A. *Early Islamic Pottery*. London, 1947.

LANE, A. 'Glazed Relief Ware of the Ninth Century', *Ars Islamica*, VI (1939), 56-65.

LANE, A. 'Medieval Finds at Al-Mina in North Syria', *Archaeologia*, LXXXVII (1938), 19-78.

LANE, A. 'The Ottoman Pottery of Isnik', *Ars Orientalis*, II (1957), 247-81.

LUNINA, S. B. 'The Pottery Industry in Merv from the Tenth to the Beginning of the Thirteenth Century', *Akademiya Nauk Turkmenskoi SSR Trudy Tuzhno-turkmenistenskoi Arkheologicheskoy Kompleksnoi Ekspeditsii*, XI (1962), 217-48.

MARÇAIS, G. *Les faïences à reflets métalliques de la grande mosquée de Kairouan*. Paris, 1928.

MAYSURADZHE, Z. *Keramika Afrasyaba*. Tbilisi, 1958.

MEINECKE, M. *Fayencedekorationen seldschukischer Sakralbauten in Kleinasien*. 2 vols. Tübingen, 1976.

MICHEL, H. V., ASARO, F., and FRIERMAN, J. D. 'Provenance Studies of Sgraffito and Large Green Glazed Wares from Siraf, Iran', *Proceedings of the*

Conference on Applications of Physical Science to Medieval Archaeology. Berkeley, 1975.

MICHEL, H. V., FRIERMAN, J. D., and ASARO, F. 'Chemical Composition Patterns of Ceramic Wares from Fustat Egypt', *Archaeometry* XVIII (1976), 85-94.

NAUMANN, R. 'Eine keramische Werkstatt des 13. Jahrhunderts auf dem Takht-i-Suleiman', *Beiträge zur Kunstgeschichte Asiens In Memoriam Ernst Diez*, ed. O. Aslanapa, 301-7. Istanbul, 1963.

OLIVER, P. 'Le décor des filtres de gargoulettes de l'Égypte musulmane', *Mélanges Maspero*, III (1935-40), 33-9.

PHILON, H. *Early Islamic Ceramics: Ninth to Late Twelfth Centuries*. London, 1980.

PINDER-WILSON, R. 'An Early Fatimid Bowl Decorated in Lustre', *Aus der Welt der islamischen Kunst, Festschrift für E. Kühnel*, ed. R. Ettinghausen, 139-43. Berlin, 1959.

POPE, A. U. 'The Ceramic Art in Islamic Times, A. The History', *SPA*, II, 1446-1665.

REITLINGER, G. 'Unglazed Relief Pottery from Northern Mesopotamia', *Ars Islamica*, XV-XVI (1951), 11-22.

RICE, D. T. 'The Pottery of Byzantium and the Islamic World', *Studies in Islamic Art and Architecture in Honour of K. A. C. Creswell*, 194-236. Cairo, 1965.

RIIS, P. J., and POULSEN, V. *Hama: Fouilles et recherches (1931-1938)*, IV (part 2), *Les verreries et poteries médiévales*. Copenhagen, 1957.

ROSEN-AYALON, M. *Mémoires de la Délégation Archéologique en Iran, Mission susiane: Ville Royale de Suse*, IV, *La poterie islamique*. Paris, 1974.

SARRE, F. 'Drei Meisterwerke syrischer Keramik, Neuerwerbungen der islamischen Kunstabteilung', *Berliner Museen*, XLVIII (1927), 7-10.

SARRE, F. 'Islamische Tongefässe aus Mesopotamien', *Jahrbuch der Königlichen Preussichen Kunstsammlungen*, XXVI (1905), 69-88.

SARRE, F. *Die Keramik von Samarra. Die Ausgrabungen von Samarra*, II. Berlin, 1925.

SARRE, F. 'Die Kleinfunde', *Baalbek: Ergebnisse der Ausgrabungen und Untersuchungen in den Jahren 1898 bis 1905*, III, 113-36. Berlin and Leipzig, 1925.

SAUVAGET, J. 'Tessons de Rakka', *Ars Islamica*, XIII-XIV (1948), 31-45.

SCERATTO, U. *Ceramica irachena del IX-X secolo*. Rome, 1968.

SIMPSON, M. S. 'Narrative Structure of a Medieval Iranian Beaker', *Ars Orientalis*, XII (1981), 15-24.

VOLOV (GOLOMBEK), L. 'The Plaited Kufic on Samanid Epigraphic Pottery', *Ars Orientalis*, VI (1966), 107-33.

WATSON, O. 'Persian Lustre-Painted Pottery: The Rayy and Kashan Styles', *Transactions of the Oriental Ceramic Society*, XL (1973-5), 1-19.

WHITEHOUSE, D. 'Islamic Glazed Pottery in Iraq and the Persian Gulf: The Ninth and Tenth Centuries', *Annali Istituto Orientale di Napoli*, XXXIX, N. S. XXIX (1979), 45-61.

WILKINSON, C. K. 'Christian Remains from Nishapur', *Forschungen zur Kunst Asiens In Memoriam Kurt Erdmann*, ed. O. Aslanapa and R. Naumann, 79-87. Istanbul, 1969.

WILKINSON, C. K. 'The Glazed Pottery of Nishapur and Samarkand', *Bull. MMA* (November 1961), 102-15.

WILKINSON, C. K. *Nishapur: Pottery of the Early Islamic Period*. New York, 1973.

YUSUF, ABD AL-RA'UF ALI. 'Khazzafun min al-asri al-fatimi wa asalibuhum al-fanniyya', *Majalla Kulliyat al-Adāb (Bulletin of the Faculty of Letters)*, Cairo University, X (1958), 173-279.

ZAUROVA, E. Z. 'Ceramic Kilns of the 7th-8th Century at the Town Ruins of Merv', *Akademiya Nauk Terkmenskoi SSR, Ivzkno-Turkmenistanskoi Arkheologicheskoi Kompleksnoi Ekspeditsii*, XI (1962), 174-216.

4. Glass and Crystal

BERKOFF, A. E. 'A Study of the Names of the Early Glass Making Families as a Source of Glass History', *Studies in Glass History and Design: Papers Read to Committee B. Sessions of the VIIIth International Congress on Glass held in London 1-6 July, 1968*, 62-5. London, n.d.

ERDMANN, K. '"Fatimid" Rock Crystals', *Oriental Art*, III (1951), 142-6.

ERDMANN, K. 'Islamische Bergkristallarbeiten', *Jahrbuch der Königlichen Preussischen Kunstsammlungen*, LXI (1940), 125-46.

ERDMANN, K. 'Islamische Giessgefässe des 11. Jahrhunderts', *Pantheon*, XXII (1938), 251-4.

ERDMANN, K. 'Neue islamische Bergkristalle', *Ars Orientalis*, III (1959), 200-5.

ERDMANN, K. 'An Unknown Hedwig Glass', *The Burlington Magazine*, XCI (1949), 244-8.

ETTINGHAUSEN, R. 'An Early Islamic Glass-Making Center', *Records of the Museum of Historic Art, Princeton University*, I (1942), 4-7.

GRAY, B. 'Thoughts on the Origin of "Hedwig" Glasses', *Colloque International sur l'Histoire du Caire*, 191-4. Cairo, 1969.

HASSON, R. *Early Islamic Glass*. Jerusalem, 1979.

LAMM, C. J. 'Das Glas von Samarra', *Die Ausgrabungen von Samarra*, IV. Berlin, 1928.

LAMM, C. J. *Mittelalterliche Gläser und Steinschnittarbeiten aus dem Nahen Osten*. 2 vols. Berlin, 1930.

LAMM, C. J. *Oriental Glass of Medieval Date Found in Sweden and the Early History of Lustre-Painting*. Stockholm, 1941.

LAMM, C. J. 'Les verres trouvés à Suse', *Syria*, XII (1931), 358-67.

OLIVER, P. 'Islamic Relief-Cut Glass: A Suggested Chronology', *Journal of Glass Studies*, III (1961), 9-29.

PINDER-WILSON, R. 'Cut-glass Vessels from Persia and Mesopotamia', *British Museum Quarterly*, XXVII (1963-4), 33-9.

PINDER-WILSON, R. H., and SCANLON, G. T. 'Glass Finds from Fustat: 1964-1971', *Journal of Glass Studies*, XV (1973), 12-30.

RICE, D. S. 'A Datable Islamic Rock Crystal', *Oriental Art*, N. S. II (1956), 85-93.

SCHMIDT, R. 'Die Hedwigsgläser und die verwandten fatimidischen Glas- und Kristallschnittarbeiten', *Schlesiens Vorzeit in Bild und Schrift*, N. F. VI (1912), 53-78.

5. Metalwork

AGA-OGLU, M. 'About a Type of Islamic Incense Burner', *The Art Bulletin*, XXVII (1945), 28-45.

AGA-OGLU, M. 'A Preliminary Note on Two Artists from Nishapur', *Bulletin of the Iranian Institute*, VI-VII (1946), 121-4.

ALLAN, J. *Islamic Metalwork: The Nuhad Es-Said Collection*. London, 1982.

ALLAN, J. *Nishapur: Metalwork of the Early Islamic Period*. New York, 1982.

ALLAN, J. *Persian Metal Technology 700-1300 A. D.* Oxford, 1979.

ALLAN, J. 'Silver: the Key to Bronze in Early Islamic Iran', *Kunst des Orients*, V, II (1976/7), 5-21.

BAER, E. *Metalwork in Medieval Islamic Art*. Albany, 1982.

BARRETT, D. *Islamic Metalwork in the British Museum*. London, 1949.

BUCHTHAL, H. 'A Note on Islamic Enameled Metalwork and Its Influence in the Latin West', *Ars Islamica*, XI-XII (1946), 195-8.

DIAKONOV, M. M. 'Ob odnoi rannei arabskoi nadpisi', *Epigrafika Vostoka*, I (1947), 5-8.

DIMAND, M. S. 'A Review of Sasanian and Islamic Metalwork in *A Survey of Persian Art*', *Ars Islamica*, VIII (1941) 192-214.

ETTINGHAUSEN, R. 'The Bobrinski "Kettle", Patron and Style of an Islamic Bronze', *Gazette des Beaux-Arts*, 6e sér., XXIV (1943), 199-203.

ETTINGHAUSEN, R. 'Further Comments on the Wade Cup', *Ars Orientalis*, III (1959), 197-200.

ETTINGHAUSEN, R. 'Sasanian and Islamic Metal-Work in Baltimore', *Apollo*, LXXXIV (December 1966), 465-9.

ETTINGHAUSEN, R. 'Turkish Elements on Silver Objects of the Seljuk Period of Iran', *Communications of the First International Congress of Turkish Art, Ankara, 1959*, 128-33. Ankara, 1961.

ETTINGHAUSEN, R. 'The "Wade Cup" in the Cleveland Museum of Art, Its Origin and Decorations', *Ars Orientalis*, II (1957), 327-66.

GIUZALIAN, L. T. 'The Bronze Qalamdan (Pencase) 542/1148 from the Hermitage Collection (1936-1965)', *Ars Orientalis*, VII (1968), 95-119.

GIUZALIAN, L. T. 'Bronzov'ui kuvschin 1182', *Pamyatniki Epokhi Rustaveli*, 227-36. Leningrad, 1938.

GIUZALIAN, L. T. 'Vtoroi Geratskij Kotelok', *Trudy Hermitage*, XIX (1978), 53-83.

GRABAR, O. *Sasanian Silver*. Ann Arbor, 1967.

GRAY, B. 'A Seljuq Hoard from Persia', *The British Museum Quarterly*, XIII (1939), 73-9.

HARIRI, R. 'Metalwork After the Early Islamic Period', *SPA*, III, 2466-2529.

HARPER, P. *The Royal Hunter: Art of the Sasanian Empire*. New York, 1978.

HERZFELD, E. 'A Bronze Pen-Case', *Ars Islamica*, III (1936), 35-43.

JAMES, D. 'An Early Mosul Metalworker: Some New Information', *Oriental Art*, XXVI (1980), 318-21.

JENKINS, M. 'New Evidence for the History and Provenance of the So-called Pisa Griffin', *Islamic Archaeological Studies*, I (1978), 79-81. Cairo, 1982.

JENKINS, M., and KEENE, M. *Islamic Jewelry in the Metropolitan Museum of Art*. New York, 1982.

KAHLE, P. 'Die Schätze der Fatimiden', *Zeitschrift der Deutschen Morgenländischen Gesellschaft*, N.F. XIV (1935), 329-62.

KATZENSTEIN, R., and LOWRY, G. 'Christian Themes in Thirteenth-Century Islamic Metalwork', *Muqarnas*, I (1983), 53-68.

MARSHAK, B. 'Bronzovoi Kuvshin', *Iran i Srednia Azia*. Leningrad, 1973.

MARSHAK, B. 'Ranneislamskie bliuda', *Trudy Hermitage*, XIX (1978), 26-52.

MAYER, L. A. *Islamic Metalworkers and Their Works*. Geneva, 1959.

MELIKIAN-CHIRVANI, A. S. 'Les bronzes du Khorasan I', *Studia Iranica*, III (1974), 29-50.

MELIKIAN-CHIRVANI, A. S. 'Bucklers, Covers or Cymbals? A Twelfth-Century Riddle from Eastern Iran', *Islamic Arms and Armour*, ed. R. Elgood, 97-111. London, 1979.

MELIKIAN-CHIRVANI, A. S. 'Le griffon iranien de Pise (Matériaux pour un Corpus de l'argenterie et du bronze iranien, III)', *Kunst des Orients*, V (1968), 68-86.

MELIKIAN-CHIRVANI, A. S. *Victoria and Albert Museum. Islamic Metalwork from the Iranian World, 8th-9th Centuries*. London, 1982.

MEYER, E. 'Romanische Bronzen und ihre islamischen Vorbilder', *Aus der Welt der islamischen Kunst*, ed. R. Ettinghausen, 317-22. Berlin, 1959.

RICE, D. S. 'The Brasses of Badr al-Din Lulu', *Bulletin of the School of Oriental and African Studies*, XIII (1951), 627-34.

RICE, D. S. 'Inlaid Brasses from the Workshop of Ahmad al Dhaki al Mawsili', *Ars Orientalis*, II (1957), 283-326.

RICE, D. S. 'Studies in Islamic Metalwork - II-IV', *Bulletin of the School of Oriental and African Studies*, XV (1953), 61-79, 232-8; XVII (1955), 206-31.

RICE, D. S. *The Wade Cup in the Cleveland Museum of Art*. Paris, 1955.

ROSS, M. C. 'An Egypto-Arabic Cloisonné Enamel', *Ars Islamica*, VII (1940), 156-67.

SARRE, F. 'Die Bronzekanne des Kalifen Marwan II im Arabischen Museum in Kairo', *Ars Islamica*, I (1934), 10-14.

SARRE, F. 'Bronzeplastik in Vogelform, ein sasanidisch-frühislamisches Räuchergefäss', *Jahrbuch der Preussichen Kunstsammlungen*, LI (1930), 159-64.

SAUVAGET, J. 'Remarques sur les monuments omeyyades, II. Argenteries "sassanides"', *Mélanges Asiatiques* (1940-1), 53-6.

SCHNEIDER, L. T. 'The Freer Canteen', *Ars Orientalis*, IX (1973), 137-56.

SMIRNOV, Y. I. *Vostochnoe serebro: Argenterie orientale*. St Petersburg, 1909.

WIET, G. 'Un nouvel artiste de Mossoul', *Syria*, XII (1931), 160-2.

6. Numismatics

LANE-POOLE, S. *Coins of the Urtuk Turkumens, Foes of the Crusaders*. London, 1875.

WALKER, J. *A Catalogue of the Arab-Byzantine and Post-Reform Umayyad Coins*. London, 1956.

WALKER, J. *A Catalogue of the Arab-Sassanian Coins*. London, 1941.

7. Textiles and Rugs

BENOIT, F. 'Fragments de tissus fatimides trouvés dans la tombe d'un archevêque d'Arles', *Cahiers d'archéologie*, I (1945), 57-62.

BODE, W., and KÜHNEL, E. *Antique Rugs from the Near East*, trans. C. G. Ellis. 4th rev. ed. Brunswick, 1958.

COMBE, E. 'Tissus fatimides du Musée Benaki', *Mélanges Maspero*, III (1935-40), 259-72.

DAY, F. E. 'The Inscription of the Boston "Baghdad" Silk - A Note on Method in Epigraphy', *Ars Orientalis*, I (1954), 191-4.

ERDMANN, K. *Seven Hundred Years of Oriental Carpets*, ed. H. Erdmann. Berkeley and Los Angeles, 1970.

ERDMANN, K. 'Zu einem anatolischen Teppichfragment aus Fostat', *Istanbuler Mitteilungen*, VI (1955), 42-52.

ETTINGHAUSEN, R. 'New Light on Early Animal Carpets', *Aus der Welt der islamischen Kunst*, ed. R. Ettinghausen, 93-116. Berlin, 1959.

FALKE, O. VON. *Kunstgeschichte der Seidenweberei*. 2 vols. Berlin, 1913.

GEIJER, A. 'Some Thoughts on the Problems of Early Oriental Carpets', *Ars Orientalis*, V (1963), 79-87.

GUEST, A. R. 'Notice of Some Arabic Inscriptions on Textiles at the South Kensington Museum', *Journal of the Royal Asiatic Society* (1906), 387-99.

KÜHNEL, E. *Islamische Stoffe aus ägyptischen Gräbern in der islamischen Kunstabteilung und in der Stoffsammlung des Schlossmuseums*. Berlin, 1927.

KÜHNEL, E. 'Zur Tiraz-Epigraphik der Abbasiden und Fatimiden', *Aus fünf Jahrtausenden morgenländischer Kultur: Festschrift Max Freiherrn von Oppenheim zum 70. Geburtstage gewidmet*, ed. E. F. Weidner, 59-65. Berlin, 1933.

KÜHNEL, E., and BELLINGER, L. *Catalogue of Dated Tiraz Fabrics, Umayyad, Abbasid, Fatimid*. Washington, 1959.

LAMM, C. J. *Cotton in Medieval Textiles of the Near East*. Paris, 1937.

LAMM, C. J. 'The Marby Rug and Some Fragments of Carpets Found in Egypt', *Svenska Orientsällskapets Arsbok* (1937), 51-130.

MARZOUK, M. A. A. 'The Evolution of Inscriptions on Fatimid Textiles', *Ars Islamica*, X (1943), 164-6.

MAY, F. L. *Silk Textiles of Spain: Eighth to Fifteenth Century*. New York, 1957.

SCHMIDT, J. H. 'Persische Seidenstoffe der Seldjukenzeit', *Ars Islamica*, II (1935), 84-91.

SERJEANT, R. B. 'Materials for a History of Islamic Textiles Up to the Mongol Conquest', *Ars Islamica*, IX (1942), 54-92; X (1943), 71-104; XI-XII (1946), 98-145; XIII-XIV (1948), 75-117; XV-XVI (1951), 19-85.

SHEPHERD, D. G. 'A Dated Hispano-Islamic Silk', *Ars Orientalis*, II (1957), 373-82.

SHEPHERD, D. G. 'Hispano-Islamic Textiles in the Cooper Union Collection', *Chronicle of the Museum for the Arts and Decoration of the Cooper Union*, I (1934-5), 365-73.

SHEPHERD, D. G., and HENNING, W. E. 'Zandaniji Identified', *Aus der Welt der islamischen Kunst*, ed. R. Ettinghausen, 15-40. Berlin, 1959.

THOMPSON, D. *Coptic Textiles in the Brooklyn Museum*. Brooklyn, 1971.

WEIBEL, A. C. 'Francisque-Michel's Contribution to the Terminology of Islamic Fabrics', *Ars Islamica*, II (1935), 219-24.

8. Woodwork, Stone Carving, Shadow Plays, Ivories

ANGLADE, E., and RUTSCHOWSKAYA, M. H. 'Les bois égyptiens du Musée du Louvre (VIe-IXe siècle)', *Art and Archaeology Research Papers*, XV (1979), 1-8.

BECKWITH, J. *Caskets from Cordoba*. London, 1960.

ERDMANN, K. 'Die beiden türkischen Grabsteine im Türk ve Islam Eserleri Müzesi in Istanbul', *Beiträge zur Kunstgeschichte Asiens In Memoriam Ernst Diez*, 121-30. Istanbul, 1963.

ETTINGHAUSEN, R. 'Early Shadow Figures', *Bulletin of the American Institute for Persian Art and Archaeology*, VI (1934), 10-15.

FALKE, O. VON. 'Elfenbeinhörner, I.: Ägypten und Italien', *Pantheon*, IV (1929), 511-17.

HERZ, M. 'Boiseries fatimites aux sculptures figurales', *Orientalisches Archiv*, III (1913), 169-74.

JACOB, G. *Geschichte des Schattentheaters im Morgen- und Abendland*. 2nd ed. Hanover, 1925.

JENKINS, M. 'An Eleventh-Century Woodcarving from a Cairo Nunnery', *Islamic Art in the Metropolitan Museum of Art*, ed. R. Ettinghausen, 227-40. New York, 1972.

KÜHNEL, E. *Die islamischen Elfenbeinskulpturen VIII.-XIII. Jahrhunderts*. Berlin, 1971.

LAMM, C. J. 'Fatimid Woodwork, Its Style and Chronology', *Bulletin de l'Institut d'Égypte*, XVIII (1936), 59-91.

MARÇAIS, G. 'Les figures d'hommes et de bêtes dans les bois sculptés d'époque fatimide conservés au Musée Arabe du Caire: Étude d'iconographie musulmane', *Mélanges Maspero*, III (1935-40), 241-57.

MAYER, L. A. *Islamic Wood Carvers and Their Works*. Geneva, 1958.

OTTO-DORN, K. 'Türkische Grabsteine mit Figurenreliefs aus Kleinasien', *Ars Orientalis*, III (1959), 63-76.

PAUTY, E. *Catalogue général du Musée arabe du Caire: Les bois sculptés jusqu'à l'époque ayyoubide*. Cairo, 1931.

PAUTY, E. 'Sur une porte en bois sculpté provenant de Bagdad', *Bulletin de l'Institut Français d'Archéologie Orientale*, XXX (1931), 77-81.

RIEFSTAHL, R. M. 'A Seljuq Koran Stand with Lacquer-Painted Decoration in the Museum of Konya', *Art Bulletin*, XV (1933), 361-73.

STERN, H. 'Quelques œuvres sculptées en bois, os, et ivoire de style omeyyade', *Ars Orientalis*, I (1954), 119-31.

LIST OF ILLUSTRATIONS

century. Colours and gilding on parchment. H 8 in: 20.5 cm. *Washington, D.C., Freer Gallery of Art* (Photo museum)

101. Page from a Koran, detail of sura opening, ninth/tenth century. Colours on parchment. *Cairo, Dar al-Kutub* (Moritz)

102. Page from a Koran, sura opening, MS. 30, f. 60r, ninth/tenth century. H of page 9⅜ in: 23.8 cm. *Washington, D.C., Freer Gallery of Art* (Photo museum)

103. Frontispiece from a Koran, MS. Rutbi 198, probably tenth century. Colours and gilding on parchment. *Tunis National Library*

104. Bookbinding, probably tenth century. Leather with blind tooling. *Tunis National Library (Objets kairouanais, 1)*

105. Illuminated page from a Karaite Hebrew manuscript, Tiberias, 895. *Cairo* (Paul Kahle, *Der hebräische Bibeltext*)

106. Frontispiece from a Koran, MS. 1406, ninth/tenth century. Colours and gilding on parchment. H 4¾ in: 12.2 cm. *Dublin, Chester Beatty Library* (Pieterse Davison Int. Ltd)

107. Huntress fresco (copy) from the Jawsaq palace, Samarra, ninth century (E. Herzfeld, *Die Malereien von Samarra*)

108. Cordova, Great Mosque, 784-6, 833/52, 961/76, and 987, plan

109. Cordova, Great Mosque, 784-6, 833/52, 961/76, and 987, construction

110 and 111. Cordova, Great Mosque, maqsura and mihrab, 961/76 (Mas and Instituto Arqueológico Alemán de Madrid)

112. Cordova, Great Mosque, al-Mansur's addition, 987 (Instituto Arqueológico Alemán de Madrid)

113. Cordova, Great Mosque, polylobed arch, 961/76 (Instituto Arqueológico Alemán de Madrid)

114. Cordova, Great Mosque, dome in front of mihrab, 961/76 (Mas)

115 and 116. Toledo, Bab Mardum, *c.* 1000, general view and dome (Mas)

117. Cordova, Great Mosque, marble fragment from mihrab area, 961/76 (Mas)

118. Madinat al-Zahra, begun 936, reception halls (Mas)

119. Cordova, Great Mosque, mosaics in the mihrab, 961/76 (Mas)

120. Cordova, Great Mosque, capital, 961/76 (Mas)

121. Tinmal, congregational mosque, *c.* 1035, plan (G. Marçais, *L'architecture musulmane d'Occident*) and general view (J. Powell)

122. Rabat, congregational mosque, 1196-7 (J. Allan Cash)

123. Rabat, Oudaia Gate, Almohad (J. Powell)

124. Tinmal, congregational mosque, *c.* 1035, dome in front of the mihrab (J. Powell)

125. Fez, Qarawiyin mosque, mostly 1135, muqarnas dome (H. Terrasse, *Archéologie méditerranéenne*, 11)

126. Stucco doorway from the Aljaferia, Saragossa, eleventh century. *Madrid, Museo Arqueológico Nacional* (Photo museum)

127. Casket, probably Madinat al-Zahra, *c.* 962. Ivory. H 4½ in: 11.4 cm. *London, Victoria and Albert Museum* (Photo museum)

128. Pyxis of Subh, probably Madinat al-Zahra, 964. Ivory. H 7 in: 18 cm. *Madrid, Museo Arqueológico Nacional* (Photo museum)

129. Prince, fan-bearer, and lutanist, and two falconers, two sides of the pyxis of al-Mughira, probably Cordova, 968. Ivory. H with lid 6⅞ in: 17.6 cm. *Paris, Louvre* (Photo museum)

130. Pyxis with vegetal designs, probably Madinat al-Zahra, *c.* 970. Ivory. H with lid 6½ in: 16.5 cm. *New York, Hispanic Society of America* (Courtesy of the Hispanic Society of America)

131. Casket of Abd al-Malik, probably Cordova, 1004/5. Ivory. H 7½ in: 19 cm. *Pamplona, Museo de Navarra* (Mas)

132. Pyxis of Abd al-Malik with arcading, probably Cordova, *c.* 1005. Ivory. H with lid 7⅞ in: 20 cm. *Braga Cathedral* (E. Kühnel, *Die islamischen Elfenbeinskulpturen: VIII.-XIII. Jahrhundert*, 1971)

133. Casket, Cuenca, 1026. Wood faced with ivory. H 13⅜ in: 34 cm. *Burgos, Museo Arqueológico Provincial* (Mas)

134. Basin, Madinat al-Zahra, after 936. Stone. *Madrid, Museo Arqueológico Nacional* (Photo museum)

135. Fragment, Granada, eleventh century. Stone. *Madrid, Museo Arqueológico Nacional* (Photo museum)

136. Algiers, Great Mosque, minbar, 1097

137. Marrakesh, Qutubiyya Mosque, minbar made in Cordova, late twelfth century

138. Chasuble of Ali ibn Yusuf ibn Tashfin (detail), probably Almería, 1107/43. Silk. *c.* 4 by 16 ft: 1.25 by 5 m. *Quintanaortuña near Burgos* (Mas)

139. 'Baghdad' silk from Burgo de Osma, probably Almería, twelfth century. 19¾ by 17¾ in: 50 by 45 cm. *Boston, Museum of Fine Arts* (Ellen Page Hall Fund; courtesy, Museum of Fine Arts, Boston)

140. 'Lion strangler' silk from Vich, probably Almería, twelfth century. 17 by 15 in: 43 by 38 cm. *Cleveland Museum of Art* (Purchase from the J.H. Wade Fund; photo museum)

141. Bicephalic bird silk from Vich (detail), probably Almería, late twelfth/early thirteenth century. 20⅝ by 40¼ in: 52 by 102 cm. *Cleveland Museum of Art* (Purchase from the J.H. Wade Fund; photo museum)

142. 'Drinking ladies' silk, possibly Seville, twelfth/thirteenth century. *New York, Cooper Hewitt Museum* (Gift of J.P. Morgan; photo museum)

bronze. *Mount Sinai, St Catherine's Monastery* (Dr Elizabeth Ettinghausen)

188. Griffin, probably Egypt, eleventh/twelfth century. Cast bronze. H *c.* 3 ft 3 in: 1 m. *Pisa, Campo Santo Museum* (Alinari)

189. Monochrome lustre-painted dish with scarf dancer, Egypt, late eleventh/twelfth century. Diameter 10¼ in: 26.1 cm. *Washington, D.C., Freer Gallery of Art* (Photo museum)

190. Monochrome lustre-painted bowl fragment with reclining figure pouring wine, Egypt, late eleventh/twelfth century. Maximum dimension 13⅜ in: 34 cm. *Cairo, Museum of Islamic Art* (Bernard O'Kane)

191. Monochrome lustre-painted dish with reclining lady, Egypt, late eleventh/twelfth century. Diameter 11¾ in: 30 cm. *Cairo, Museum of Islamic Art* (Bernard O'Kane)

192. Monochrome lustre-painted bowl with cockfight, Egypt, late eleventh/twelfth century. Diameter 9⅜ in: 23.7 cm. *London, Keir Collection* (Photo Keir Collection)

193. Monochrome lustre-painted bowl fragment with Christ blessing, Egypt, late eleventh century. Maximum dimension 4⅜ in: 11 cm. *Cairo, Museum of Islamic Art* (Bernard O'Kane)

194. Man with a camel, detail from a wooden board, Egypt, late eleventh century. L of board 11½ ft: 3.5 m. W 10⅝ in: 27 cm. *Cairo, Museum of Islamic Art* (Bernard O'Kane)

195. Drinking party, detail from a wooden board, Egypt, late eleventh century. L of board 11¾ ft: 3.57 m. W 10¼ in: 26 cm. *Cairo, Museum of Islamic Art* (Bernard O'Kane)

196. Acrobatic scenes, detail from a wooden board from Dayr al-Banat, Egypt, late eleventh/twelfth century. *Cairo, Coptic Museum* (Bernard V. Bothmer)

197. Plaque, probably Sicily, twelfth century. Ivory. H 11⅞ in: 30.3 cm. W 2¼ in: 5.8 cm. *Berlin (Dahlem), Staatliche Museen, Preussischer Kulturbesitz, Museum für Islamische Kunst* (Photo museum)

198. Plaque with hunter and harvester, probably Sicily, twelfth century. Ivory. H 6¾ in: 17 cm. W 3 in: 7.5 cm. *Florence, Museo Nazionale* (E. Kühnel, *Die islamischen Elfenbeinskulpturen: VIII.-XIII. Jahrhundert*, 1971)

199. Plaque with scarf dancer, probably Sicily, twelfth century. Ivory. H 4⅞ in: 12.5 cm. W 2⅞ in: 6.2 cm. *Florence, Museo Nazionale* (*ibid.*)

200. Palermo, Cappella Palatina, ceiling painting of scarf dancer, *c.* 1143 (Istituto Centrale per il Catalogo e la Documentazione, Rome)

201. Palermo, Cappella Palatina, ceiling painting of porter with barrel, *c.* 1143 (Istituto Centrale per il Catalogo e la Documentazione, Rome)

202. Palermo, Cappella Palatina, ceiling painting of servants drawing water, *c.* 1143 (Istituto Centrale per il Catalogo e la Documentazione, Rome)

203. Palermo, Cappella Palatina, ceiling painting of shepherd carrying a ram, *c.* 1143 (Istituto Centrale per il Catalogo e la Documentazione, Rome)

204. Palermo, Cappella Palatina, ceiling painting of banqueting prince, *c.* 1143 (Istituto Centrale per il Catalogo e la Documentazione, Rome)

205. Palermo, Cappella Palatina, ceiling painting of horseman fighting a dragon, *c.* 1143 (Istituto Centrale per il Catalogo e la Documentazione, Rome)

206. Siraf, mosque, plan as in the later ninth century

207. Isfahan, Great Mosque, plan as in the tenth century

208 and 209. Damghan, mosque, possibly eighth century, court (Roger Wood) and plan

210 and 211. Nayin, mosque, probably tenth century, view towards qibla (Roger Wood) and plan (E. Galdieri, *Isfahan: Masjid-i Guma*, 1973)

212 and 213. Nayin, mosque, probably tenth century, details of stucco work (Islamic Architecture Archive, Edinburgh; Bernard O'Kane and Robert Hillenbrand)

214. Hazara, mosque, plan

215. Hazara, mosque, view of interior

216. Balkh, nine-domed mosque, ninth century (J. Powell)

217 and 218. Niriz, mosque, 973 and later, iwan (Islamic Architecture Archive, Edinburgh, Robert Hillenbrand) and plan

219. Bukhara, Samanid mausoleum, 914/43(?), section

220 and 221. Bukhara, Samanid mausoleum, 914/43(?), exterior (Novosti Press Agency) and interior (J. Powell)

222-4. Tim, mausoleum, 977-8, façade, cross section, and dome

225 and 226. Gunbad-i Qabus, with detail, 1006-7 (J. Powell)

227. Muqarnas niche from Nishapur, tenth century. *New York, Metropolitan Museum of Art* (Photo museum: The Metropolitan Museum of Art, Museum Excavations, 1937, and Rogers Fund, 38.40.249)

228. Isfahan, Jurjir mosque, tenth century, detail of façade (Islamic Architecture Archive, Edinburgh, Bernard O'Kane)

229. Slip-painted bowl with decoration of 'hearts', Nishapur, tenth century. Diameter 4¾ in: 12 cm. *New York, Metropolitan Museum of Art* (Photo museum: Excavations of the Metropolitan Museum of Art, 1937, Rogers Fund, 38.40.168)

230. Bowl with warrior mounted for the hunt, Nishapur, tenth century. Diameter 15 in: 38 cm. *New York, Metropolitan Museum of Art* (Photo

Iran, twelfth century. Diameter 9⅛ in: 23.2 cm *Washington, D.C., Freer Gallery of Art* (Photo museum: 29.11)

366. Monochrome lustre-painted bowl, Iran, twelfth/early thirteenth century. Diameter 8 in: 20.3 cm. *New York, Metropolitan Museum of Art* (Photo museum: Rogers Fund, 1916, 16.87)

367. Monochrome lustre-painted bowl, Iran, 1191. Diameter 15 in: 38 cm. *Chicago, Art Institute* (Photo museum, Logan Patten Ryerson Collection, 1927.414)

368. Mina'i bowl, Iran, late twelfth/early thirteenth century. Diameter 8½ in: 21.6 cm. *New York, Metropolitan Museum of Art* (Photo museum: Fletcher Fund, 1964, 64.178.2)

369. Mina'i bowl with gilding, Iran, thirteenth century. Diameter 8⅛ in: 20.4 cm. *Washington D.C., Freer Gallery of Art* (Photo museum)

370. Underglaze slip-painted bowl with sgraffiato design, probably Iran, twelfth century. *Oxford, Ashmolean Museum* (Photo museum)

371. 'Macy' jug, underglaze-painted and reticulated, Iran, 1215-16. H 8 in: 20.3 cm. *New York, Metropolitan Museum of Art* (Photo museum: Fletcher Fund, 1932, 32.52.1)

372. Monochrome lustre-painted bowl, Iran, 1211. Diameter 19½ in: 49.5 cm. *Philadelphia, University Museum* (Photo museum)

373. Monochrome lustre-painted star tile, probably Kashan, 1211-12. Diameter 12⅜ in: 31.5 cm. *New York, Metropolitan Museum of Art* (Photo museum: H. Havemeyer gift, 40.181.)

374. Panel of monochrome lustre-painted tiles, probably Kashan, *c.* 1220. *London, Victoria and Albert Museum* (Photo museum)

375. Underglaze- and lustre-painted ceramic mihrab, Kashan, 1226. H 9 ft 3¾ in: 2.84 m. *Berlin (East), Staatliche Museen* (Photo museum)

376 and 377. Mina'i plate with battle scene (interior) and representations of heroic deeds (exterior), Iran, mid thirteenth century. Diameter 18¾ in: 47.8 cm. *Washington, D.C., Freer Gallery of Art* (Photos museum: 43.3)

378. Two pages from a Koran, no. 4316, ff. 2v-3r, probably Iran, 1073-4, 10¼ by 8 in: 26 by 20.5 cm. *Mashhad, Imam Riza Shah Shrine Library* (World of Islam Festival Trust)

379. Page from a Koran, no. 1438, f. 40a, probably Iran, 1186. 17 by 12½ in: 43 by 31.5 cm. *Dublin, Chester Beatty Library* (Pieterse Davison Int. Ltd)

380. Carpet page with geometric designs from a Koran, no. NE-P27, Hamadan, 1164. 16⅜ by 11¼ in: 41.5 by 28.5 cm. *Philadelphia, University Museum* (Photo museum)

381-3. Two figures in a tent, king between Warqa

and Gulshah, and Warqa in battle, from *Warqa wa Gulshah*, MS. Hazine 841, possibly late twelfth century. *Istanbul, Topkapı Sarayı Library* (Photo Topkapı Sarayı Library)

384. Enamelled bronze bowl, probably northern Mesopotamia, twelfth century (third quarter). Diameter 8⅞ in: 22.6 cm. *Innsbruck, Tiroler Landesmuseum Ferdinandeum* (Photo museum)

385. Mirror of Artuq Shah (back), probably northern Mesopotamia, mid thirteenth century. Bronze. *Harburg, Graf Oettingen-Wallerstein Collection* (Courtesy Graf Oettingen-Wallerstein)

386. Ewer, Mosul, 1223. Brass inlaid with silver. H 15 in: 38 cm. *Cleveland Museum of Art* (John L. Severance Fund; photo museum)

387. Ceramic *habb* (water storage vessel), probably northern Mesopotamia, thirteenth century. *Damascus, National Museum* (Photo museum)

388. Screen, formerly used in the Musalla al-Idayn, Syria, 1104. Wood. *Damascus, National Museum* (Direction Générale des Antiquités et des Musées, Damascus)

389. Hama, mosque of Nur al-Din, minbar (destroyed), 1163 (*Ars Islamica*, X, 1943)

390. Jerusalem, Aqsa mosque, minbar (destroyed), Aleppo, 1168-74. Wood

391. Geometric design on a pair of wooden doors dated 1219 in the citadel of Aleppo

392. 'Arenberg' basin, probably Syria, 1239/49. Brass inlaid with silver. H 8⅞ in: 22.5 cm. *Washington, D.C., Freer Gallery of Art* (Photo museum)

393. Ewer, probably Syria, 1232. Brass inlaid with silver. H 14½ in 36.7 cm. *Washington, D.C., Freer Gallery of Art* (Photo museum)

394. Plate, black-painted under turquoise-green glaze, Raqqa, Syria, late twelfth/early thirteenth century. Diameter 10½ in: 26.6 cm. *Washington, D.C., Freer Gallery of Art* (Photo museum)

395. 'The Luck of Edenhall', probably Syria, thirteenth century. Glass with enamelling. *London, Victoria and Albert Museum* (Photo museum)

396. Solon and his students from al-Mubashshir, *Mukhtar al-Hikam*, MS. Ahmet III, 3206, f. 24r, probably northern Mesopotamia, early thirteenth century. *Istanbul, Topkapı Sarayı Library* (Photo Topkapı Sarayı Library)

397. Dimna and the lion from *Kalila wa Dimna*, MS. Ar. 3465, f. 49v, probably Syria, 1200-20. *Paris, Bibliothèque Nationale* (Photo Bibliothèque Nationale)

398 and 399. Abu Zayd before the governor of Merv and scene before a village from al-Hariri, *Maqamat*, MS. Ar. 5847, ff. 26r and 138r, Baghdad, 1237. *Paris, Bibliothèque Nationale* (Photo Bibliothèque Nationale)

INDEX

Bold numbers indicate principal references.
Entries in *italic* may be used as glossary definitions.